Hadrian's Villa and Its Legacy

PUBLISHED WITH THE ASSISTANCE
OF THE GETTY GRANT PROGRAM

Hadrian's Villa

WILLIAM L. MACDONALD AND JOHN A. PINTO

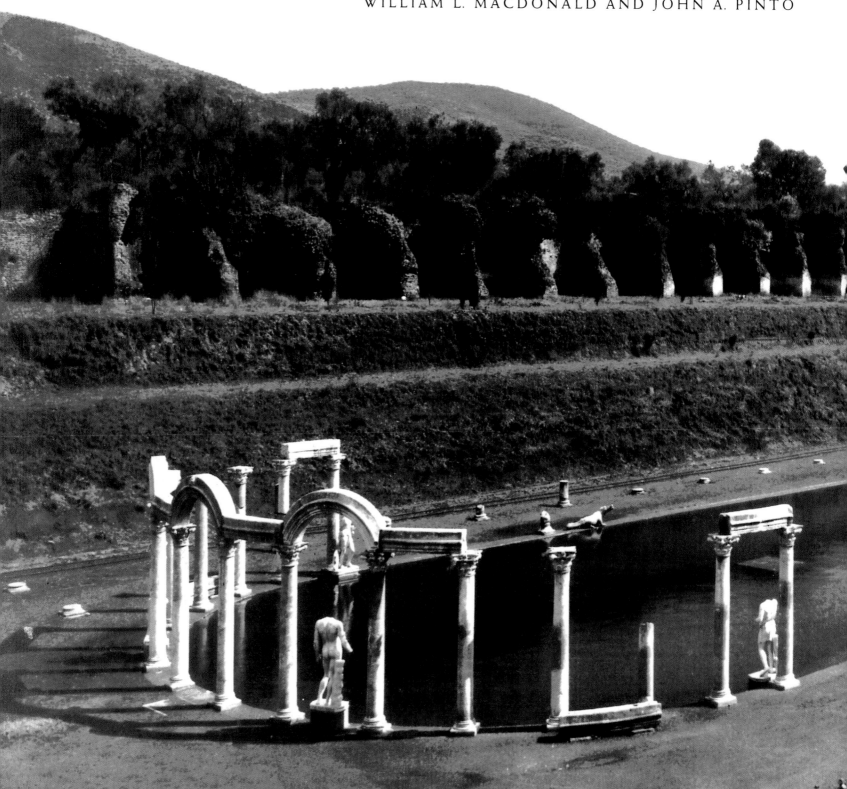

and Its Legacy

YALE UNIVERSITY PRESS NEW HAVEN & LONDON

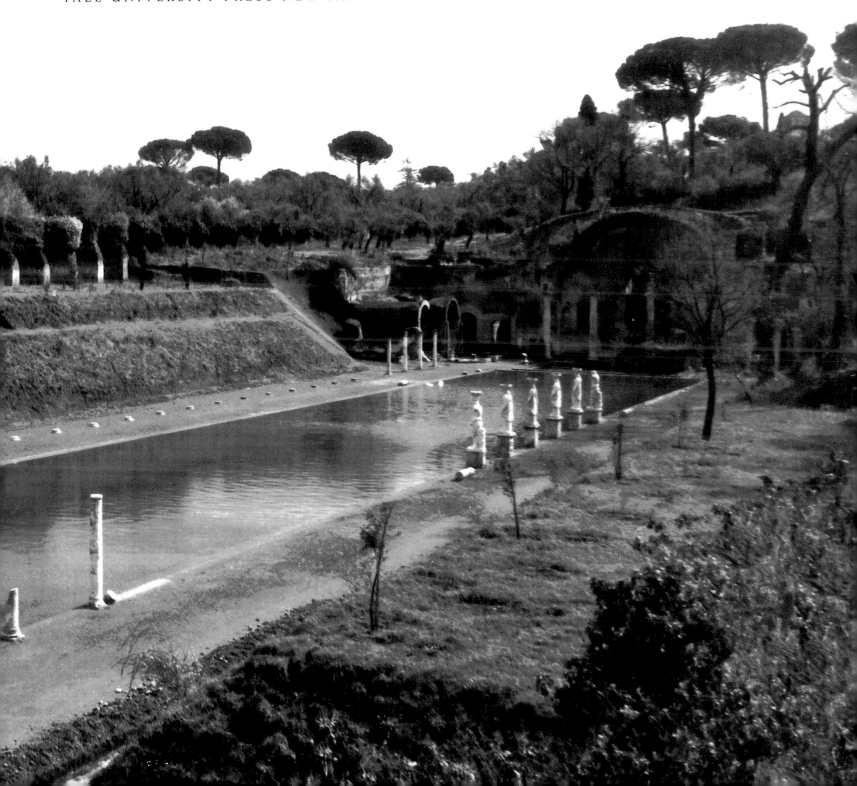

*Title page: Scenic Canal, with
the buttressed Upper Park wall
beyond, looking southeast (1970s)*

Designed by Nancy Ovedovitz. Set in Monotype Fournier type by Tseng
Information Systems. Printed and bound in Singapore.

Library of Congress Cataloging-in-Publication Data
MacDonald, William Lloyd.
Hadrian's villa and its legacy / William L. MacDonald and John A.
Pinto.
 p. cm.
Includes bibliographical references (p.) and index.
ISBN 0-300-05381-9 (cloth)
 0-300-00685-1 (pbk.)
1. Hadrian's Villa (Tivoli, Italy) 2. Hadrian, Emperor of Rome,
76–138—Homes and haunts—Italy—Tivoli. 3. Architecture, Domestic—
Italy—Tivoli—Influence. 4. Architecture—Italy—Tivoli—
Influence. 5. Tivoli (Italy)—Buildings, structures, etc.
I. Pinto, John A. II. Title.
NA327.T5M23 1995
725'.17'09376—dc20 94-28183
 CIP

A catalogue record for this book is available from the British Library.

The paper in this book meets the guidelines for permanence and durability of
the Committee on Production Guidelines for Book Longevity of the Council
on Library Resources.

10 9 8 7 6 5 4 3 2

for Nicholas and James
and in memory of Spiro Kostof

Contents

Acknowledgments

For permission to work at the Villa we are indebted to Maria Luisa Veloccia Rinaldi, Soprintendente ai Beni Archeologici per il Lazio; for cheerful assistance at the site we are grateful to Adriano D'Offizi, Villa caposervizio. Our work was supported by the American Academy in Rome, Dumbarton Oaks, the Getty Center for the Fine Arts and the Humanities, and the Spears Fund of the Princeton Department of Art and Archaeology. To the architect Michael Lawrence, our Decrianus, we owe both thirty-one drawings and many constructive suggestions.

Guy P. R. Métraux read a draft of the entire text, and we have profited greatly from his corrections and suggestions. Others kindly read and commented on chapters and sections: Mary T. Boatwright, Bruce Boucher, Brendan Cassidy, Allan Ceen, David Coffin, Joseph Connors, Sterling Dow, Carolyn Kolb, Ramsay MacMullen, Myra Nan Rosenfeld, and John Wilton-Ely. For topical assistance we thank Herbert Benario (help with the *Historia Augusta*); Herbert Bloch (sound advice); Michael Clark (translations from the German); Martin Kleibrink (communion at the site); Phyllis W. Lehmann (for calling our attention to the late Karl Lehmann's folder of Villa notes); Lucilla Marino (Librarian of the American Academy); Robert Mangurian, Mary-Ann Ray, and George Newburn (discussions at the Villa and in California about their Villa project—measuring

and surveying the entire site); and the architect Euge-
nia Salza Prina Ricotti (conversations about matters
of mutual interest). Help generously given by others
is acknowledged in the notes and illustration credits.
And we recall with pleasure the company, over the
years, of Meg Pinto, Allan Ceen, Frank Brown, Ferdi-
nando Castagnoli, and Norman Neuerburg on the High
Ground and in the Underground Galleries.

The plans and drawings are on the whole only general
guides to the site and its buildings. Dates are A.D. unless
otherwise indicated. Measurements in feet refer to the
Roman unit of 0.296 meters.

Hadrian's Villa and Its Legacy

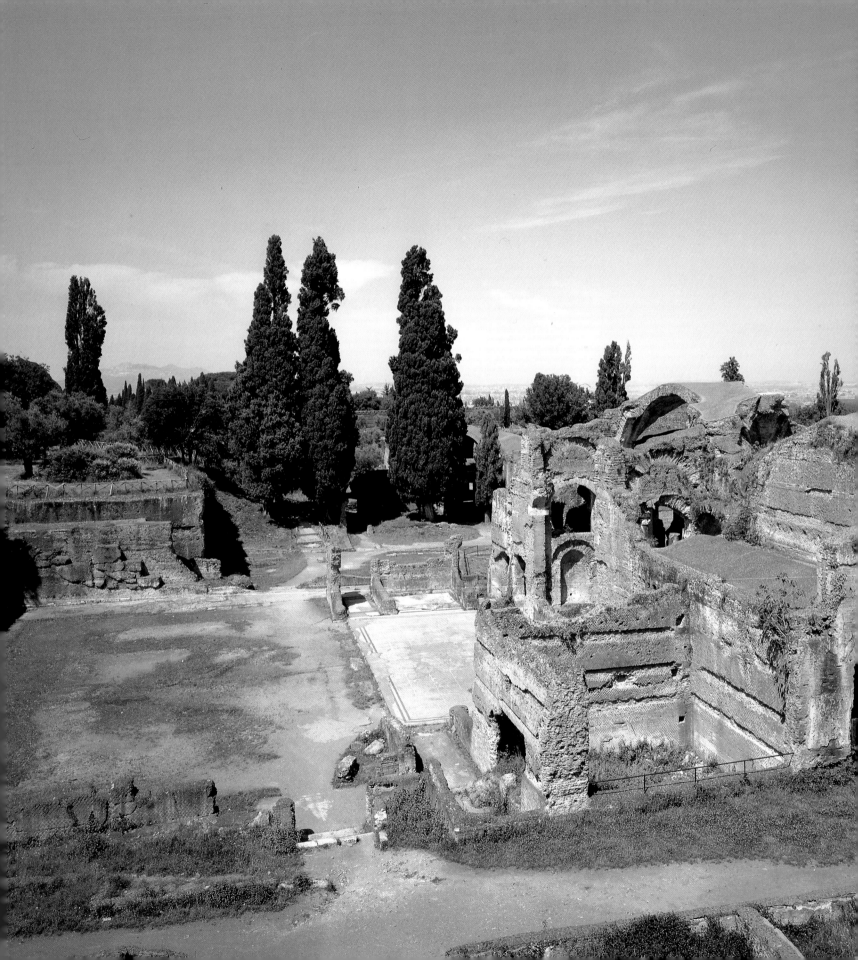

I

Introduction

The army of artists and workmen who early in the second century fashioned the landscape and the scores of buildings of Hadrian's Villa began a chain of artistic events whose measure has yet to be taken. Set among extended terraces on a vast, uneven tract below Tivoli and adorned throughout with fountains, pools, and sculpture, the Villa spread across an area twice that of Pompeii. Because of its novel forms and planning and brilliant visual and allusive invention, it is a major achievement of Western art.

That would be enough to recommend any monument. But ever since the early Renaissance, when architects and scholars began drawing at the site and writing down their impressions of it, imagination has fed on the great field of ruins and on the thought that the design and imagery of Hadrian's Villa may reveal something of the learned, enigmatic emperor's personality and taste. Direct architectural influence began in the sixteenth century. Artists, landscape planners, and writers came in increasing numbers. By the end of the eighteenth century, with a sense established of the site overall, printed descriptions and views of its scenically dilapidated buildings circulated widely, and much Villa sculpture, dug from the ruins, could be seen in Rome and beyond. Architects, scholars, artists, and students continue to draw and study the relics of Hadrian's

1

The rear court and eastern part of the Larger Baths, looking northwest (1987)

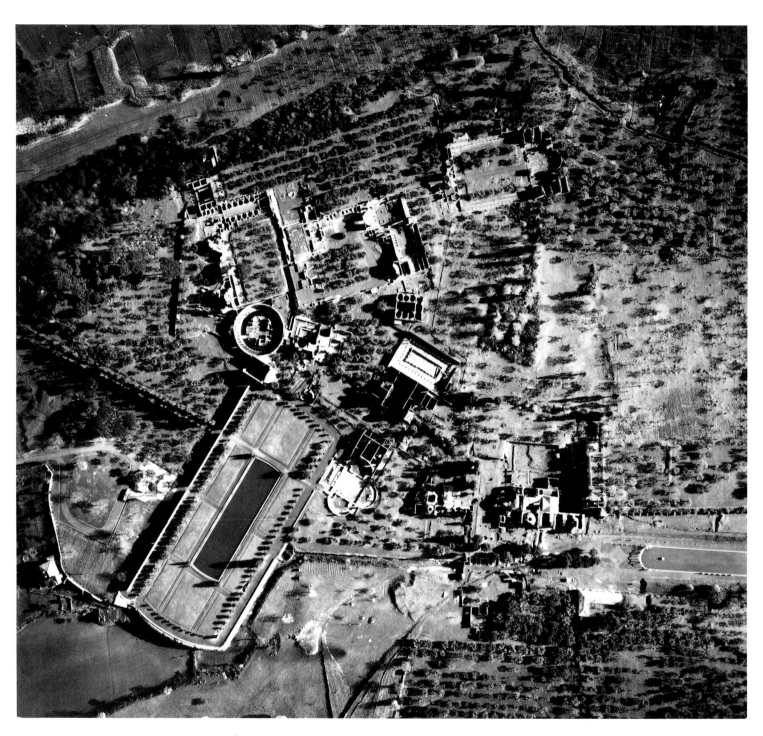

1 *Aerial view of government property; East Valley at the top (1964)*

extraordinary retreat, for its affective and instructive potential remains undiminished.

These artistic and historical values of the Villa are found not only in its tangible remains but also in art and scholarship from the Renaissance to the present day. The Villa is a paradigm of classicism's role in Western art, and its extended history is an unusually full record of the cross-currents and projections visionary creations generate. We have attempted to tell this story, to appraise the Villa as a major monument of Greco-Roman culture and an abiding artistic force in later times. That it was not simply an eccentric compilation, a dead end, is for us a paramount concern. A fresh view has been sought, and in that spirit some traditional building names, inappropriate today, have been abandoned.

ROMAN VILLAS

During the late republic and early empire, not to have large country villas was unthinkable for Romans of wealth and rank. Cicero, who was only fairly well off, had at least eight. By Hadrian's day the Roman countryside and seashore, within what seems to have been for senators the expected residential limit of twenty miles from the capital, was dotted with them. Of the seaside retreats, the best known today is the Laurentine villa of the younger Pliny (probably 61–112), one of Trajan's advisers, a lawyer and senior administrator who reached the consulate in the year 100. After saying in his *Letters* that his neighbors' places below Ostia look like "a number of cities," Pliny describes in detail his own — the source of many later restoration attempts. He also describes his Tuscan villa, near Tifernum (Città di Castello) in the Appenine foothills, and he mentions a third under construction on the shore of Lake Como. As he takes his readers across his gardens and grounds and through chambers and suites, pointing out views and landscaping and commenting on architectural features and functions, Pliny brings the Roman luxury villa into sharp focus.

A proper villa is a place for restful leisure, or *otium,* the opposite of *negotium,* business or non-rest. Some of Pliny's rooms are far removed from any noise, even that of the servants' Saturnalia. Much is made of his villas' settings — of the sea and the mountains, of the seasonal winds and weather — so important to successful planning. Woods, meadows, and views both natural and contrived are essential to the overall effect. Though rural and peaceful, these places are handsomely gotten up; nothing is wanting, and nature has so to speak been organized by gardeners and watermen. Terraces and hedges push out across the terrain. The villas are partly self-sustaining, with farmlands, kitchen gardens, ample firewood, and milk cattle; the Mediterranean offers prawns and sole. The seaside villa has a wineroom and granary; from Tifernum he may ship produce down-Tiber to Rome. Fruit trees, in particular figs and mulberries, are common, and Pliny points out rosemary, violets, roses, acanthus, ivy, laurel, box, plane trees, and cypresses. His extensive topiary, "in a thousand shapes," includes animals, names spelled out in huge letters, and "small goals" (conoidal racetrack features). Box hedges rise in tiers. Jet fountains high and low are common; he has some chairside miniature ones, too. Pergolas, marble benches, pools, waterfalls, and man-made streams are artfully set out across the grounds.

Pliny speaks of "the places I have largely laid out myself or where I have perfected an earlier design." His estates are as representative of his way of life as is the stylish elegance of his letters; his sometimes disingenuous tone doesn't undercut the usefulness of his evidence. He is proud of his waterworks, a Roman passion. He describes, for example, a dining area, or *triclinium,* within the Tifernum villa's "hippodrome," an elaborate garden and strolling-ground of hairpin plan like a stadium for foot races (one had been built on the Palatine for Domitian in the 90s). Pliny's is lined with trees and shrubs, and

at the upper end [of it] is a curved dining couch [*stibadium*] of white marble, shaded by a vine trained over four small cipollino columns [gray-green veining]. From under the couch water gushes forth as if pressed out by the weight of those reclining there; it is caught in a stone tank and then passed to a finely worked marble basin, regulated by a hidden device

and thus kept from overflowing. The hors d'oeuvres and main dishes are placed round the basin's edge, but lighter offerings float about in bird-shaped boats. A fountain opposite plays high into the air and then falls back into its pool.

A fair sample of such devices, this elaborate conceit is reflected in remains at Sperlonga, Pompeii, and Hadrian's Villa.

Both of Pliny's villas have many rooms. Of varied shapes, they are arranged in asymmetrical overall plans. Missing is the imposing presence of a Renaissance villa's grand central block, layered horizontally according to rank and function. Most indoor activity takes place on the ground floor, though here and there rooms are found higher up, places where one may take in the view or perhaps dine, according to the weather. Pliny's flowing plans link areas for specific purposes, suites for reception, dining, bathing, reading, and working. Each has its service features alongside—kitchens and servants' quarters, furnaces and storage areas. Planning of this kind implies numerous secondary foyers and passageways, as well as many smaller spaces, such as the pantries and linen closets all large households require. Courtyards, some with curved plans, provide light and air and space for internal gardens. Secluded satellite features are reached by way of colonnades or arcades, or by covered cryptoporticoes set beside extended terrace walls but open to the view through windows opposite.

At the seaside the library has a curving wall of windows that "lets in the sun as it moves round and shines in each window in turn." The baths have duplicate half-round cold plunges set opposite each other across a central chamber open to both. A heated pool with a sea view has hot plunges and rooms for sweating and oiling nearby. The Tifernum villa has a large outdoor swimming pool as well as the standard indoor one. In addition to the baths' heated rooms and plunges, some bedrooms—and a detached seaside suite—are warmed the usual Roman way by circulating heated air between double floors and up through wall flues. Even the servants' and slaves' rooms are "mostly" presentable, suitable for guests, while one fine bedroom is finished in white marble.

The indigenous core of luxury villas was the traditional Roman farm, an architecturally unpretentious place worked by aristocrats and commoners alike. That of Scipio Africanus, who at the end of the third century B.C. had conquered Spain and defeated Hannibal, was seen centuries later in Nero's time by Seneca, who found it mean and dark. Seneca pictures Scipio working the soil with his own hands, and his description of plain workaday buildings rings true. But as with so many Roman traditions, Scipio's way of life disappeared in the flood of changes that followed Rome's conquests, particularly of the Hellenized east, in the second century B.C.

The literature, art, and learning fostered in such sophisticated capitals as Pergamon and Alexandria and, in due time, in a revitalized Athens, profoundly and permanently altered Roman culture. Vitruvius's learning and standards, the rage for Greek art, and the ascendancy of Greek thought in numerous subjects are examples of this. Plain farms would no longer do for men of affairs. Cicero's father, for instance, transformed his farm into a place for study. The luxurious appointments of town mansions were equally necessary in the country. Slaves and great wealth flowed from conquest and exploitation, and country estates took on something of the brilliance and prestige of Hellenistic palaces. The Roman magnate now could point to his Painted Stoa (Poecile) or his Academy, though he need not be concerned with precise resemblances to the originals in Athens. He might have a garden stadium like Pliny's, a fancy derived ultimately from running tracks adjoining Greek gymnasia. He could have a Nile, or at least a canal (*euripus*), and would hardly fail to possess one or more grottoes, dark semi-caves for the nymphs, with ferns and water dripping from roughened stones. Thus he connected himself, however tenuously, with learning and high culture.

Masterpieces of art were eagerly acquired and sometimes specially housed (Augustus's lieutenant Agrippa proposed unsuccessfully that great works be made public property). Gifted artists and craftsmen flocked to Rome. There were architects, gardeners, watermen, painters, sculptors, and mosaicists, as well as specialists in stucco, wood (cabinetry, inlay, marquetry), bronze,

silver, gold (solid and leaf), gems and cameo stones, glass, textiles, terra-cotta, and ivory. Cicero ranks architecture with law and medicine among the professions. Tomb inscriptions and casual literary references show that architects might be household staff members; we hear of shortages. Builders and an architect are found with Marcus Cornelius Fronto (about 95–167), tutor and friend of Marcus Aurelius, as he converses with learned and high-born friends.

By his side stood several builders, who had been summoned to construct new baths for him and were showing him different designs drawn on pieces of parchment. When he had selected one . . . he asked about the cost of the completed project. And when the architect said it would require about three hundred thousand sesterces, one of Fronto's friends said, "And another fifty thousand, more or less."

Such an architect had in train master carpenters, hydraulic and heating experts, glaziers, plumbers, master masons. Whatever his homeland, his bath architecture would be Roman, not Greek, making much of spatial effects and surface decoration, with any columns or other design elements of Greek origin assigned to largely secondary roles. He could, however, design in the Greek manner on demand and produce, for example, a round Greek temple like that at Hadrian's Villa.

These specialists and craftsmen gave form to their patrons' need for the historical and literary conceits essential to luxury villas. They constructed places of ostentatious, conspicuous seclusion where the owner and his friends strolled and dined and discussed learned questions in contrived, allusive landscapes. Petronius's vivid send-up, in the *Satyricon*, of a rich parvenu's evening preserves the essentials: relative rank and wealth (the patron and those receiving his bounty), the banquet, the discussion of defined subjects—here, Trimalchio's grandly vulgar tomb and its inscription (to include "he never listened to a philosopher"). His house has villa pretensions with its three libraries, four dining rooms, marble portico, large-scale wall paintings, and twenty-odd bedrooms.

From the physical extent of great villas and their domestic rituals arose a formidable complexity. But that did not produce standardization or mindless repe-

tition, for patrons required of their architects and artists individualized realizations and elaborations of the basic theme: a dwelling with peristyles and reception halls, some pavilions, extensive gardens, waterworks, and fine views, as well as the necessary support structures. Archaeological evidence for wide variety in planning is convincing. In the later republic and early empire, many changes had been rung on basic villa types such as those extended laterally and screened by facade colonnades or those raised on large platforms flanked in part by vaulted cryptoporticoes. In the high imperial age, grand luxury villas with numerous detached structures set out in extensive grounds often appear irrationally planned.

Roman poets refer frequently to these retreats; villa life loomed large. Vitruvius aside, no technical writing has survived. Villas were favorite subjects for painters and mosaicists, and splendid stucco depictions of a pavilioned garden landscape are preserved in the Terme Museum in Rome. Excavations record luxury villa development in considerable detail. At Salpi, halfway between Barletta and Manfredonia, for example, remains of a villa of about 200 B.C. have been found, with peristyles set laterally on either side of an atrium house of the familiar Pompeian type. Presumably recording early Hellenistic influence in southeastern Italy, the three elements were arranged in line along what was then the shore of Lago di Salpi. Secondary buildings adjoin this core, and a cistern stood nearby. The concept of the luxurious retreat was steadily elaborated, and by Augustus's time such places were common features of the Italian landscape.

The Julio-Claudians built many villas, sometimes on the sites of earlier, lesser establishments, often in dramatic settings. At Capri, where both Augustus and Tiberius erected rather compact villas atop the cliffs, a dozen imperial residences eventually arose. Nero had a seaside villa at Anzio, his birthplace. At Subiaco his innovative architects set out pavilions, fountains, and terraced gardens on both sides of narrow artificial lakes formed by damming the Aniene where it flows through a gorge on its way to Tivoli and the Tiber. Nero's immense palace-estate in Rome, the Domus Aurea, was

in effect a huge villa in the city—*rus in urbe,* as Martial says, a place of imitation rusticity. Suetonius says that it included "a pond like the sea [where the Colosseum now stands] surrounded with buildings to represent cities, besides tracts of country . . . [with] fields, vineyards, pastures, and woods." Scattered through a private park opened up in part by the Great Fire of 64, the Domus Aurea covered much of the Palatine, Caelian, and Oppian hills and the valleys in between.

By then the luxury villa was in some degree a laboratory for architectural and artistic experiment, and therein lies much of its historical significance. Wealth, ample space and water in the country, and the presence of reliable, sometimes splendid, artistic talent made experiment not only possible but welcomed by aristocrats and wealthy upstarts. City mansions, though luxurious, stood mostly on expensive, circumscribed plots lacking the space for required displays of wealth and status, for villas were social statements as much as country retreats. Yet urban amenities could not be abandoned, and by the end of the first century sprawling places like Pliny's, with banquet halls, baths, libraries, and extensive gardens, were common.

Domitian's Albano villa straddled the scenic ridge between Lake Albano and the downward slope leading westward to the Tyrrhenian shore, and Trajan built a see 124 rural retreat outside Civitavecchia that Pliny calls "a beautiful villa overlooking the sea, surrounded by the greenest of fields"; remains of both exist. When Hadrian succeeded Trajan in 117, scores of grand villas stood in the hills east and southeast of Rome and along the seashore above and below the Tiber mouth. The Bay of Naples was particularly popular. Away from these favored areas were many other villas, such as Pliny's at Tifernum and Lake Como, often developed from an ancient nucleus, the family farm. Elsewhere, the central cores of huge agricultural establishments increasingly resembled the luxury villas of Roman grandees.

Hadrian naturally followed suit. He would have done so even without his passion for architecture and art. Remains of one of his villas survive at Palestrina on nearly level ground below the great Sanctuary of Fortune. In Rome, within the Sallustian Gardens, a large imperial estate, Hadrian built at the head of the rising draw between the Pincian and Quirinal hills a domed rotunda, flanked by multistoried structures, opening to the view southwest down the valley, all in the grand villa manner and in part still standing. At Tivoli (the Roman Tibur) work started on the great Villa in 118 where a comparatively modest earlier establishment stood; by the mid-130s construction had all but ceased.

THE EVIDENCE

Ancient written references to Hadrian's Villa are few. Inscriptions record the presence there of minor functionaries. And at Delphi other inscriptions preserve portions of letters from Hadrian, one of them sent there from Tivoli—that is, from the Villa—in the late summer of 125; it deals with disputes between Delphi and the Amphictyonic League. A dedicatory inscription to Hadrian, of December 135, recording the thanks of southwestern Spanish municipalities for benefits received, was found in Tivoli; the grants would have been issued from the Villa, where the stone almost certainly stood originally (Villa marbles were taken up to Tivoli in great quantity over the centuries). These scattered data record state business at the Villa and suggest that the emperor was in residence there in August–September 125 and perhaps in December 135. The dates are consistent with the approximate chronology, thus far established, of his long travels in the provinces—between 121 and the summer of 125, and again between the summer of 128 and 132 (exact dates and the details of his itineraries remain mostly elusive).

Four references to the Villa survive in Roman literature. Three are in the *Historia Augusta* (HA), vexatious imperial biographies covering, with some third-century omissions, the period from 117 through 284, that is, from Hadrian's accession to that of Diocletian. These were written by a single, often mendacious late fourth-century author who used earlier sources indiscriminately. The first two Villa references are found in what purports to be Hadrian's biography. In one passage Hadrian is said to have had a severe illness, toward the end of his life, while at the Villa (in Villa Tiburtina).

Then, a little further on, are two sentences central to the Villa's story:

[Hadrian] fashioned the Tiburtine Villa marvelously, in such a way that he might inscribe there the names of provinces and places most famous and could call [certain parts], for instance, the Lyceum, the Academy, the Prytaneum, Canopus, the Poecile, the [Vale of] Tempe. And, in order to omit nothing, he even made an underworld.

Tiburtam Villam mire exaedificavit, ita ut in ea et provinciarum et locorum celeberrima nomina inscriberet, velut Lyceum, Academian, Prytaneum, Canopum, Poicilen, Tempe vocaret. Et, ut nihil praetermitteret, etiam inferos finxit.

Though Hadrian's travels aren't mentioned, they naturally come to mind, and it is often said that Hadrian reproduced famous buildings at the Villa or that he recorded there his travels by less realistic yet effective means, though these are almost never defined. Lyceum, Poecile, and Academy reflect the traditional villa nomenclature of allusion, mentioned above, which is expanded by adding the provinces and Canopus. The four Athenian locales are fairly well understood today, and the Thessalian Vale of Tempe is much as it was in Hadrian's time. The Prytaneum (council house) seems a bit out of place, with respect to the tradition, but not as much so as Canopus, of which only a few stones remain (the notorious canal, leading to Canopus from Alexandria, has vanished completely). The inclusion of the provinces is striking. How might they have been represented, if indeed representation was sought? In short, the passage revealingly combines customary usage with specifically High Empire subjects (the provinces) and a Ptolemaic creation well known to the Romans.

Of the six names, four remain in use and one (Lyceum) maintains a shaky hold on the ambulatory of the Southernmost Ruins; only Prytaneum has perished. The Park Grotto and Underground Galleries induce thoughts of the netherworld (animated also by an extended network of subterranean corridors). Sixteenth-century antiquarians, stimulated by the HA and allusive names found in earlier texts, enthusiastically but uncritically labeled a score of Villa structures, for example the Temple of Apollo, Plutonium, Serapeum, and Prae-

torium; many others are recorded in five centuries of Villa literature, few of them based on architectural evidence. Still, the East Valley makes a plausible Vale of Tempe, particularly when seen from the East Belvedere, though it hardly equals the scale and drama of the Thessalian original. And a majority holds that the Scenic Canal is Hadrian's Tiburtine Canopus, which may be, but it is both more than that and far removed, in appearance, from the original canal running east from Alexandria. That association, made so long ago, quickly led to the name Serapeum for the Scenic Triclinium because of Strabo's description (written in Augustus's time) of Canopus and its monuments, one a major temple of Serapis. More is said on the subject of traditional Villa names in our chapters on architecture.

The third HA reference to the Villa is in the biography of the Palmyrene queen Zenobia, who after her defeat by the emperor Aurelian came to Rome and lived, from 273 onward, on an estate at Tibur not far from the Villa ("non longe ab Hadriani palatio"). And the fourth literary notice appears in Aurelius Victor's *De Caesaribus* (*Lives of the Caesars*), brief popular sketches of the emperors from Augustus to Constantius II, written in the 360s. Hadrian rates barely a page, but life at the Villa is not neglected.

Then, as was his custom during periods of tranquility, Hadrian withdrew rather too negligently into the country near Tibur, turning the city over to Lucius Aelius Caesar. Following the usual custom of men fortunate enough to be wealthy, the emperor built palaces [*palatia*] there and devoted himself to banquets and to collecting statues and paintings; in the end, not without some misgivings, he provided there everything that was luxurious and lascivious. As a result, malicious rumors arose.

Reports follow of Hadrian's purported homosexuality and the new city and many statues he dedicated to his favorite, Antinous, who drowned in the Nile in October 130. Fact and abiding gossip are entwined as in the HA and sensational tales emphasized; we are told, for example, that Hadrian gave orders "to kill most of the Senate for making sport of their emperor."

The inscriptions, the reference in the HA to Hadrian's illness, and Aurelius Victor's sentence about banquets

and art relate directly to Villa life and fit modern knowledge of the government machinery and of the Villa's treasury of art and its banquet halls. Both the HA passage about Zenobia and Aurelius Victor's phrases show that in the later fourth century the Villa had not been forgotten but that by then palace had replaced villa as an acceptable descriptive term.

Important sources have been lost. Fragments of the emperor's autobiography surface a few times in the HA; other biographers have left identifiable traces there. Early in the third century Marius Maximus, a senator and ranking civil servant, included a scurrilous life of Hadrian in his series of imperial biographies (claiming, like the HA, to continue Suetonius's *Lives of the Caesars,* which end with Domitian's death in 96). None of these later works survives independently, but all were used by the HA's artful but anonymous compiler (who assumes six different names; as Hadrian's putative biographer he is a bogus "Aelius Spartianus"). The source for his striking passage about naming parts of the Villa after provinces and places, which raises potent questions, remains unknown. Thus the only ancient comment we have on the basis for the Villa's design, a comment whose enduring influence on perceptions of the Villa began in the early Renaissance, is undatable and unattributable. Naturally the passage continues to be discussed. But other perceptions of the Villa's meaning are suggested by archaeological and artistic evidence and instructive comparisons.

Written evidence of an indirect kind is preserved within the ruins. Some bricks in each of the many huge lots produced in the brickyards in and near Rome were stamped before firing—while wet and impressionable—with information about the bricks' origins in abbreviated form. The practice began in Julio-Claudian times, reached its zenith in Hadrian's day, declined thereafter, and was abandoned in the early fourth century. Brickstamp studies are highly technical; we simplify. Most stamps have now been dated and arranged in chronological order, a process based chiefly on the frequent inclusion in the stamps, from Trajan's time onward, of the names of the consuls in office when the bricks were made, and on comparative analyses of the names and marks of various estate brickyards, their owners, and master potters.

It follows that if a stamped brick is found in an undisturbed mortared structure, the contiguous building fabric cannot have been built before the date the stamp records. In theory, then, it is possible to date such structures fairly securely; other deductions can follow. But there are problems—for example, stamping may sometimes have continued beyond the dates the stamps reveal. How long bricks cured in the yards is not certain—two to four years, perhaps—and storage times, which must have varied, are unknown. Repairs, alterations, the removal of stamped bricks for preservation and study, and the order in which lots were used at the site may perhaps undermine the logic of the basic premise. Still, much has been accomplished. More than eight hundred Villa stamps were analyzed in the pioneering modern work on brickstamps, wherein Hadrianic buildings take up half the text. The most common date at the Villa is 123—a very big year for the Roman brick industry, expanded and perhaps reorganized for Hadrian's vast projects—with 124 a distant second. Other dates range from a few pre-Hadrianic examples, through stamps from years of his reign other than 123 and 124, to a very few Antonine stamps and some from the early fourth century. Discussion of this material, now augmented, continues. Two or three Villa buildings have been quite closely dated, with stamps and structural evidence, taken together, revealing phases of construction and alterations. Other criteria exist for dating, but if Villa structures as yet largely unexplored eventually become available for study, brickstamp experts may perhaps establish much of the original construction sequence across the entire site.

In contrast to the lack of written evidence, the ruins are abundant, though only part of the site has been cleared and just a small fraction excavated. The buildings are almost always incomplete and many are fragmentary; a few recorded in the past have disappeared. Now and then only wall lines can be seen, as at the eastern end of the Central Vestibule, flush with ground level. Standing ruins, restoration aside, are structural cores only, with very few exceptions shorn long ago

2 *Central Service Building, brickstamp of 123 (1987)*

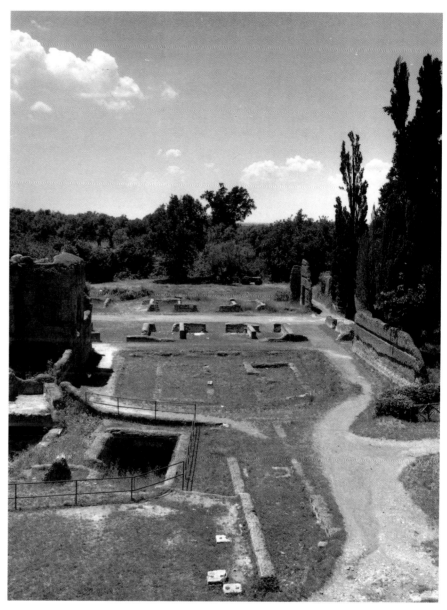

of facings and decor inside and out. Some structures, such as the Scenic Triclinium, the Service Quarters, and the cryptoporticoes, are reasonably complete, and enclosed rooms, vaulted over, are fairly common, as at the Heliocaminus and Smaller Baths and the West Belvedere. The subterranean corridors and passageways, often blocked by fallen vaults and accumulated debris, are inaccessible but for one or two stretches under the East Terraces and alongside the Water Court.

Since excavation and clearing expose structural fabric originally enclosed, staff masons regularly replace losses to weather and decay: the tops of fragmentary walls and outer surfaces of ancient vaults, for example, must be protected. Architectural restoration, in contrast, consists of re-erecting fallen columns (as at the Island Enclosure) and vaults (the Larger Baths), or rebuilding and refacing elaborate walls (portions of the Water Court interior perimeter). Most of the columns now standing were erected after 1870, when the state purchased the part of the Villa that includes the area now open to visitors; in at least one instance, modern columnar restoration was later dismantled (in the Water Court southeastern rooms). In May and June 1944 bombs and shells fell on the Villa, damaging several areas moderately (the Ambulatory Wall, the Water

3 *Central Vestibule and its eastern extension, looking west (1987)*

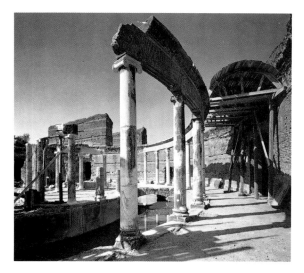

4 *Island Enclosure, restoration in progress (ca. 1955)*

Court) and the east end of the Central Service Building severely; repairs were effected gradually in the late 1940s. Thus the Villa's appearance changes.

Of state-owned properties Hadrian's Villa ranks fourth in the number of visitors it attracts, after Pompeii, the Villa d'Este, and the Uffizi; in 1986 over half a million came. So it has been necessary, in addition to carrying out structural repairs, to make the buildings both safe and selectively accessible, with suitable approach routes and entrances marked out (a son et lumière installation placed beside the Scenic Canal in the early 1960s was short-lived, as were camping facilities built in the Upper Park). The result is that original relations among the buildings and the roles of secondary spaces and features can be difficult to perceive, and this difficulty is compounded by the lack of inter-building excavation. The colonnades and garden paths are gone, as are many original stairs and ramps, and some terrace boundaries are now unreadable, with the result that many buildings appear to stand alone, un-related to their neighbors and set out at random, sug-gesting a planless disorder. The public areas are mown and trimmed, part by part, according to the seasons, but the rest of the Villa, not open to visitors, is farmed or has grown wild. Some ruins are completely overgrown, while others support later buildings (the Casino Fede,

for example, or those among the Northern Ruins). In compensation, splendid cypresses, oaks, beeches, horn-beams, and olive trees adorn the site, and the ample basins of the East-West Terrace, Peristyle Pool Build-ing, and Scenic Canal have been restored and filled. Flowering shrubs, some set where columns once stood, border the huge East-West Terrace, now the Villa's open, spacious vestibule.

Of the decorative arts employed at the Villa, stucco is the most fragile, easily dislodged from vaults and walls; a few square meters survive in the Larger Baths and the Northern Ruins and below the Doric Temple, and other work is recorded in drawings and prints made in the past. Almost all surviving vault painting is nonfigural and geometrically patterned (in the Scenic Triclinium west corridor or the Smaller Baths entrance passage, for example). Wall painting of two periods, one over the other, survives in a Garden Stadium north room and on a Central Service Building wall next to the Larger Baths; these also are based on geometric figures, with the addi-tion of painted marble veining. Instructive remains of stucco and painted plaster are displayed in the Museo Didattico (installed in the eighteenth-century casino Michilli beside the parking lot). Floor mosaics, some protectively covered, are common though usually frag-mentary; those in the Hall of the Cubicles are largely intact. Figural, pastoral, and animal scenes in mosaic, lifted long ago, are scattered among several museums, and vault mosaics both pre-Hadrianic (in the Residence Cryptoportico) and Hadrianic (in the Scenic Triclinium and Smaller Baths) are known.

Restored marble pavements adorn several rooms, as in the Arcaded Triclinium; bits of marble wall facing are still in place at pavement level here and there. Mor-tar setting beds preserve numerous wall and pavement patterns even though the marblework has vanished. Architectural marbles (columns, capitals, moldings, en-tablatures, and so on), prized by lime burners or carried off to Tivoli or Rome, have largely disappeared, and what can be seen today is only a very small frac-tion of what once existed; small finds are exhibited in the Museo Didattico. But because Hadrianic decorative art and architectural sculpture survives elsewhere, the

original appearance of Villa buildings and their surfaces is not entirely beyond recall.

Some sculpture survives at the site and more can be seen in museums in Rome and elsewhere; losses, presumably large, are incalculable. Find spots, when recorded, are not necessarily the original ones because vandals and lime burners toppled and moved pieces at will. Scores of statues and fragments and architectural marbles were cast, at some unknown time, into the Bog; few even of the original positions of the Scenic Canal finds of the 1950s can be located precisely. The study of all this sculpture, so diverse in style and subject, involves thorny problems of its programmatic role at the Villa, difficulties central to the evolving interpretation of imperial art and of Hadrianic art in particular. Was the emperor an eclectic collector or did this variety have its own common purpose? Can Hadrian's personality and interests be persuasively connected with the taste and predilections the surviving sculpture apparently records? Such questions resemble those evoked by the design and effects of unusual Villa buildings, which also point to the central question asked of the Villa: what was Hadrian trying to do, to say? In considering these matters, nonfigural sculpture should not be forgotten — the pilasters, small friezes and garlands, vases, candelabra, and miniature architectural elements, some of which are housed in the Museo Didattico.

The final ancient source is the terrain, which has much to tell. Its configurations aid in the interpretation of the position and function of certain buildings, and the terracing, carried out on a vast scale, records planning principles and decisions about the advantages and disadvantages inherent in the natural contours. Chines and draws were reshaped in part, and massive earth engineering is documented by the high buttressed walls of the Upper Park and West Terrace and the massive, many-chambered concrete support system for the leveled reaches of the East-West and Angled Terraces; the sanctuary at Palestrina and the Markets of Trajan come to mind. Nature was reorganized to effect an artificial naturalness, strengthen the sense of relative heights, and fix viewing points and suitably oriented pavilions upon broad, solidly based horizons. And so

these features and the spatial and line-of-sight connections among them were often determined by the terrain's natural features, however much they were recontoured — all as typically Roman as the practical use of the East-West and Angled Terrace substructures as Service Quarters.

Although the Villa has urban features, any overall or conceptual connections with towns and cities seem tenuous, and not just because of its unusual plan and lack both of internal streets and of the ubiquitous Roman urban buildings (honorific arches, markets, senate houses, various cult structures, municipal basilicas). In an actual Roman town most surviving structures readily reveal their functions, but only about a quarter of the sixty-odd buildings we know of at the Villa do this — the baths, theatres, scenic fountains, Garden Stadium, Library, and Doric Temple (restored) that together record the powerful extramural thrust of Roman urban design. Other Villa buildings resist classification because of either their unusual design or their ruinous condition or inaccessibility, though the two Belvederes and two or three elaborate banquet halls seem properly identified.

It is upon this unique architectural diversity, which includes buildings lying well outside the familiar Roman typology, that the identification of the site as Hadrian's Villa ultimately rests. The connection with the celebrated HA passage was made as early as 1461, when Pius II and his companion, the antiquarian Flavio Biondo, visited the ruins after a pastoral trip to Tivoli.

5 *Museo Didattico, marble fountain(?) in the form of a stadium (1992)*

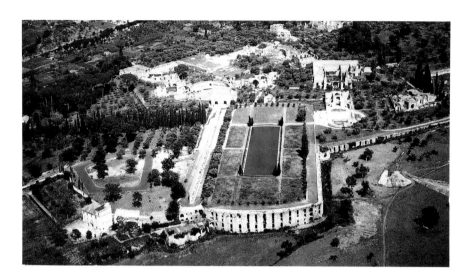

6 *Aerial view across the East-West Terrace, looking east (1964)*

ture and its programmatic content, surface decoration, dating refinements, the site's perimeter, and the extensive underground passageways. Detailed studies of a few individual buildings have been published. Knowledge is accumulating about the numerous invaluable graphic records made on the site by architects and artists—the first whose work has been preserved was apparently Francesco di Giorgio Martini in the late fifteenth century—and about the destructive treasure-seekers and collectors who ransacked the Villa for so long. Topical studies and sporadic excavation continue.

HADRIAN

The best known view of the emperor is Marguerite Yourcenar's, in her *Mémoires d'Hadrien* (1951); the book is splendid fiction, of which Mary Renault said that it "arguably deserved the Nobel." Sensitive, deeply felt, it imaginatively constructs the character and concerns of the all-ruler whose intelligence and self-awareness are edged with cynicism and weariness and sometimes suppressed by a streak of barbarism. Not a word of conversation is quoted. Addressed to the young Marcus Aurelius, the book reads as an extended rumination on the human predicament illuminated by a Mediterranean light and propelled by a meditative curiosity. The protean empire is at Hadrian's fingertips. Because of its historical detail, the novel suggests a work of scholarship; a bibliographical appendix gives the author's view of Hadrianic studies at mid-century. That her story is "not devoid of a few errors," as Yourcenar says of her portrait of Antinous, is natural, for nearly every aspect of life and art in Hadrian's day is contemplated, including the ambiguous nature of emperorship.

They recognized that what they saw was not Tivoli Vecchia, as it had been called, but the great imperial Villa. Their discovery was soon confirmed by the recovery of corroborative sculpture and by scholarly study sparked also by the publication, in 1475, of the HA at Milan.

Serious exploration of the site was begun by Pirro Ligorio (1513–1583), one of whose manuscript descriptions was published in 1668 in a version edited by Francesco Contini, together with a large-scale map. In 1751 there appeared another edition, with a smaller map (hereafter Ligorio-Contini). In these works, as in the great annotated plan of the Villa by Giovanni Battista Piranesi (1720–1778), finished by his son Francesco and published by him in 1781, building and area names are from today's perspective sometimes fanciful and the commentaries inventive. But Piranesi's plan is a work of genius, the watershed study of the Villa. It remains the best site plan in spite of errors and the inclusion of far southern structures not part of the Villa, and it records data otherwise unknown.

Modern study began with Hermann Winnefeld's monograph of 1895. The current, accelerated phase can be traced to the quickened interest in Roman architecture and art of the 1920s and 1930s reflected in Heinz Kähler's book of 1950. Since then, topical works have focused on such vexing problems as Villa sculp-

Her objective is not that of the professional historian (she accepts the HA "biography" uncritically) but that of a philosopher of character concerned to draw a compelling picture of the dominant figure of an age. She worked on the book, off and on, for nearly thirty years, looking at what Hadrian looked at and spending time at the Villa. To some degree the result is a self-portrait, an inspired removal to the second century of a remarkable twentieth-century mind. Good on Hadrian's

philhellenism and his concern for urban well-being, she is less successful with the Villa, which she mislocates. She has Hadrian call it "the tomb of my travels, the last encampment of the nomad, the equivalent, though in marble, of the tents and pavilions of the princes of Asia."

Until the last pages of the book, which takes the form of a letter, Hadrian writes from the Villa, where he "holds audience with his memories." There he instructs his artists and makes sure the right materials are used for sculpture and paneling. He appraises color in art and the power of stone to express strength and mood. The buildings are a mixture of fact and fancy—audience halls, the Island Enclosure, an observatory, and Egyptian chapels, for example. Masons, sculptors, mosaicists, secretaries, and household staff appear. Hadrian recalls musical concerts and banquets and describes performances in the Villa's theatres; little is said of the waterworks to which Eleanor Clark, in her lively essay, responds so perceptively. This treatment of the Villa reflects the way the book is constructed throughout. To a base of known facts inventive but not always plausible additions are made, and upon that serviceable foundation the author's impressive vision is constructed in a "style . . . uniform and enchanting." But her descriptions of Hadrian's temperament and thoughts are largely inventions—intriguing but unverifiable.

The *Mémoires* are not alone in this. Other writing, including that of some scholars, is just as inventive though never as elegant. This is partly because the vivid life in the HA, "a peculiar and repellent amalgam . . . [a] torment," is difficult to resist, though its truths can be hard to identify. What it and other ancient texts seem to promise, sober analysis must often question. In the HA and elsewhere, mistakes from ignorance and the arbitrary use of excerpts from earlier writers are common. The desire to entertain and a long tradition in ancient historical writing of making up ostensibly instructive situations and speeches compound the difficulties these sources generate. A strong bias against emperors usually colors the writings of senators. Denigration or slander of Hadrian makes another emperor or the writer himself (and his class) look the better, a

familiar device found throughout Roman case-pleading and panegyrics. So what may look like promising material for a study of Hadrian the man—in Fronto and Cassius Dio (both senators), in the HA, and in scattered information elsewhere—can rarely be taken at face value.

Facts about Hadrian's reign and public career are more reliably documented; these sources may be refractory, but they are mostly more specific than the literary ones. Specialists who study and interpret inscriptions, coins, papyruses, the legal system, the administrative machinery, and the careers of imperial officials continue to fit parts of the puzzle together as technical procedures are refined and new information surfaces. An immense amount of archaeological evidence for construction across the empire in Hadrian's time is reported in widely scattered publications; studies of Hadrianic art are more accessible. But the scarcity of reliable information about Hadrian's life and personal qualities, and the formidable problems of interpreting what there is (which naturally lead to disagreements), suggest that an accurately filled-out, critical biography, if one is possible at all, will be a long time in coming.

This predicament affects Villa studies, in particular issues raised by long-lived, much-discussed questions. Was Hadrian directly involved in planning the Villa and in creating its visual effects? If he was, in what ways and to what extent? Was he an architect, as some claim? Another question often follows, one stimulated by the fragmentary and contradictory nature of the ancient testimony: if Hadrian was involved, if he did prepare designs, what if anything do the results reveal about his interests and personality? Although the sources don't answer these questions, they do supply glimpses of the man and materials for a broad outline of the kind of life he led. The following sketch is neither gospel nor guesswork; if it isn't exactly right, neither is it based on swallowing the ancient sources whole. Our object is to give some sense of Hadrian's circumstances and interests before turning to a discussion of the forms and artistic character of his Villa.

Hadrian (Publius Aelius Hadrianus) was born, probably in Rome, on 24 January of the year 76, the seventh

of Vespasian's reign, into a prominent family originally from Italy but long settled in Italica, near Seville; he had a sister, Domitia Paulina. He was the son of a cousin of Trajan's, whose grandniece Sabina he married in 100, perhaps at the empress Plotina's urging. Sabina, the daughter of Lucius Vibius Sabinus and Matidia (Trajan's sister's daughter), was born in 88 (perhaps 87) and died in 136 or 137. Hadrian insisted on the deference due her and she traveled with him, and although little else is known about their relationship, rumor said the marriage was unhappy; they had no children. Much later it was suggested that she had refused to have his child and that he had poisoned her.

Well educated, fluent in Greek, a seasoned soldier and administrator, Hadrian became emperor at Antioch on 11 August 117, early in his forty-second year. He outlived Sabina and died on 10 July 138 at Baiae, on the west shore of the Bay of Naples, having reigned almost twenty-one years. He may have been influenced by Epicurean as well as by Stoic thought; the empress Plotina, his friend and patroness, who outlived Trajan, was connected with the Epicurean community at Athens. One of Hadrian's secretaries—learned, very senior officials—was a philosopher, Avidius Heliodorus, probably an Epicurean, later governor of Egypt. Hadrian chose other exceptional men for the highest posts, among them Suetonius (scholar and secretary), Salvius Julianus (a major jurist and legal reformer), Arrian (a Greek intellectual, historian of Alexander and governor of Cappadocia), and Marcius Turbo (the leading general of the age and praetorian prefect).

Hadrian's coinage is diverse and abundant, as are the stone inscriptions that connect him or his lieutenants with legal and administrative matters and public works and record details of official postings and careers. Voluntarily abandoning Trajan's Alexander-like plans for eastern conquest, Hadrian attended closely to frontier security and the army's readiness, though he needed three years to extinguish a fierce revolt of the Jews, who were brutally dispersed once again. For nearly half of his reign he traveled through the empire; the Greek-speaking east particularly attracted him. Well versed in Greek culture, as Romans of his time and class often

were, he was devoted to Athens, where he had been elected archon in 112 or 113, a considerable honor.

References to Hadrian in the surviving works of writers who knew him are not numerous. Fronto's remarks are in letters he wrote to men in his circle and to his friends the emperors Antoninus Pius (138–161), Lucius Verus (161–169), and Marcus Aurelius (161–180). Fronto came from Cirta (Constantine) in Africa and was educated in Rome, where he became the leading advocate of his day and a ranking man of letters. He had a civil career, holding administrative and judicial posts under Hadrian. Consul in 143, in the late 150s Fronto was named governor of the province of Asia, a post he may not actually have taken up. A senator, fluent in Greek, he was an orator of distinction, pleading major cases, including one in which he was pitted against the formidable Athenian sophist Herodes Atticus.

Fronto appears in Aulus Gellius several times in addition to the bath-plans scene, and letters to and from his imperial friends survive. He saw Hadrian often—in the senate, where he praised the emperor in speeches he later says "are constantly in everybody's hands," the palace, and other venues. As men of learning they shared certain interests, but friction between Hadrian and other learned men is known and is possible, even likely, with Fronto. Fronto was too young to be named consul in Hadrian's day (he was born some twenty to twenty-five years later than the emperor), and he apparently had no military experience.

For whatever reasons, Fronto seems to envy Hadrian and is ambivalent about him when he writes about the emperor after his death in 138. He admits that when Hadrian was alive he praised him because he was "my master, but today I [write] for myself . . . to please myself," a clear confession that he kept his private opinions in check while the emperor lived. He says that with Hadrian he lacked the confidence love requires but that he nonetheless revered him greatly while wishing to appease and propitiate him as one would the gods of war and the underworld: in other words, he feared him. Since these remarks are addressed to the young Marcus Aurelius, the designated heir of Antoninus Pius and adopted grandson of the deified Hadrian

(who in life had arranged the sequence of succession), one would expect Fronto to be circumspect. So perhaps the distance between him and Hadrian was greater than he allows. On his own admission, his earlier praise of the emperor was in some degree false or misleading. Would Hadrian, perceptive and intelligent, with much experience of reading people, have failed to notice?

Fronto fiercely criticizes Hadrian's military policies. Perhaps he agreed with those who found the withdrawal from some of Trajan's conquests and the new policy of no further expansion—an astonishing and historically potent volte-face—hard to accept. But most of what Fronto has to say on the subject is found in flattering letters written after 138 to the indolent Lucius Verus, whom he credits with eastern victories surely the work of the general Avidius Cassius. By denigrating Hadrian, Fronto can portray Verus as a restorer of the eastern army's discipline and morale, and he goes so far as to call the soldiers cowardly and drunken before Verus took command: Hadrian, in Fronto's view, had ruined the armies. But this is a topos, and Fronto, not a military man, makes errors, though typically he picks up on Hadrian's parsimony in awarding decorations to senior officers, a demonstrable fact. When he says that "the army never after saw a general like [Hadrian]" it is hard to tell if he means to praise Hadrian or to dismiss him contemptuously; some now think the latter. Ample evidence confirms the benefits of Hadrian's military policies, and those who have experienced or studied military life may recognize in the emperor's highly professional and detailed addresses to certain units in Numidia (eastern Algeria) the authentic voice of the visiting commanding general.

These muddles and ambiguities are typical of the written sources. Fronto, having indicated his real feelings to the young Marcus Aurelius and his resentment of Hadrian in falsehoods addressed to Verus, largely changes his tune when writing to Marcus as emperor (Verus ranked but did not perform as such): his tone, with one or two exceptions, now becomes circumstantial and sometimes complimentary, for he puts his private feelings aside, as he does with Verus when the eastern war is not the topic. In these later letters, free of military references, Hadrian's devotion to peace and his freedom from empty ambition are emphasized. Hadrian is described as a zealous ruler who "diligently traveled the earth's circle" but was also devoted to music, especially to that of the flute, and to magnificent banquets; Fronto would know these things from experience. In saying that Hadrian was a learned ruler, he may be suggesting that in this he was unusual, that previous rulers were not learned or were clearly less so—Trajan, for example. Fronto implies that Hadrian was skilled as well as learned, a leader as well as a sovereign, no mean compliments, considering the source. When he says that Hadrian might speak in a spuriously archaic way, he may have in mind the fashionable learned discussions centered on linguistic and literary topics that the emperor so enjoyed.

Suetonius, born perhaps in 69, knew Hadrian well and must have known Fronto. He held major offices under Trajan and served Hadrian as his chief of correspondence, perhaps from 117 to 122; the date of his death is unknown. He probably composed his *Lives of the Caesars* during the first decade of Hadrian's reign. The younger Pliny was a friend and mentions Suetonius in his letters. In the HA, Hadrian is said to have dismissed Suetonius for overfamiliarity with Sabina, but this probably comes from Marius Maximus and doesn't compell belief. Hadrian appears only once in the *Lives*, when Suetonius says that he gave the emperor an antique bronze statuette of the young Octavian, the future Augustus, inscribed with almost illegible iron letters. He says Hadrian cherished the gift and kept it in a place of honor—in his bedchamber, beside representations of his household's guardian spirits. An apposite gift, and a welcome one, for Hadrian took Augustus as his model in significant ways; his relationship with Suetonius was probably more than a purely formal one. The gift is an instance of the material in Suetonius's lives of Augustus, Tiberius, and Nero in which "it is tempting to catch fleeting glimpses of Hadrian" because of similarities between the character traits and events described there and Hadrian and his career. Suetonius seems to have emphasized these parallels, of which his gift to his master was a sign.

Suetonius, learned and committed to research, was well known and well connected, a man of subtlety and typical of members of Hadrian's inner circle; as Philostratus, biographer of the sophists, says, "Of all the emperors, Hadrian was the most disposed to foster merit." But Suetonius's numerous writings on grammatical and other technical subjects, and his lives of kings, illustrious men, and famous courtesans, are either lost or preserved in fragments, so that the *Lives,* which survive almost complete, overshadow his other work. Passages in the *Lives* that seem lurid today, as well as the repeated discussions of attempts to predict the future faithfully, reflect aspects of Roman life, and "the picture of Suetonius as catering for a vulgar, tasteless, trivial and prurient audience must be abandoned": Suetonius the scholar followed traditional attitudes toward biography.

Arrian's connection with Hadrian is equally pertinent. He was born probably in the late 80s and died after 144. A senior commander and governor, he was a historian and humanist. In his youth, perhaps in 107–109, he studied with Epictetus, the great Stoic teacher, for whose thought and teaching the only surviving direct evidence is in Arrian's lecture notes (often called Epictetus's *Discourses*), a selective but representative record. Arrian was consul in 129 and was sent by Hadrian in 131 to govern Cappadocia, where he remained for six or seven years. There he either defeated or outmaneuvered an invading Alan horde in 135. Hunting, comets, tactics, exploration, and geography interested him almost as much as history and philosophy, and he wrote about them all. Arrian and Hadrian were bound in friendship by common interests and philhellenism. Several of Arrian's reports to Hadrian survive, some official, others more personal in tone, and he dedicated a work on infantry exercises to the emperor. In strong contrast to Fronto, he praises Hadrian's military policies and training. In his *Periplus* (coastal guide) *of the Black Sea,* a kind of verbal map, he speaks familiarly of the emperor's travels. When he describes Trapezus (Trabzon, on Turkey's Black Sea coast), and mentions a hilltop temple there with Hadrian's statue in it (or perhaps beside it), he says that the statue "is in a quite

suitable posture, facing the sea, but as to workmanship it is neither a good likeness nor otherwise handsome. Please send a statue in the same pose worthy to be called yours." Further on Arrian seems to allude to Hadrian and Antinous when praising Achilles' devotion to Patroclus.

Among others who knew Hadrian, the philosopher and rhetorician Favorinus, of Arles, glimpsed (in a text) in the palace forecourt, quarreled with the emperor and lost favor. He was exiled, but only for a time, for Hadrian was kept in check by reason. Favorinus is famous for a quip: when friends said that he should not have yielded to the emperor's criticism of his opinion on a minor point, when in fact he was right, he replied that they must allow him "to regard as the most learned of men the one who has thirty legions." Polemo, a much sought-after sophist from Phrygia (west-central Asia Minor), one of Hadrian's freedmen mentioned by Fronto and the subject of a biography by Philostratus, traveled with the emperor in the east and counted him a friend. Writing on physiognomy as an interpretive resource, Polemo describes Hadrian's brilliant gray eyes, to him a sign of high character. And the antiquarian Phlegon, from Caria (southwest Asia Minor), another of the emperor's freedmen, wrote a history of the Olympic games and a study of the toponomy and topography of the city of Rome, among other subjects. Hadrian may have published his autobiography under the name of an educated freedman, as the HA declares in a passage in which Phlegon's works are said to be Hadrian's.

Clearly, learning counted heavily toward admission to the emperor's immediate circle. The capacity for hard work also lay behind the careers of most of Hadrian's lieutenants. Marcius Turbo, for some years Hadrian's right-hand man, impressed his contemporaries with his long working hours and is said to have remarked that a praetorian prefect should die on his feet. Greek scholars and officials stand out, and not just Arrian, Polemo, and Phlegon, for there were many others, for example the rhetorician Dionysius of Miletus, the sophist Marcus of Byzantium, and a rector of the Alexandria Museum (a kind of institute for advanced studies) who was brought to Rome as an imperial secretary. Hadrian's

trans-Mediterraneanism was enlarged, for example, by the African Fronto (Suetonius may also have been from North Africa), the Gaul Favorinus, and Turbo from the south coast of Dalmatia. This distribution suggests not only philhellenism but a policy of picking suitable executives and counselor-companions irrespective of ethnic and social origins. Hadrian was not the first Roman ruler to employ scholars and other talented men from outside Italy, but he made it common, a strong reflection of his empire-wide outlook and his wide-ranging interests.

The only biographical text of any length written after Hadrian's death, other than the chapter in the HA, is in Dio's *History*. A Greek from Nicaea in northwest Asia Minor, Dio became a senator late in the second century and subsequently reached the consulate. Of his chapter on Hadrian only Byzantine excerpts survive, probably chosen largely for their anecdotal content and running in modern form to about twenty pages of Greek. Stories and gossip interweave with strong approval of Hadrian's military policies, a ringing endorsement of Turbo, and a description of Hadrian's personality of the inchoate kind found in the HA. In the fourth century there appear two potted biographies, the one, mentioned above, by Aurelius Victor (an African, governor of a Danube province and prefect of Rome) in his *Lives of the Caesars*, the other a long paragraph by his anonymous epitomist.

An anecdote in Dio, often quoted, describes an encounter between Hadrian and a woman who made some request of him as he passed by. "I haven't time," he told her. "Then cease being emperor," she shouted after him, so he turned back and heard her out. True or not, the story encapsulates a basic truth about emperors' lives. Much of their work consisted of responding (with the help of secretaries and counselors, if needed) to the requests that came in a stream of audiences, letters, petitions, entreaties, and appeals from lower authority; a number of Pliny's to Trajan survive. The *amici*, the emperor's advisers and close friends, entered their own bids. Cities sent embassies, led often by eminent— and expensive—orators, to emperors in the hope of obtaining money, lowering taxes, or gaining coveted municipal titles, redress of wrongs real or imagined, or aid in the wake of disasters. "If we follow our evidence, we might come almost to believe that the primary role of the emperor was to listen to speeches in Greek."

So Hadrian must govern wherever he is—in Egypt, in Northumberland, or at the Villa. Powerful secretaries headed departments of Latin correspondence, Greek correspondence, study and research, the imperial libraries and archives, the emperor's law court, accounting, and so on; all were replaceable at his pleasure. Under them the translators, copyists, and clerks saw to the details and to the files containing letters, memoranda, past decisions, and reports. Documents proliferated steadily. The emperor Julian complains of "all the letters and petitions . . . [that] travel around with me everywhere, following me like shadows." And unless he wished to go to Rome almost daily, Hadrian would have had to accommodate at the Villa the chief secretariats, as well as the Praetorians and all those who served him and Sabina and their guests and kept the huge establishment functioning. When the court traveled, essential personnel, probably chiefly from the departments of correspondence, did also, together with at least some of the amici. The magnitude of advanced planning for extended imperial journeys, well attested, stemmed in great part from the fact that where the emperor was, there also was the government.

Of Hadrian's famous journeys Fronto says that "monuments of his travels can be seen in many cities of Asia and Europe, many stone tombs among them." Fronto's omission of Africa is curious, given his origins and Hadrian's numerous African buildings and utilitarian structures. But inscriptional and archaeological evidence abundantly confirm Fronto's statement: Hadrian's works are recorded, in great quantity, from one end of the empire to the other. He ordered up new towns, extensions of existing towns, and innumerable single structures. Other works were sponsored by municipal councillors and magnates eager to honor him and sometimes to record his presence among them. The tombs Fronto mentions have been thought the result of Hadrian's supposed bloodthirstiness, the graves of Hadrian's slaughtered but unnamed enemies and

thus somehow connected with Fronto's reference to the gods of war and the underworld. But surely he refers to Hadrian's habit of rebuilding and repairing ancient monuments, of which attention to the dilapidated tombs of heroes and philosophers was a natural and traditional part. Both Dio and the HA say that he restored Pompey's tomb at Pelusium (at the eastern corner of the Nile delta), Dio remarking that it was ruinous, the HA saying that the emperor's work was "on a more magnificent scale" than that of the original. Dio adds that Hadrian, on seeing the fallen structure, reflected that it was odd to find in ruins the grave of one with so many shrines to his memory. Hadrian could not resist the urge to build, and the repair of such tombs fitted well with the belief in the empire's timelessness and in its peaceful, ecumenical mission that his coins proclaim and that lies behind his principal policies and reforms.

Few regions remained unvisited. For five or six years, beginning about 95, Hadrian served with legions in the field in what are now Hungary, Bulgaria, and western Germany. In 106 he took command of a legion stationed at Bonn that was soon ordered to Dacia (Romania) to participate in Trajan's second campaign there. In 107 he became governor of Lower Pannonia (Budapest to Belgrade), and in 117, not long before Trajan's death, he was named governor of Syria; he was in Rome at least part of the intervening time, and other, nonmilitary travel is attested before 117. This extensive movement usually involved far more than just getting from one place to another. Hadrian's intense curiosity and varied interests required personal observation and exploration, for which there is much evidence. He knew and studied the natural features, the cities, and the arts of the Greco-Roman world and understood them at least as well as any of his contemporaries.

During his reign he was away from Italy for about nine and a half years. Having taken almost a year to reach Rome after his accession, in order to settle affairs in the east and along the lower Danube, he first saw the capital as emperor in July 118. The sources for his subsequent trips are imperfect, but an outline can be suggested.

The first trip, from April 121 until the summer of 125:

121	Gaul, Germany, and the middle Danube
122	Britain, Gaul, Spain
122/123	winter in Tarragona
123	Syria, Cappadocia, Bithynia
123/124	Nicaea, Nicomedia (for the winter?)
124	western Asia Minor
	29 August, in Ephesus
	Rhodes, Greece
124/125	winter in Athens
	Peloponnesus, mid-Greece, Sicily
	back in Rome by mid-summer

The second trip, from early to mid-/late summer of 128:

Africa, Mauretania, Numidia, back to Rome

The third trip, from the late summer of 128 until 132:

128/129	winter in Athens
	Ephesus and western Asia Minor
	eastern Asia Minor, the Cilician Gates
129/130	fall and winter in Antioch
	Palmyra, Arabia, Judea
	Alexandria and the Nile trip
	back to Alexandria
131/132	winter in Athens
132	back to Rome

Thus Hadrian's firsthand knowledge of the ancient classical world and the sources' emphasis on his curiosity are validated. The trips record his fascination with Greece and especially with Athens; Ephesus, Antioch, and Alexandria were other favorite cities. When Hadrian's experiences before 117 are included, the data show that he traveled for at least eleven years, and probably more. He was intent on seeing things for himself and on settling disputes in the time-honored way. He was a planner who wrote everything down; the fourth-century memory of his immense labors must be accurate. Of the provinces, he apparently knew those of the Rhine-Danube frontier, Greece, and Asia Minor best, with those of the Near East close behind. He was a serious sightseer who climbed the great mountains, examined the ancient wonders, and consulted the oracles; he knew of the mysteries and was initiated at

Eleusis and later raised there to the higher grade. He heard the Colossus of Memnon sing and he debated with scholars at Alexandria. But at the same time he inspected, judged, regulated, and criticized. He showed himself across the empire, an essential feature of his reign, of his curatorial program. He came to see, and to be seen — as both symbol and executive. The cost of having him about, beyond his own cash payments, was defrayed and more by his gifts of buildings and public works, presents to temples and municipalities, and, on occasion, reductions of taxes and fees. His presence, to many an honor, generated much additional building by wealthy citizens who thus associated themselves with him.

From the outline of his major trips a rough chronology of Hadrian's Italian years can be deduced. He was at home from midsummer 118 until April 121. The next stay lasted from 125 until the late summer of 128, with the exception of his brief North African trip that same summer; when he came home in 132 he stayed until his death. So he was at Rome or Tivoli, excursions in Italy excepted, for about eleven and a half years. During his first two Italian periods, construction at the Villa was intense. While he was away on his first trip, the Roman brick industry, judging from the stamps, expanded greatly. And no wonder. Work on the Pantheon began in 118, and soon the Temple of Venus and Rome, the enormous Mausoleum, and perhaps the buildings in the Horti Sallustiani were under way, together with other new works large and small and many restorations. Something like half of the exigent port city of Ostia, where Hadrian twice held the chief magistracy, was built (or rebuilt), while at the same time the brickyards, quarries, and marble yards had also to provide for the Villa. Similarly large campaigns of construction and improvement were carried out in the provinces.

Hadrian's absences from Rome seem neither to have disrupted his strenuous administrative life nor to have encouraged insubordination at home; the tranquillity of his successor's reign can be credited in great part to his farsighted methods. Like Trajan, Hadrian left Christians alone unless they disobeyed the law; stories of martyrdoms in his day are apparently Christian in-

ventions unknown before the fourth or fifth century. In any event, Christianity was only one of many cults and sects, all of them tolerated. In the east, Hadrian, like some of his predecessors, was regarded as divine, a not uncommon phenomenon in view of the ancient belief that the gods, properly served and supplicated, might grant health and long life and, more pertinently in respect of Hadrian's resources, material success. An imperial cult had long existed, and recent work shows that it was not just a political and social rigamarole but the focus of genuine religious feeling, particularly in the east. And it was not only Hadrian's largesse that might recommend him, for he ameliorated the conditions of slaves, forbade castration, and on the whole was an alert, responsive ruler for whom the rule of law was almost always the final authority.

Although by the standards of the day he was an enlightened man, he was not a philosopher prince, though he may have wished to be thought so. The relevant texts were mostly written by senators, whose antipathy to Hadrian long survived, but that he was thought strange and different is certain. A meddlesome and perhaps querulous autocrat, backed by lineage, learning, and the army, cannot have been easy to deal with. Like Favorinus, most walked softly; admiration came chiefly from a distance. At the beginning and end of his reign, some leading men thought traitorous were executed, four by Hadrian's subordinates, others apparently at his order. Yet no proscriptions or bloodbaths occurred. In the unending, depressing story of absolutism, he stands well back from the threshold of damnation.

Like most people in antiquity, Hadrian was interested in portents and omens. His horoscope was important to him; interest in technical astrology was normal. But we have little evidence for what he thought about such things, for his private beliefs, save for his Eleusinian commitment. He observed traditional religious forms punctiliously and insisted that others do likewise. Typical of the obscurity of his personal history is knowledge of his relationship with Antinous. The story is perplexing and solid fact rare; prolonged speculation has yielded little. That Antinous and Hadrian were lovers is almost impossible not to believe. Yet the emperor took

the young man with him to Egypt (June–October 130), together with Sabina, her ladies, and members of his inner circle, for all the world to see. After Antinous drowned, some apparently thought he had sacrificed his life to assure Hadrian's immortality or some such thing; it seems even to have been rumored that the emperor had ordered Antinous's death.

What happened after the drowning is astonishing: Hadrian perhaps founded but certainly encouraged a cult of Antinous—centered on an elaborate new city beside the Nile built in his memory and bearing his name. The cult quickly took root, spread, and flourished as Antinous was deified, apparently spontaneously, as Osirantinous. Statues survive showing Antinous with Osiris's attributes, as well as with those of other traditional divinities. Eastern cities struck coins with Antinous's name and image; he became another celestial benefactor. In this extraordinary demonstration of Antinous's popular appeal, Father Nile, renewal, Hadrian the *restitutor orbis terrarum,* and perhaps a collective need to believe in the efficacy and goodness of a new and youthful god all intertwine. There is more here than sex or love alone.

Hadrian is said to have been tall and powerfully built. A coin issued shortly after Trajan's death depicts both men, with Hadrian somewhat taller—probably the truth, for Trajan was Hadrian's adoptive and deified father and his image was presumably immune from public diminution. Hadrian was an excellent horseman and an avid hunter. Relief scenes of him hunting and sacrificing are preserved on Constantine's Arch in Rome: Antinous is there, and a scene of a lion hunt may commemorate a hunt Athenaeus describes. The emperor's long military service inured him to rough outdoor life; anecdotes in the HA and Dio stress his strength and agility.

In raising a beard he appropriated the chief facial attributes of the Greek hero; Polemo's influence may have been at work. The full beard and hair, precisely arranged and combed, were essential parts of the emperor's official image, one carefully worked out and repeated across the realm, a matter of high policy.

But in state portraits, within his armor and behind his beard and largely free of signs of aging, the man himself partly disappears, having become a universalized personality whose pictorial conception—not the actual form—is related to the cool, idealizing images of Augustus. But some of Hadrian's portraits and their progeny are revealing. A head in the National Museum of Athens, which may represent Hadrian or a man who took Hadrian as his model (a common thing), has a beard less full than that of the specifically imperial portraits and a luxurious coiffure loosely arranged. Those features, and the effect of the cutting of the eyes, suggest a sense of relaxed watchfulness, of a contemplative, perhaps superior, observer. Some have thought the head a portrait of Hadrian before his accession, perhaps made when he was archon and aged about thirty-six, but the treatment of the eyes argues for a somewhat later date. Still, it might be a reminiscence of an earlier time cut some years later. Its importance lies in its personalized imperial iconography and its intimations of the emperor's interests and character. Some of these features appear again in a portrait in the Alexandria Museum of Hadrian in later life.

The identifying facial features found in Hadrian's stone and bronze portraits show up consistently in his coin profiles, which are finely wrought and carefully detailed. The nose is long and straight, usually with a distinctive, narrowish tip. The upper lip is a bit short in proportion to other facial features, the chin firm, with a noticeable, rounded projection. The ears, when visible, stand well out from the skull. The eyes Polemo admired are emphasized by new techniques seen in the Athens head: the irises are highlighted by sharply cut, shadowed cavities, the pupils described by engraved circles. Instructive sculpture is not limited to portraits of the emperor or those close to him, such as Sabina and Antinous or the Ephesus relief of the imperial family now in Vienna. The provinces, for example, were personified by statues standing beside the Olympieion in Athens and in the reliefs, now in the Palazzo dei Conservatori, made in Hadrian's honor shortly after his death. Provincial and military coin issues complement these images.

Scattered evidence suggests that Hadrian wrote well — sometimes amiably, as when he answers a petition from Plotina about the governance of an Athenian Epicurean sodality, sometimes with asperity, as when he allows himself an oath when threatening dire consequences for those who disobey the law. Chancery documents aside, his style is clear and elegant. In addition to an autobiography, he wrote poetry — of modest quality, judging from what has survived, save for his famous address to his soul. He published two books on grammatical topics (multiple copies were distributed to libraries, amici, and other interested parties), which later authors sometimes cite. Some epigrams in the *Greek Anthology* are attributed to him, and fragments of letters and legal documents survive. In composing scholarly papers he was aided by a research secretary, who helped with historical references; Hadrian once cites an opinion by Augustus, adding that the first emperor was not a perfect scholar and may have been speaking as a layman. Of his speeches, dictated to stenographers, he published

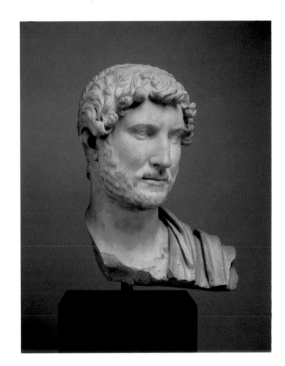

7 *Bust of Hadrian, Metropolitan Museum of Art, New York, Collection of Shelby White and Leon Levy (1990)*

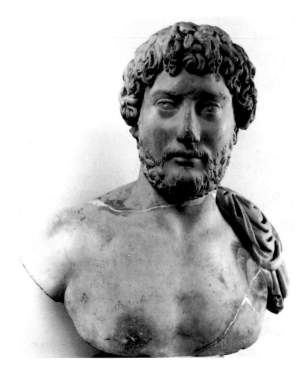

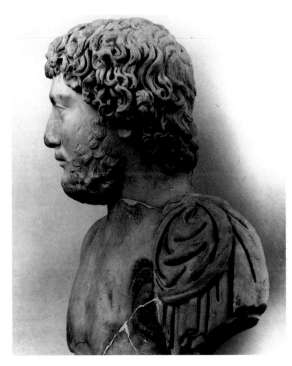

8 *Head of Hadrian(?), National Archaeological Museum, Athens*

9 Hadrian, gold coin of 127, Fogg Art Museum, Harvard University

emperor, for the Temple of Venus and Rome. The HA reports that

with the aid of the architect Decrianus [Hadrian] raised the Colossus [of Nero] and, keeping it in an upright position, moved it away from the place where the Temple of Venus and Rome is now, though its weight was so vast that he had to use as many as twenty-four elephants. This statue he then consecrated to the Sun, having removed Nero's features; and he also planned, with the help of Apollodorus, to make a similar one for the Moon.

Pliny's statement about making plans himself, Cicero's remarks, and Fronto's discussion with his architects also confirm that grand patrons were expected to have knowledge of architecture.

Hadrian is said to have painted and modeled. Aurelius Victor's epitomist adds to Hadrian's interest in music and geometry (noted by earlier writers) an ability to sculpt in stone and bronze equaling that of Praxiteles. More useful is his statement that the emperor enrolled builders, geometers, architects, and other artisans and specialists in paramilitary cadres. The passages in both Dio and the HA are circumstantial and believable, and the epitomist conveys a sense of the organization Hadrian' innumerable projects required. An active emperor-architect can readily be imagined behind the texts. But because it was Hadrian's distinctive and ubiquitous personality and his unusual array of talents that fascinated people, embroidery by chroniclers and the loose-tongued was surely common. All that can be assumed, in the case of the Villa, is that serious discussions took place among the emperor, his architects, and his artists; silence on Hadrian's part is highly unlikely. That in the broadest sense the Villa was Hadrian's creation cannot be doubted, even though no known substantive evidence confirms his direct involvement in the design and decision-making processes. Finally, a thought should be given to Decrianus and the other professionals (for whom Decrianus's name must stand) who carried out Hadrian's orders.

a dozen. But because the surviving evidence is both random and woefully incomplete, access to his thought and personality by way of his writings is severely limited.

Unlike the Pantheon, or the Ostian works, whose state of preservation supports interpretation and analysis, the Villa, too, is woefully incomplete; the resulting difficulties are compounded by its size. Analogy thus plays an important role in our investigation, a procedure much aided by Hadrian's building activity, which was in the line of Augustus, Herod, Nero, Domitian, and Trajan and extended to Constantine (author of perhaps the largest city-building effort in Western history) and Justinian. Hadrian's vast programs convey a broad sense of the art and architecture of the age, and this facilitates assessing the Villa's design and details; for example, Hadrian's works overall are as varied in form and effect as those of the Villa, and clear-cut artistic connections can be made between Villa elements and evidence elsewhere.

The texts document Hadrian's interest in planning and design. Dio provides two important anecdotes: in one, a work by Apollodorus, Trajan's architect, is criticized by Hadrian, who is told to "be off and draw [his] gourds" (umbrella-shaped vaults?); in the other, Apollodorus criticizes the design made by Hadrian, now

Hadrian's propaganda proclaimed a golden age, a vast and prosperous community unending, the right-

ness of the imperial order. He worked hard to continue and consolidate a responsive government controlled by rule of law. But a harsh, often repressive world was obscured by the elegant slogans, a world, as so frequently happens, whose principles are more attractive than its practices. Yet Roman art and architecture fascinate and instruct because their authority has endured so long and because they express unequivocally their social and political foundations: power, order, status, a mythic history, and the belief in a Greco-Roman union guarded by well-disposed deities. From forms embodying these concepts, Mediterranean talent fashioned such persisting symbols as the Pantheon, Hadrian's great temples, baths, urban works east and west, and the elegant Villa pavilions and spaces in which his art rephrased the past in the final and perhaps most instructive manifestation of classical forms. In Hadrian's day, Greek culture regained lost momentum and Greek art took a leading place within the Roman frame. Of all this Hadrian's Villa is an elaborate portrait, as it is also of the man most fully representative of the age.

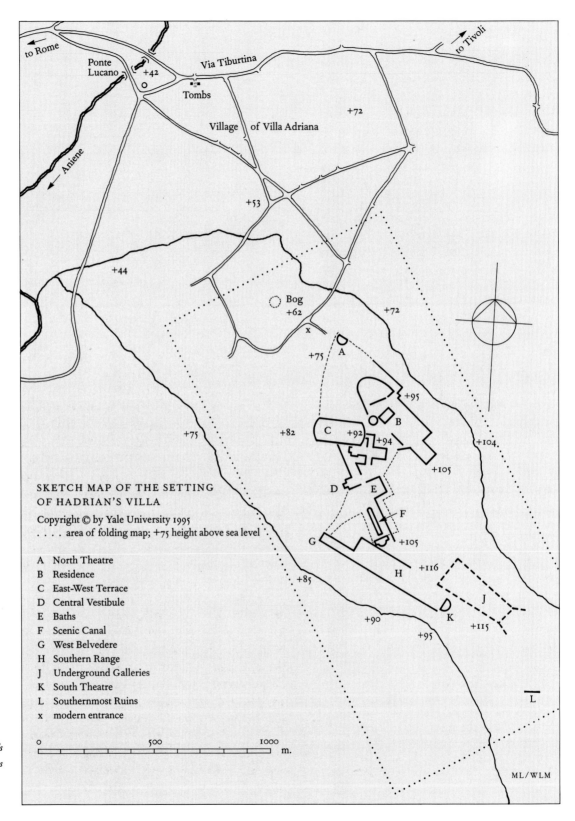

to Rome

to Tivoli

Ponte
Lucano
+42

Via Tiburtina

Tombs

Village of Villa Adriana

+72

Aniene

+53

+44

Bog
+62

x

+72

A

+75

+95

B

C +92

+104

+82

+94

+75

+105

D

E

SKETCH MAP OF THE SETTING
OF HADRIAN'S VILLA

Copyright © by Yale University 1995
. . . . area of folding map; +75 height above sea level

F

G

+105

H +116

A North Theatre
B Residence
C East-West Terrace
D Central Vestibule
E Baths
F Scenic Canal
G West Belvedere
H Southern Range
J Underground Galleries
K South Theatre
L Southernmost Ruins
x modern entrance

J

+85

K D

+115

+90

+95

L

0 500 1000
 m.

ML/WLM

10 *Sketch plan of the Villa's
environs*

II

The Site

The ancient Via Tiburtina left Rome through the Porta Tiburtina (now the Porta San Lorenzo) and ran eastward fairly directly across the Campagna, the low but gullied and undulating plain of the Roman countryside; the modern Tiburtina mostly follows the same line. A branch line leading to the Villa left the Tiburtina about 5 kilometers southwest of Tivoli, crossing the Aniene on an ancient bridge, still standing and now called the Ponte Lucano. Half a kilometer further along, a road leads south through the largely modern town of Villa Adriana to the present entrance of the Villa proper. By road, the distance from central Rome is 19 Roman miles (28 kilometers, three or so hours on horseback), by direct line, 17. 10

The Aniene, chief tributary of the Tiber, rises 50 kilometers further east, on the southern slope of Monte Tarino, in the rugged Simbruni range; it flows into the Tiber in Rome's northern quarter. As it descends from an altitude of nearly 2,000 meters almost to sea level, dramatic gorges and cascades mark its searching, winding course before it reaches the Campagna plain just below Tivoli. The midriver scenic sites invited villa-building, as by Nero at Subiaco. Closer to Rome, the steep slopes of Tivoli had long been popular villa terrain, partly because of the views over the Campagna with Rome in the western distance. Scores of

villas there, some very grand, are known. Much lower down, just southeast of where the Tiburtina crosses the Aniene, Hadrian built his Villa.

THE SETTING

The site lies 4 kilometers southwest of Tivoli, at the edge of the Campagna but on slightly higher ground. Just to the east and northeast the hills rise fairly sharply to 500 and 1,000 meters. Views from the Villa are different from those higher up—splendid though they can be—for the Villa is further west and so commands a wider prospect. From atop the West Belvedere a 180° panorama extends from the Castelli Romani in the south, centered on the Alban peaks, around to Monterotondo and Soracte (40 kilometers away) to the northwest; east of these landmarks the forward wall of the Sabine range appears. Much of this could be seen from the edge of the East-West Terrace, and all of it from atop the South Theatre, the highest Villa point.

The climate is that of Rome: spring and fall excellent, summer dry and hot to very hot, December–February chilly or cold and sometimes rainy. The duration and angles of sunlight are those of 42° north, schematically the same as at Barcelona or Chicago. The site is sheltered by mountains from the worst northern and eastern weather and open to the generally favorable west winds. But it can also be in the path of the summertime scirocco from Libya.

Water came from one of the four metropolitan aqueducts—Marcia, Claudia, Anio Vetus, and Anio Novus—which on their way from the upper Aniene to Rome ran close together, along the slope of Monte Ripoli, some 200 meters higher than the Villa. Of the four, the Anio Novus is the most likely Villa source because not long before Hadrian started building the quality of the Anio Novus water had been greatly improved by changing its source. Whichever great line was tapped, it was done a little more than 2 kilometers due east of the Villa. From there the water was carried mostly underground and then, with the change of terrain near the Villa, on aqueduct bridges; at some point the line divided into two branches, one marked by a few arches still standing on the high ground of the Southernmost Ruins. It is unlikely that Hadrian's system was an independent line; had it been, the indefatigable aqueduct explorers would presumably have found it, for it would either have crossed the skein of the four primary lines or have followed their route. Whatever the physical arrangements, the Villa's consumption of water was prodigious, as will be seen.

Hadrian's choice of site perplexes many. Lanciani speaks for the majority, saying that he "has never been able to understand" why such a poor, insalubrious place was chosen. Why not build on the upper, cooler slopes? His contemporary Boissier, rarely given to doubt, says "there is no simpler and, at the same time, wider horizon; none that can give such a feeling of peace and solemnity, of variety and proportion." Gusman agrees, finding the site admirable, well suited to the emperor's "exigeantes fantaisies." Ashby straddles: the place is unattractive, but with more room for extended gardens and terraces than on hillside terrain. Aurigemma, though surprised that Hadrian didn't build on the slopes, points to the site's advantages, saying that it "does not oppress one by its magnificence" but is "quiet and restful and at the same time vast and varied." Other suggestions have been made: the emperor wished to distance himself from the other villas, Sabina's family may have owned the earlier villa. Re-

11 *View from the west rim of the East-West Terrace, looking north (1987)*

12 *(opposite) Agro Tiburtino, map by Cabral and Del Re (1778)*

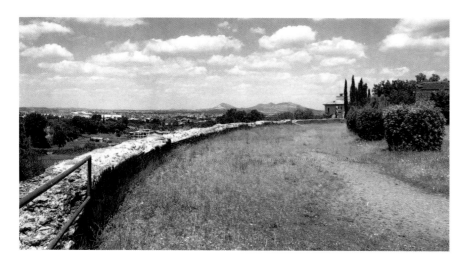

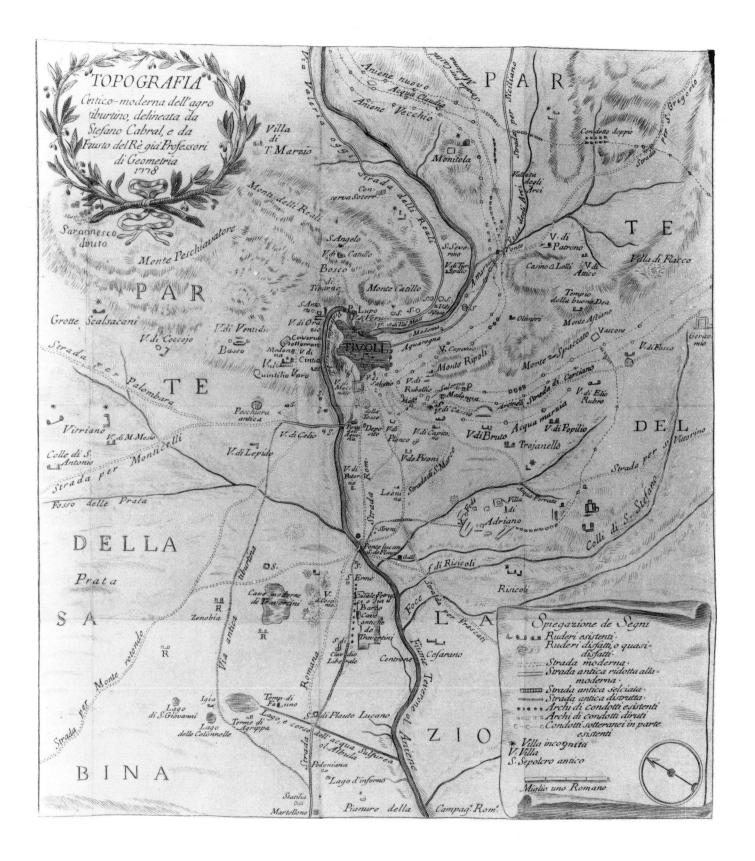

TOPOGRAFIA
Antico-moderna dell'agro
tiburtino, delineata da
Stefano Cabral, e da
Fausto del Rè già Professori
di Geometria
1778

Spiegazione de Segni
Ruderi esistenti.
Ruderi disfatti, o quasi disfatti.
Strada moderna.
Strada antica ridotta alla moderna.
Strada antica selciata.
Strada antica disrutta.
Archi di condotti esistenti.
Archi di condotti diruti.
Condotti sotteranei in parte esistenti.
Villa incognita
V. Villa
S. Sepolcro antico

Miglio uno Romano

13 *Southernmost Ruins, aqueduct arches (1987)*

cently, Hadrian's ambitious architectural and landscape plans for the Villa have surfaced again as primary explanations for his choice of site, and they are the ones that make the most sense.

Building above the aqueduct line would cause major problems, and the sloping land below it was already taken. The lower site was more convenient than the upper ones, assuming frequent traffic between the Villa and Rome, and the old villa provided adequate quarters during the first year or two of construction. And the site's natural if partial protection from winter weather made it, in theory at least, more attractive in that season than locations higher up. In time, many provisions were made at the Villa for summer and winter conditions, such as strategic as well as ornamental use of great quantities of water, the northern orientation of summer banquet halls, the numerous cool underground walkways, and basic applications of the Venturi principle. Radiant heating in baths and private chambers tempered the winter cold, sunshine and the lack of it were significant planning factors, and high enclosure walls protected elevated, exposed locations. More on all of this later; here we wish to suggest that the potential and the uses of the site were carefully thought through, and that the site and the Villa are well suited to each other.

THE TERRAIN

Two southeast-northwest valleys, roughly parallel, define the longer sides of the site. They lie about 500 meters apart at the Southernmost Ruins and nearly a kilometer apart further north. The valleys — their streams now defunct — are bordered largely by cliffs of eroded reddish tufa that diminish in height toward the

northwest as the land between them falls; the maximum valley-Villa differential is about 25 meters. This configuration gives the Villa strong topographical identity and considerable privacy. Within the site the terrain is irregular, a typical Campagna landform, originally made up of rounded low ridges and a steep gully or draw where the Scenic Canal is. This somewhat rough ground, which drops almost 60 meters from the Southernmost Ruins to the Bog, was greatly altered by Hadrian's engineers, as the massive, buttressing forms of the Service Quarters and the Central Service Building record. Earth moving and terracing were carried out on a grand scale.

The Villa's median axis lies 27° west of north, its straight-line length 2 kilometers. Two major changes in level occur, from the Bog to the East-West Terrace (32 meters), and from there to the Upper Park (24 meters); lesser differentials are common and not always gradual. Because of the terrain and Hadrian's use of it, no controlling plan line extends across the site and no single building dominated the whole. Most individual buildings are symmetrical, and several groups of buildings are orthogonally related, but plan relations among groups can appear irrational, and this, too, is often related to the terrain.

Because the Villa has no central axis, the site is difficult to apprehend; understanding comes only from exploration, and that also is a key to the place, for immediate revelation was not intended. From the neighborhood of the aqueduct lines on Monte Ripoli it takes time to distinguish the Villa's position; the ground appears to be quite flat, and only the tawny, reddish-brown ruins of major structures stand out — the great Ambulatory Wall and the spreading, protective walls of the Peristyle Pool Building, for example. As one enters the site today, the Villa doesn't look like much at all, disappointing visitors as they approach what seems to be just another Campagna domain: there is no aerie, no drama, no imposing, properly imperial structure. Only later, in the Island Enclosure perhaps, or by the Scenic Canal, will the Villa begin to reveal itself as a place as complex and puzzling as Hadrian himself.

No certain evidence of the Villa perimeter survives,

but it seems unlikely that it would have reached past the Aniene, the Via Tiburtina, the juncture of the Tivoli hills with the East Valley, and the open ground beyond the Southernmost Ruins. The cliff edges make sense as limits of the built-up Villa, but there was construction on the East Valley floor and also down below the oval structure northeast of the Water Court where the slope is very steep. Southeast of that point, the cliff surface was deliberately undercut below the crest in order to add to the scenic content of the view, but whether there were viewing points in the Valley proper is moot. Excavation in the Valleys might prove fruitful. It was long thought that a substantial villa at Santo Stefano, well south of the Southernmost Ruins, was part of Hadrian's establishment, but archaeological evidence argues otherwise; in any event, it is far from the Villa's center.

It was also held in the past that two large tombs, one well preserved (on private land just south of the Tiburtina and about 400 meters east of the Ponte Lucano), marked the Villa's ancient entranceway. A Roman road apparently passed between them, but as they were part of a larger group of tombs, of which some other examples were seen long ago, and are too far apart and symbolically unsuitable, the idea isn't tenable. The conjecture that the perimeter entrance was in fact much further south, by a huge rectangular plaza that apparently adjoined the North Theatre on its northwest side, is plausible. If it is correct, the ancient gateway was only 40 meters or so north of the present entrance kiosk. We think it may have been still further north, perhaps where the entrance road crossed the eastern stream. But nothing is certain.

Calculation of the Villa's area is crippled by these obscurities. Estimates vary greatly. But if the valley margins, the line of the Southernmost Ruins, and a fourth border somewhat north of the present entrance are used to establish the perimeter of built-up and landscaped ground, the figure is about 120 hectares (300 acres). Nero's urban Domus Aurea spread over some 50 hectares, and within their walls Pompeii and Ostia occupied 65 and 67, respectively. Scale is also suggested by the 117 hectares of Kew Gardens, the 146 of Hyde Park, and the

14 *Oval arena and Water Court substructures, looking west (Penna no. 42)*

15 *Tombs beside the Via Tiburtina, drawing by Piranesi (ca. 1775)*

143 of the extended Washington Mall. The conventional small-scale plan often reproduced shows something like half the Villa because that is what the state owns (about 65 hectares, not all accessible) and it is where almost all excavation and clearing has taken place. Some versions include the privately owned Southern Range. So, for understandable reasons, erroneous concepts of the extent and nature of the Villa's overall plan are common. Fortunately, a modern comprehensive plan is in print.

Stretches of the original, solidly paved road system have been seen from time to time; one (restored?) is visible east of the Museo Didattico. Whatever the route of the main approach road from the Tiburtina, it arrived from a northeasterly direction to skirt the northwest flank of the so-called Palestra. Shortly afterward it split in two. The western branch ran straight south along fairly level ground to the area below the East-West Terrace. There it branched again. Its left-hand, service branch hugged the south and west faces of the Service Quarters and then entered the substructure of the Central Vestibule. The right-hand or formal one took much the same route but at some distance from the buildings;

16

16 *Service Quarters, area at the junction of the East-West and Angled Terraces, looking northwest (Penna no. 82)*

a wall separated it both from them and from the service branch. It, too, reached the Vestibule, but at its formal entrance, higher up.

The eastern main branch also split in two. Its eastern route led south of the Doric Temple Area, where it went underground; the passageway can be seen where the avenue of cypresses cuts across it as well as in the northeast corner of the East Terraces. The other route rose toward the Ambulatory Wall but may have turned abruptly east before reaching it. Other roads would have existed outside the built-up area. Within, roads went underground. The one running under the East Terraces, for example, ran past the Water Court and the Park Rotunda and on to the north corner of the Underground Galleries by way of which it reached the Southernmost Ruins, a distance underground of 1.6 kilometers. Along the route were several junctures with other subterranean passages. From the east corner of the Underground Galleries a secondary line ran out to a vast underground deposit of pozzolana, a volcanic gravel used in the best Roman hydraulic concrete.

The main north entrance would be the chief Villa security point. Ceremonial arrivals required a different setting, not by the main gate but further south, somewhere along the rim of the second main level of the site. Requirements included a more or less northwest orientation, a spacious, formal reception salon, service and staff facilities, and a setting for the religious observances traditional upon entering a Roman home.

The Central Vestibule is located and planned appropriately. The road to it passed by a temple, now lost but known from early observations; aerial photos confirm its location. In the 1830s Penna recorded the appearance then of the Vestibule facade, whose design is apposite. A wide axial staircase rises from the roadway to a small terrace before the portal proper, and lesser stairs flush with the building's facade also rise to the terrace, the four elements being arranged in a T-shaped plan. To the left the ground falls away toward the junction, well below, of the eastern branch road with the Vestibule. Two massive piers with broad niches (fountains?) flank the portal; the whole composition is on the centerline of a ceremonial hall beyond. Inside, a religious pre-

17

18

19

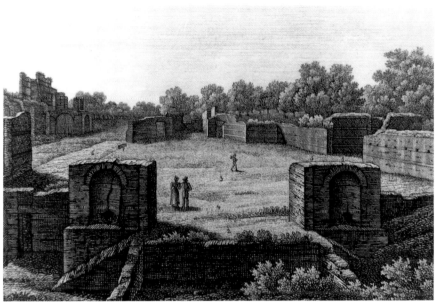

17 *(left) Road leading east under the East Terrace (1991)*

18 *Central Vestibule, entrance, looking south (Penna no. 79)*

19 *Central Vestibule, plan*

cinct was found on the right. On the main axis an apsidal chamber, screened by columns, may have been the emperor's waiting room. To the left, toward the Bath buildings, smaller side chambers and the ubiquitous side passages led east through an open hall set north-south.

Both flanks of this eastern hall were screened by columns, and the design of the southern flank resembles the Portico Suite, another building proposed as the Villa's ceremonial entrance. Its design is also suitable. If the road that comes up the hill toward the Ambulatory Wall continued east, it would have closed on the twenty-odd niches of the Fountain Court north wall and led almost directly to the Suite. Perhaps the Suite was the emperor's ordinary entrance, near the Residence, used also by senior staff. There the household could greet Hadrian or see him off. So it may be that both buildings were formal entrances, one for state visitors, the amici, ambassadors, and the like, the other for the emperor and those close enough to him to have access to some parts of the Residence. In this connection the position of the Heliocaminus Baths on the opposite corner of the Residence Quadrangle takes on more significance than their proximity to the Residence alone suggests, as bathing after a journey was customary. This interpretation, if correct, reinforces the suggestion that praetorian officers were quartered in the Hall of the Cubicles, hard by the Portico Suite (the Hall resembles somewhat the Barracks of the Vigiles at Ostia).

Choosing the site required an excellent eye for land and the imagination to see what might be done with it. The physical scale is right. The rise and fall of the ground is neither mere undulation nor so grand as to require excessive effort. Some Roman precedents are ignored, for the Villa has no atriums nor any shoreline or other dominant natural feature. Nor are there intimations of what was to become, much later, a Romantic ideal—a wild, dramatic landscape. Once the Residence and its environs were developed, the extended Villa was adapted to a terrain whose configurations invited the construction of separate clusters of buildings; experiment flourished. Without a center, without connective

allées, the Villa revealed itself only as it was traversed point to point. It is a place of considerable subtlety.

APPARENT DISORDER

It is not just the omission of half the site that makes conventional Villa plans inadequate. They are simplified archaeological records, showing only those parts of the surviving fabric that have been measured and then reproduced on the drawing board. Since most original inter-building features except terrace walls and underground passages are unknown, greater isolation of buildings and building clusters is implied than was in fact the case. The result is like a map of overlapping flotsam, bound more by wind and weather than by any conceptual framework and thus likely to be rearranged at any moment. Through no fault of their authors, these modern plans lack cohesion, and that helps explain why the Villa's configuration is sometimes described as idiosyncratic, irrational, or baroque. And if formal order is expected—a dominant feature served by hierarchical symmetries, an arrangement as old as architecture itself—the Villa's extended plan may appear inappropriate or even inexplicable. Its apparent disorder, however, is not the result of heedless, piecemeal work.

In assessing what is known of the plan, its character and particulars, it is useful to recall that the word plan is ambiguous. In the present context it has two basic meanings, the guiding image made before construction, and the architectural map made much later of the remains. Today the first usage refers to building and site plans, both the diagrammatic instructions prepared for engineers, builders, and a dozen other specialists, and the simplified form for the client. The second is a different matter, a record of evidence found. Confusing the two meanings leads easily to erroneous inferences, and it is worth saying that Hadrian's plan doesn't exist and that those that do are bound to be seriously incomplete. Site plans are by nature deceptive and promise more than they can deliver—a glance at a Villa plan can take in the known major features, but even prolonged study of it won't reveal why the buildings lie about untidily on

hilly ground or how they were related to one another, if at all. And only excavation can fill in the gaps.

The meager ancient written evidence for client-architect relationships, planning methods, and solutions of simple structural problems fails to account for the means by which imperial monuments were conceived and built. The texts, from Cicero and Vitruvius to Aulus Gellius and Dio, only confirm what the buildings prove, that rulers and magnates liked to build and that senior architects dealt with them directly; the decision-making process, whence tangible expressions of style and meaning spring, is unrecorded. Invaluable as the knowledge, found in Dio and the HA, of Hadrian's architectural interests is, it does nothing to explain the Villa plan. Other luxury villas help some, but because Hadrian's creation is in important ways unique, any attempt to explain its plan must evolve from the evidence of the site itself.

The pre-Hadrianic roads at the site were inadequate. New ones, and at least part of the underground arterial system, were needed to support the renovation and expansion of the earlier villa (of which the cryptoportico and the general outline were preserved). Construction soon spread beyond the Residence, but not always in the successive steps the site plan seems to imply. Empty spaces left between buildings were filled in and functionally complete structures altered and extended, common events throughout the coming years. Stairs, fountains, and secondary chambers were inserted at will, and passageways and corridors multiplied as the Villa expanded, so much so that in effect it has two plans, one for the emperor's own ground, the other for service, conveyance, and storage that comprises a largely interconnected support system, above and below ground, for Villa life.

21 The earlier villa remains in the Residence area extend from the deep nymphaeum beside the Residence Quadrangle to the Ceremonial Precinct border, with extensions toward the East Terraces. Begun in the late second or early first century B.C., the place was modified about mid-century and again, on a lesser scale, in Augustan times. The main block plan was traditional, of the kind familiar from elaborate Pompeian houses,

20 *Passage from the North Service Building (left) to the Peristyle Pool Building, looking south (1987)*

22

except that a large garden (later the Residence Quadrangle) lay in front of the house, which rose from a podium or base enclosing the cryptoportico. The house, set northwest-southeast, was flanked by spacious peristyles, like the earlier villa at Lago di Salpi. Hadrian retained the nymphaeum (with its side corridors), the podium, and the sequence of traditional Roman domestic spaces, aligned on the principal axis: the atrium, with duplicate, facing side chambers, and the *tablinum* (originally, in Roman houses, a sleeping room, later a family office and records room). Beyond lay an axially elongated peristyle with a file of eight cubicles along one side, and past that, a garden culminating in a theatre-like nymphaeum (later the Residence Fountains) set on rising ground.

The transverse peristyles lay on the extended atrium cross axis. The area to the northeast, toward the Valley, may have been lower than the podium, for the cubicles have windows. The open space on the opposite side of the main structure probably contained a garden with a nymphaeum, flanked by small fountains, on its south-

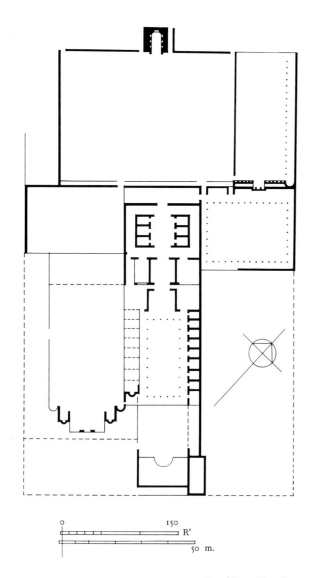

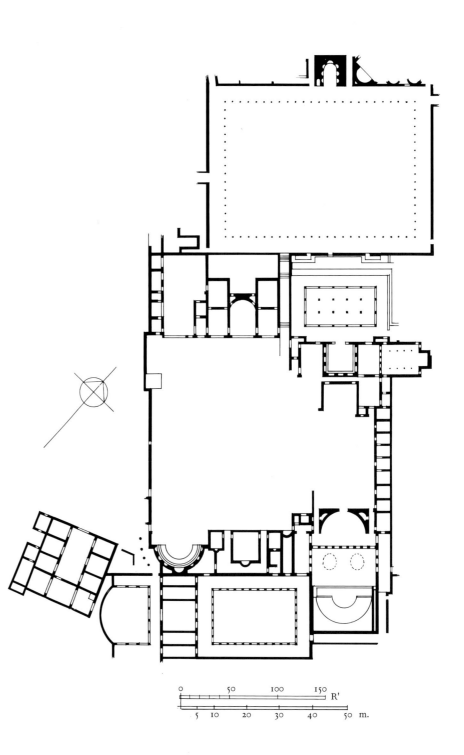

21 *Republican villa, plan*

22 *Residence, Ceremonial Precinct, and North Service Building, plan*

0 150 R'
5 10 20 30 40 50 m.

east side; these, together with two cisterns, were added in the mid-first century B.C., when the dogleg northeast cryptoportico may also have been added. The entire 100-by-165-meter plan, uncompromisingly rectilinear, was generated from the nymphaeum-to-nymphaeum core axis.

In Hadrian's renovation the atrium was transformed into a multicolumned structure perhaps open to the sky, and the tablinum was remodeled as the emperor's Library. But the elongated southeast peristyle appears to have been preserved; certainly its flanking cubicles were. Past the peristyle, but facing it, arose a large vaulted apse, and northeast of the new Library an elegant small basilica was added. The new living quarters lay just southwest of the old atrium and peristyle along a parallel axis. At the south corner, beside the earlier nymphaeum and small fountains, a large, semidomed nymphaeum-triclinium, 12 meters in span, was built. Opposite and northwest of these, where one of the earlier peristyles formerly stood, Hadrian built a five-room suite centered on a large chamber with a fountain set into its curved back wall; two private lavatories behind this wall could be reached either from symmetrical flanking pairs of rooms completing the suite or from the main chamber. To the northwest a small terrace lay at a height about halfway beween suite and Quadrangle levels; to the southeast, on the axis between the suite and the nymphaeum-triclinium, there was presumably a new peristyle, from which doors and passages led southwest into open ground. It seems logical to suppose that the Heliocaminus Baths, hard by the Residence northwest corner, were accessible from the five-room suite, but the ruins between the two structures are largely illegible.

The suite recalls domestic planning elsewhere, at Pompeii and in Nero's Domus Aurea, and in the private suite Rabirius designed for Domitian, visible in the lower level of the Domus Augustana on the Palatine. Nothing now known at the Villa, except perhaps for the rooms immediately northeast of the nymphaeum-triclinium just mentioned, has on the grounds of planning and location a better claim to be the imperial private apartment: the main space and its symmetri-

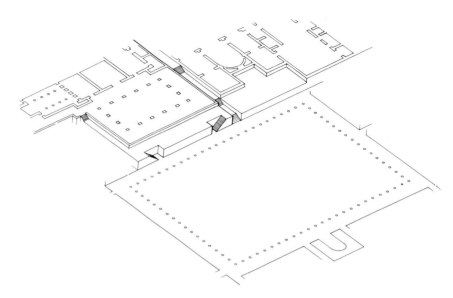

23 *Residence Quadrangle and northern sector of the Residence, looking southwest*

cal side chambers, the fountain and the lavatories, and the transaxial enfilade of openings, running northeast-southwest along the front of the whole composition, designed for surveillance and service, all suggest this. The proximity of the Library, triclinium, and what seems to have been an arborlike columned structure over the old cryptoportico are, on this reading, appropriate neighbors.

The early villa's plan affected the character of the extended Hadrianic one. Several major works run parallel to the villa's long axis: the East Terraces, the Hall of the Cubicles, the Portico Suite, and the East Belvedere. The Ceremonial Precinct is parallel to the early villa's transverse axis. Further afield, the Water Court, Upper Park east wall, Platform Structure, and centerline of the Underground Galleries deviate only slightly from the pre-Hadrianic orientation.

More important is the jarring shift away from the earlier scheme that took place, in the first years at the Villa, with the construction of the Fountain Court and its East and West Buildings, the Island Enclosure, the Heliocaminus Baths, and the North Service Building. This schismatic planning declared its independence of the Residence and its dependencies, which it partially

rings, as Hadrian's attention swung toward the north. The next group (the building sequence makes little difference for our purposes)—the East-West Terrace, Apsidal Hall, Arcaded Triclinium, Stadium Garden, and Peristyle Pool Building—is set on the cardinal compass points. The Scenic Canal valley dictated the axial cohesion of the Angled Terrace, Central Vestibule, and two Baths; the Central Service Building and the Upper Park almost follow suit. Throughout, however, minor deviations, usually undetectable on the ground, thrive.

That the older villa's central axes weren't extended west and south was due partly to the terrain but principally to the decision, made early on, before Hadrian left (in the spring of 121) on his first major trip, in favor of independent siting. Many buildings that followed were thought out and largely executed as independent entities—the radically designed Smaller Baths, for example, or the scalloped interiors found at the ends of the Water Court long axis. The novel interior axial directives of the Central Vestibule are satisfyingly coherent and functionally efficient, and the Scenic Canal and Triclinium are effectively integrated with each other and with the landscape. In the Arcaded Triclinium, a half-stated earlier fountain-and-court design was later brought successfully to maturity with a light touch. The Garden Stadium has a traditional background, yet the cross-axis connecting it with the Triclinium not only links two interfacing levels in a sophisticated way but is the vehicle of brilliantly conceived successions of scenic disclosures in both directions.

Farther south, in the Southern Range, high originality reappears in the Reverse-Curve Pavilion. The same is true, in a very different fashion, of the Underground Galleries; and the planning of the South Theatre also belongs in this category if eighteenth-century observations are correct. All of these varied structures were carefully thought through at the design stage. Of course this is true of all successful buildings. But the underlying concepts of original works at the Villa appear fully resolved, without inept or uncongenial features to be rethought in the next attempt.

An impression of disorder arises, then, from several factors: the Villa's unexpected juxtapositions, its appar-

ently isolated structures, the opposition to the older villa's foursquare plan, and a drive to make original architecture. And the presence of readily identifiable, traditional buildings—such as the Doric Temple, the Larger Baths, and the Service Buildings—strengthens the impression of an overall architectural inconsistency.

Even so the Villa is orderly, for artistic and experiential principles underly its apparent disarray. The modality of this order is not that of geometrically rational planning, with its insistence on directional guidance and ready accessibility, but of successive experiences of the Villa's ostensibly independent buildings and the gardens among which they were set. Enclosing different Villa activities, the exteriors (and the plans) of these structures began to vary emphatically once the Residence perimeter had been left behind. It is as if a great house had come apart, its plan deconstructed by a centrifugal scattering of its functional components. Because of this the Villa could be taken in only by walking about, and that is fundamentally what the plan we have describes. Few views yielded much about what lay beyond them. Major buildings could be discerned roundabout, but direct, open approaches to them were rare. Even the long, gently rising traverse from the East-West Terrace to the Scenic Triclinium was broken by the Central Vestibule, where, typically, architectural elements stood athwart the view.

An outline at least of the Villa's overall plan existed from the beginning. The main, spinal underground service route, described above, connects the Residence area with the whole southeast quarter, suggesting that much if not all of the route was in place to facilitate early work (on this reading the Underground Galleries, intended for a different use later on, were for the time being simply a link in the extended system). Tunnels muffle sound. Pozzolana was used from the start in nearly every stage of construction; even if it didn't come from the southeast cave, the corridor facilitated bringing building materials in from the south, away from the Via Tiburtina approaches. Large-scale ground preparation and terracing takes time—sometimes more than that needed to erect a building complex on a terrace. And terraces make serviceable builders' yards. At

least one main water-line was needed from the start (assuming none was in place already, that the earlier villa depended on its ample cisterns; even if there was an existing line it wouldn't have been adequate for Hadrian's long-range purposes). No great building site can be without supplies, access routes, yards, water, drainage, and workers' facilities. Not to have thought these matters out beforehand is unlikely. This is not to say that everything was necessarily fixed from the beginning, but a core plan, related to terrain, water supply, and the positioning of the Residence was needed. If we assume that Hadrian acquired the land in order to build on it, not just to renovate the older villa, then as soon as the extended site was surveyed and studied, essential planning decisions would have to be made and preliminary matériel calculations begun.

In seeking explanations of the Villa's disorderly pattern, it is useful to separate for a moment its chief enclosures—buildings, peristyles, and courts—from intervening areas. It is the enclosures' independence from each other on the plan, a detachment sometimes approaching isolation, that catches the eye. In addition to their inherent functions (not always declared by external appearances), such as dining or repose or taking in the view, they were also objectives, outstanding fixed points or goals within a stroller's garden landscape. Some enclosures turned their backs on the Villa at large. Some are architectural cages, riddled with windows, or with column screens in place of certain walls, or both. Either way, the change when passing from open ground into an enclosure was strongly marked and often enhanced by an entrance passage or door small in contrast to the structure itself.

The evidence suggests that the Villa plan was in fair part derived from the creation of specific experiential effects, deliberate plays of contrast between nearby buildings and among the open, half-open, and enclosed spaces enchained for diversion of the senses. Perhaps these effects were not predetermined, but their presence in earlier Roman design makes it probable that they were. In the ancient atrium house, for example, sequences of light and shade are regularly found along the central axis running from the street entrance to the rear court or peristyle. Carefully calculated approaches, in which the full effect of the final, major feature is masked until it is in fact reached, are recorded in many monuments, among them the sanctuary at Palestrina and the Pantheon. In circumnavigating the Residence the differences in forms and spaces, as one building succeeded another, would be strongly stated, not the least because of varying light sources and patterned, multicolored surfaces. In such terms there is a wholeness to the Villa, a consistency of concept, although these serial experiences of strongly contrasting surroundings, effectively and sometimes climactically arranged, contribute to the apparent disorder.

For these experiences to be the more effective, most principal enclosures were set apart. Gardens and terraces in the intervening spaces functioned as transitional areas as well as pleasurable locations in their own right. There, under the open sky, in the presence of the Villa's broad expanse and with views perhaps of the Campagna and the mountains, a sensation was induced of spatial amplitude in strong contrast to the affective qualities of the built enclosures.

Thus in some degree the overall plan can be explained. Its orientation is that of terrain marked out by the valleys. The southwest flank, like that of Italy's west coast, is the winter side, facing the sunset and its afterglow. During the early morning hours of summer, the mountains keep the sun from the northeast flank. The irregular architectural configurations are due in part to a need for intermittency, for effective, contrasting settings for sophisticated buildings. The terrain explains most of the conflicting axes and their oblique juxtapositions, while architectural experiment often accounts for erratically shaped, leftover spaces between buildings. Some lengthy and influential plan-lines exist, such as those determined by the early villa's central axis or the long reach, with its several collateral events, from the East-West Terrace to the Scenic Triclinium. And it may not be coincidence that the long axis of the Arcaded Triclinium, when extended eastward, aligns with the center point of the Water Court southwest hall of reverse-curve plan.

Overriding rectilinearity, by disclosing immediately

24 *Villa zones*

24

25 *(opposite, top) Hall of the Cubicles, Portico Suite, and East Belvedere, plan*

26 *(opposite, bottom) Aerial view of the Residence and surrounding structures (1961)*

the Villa's underlying organization and therefore the nature of interbuilding relations, would have defeated Hadrian's purpose. A monumental central building, implying hierarchies of forms and spaces and therefore a scale of values, would have done the same. Instead, the Villa was conceived as an aggregation of artistic and functional elements in settings first open, then closed, a kind of three-dimensional parataxis. This objective was much aided by the terrain, whose essential role in forming the Villa's character is brought home by imagining the Villa set down on a large, level space—an otherwise building-free Campus Martius, say, or a modern metropolitan airport. The disorderly order of the Villa was intimated in the planning of such estates as the Domus Aurea and that at Val Catena. But in extent and complexity Hadrian's creation superseded them all.

READING THE PLAN

Although envisioning the Villa plan as the sum of several grand parts surely violates Hadrian's intentions, it does help to make sense of his extended, irregular composition. The divisions described here are simply conveniences, suggested because internal features such as axial cohesion or topographical continuity differentiate one area sufficiently from the others. Our boundaries are artificial: they do not represent barriers, nor do they suggest sequences of construction. Of course putting all these divisions together won't produce the original overall plan because excavation is incomplete.

Our seemingly awkward choices are justifiable. The bisection of the East Terraces is effected in fact by the interposition of the East Belvedere between their northern and southern reaches, and the Central Service

Building is included in two divisions because its upper-most story belongs to the high ground of the Upper Park, whereas the structure below faces the opposite way and serves a different purpose. In addition, the Service Quarters are divided where they change direction to the southwest.

I. The Residential Core. Neither Hadrian's alterations and additions to the old villa (described above) nor his new Ceremonial Precinct deviate from the axial directives set out long before. The result is a clearly defined, compact assembly of rectangular features, an island of largely predictable and well-mannered architectural events in sharp contrast with the varied directionality and unusual plan-shapes of adjacent buildings. The longer axis of this division is almost parallel to the median northwest-southeast axis of the Villa overall.

II. Beside the Residential Core. Most of these buildings and spaces, except the North Service Building, lie more or less at the level of the Residence Quadrangle and thus well below the Residence. The orientation and right-angled clarity of the Residence plan are repeated
25 in the new buildings by its north corner—the Hall of the Cubicles, the Portico Suite, the East Belvedere—and in the outlines of the adjacent East Terraces. But elsewhere the situation is radically different, for the
26 other structures beside the core ignore the plan-lines of the Residence completely. These other structures extend from the North Service Building clockwise around to the Portico Suite's boundary wall. They share a generalized northerly orientation (the Heliocaminus Baths long axis parallels that of the Fountain Court West), in strong diagonal opposition to the core plan. Each building touches or nearly touches the core's perimeter but is an independent entity, a condition emphasized by the striking differences among the individual designs. No geometrical planning principle governs the locations of these buildings, so the open spaces between them can be very oddly shaped.

The core and its perimeter buildings are contemporary in the sense that all Hadrianic work there was done between 118 and 125, save for the Ceremonial Precinct, built later on. Hadrian was in Italy from 118 until 121,

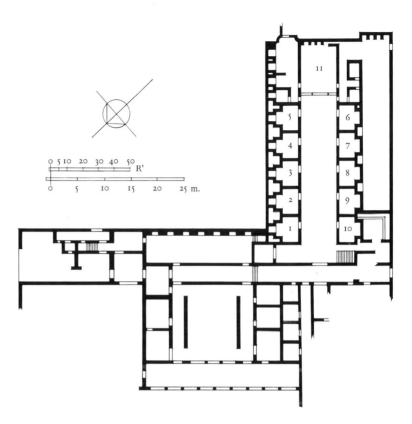

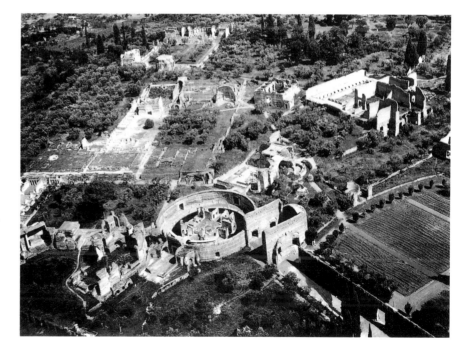

and during that time the Residence renovations were pursued and the placement and design of the new buildings presumably approved, if not actually prepared, by him; construction began before his departure. Observed together, these earliest Villa works—the Residence and the wholly new structures beside it—are good guides toward understanding the Villa's overall plan insofar as it is known.

Traditional architecture is not abandoned but is mixed in with original, often radically original, buildings. The North Service Building is a plain, utilitarian affair as its plan reveals, closely related to similar column-less structures in Rome and above all at Ostia. The Heliocaminus Baths, whose plan outline may seem extravagantly irregular, are typical of a fairly large group of boldly asymmetrical Roman bath buildings of moderate size with very tightly organized spaces, whose southwest flanks were designed to take maximum advantage of the afternoon sun in winter; Hadrian's building may be an early example. The plans of the Hall of the Cubicles and Portico Suite at first appear familiar, partly because of their rational organization, but exploration reveals innovations. Then there are the brilliant

plans and spatial complexities of the Island Enclosure and the two Fountain Court buildings, all unique, as far as we know, in Roman architecture. And the backdrop to all this is the largely traditional experience of the Residence and its Quadrangle, which, recalled as one entered the new buildings, would have seemed staid and predictable. Further afield, unfamiliar architecture often appears beside traditional work—the Smaller Baths next to the Larger, for example, or the becolumned Scenic Canal flanked by its parallel Block.

Each building beside the Residential Core is set clearly apart from its neighbors, except for the Hall of the Cubicles (more independent of the Quadrangle and the Portico Suite than the plan suggests). Connective stairs and corridors exist, but they are largely conveniences external to the buildings proper. The rational building mass of traditional architecture gives way to designs, for varied functions and experiences, irrationally positioned at irregular intervals; there are almost no party walls. The nature and effects of these buildings thus derive from both their plans and elevations and from their indifference to their neighbors. Common at the Villa, this urge to make independent architectural statements, most with their own open ground around them, determines the character of the overall plan as much as the jackstraw pattern of the terrain-inspired oblique axes.

These two practices may not exactly be principles, but they contribute powerfully to the controlled looseness, the tight scattering of buildings, that makes the Villa plan so unusual. Because of them, the profusion of invention is emphasized: the dozen or so great buildings almost all stand alone, apart but not truly isolated, each one of a kind. The Fountain Court and its buildings are instructive. The two buildings are constructed on divergent axes and separated by the bulk of the pre-existing nymphaeum. The forward border of the Court is canted, perhaps in response to the line of the West Building's north face. A long, narrow canal, parallel to the border, joins shallow octagonal fountain basins set just east of the two buildings' centerlines. A small west section of the Court lies below the rest, at the level of the projecting north entrance of the Island Enclosure that eases

27 *Fountain Court, plan*

0 10 50 100
⊢⊣⊢⊣⊢⊣⊢⊣⊢⊣⊢⊣⊢⊣ R'
 5 10 15 20 25 30 m.

past the Quadrangle west corner, independent of the tall West Building rising beside it (the Enclosure and the West Building are connected by a switchback stair system reached through an inconspicuous doorway in the Enclosure ring wall). Though the Court plan is irregular, its identity is confirmed by the forward wall, the canal and its fountains, and a slightly raised, broad walkway running along the inner face of the asymmetrical re-entrant space between the two clearly separated Court Buildings.

III. The Northern Group. The East Terraces north of the residential core and its surroundings divide into two parts. One, roughly U-shaped, begins at the foot of the Fountain Court boundary wall and the Portico Suite (the north face of the wall, with its twenty-four niches, double stairs in the middle, abuts a nymphaeum facing the Island Enclosure entrance hall). At the curved northern end, stairs descend beside a well-preserved cistern to the Doric Temple Area level; buttressing of the curved retaining wall survives not far to the south. The second part lies beside the first, at a lower level but well above the East Valley, and extends from the East Belvedere to the Doric Temple; its north face meets the sheer drop in front of the Doric Temple at a right angle. Near the curving wall a stretch of the underground arterial road is visible; both the road and the nymphaeum below the Temple have recently been partly restored.

The Temple stood in a semicircular precinct whose chord is in effect the edge of the sheer east wall just mentioned and whose curve is expanded by apsidal extensions set out from the center of the Temple. The original effect, obscured by the Casino Fede, was probably intended to evoke the temple promontory at Knidos, where an open tholos contained Praxiteles' celebrated statue of Aphrodite. The Villa building has been partially but somewhat inaccurately restored.

Just northeast of the Temple, but much lower down, are the Northern Ruins, heavily overgrown and difficult to understand. They consist of a large cluster of buildings of varying plans suggesting utilitarian, perhaps military functions. To the west, the North Theatre is built into rising ground (a second, "Latin" theatre, shown on older plans just east of the Ruins, never

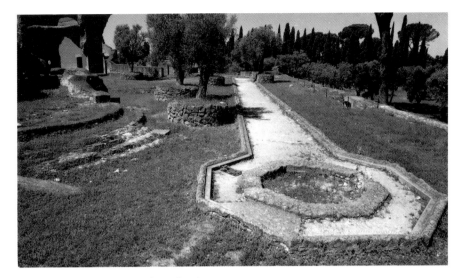

28 *Fountain Court, looking southwest (1987)*

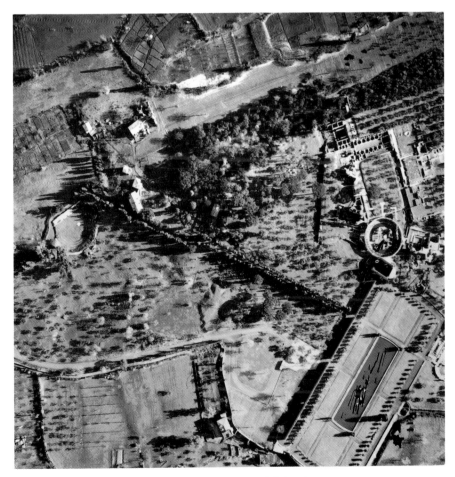

29 *Aerial view of the Northern Ruins, North Theatre at center left (1964)*

30 *Fountain Court, north wall,*
looking southwest (1987)

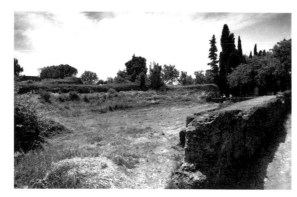

31 *Nymphaeum below the Doric*
Temple, and the Casino Fede
(left) and the Northern Ruins,
looking west (early 1900s)

32 *North Theatre, stage building*
to the right, looking west (1987)

existed). Piranesi includes a huge courtyard extending from the Theatre's west flank, but nothing is visible there today. The Theatre stage, with its undercroft, and the bowl of the cavea, are fairly well preserved. The Bog, now dry, lies about 300 meters northwest of the Theatre; a huge cache of Villa marbles was found in it in the eighteenth century.

Other than the dramatic setting of the Temple and the size and positioning of the Terraces, little here contributes to plan analysis. The Theatre axis (parallel to that of the southern main block of the Ruins) provides for maximum afternoon illumination of the stage and a corresponding degree of comfort for the spectators.

IV. The East-West Group. Orthogonal overall, the group divides naturally into two parts. The first comprises the Apsidal Hall, the immense East-West Terrace—about 230 meters long—the Ambulatory Wall flanking the Terrace, and that part of the Service Quarters supporting the western and southern rims of the Terrace overlooking the West Valley. The second part consists of the ensemble, of distinctive cross-shaped plan, of the Arcaded Triclinium, Stadium Garden, and Peristyle Pool Building (elevated prominently above the other buildings). At its highest level, the Peristyle Pool Building has a large pool, surrounded by a walled-in peristyle with a cryptoportico below; of the contiguous structure to the west, the lower portion belongs functionally to the Stadium Garden, which lies at about the same level as the Triclinium and the Terrace. Evidence for changes in plan during construction is widespread throughout the group.

Connections with neighboring buildings were limited primarily to small openings and modest corridors, and the Apsidal Hall appears in plan to be merely a transitional space between the vast Terrace and the Island Enclosure. No entrance to the Peristyle Pool Building is clearly declared, and the upper level, gained only by minor staircases, was sequestered behind lofty walls, like the Island Enclosure. When the Smaller Baths were built, later on, no access was provided from the Stadium Garden; a maintenance corridor entered from the Baths walled courtyard doesn't count. At the other end of the Stadium, the Heliocaminus Baths, on higher ground,

see 337

ignore its presence. But the Arcaded Triclinium is open
to both the East-West and Angled Terraces; the perime-
ter of the Angled Terrace is determined, like that of the
Fountain Court, largely by the outlines of independent
buildings — the Arcaded Triclinium and Smaller Baths.
A courtyard garden was placed between these two at
some stage.

33 *V. The Angled Extension.* From the East-West Ter-
race to the Scenic Triclinium a 460-meter axis deter-
mines the orientation of the two Baths, the Central
Vestibule, the Canal Block, and the Scenic Canal and
Triclinium; the long axis of the Central Service Building
and the line of the Upper Park west wall deviate from
this directive only slightly. The two Baths, their hot
rooms facing southwest, form a T-shaped cluster with
the Vestibule but share no common ground with it. Be-
hind the Larger Baths, the steeply rising ground was cut
back to provide an exercise court, whose eastern side
is lined by a cryptoportico joined to other underground
passages.

The Vestibule, a huge complex 115 meters long, with
its own multilevel subterranean system and connec-

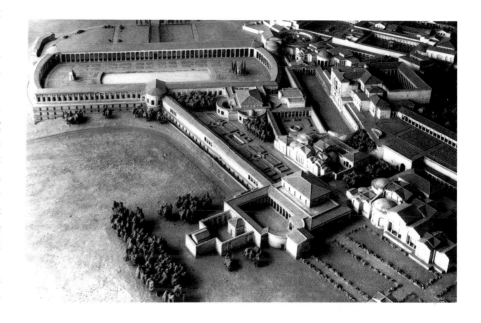

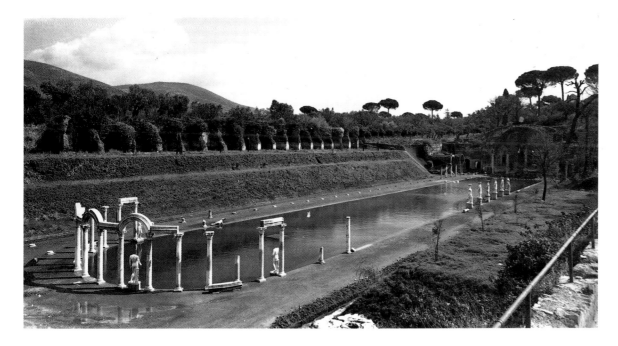

33 *Model showing the Central
Vestibule and Angled Terrace and
their environs, looking north*

34 *Scenic Canal, with the
buttressed Upper Park wall
beyond, looking southeast (1970s)*

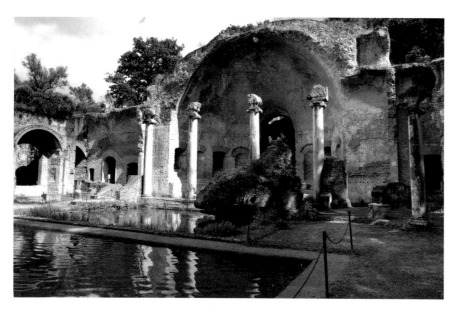

35 *Scenic Triclinium, looking southeast (1987)*

tunnel-like deep into the precipitous hillside. Staircases connect with the high ground, on both sides of the Triclinium and at either end of the Service Buildings. The huge terraces flanking the Canal and Triclinium, invisible from below, are the most independent Villa features, largely walled off and with the exception of the Southern Range not much built over.

VI. The Southwest Axis. This comprises the West Belvedere, the vast, walled West Terrace, 305 meters long, and the Southern Range. From the Belvedere the land falls slowly but steadily to the level area beside the Service Quarters and the East-West Terrace, yet quite steeply to the West Valley floor nearby. Up on the Terrace the ground rises gently toward the Reverse-Curve Pavilion and beyond to the Southern Range, with its Circular Hall; these contours are not necessarily those of Hadrian. Nothing stands now on the Terrace.

Though the Belvedere has lost its deep, northwest porch and its crowning, tholos-like feature, a massive, domed lower story is well preserved. The tholos once rose well above Terrace level; stone footing-blocks for the columns survive. The Reverse-Curve Pavilion, with its rounded, projecting wings, is ruinous and overgrown. From it, on axis, a corridor ran to the baths and cisterns of the far part of the Southern Range. The walls of a large courtyard, lying beside the corridor, stand in part; beyond the courtyard to the north and northeast a dense constellation of small rooms nearly surrounds the Circular Hall (half of its wall stands) and its dependencies. The entire Range, splendidly sited above the valley, may have been an alternative residence.

Because the southeast corner of the Range angles south along the projected line of the Upper Park wall, the Park existed before the Southern Range was built; thus the southeast border of the Park, a wall of fountains, lies partly on ground the West Terrace wall would enclose had it been continued to the southeast, alongside the whole length of the Southern Range, toward the Underground Galleries.

As the Scenic Canal and Triclinium occupy a steeply defined declivity, so the West Terrace and the Southern Range lie on a long ridge above the West Valley, whose highest ground was appropriated for the South-

tions, is an ingenious example of Roman crossaxial planning. Ruinous, hard to read, it was achieved like the Arcaded Triclinium and the Stadium Garden by changing and extending an original, less elaborate structure. The angled extension's main axis passed through it, screened by columns and perhaps by wall segments all long since gone. To the southwest, the ground rises toward the West Belvedere, high above the West Valley; it also rises slightly to the southeast, toward the colonnaded rim of the Scenic Canal.

Leaving the Larger Baths on the left, one finds manmade and natural features converging on the broad, vaulted hood of the Scenic Triclinium in the distance. The repeated units of the long, low Canal Block (half of its ground floor is preserved) and the colonnaded walkway opposite both suggest forward motion. The Canal itself, 121.40 meters long and 18.65 wide, does also, an impetus reinforced by the buttressed Upper Park wall, high up on the left, and the reshaped, steep, but terraced slopes of the draw. The Triclinium, the terminal feature of this elaborate composition, is cradled in the high ground around and beside it. Twin pavilions flanked a reflecting pool just in front of the great vault (partly fallen); behind it, a wide axial recess runs

34
35

ern Range — the Reverse-Curve Pavilion, Circular Hall, baths, and numerous courts and rooms. The elongated Terrace, free of substantial buildings, framed, northwest from the Pavilion, views of spectacular scenery, with the Belvedere tholos silhouetted in the middle distance.

VII. The High Ground. This huge area includes the Upper Park and its buildings, the Underground Galleries, and the Southern Theatre and Hall. The Park's eastern border is intimated by a ruined wall lying on the East Valley side of the Park Rotunda and the Platform Structure; its shorter sides fall along the lines of the Central Service Building and the fountain wall just mentioned. The Rotunda's structural core is preserved, as are the Platform Structure's northern underpinnings; the essential elements of the Park Grotto, including its long approach path — which slopes gently downward toward the sunken Grotto proper — are visible. What remains of the Hall lies underground; of the Theatre the stage building's structural core is well preserved and part of the circular shrine atop the auditorium still stands.

The Underground Galleries, broken open on the north side, are well preserved but dangerous and inaccessible. The Galleries are connected with the long, subterranean trans-Villa artery of which they are a component, and from them branches give off to the Southern Gallery and Hall and the Southern Range. The Park surface rises slightly toward the Galleries, where the terrain is nearly level, and past them it falls somewhat to the south over the approximately 370 meters separating it from the Southernmost Ruins, whose chief features are a heavily buttressed terrace wall and an east-west ambulatory whose curving ends can be made out. Nearby wall fragments are reported, and a few aqueduct arches survive between the terrace and the Galleries. Conditions across all the High Ground are such that discussion of function and meaning must be largely speculative.

VIII. The Water Court Area. The Water Court, with its unusual vestibule and internal waterworks, was added after the Residence and its surrounding buildings were finished; it is more or less contemporary with the Ceremonial Precinct. The Court is justly famous, but its adjacent eastern structures are also worth study. One reached the Court from the Residence by walking up rising ground past the Fountains (through a corridor?) toward the southeast, or from the East Terraces by way of passages and stairs off the north Court corner. The underground artery skirts the east edge of the area, and from it a branch runs southwest under the vestibule. Beyond the line of the artery the ground falls steeply to the East Valley floor.

The 100-meter main axis veers away slightly from that of the Residence. On site plans the Water Court appears isolated (because the ground to the south and west is unexcavated), an effect emphasized by its triple enclosure and the rounded volumes at the ends of the main axis. A reservoir stands outside the south corner, and a number of unexplored rooms branch off the east corner and beyond, between the Court and the Ceremonial Precinct. Hard by the north corner, at Court

36

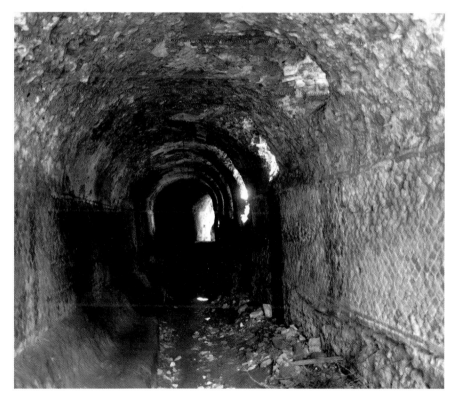

36 *Subterranean road below the Water Court, looking northwest (1991)*

level, facing the Valley, is a major nymphaeum with a pool and indications of a balcony; below this level lie numerous rooms to the north and south, and between them, an oval arena (*ludus*), with seats.

Openings in the outer Court wall are not obvious; it was a secluded place. Within the central area an axial water channel separated planted areas; beyond lay a centralized chamber with fountains enveloped by sinuous colonnades and backed by a wide, curving nymphaeum, all flanked transversely by duplicate rectangular rooms. The Court epitomizes that spatial internalization common at the Villa: from the unique domical vestibule to the nymphaeum, by way of bordering, covered walkways, the visitor experienced a private world of waterworks, gardens, art, and architecture, an interior landscape of ordered and regulated nature. But just outside the high northeast wall lie wide views of the Valley and the landscape to the north and east.

III

Familiar Architecture

The Villa records both the principles and the potential of classical architecture. The long evolution of Greco-Roman design—from the Doric mode to the multichambered Roman baths, from the colonnade to the dome—is, so to speak, passed in review. Many Roman building types can be seen. But side by side with these familiar forms strikingly original buildings confidently carry the dynamic of classical architecture into territory previously unexplored. The creative impulse in Roman architecture is revealed more fully here than anywhere else.

Even so, every Villa building is fashioned from such traditional parts as columns, arches, and vaults. Those that may seem to be new have roots in earlier work; the tall, slender pillars of the Ceremonial Precinct, for example, can be seen in older villas and at Pompeii, and the Villa's famous scalloped vaults are foreshadowed by the segmented ones of the Tabularium and Nero's and Domitian's palaces. Since almost no new basic design features appear, and since almost all the structural techniques used have sound pedigrees, architectural innovation at the Villa is based entirely on deploying and combining familiar classical forms in unprecedented ways. Not all Villa buildings use the entire classical repertory. At one end of the spectrum are such starkly utilitarian structures as the Service Buildings and Quarters, largely devoid of traditional trim and composed

almost entirely from walls and vaults. At the other end are elaborate, sophisticated buildings alive with classical devices, for example the Water Court and the Island Enclosure.

Villa architecture thus displays almost the full trajectory of Roman design — traditional, contemporary, and revolutionary — from the late Republic onward. Established architectural thinking can be read in a building that stands next to one of startling originality. For the historian and architect the Villa is a master text shot through with surprises, the only surviving place of its kind, a document without equal. An even moderately detailed second-century description of it, had such a thing existed and survived, would long ago have supplanted a fair part of the conservative treatise on classical architecture Vitruvius wrote a century and a half before Hadrian became emperor.

ESTABLISHED THEMES

Trajan was a major builder. Rome's last forum with its adjacent monuments, the elaborate baths on the Esquiline hill, and an entirely new port and emporium beside the Tiber mouth, among other works, all arose in little more than a decade. But when he left Rome for the east in 113, never to return, large-scale work ceased, in part because his distant Parthian campaigns were so costly. His architects and builders — some surely veterans also of Domitian's ambitious projects of the 80s and 90s on the Palatine and elsewhere — were not long idle, however, for in a very few years they were at work for Hadrian.

The new emperor renounced conquest and sought a peaceful world. From this, and from Hadrian's strong artistic interests, architecture and art benefited greatly. Resources previously absorbed by warfare might now revert to public works, and the lines of communication and supply that brought building materials and specialists (some with new ideas and methods) to Rome functioned unhindered. The tempo of Tiber-side brickmaking quickened greatly; quarrying, shipping, and dressing marble were major trans-Mediterranean enterprises. Laborers and craftsmen were in plentiful supply,

for part of Hadrian's monumental building program in the capital began at least as early as 118. In 120 huge buildings were well under way, soon to be joined by the largest building project ever undertaken in the capital, the emperor's new mausoleum. By then the Villa was growing rapidly.

Under these conditions proven, well-established ways of making and finishing buildings could hardly be abandoned, so Villa architecture is laden with familiar features from the past. Of course the basic architectural character of several kinds of buildings, such as theatres or libraries, had already been stabilized along largely functional lines. Here it may be useful to examine certain habits of design, signatures of High Empire architecture, seen throughout the Villa. Like vaults and columns part of the architect's stock-in-trade, these themes are also essential instruments of Roman imagery and effects.

Building plans are fashioned almost entirely from squares and other rectangles and of circles and circular curves; eccentric, irregular forms are rare. Structures with simple, single-shape plans exist at the Villa — freestanding round buildings, for example, or terraces and peristyles — but most of the buildings rise from plans of greater complexity. Rectangles of different shapes may be arranged along a single axis (with due attention to tranverse opportunities), as at the Ceremonial see 22 Precinct and the Stadium Garden, or they can be laid see 87 out in parallel rows, as within the Portico Suite or the see 25 Central Vestibule. Where a plan is generated from a see 19 single, central point and the design potential inherent in radiality is developed, as for example at the Water see 114 Court nymphaeum chamber or the Island Enclosure, see 95 the results point toward a new kind of architecture. In some cases several circles are used, as in the planning of the Smaller Baths or the Reverse-Curve Pavilion, where see 106, 111 circles underlie precocious spatial compositions.

Much in Villa planning, as in Roman planning generally, evolves from the shape and inherent properties of the square. Square rooms are common, as for instance in the Larger Baths or the Fountain Court buildings. The see 81, 76, 91 larger, western court of the Central Vestibule, expanded see 19 to the south by an exedra, is square, and the central

see 125

feature of the Arcaded Triclinium is based on a square figure, though the results are somewhat askew. Double squares show up, as in the rectangle of the East-West Terrace, one side of which is formed by the Ambulatory Wall, or that of the platform of the temple, recorded by Piranesi, that once stood beside the Service Quarters. Grids of 5-foot modules (1.47 meters on a side) are common, though one must be prepared to accommodate discrepancies, slight on the whole, resulting from Roman methods of laying out, constructing, and finishing buildings. So although a grid or dimensional ratio imposed today on a measured plan of a Villa structure may not exactly fit either the inside or the outside walls of the room or building in question, a near fit is a strong indication of the designer's working method.

As so often happens in classical and classicizing architecture, regular shapes somewhere between single and double squares are common. Ratios of width to length vary greatly. That of the arcaded enclosing wall of the Water Court is .83:1.00, of the rectangular portion of the Apsidal Hall about the same, .8:1.00. The common ratio based on the relation between the side of a square and its diagonal (1.00:1.414), that is, on $\sqrt{2}$, was used for example in laying out the Residence Quadrangle and the pillared main space of the Ceremonial Precinct. The celebrated ratio .618:1.00 (from the equality of the two ratios .618:1.00 and 1.00:1.618 — the golden section), determined plans such as those of the rounded-corner terrace alongside the east flank of the Residence, the outermost rectangle of the Peristyle Pool, and the huge court Piranesi records as extending northwest from the North Theatre. Both the $\sqrt{2}$ and .618 figures are easily laid out.

Smaller spaces range through the same widely varying ratios. Elevational ratios can be difficult to determine.

see 69

The diameter to height ratio of the Circular Hall was about .75:1.00, of the rectangular portion of its attic windows about .71:1.00, and its large doorways are two-square rectangles. At the Smaller Baths the mullioned west window of the large pool (room 18) was derived from a square overall; in the interior, many doorways are 5 feet wide but heights vary. Large spaces and important rooms are more likely to give evidence

of underlying modular grids and classical width-to-length ratios than lesser areas. Small rooms, as so often happens in architectural planning, are frequently the product of plan divisions determined by extensions and extrapolations from a central or other main space; the rooms laterally flanking the Water Court nymphaeum chamber are good examples of this, as are the forward, transverse, and relatively small-scale features of the Scenic Triclinium.

But rectangles, the square in particular, have other functions in Villa planning. One is that by inscribing a circle in a square, the square's centerlines can be used to position openings into the circle, and its sides can mediate relations between the circular form and adjacent structures or open spaces. The square's diagonals locate internal niches, and these secondary axes, when combined with the two primary ones, enliven a circular interior and give it its bearings, so to speak. These features can be seen in the circular rooms of the Smaller and Larger Baths, the ground floor space of the West see 106, 81 Belvedere, and to a degree in the Circular Hall with its multiple perforations. The elaborate dispositions of the plans of the Water Court nymphaeum chamber and the central platform of the Island Enclosure derive in part from this same integration of square and circle.

The division of rectangles into four or eight triangles was a staple of Roman planning and design, seen in railings (pictorial representations are common), paving patterns in mosaic and cut marble, and vault forms and vault decoration; even the bricks used to face walls of concrete are usually triangular, made by sawing square bricks into four triangles. But the influence and effect of triangles on architectural design can be seen even when they don't appear on plans. The Fountain Court West, see 91 for example, is laid out as two squares of different sizes set in line but distanced slightly — and ingeniously — by see 399 a narrow intervening passage, the whole rigorously orthogonal. But both of the square chambers were groin vaulted, and in the larger one the structural corner piers were brought forward, on the diagonals and under the vault lines, so that the arching canopy above, with its emphatically triangular divisions, was anchored visually as well as structurally in the supporting fabric

below. The proportionately large recesses of the small chamber intimate a cross-shaped plan, an implication more fully stated in the northern chamber of the Fountain Court East and carried to its logical conclusion see 76 in cross-shaped rooms found on the southeast side of the Northern Ruins and beside the Stadium Garden's eastern extension, up at Peristyle Pool level. In these last two spaces, the diagonal assertiveness of the inner angles of the cross is essential to the architectural effect.

Rectangular plan-shapes augmented by curved extensions appear throughout the Villa (as they do in imperial architecture generally): niches, apses, and exedras often as wide as the rectangles they adjoin. Surprisingly broad segmental curves are common, as at the Ceremonial Precinct, the Central Vestibule (two), and the large room or court beside the Circular Hall; these plans may have their own axial extensions, as in the case of the Central Vestibule north-south composition. Both ends of the East-West Terrace and the Smaller Baths large pool are segmental. And the large-scale Roman apsidal building standing free is represented at the Villa by the Scenic Triclinium, with its semidome and niches, a common plan-type, seen also in the triclinium-nymphaeum at the south corner of the Residence, the apsidal extensions of the Doric Temple Area semicircular court, and the nymphaeum above the Scenic Triclinium at the south end of the Upper Park wall; in Rome it appears on the upper level of the Domus Augustana, toward the Circus Maximus, as well as just northeast of the neighboring stadium garden, and on the Marble Plan of the city (beside the word Serapaeum) as well.

Columned porches of half-circular or nearly half-circular plan front the Fountain Court East and the structures flanking the Scenic Triclinium's reflecting pool. A kind of half-tholos, this device is also reflected in the planning of the Water Court nymphaeum chamber and the Reverse-Curve Pavilion; the Pavilion might be said to have eight such—four concave, four convex. Related planning is found at the north-end colonnade of the Scenic Canal and the exedras of the Arcaded Triclinium. A few other figures related to the circle are found at the Villa: the oval structure below and east of the Water Court, the half-moon shapes of the neighboring nymphaeum, the irregular octagons of the Heliocaminus and Smaller Baths, and the regular ones of the Water Court vestibule and nymphaeum chamber, among others.

The curvature of vaults, door and window openings, and so on needs no comment. But arcades do, because the Villa is advanced in this respect and has several types. Two are found at the Water Court: the blind arcade of the encircling wall and the responding pier arcade of the innermost rectangle. Inside the see 118 Court vestibule the lunettes, arranged on the octagonal plan, intimate the arcade that once encircled the see 116 exterior superstructure, its arches rising from projecting stone consoles. The arches of the Arcaded Triclinium were fashioned over semicircular plans. At the Scenic Canal the north colonnade entablature breaks up into arches, and the columns of the Scenic Triclinium facade carried a centered arch. Arches between the free-standing caryatids and sileni along the Canal west border have been suggested: in this scheme the sections of horizontal entablature once carried by the figures alternated with arches rising from granite columns set between the figures. Finally, it may be that a wide, arched opening stood in the middle of the East-West Terrace west colonnade, and perhaps the Larger Baths circular room opened to the west through arched windows set out on the circle's rim. The evidence for arches rising from curved plan-lines is part of the Villa's claim to attention; modern references to its avant-garde architectural status are not amiss.

Much has been written on the circle and the circular curve in architecture, on their focal, radial, seamless, and cosmological content. It is at the Villa that they come well forward in sophisticated architecture. In nymphaea and theatres, in niches and thermal chambers they are expected, but why does the great East-West Terrace have segmental ends? Who first ran columnar arcades along curves? Where do the reverse-curve plans of the Villa come from? The answer, broadly conceived, to all such questions, is that compass work increasingly fascinated the Roman architect, greatly stimulating his imagination and widening his design repertory, particularly as concrete construction was perfected, and

accepted, by master designers. New kinds of spaces appeared, spaces patrons came to expect. Furthermore, the use of circles to indicate powerfully the idea and location of a center (a major reason for the success of the dome), largely lacking in rectangular planning, suited both symbolic and practical needs of the age: the social focus of the wide, curving *stibadium* (a dining couch or divan) of the Scenic Triclinium, for example, resonated with the overarching, light-struck canopy above, the vault of Caesar's presence. Typically, the Romans recognized in a simple concept its potential for sophisticated development. What they accomplished with the curve parallels the advances they made by increasing the ways in which the orders were deployed and thus the fundamentals of classical design.

see 132

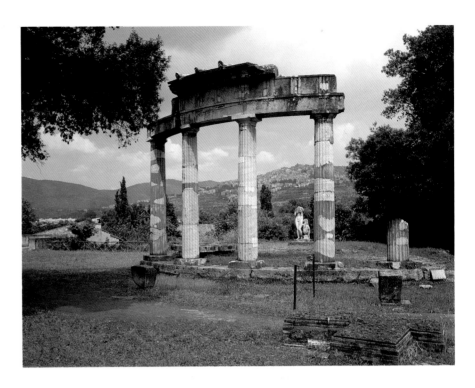

Quantification of the use of the orders at the Villa is impossible because little evidence other than indications of column positions survives. For what it is worth, about nine-tenths of the existing capitals and identifiable fragments are fairly evenly divided between Ionic and Corinthian. Rather more Doric work is seen than might be expected at a second-century imperial site, for in addition to the Doric Temple and West Belvedere tholos, Doric pieces lie about, for example at the Central Vestibule and atop the Central Service Building; others were seen in the vicinity of the Park Rotunda. The Ceremonial Precinct pillars (not limited to those in the basilica) are Roman Doric, as is a pillar fragment in the Smaller Baths. The Peristyle Pool Building order is Composite, that of the Water Court nymphaeum chamber Corinthian, but with the normal volute rotation reversed (its spiral is upside down, turning in toward the center of the capital rather than out and away from it) and the bell leafage blank. Spirally fluted shaft fragments survive in the Stadium Garden. Mixed orders appear in such individual buildings as the Island Enclosure and Larger Baths. Among the architectural fragments in the Museo Didattico are two Corinthian pilaster capitals of rosso antico, in very low relief, the descriptive lines lightly engraved in the stone, and seven small Ionic capitals (0.17 meters across) with unusual volute centers apparently derived from a many-sided Platonic solid, all cut in relief in white marble.

37
38

39

40

41

37 *Doric Temple, looking northeast (1987)*

38 *Central Vestibule, Doric fragment (1987)*

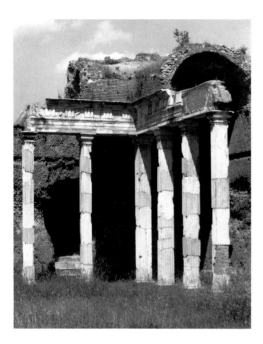

39 *Ceremonial Precinct, northeast corner, restoration (1988)*

40 *Peristyle Pool Building, columns at the northeast corner (1988)*

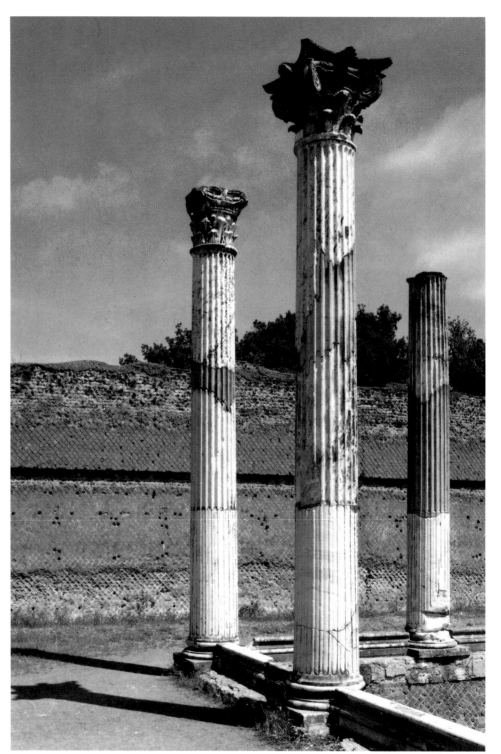

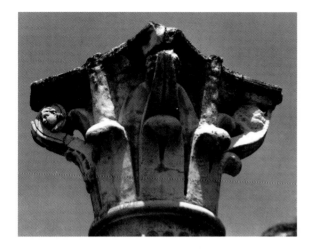

41 *Water Court nymphaeum capital and column base (1987)*

Pilasters are common; telltale bases and projecting concrete cores abound, as at the Stadium Garden. Pilasters divide the western, uppermost wall of the Central Service Building. Inside both the Circular Hall and the Water Court's arcaded wall, terracotta orders (later stuccoed over) three-quarters round project from the wall surfaces proper. Another nonstructural use of the orders, an essential aspect of high empire design, is scenic or decorative, the kind of employment given columns in elaborate stage and nymphaeum design. The curved, wide fountain of the Water Court nymphaeum chamber, with its seven alternating rectangular and curved niches, was decorated with eight small, freestanding columns of colored marble set tight to the back wall, beside the niches. The niche floors are well above pavement level, so the columns rose from tall pedestals of concrete (once faced with marble panels) carrying the carved marble blocks upon which the column bases sat. These columns were part of an elaborate marble enframement of the curving backdrop of the fountain and its pool, in the manner of innumerable scenic urban monuments across the empire. A variation on this theme places columns on stone consoles (common at the Villa) cantilevered out from a niched wall, as along the north facade of the Smaller Baths.

To envision the Villa's many colonnaded walkways requires effort. The most useful restoration is the partial one beside the Scenic Canal because it gives a good

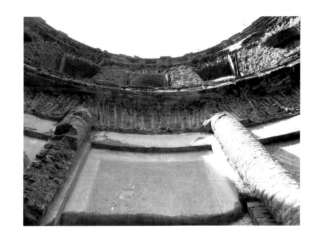

42 *Circular Hall, interior detail (1987)*

43 *Smaller Baths, exterior north wall (1987)*

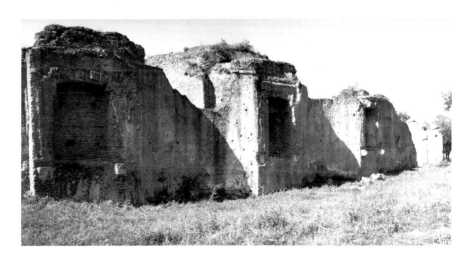

44 *Scenic Canal, east colonnaded walkway (1987)*

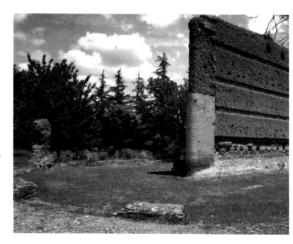

45 *Ambulatory Wall, west end turning curve with column positions (1987)*

idea of the colonnaded paths leading from one building or vantage point to another, the Villa equivalents of urban porticoes. These were not necessarily roofed; some were open-frame pergolas. But they were there, roofed or not, along the ambulatories, atop the terraces, and within the courtyards. Paintings of villas frequently show them, texts refer to them; and the ancient tradition of building long colonnaded, sheltering spaces and passageways had not in Hadrian's time lost momentum. At the Ambulatory Wall scores of column positions and socket holes for rafters are preserved: forty columns stood on each side, and from their entablatures tiled roofs some 200 meters long sloped upward to meet the centered, spinal Wall.

A versatile architectural device, adaptable to a variety of uses and plans, the colonnaded portico derives its artistic power from simple principles: steady repetition, and the resulting alternation of slender verticals, standing in the light, with larger, shaded voids. Within, the lighting during good weather changes steadily along the extended inside-outside space defined by the columns, wall, and roof. A screen, a filter, of lighter structure than space-enclosing architecture, a colonnade strongly alters the character of the building or terrain possessing it. Its even seriality marks off distance and space while providing a clearly organized setting for activity beside and within it; it is a visual module, a regulating presence.

All of the known Villa colonnades are level; ramping ones existed in Roman architecture, as at the Palestrina sanctuary, and the Villa terrain may have required some. In addition to straight and circular-curve plan alignments, one undulating pattern is known, that on the southwest rim of the outer, lunette-shaped pool of the nymphaeum just outside the Water Court north corner. Vitruvian intercolumniations — ratios of column diameters to spaces between columns — are found: 1:4 (araeostyle) at the Portico Suite inner row, 1:3 (diastyle) in the long south colonnades of the Stadium Garden, and 1:2 (systyle) along the east side of the Arcaded Triclinium central square, for example. But much spacing is non-Vitruvian, such as that of the Scenic Canal double colonnade (1:8.7, suggesting a pergola), or that

beside the rectangular north fountain of the Arcaded Triclinium (1:5.2).

Although the number of columns at the Villa is incalculable, any appraisal of Villa architecture must take into account the probability that the original figure was very large indeed. The Ambulatory Wall inner sequence continued around the East-West Terrace, a total of 152 columns for the two structures. Eighty-two stood around the Residence Quadrangle, and a similar number beside the Scenic Canal. The Water Court had 60 between its arcades, plus the 36 of the nymphacum chamber and its satellite spaces and the 8 of the vestibule interior, while the Peristyle Pool count is 40. Innumerable pilasters, colonnettes, and other nonstructural orders, some made of terracotta, stucco, or marble inlay, gave Villa architecture a rather more classical appearance, both inside and out, than its bare bones suggest today. And as the provision of garden and terrace colonnades is virtually certain, the visual contrast between buildings and open spaces, now so strong, would have been less obvious in Hadrian's day.

The duplication of design units other than the orders is common. Some schemes are simple—the cell-like spaces of the Canal Block, Service Quarters, and northeast side of the Residence. Those of the Hall of the Cubicles are more elaborate but follow the same principle, one seen repeatedly in Roman markets, streetside shops, warehouses, and other building types composed of the repeated linear duplication of a common spatial unit. A perhaps less obvious example is what might be called multiple enframement, which consists of surrounding the central core or space of a building with two or more concentric enclosures—walls or colonnades or arcades or combinations thereof—in the fashion of the building of Eumachia by the Forum in Pompeii. The Island Enclosure is the obvious example, but several orthogonal buildings follow the same principle: for example, the Peristyle Pool Building and the Water Court. The idea was also clearly stated in the Northern Ruins, Arcaded Triclinium, Stadium Garden, and Southern Hall. In some cases the resulting outer passageways accommodated service functions (as at the Water Court); in most the architect sought to exploit

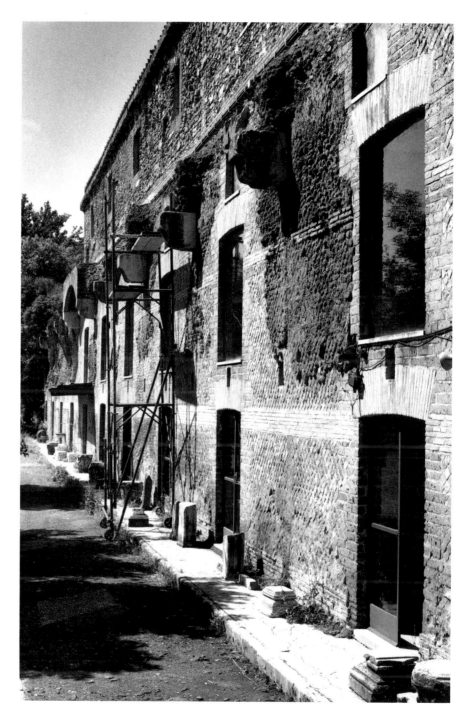

46 *Canal Block, facade looking south (1987)*

contrasts among walls, colonnades, and perhaps arcades. It is as if the lines of the multiplied mouldings enframing an inscription plaque or window had been transferred to building plans, where the results were much the same as those mouldings produce: redoubled emphasis on the shape and the very existence of the engirdled, central area. Upon entering such a building, one feels its underlying geometry and its spatial character more strongly than if only one wall or colonnade has been passed.

The importance of the five partly built-up, buttressed terraces has already been noted. Of these the largest by far is the Upper Park, which, measured from the Central Service Building to the east-west fountain wall north of the Underground Galleries, and across the mean distance between the Park wall above the Scenic Canal to that running from the Water Court to the Platform Structure (somewhat arbitrary but convenient boundaries), covers some 50,000 square meters. The Eastern Terraces enclose the next largest such area, about 24,000 square meters. The West Terrace follows with 20,000, then the East-West Terrace with approximately 19,000; the Angled Terrace covers a little less than 5,000. Taken together, these leveled surfaces account for almost a tenth of the Villa's total area, whose eastern and western boundaries they largely if intermittently define. As a result, few major buildings other than the Service Quarters and the Belvederes reach the valley rims. From almost any point in the Villa between the Doric Temple and the South Theatre, views across the valleys and beyond, from terraces planned in part for that purpose, were not far to seek.

Of the vast, mostly interconnected underground network only the cryptoporticoes fall under the heading of an established theme. The word cryptoporticus may have been invented by the younger Pliny, for it appears first in his *Letters*. He uses it three times, once when describing an elaborate version he built at his seaside villa: "[. . . from this place] a cryptoportico, large as a public building, extends. It has windows on both sides, but more on the seaside, for on the garden side they are in every other bay. On a fine, windless day all windows are open, and in bad weather those on the windless

side can be opened. In front is a terrace" Clearly this structure was largely, even entirely, above ground. Probably Pliny used the word crypta (an underground room) to show that his building was not a *porticus* (a colonnaded walkway), but walled and vaulted. Today the word cryptoportico is used chiefly to indicate either vaulted underground corridors joined in a rectangular plan, placed below a peristyle and lit by raking windows let into the vault haunches (less often by openings overhead), or a similar corridor set along the side or sides of a terrace or elevated building, with normal windows along one side; numerous pre-Hadrianic examples of both are preserved. (By extension, but incorrectly, the word is sometimes applied to other kinds of underground passages, not intended, like proper cryptoporticoes, primarily as strolling places protected from heat and bad weather; they might be used also for storage.) Three survive at the Villa structurally intact: the republican cryptoportico under the Residence, the one inside the Peristyle Pool Building, and that beside the Larger Baths, along the east face of the exercise court; all three connect with neighboring structures by underground passages.

The arterial north-south underground line, averaging 3 meters in width and thus suitable for wagons, that runs for some 1.6 kilometers from the Doric Temple Area to the Southernmost Ruins, via the Water Court, Upper Park, and Underground Galleries, has already been mentioned. It can be seen on government land, for example where it was broken through for the construction of the avenue of cypresses running north from the East-West Terrace, and near the northeastern corner of the East Terraces, where the vaulting has partly fallen in; another part can be examined by the north side of the Water Court. Extensions travel from the main artery to the Park Rotunda, the Southern Hall and beyond, the South Theatre, and the pozzolana pits noted earlier. Presumably the spur by the Water Court continued to the southwest; another strikes out from the Underground Galleries toward the Southern Range.

Pedestrian passageways run under the Central Vestibule and lead toward the Smaller and Larger Baths; others line the northeast perimeter of the West Terrace.

From the Terrace an extension led in the direction of the Central Vestibule; off that, in turn, a spur ran to the Canal Block. Another long stretch is preserved under the north face of the East Terraces; it proceeds from a point not far from the nymphaeum (recently partly restored) under the Doric Temple. Only part of the extensive water delivery and drainage system is known, but a total of some 4.8 kilometers of underground passages of various kinds have been tracked, some constructed, the rest tunneled. Finally, near the main artery, southeast of the Park Rotunda, is an unusual, multichambered underground storage facility; Penna gives a view of the interior. To a central corridor at least 60 meters long, at least twenty-one chambers, each about 5 meters deep and 1.2 wide, are joined more or less perpendicularly to the corridor, the whole cut from the living rock and lined with waterproof cement and intended for the storage of snow from the high Appenines through the summer.

The Underground Galleries, enclosing within the ground lines representing their inner boundaries 30,200 square meters, still preserve indications of seventy-odd oculuses, many of them still open; four were lost in a cave-in (or break-in) on the north side at some time unknown. This unusual lighting system calls attention to the large number of nonvertical openings elsewhere at the Villa—horizontal, raking, round, or rectangular. Many have been lost, but more than a hundred survive in a variety of building types and in the underground passageways. Familiar today in cryptoporticoes, circular bath building rooms, and the Pantheon, nonvertical windows were particularly attractive to Villa designers, who fashioned with them new ways of lighting interior spaces—another example of the exploration of previously undercapitalized possibilities inherent in concrete vaulting.

That technique, used throughout the Villa, was perfected in the half-century before Hadrian's accession. The quality of the work and of the materials is high; surviving pre- and post-Hadrianic construction and repairs stand out because the building techniques are different and the workmanship is almost always less orderly (recent restoration, however, is properly done).

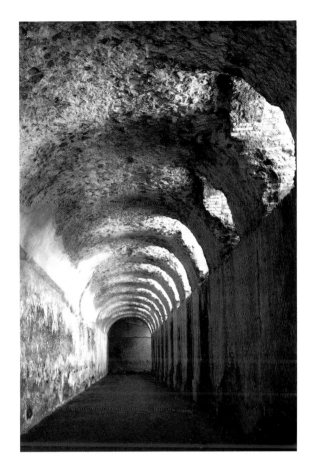

47 *Peristyle Pool Building, cryptoportico east gallery, looking south (1987)*

Hadrianic piers and walls throughout are laminated vertically: relatively thick cores of well-made concrete are faced with thin skins of brick or small stones or a combination of the two. Core and facings went up in stages, the facings acting to a degree as shuttering (formwork). As the work cured and dried, the mortar of the core married that of the facings, forming an extremely strong and durable rocklike fabric. The small facing stones were cut into pyramids from the local tufa and set horizontally, point-in, their bases forming network patterns (*opus reticulatum*, about ninety stones to the square meter); many large areas survive, though neither this stone skin nor brick facing was meant to take the weather. The Ambulatory Wall and North Service Building, for example, are faced largely with reticulate work, and a perfectly preserved, exactly

48 aligned stretch can be examined at the north end of the Smaller Baths open court.

All vaults were of unfaced concrete, all colonnade roofs (and those of some enclosed spaces) wood-framed see 128 and tiled over. Some evidence suggests roofs of flat concrete slabs. The prevalence of concrete does not rule out the possibility of comparatively lightweight architecture, particularly of superstructures, made of wood. The constructions necessary to erect complex vaults, to make trusses, cranes, huge waterwheels, and so on show how skillful the carpenters, joiners, and smiths were. Elaborate wood architecture and decoration would not have been beyond those who routinely made temporary but very powerful structures of wood, or out of the reach of specialists responsible for doors and doorframes, cabinets, furniture of rare materials, and other exactly crafted appointments.

Some Villa buildings are almost completely formulary, work any moderately competent architect and builder could successfully run up. Others are inventive reinterpretations of well-known building types. The remaining ones are truly original (for some there are no convincing analogues whatsoever). Yet Villa buildings are largely composed of established design elements, many well-worn and of considerable antiquity. By appraising these anew, and by deploying and assembling them in novel ways, Hadrian and his architects gave the Villa much of its unusual architectural quality.

48 *Smaller Baths, exercise court north wall, reticulate facing (1987)*

ORTHODOX BUILDINGS

These are buildings, such as theatres or temples, common in pre-Hadrianic architecture. Their functions are mostly evident, although simple types long used for various purposes—that of the Apsidal Hall, for ex- see 337 ample—may be exceptions, and some familiar forms, for instance the Canal Block, and perhaps the Park Rotunda, were adapted to new uses. Since Roman building typology is on the whole well understood, we emphasize features important in the context of the Villa rather than characteristics of individual types. Fountains and pools, luxury villa necessities, are discussed in chapter VI.

The Doric Temple and the East Valley rate serious 49 consideration as parts of the Villa that Hadrian named, if the HA passage is taken at face value, after "places most famous." The presumed architectural prototypes for other Villa buildings have long since disappeared, but in the case of the Doric Temple there are substantial possibilities. Julius Caesar in his gardens on the Quirinal hill, for example, had a circular temple to Venus-Aphrodite (from whom he claimed descent); it reflected the design of similar round shrines in the Greek east. At Knidos, on the southwestern Turkish coast, remains have been found of a Doric tholos that might be the temple described in an ancient text, an essay on love found today with the works of Lucian (second century) but written somewhat later. The writer gives a fairly detailed description of a famous old Aphrodite temple and its splendid gardens, as well as one of Praxiteles' celebrated statue of Aphrodite, which Knidos had purchased from Kos and placed in the temple; a Roman (presumably Hadrianic) replica of this statue has been found at the Villa where the Doric Temple stood. In spite of this, and in spite of the unquestionable similarity of the two buildings, some caution is necessary. The identification of the Knidos remains is debated, partly because the ancient description doesn't fit them very well and the ground around them is inadequate for the gardens "Lucian" so enjoyed. But if this particular Knidos building did indeed house Praxiteles' masterwork, direct connection with the Villa seems likely; if it didn't, the Doric Temple nevertheless belonged to

a demonstrable tradition of circular Doric shrines to Aphrodite.

In spite of the physical differences between the East Valley, stretching southeast from the Doric Temple, and the real Vale of Tempe, the Valley was almost certainly Hadrian's Tempe; only this and Hades, of the Villa places named in the HA, can in our opinion be identified with some confidence. Famous in antiquity, a spectacular natural wonder thought to have been rent in the earth by a seismic convulsion, and the scene of crucial historical events, Tempe is a narrow canyon about 8 kilometers long through which the Peneios flows to the sea, separating Olympus from Ossa. Strabo often mentions it and Ovid describes its "steep-wooded slopes . . . and cave of overhanging rock" toward the end of his moving account of Apollo and Daphne.

That Hadrian would find in the East Valley a memory of Tempe is not surprising, given the strength of the long tradition of naming luxury villa structures and grottoes and domestic sanctuaries after famous buildings and sites (he may also have had in mind the Tivoli cataracts with their superposed temples). To make the wide and attractive but relatively undramatic East Valley more like Tempe, the tufa escarpment was cut back, creating or emphasizing the overhang. And because a Spring of Aphrodite lies at one end of Tempe itself, it may be significant that at the Villa the Doric Temple, sheltering its statue of Venus-Aphrodite, rode above the elaborate nymphaeum set directly below it, down almost at Valley level. If this identification is correct, the passageway leading southeast from the Temple, mentioned above, together with the major structures outside the Water Court and the streamside ruins just to the south, could have comprised an extended route designed to induce something of the effect of passing alongside the original Tempe in Greece (not, however, without preserving an awareness of the revisionist quality of replication all luxury retreats depended on to display traditional cultural images in contemporary settings). That there was a route alongside the East Valley is certain; that it was essentially experiential seems confirmed by its Valleyside windows and the presence at the Villa of similar routes, as for example from the

49 *East Valley from the East Belvedere, looking south (1957)*

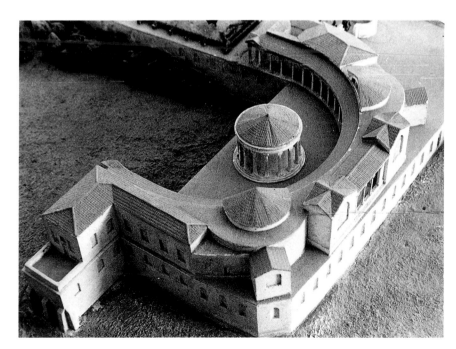

50 *Doric Temple Area, model, looking southeast (1968)*

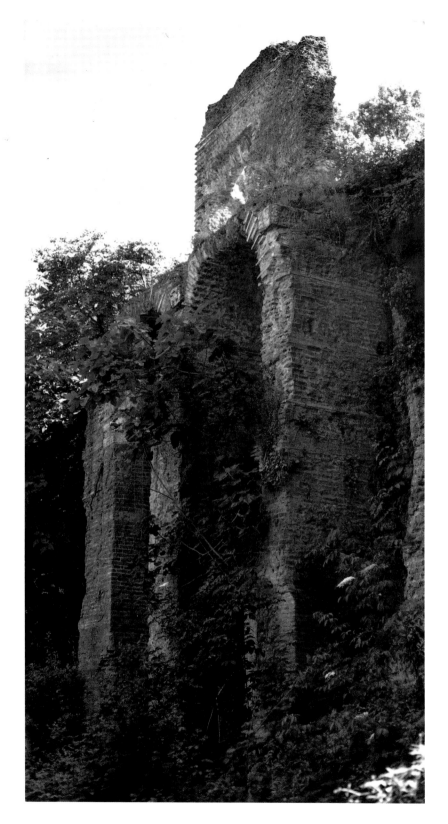

Central Vestibule to the Scenic Canal and Triclinium, or from the West Belvedere to the Reverse-Curve Pavilion. It is worth repeating that the Villa was a place where views and arrangements of natural and man-made forms often alluded to the mythical, literary, and historical past and that these views and arrangements were managed by carefully thought-out artistic mechanisms. The mental and sensory responses thus evoked emphasized the Villa's cultural content.

Each Valley had its viewing tower. The East Belvedere stands at the juncture of the northern, lower stretch of the East Terraces and the long, higher one to the southeast. The upper rooms and viewing platform were reached by a long stair rising from the northern Terrace or through a passageway behind the Portico Suite. The platform proper is supported by three tall spur walls joined at the top by barrel vaults. Of the West Belvedere only the ground-story central block survives. It once had a northwest porch, terminating in see 349 two broad niches (in the manner of the Pantheon portico) with a corbeled balcony above. The well-preserved domed room within the block was entered either from the porch or through side entrances; set about with niches, it may have centered on a fountain. This two-story design of a sturdy block carrying a tholos was a familiar theme, much used for tombs as well as for memorials, as for example at La Turbie, above Monte Carlo, of 7/6 B.C. Very probably the Villa had other towers, judging from the prominence of freestanding towers in paintings both of villa grounds and of idyllic landscapes.

The only known free-standing Villa temple, other than the Doric one (more a shrine than a proper temple), lay below and just south of the East-West Terrace. The outline of its raised platform, about 20 by 40 meters, excluding the access stairs, is that of a major structure. The platform fits the plausible restoration Piranesi makes by extrapolating a six-by-twelve-column building from some wall fragments visible in his day, producing a traditional Roman temple plan. The building's position and orientation are significant. Ranking visitors could see it first upon drawing abreast of the north end of the Service Quarters and then would face it di-

51

52

rectly, elevated above them somewhat, as the road to the Central Vestibule main entrance began to turn east. But what it stood for, what meaning it conveyed, other than a generalized religious one, is uncertain. Its dedication, if known, could be an invaluable clue to the religious content of the Villa; neither Piranesi's claim that it was a temple to Mars nor Egyptianizing sculpture fragments found nearby are conclusive.

Two shrines can be identified with confidence, the enclosed tempietto at the southeast end of the Central Vestibule and the circular building atop the South Theatre. The Vestibule building was probably a *lararium*, for the household spirits; another shrine would have been found in the Residence. Some of the many statues of gods and goddesses found at the Villa stood in shrine-like settings. Analogical evidence sometimes helps in assessing the probability that a specific type of shrine or setting would have been used for a given deity, but firm testimony for the original locations of most Villa statues is lacking (a serious limitation on interpretive studies). Adequate apsidal spaces with axially centered niches or blocklike statue bases, common at the Villa as in Roman architecture generally, readily invite identification as religious or quasi-religious locations. For example, the apsidal south chamber of the Fountain Court East and room 7 in the Smaller Baths may have been shrines.

In Hadrian's renovation and extension of the older villa, the private quarters of the Residence were located to the southwest, past the line of the stairs and corridor leading southeast from the Quadrangle into the Residence. On the other side of this line the architecture changes distinctly, bearing the earmarks of places for administration, for records and books, paperwork, and discussions: the Library, basilica, and cell-like offices (eleven can be identified; probably a second file lined the opposite side of the axial peristyle). Naturally the emperor would frequent this area, which was connected to the Residence Fountains area and thence with the Ceremonial Precinct. In the other direction, to the north, are the pergola or court set above the Residence Cryptoportico and the remains of what may be a bath, with a round lavatory chamber alongside. Much of this north-

53

see 22

54

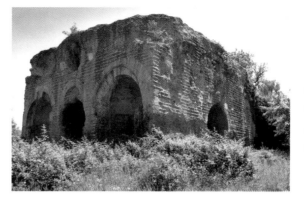

51 *(opposite) East Belvedere from below, looking south (1987)*

52 *West Belvedere, looking east (1987)*

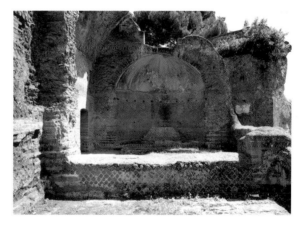

53 *Fountain Court East, interior and apse (1987)*

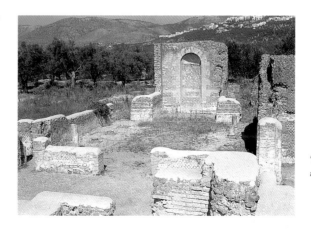

54 *Residence basilica, looking northeast (1962)*

ern area is interconnected by the underground corridors that branch off from the Cryptoportico. So we think that half or more of the Residence area was given over to staff personnel and their work; probably the Hall of the Cubicles, also accessible via the underground passageways, was party to the nonprivate area of the Residence.

These arrangements are significant, not only because they relate to Villa life but also because little is known of Roman architectural provisions for administrative functions, whether for a grand villa or for those centered on the emperor. It appears that administrative clerks worked in the chambers beside the peristyle and their superiors in the corner rooms there. The relation among the Library, the basilica, and their surroundings are typically Roman: an ingenious interconnection of outdoors and indoors is facilitated by passageways and interposed generous spaces, such as the one in front of the basilica. The Library, whose contents need not be thought solely administrative in nature, is entered only from the pergola because of its necessarily uninterrupted protective walls. It is tempting to think of the suite just to the west as that of the emperor's chief administrative officer, in part because the ruins suggest that it may have connected directly with the private quarter. We suspect that business, at the upper levels at least, was sometimes carried on while strolling: if this is correct, the pergola, peristyle, and Terraces were

integral parts of the functional as well as recreational planning of the Residence. These remarks relate to work performed under the emperor's eye; the balance would have been accommodated elsewhere, perhaps in the extensive Northern Ruins.

The Library is of standard design, of the kind found, for example, at what may be Trajan's Civitavecchia see 124 villa; indeed it is a reduced version of Trajan's libraries set beside his column and basilica in Rome. Its outline, determined by the old villa's tablinum, is emphasized in the interior by a step running around three sides. Eight rectangular niches contained the compartmentalized woodwork holding the scrolls; a single axial, curved niche in the back wall once enframed a statue. Paving-level base-stones for columns are preserved in front of the pierlike wall sections between the niches, completing an architectural type familiar around the Roman world. The basilica next door, too small to have been an audience hall, bears a schematic resemblance to the one in the Domus Flavia but from the point of view of typological evolution is more confidently managed. Its interior columns are proportionately further out from the side walls than those of the Flavia, and its deep rectangular terminal space, with its niche, more successfully emphasizes the building's long axis and thus perhaps the significance of a presiding image at the far end.

The five-room suite at the Residence east corner, described above as probably the emperor's own, is prefigured in Nero's and Domitian's palaces in Rome. At the Villa the principle is the same: five interconnected rooms, three facing a court, are symmetrically composed around the largest one, with transverse openings aligned across the whole. The Domus Aurea plan is more complicated than the Villa's and riddled with additional openings, but a basic planning idea is common to both places. At the Domus Augustana lower level, the scheme is more compact and more elaborate than that of the Domus Aurea. The transverse replication of rooms is gone, but the centered room with flanking chambers (now with narrow corridors intervening) remains the same. The scheme appears later at the Piazza Armerina see 239 villa, in the sophisticated private suite just south of the

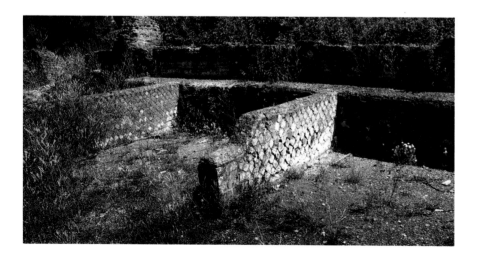

55 *Residence, northeast border cubicles, looking north (1987)*

basilica (a bit to the west, cell-like rooms are lined up beside the main peristyle, recalling the Villa).

The transverse enfilades are significant; each apartment has them. They are probably for security—they would simplify surveillance of those entering and leaving the rooms. If this is correct, and if we read the ruins directly opposite from Hadrian's suite properly, there is a second, smaller such apartment there, backed by the Ceremonial Precinct wall. The flanking chambers were fountains in the old villa, replaced by Hadrian with a huge one, the triclinium-nymphaeum, next door. This last may have influenced the design of the great Scenic Triclinium.

The Southern Range has been identified as a second residence, a place on higher ground to be used according to weather and season. The idea is attractive and probable, particularly since baths were seen there in the sixteenth century. It does not require imagination to see in the rooms along the north and east flanks of the courtyard the necessary imperial installations, and the duplication of the Central Precinct's broad southwestern room beside the Circular Hall is suggestive, as is the unique Reverse-Curve Pavilion at the edge of the West Terrace. It is difficult to resist the imperial implications of the Southern Range.

Of other known Villa dwellings, the Canal Block, Service Quarters, and Hall of the Cubicles remain. This is not to suggest that no one lived in the Service Buildings, but we think that they were used largely for storing goods and supplies and doubt that the North Service Building, so near the Residence, would only house servants and workers. The Canal Block is of familiar utilitarian design of the kind seen throughout Ostia (where half of what has been excavated is Hadrianic) and at the Markets of Trajan. The Block consists of two stories of thirty-odd shoplike chambers, with lavatories at either end of the building; the upper story faced west and gave onto higher ground. It was presumably intended for guests or for officials on duty with the emperor; the choice location, close to the Baths, the Scenic Canal and Triclinium, and the Central Vestibule, implies privilege, as do fragments of painting and mosaic and the comparative isolation of the upper rooms.

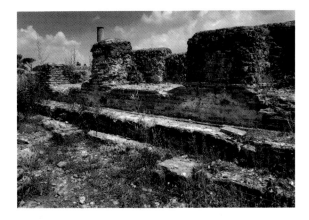

56 *Library, southeast wall, looking east (1987)*

57 *Residence, nymphaeum triclinium, looking east (1957)*

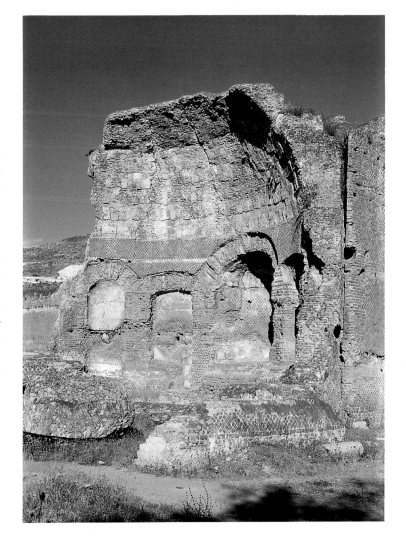

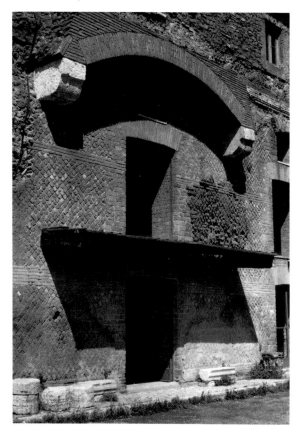

58 *Canal Block facade, detail looking west (1987)*

The Canal Block was a large cut above the Service Quarters, with their approximately two hundred rooms, mostly vaulted boxes. These are stacked two, three, and even four stories high, depending on the south-north fall of ground, underneath the edges of the Angled and East-West Terraces; the maximum known number of rooms at any one level is about sixty. Of typically Roman functional design, these structures do double duty by supporting the Terraces while providing rough but adequate living spaces. Stair stacks and lavatories survive; some may be missing, for up to perhaps seven hundred persons could be quartered here. No doubt there were other provisions for Villa servants, workers, and slaves—off the northwest corner of the Service Quarters or in the Northern Ruins, or in other places yet unidentified.

The Service Buildings, largely unadorned, are also orthodox functional works. The North Service Building plan is almost exactly like that of a structure at the Civitavecchia site: a broad central corridor or hall is flanked by facing rooms (six in all at both sites), with a transverse corridor at the end, a warehouse configuration. The Central Service Building (dual purpose like the Service Quarters) supported and buttressed the

59
see 346
60
61
see 22
see 348
62, see 338
63

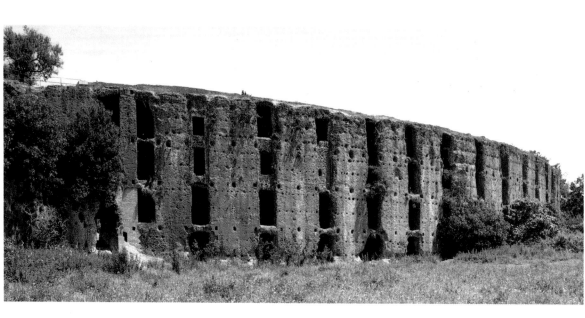

59 *Service Quarters under the East-West Terrace west rim, looking east (1987)*

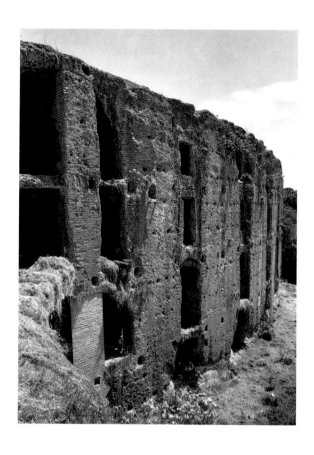

60 *(top left) Service Quarters, looking south (1987)*

61 *(top right) Service Quarters under the Angled and East-West Terraces, looking north (Penna no. 81)*

62 *(bottom left) Central Service Building, looking southeast (1987)*

63 *(bottom right) Central Service Building, ground-floor plan*

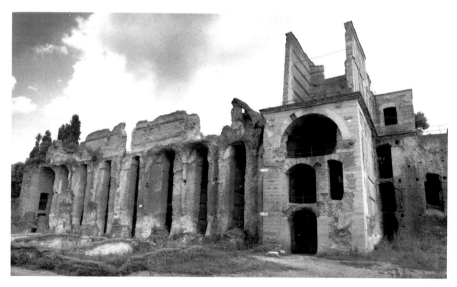

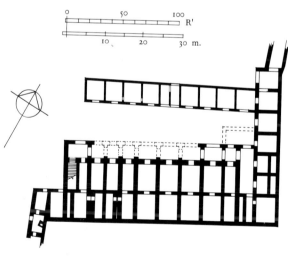

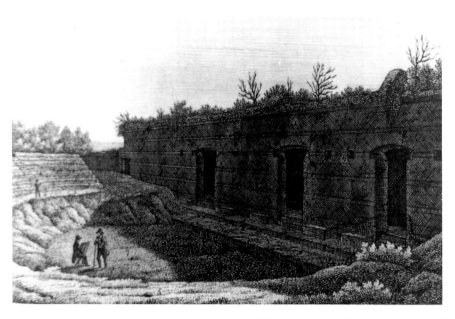

64 *South Theatre, interior, looking west (Penna no. 115)*

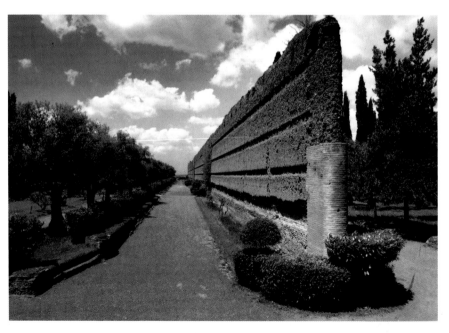

65 *Ambulatory Wall, south face, looking west (1987); seven laps =*
one Roman mile

Upper Park north rim and contained, on three levels, about twenty-five deep chambers, set one behind the other, in pairs, north-south. An internal switchback staircase at the west end joins the levels; on the east a wide external stair leads up to the Park. In front of the clifflike building, which bears some resemblance to the Temple of Venus and Rome platform and the elevations of large Ostian *insula* courtyards, lies a row of *taberna*-like chambers. Once partly two stories high, the row is almost parallel to the Building's main axis, with a lavatory in the middle. Not the least interesting aspect of Villa design is that these four plain, unclassical structures—Canal Block, Service Quarters, and North and Central Service Buildings—were set down among such contrasting forms. Though they were utilitarian, distinctly not part of the elaborate architecture intended for the enjoyment of the emperor and his guests, they could not be ignored—certainly not the Canal Block, with its shopfronts and balconies, nor the Service Quarters, rising above a main approach road; these structures strengthen the impression that Hadrian included something of everything he found worthwhile in the architecture and art of his wide Greco-Roman world.

The South Theatre is straightforwardly Roman in outline, for the forward edge of the stage is the chord of the semicircle of seats; the building faces northwest. Both the circular shrine in the upper seating area and the vaulted stage building (*scenae frons*) are partly preserved. But within the seating area the plan diverged markedly from the Roman urban norm. And the plan of the North Theatre, facing northeast, appears to be something of a hybrid. Its semicircular seating did not apparently reach the stage as in the usual Roman theatre plan, and the wall around the seating area travels somewhat beyond the half-circle mark; both features are typically Greek. Neither the stage building nor the upper shrine or temple has survived.

The two Ambulatories (one in the Southernmost Ruins) are architecturally self-explanatory. Of the remaining orthodox buildings little can be said. The Apsidal Hall strongly resembles Roman auditoriums and civic council buildings; it was not a library. The unexplored Platform Structure (an arbitrary name) is villa-

like (it suggests part of the west block of the Villa of the Mysteries at Pompeii), but it, too, may be a utilitarian building. The Park Rotunda, usually thought to be a tomb and sometimes restored with a ring of columns around it, may have been built for a quite different purpose.

Most established Roman building types seen in cities and towns show up at the Villa. It was not the place for a free-standing honorific arch, but the Central Vestibule main entrance, judging from the remains and Penna's view, resembles elaborate entranceways to urban public spaces that were framed with the architectural imagery of honorific arches. The Villa ruins, if we read them correctly, don't often record the presence of the ubiquitous, multipurpose temple-front motif seen throughout Roman public and private architecture ranging from temple-sized facades of columns supporting pediments through various reductive versions of the same idea, all disembodied temple images. But it is hard to imagine the Villa without them. Those who made the modern model couldn't resist them, for they appear on the East Terraces south range and just west of the Canal Block. And inspired probably by the arched central intercolumniation of the Scenic Triclinium facade, they put a Serliana-like temple front, of the kind seen at Split, at the junction of the East-West and Angled Terraces, and four more on the Central Service Building's superstructure facades. Smaller, two-column structures may be suggested by niches, particularly in nymphaea, and we assume that the columns flanking the Smaller Baths north entrance (base-blocks remain) carried a pediment.

TRADITION ENLARGED

In Hadrianic architecture the grand size of familiar forms catches the imagination—the Pantheon rotunda and the Mausoleum, at the Villa the Scenic Canal or East-West Terrace. Less recognized, perhaps, is the evidence, abundant at the Villa, for greatly increased sophistication in the design and spatial character of well-established building types. In general, these changes resulted from ingenious elaboration, again the result of exploring new design possibilities. Characteristics

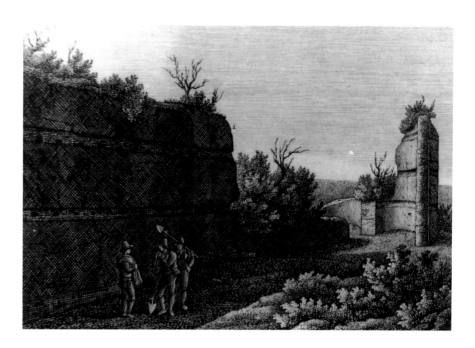

66 *Southernmost Ruins, ambulatory wall and return (Penna no. 118)*

67 *Southernmost Ruins, remains of the ambulatory return (1988)*

identifying functions are largely preserved, unlike the buildings discussed in the next chapter whose purposes may be obscured by radical design.

68, see 25

A good example of elaboration, the Hall of the Cubicles derives from a common utilitarian scheme in which repeated, often matching chambers flank a central corridor. Warehouses and inns use it; so does the North Service Building. At the Hall the three-recess sleeping rooms, their fine mosaic pavements still in place, give way on the south to a space usually identified as a shrine, in part on the analogy of one (an Augusteum) in the fire-brigade barracks at Ostia (the suggested architectural connection between the Hall and the barracks is probably untenable; the barracks is a courtyard building, in effect an insula, covering four times the area of the two-square Hall plan). Elaboration comes in the sleeping-room shape, not a common one, its use in place of the usual plain, four-square chamber (the household *cubiculum*), in the ingenious cryptoportico-like lighting of the eastern rooms, which are set well below East Terrace level, and in the elegant decor, which once included mythological paintings on at least some chamber walls. In this way a simple concept was transformed into accommodations for ranking

68 *Hall of the Cubicles, looking northwest (1983)*

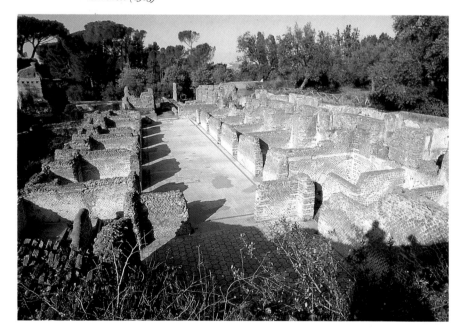

guests or the praetorian officers on station, or perhaps for members of the emperor's senior administrative staff. From the familiar corridor-building scheme the designer obtained an exact equality of accommodation for these people, who by walking south, past the servants' rooms, could proceed to the Residence by the underground route.

The Circular Hall, in the Southern Range, is an ancient, elementary form newly interpreted. The cylindrical space has four ground-story exterior sides determined by a circumscribing rectangle. The southeast and northeast ones are almost tangent to the curve, the northwest one is displaced from it slightly more, the southwest one more again. As a result the adjacent large southeast space, closed by a wide segmental wall, immediately confronts the rotunda's interior; the same direct relation is seen on the northeast side. On the northwest an unusual thing happens: diagonal passages flank an axial one, with the intervening structure reduced both by niches inside the Hall and out and by one of the rectilinear recesses flanking the southwestern approach (emphasized by its depth). The southwest-northeast axis, with its two sets of triple openings, is spatially the major one. Beginning in the large courtyard, it traverses the Hall and ends in the fairly modest northeast chamber. In the transverse direction, however, the three passages point to the single southeast opening and thus to the expanded space beyond, for the diagonal passages are not set out radially but are aimed toward the opening opposite (their longer wall lines, extended, run to the area of the southeast opening's interior corners).

69, 70

So the Circular Hall, with its ten ground-level perforations, is not only a connective chamber that serves several spatial constituencies, like the Domus Transitoria rotunda in Rome or the Smaller Baths octagonal room (seven openings), but also a mechanism that depending on the need of the moment, could funnel people from the northwestern anteroom into the rotunda, in preparation for bringing them, in an orderly way, into the broad southeast chamber. One thinks of a circle as an enclosure, but here it is the basis of an intermediating architectural space, a species of dis-

71

72, 73

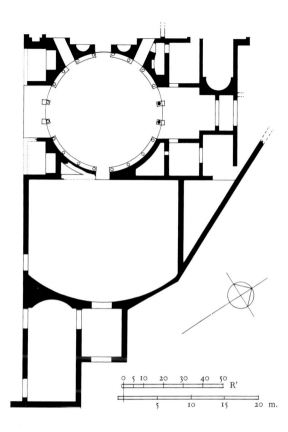

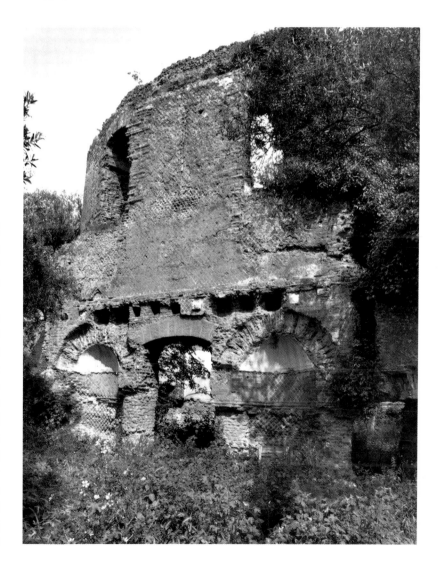

69 *Circular Hall and environs, plan*

70 *(below) Circular Hall, northwest facade, looking east (1987)*

tribution center. Its twenty internal bays are defined by barely engaged columns; the wall surfaces between them are empaneled. In the unencumbered upper story the twenty divisions reappear as niches alternating with windows—a very early rotunda clerestory.

The Central Vestibule was less a building than a chain of courts and passages. Its middle feature lies at the crossing of two substantial axes, one lying between the Smaller and Larger Baths, the other the grand 450-meter line between the East-West Terrace and the Scenic Triclinium. The parts are familiar. The large reception court is shaped like the Apsidal Hall, its telescoped shrine area extending to the west, its reception room to the south. Possibly roofed, the central block was a mediating space furnished with rooms for the officiating staff, a ceremonial gnomon open to through traffic on all four sides with colonnades facing the Terraces and the Scenic Canal. Eastward lay a garden, echoing the main reception court plan and set tightly between

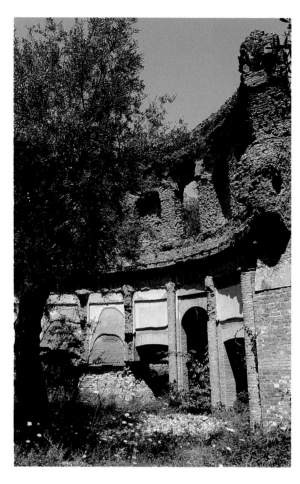

71 *Circular Hall, interior, looking northeast (1973)*

72 *(far right) Curved wall of the chamber just southeast of the Circular Hall, looking southeast (1987)*

73 *Circular Hall, flanking peristyle, looking southeast (Penna no. 110)*

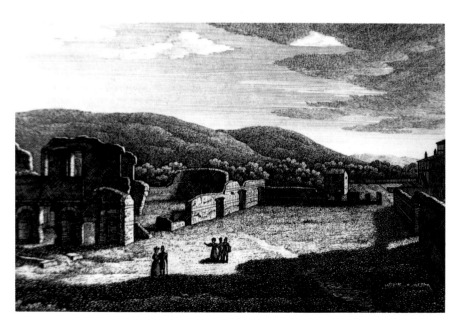

the two Baths (with which there seem to have been no ground-level connections); further to the east a corridor led to an underground passage rising to the level of the Upper Park. Overall the Vestibule lacks focus: the plan is something of a makeshift, lacking the clarity of the Ceremonial Precinct sequence. Perhaps it was difficult to resolve tensions between the two axes, or maybe the building was extended more or less ad hoc, west to east, after the large court was finished and in use. In any event it is an instructive example of Roman readiness to fashion plans out of multipurpose elements long in circulation.

The Portico Suite may have been a Villa entry point (it has been suggested), but if so only until the Central Vestibule was built. It resembles somewhat the Vestibule central block in plan but lacks an appropriately formal approach up and across the lengthy, stepped terraces in front of it. The front wall may have been solid and stairless; excavation is needed. The plan is probably best interpreted as that of a triclinium, but alterations to the structure may mean that it was first an entrance and later converted. The front portico and the central chamber would give diners a choice of venue according to requirements or desire, and the side chambers and narrow corridors fit service needs. Just behind the suite is the long corridor connecting the Residence Quadrangle and the East Belvedere corridor (where there were two small lavatories). Behind that in turn lies a vaulted gallery, unsuited for court traffic — and unneeded, given the corridor. Its location and design suggest that it was a kind of pantry serving both the Portico Suite and, by way of intermediary spaces and appropriately narrow

74

75

see 343

passages, the Belvedere. In this reading the broad, low-set gallery niches would hold cupboards. The gallery space is roofed with a quarter-round vault of the kind seen in other service areas, for example alongside the Bath buildings, or just past the north end of the Stadium Garden.

The Fountain Court East lies at a 45° angle from the main axes of the Residence and its orthogonally aligned satellites. It may have been a triclinium or a shrine to Antinous—it is difficult to think of it as both. But it was built before Antinous's death in 130, and as there is much evidence of subsequent renovations and additions, particularly along the east side of the main structure, its function may have been changed. All but one of the half-dozen eastern chambers connect with the main structure, which suggests that they were service areas. Perhaps the building was begun as a *diaeta*, or auxiliary living room, a summer house facing north. It was at least two stories high, but because the ruins are confusing—partly due to Hadrianic alterations—its original form will remain elusive until the fabric is studied in detail. In the broadest sense, the importance of the Fountain Court East lies in its pronounced departure from the principles and orientation of the earlier villa. With the Island Enclosure it begins the dispersal of novel leisure buildings across the site; the modest Residence, a restricted domain, was soon eclipsed.

That restriction accounts also for the Heliocaminus Baths (the name comes from its circular room, once thought sun-heated, actually a sweat room [*sudatio*] heated in the usual Roman way; the traditional name is however serviceable). Although the perimeter is irregular except on the east, the plan has firm rectilinear underpinnings; a hot plunge and the outdoor swimming pool were altered in Hadrian's time. The long axis parallels that of the Fountain Court West. Like all Roman baths it has no exact counterpart, but somewhat similar buildings appear on the Marble Plan of Rome, and if the Heliocaminus plan is reversed, the result is conceptually close to the Ostian Forum Baths plan, a larger building dating from the time of Antoninus Pius. The Villa building belongs to that very considerable number of baths in which architects rang innumerable

changes on the same basic theme: entrance, dressing room, lavatory, pools and plunges with different water temperatures, and other specialized spaces as needed. Within the Heliocaminus Baths an octagonal room of slightly irregular plan is well preserved, including its vault, which, with the standing half-shell of the circular room, gives some idea of the roofing complexities and silhouettes of asymmetrically planned bath buildings containing such dissimilar volumes.

Planning at the Larger Baths is more conservative. Based on metropolitan practice, it provided, within a right-angled perimeter, space and facilities for far more people than the Heliocaminus Baths could accommodate. Thus the building has a cross-vaulted central hall and a large external exercise ground, as well as two indoor pools (the Heliocaminus Baths outdoor swimming pool was larger, however, than the indoor one here). The entrance hall, on the south side, faces the Central Service Building, and that, taken with the size and planning of the Baths, suggests they were used by Villa staff and workers. The stucco work mentioned earlier survives on the dressing-room vault, and in the central hall a large, ragged portion of the original cross-vault rises precariously from three of its four supports. The line of the circular sun room and the hot-plunge rooms lies parallel to the extended Scenic Canal axis and, together with the neighboring Vestibule and Canal

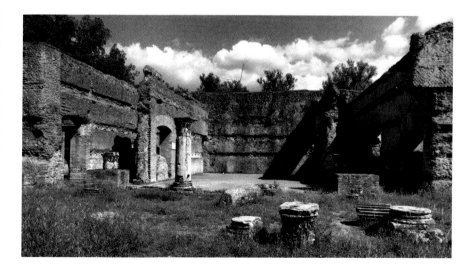

74 *Portico Suite, looking southeast (1987)*

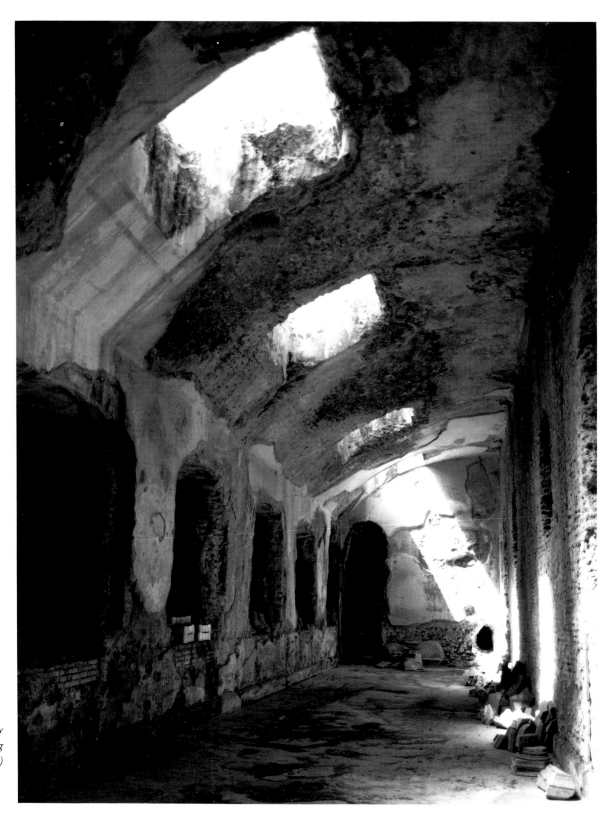

75 *Portico Suite, vaulted gallery along the southeast side, looking southwest (1987)*

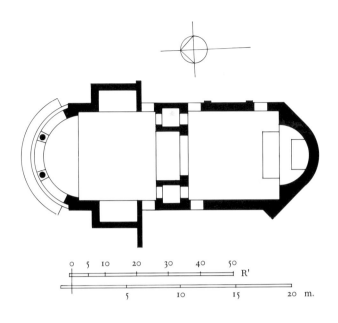

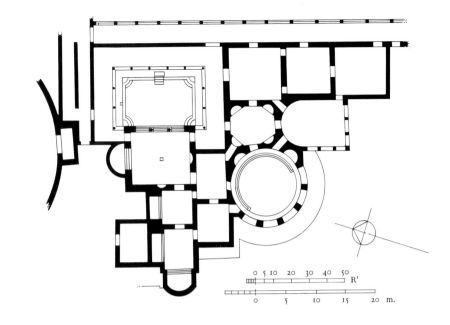

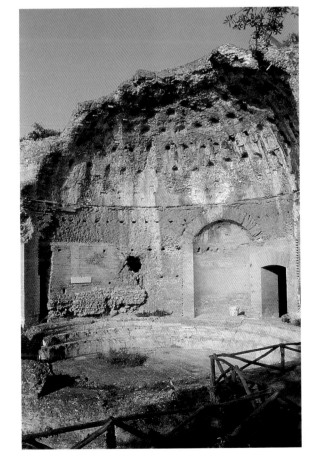

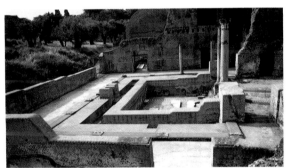

76 *(top left) Fountain Court East, plan*

77 *(top right) Heliocaminus Baths, plan*

78 *(bottom left) Heliocaminus Baths, circular room, looking northeast (1981)*

79 *(center) Heliocaminus Baths, outdoor pool, looking south (1987)*

80 *(bottom right) Heliocaminus Baths, vault of octagonal room (1991)*

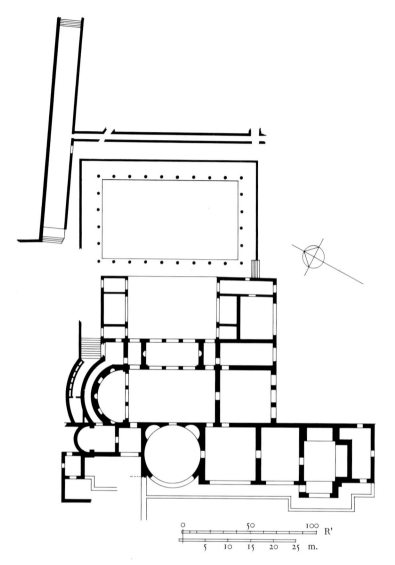

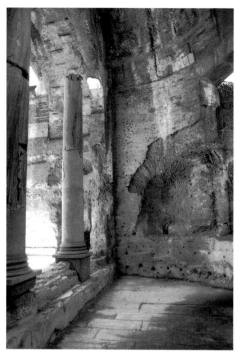

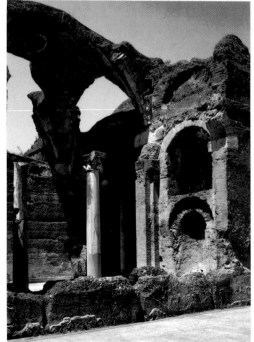

81 *Larger Baths, plan*

82 *(top right) Larger Baths,
semicircular pool and
columns (1987)*

83 *(bottom right) Larger Baths,
view toward the semicircular pool,
looking west (1987)*

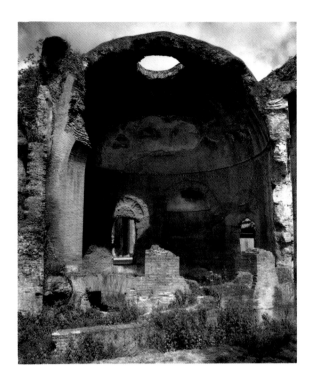

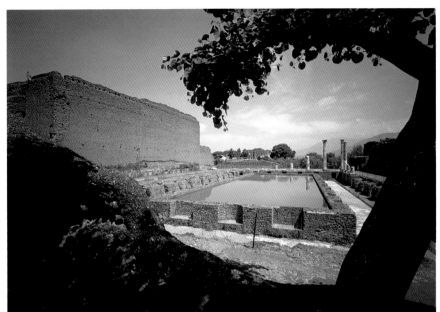

Block, intimates a loosely defined plaza open to the gradually rising ground to the west.

85 Connected by stairs and passageways with the Sta-
dium Garden and the Residence, the walled-in Peri-
86 style Pool Building is a coherent architectural unit. Its
cryptoportico lies beneath the broad walkway bordered
by the high outer walls and the peristyle colonnades.
On their inner sides these colonnades mark the line of
a wall perforated by the pavement-level cryptoportico
windows. Between that wall and the niched Pool wall
runs a second, lower walkway; the wall brings the water
level close to that of the broad outer walkway. The
Pool has been thought a fishpond (a common feature
of luxury villas) surrounded by statues in the niches.
But if the niches were originally of the normal type, tall
enough to take statues, their wall would mask the Pool
completely; on the other hand, if the restoration is cor-
rect and approximates the wall's original height, statues
in the niches would stand partly en-niched and partly
free and clear, an unusual sight. If the Pool was a fish-

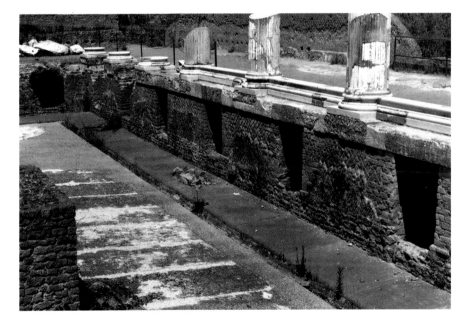

0 50 100
R'
10 20 30 m.

87 *Stadium Garden, plan*

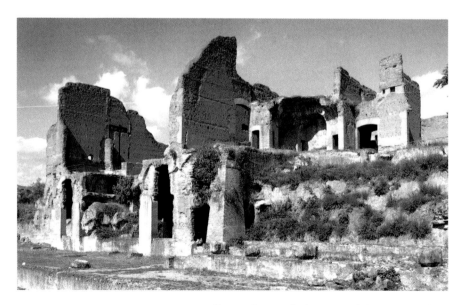

88 *Stadium Garden, east flank structures, looking northeast (1987)*

pond, might the low niche floors, just a step up from the inner walkway, have accommodated those who wished to fish? The smaller spaces immediately to the west, at Pool level but on the other side of the Pool's high west wall, are arranged around a large, heated salon opening out over the Stadium Garden below; other rooms just to the south and generally at the same level suggest a bath installation. The salon, located directly over an elaborate ground-level Stadium suite, belongs together with its neighboring rooms both to the Garden and to the Pool area.

Of all the traditional building types ingeniously elaborated at the Villa, the Stadium Garden is the most important. It is one of the allusive forms familiar from the texts, essential to villa life and immediately identifiable, and it has been excavated and thoroughly studied, a rare event at the Villa. Because of this, Pliny's stadiumlike locale is better understood, and the whole idea of garden conceits with long, narrow plans, curved at one or both ends, has been brought into clearer focus. These stadiumlike places, variously called hippodromes and circuses, were strolling areas fitted out with fountains and pools and decorated with shrubs,

87

perhaps trees, planted beds, and pavilions. The older literature insists that entertainments if not games were held within them, but although that is possible, it goes against the purpose of such places, and would have been possible at the Villa only on a small scale because the sole appropriate plan space was occupied by a squarish shallow pool, 21 meters on a side, between the east suite just mentioned and the Arcaded Triclinium east entrance. Perhaps stadium-shaped gardens began, in the later Republic, in imitation of urban public structures, but they soon became, like many villa features, secluded places for relaxation, mild exercise, and conversation. The Stadium Garden plan only approximates that of a real stadium (a place for footraces often used also for entertainments) but fits in well with the outlines of similar if sometimes less elaborate structures at other villas and in imperial palaces. It was not the objective of villa architects to create stadiums or circuses, but only to suggest them; for luxury villa purposes it was necessary to differentiate clearly between the real and the effectively allusive.

The Arcaded Triclinium east extension and the East-West Terrace wall were in place before construction began. The northern part of the Stadium, built first, connected the two existing structures, and the small axial, apsidal room was added to the Terrace. Three sides of this new Stadium north court were colonnaded, and within that space pools and a roofed pavilion were provided (and later, fountains and planting). The elaborate suite on the east side, across from the Triclinium extension, was built at the same time; later on the southern part of the Stadium was put up, with its own pavilion and a stepped, semicircular nymphaeum at the far end, where water stairs alternated with planting beds on either side of a grotto. Thus in the end most of the Stadium floor was built over, in a repeating open and closed rhythm; no space for running or for horse exercises existed.

This additive process, of which only a summary has been given, is significant: Villa designs were changed during construction and a building thought complete might later be altered extensively; Hadrian came and went, and plans were changed. Some areas verge on pastiches, that off the Water Court north corner, for example; and improvisation sometimes took place during construction. More important is the sense of experiment that major changes and additions record — the enlargement of the Arcaded Triclinium, for example, or the alteration of the earlier villa. And even if the basic Stadium Garden plan was in hand before any construction began — there is evidence of this at the curved southern end — it was certainly not followed without deviation throughout. Experiment was not limited to the design process, to the time before the construction of a building or area commenced.

IV

Unfamiliar Architecture

Dio separates Hadrian's dealings with the Senate from the many other duties his offices and paramountcy imposed. "He transacted with the aid of the Senate all the important and most urgent business, and he held court with the assistance of the foremost men, now in the palace, now in the Forum or the Pantheon or various other places, always seated on a tribunal so that whatever was done was made public." The Ceremonial Precinct provided the appropriate Villa setting—immediately seen as different from the domestic and pleasure buildings found in luxury villas—for holding court and giving audiences. Set conveniently beside the Residence, the Precinct audience hall connected with the emperor's private quarters by way of a short, curving colonnade leading toward a Residence entry also linked to the Peristyle Pool Building. Persons attending court or an audience would enter the Precinct by way of the Residence Fountains; other openings for staff and service include those communicating with offices or service facilities situated between the Residence and the Water Court.

The Precinct plan seems familiar at first glance. It see 22 is a model of clarity immediately read as describing the kind of axial ceremonial or liturgical building common in later architecture. And two of its three parts are traditional: the Roman civic basilica and the tablinum-

like central space with its parallel passageways. In the audience hall beyond, the curving back wall is reminiscent of the tribunal Vitruvius designed for his Fano basilica, which was "shaped like a hemicycle less than a semicircle [in plan] . . . on the open side forty-six feet wide, its curvature fifteen feet deep . . . [providing space for] those who stand before the magistrates." But we know of no similar three-part building in pre-Hadrianic Roman architecture. Here the basilica can be seen as a preamble to the audience hall; the functional sequence reads gathering place, selection and security area (governed by what will later be called chamberlains), and Caesar's tribunal. There one can still distinguish the dais, perhaps the place for the emperor's modest throne (a four-legged wooden stool, draped and pillowed, on the lines of the one he is seen sitting on in the marble relief of Sabina's apotheosis now in the Conservatori Museum). Column screens defined this terminal, most potent Precinct space.

The Palatine offers no useful comparisons. Both the Aula Regia (perhaps an audience hall) and the Cenatio Iovis (the imperial dining hall) have been brought forward, but each is a unitary chamber and both lack prefatory spaces; only the mildly curved terminal wall of the Cenatio Iovis brings the Villa building to mind. The Ceremonial Precinct basilica is a common type, best known from Pompeii (whose basilica is almost exactly the same width and length as the Ceremonial Precinct overall). It is natural to assume that the central area was roofed, with clerestory walls rising above the files of pillars; the aisles were barrel-vaulted, as the restoration shows. Doric pillars are common and can be seen, for example, at the villa of Poppea at Oplontis or the insula of Julia Felix at Pompeii; the aisle vaulting may have derived from that of Trajan's Basilica Ulpia in Rome.

Of the few surviving earlier buildings intended for imperial ceremonies and state business, none appear to use the civic basilica. It was an audacious designer who put that long-established instrument and symbol of civic government at Caesar's disposal by making it an anteroom to the locus of his overriding power. The Precinct appears to be an *aula palatina*, a place de-

90

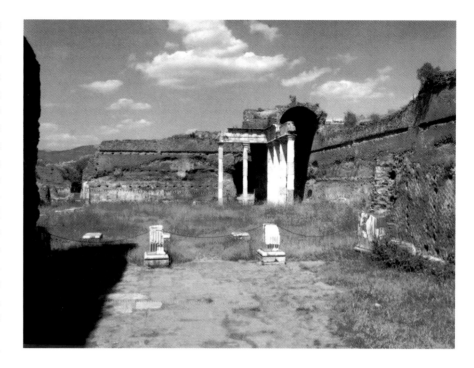

89 *Ceremonial Precinct, looking northeast from the southwesternmost chamber (1987)*

90 *Ceremonial Precinct, restoration detail (1987)*

signed specifically both for the exercise of a prince's authority and for the experiential reinforcement of that power through sequential events leading to a focused setting for the prince himself. The concept had a long future, and whether or not it originated at the Villa, the Ceremonial Precinct may be the earliest surviving example of it; if so, the building is an invaluable historical document.

91 The multistory Fountain Court West, like the Ceremonial Precinct, has no known antecedents, though the neighboring East building probably contributed its plan and some influence is perhaps traceable to villa belvederes. But it is quite different from these other structures, for it is a tower containing suites of rooms, like the one Martial's Faustinus had at his Baiae villa, overlooking his laurel groves, or Pliny's two Laurentine towers: "Here a tower [*turris*] rises, with two living rooms [*diaetae*] at ground level and two above, as well as a dining room [*cenatio*] that commands the wide sea and the whole shore with its very charming villas. There is another tower with an upper room open to both the rising and setting sun . . . while below is a dining room [*triclinium*] . . . [that] looks onto the garden and the walk [*gestatio*] surrounding it." Towers

91 *Fountain Court West, plan*

like Pliny's appear repeatedly in paintings, mosaics, and stuccos of villa scenes and landscapes. The varied forms and often imaginative examples depicted in such scenes prove what archaeology thus far has not, that villa towers (often entered through porticoes), topped either by open but roofed spaces or by enclosed chambers with windows, were commonplace. Many are simple affairs, while others have several rooms and balconies; sometimes the uppermost windows are fitted with vertical slats, presumably adjustable, to catch or deflect the moving air. A good record of the tradition of elaborate Roman villa and palatine towers is preserved in the courtyard mosaics of the Great Mosque at Damascus. see 241

The West building ruins are difficult to read. Hadrian changed the building after construction was well under way, and the east and south sides of the two main chambers were all but enveloped in additions. Then in the mid-nineteenth century and again in the 1960s substantial interventions were necessary to preserve and stabilize what remained of the fabric. The ground-floor plan, mentioned above, is clear. Rooms above were reached by a switchback staircase rising from the Island Enclosure; some interconnected by exterior galleries. The service stairs are inside the building. The heated, upper-floor main salon opened out in the direction of Monte Gennaro, whose highest peak (the Zappi, 1,270 meters) lies 13 kilometers away, about 15° east of north.

Unlike the Ceremonial Precinct, a spacious building for state business and occasions, the Fountain Court West was a comparatively small-roomed retreat for the emperor, a place for otium, for a spell of freedom from responsibility, or for work requiring solitude. The northern orientation brings summer weather to mind, but the heated area argues for all-weather use. From the upper chambers, removed from Villa activity, Hadrian could contemplate the unchanging mountains or his Villa, or take up his literary or artistic studies. If he wished for company, there was space for a few friends. Then the views could lead to those literary and aesthetic discussions about nature and its powers and associations so dear to educated Romans: the Campagna, the mountains, and the Villa gardens and their art would provide ample subjects. One not only admired

what was seen but was expected to recognize there allusive and even didactic qualities, as Pliny and other writers make clear; in this the effects of the Roman interest in organizing nature would not be lost. In the ground-floor rooms, one view may have been entirely internal, for whatever stood in the southernmost niche was seen from the northern room through an interior window. If the northern room was used as a triclinium, a mythological or historical scene in relief or standing figures, seen in the background, could have given this apartment its name and stimulated relevant dinner discussion.

The originality of the Fountain Court West and the Ceremonial Precinct commands attention. In contrast with what is known of Roman architecture at other sites, the Villa is alive with innovation; baths aside, no other site has so many buildings that deviate so distinctly from established practice, and few have any at all. This has sometimes had the effect of excluding the Villa from the mainstream of classical architecture studies and denying it the attention given to more traditional sites, but in recent years the situation has changed somewhat for the better.

Hadrian and his gifted staff gave new life to the long and continuing evolution of the style they inherited — no small accomplishment in any period — by seeking within it new and meaningful artistic expression. Like others to come, they saw that classicism was not exhausted, that its artistic potential had by no means been fully explored.

CIRCULAR PATTERNS

In sharp contrast to the Fountain Court West, the Island Enclosure is decidedly horizontal and internalized. It lies about 2.5 meters below the Residence Quadrangle and almost as much below the Fountain Court West ground floor, and from the higher ground at the south and east it appears to be partly sunken in the earth. Of adjacent areas only the Apsidal Hall and the northern open ground lie on the same level. As at the Fountain Court West, changes were made in Hadrian's lifetime; the north stair system, for example,

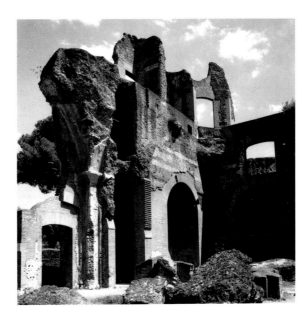

92 *Fountain Court West, interior, looking southeast (1987)*

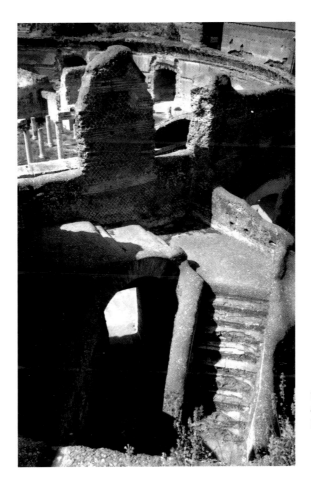

93 *Stairs between the Island Enclosure and the Fountain Court West, looking southwest (1987)*

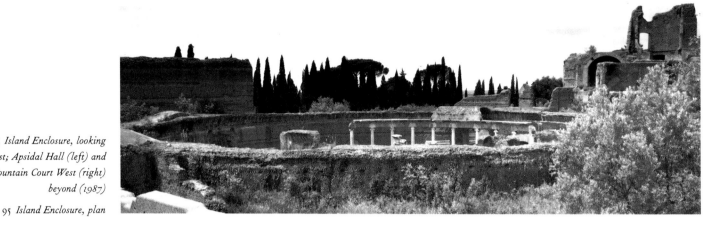

94 *Island Enclosure, looking northwest; Apsidal Hall (left) and Fountain Court West (right) beyond (1987)*

95 *Island Enclosure, plan*

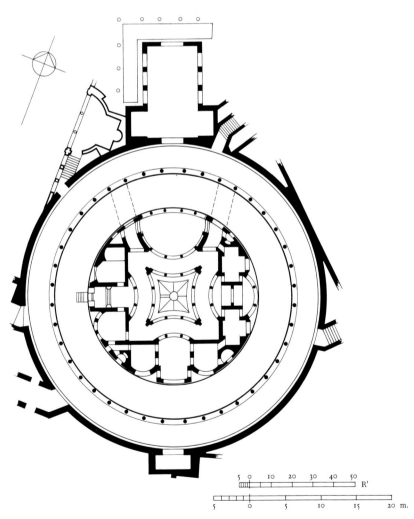

was rebuilt and several openings between rooms on the Island were altered. At some point, probably also in the emperor's lifetime, an arched masonry bridge replaced the western of two retractable wooden ones over the ring canal, and a northwest doorway was cut through the ring wall. Like the Stadium Garden, the Island Enclosure has been carefully studied.

Other basic features should be pointed out. The main axis is about 19° west of north, and a 5-foot planning module was used throughout: 30 units, or 150 feet, for the overall diameter, 24 for the circle upon which the ring portico columns are centered, and so on. The Enclosure's actual diameter is 44.20 meters overall, almost exactly 150 feet (the Pantheon cylinder's internal diameter is 43.80 meters, a difference of 1.5 feet). In addition to the north stair system, a staircase comes down on the west from the Residence Quadrangle, and another, external one, perhaps a maintenance facility, once rose next to the ring wall northwest doorway. The Enclosure proper opened on the north through a spacious entrance hall (with north and west external colonnades) toward a nymphaeum on axis, set beside the Fountain Court's northwest corner. On the west side of the ring two passages lead to the Apsidal Hall; from the southern one an underground passageway communicated with the Stadium Garden and the East-West Terrace axial chamber.

The ring portico is clarity itself: forty unfluted Ionic

columns, evenly spaced except beside the main north-south axis, once carried an attic masking the walkway vault. In contrast, the Island, with its fluted Ionic order, has twenty-two well-defined spaces in little more than a third of the Enclosure's area overall. These spaces are arranged in three suites, plus an exedra-shaped court, placed around a central peristyle whose incurving colonnades respond to the intrusive centered arcs of the four surrounding features. The eastern suite consists of a lounge or library with symmetrical side rooms, the southern of a centered salon or triclinium also with matching dependencies, and the western one is a three-part bath. All rooms interconnect with their neighboring ones except the north bath chamber with its heated floor and plunge; curving entrance corridors lead from the bridges past the exedra court to the central peristyle. The peripheral wedge-shaped spaces on the diagonals, reading clockwise from the north, contained a lavatory, a fountain or wash-basin, another lavatory, and the sunken furnace room for the baths. Steps lead up out of the centered cold pool to a flight descending into the ring canal.

Both cardinal axes are transparent, running between repeated openings and pairs of columns, but only the south-north axis, extending from the Enclosure's southernmost chamber to the north fountain just mentioned, connects—at the end of a long vista—with open ground. Unless this view is deliberately sought

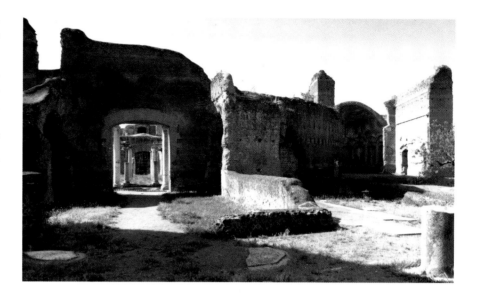

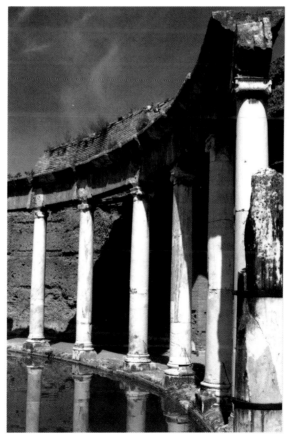

96 *Island Enclosure, main axis looking south; Apsidal Hall to the right (1987)*

97 *(below left) Island Enclosure, southwest quadrant (1987)*

98 *Island Enclosure, ring colonnade, looking northwest (1987)*

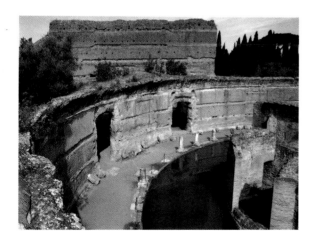

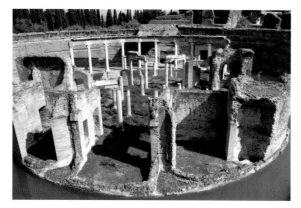

99 *Island Enclosure, the Island, looking north (1987)*

100 *Island Enclosure, peristyle and environs, looking north (1955)*

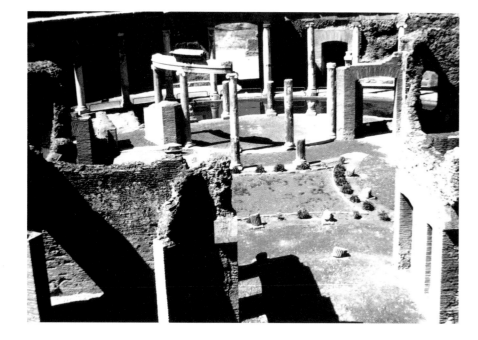

101 *Island Enclosure, frieze detail (1987)*

out, there is little awareness of the world outside. Of the six openings that lead through the ring wall, four are doglegs and two of these are visually blocked by their rising stairs. The northwest doorway, small and almost incidental, gave onto the windowed wall of the external staircase structure just outside, and the short western passage led not to open ground but to the Apsidal Hall interior. There was a lot to be seen inside the Enclosure, however, besides water and architecture. The ring wall's inner structural surface was first painted red (the brick banding) and yellow (the stone reticulate), to be replaced later with stucco, painted red and black, above a new marble base moulding. At irregular intervals around the ring wall, six large recesses, about 2.9 meters broad and 3.6 high, once contained large-scale, marble-framed works of art, medium or media unknown. And on the Island the curved colonnades' entablatures carried friezes of winged putti driving chariots and accompanied by processions of marine animals, tritons, and mythological figures. During the restorations of the mid-1950s, when the walkway vault section was built and columns now standing there and on the Island were erected, sections of these friezes were returned to their original positions; they have been brought back together on paper with other sections and fragments, long since dispersed, and with drawings of lost evidence, in a detailed analysis rich in comparative material.

see 97

101, see 377

Two closely connected topics—design sources and function—dominate modern discussions of this extraordinary place, with building typologies their chief touchstones. In the past it had been called, among other things, a natatorium (not an ancient word) or swimming-place, because of the canal, and for a long time thereafter a maritime theatre, in view of the friezes and a notion that ancient theatres might be round. Today it is called an island villa, an improvement over maritime theatre but somewhat misleading because Roman villas are spread-out estates accommodating many persons, a different functional and architectural species than the Island Enclosure. It could be called a casino, but the word is vague and suggests a pleasure pavilion set out in the grounds of a great house and

ignores the Island's setting. Because of these things, and in order to discuss the Enclosure's sources and essential character without having placed it in a specific typological category, we have chosen, as for other Villa buildings, a neutral name.

The Island plan is foreshadowed in part in the geometry of the Domus Augustana lower court, one of the private sections of Rabirius's palace for Domitian. Within a large, shallow pool a low platform or island, with fountains and planting beds, was divided by semicircular canals defining a centered figure with concave borders; three-room suites flank the court on two sides. At the Villa the open water is confined to the ring canal, buildings are placed on the Island, and the plan is balanced by a third suite and the exedra-shaped court (the rectangle implied by the junctions of these four features is, like that of the Augustana court, an oblong). The Island suites, ingeniously fitted to their circular setting, may also be related in some degree to earlier architecture. In the eastern suite, similarly scaled spaces found at the Augustana upper level appear to have been rearranged (there may be influence here also from the Domus Aurea Esquiline wing). The baths, with their three chief rooms aligned, are similar in planning and in size to domestic baths of the kind seen, for example, in the House of the Cryptoportico at Pompeii. Perhaps the southern suite is related to the Residence private apartment, and the exedra could be based on the Augustana's upper-level, semicircular vestibule.

But these palatine features take second place to their Island setting, whose concentric circles have been likened to those in Plato's description of Poseidon's Atlantis. Islands, to the Romans, could, like ships, be places of refuge voluntary or enforced, and the Romans adopted the Greek tradition that the gods' favorites dwelled after death on Islands of the Blessed. Cicero's friend Atticus admires islands, and at one point Cicero remarks that a district in Syracuse was known as The Island (that is, Ortygia), which might explain why Augustus called his Palatine housetop refuge Syracuse, though another, more probable explanation is discussed shortly. The Sperlonga seaside villa's island, by keeping owner and guests isolated, may have encouraged contemplation of the sea and caves. At the Villa the inhibition of access isolation requires was doubly ensured by the encircling outer wall and the canal (which served, with Roman practicality, as a swimming pool). The result is an imaginative, clever, symbolically resonant and very Hadrianic place.

Canals for swimming seem not yet to have turned up in Roman bathing installations. But once the decision was made to build a circular Island retreat complete with a bathing suite, the use of the ring canal for swimming (maximum water depth 1.5 meters) followed naturally and gave Hadrian a choice of unheated venues according to season and weather like that available at many municipal baths. Pre-existing structures suggest the ring portico's design. On the fourth level of the Sanctuary of Fortune at Palestrina two recessed hemicycles of half-ring plan were formed in the same fashion: outer walls and concentric inner colonnades supported annular vaults, leaving the central spaces open. And at the Markets of Trajan, on the second level of the hemicycle facing the Forum, a similar principle appears in a long, windowed, annular-vaulted corridor. Other influences might have been at work. The suggestion that Agrippa's Pantheon may have consisted of an entrance portico giving onto a circular court (whose dimensions could later have determined those of Hadrian's great rotunda) with an annular-vaulted colonnade, is intriguing. And it may be that large round tombs with internal annular corridors, common enough, belong among the ring portico's ancestors. A variety of circular structures antedate the Villa, but save for round temples such as the one at Epidauros only a few contain intrinsic internal architecture.

Recently it has been argued that a refuge built by the tyrant Dionysius I (ca. 430–367 B.C.) of Syracuse was what Augustus had in mind in referring to his housetop study as "Syracuse"; the Island Enclosure may somehow stem from the same source. Dionysius's retreat was within his fortress-palace on the island of Ortygia, connected then as now to the Syracusan mainland by a bridge. It consisted of a small island surrounded by a canal crossed only by a movable gangway, dimensions and details unknown. That Hadrian knew of the retreat

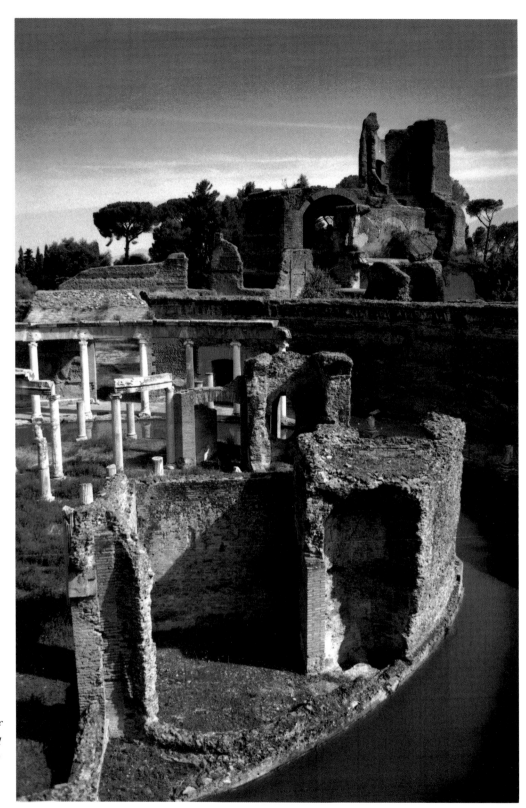

102 *Island Enclosure, eastern half of the Island, looking north toward the Fountain Court West (1987)*

makes sense; if he did, that he made use of the idea is plausible. But other, perhaps more persuasive evidence is found in the fortress-palace of Herodium, built for Herod the Great (ca. 73–4 B.C.). Its essentials survive.

Constructed probably between 23 and 15 B.C., Herodium lies about 12 kilometers south of Jerusalem and thus not far southeast of Bethlehem, a striking example of Herod's widespread, sophisticated building program. The evidence ranks Herodium with his new port and city of Caesarea Maritima, and with Masada, Samaria/Sebaste, his winter palace at Jericho, and the new Temple at Jerusalem, and in architectural originality it is the equal of any of them. In its day Herodium was well known. Josephus describes it more than once. In the *Wars* he speaks of Herod's foundations, saying that

he did not neglect to leave memorials of himself. Thus he built a fortress on the Arabian frontier and called it after himself Herodium. And an artificial hill in the form of a breast, not far from Jerusalem, was given the same name but was more lavishly embellished. The crest he crowned with round towers; the enclosure was filled with beautiful palaces, whose magnificence was not limited to the apartments' interiors for the outer walls, battlements, and roofs all had wealth profusely lavished on them. At immense expense he had an abundant supply of water brought into it from a distance, and provided an easy ascent by two hundred steps of the purest white marble, the mound, though artificial, being of a considerable height. Around the base [of the hill] he built other palaces for . . . his friends. Thus in the fullness of its resources this stronghold resembled a town, and in its restricted area [the hilltop] simply a palace.

The town with its monumental buildings, a huge pool (about 50 by 70 meters, with a round building, perhaps a tholos, in the middle), and a long narrow stadium or race course, lay below and to the north of a fairly steep and largely freestanding hill. On top of this the king built his new seat, and when it was finished his engineers reshaped the hill's upper part with fill reaching halfway up the structure's round exterior, producing a conical silhouette from which the towered fortress rose as if from the crater of a symmetrically formed volcano. It was a powerful building, with towers on the cardinal axes, and its outer wall was some 63 meters in diame-

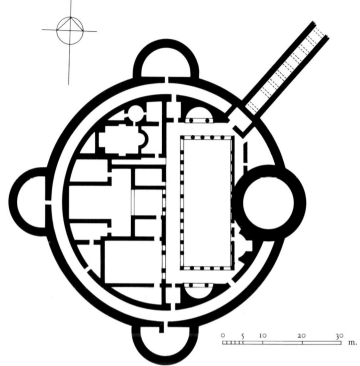

103 *Herodium, plan*

ter. The east tower, more robust and larger than the others, probably rose some 40 meters above the palace pavement and may have contained, at the top, a suite for the king; huge towers were a Herodian specialty. To Hadrian, might Herodium have been one of the "places most famous" of the HA description? And could the Fountain Court buildings have in some measure been derived from Herod's towers? Herod's earth engineering, great pool, race course, and "other palaces" suggest an image not dissimilar from that of Hadrian's Villa. And both men incorporated architectural symbols from other lands, used water lavishly, and dispersed well-appointed buildings across a landscape. A sympathy of intent, if not a direct connection.

Herod's hilltop palace, circular but for the intrusive great east tower, was framed by a walled-off walkway about 3.4 meters wide. The planning and architectural details of the palace, a major Romano-Hellenistic monument, are of great interest. A large, oblong open

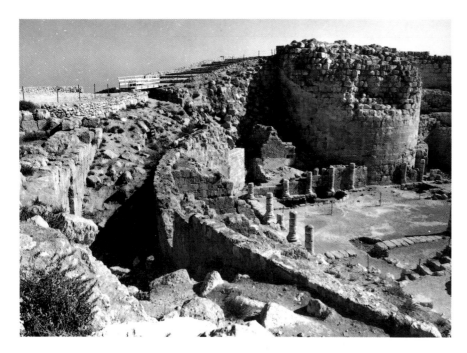

104 *Herodium, ring walls and peristyle, looking east (ca. 1979)*

court, with facing but nonaxial exedras on the shorter sides, nearly fills the circle's eastern half. The western half contains, from north to south, a Roman bath suite with a domed hot room, reception rooms, and private quarters. The reception suite, centered on the main east-west axis of the palace, consists of a vestibule and a main T-shaped hall rather like the *alae* and tablinum of a Roman atrium house; the chief private room, flanked by the usual satellite spaces, connects directly to the reception area and open court. Irregularly shaped areas formed by the junction of orthogonal structures with the curving inner walkway wall were put to use, for example by the courtyard exedras and the baths' smaller rooms. Security was paramount. The hillside stairs, some 6.5 meters wide, are uncovered until they go underground, in a tunnel up through the fill, for the last 40 meters to the fortress wall. Only five small openings lead into the palace area from the circular walkway. Those to the courtyard portico closest to the king's own chambers first open into small, squarish rooms that may have functioned as vantage courts; where the access stairs meet the walkway there seems to have been a similar arrangement.

Differences and similarities at Hadrian's Island Enclosure will be self-evident; the most significant connections are plan concept and function. Did Hadrian know Herodium? His interests and nature argue for it but taken alone prove nothing. But he had been in Judea as early as 113 or 115. Later, as Trajan's chief officer in Syria, he would of necessity as well as by temperament have taken a keen interest in Judea, a province (in Hadrian's day Syria Palaestina) since 70. And between his accession at Antioch on 11 August 117 and his final departure from his headquarters there early the following October, Hadrian traveled south; he thus had at least two opportunities to see Herodium before the Villa was begun. Hadrian probably knew Josephus's works and could not at the beginning of his reign been ignorant of either Herodium or Herod's close connection with Rome (he had been there twice, and in 37 B.C. Roman troops had stormed Jerusalem for him). The king's subsequent dependence on his patron Augustus, Hadrian's own model in significant ways, would also have been known to Hadrian: as Octavian, Augustus confirmed in 30 B.C. Herod's authority and gave him the city of Samaria (which the king rebuilt and soon named Sebaste in honor of his patron's new title of 27 B.C.), then as Augustus he added the territory for Caesarea, similarly named. Many signs, Hadrian's fascination with architecture and monuments not the least of them, point toward the high probability that he had direct knowledge of Herodium as well as of its artistic and political connections with Rome. And the Herodium palace is apparently the only known ancient structure, pre-Hadrianic or otherwise, that the Island Enclosure resembles.

Island architecture is eclectic, with themes and shapes from the atrium house and its ancient parts and above all from the ubiquitous Mediterranean peristyle houses and mansions and their palatine offspring. Its rational plan produces, for example, peristyle columns set on arcs of 50-foot circles, which if extended are tangent to the circle of the ring columns' centers. But the essential character and force of the Enclosure overall arise less from these organizational features than from the un-

usual concept of which they are the servants: a moated, idealized retreat sequestered within a perfect, seamless figure. Consideration of scale, function, and imagery is thus essential.

The Island is said to have been a miniature villa, suggesting that its architecture was disproportionately reductive. Is this correct? To miniaturize architecture is to reduce its scale toward that of a dollhouse, as for example at the charming town in the Childrens' Garden at Coimbra (half-scale), Madurodam at the Hague, or France Miniature at Élancourt. But the Island covers some 510 square meters (5,800 square feet), an area equivalent today to that of a large house or spacious luxury duplex. Its rooms are no smaller than many at the Villa—in the Southern Range, in the pavilions beside the Scenic Triclinium, and elsewhere. Both levels of the Domus Augustana have such spaces; the upper one has a dozen. The Island rooms are scaled for their purpose—Hadrian's pleasure, taken alone or with a few people close to him; servants, presumably, would not remain there with him, for the plan contains no provisions for servants and their activities. It was not a place to live in, but to go to, and its scale derives from that. It wasn't cramped, just comfortably sized, rather domestic. Thus the dimensions of the rooms: about 14 by 18 feet for the central south chamber, a 20-foot axis for the baths central room, and so on. Behind this connection between function and size lies a fundamental Villa principle—the wide variety of different kinds of places to visit, in the manner of Pliny's villas but on a greater scale, one suitable to Hadrian's temperament and interests. The Island Enclosure was a station on the peripatetic circuit of intellectual and aesthetic enjoyment a grand luxury villa provided. And its privacy suggests a studio or workplace, though the multiplication of rooms may argue against the idea.

see 95

The views, carefully calculated and framed, can still be traced; the ruins suggest the original sequences of light and shade, of open and closed spaces, so important in Roman architecture. A lightweight structure could have risen from the peristyle. At this remove, relating the architecture to the marine and chariot-race friezes

is difficult, but such scenes were staples of Roman art and may have been included for aesthetic rather than symbolic purposes. Yet it is hard to resist the notion that some overriding meaning is expressed here symbolically; anything this original, indeed startling, provokes prolonged speculation. In view of Hadrianic and other monuments elsewhere it may be that a concept outside of purely Villa concerns inheres in the design, that part of the pleasure of using the place lay in knowing this. We leave questions of possible cosmological references to others but observe that this ingenious geometrical web and its circular government, with powers of implied radial expansion and convergence, could have had ideal connotations, could carry within it those strong implications of celestial shapes and paths found in other Roman art and architecture. At the least there seem to be implications here of an ideal shape, an autonomous one and therefore perhaps a mirror of perfection.

The Island Enclosure is a kind of built coin, with Hadrian the sentient man at its center replacing the coin's image of Hadrian the all-powerful, the undeniable autocrat. It is so different and so well conceived that it is a major work, if not a masterpiece. Having it provides a useful opportunity to reflect on the nature of classical architecture, on what it was capable of, and on the difficulties that analysis in traditional typological terms may bring. Finally, the plan of the Island suggests important connections between patterned floor mosaics and Hadrianic architecture, a topic the Villa is well equipped to illustrate. Before taking up this revealing subject, we discuss the Smaller Baths.

Two primary decisions determined the Island Enclosure plan: the sizes of the concentric circles and the arrangement of the Island's spaces. The building's encircled autonomy causes neighboring structures to be connected with it, rather than the other way around. The architect of the Smaller Baths, however, must conform both to the Villa's long northwest-southeast axis (with which half a dozen buildings would eventually be aligned) and to the (pre-existing?) south wall of the square court fitted into the Stadium Garden–Arcaded Triclinium angle. He began where that wall meets the Stadium Garden curve, from which point a rectilinear

105 *Smaller Baths, looking southwest from the Peristyle Pool Building (1987)*

106 *Smaller Baths, plan*

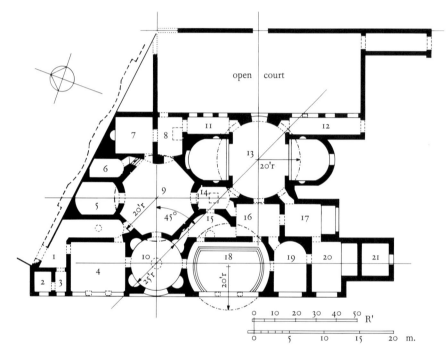

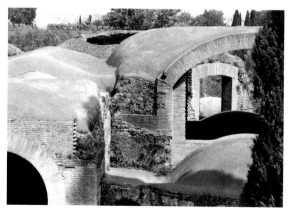

107 *Smaller Baths, roofs, looking north; the openings, from left to right, give onto rooms 17, 9, 13, and 9 (1968)*

framework was extended whose orientation was determined by the neighboring northwest-southeast line. Locating the east court, 100 feet long, was the next step. Then the center line of rooms 13 and 16 was established by extending the court's transverse axis, and that of 9 and 10 by extending the line of the court's north wall. The cross-axis of 9 located 5, 14, and the north wall of 17, and so on. The position of 10 determined both the location of the building's southwest wall and the alignment of the rooms along it. Rooms 9, 13, and 18 all are based on circles 40 feet in diameter, their centers determined by appropriate locations on the orthogonal framework. The internal circle of 10 is 25 feet in diameter, and those of the segmental arcs of 5 and of 13's cold plunges are about the same. A complicated plan thus evolved from successive decisions that involved placing circles on a grid in such a way as to produce a frictionless functionalism: each different space responds immediately to its neighbors, like a chambered Roman reservoir.

Views of the neatly aligned west flank rooms falsely suggest a traditional bath building. The truth was masked also by the north wall and the fact that the building was tucked away and hard to see; even today the only comprehensive view is from the upper levels beside the Stadium Garden. The entranceway was small, almost incidental, subordinated to the scenic wall into which it was set. Like some other Villa buildings, such as the Ceremonial Precinct or the Water Court, the Baths lack an entrance facade of the kind that implies that a rational arrangement of architectural events lies beyond, that what will be seen and experienced there will relate to what the exterior promises. In this sense the outside of the building is neglected. Once inside, the Baths' maze is made navigable by thirty-odd doorways and passages connecting the twenty-two spaces (of which only four were denied multiple entrances). This closely packed place is enlivened by the variety of room-shapes, almost none repeated; all but one (room 4) were vaulted, and the diversity of vault shapes and heights is exceptional. Unlike most classical buildings, the Smaller Baths reveal no apprehensible governing principle of design. If Roman bathing habits

see 344, 345

107, see 221

were unknown, the Baths might be taken as architecture for architecture's sake.

Convincing historical antecedents for the plan seem not to exist unless it reaches back in some vague way to random room dispositions of the kind found in Greek baths, for example at Cyrene or the Piraeus. The only traditional features are certain room-shapes, such as the paired cold plunges and their common hall (room 13), and the installations for varied air and water temperatures and levels of humidity, perhaps even steam, in the different rooms. Otherwise the building is original. Its rooms are fitted together in a kind of superb architectural joinery. Nonfunctional spaces have been pared down or discarded, and internal walls often bear loads from three vaults, sometimes four. Underlying these arrangements are the circles and circular segments, struck from points fixed by the plan's gridlike underpinnings, that make the building unique. Pre-Hadrianic asymmetrical bath plans exist because of the difficulty of rationally ordering the necessary room-shapes, particularly in small or medium-sized buildings (the larger the bath the greater the likelihood of symmetry because of the space available; in huge imperial and other metropolitan baths, duplicate sets of rooms all but guarantee symmetrical plans). But no other known Roman building approaches the splendidly efficient and economical dovetailing of forms or the variety of spatial experience of the Smaller Baths.

The Baths plan, intentionally or not, may resemble that of the Villa. It fits conceptually with the Villa scheme as a whole; there is a sympathy of principles and forms. Both have several axes across well-defined distances that intersect orthogonally and obliquely. In the Baths these patterns are reductive, and in the Villa they may traverse great distances, but the principles are much the same. At first the Villa axes were loosely focused on the eccentrically placed Island Enclosure, a configuration reflected in the Baths by the fact that room 10 is the anchor of the axes 4–10–18–19, 10–9, and 10–15–14–13–12 (there is an unimpeded view along this last, lying along a 45° angle from the rectilinear scheme described above). Other similarities exist. For example, room 18 represents, in this scheme of things,

108 *Smaller Baths, room 13, looking southwest into the south pool (1968)*

109 *Smaller Baths, looking southwest from room 10 along the line of rooms 10, 15, 14, 13, and 12 (1987)*

the East-West Terrace: both have the same plan-shapes overall and for their pools. The islands of near symmetry within the Baths — around 13, or 9 — resemble such similarly balanced Villa groups as the one composed of the Arcaded Triclinium, the Stadium Garden, and the Peristyle Pool Building. It is as if principal Villa features had been realigned by arranging a huge folding carpenter's rule to conform with the Villa's main, flexed axes and then shrunk to the confines of the Baths, its angles compressed to fit inside their borders with some leftover sections strung out to the south. At the very least, a sense of the Villa's disjointed plan inhabits that of the Baths.

The novel architectural thinking that produced the Island Enclosure central plan is also recorded at the Baths. Both are profoundly interiorized, with little regard for classical room sequences. Both are ingeniously compacted, and this, with their interiority, generates a profusion of paths and possible goals. Established room-shapes, if used, are fitted into nontraditional overall plans, for functional needs conform to overriding artistic imperatives. The results are as nearly original as premodern architecture can be. Of earlier buildings only Domitian's palace preserves evidence of this kind of planning, chiefly in a suite of rooms along the Domus Flavia peristyle northwest side. There Rabirius began with five 40-foot circles in line. On the center circle he fixed an octagonal room, on the end ones half-circular and half-square chambers; the two circles in between, each with its own half-circular feature, distanced the end chambers from the octagon. To the southeast, the rooms between the Domus Augustana upper peristyle and the palace stadium are based on similar principles but with less differentiated results. As at the Villa, these palatine designs evolved from imaginative uses of the circle and its radial potential.

Circular planning produced other novelties. The plan shapes of the walls at the Baths and the Island Enclosure not only help to define some new, nonclassical spaces but, together with those of the Domus Flavia suite, are in themselves the record of new structural forms — usually a reliable index of serious architectural change. The structures connecting the southern

Island suite with its neighbors, or the solids around the Baths circular room are good examples; there are many others. In both buildings the inherent qualities of circles augment or replace traditional linear planning organization, so any extended internal axial authority is much reduced if not eliminated. Intersecting circles, extended radial alignments, and tangential volumetric assemblies give these buildings special qualities. And where there are circles there are squares, visible or not, with their own axial influence and 45° contributions; taken together, these two elemental geometric shapes are potent tools.

Mosaic patterns use these same shapes, so striking similarities exist between them and architectural plans. Ample evidence survives for pre-Hadrianic parallels — the central feature of the Domus Augustana lower court, for example, is prefigured in a mosaic at Pompeii, where mosaics with concentric, repeating, and intersecting circles are found. Starting work, the mosaicist and architect proceed along the same lines by preparing plans based on rational if sometimes elaborate geometric configurations. For the mosaicist the plan is the work, for the architect only its beginning; both use circles and squares. At the Hall of the Cubicles the artists (more than one was at work) have left a most useful record of affinities between mosaic pavements and architectural planning. These black-and-white mosaics in the central panels of the cubicles are all patterned with repeating circular or rectangular shapes either deployed on a grid or extended from the grid intersections. The Island Enclosure peristyle shape is immediately recognizable in the mosaics of rooms 1 and 10, the Enclosure plan-scheme is intimated by the design in room 2, and the ubiquitous Roman octagon appears in room 8. The chrysanthemum pattern of room 3 suggests the protruding curves of the Arcaded Triclinium and the Water Court vestibule. In room 9, the pattern is based on repeating orthogonal alignments of larger and smaller circles, though the pattern is never fully achieved because of the delimiting frame. The circles there are reminiscent of the Smaller Baths circles and, intersecting, produce among them octagons with incurving sides much like the Baths octagonal room.

see 202
see 201
see 199
see 203
see 200

110

The frame corners hold quarter-circles as the Island nichelike spaces hold the fountain and the lavatories, and along the borders are the half-circles found in palatine and Villa plans.

Other connections suggest themselves. The mosaicist must often deal with the juxtaposition of straight lines and curves. Sinuous reverse curves appear, as in the flowing garlands that surround the central circles of room 9. The shapes that are in essence left over after the major figures have been laid in can be just as expressive as their neighbors; again room 9 is instructive, where largely abstract forms create a strong figure-ground tension. And in mosaic terms is not the Island an emblema within its Enclosure? Perhaps the Enclosure plan is distantly related to the popular single-circle and concentric-circle mosaics, of which many examples survive. Clearly, both artists and architects were intrigued by the circle and its properties, and in adapting them so successfully they achieved something of a revolution in design. The circle was common enough in architecture before Hadrian's time, but in Hadrianic work, particularly at the Villa, its dynamic potential was understood more fully and used in more sophisticated and effective ways.

The Island Enclosure is almost wholly right, complete and self-limiting, whereas the Smaller Baths are less right than assertive, challenging; both demonstrate what gifted architects could do in going beyond accepted boundaries of design. Both buildings are deftly crafted works of great imagination, different from all other Roman architecture. But this difference doesn't define their importance in the history of architecture; on the contrary, they are, with the Water Court and the Reverse-Curve Pavilion, telling benchmarks of classical architecture's boundaries. For the study of Roman architecture the Baths stand out by underlining strongly the unlikely and exceptional variety of bath design and by emphasizing the significance of the fact that bath buildings often affront traditional classical dignity and decorum. Bath studies, largely concentrated on typology and function, have a long way to go, and the Smaller Baths, in their individuality and seeming waywardness, can encourage productive departures from

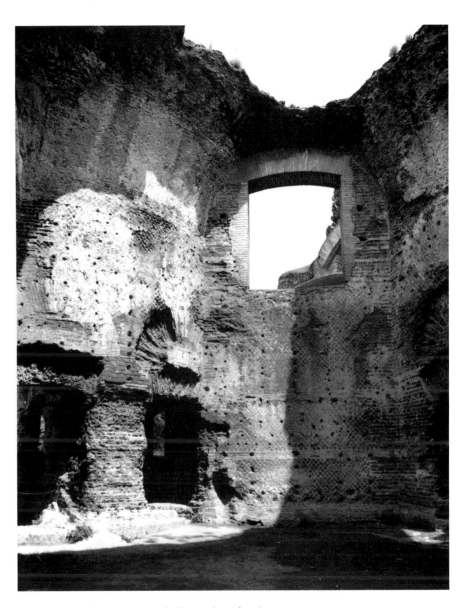

110 *Smaller Baths, room 9 interior looking southeast (1987)*

traditional thinking as an example of design rather than function. They are a rarity in classicizing architecture of any period, places of controlled irregularity, and this helps to point up the partiality of established definitions of classical architecture, which often ignore presumed aberrations and evidence of high originality. And normative typological and functional analyses falter somewhat when faced with the Baths or the Enclosure, so independent of tradition, so un-Vitruvian. Hadrianic architects and artists didn't know they were practicing what is now called classical design, and some of them were far more inventive than the phrase (with its overtones of rules and propriety) implies; this their buildings at the Villa and elsewhere prove beyond doubt. Their elegant work with circles records an enthusiasm for pushing on, for searching out new possibilities, and records that indifference to comfortably familiar buildings creative architects often flaunt.

REVERSE CURVES

Evidence for the creative use at the Villa of the circle and its inherent properties includes serpentine boundaries and enclosures formed by joining arcs sequentially, now concave, now convex. Reverse-curve patterns exist in pre-Hadrianic pavements, but apparently not in architecture. Perhaps planning the Island Enclosure directed attention to the idea; certainly it is found in the Hall of the Cubicles mosaic, and the ways mosaic artists constructed their patterns are so similar to those the architects used that another connection seems certain. No regular sinuous alternation, wherein identical but alternatingly reversed arcs are joined at points lying in line, as at Jefferson's Charlottesville garden walls (restored), have been found. Of the three Villa examples—the Reverse-Curve Pavilion, the Water Court nymphaeum, and the nymphaeum by the Water Court north corner—only the Water Court repeats the same arcs consecutively, and as at the Arcaded Triclinium, somewhat awkward junctions were smoothed over. The Court and the Pavilion are celebrities of Villa studies, but the Court external nymphaeum is at least as significant. And although the planning of these buildings

is an important subject, their architectural qualities of form and space are equally vital. All three are essentially wall-less and cagelike and include a most unusual feature, perhaps never seen in earlier architecture, undulating entablatures. Their dramatic reversals of direction, of shifting visual and volumetric formations and views, defined a new kind of architecture.

Close to the steep fall of ground from the West Terrace line, on high ground and open to the air, the Reverse-Curve Pavilion served as a belvedere. The plan geometry is complex. A major, governing circle, 26.5 meters (90 feet) in diameter, was encroached upon on its cardinal axes by four incurving, columned exedras resembling that of the Island Enclosure; they were joined by curving corridors formed between the remaining four arcs of the central circle and short, concentric inner arcs. In the northwest exedra, overlooking the West Terrace, was a segmentally shaped pool. The exedra on the opposite side was screened first by a straight colonnade and then by a rectangular room centered on a long, narrow corridor that reached all the way down the west side of the large Southern Range court. Parallel to the cross-axis of the main circle, pairs of chambers terminating in apsidal forms projected well out from the Pavilion's main body; all parts of the building intercommunicated. Fragments of the niched piers between the main circle and the projecting chambers still stand. Windows gave onto the four large niches.

In some ways the Pavilion plan resembles that of the Island Enclosure turned inside out. The Pavilion is externalized, its exterior reverse curves much more strongly stated than those of the interior. With chambers pushing out strongly from the central core the Pavilion probes the surrounding space, whereas the Island Enclosure all but denies its existence. At the Pavilion the governing circle lies inside the building, not around it like the Enclosure wall, walkway, and canal, which form a buffer between the outside world, and the Island, whose chambers, turned inward, huddle together in near isolation. Yet the Enclosure plan, balanced and ingeniously rational, is the better integrated. At the Pavilion the geometry is just as rational, but the large circle fails to unify the design satisfactorily, and

the four chambers—which with their large openings are themselves pavilions—strain to disengage themselves from their common core. What the elevation and superstructure of the Pavilion may have been we do not know, but the plan and the size of the structural members suggest a wooden roof over the central space; the smaller volumes may have been vaulted.

Of the external curves only the northeast and southwest exedras appear to be semicircular in plan, but that is because they join the straight sides of the projecting chambers well out from the line of the chambers' back walls in patchwork transitions. All the building's reverse curves are, like so many Villa curves, less than semicircles. Apparently the radial depth of full half-circles produced designs too static, or perhaps too assertive or intrusive. Inside the building the intersections are unusual: plan circles of different sizes collide one with another. The geometric figures locating the center points of all the different Pavilion curves are easy to supply, but they don't explain why the fluidity inherent in the junction of full half-circles, apparent to any designer, was so carefully avoided. Perhaps Hadrian and his architects, obviously talented, were in thrall to a fundamental fact of classical design, the necessary individuality of all major constituent parts of a building, parts whose clear-cut readability must be preserved. Once two circles, of the same or different size, are placed in tangency, and walls or colonnades are run from that point in opposite directions, classical clarity and definition are obscured; by joining segments of circles, at least some of the necessary differentiation among building parts is preserved.

114 At the Water Court a six-fountain, reverse-curve structure was the climactic element of a huge building (about 59 by 88 meters, 2:3) that embodied several unusual features. From the east corner of the corridor outside the Residence Fountains a fairly narrow walkway, with columns along its east side, led to an octagonal vestibule that gave onto internal walkways

115 enclosing the open Court proper. The vestibule, with windows on the transverse axis and semicircular niches on the diagonals, was roofed by a gored dome whose eight scalloped interior panels rose to an oculus. Slim

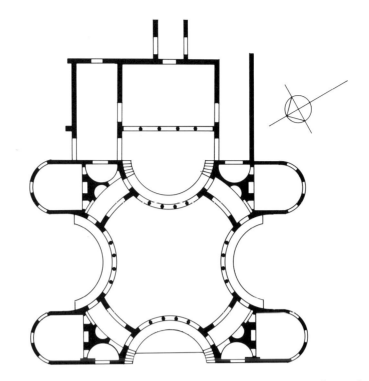

111 *Reverse-Curve Pavilion, plan*

112 *Reverse-Curve Pavilion, looking east (Penna no. 108)*

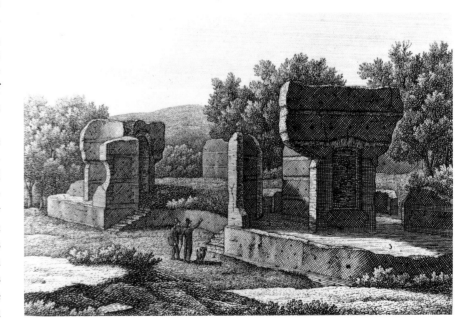

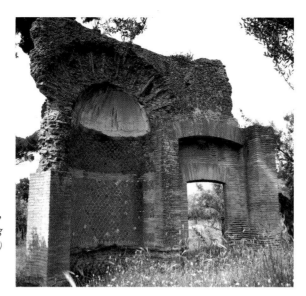

113 *Reverse-Curve Pavilion, interior of north pier, looking north (1987)*

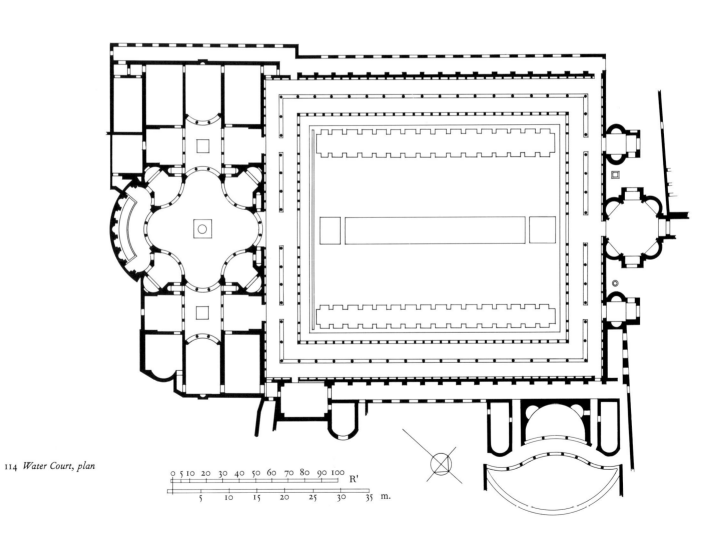

114 *Water Court, plan*

0 5 10 20 30 40 50 60 70 80 90 100 R'

5 10 15 20 25 30 35 m.

columns stood below, against the octagon's interior angles; above them impost blocks, the cores of some still in position, appeared to support the vault arrises. And because the arches formed by the intersection of the concave panels with the octagon's vertical sides also appeared to spring from the impost blocks, an architectural image of a diadem was created, one repeated effectively on the vestibule's exterior. When the original marble and mosaic sheathing was intact, muting the present substantiality of the exposed concrete fabric, the double ring of interior arches and the converging gores of the vault above would have conveyed an impression of comparatively effortless support, of a certain lightness of structure.

To gain the Court from the vestibule, whose inner face lies on the line of the building's perimeter wall, one crossed two peristyle walkways, set one within the other. The first was marked by files of columns, the second, bordering the open Court, by an arcade on piers; all three vertical systems shared a common timber and tile roof. The perimeter wall inner faces carried blind arches empaneled between engaged columns, all of brick stuccoed over. On the innermost system's arcade piers, engaged columns, on the sides facing away from the Court, responded to those of the perimeter wall. Outside that wall, along its northeast and southwest sides, cross-vaulted and windowed corridors, entered from the corners of the Court, ran the length of the building. A broad, shallow canal, with a deeper central channel, lying on the axis of the open Court, was flanked by trees and by planting beds marked off by low vertical borders made of thin sheets of marble as at the Island Enclosure.

The Water Court plan resembles schematically that of the Domus Augustana lower court, with its bordering arcade, central waterworks, and domed octagonal room closing the longer axis, and, among later buildings, the Round Temple and its court at Ostia. The multiple wrapping of the Villa peristyle is foreshadowed, for example, by that of the building of Eumachia at Pompeii. With its ample spaces for perambulation and service and its grand nymphaeum chamber cooled and freshened by the six fountains (the terminal one a major,

116

117

see 339, 340
118

119

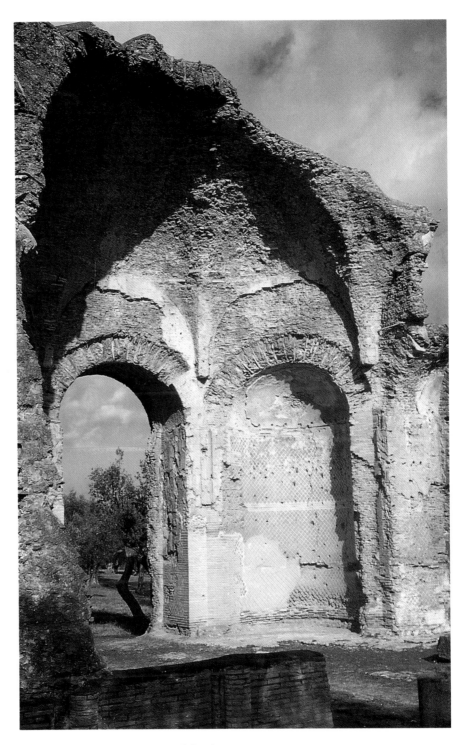

115 *Water Court, vestibule, looking north (1955)*

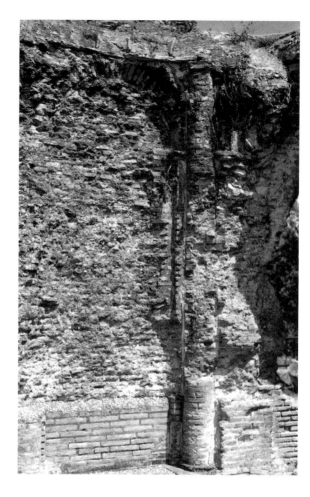

116 (top left) Water Court,
vestibule exterior, looking
east (1987)

117 (bottom left) Water Court,
northwest interior flank, looking
north (1987)

118 (top right) Water Court,
northwest interior wall,
detail (1987)

119 (bottom right) Water Court,
southwest internal flank, looking
southeast; blocks (left) mark the
enclosure colonnade (1987)

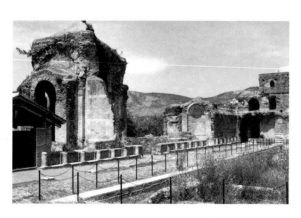

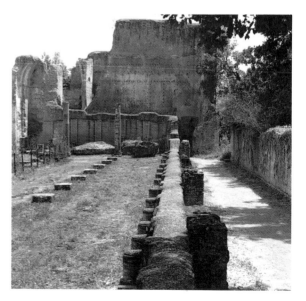

indoor nymphaeum), the Court was an enclosed garden with splendid waterworks, another remarkable place to visit and linger in. Of the sculpture once seen there only some column and pilaster capitals and pieces of friezes with marine and hunting scenes remain. Restored portions of the walkway paving can be seen, and in the western of the two small chapel-like structures flanking the octagonal vestibule part of the original mosaic pavement, brilliantly colored, has survived together with fragments of marble wall sheathing. Between the Water Court and the East Valley are a number of structures, among them the oval arena lying below the Court level but well above the Valley floor and the large nymphaeum, with reverse-curve features, at Court level; to the north, stairs descend to small rooms facing the East Terraces.

The plan of the internal reverse-curve structure of the famous nymphaeum chamber is based on a 70-foot circle centered on a fountain. On the diagonals, beyond the inward-turning curves, four additional fountains played, and the large, curving fountain stood on axis at the rear. On either side of this elaborate design, duplicate six-chamber suites (plus a south-corner extra room), resembling the Residence apartment in plan, connected with the nymphaeum chamber on its transverse axis by way of small open courts with centered square pools in the manner of traditional atria. Secondary curving column screens at the far ends of the courts opened up a building-wide view between statue niches in the enclosure wall. The rooms of each suite intercommunicated, and lavatories were placed between the courts and the main chamber in small narrow spaces created by the planning forms.

As at the Reverse-Curve Pavilion, the chamber arcs are segmental (about 96°). Those on the cardinal axes are extended by the pier faces, those on the diagonals are not. These pier-and-two-column units, taken individually, are conceptually like the porches of the Fountain Court West and the Scenic Triclinium forward pavilions. Half-circles, in the nymphaeum chamber sequence, could not be used because the resulting space would have been badly cramped, hemmed in by a figure like that of a symmetrical, four-knobbed piece of a jig-

120

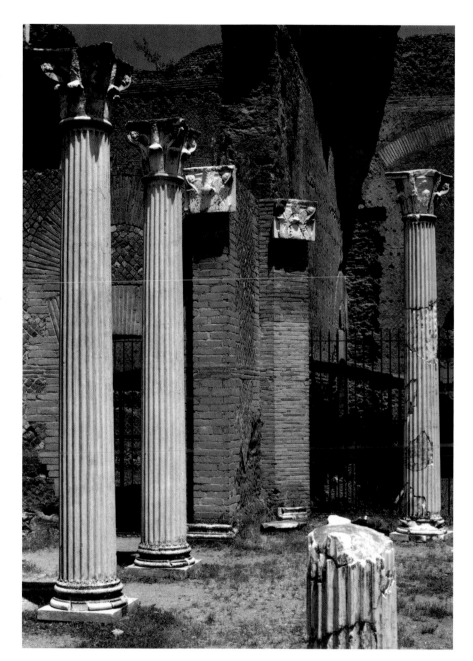

120 *Water Court, columns in the chamber just northeast of the nymphaeum (1987)*

1 0 0 U N F A M I L I A R A R C H I T E C T U R E

saw puzzle. The question of whether the chamber was roofed is unresolved. If unroofed, it stood between two other skylit spaces, in opposition to the Roman habit of alternating light and shade with roofed and unroofed spaces succeeding each other. An unroofed chamber would have left the sinuous entablature standing free, an unusual and irrational thing both visually and structurally, and if the inner edges of roofs (if there were any) over the adjoining spaces rested on the entablature, the view from the inside would presumably still have been of a sinuous, vertical stone ribbon lacking a superstructure. And if, as seems correct, the chamber was the central locus of an imperial summer triclinium, would the emperor be left uncovered? To supply this ingeniously centralized space with a roof raises as many questions as to deny it one: the complications resulting from the effect of the plan on the junctions of varied and novel roofing forms, for example, are difficult to envision. Many think the chamber was vaulted in concrete, but that would probably put too much weight on an unusually high support-to-span ratio (1 : 12 across the 70-foot circle diameter). A comparatively lightweight carpentry construction is possible, even likely, but nothing is certain.

The planning is a telling investigation into the potential of colonnade screens and the possibilities inherent in creating centralized spaces of complex plan. Compared with the Reverse-Curve Pavilion the design is fluidity itself; like the Island Enclosure, it is complete and self-contained, without unresolved or jarring solutions. The broad terminal nymphaeum, its plan curves struck from the same center as the pier-and-column arc before it, is so neatly fitted into the whole design that in spite of its formal individuality — it is the only unduplicated major shape in the building — it fits smoothly into the overall effect. Cardinal and diagonal axes are released and then caught by the underlying design rhythms, and repeated effects of parallax came steadily into play as the building was traversed. At the same time the building was truly and forcefully centralized; to combine effectively in one scheme strong horizontal and vertical axes with multiple and mirrored

views while suggesting the presence of a boundary of water was a triumph.

Part of the vault and walls of the nymphaeum built against the Water Court exterior north corner and facing the East Valley still stands. An inner pool, slightly more than a half-circle in plan and about 12 meters (40 feet) across, was covered by a slightly extended half-dome whose chambered supporting structure can be seen from the Water Court rising above the Court's outermost, cross-vaulted corridor. Beside this structure small chambers projected their apsidal ends out toward the front of the pool. A sinuous transverse walkway separated the pool and its side chambers from a much larger one, open to the air, beyond. The facing, columned borders of the two parts of the composition, their plan-lines matching exactly, first curved slightly out toward the Valley, then inward in broad, shallow arcs, and gently reversed direction again at the other end; the plan curves lie along two small circles tangent to much larger circles (the long arcs of the two pools). The results may be the most fluid reverse curves in Roman architecture; in execution they were interrupted by narrow passages between the smaller pool and its side chambers. The multicurved shape of the larger pool, with its wide segmental Valley-side boundary, is unknown elsewhere.

Possibly the ancient tradition of reverse-curve moulding profiles has some connection with these Villa designs — the cymas, for example, and the column-base layering of a torus (convex) above a scotia (concave), and the like; perhaps the ubiquitous flowing vine and acanthus carvings played a part. Certainly artists and craftsmen were thinking along the same lines as the architects who designed the Villa's reverse-curve structures. The Water Court capitals with their reverse curves, like those of the augur's wand (the *lituus*), forecast those of Borromini, as at San Carlo alle Quattre Fontane, in the Lateran nave, or on the bell tower of Sant'Andrea delle Fratte; his declared interest in the Villa and enthusiasm for evidence of originality and novelty in ancient carving suggests a connection. These Water Court capitals (both pilaster and column examples are preserved) enclose small faces, in profile,

121
122

123

see 41

see 277

see 200 within the final, uppermost volute turn. The reverse curves of the mosaic in room 9 at the Hall of the Cubicles, with their flowing wreaths and garlands of laurel and oak—particularly those entering the large central circle—follow paths like those of the Water Court nymphaeum chamber plan. Close in spirit also is a reverse-curve pattern in a Neronian marble pavement, and some pre-Hadrianic mosaics, as at Ostia, offer similar evidence. Reverse-curve patterns in floor mosaics and marble pavements had a long run after Hadrian's day.

For such architectural forms and volumes there seem to be no discernible antecedents. But Hadrianic examples exist outside the Villa, so these developments were by no means kept hidden but could be seen, for example, at the vestibule of the so-called Temple of Venus at Baiae or in the sophisticated architectural tomb near Santa Maria in Capua Vetere known as La Conocchia. At Olympia, Roman second-century changes in the Leonidaion produced a reverse-curve plan within the central peristyle. But like the gored and paneled Hadrianic domes, of which other examples survive away from the Villa, the novel ideas about curved planning Hadrian and his architects pursued took root only later on. The presence of reverse-curve plans and gored vaults in late antique and medieval architecture may not stem directly from Hadrianic examples, for intermediating connections are probable (the direct influence the site's novel buildings had on architects in the seventeenth and later centuries is taken up later). The reverse-curve buildings are the strongest surviving evidence for the vitality of the experimentalism Hadrian fostered at the Villa. The awkwardnesses seen here and there are proof of originality: the design problems were new, and no body of experience suggested how they might be solved faultlessly. At some points, for the reasons given above, a certain rigidity may mar the effect the emperor hoped for, and some undeniably static passages and relations stand out. But these buildings are not failures, nor are they sterile, as has sometimes been said, because they represent creative explorations of the art of architecture, as later masters recognized.

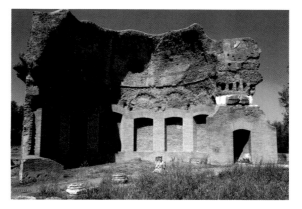

121 *Water Court, external nymphaeum, looking southwest (1987)*

122 *Water Court, external nymphaeum, and remains just to the north, looking southwest; vestibule at the far right (1988)*

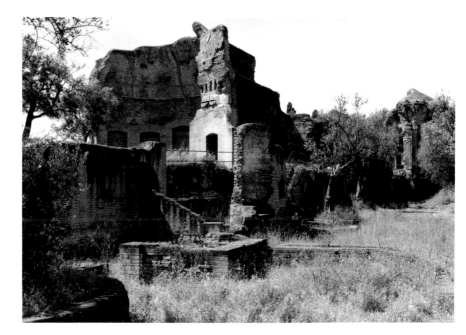

123 *Water Court, external nymphaeum, pool area in front of the nymphaeum proper, looking northwest (1987)*

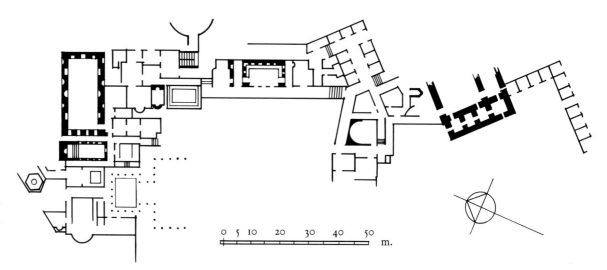

124 *Near Civitavecchia, Trajan's villa(?), plan*

0 5 10 20 30 40 50 m.

BANQUET HALLS

124 Pliny spent some time at Trajan's Civitavecchia villa as a member of the imperial council. He enjoyed the work—giving legal advice—and the opportunity of seeing the emperor close up, in "his lighter moods, in the sort of country setting where [they] are easily revealed." The council heard a case a day, then

enjoyed . . . relaxing in the evening. The emperor invited us every day to dinner, simple affairs if you reflect on his position. We were entertained sometimes by recitations, or else the night was prolonged by pleasant conversation. . . . I took great pleasure in the importance of the cases, the honor of being an adviser, and the charm and informality of our social life, and was no less delighted by the place itself. The villa is very beautiful.

The emperor's presence aside, these evening gatherings were ordinary experiences for Pliny, for Roman society revolved around dinner parties. His Laurentine and Tifernum villas each had several dining rooms, including at Tifernum an everyday place (*cenatio*) for entertaining a few personal friends, more or less en famille, for supper (*cena*). Trimalchio's gaudy mansion has four, one of them big enough to accommodate all the guests, hangers-on, slaves, and entertainers attending the famous banquet, that splendid send-up of a rich man's indulgence played out by a crass new millionaire.

Any house or villa of consequence must contain facilities appropriate for the *convivium*, or banquet. This for a long time was an all-male affair, the women dining separately but often joining the men afterward. By Hadrian's time, however, banquets in aristocratic circles at least might be attended by men and women both. Because the dinner party was such an important upper-class social function, ranking with bathing as an indispensable activity, the literary record is ample and includes information about entertainment and topics of conversation. Statius imagines a thousand tables set for one of Domitian's banquets he attended on the Palatine. Juvenal, somewhat older than Hadrian (of whom he approved), repeatedly uses dinner parties and exotic food as ammunition for his slashing indictments of Roman folly and immorality.

As imperial architecture evolved, so did dining-room terminology: in due time triclinium (a room for dining couches arranged on three sides of a rectangle), ever more loosely used, might mean a reception room, and tablinum (first perhaps a bedroom, then a records and reception room) a dining room. The Greek oecus, introduced into Roman architecture at the same time as the peristyle, was a high-ceilinged all-purpose room with internal columns frequently used for dining; cenatio simply indicates an eating-place. Thus at Pompeii and Herculaneum traditional dining rooms can usually be identified, but less chance for that exists elsewhere because no single definitive architectural form existed. At the Villa helpful evidence survives: both the Scenic Triclinium and the Residence preserve the structural

core of a stibadium set under a vaulted canopy open to the view.

Hadrian could eat wherever he wished. He could dine alone, or with Sabina, or with counselors or amici, with a few guests or a large crowd. There were locales for all eventualities, and dining furniture could be set up almost anywhere. Large numbers of people and lavish entertainment required a lot of space. The emperor was devoted to banquets. He enjoyed going out to dinner and invited ordinary people to his own, according to the HA, which also says that in order to be sure that lesser folk got the same food he did, he ordered theirs brought to him first. He is said to have offered tragedies, comedies, and farces as entertainment, as well as recitations, poetry readings, and music. The evidence for his banquets found in Fronto, Dio, the HA, and Aurelius Victor, and the role of elaborate dinner parties in Roman society, explain the attention given to banquet facilities in Villa planning. It also helps to explain why so many Villa structures have from time to time been called triclinia, among them the Portico Suite, the Water Court, the central room on the Stadium Garden east side, the Southern Hall, and both Fountain Court buildings.

An analysis of 1950 of the Arcaded Triclinium emphasizes architectural connections with the Domus Flavia banquet hall; subsequent writers follow suit. Because of that, and for convenience, we too call the building a triclinium, but with reservations. In the plan, Palatine influence is clearly at work, though the imperial audience chambers may have been as important in this as the banquet hall; in any event, enough is known about Hadrianic buildings to suggest that function doesn't always follow form, a divergence particularly noticeable in dining hall design. The Triclinium lacks service passages and facilities (the easternmost rooms can be reached from the east exedra only by traversing intervening spaces), and is perforated, both internally and along its perimeter, by thirty-odd openings, an oddly cagelike scheme, perhaps, for dining. The building turns its back on the Stadium Garden (though area plans make it look as if the Triclinium east wing connected the two), which could be reached only by ex

ternal walkways some 30 meters long; seven windows gave onto the Triclinium's easternmost rooms from the Garden. The purpose of this east wing, with its entrances all at the west end and its unusual plan overall, is puzzling. Perhaps the central room was an audience hall or a shrine, or perhaps the whole seven-room suite was an art gallery. Whatever it was, it was not the formal response to the axially placed Stadium Garden suite that plans of the Garden-Triclinium area imply.

In its first phase, the building consisted of three major elements arranged in an axial north-south sequence (all about 2° out of true). The first element, a wall-less, columned pavilion containing a large rectangular pool from which rose a mastaba-shaped fountain, opened directly onto the East-West Terrace. Beyond the pavilion, but spatially continuous with it, lay the main hall, somewhat longer than wide, perhaps the largest roofed space at the Villa. The southernmost element was a semicircular exedra as wide as the hall, enclosing within its solid exterior structure a curving, arcaded walkway and a garden with fountains visible from the hall through internal windows. In a sense, there is noth-

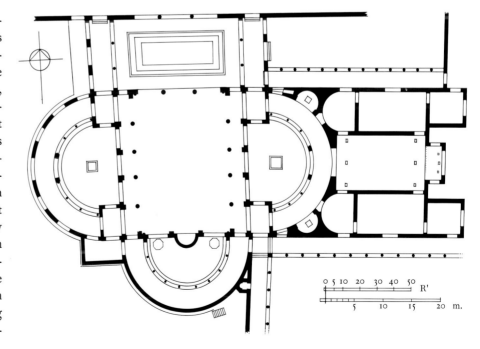

125 *Arcaded Triclinium, plan*

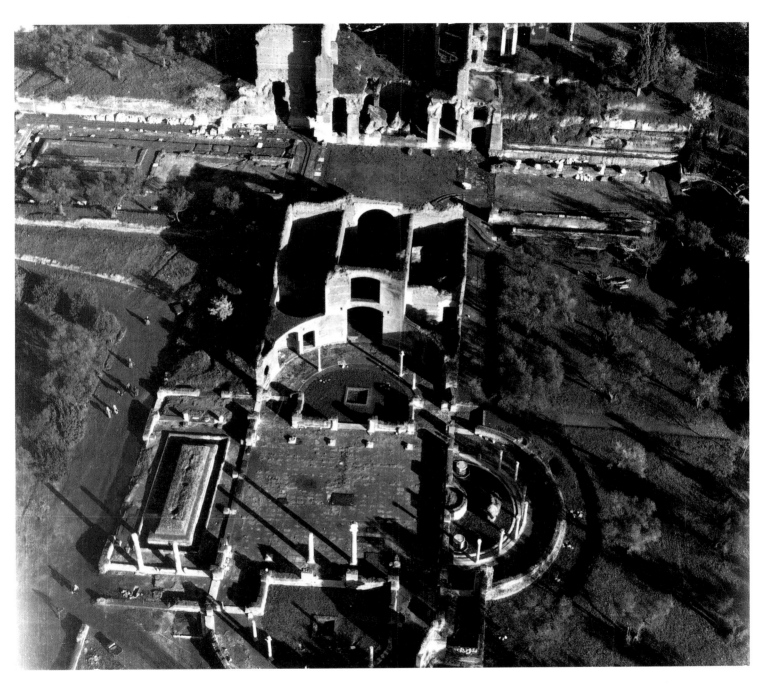

126 *Arcaded Triclinium, aerial view, looking east to the Stadium Garden (1964)*

ing unusual about this scheme—an anteroom, a hall, and a hall-wide apse.

But Hadrian soon transformed this familiar Roman configuration into something quite different from earlier versions by adding internal arcades, not only to the south exedra but within the central hall as well, by using only one solid exterior wall to give the Triclinium a powerful spatial orientation and by allowing views, but not paths, along some major planning axes. The pavilion pool was meant to be contemplated from alongside. Large windows connected the central hall (anchored axially by a good-sized niche) visually with the exedras, whose entrances, at the ends of the arcaded aisles, were inconspicuous. From the north, the hall could be gained only after traversing the pavilion's aisle-like passageways and then turning, within projecting, intermediating spaces, abruptly into it. The provision of duplicate intermediating spaces at the hall's south corners may suggest that the east and west exedras, with their centered fountains, were in mind from the beginning.

Adding those didn't much change the building's planning and visual principles. The outer ring, so to speak, suggested by the pavilion aisles and the south exedra walkway, was made continuous around three sides, and the internal views to the south were repeated east and west. The new east wing, which in plan vaguely resembles the Residence apartment, shows in its central chamber signs of presentation, whether of the emperor or of images: the broad rectilinear eastern niche has a slightly raised floor and seems to have been marked off by a transenna of sorts, in the fashion of the Domus Flavia basilica, but for us the wide window in the niche argues against its identification as a tribunal. From the Angled Terrace the entire wing would once have been very noticeable, with high walls as the restored arches suggest, though it would have lain well below the uppermost level of the structure on the other side of the Stadium Garden. At least part of the east wing was roofed with a mosaic-paved terrace (reached by a staircase—there may have been others—fitted into the north corner of the east exedra's thick perimeter wall) that was probably made of concrete slabs; fallen

129

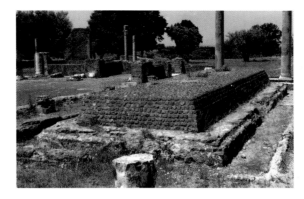

127 *Arcaded Triclinium, northernmost fountain, looking southwest (1987)*

128 *Arcaded Triclinium, eastern extension, looking west (1987)*

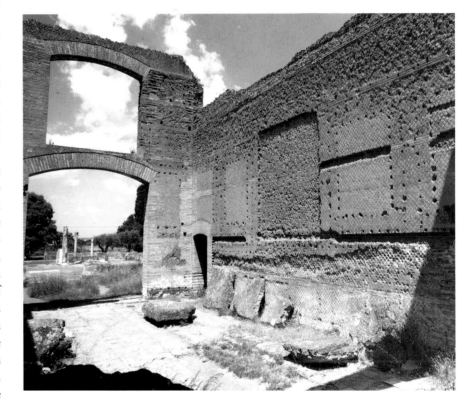

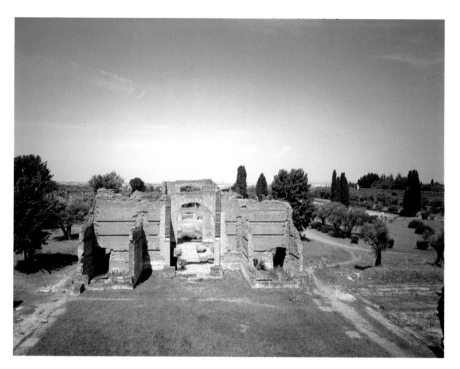

129 *Arcaded Triclinium, looking west (1987)*

pieces, complete with floor mosaic, survive. Balconies at appropriate viewing points, like the one on the Residence Fountains northwest facade, should not be ruled out. The largest southern chamber in the east wing was heated, and the walls of the big central room preserve unequivocal evidence of large paintings, mosaics, or reliefs.

A search for precedents turns up little. Conceptual aspects of the Domus Flavia banquet hall reappear in the Triclinium, but planning and circulation at the Villa are of a different order, more complex and less unified. It is worth remarking that the aisles formed by the central hall internal arcades are narrow like those of the apsidal Domus Flavia basilica and that although there are no colonnades in the neighboring banquet hall, there are views from it into the flanking fountain chambers, suggesting the similar arrangements at the Villa. It is possible to see in the Palatine hall a forerunner of trilobed planning, but none of its three curved perimeter walls subtends more than 60°, and as a result the plan suggests that Rabirius, though he

may have been prefiguring the future here as elsewhere, was for the moment suspended between orthogonal and circular planning.

Perhaps the Triclinium is the first trilobed building in classical architecture, a form popular with late antique and early Christian architects. It may also record the beginnings, in planning at least, of two-shell design, wherein a high, large central space, with its own windows, is wrapped in a circumscribing, lower aisle-like structure of the kind seen for example at San Vitale in Ravenna, San Lorenzo Maggiore in Milan, and the Bosra Cathedral. The presence in the Triclinium of arcades rising from curved plan-lines presents a problem. Is this their first appearance, and if not, what are their antecedents? In the turning stretches of aqueduct bridges or the windowed curving walls of bath chambers? Whatever the answers, the Triclinium is certainly as original as any Villa building. It planning, though sophisticated, is in places clearly experimental. The east and west exedras, of the same radius as the southern one, are adjusted to the greater length of the central hall somewhat awkwardly, and it is difficult to understand why the hall internal arcade plan-lines were not determined by the position of the piers at the north ends of the south exedra walkway arcade. We cannot explain the function of the anomalous and asymmetrical southwest chamber.

Still, it is a solidly Roman design, made of familiar parts and containing, as so many Roman buildings do, numerous formal replications. The northern and southern chamber sequences of the east wing, for example, are conceptually the same as the hall-exedra sequence of the original structure. The waterworks—at least five fountains, of which three were axially sited, plus water channels tracing the exedra arcades on their inner, garden sides—are all but predictable. The sequences of open and partly open space produced Roman contrasts of light and shade not unlike those of the Island Enclosure; in both places curving roof-lines and walls generated lively variations of illumination and of shadow forms. In the central hall at least the marblework, of both pavement and orders, was exceptionally fine. On entering the building from the East-West Terrace one

130

first passed through the Terrace colonnade and then walked by the pool, open to the sky, along another roofed passage. The timber and tile roof of the central hall, which might have been carried on clerestory walls, kept out most direct light there, but the space was opened up on all four sides. From three of these the open exedras, edged by shadows thrown by their own curving walkways, brought, like the pool pavilion, sun or moonlight into the building. Water, colored surfaces, and variations in lighting were as important to the building's visual effects as its structural frame. The east-west axial view through the entire complex to the Stadium Garden passes through openings that define eight mostly different spaces with varying sources of light, besides crossing a brightly colored, polished marble floor and at least two fountains.

Probably the building was multifunctional: Hadrian might use it as a dining hall, a reception suite, or a kind of elaborate detached casino or gazebo (how it was shut up against the weather can confidently be left to the Roman craftsman's ability to make complicated, effective fittings). Its historical significance lies in a loosening, even undermining, of spatial certainties, possibly in a search for a statement or demonstration of earth-sky relations—known in other Hadrianic monuments. Though roofed, the central hall had almost no walls, which created a spatial freedom of the kind seen in an elementary state in street-straddling urban four-way arches. In the Triclinium the exedras largely arrested the escaping central space and turned it back toward its source while drawing their own space from the sky. The repeated arcades, with their point loads and implied structural ambiguity, were effective instruments of spatial fluidity, framing incomplete views and glimpses and accentuating ambivalent coulisse effects of overlapping and interpenetrating volumes. Space, in other words, moved unhindered through the exedra-hall formation, formed and then re-formed by columns, arches, wall sections, and doorways, by covered and then uncovered spaces, by niches and by windows. In that way the freedom of the sky was perhaps described in some degree by earthbound, tangible construction. The Arcaded Triclinium was not just a novelty, no more than were the

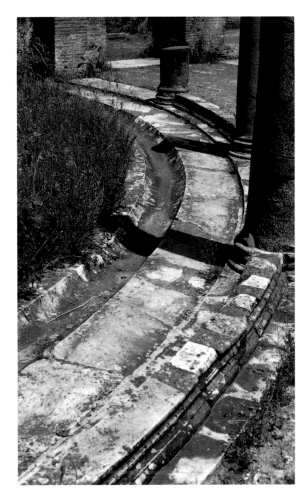

130 *Arcaded Triclinium, water channel and columns in the south exedra, looking east (1987)*

131 *Arcaded Triclinium, south exedra and environs, looking west (1987)*

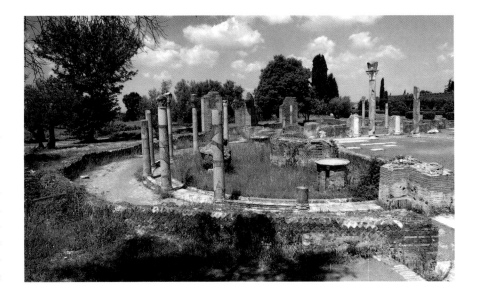

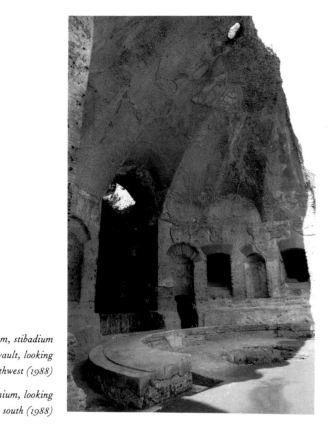

132 *Scenic Triclinium, stibadium and its vault, looking southwest (1988)*

133 *Scenic Triclinium, looking south (1988)*

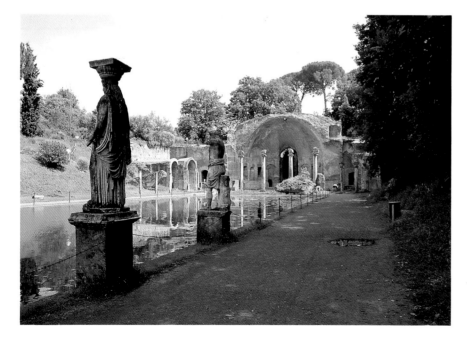

Island Enclosure or the Smaller Baths; like them it was a serious, original exploration of architecture as space.

The large stibadium—about 13 meters across—under the Scenic Triclinium half-dome verifies its use as a banquet hall, but that wasn't its only purpose, as its design, setting, and union with the Scenic Canal make clear. Although the principal features of both elements can be read fairly easily (the Canal is a restoration), changes and losses have occurred. The view framed by the Central Vestibule is lost, and the valley terrace edges—of two levels, on the east, between the Canal and the Upper Park—are no longer clear. The architectural restoration at the Canal north end has been questioned, and the effect on the whole composition of the original garden-bordered colonnades (single on the west, where the caryatids and sileni were included, double on the east) must be deduced from the partial restorations. The collapse of the forward part of the great Triclinium roof, in effect a huge barrel vault about 5 meters deep that extended, like a hood, directly from the semidome still standing, causes an unreliable impression of the original, not the least because the 52-meter (175-foot) transverse element joining the Triclinium's chief parts is now difficult to envisage; it passed under arches supporting the barrel vault. The vertical plane along which the break came masks a Pantheon-like honeycomb of interior chambers on two levels of the semicircular building behind. An arched entablature joined the central two of the four facade columns. How the facade above, rising toward the forward edge of the hood vault, was treated is uncertain. If it was left open, the vault behind was seen through a void shaped somewhat like that of half of a holed coin; consoles survive in the facade surfaces of the fallen pieces of superstructure. The semidome was encrusted with mosaic and consisted of alternating spherical and concave gores tapering toward its summit.

What of the Egyptian connection? Hadrian's interest in Egypt is well documented; he had been there before his visit in the summer and fall of 130, at the end of which, on 30 October, Antinous drowned. Antinoopolis was then founded, and at some point the emperor built a new quarter, carrying his own name, in Alexan-

132

133, 134

135

dria, where either he or Trajan built a temple to Serapis; other Hadrianic works in Egypt are known. Numerous sculptures of Egyptian content, including two of Antinous as Osiris and one of the Nile, are known to have been at the Villa. Of these, six—among them a sphinx and a crocodile—turned up when the Scenic Canal was dug out; others are known. By itself, the presence of Egyptianizing art lends little weight to an Egyptian interpretation of the Canal and Triclinium because Egyptian deities and images were common in imperial art, often mixed with non-Egyptian subjects in a most catholic way. It seems likely that the Triclinium at least was built before 130, and it is unlikely that the Canal was an independent project.

Strabo, who went to Egypt in 25 B.C. and stayed for several years gathering data for his *Geography*, says that on foot the town of Canopus is

120 stadia [22 kilometers] from Alexandria, and is named after Canopus, Menelaus's pilot, who died there. It contains the temple of Serapis, which is honored with great reverence and effects such cures that even the most reputable men believe in it and sleep in [the temple]—either in person, or have others do it for them. Some writers record cures, and others the virtues of the oracles there. But on the other hand there is the crowd of revelers who go down from Alexandria by the canal to the public festivals; for every night and day there are crowds on the boats who play flutes and dance without restraint and with extreme licentiousness, both men and women, with each other and with the Canopeans, who have places close to the canal adapted to relaxation and carrying-on of this kind.

The younger Seneca, writing in the 50s, says that at Canopus "luxury indulges itself to the utmost." Juvenal finds the town infamous and, always adept with odious comparisons, at one point finds Rome an even worse place than Canopus. By Juvenal's and Hadrian's time the name was synonymous with degeneracy, as was that of Baiae in Italy. But Canopus was a religious center, a place of pilgrimage, however liberated in its devotions, where worship of the Nile, Adonis, Serapis-Osiris, and Isis, in a religious syncretism typical of the age, was combined with the healing techniques of incubation and the stimulus of oracular revelation.

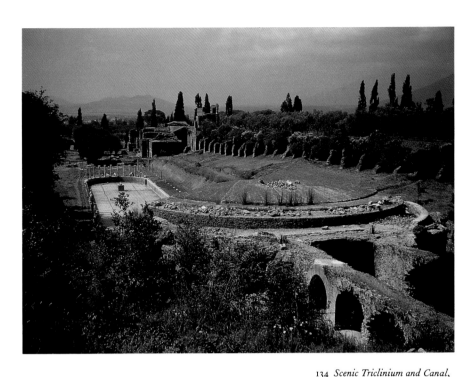

134 *Scenic Triclinium and Canal, looking north from above (1956)*

135 *Scenic Triclinium, analytical sketch of interior surfaces; the vault broke along the dotted line*

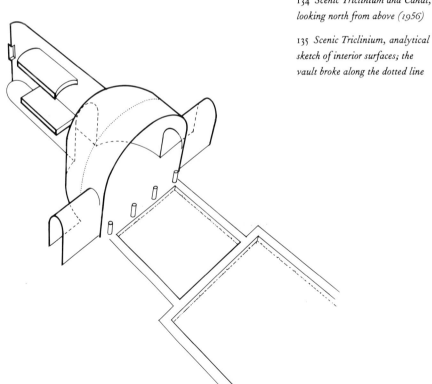

Of the canal nothing is visible. It ran past the quarter in eastern Alexandria known as The Hippodrome and left the city, headed northeast, near the present Antoniades Gardens, either joining the westernmost branch of the Nile (no longer extant) a little south of Abu Qir Bay, or the bay itself. The town proper was beside the sea, west of the bay; it is not certain how close to it the canal ran. Very little of Canopus has survived, partly because during the First World War the ruins were dismantled for paving stones for military roads. An inscription identifies the location of a temple to Osiris, and it is assumed that the reference is to Serapis-Osiris. Fragments of seaside baths are clearly Roman; no overall plans of these or of the temple can be recovered. The major finds of sculpture, all pre-Ptolemaic, are in the Alexandria Museum, and there has been much unauthorized digging.

Known Roman temples to Serapis, such as those at Ephesus or Pergamon, bear no resemblance to the Scenic Triclinium. Nothing remains of either the second-century temple at Alexandria or the one at Canopus. Since the cult was essentially of Ptolemaic inspiration, the Canopus temple, perhaps the work of Ptolemy III (246–221 B.C.), would have been based on ancient Egyptian forms. The comparison often cited in discussions of the Triclinium is a huge (about 52 meters across) semicircular structure in the Campus Martius recorded on the Marble Plan. Its curve, facing north, was fronted by an east-west colonnaded walkway beside which lay a rectangular court (less likely a hall), inscribed SERAPAEVM, with monumental archways at each end; the eastern archway is seen in the Vatican Haterii relief, marked ARCVS AD ISIS. Domitian is said to have built a Serapeum, and appropriate figural and architectural sculpture was found in the area. But that the inscription on the plan refers both to the court and to the semicircular structure is, it appears, an assumption based in part on the form of the Villa building, whose association with Serapis is fanciful.

The building in Rome apparently had some of the characteristics of a grotto. The curved walkway, lined on one side at least with columns, enclosed what may have been a garden court and led south to an extended

axial corridor that terminated in an apse. The laconic graphic information on the plan suggests that the building was not vaulted, but that in addition to the axial extension three or four small spaces, perhaps shrines or chapels, faced the curving walkway. Above and just northeast of the Palatine Hippodrome garden are ruins of a nymphaeum of similar plan, said to be Domitianic; Rabirius's name again comes naturally to mind in connection with the Palatine and the Campus Martius buildings. And there is the Residence triclinium at the Villa. Although it has no axial extension, it is semicircular, preserves its stibadium, and was piped for waterworks. With respect to the question of Egyptian influence on the design of the Scenic Triclinium, the present answer apparently is that there was none; of Roman, however, there was a great deal, and it derived from the design of grotto-nymphaea, not from temples to Serapis. But new evidence may turn up.

Without the appearance of Canopus in the HA, the Scenic Triclinium would probably never have been called a Serapeum. For a long time at the Villa the name Canopus normally encompassed both Canal and Triclinium. The name Serapeum came into use because of Strabo, but became the usual name for the Triclinium only with the clearing of the building and the excavation and restoration of the Scenic Canal in the 1950s. The two names seemed to fit the texts. At the Villa an elongated pool stretches toward a substantial structure, supposedly in the manner of the Egyptian canal and temple (which almost certainly was not the case). There is we think a better way to explain the Scenic Canal: big, artificial sheets of water were fairly common. For example, Agrippa's pavilion-lined lake (*stagnum*) in the Campus Martius, probably fed by the Aqua Virgo, was large enough to accommodate a banquet raft of Nero's and its towboats. Nero's lake within the Domus Aurea, where the Flavian Amphitheatre stands, was fed by a cascade, produced by Aqua Claudia water that flowed down the Caelian slope, and his engineers, twice damming the Aniene, made that beautiful long lake for him at Subiaco. Both the East-West Terrace pool and the Scenic Canal reflect this tradition. The depth of the Canal water (from about 1.5 meters at the south end to

perhaps twice that at the north) and the apparent lack of steps leading into the water may argue against the use of the Canopus for swimming.

The Egyptian question, then, leads back to the passage in the HA. What is meant by Canopus—the canal, with its coarse revelry, the town (a place of religious significance and pilgrimage), or the sanctuary of Serapis? More important, why does the name appear in the text at all? It bears no relation to the other names, which in the tradition of villa nomenclature speak to the durable fame and culture of Greece (Tempe we have discussed; the underworld and the provinces appear below). The Athenian Academy (Akademia) and Lyceum (Lykeion) were founded in the sixth century B.C.; the Academy endured for a millennium. The Prytaneum or city hall went back to the age of Theseus himself, and in Hadrian's time the council chairmen (prytaneis) met and dined in the Tholos (Prytanikon) near the southwest corner of the Agora. On the north side, about 475–450 B.C., the Poecile (Stoa Poikile, Painted Stoa) was erected, and soon the great paintings done on wood panels by Polygnotos and others showing Athens's legendary and historical victories were in place; Pausanias admired these six centuries later.

In this company Canopus sits uneasily, except perhaps for the reference to the provinces, to which it could conceivably be attached in the reader's imagination. Might it be that a source "Aelius Spartianus" used had inserted the name because, like Aurelius Victor and others, he believed in Hadrian's debauchery and thought Canopus a suitably scurrilous reference? Perhaps "Aelius" made the insertion himself, for the same reasons. Juvenal, after all, writing not before 127, used Canopus in just that way, not in regard to Hadrian but in condemnation of the Egyptians and as a synonym for depravity, confident his readers would understand. Though the Scenic Canal may have reminded people in some general way of the Canopic canal, that Hadrian named it Canopus is unlikely. If, however, he did, it was not to suggest that his work resembled the Egyptian original, for his Canal belonged to a Roman tradition of ornamental villa waters and was eclectically embellished with sculpture that drew on several traditions,

including the Egyptian but with the Greek predominating. Possibly a different building or precinct at the Villa, unknown today, was called Canopus. Ligorio, for example, speaks of a gateway with two male-figure pillars in Egyptian style. Egyptian or Egyptianizing fragments and figures are reported as found at different Villa locations, and Gavin Hamilton retrieved Egyptian pieces when he drained the Bog in 1769–1770. The ten Egyptian statues of red marble found in the Service Quarters—placed there after Hadrian's time—may have been part of the same work to which fragments of Egyptianizing sculpture, once seen at the neighboring temple site, also belonged.

Because of its setting, the Scenic Canal, 121.4 meters long, is unlike grand post-Renaissance waters, those of Versailles, for example, or Caserta. On the floor of its draw it appears from the Upper Park or West Terrace, or from the top of the Canal Block, more like a stylized mountain tarn than an extravagant pièce d'eau. Its bright algae-green color today, no fault of Villa caretakers, robs it of its reflective function, originally reinforced by a travertine lining; those who saw it when the water was clear, in the late fifties and early sixties, will recall its bright blue daytime sheen. It has sometimes been thought that it was originally a still water (as it is now), but with the Triclinium waterworks in motion this could not have been, for the flow was, as with all Villa water, from the southern quarter to the northern, and the drainage conduit for the entire Triclinium-Canal system led out from the center of the Canal's northern arc. About 20 meters from each end, masonry pedestals stood on axis out in the water. The northern one may have carried the stone crocodile, mentioned above, which was fitted out as a fountain, the water issuing from its mouth; the southern perhaps carried a marble representation of Scylla. Boats are possible (though nothing large could be passed between the columns, and their presence, moored or in motion, might detract from the overall effect). Interest naturally focuses on the Canal sculpture, but in the overall composition the statues—and the colonnades—were subordinated to the water they faced, and lightly sketched its reach and shape.

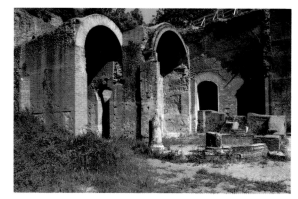

136 *Scenic Triclinium, east pavilion, looking southeast (1987)*

137 *Scenic Triclinium and west pavilion, looking southwest (1985)*

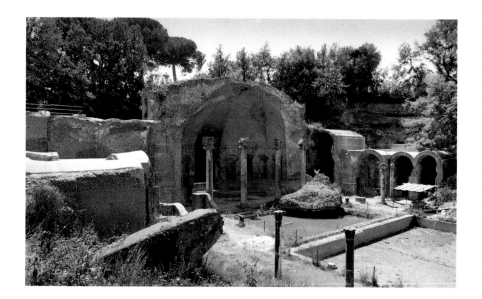

The planning, which on paper appears predictable and rational, is in fact based on a dynamic spatial concept wherein nature, art, and architecture are unified. The perspective lines of the Canal drive toward the vault, its size emphasized by the smaller, forward pavilions, and the vault and its dimly perceived tunnel extension absorb the forces moving toward it, even welcoming them. In Roman architecture the idea is familiar, but here in such a setting and on a scale that allows effective graduated transitions it becomes an original work at once subtle and monumental.

The pavilion suites beside the reflecting pool were 136
diaetae, open to the air and the view, each with an apsidal withdrawing room and lavatory. Corridors allowed servants to circumnavigate freely, and beside the western suite stairs rose to the West Terrace. The Upper Park could be reached, by way of the nymphaeum above and southeast of the Triclinium, from stairs behind the eastern Triclinium suite. The different parts of the Tri- 137
clinium were joined by the transverse east-west element mentioned above, whose central portion stood under the vault now fallen. The building's structural fabric, nearly intact, with many vaults still in place, is complicated. As at the Pantheon, the layered horizontal zones of the design are not vertically congruent: the seven upper panels of the standing part of the main vault rise above a nine-part story below. Of these nine divisions 138
the central, widest one opens to the axial extension within the hillside; behind the others (alternating in size, shape, and function) are radially shaped internal chambers; below one a later passage leads southeast to a group of oblong chambers. These, plus a lavatory and the stairs just mentioned, are set in echelon to conform with the central spaces; the penultimate chamber, lit by an oculus, was the only one from which, up a short flight of stairs, the axial extension could be reached. On the other side of the core a single large room, of dogleg plan, with large skylights, hugs the central form and opens only to the transverse corridor. None of these asymmetries is visible from the Canal.

Radiating chambers are also found at the middle 139
and upper horizontal zones of the central vault, four on each side at both levels. The middle ones are low, the uppermost more than twice as high, but all are

Without the Canal, the Triclinium would seem isolated, the property of the steep ground rising beside and behind it. The Canal draws the Triclinium's interior out toward the open, and the Triclinium makes the Canal whole and gives it a reason to exist. Their driving axial connection and the focusing power of the great hooded vault, both so forcefully fixed by the strongly defined draw, connect inextricably the two contrasting forms, one planar and the other supremely volumetric. Their physical bond, however, is mediated in a zone of smaller-scale events lying athwart the long axis — the squarish reflecting pool and its flanking pavilions.

vertically congruent with the ground-story ones. This twenty-four-chamber cellular system both reduces the amount of structure and provides effective buttressing. Directly over the uppermost chamber vaults and well above the springing line of the great vault, run water distribution channels fed by twin aqueduct spurs that drew on the line running in from the southeast. Settling tanks and vertical shafts for piping are still visible, as is an open tank of lunette plan. From the level of these installations the vault extrados rises, but only a little: it becomes almost flat, with an overall angle of rise of a bare 12°, after a base of three low steps of semicircular plan vaguely like the step-rings of the Pantheon dome. The resulting surface, with its gently rising curve, resembles a halved saucer turned upside down. Toward the top of what remains of the vault there is a small oculus-like opening, probably not original; it isn't quite at the crown of the vault curve and lies in a clearly cut rectangular depression, apparently original and incompletely preserved because of the fall, in which it is tempting to place, in the imagination, a statue base.

The axial extension is tall, narrow, and long (22 meters, 75 feet), a dramatic space even without its water. Instead of a floor it had a pool, its water level about 1.5 meters above that of the open pools to the north. Over the middle portion of this pool a platform about 8 meters long, joined to the extension's side walls and gained from the east by the short stairway just mentioned, lay barely above water level. From this platform the view south extends only to the teminal apsidal wall with its niche. That area, from the southern edge of the platform to the apse, is open to the sky, but the platform itself is roofed by a matching length of barrel vault placed just below the base of the aqueduct arches. The view leads in the other direction, across the northern portion of the pool, also open to the sky, and then over the stibadium and through the facade's arched central intercolumniation out to the open pools and beyond. In effect the extension thus has two huge skylights, both directly above tightly defined sheets of water. The long, niched side walls reach all the way up to the aqueduct channels, nearly to the level of the semidome's external base, and are broken only by the triple arcades. This height, emphasized by the relative narrowness of the

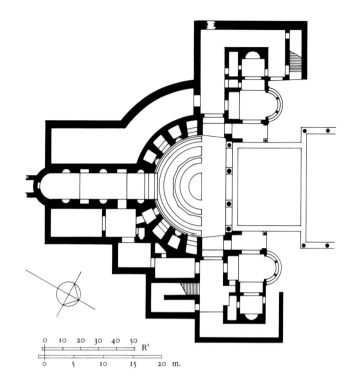

138 *Scenic Triclinium, plan*

139 *Scenic Triclinium, looking west (ca. 1953)*

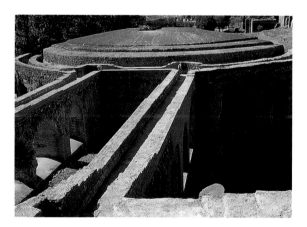

140 *Scenic Triclinium, water channels and vault exterior, looking northwest (1957)*

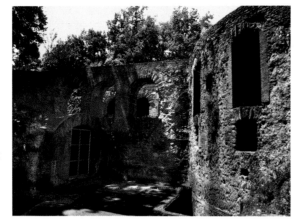

141 *Scenic Triclinium, east flank detail, looking southwest (1992)*

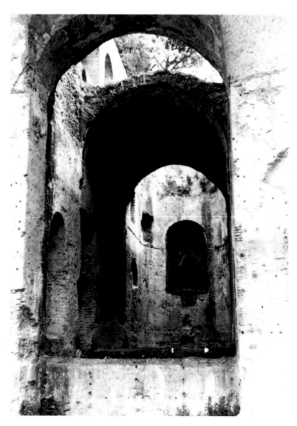

142 *Scenic Triclinium, axial extension, interior, looking south (1963)*

extension, vividly creates the effect of a partly buried trough, of a demi-crypt. And the design is finished off at the south end in an extraordinary way: the half-cylinder of the apsidal surface rises nearly all the way up to the water channels and ends abruptly, without architectural comment, giving shape to the light and drawing it down.

Inside the extension, with the waterworks running, the air would be damp and even misty and alive with the sound and movement of water dropping from the far niche (encrusted with grotto stone) to the pool below. The platform and walls were sheathed in colored marble, and the side niches, inlaid with glass mosaic, would register like the water the constantly changing light. Piranesi saw mosaic on the vault over the bridge-platform, which would have seemed like a raft, particularly if the water flowed swiftly underneath it. Somewhere, perhaps in front of the stibadium or from the Scenic Canal platforms, rose jets; the watermen had a 14-meter drop to work with, and their plumbers were accustomed to such assignments. The extension pool water passed through piping to the stibadium's two concentric canals, and by a different route to the half-round ornamental pool in front of it; these three in turn fed the reflecting pool. The Canal drew its water from the extension pool by a separate channel that ran beneath the others; bypasses and overflow channels ensured a smoothly running system. These technical details show how carefully thought-out the whole project was. They demonstrate in practical terms both the architect's command of structural and hydraulic mechanics and his ability to design successfully, for a difficult site, an original building of multiple functions and complex imagery.

Over the diners the great vault, with its bowerlike gathering of rising, alternating gores, was encrusted with mosaic; portions of the cement bed, picked out to hold the setting mortar for the tesserae, survive. Writers differ about their colors: white, green, blue, yellow, and red are mentioned; as recently as the early 1960s very irregular glass-paste tesserae — orange, green, deep blue, and neutral — could be seen lying by the stibadium. The vault proper, radially gored, is one of several Hadrianic

structures with similar internal surfaces. Here perhaps it functioned, somewhat like the water, refractively, re-arranging and agitating the pattern of light and shade a simple spherical surface would record. And light was as important here as in any enclosed building: the architect has left the impression that it concerned him as much as any other factor that all the water and the colors of the marbles and mosaics existed to serve the light.

At the Canal, under the open sky, nothing is hidden. Though the Triclinium in the distance does not appear to be particularly large, its function as a spatial counterpoise to the Canal is clearly stated by its harboring, shadowed concavity. Beyond it the grotto, the powerfully expressive coda of the entire composition, is almost invisible until the end of the Canal is reached, and the effect of its sunken, perforated volume is largely confined within its walls. Throughout the journey south, from the valley entrance to the grotto platform, architecture, sculpture, water, planting, and multicolored surfaces intermixed in a proto-baroque unity of the arts, but because it is a Roman place its parts preserve their formal individuality, and no truly baroque interdependence exists among them. Locomotion reveals the generative principle of the place, a serial lessening of spatial freedom and a resulting increase in spatial containment: first unwalled openness, then a specific volume shaped and directed by an architecture whose effect depends in great part on the nicely defined emptiness in front of it, and finally an architecturalized secret, an inner, almost buried chamber. This is an ancient Mediterranean idea, that of the cave-like sanctuary or shrine with a regularized approach—the hillside tomb-chamber with its dromos, an avenue pointing directly to a temple or sanctuary containing a final, secret room.

Hadrian would recline at the center of this, at the middle position of the seven-part stibadium, a few intimates and honored guests beside him and others at couches set up nearby and thus dine, as Dio says, "in the company of all the foremost and best men, [with whom such a] meal together was the occasion for all kinds of discussions." In the distance, before twilight, the peak of Montecelio could be seen, about 9 kilo-

143 *Scenic Triclinium, axial extension, southern end (1988)*

meters away and just off the Triclinium axis, rising by the Central Service Building west wall. Forming a dramatic backdrop behind the emperor was the grotto, the sound and flow of its water carefully regulated. Though sculpture can be imagined on the internal platform, perhaps it was just a viewing place, its importance emphasized by the tunnel-like approach through which Hadrian might lead his guests. In front of the stibadium the long transverse corridor provided an unobstructed surveillance line for security personnel, in the fashion of the Residence enfilades.

The place readily engages the imagination; explanations range from the psychosexual to the religious and often see it as an expression of Hadrian's personality. An age that found the Villa bizarre could easily accept

144 *Scenic Triclinium, restored section by Sortais (ca. 1888–1890)*

Egypt as the source of the Canal and Triclinium, particularly since the Romans, entranced by exotic Egypt, had enthusiastically taken up Egyptian art and modalities of contemporary Egyptian religion. But in fact the Triclinium is a banquet hall composed of an elaborate, two-part grotto, and in our opinion the Canal is most likely the hall's ornamental water. This coupling descends from arrangements at the villas Cicero, Pliny, and others describe, villas with canals named after the fabled Nile, with strolling grounds called after the august Athenian Academy, and with numerous grottoes; archaeological testimony bears out the texts. Hadrian found his basic concept in tradition—as at the Pantheon and his mausoleum—but matched it grandly to a superb site and rethought entirely both the architecture and the decor.

Signs of Hadrianic modernism survive throughout. The great vault's facade, above the four cipollino columns, carried a line of sturdy stone consoles (some survive in the fallen structure) projecting from the brick-faced concrete fabric, an unclassical thing to do. They may have carried an entablature, perhaps made of bricks stuccoed and painted over, as at the Smaller and Larger Baths, or even a shallow balcony, as on the Canal Block, or perhaps a miniature arcade, such as those on the mansion of the Horti Sallustiani at Rome. The Triclinium's sophisticated geometry and geometric intersections are also Hadrianic hallmarks. And to raise the banquet exedra to monumental size and at the same time build it forward well past the exedra's chord was as far as we know original. The resulting form was somewhat like that of a great Muslim iwan, a vaulted semi-enclosure walled on three sides but open to the space in front of it, an effective and suggestive architectural statement.

For the history of architecture and art, the power and value of the place is best shown by the attention architects and artists have paid it; they cannot resist it, as the views and sketches of Quarenghi, Piranesi, Rossini, and numerous others show. Louis-Marie-Henri Sortais, in an elegant Beaux-Arts restoration of 1893, got the architectural form more nearly right than anyone else has, no easy thing to do, particularly before the building was cleared, and Le Corbusier's spare but brilliantly evocative pencil sketches of 1910 are famous. No doubt the unrestored, ruinous condition of the Triclinium, found in the overgrown, melancholic emptiness of the Villa before the tourist age, was immensely attractive, but that these artists recognized the exceptional architectural spirit of the place is a tribute to Hadrian's vision. And now that the Scenic Canal and Triclinium are better known, thanks to the Italian scholars and engineers who cleared and studied them, the Triclinium's artistic and functional truths are more nearly in focus.

see 310, 334
see 397
144

see 412

V

The High Ground

The High Ground extends from the area between the Larger Baths and the Water Court to the far end of the Underground Galleries and covers some 180,000 square meters. For descriptive purposes it divides conveniently into three parts: the Upper Park, with its Rotunda, Grotto, and Platform Structure; the vast Galleries; and the South Theatre and Hall (which are aligned both with each other and with the Galleries long axis). Its marked elevation and broad, nearly level terrain, together with its openness and relative lack of buildings, makes the High Ground unlike the rest of the Villa, from which it is set apart by such features as the south-facing top story of the Services Building (which turns its back to the Vestibule and Baths below and the buildings beyond them) and the long Park walls. No formal connection exists, from the east, with the Southern Range, whose angled east flank shows that the Park was already laid out when the Range was planned. Although the High Ground is not a unified, fully enclosed area, not truly independent of buildings to the north and west, it is nevertheless an identifiable Villa zone, a higher region reached by climbing steep stairs beside the Scenic Triclinium or the Service Building or by using the underground corridor and stairs rising eastward from the Larger Baths; paths presumably led up, though more gradually, from the

145

146

147

148

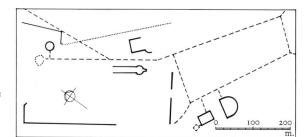

145 *High Ground, sketch plan*

Residence and Water Court areas to the less crowded ground above.

The Park contours shown here on the Villa plan record in an approximate way the accumulation and shifts of soil and debris over the centuries, not necessarily levels of Hadrianic times. Changes seem most evident in the middle of the Park: the Rotunda is now partly buried, yet the west wall crest was level; modern contour lines reflect this discrepancy. The Park was originally more nearly flat than it is now, and the shift toward the south from that level to the slightly higher Galleries ground was accommodated by the fountain wall and some now-lost intermediating structure to the east; the present contours suggest this. The Galleries terrain, in contrast, though it rises very slightly toward the southeast, remains all but horizontal; where oculuses can be seen from above, one is standing on ground very little above that of Hadrian's day. The South Theatre rises from this same level, as presumably the Hall, its scanty ruins now buried, did also. High Ground terracing was carried out on a scale even greater than elsewhere at the Villa. The Park west wall buttressing, stepped and massive, and possibly the fountain wall as well, record prodigious cutting and filling, and the Galleries terrain suggests that there the whole area was leveled, to accommodate the oculuses, before tunneling began; fill was used where stretches of the Galleries are vaulted in concrete.

149

Largely undisturbed since the scramble for statues in the eighteenth century, the High Ground has never been touched by serious excavation or restoration. In many ways it was better known before the mid-nineteenth century than it is today. Plans by Ligorio and Contini, as well as that by Piranesi (the most detailed by

146 *(opposite) High Ground, aerial view looking south; the aqueduct-like structure in the middle distance is the South Theatre facade (1964)*

far), are matched in importance by precious drawings and views by Ghezzi, Penna, and others. A few significant publications have appeared in recent years, but far less is known of the High Ground than of the rest of the Villa, and only partial descriptions and limited analyses are possible. The Platform Structure is an enigma, but the Rotunda and Hall can be rescued in part by using analogical material and vedute and drawings made long ago. The Grotto, fairly well preserved, is an example of a villa staple, in principle quite well understood. The Theatre, though some features are unorthodox, is also an example of a much-studied building type, and the Galleries are well preserved throughout almost all their length. Two main water lines flowed across the entire region, and all the major High Ground features, except (apparently) the Platform Structure, are connected to the Villa's network of subterranean tunnels, of which the Underground Galleries are the most imposing part.

The untended ruins are decaying, and the land itself may be threatened by the spread of construction seen in so much of the Roman countryside. Except for the studies just mentioned, the High Ground is drifting out of experience and memory, so that modern publications in which the Villa is discussed often include plans labeled "Hadrian's Villa" that leave the entire area blank. Yet the High Ground comprises a third of the site and contains structures whose design and functions bear on the Villa's meaning and perhaps on the emperor's religious and eschatological interests. Its elevation, lack of views out across the landscape (other than from the Theatre), and semi-isolation give it an air of separateness, a hint of an inward-looking, self-referential quality. It was clearly as important as the far better-known regions to the north, and a review of the often fragmentary, often perplexing evidence is essential. From this a sense may emerge of the true scale of Hadrian's concept and planning and of the provision on the High Ground as elsewhere of varied experiences within separate, highly differentiated settings. Speculation about other High Ground matters—needed, perhaps profitable, and in any case irresistible—is largely deferred until after this review.

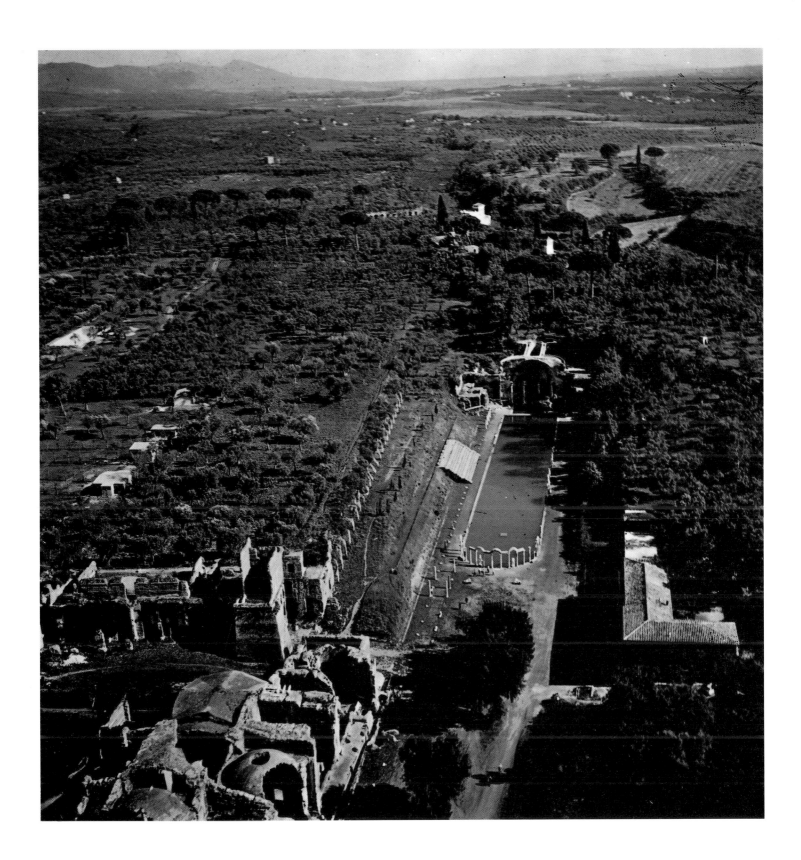

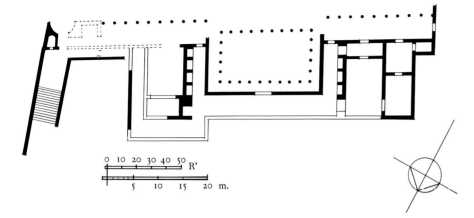

0 10 20 30 40 50 R'

5 10 15 20 m.

147 *Central Service Building, top story, plan*

148 *Upper Park, exit from the stair and corridor system coming up from the Larger Baths northeast corner, looking west (1988)*

THE UPPER PARK

In the much-published model of the Villa, the ground between the Central Service Building and the fountain wall is shown as a long, largely formal garden distinctly separated from the even larger area to the east—where the Rotunda, Grotto, and Platform Structure lie—by a straight, tree-lined allée reaching all the way to the South Theatre. But the topographical consistency of the whole region, defined above, taken together with unambiguous planning features, strongly indicates that this division did not exist. The long axis of the Grotto and its sloping avenue, the Rotunda axis fixed by its opening, and the Park west wall all are parallel (as so often in Roman architecture, the alignments are not perfect but the intent is clear), signifying a unified plan. The large and elaborate Grotto implies the presence roundabout of a thematic garden-park (on this more presently); the one goes with the other. And the fountain wall runs well to the east of the model's allée, which, even if it had existed, could not have continued straight to the Theatre. In addition, the line of the fountain wall reappears a bit further east in another, perhaps waterless stretch that reaches almost to the line on which the extended Grotto axis would lie. So the Park, we suggest, included the Rotunda, Grotto, and Platform Structure within the area bounded by the long east and west walls and the fountain wall. The northern limit is uncertain, but a good guide is the line of the Service Building facade, which runs nearly parallel to that of the fountain wall and its extension, a relation that argues for a single Park enclosure extending to or near the east valley rim.

The Service Building south-facing suite centered on a broad salon with internal colonnades on three sides and the fourth side open to the Park; colonnaded loggias ran out from the salon to the building's extremities. Service corridors and secondary rooms lay behind these features, and at the west end of the building, where the restored, pilastered walls stand, there may have been a viewing tower. The plan recalls that of the Portico Suite, which also faces a garden terrace and, to a lesser degree, resembles the suite overlooking the Stadium Garden's east side. This Service Building plan suggests not only a

parkside pavilion but also, with its corridors and lesser spaces, a dining ensemble. The orientation and plan of the work, along with the fountains in the distance (where grotto stone could be seen in the 1970s) and the Park Grotto itself, establish almost beyond doubt the presence here on High Ground of a garden park. Leveled terraces like this, some very large, watered and planted and dotted with sculpture, were by Hadrian's time well-established villa features.

The Park Rotunda. On the Ligorio-Contini plan, the Rotunda consists of a small, circular central chamber within an exterior wall buttressed internally by radiating features in the manner of the Mausoleum of Augustus. Piranesi shows a very thick exterior wall that embraces a narrow annular corridor running around the same small central space and a radial entrance corridor passing through the structure to the center; he also shows an external ring of twenty-two columns (Contini and Nibby both mention this). Penna, standing at a narrow angle to the extrance axis, shows Piranesi's features except for the columns—the entrance, a fairly thick outer wall, the radial corridor and a glimpse of its intersection with the annular one. He also records small, narrow exterior windows and a view of the dome rising from two brick-faced ring-walls of concrete, the upper stepped in considerably from the circle of the lower. Two of the windows shown have stone lintels and one has a stone sill; surely all of them in fact had both features. The vault aggregate and the brickwork are clearly shown. Today only small areas of heavily weathered concrete, part of the outer wall core, can be seen.

The date has been thought unknowable, but it is very likely Hadrianic. The outer wall diameter is 22 meters more or less, that is, 75 feet, a most Hadrianic measurement; the windows are clearly high empire features, the same as those preserved at the North Service Building and at other second-century sites; and the step-ring dome profile is typical of the early second century—the Pantheon of course comes to mind but there are other examples, such as the roofing of the north semi-domed rooms at Trajan's Markets. Experience brings trust in Penna, who shows high empire brickwork here;

150

151

149 *Atop the Underground Galleries, looking north; the clumps of bushes running diagonally left from the foreground mark west Gallery passage oculuses (1987)*

150 *Park Rotunda, looking north (Penna no. 125)*

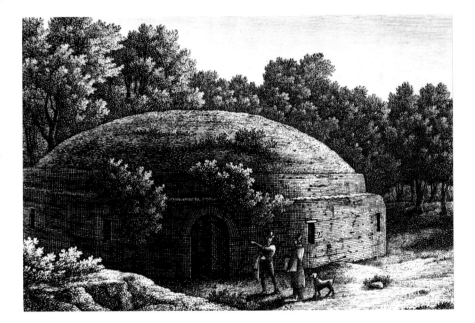

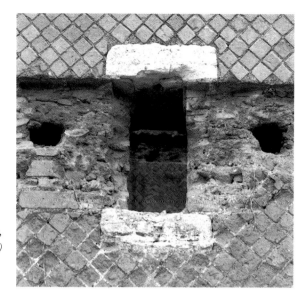

151 *North Service Building, window detail (1987)*

sign could have been found suitable. The Rotunda's massive, heat-resistant structure and its proximity to the underground snow-storage rooms suggest that it may have been a kind of cold room, a distribution center for the emperor's wines, one gotten up with columns to disguise its functions (it was, after all, connected with the main subterranean Villa artery by a tunnel traveling first west and then south and lit by oculuses, an odd appendage for a tomb). This perhaps far-fetched idea is a reaction to the almost total lack of evidence, across the whole site, for the kitchens and pantries, and the immense larders, the Villa required. We conclude that the Rotunda was very likely Hadrianic and probably not an actual tomb, that it perhaps was a utilitarian structure serving some now unidentifiable Villa need. If it was a memorial, one with quasi-sacred content, it fit the allusive, inspirited Upper Park landscape verified by the presence of the Grotto.

the actual concrete, however, is too far gone to help with dating. At the least, the idea that the Rotunda had long been standing when Hadrian acquired the property should be discarded. The discrepancies among the various representations can be partly resolved. Contini, having decided he was looking at a tomb, may have supplied it with an Augustan structure by analogy; or perhaps the horizontal, radial buttresses are still there, encased in the thick walls Piranesi and Penna saw, in which case the windows might simply be ventilating agents for curing the mass of interior concrete, in the manner of the Pantheon rotunda's exterior windows. Piranesi's exterior colonnade is probably correct because appropriate marble fragments (Doric) have been seen roundabout. Structures of unknown purpose lie to the north, and wall fragments suggest an enceinte.

But was it a tomb? The windows and columns may induce some skepticism but not necessarily denial. The arched, almost monumental entrance Penna shows does not fit well with a continuous peristyle; a porch, had one existed, would have created a quite different kind of building, a directional rotunda with a temple-front entrance, like a small Jefferson Memorial. Some have thought that the Rotunda may perhaps have been a memorial to Antinous, and for this a Pantheon-like de-

The Park Grotto. Its size indicates its importance: the overall length is about 130 meters (440 feet), and the approach, cut from the tufa and sloping slightly downward, is about 18 meters (60 feet) wide, three times the width of the sunken nymphaeum to which it leads. These dimensions are close to those of the Scenic Canal (121.40 meters long and 18.65 wide). Both the approach and the Grotto proper are heavily overgrown and partly buried, but most major features can be identified. From narrow entrances on either side of the nymphaeum, curving tunnels run out through the rock along a roughly circular line about 23 meters in diameter to rejoin the open space to the north (three openings appear in Penna's view, one as a dark shadow at the far 152 left). A narrow tunnel connects with the main underground artery. The broad nymphaeum opening, where the tunnels branch away, is arched over in brick, but the remainder of the recess is cut from the rock, with 153 a vault-shaped roof and a narrower but similar space beyond where water entered at the center. The forward, wider part of these telescoped spaces was decorated with small chunks of pumice, the balance with stucco carved to represent rough, natural stone, with pieces of pumice inserted into it. Presumably the approach side

walls were roughly cut, and the whole ensemble formed a "fantastic ornament" of the Park.

On the Ligorio-Contini plan the avenue and curving tunnels are sketched in. Piranesi shows the nymphaeum and tunnels correctly and gives an accurate plan of the approach avenue, whose pavement he divides axially into two parts, each in turn divided into ten equal, oblong sectors (for him the avenue is a "rustic stadium"). He also shows two rectangular chambers flanking the nymphaeum. The nymphaeum he connects with the Underground Galleries by way of a tunnel running south from the western curve; the line to the underground artery to the east isn't shown (Ligorio-Contini shows both). A pool in the widening flat space circumscribed by the curving tunnels has been suggested; if it existed, access to the nymphaeum was limited to the tunnels. Early on the place was thought to be the entrance to the underworld of the HA, an identification often repeated. In like manner the Underground Galleries became the underworld itself, and the Grotto approach avenue became the Styx, Hades' chief river. Although these connections may be thought too imaginative, the results of sixteenth-century antiquarian enthusiasm, the urge to name these places was correct, for the planning and imagery of the Upper Park were based on a major theme; such places were not routine arrangements of attractive pavilions and planting.

Perhaps a domesticated torrent issued from a rocky mass at the avenue's high end, in the manner of the Styx, and flowed down the slope into a sunken, shaded pool below; perhaps the viewing point was found above, rather than below; perhaps the rounding tunnels were for the watermen (for whom a torrent would be all in the day's work). Perhaps the Grotto was part of a larger scheme meant to represent the river's circuits around Hades in reduced but comprehensible fashion. Such thoughts may have little intrinsic merit, yet they point toward the need to regard attentively ancient references to Niles and grottoes in thematic gardens with rich and varied artistic adornment. And the East Valley's likely Tempe conversion is a reminder that familiar stories and locales, expressive often of essential forces and ideas pervasive in classical culture, were represented at

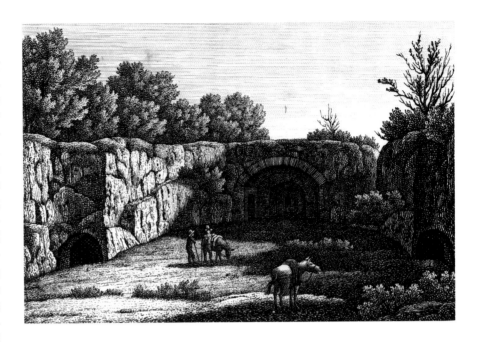

152 *Park Grotto, looking southeast (Penna no. 124)*

153 *Park Grotto, detail (1987)*

the Villa by contemporary, reductive means. The Park Grotto nymphaeum was a standard Roman installation—a rocky, watery cave—with a well-established pedigree in villa designs, but its grand approach and its position in the Upper Park suggest that it may have represented some specific timeless and elemental force or principle to which the viewer immediately related, something requiring that water and the lower earth be invoked in this particular way.

The great avenue, wider than many Roman main streets—that of Ostia, for example—implies ceremony or ritual; quite a throng could assemble there. If Piranesi's organizational pavement pattern is correct it might support this interpretation (heavy lines are used for what he and Francesco examined, considerably lighter ones for what they thought probably existed; the pavement lines are light). The contrast between the rough side walls (looming ever higher during the descent) and the pavement might suggest the contrast between the powers of nature and Roman order, with order ascendant at the beginning but nature all about at the end; there is a curious if partial prefiguration here of both the terribilità and romanticized nature of later times. Penna's people and their animals stand 1–1.5 meters above Hadrianic ground, so in antiquity the sense of a sunken enclosure would have been greater. The view gives a good sense of the small scale of the nymphaeum proper, emphasized from a distance by the long, focusing lines of the Grotto plan. Perhaps the nymphaeum, only 6 meters across, was not the major feature but a contributing one; perhaps the main weight of the Park Grotto's meaning and imagery lay in the approach and its terminal space in front of the nymphaeum, whose meaning formed only part of a larger concept.

The Platform Structure. Ligorio-Contini sketch in only a line of secondary rooms at the building's north, shorter end. Piranesi knows both these and the northern halves of the external long walls, including most of a projecting western curve (still discernible within very heavy overgrowth). From these data he develops a symmetrical plan chiefly taken up by a large temple court flanked north and south by duplicate lines of

rooms, and into the curve fits a circular Temple of Serapis, ringed by columns and facing west; his building turns its back on the Park and the neighboring Grotto. The north corner room, with openings both northwest and northeast, contained two piers set on its central axis, which with the walls supported a system of groin vaults. Penna calls the building a Temple of Pluto and Persephone, and Gusman labels it, on his Villa map, a Plutonium; both chose the theme of the underworld—Hades as Pluto, Persephone his wife and perhaps the daughter of Zeus and Styx, goddess of the underworld river—under the influence of the HA.

Because of the groin-vaulted room, the Platform Structure probably cannot have been built before the middle of the first century. If Piranesi's plan is correct in general outline, the building would be the largest known at the Villa; he may well have been right in restoring it with a large court because little else will fit this huge space sensibly. The outline resembles smaller, earlier villa plans, such as the western portion of the Villa of the Mysteries at Pompeii, or major blocks of early imperial villas on Capri. The Structure's proximity to the Grotto hints at a possible connection with it, though concrete evidence of this is lacking. Both the Structure's position within the Park's east wall and its orientation justify its inclusion among the Park's major features, but its purpose remains unclear.

THE SOUTH THEATRE AND HALL

The longer axes of these buildings are parallel both to each other and to the long central axis of the Underground Galleries, to which they are connected by narrow underground corridors. Immediately northwest of the Hall, but at an angle to it, is an underground structure, thought to be a storage building; it is connected underground to the corridor between the Hall and the Galleries. The graphic material, relatively abundant, includes the major Villa plans and their legends, several views, a detailed partial plan of the Hall, restoration drawings of the Theatre, and modern plans and sections of the storage building and the various connective corridors. This is the highest part of the Villa: the Theatre

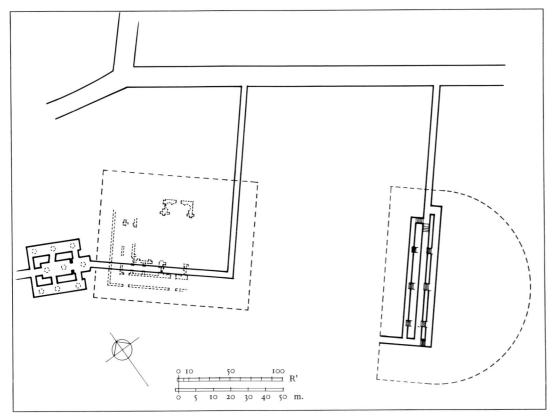

154 *South Theatre and Southern Hall, plan of underground elements*

155 *South Theatre, round building, looking southwest (1987)*

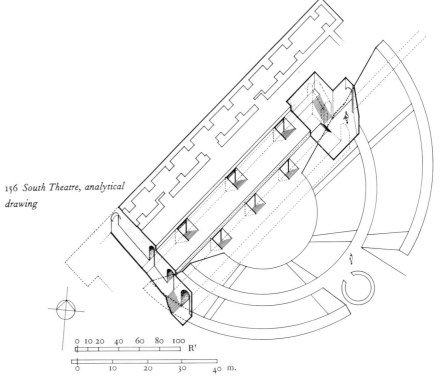

156 *South Theatre, analytical drawing*

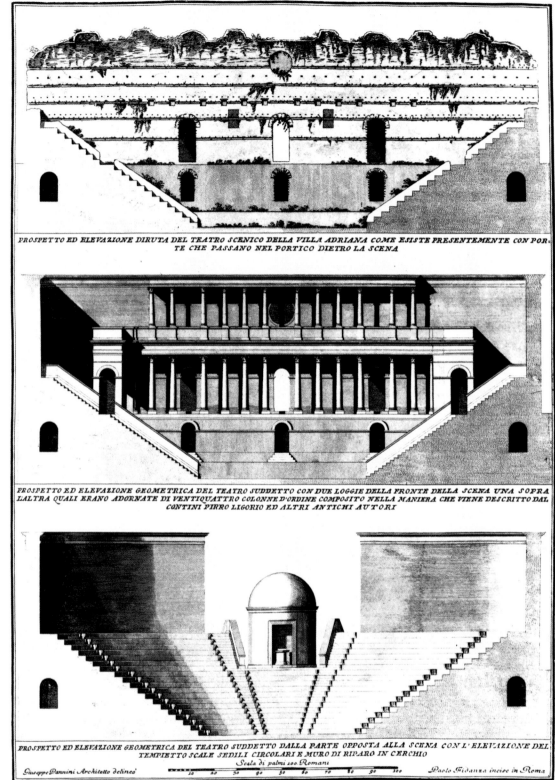

PROSPETTO ED ELEVAZIONE DIRUTA DEL TEATRO SCENICO DELLA VILLA ADRIANA COME ESISTE PRESENTEMENTE CON POR-
TE CHE PASSANO NEL PORTICO DIETRO LA SCENA

PROSPETTO ED ELEVAZIONE GEOMETRICA DEL TEATRO SUDDETTO CON DUE LOGGIE DELLA FRONTE DELLA SCENA UNA SOPRA
L'ALTRA QUALI ERANO ADORNATE DI VENTIQUATTRO COLONNE D'ORDINE COMPOSITO NELLA MANIERA CHE VIENE DESCRITTO DAL
CONTINI PIRRO LIGORIO ED ALTRI ANTICHI AUTORI

PROSPETTO ED ELEVAZIONE GEOMETRICA DEL TEATRO SUDDETTO DALLA PARTE OPPOSTA ALLA SCENA CON L'ELEVAZIONE DEL
TEMPIETTO SCALE SEDILI CIRCOLARI E MURO DI RIPARO IN CERCHIO

Scala di palmi 100 Romani

10 20 30 40 50 60 70 80 90 100

Giuseppe Pannini Architetto delineo' Paolo Fidanza incise in Roma

157 *South Theatre, stage building
elevations and restored view of the
auditorium and round building
(Pannini and Fidanza 1753)*

rises from ground about 60 meters above that of the North Theatre orchestra, well over a kilometer away. Beside it, the terrain drops precipitously to the West Valley floor; to the northwest, the baths of the Southern Range, their massive, blank-walled cisterns facing the Hall, formed the southern boundary of that clearly separate region.

The Hall has been called at various times a temple (Ligorio-Contini), an odeum (Piranesi, Gusman), and a banquet hall (Penna). The identification of the Theatre has remained quite constant, though Gusman thought it could be an odeum; theatre/odeum confusions arise in large part, even today, because no clear-cut architectural definition exists of an odeum—"the term [is] scarcely technical." Usually the word is applied to small, roofed theatrelike buildings said to be used for concerts, recitations, or rehearsals. Neither the Hall nor the Theatre qualify: the Hall plan is not that of an auditorium for performances, and the Theatre is a fair-sized building with a maximum width of at least 50 meters— that of an urban theatre of moderate size—which with
155 its crowning circular feature precludes a solid roof. The Hall, whose large central space was enclosed within corridors and at least fourteen small rooms all shot through with doorways and passages, was for banquets, as Penna correctly reasoned.

156 The Theatre faces northwest and in basic design follows the Roman norm: the semicircular orchestra and cavea both fit directly to the forward line of the stage. The stage building stands three-quarters complete, its
157 outer wall lined with windows set symmetrically beside a central entranceway. The high and narrow trans-
158 verse corridor between it and the stage-side wall is well preserved, reminiscent of similarly groin-vaulted corridors visible in Hadrianic buildings at Ostia. The stage wall proper, whose three traditional openings onto the stage are still visible, was originally embellished with two stories of projecting pavilions, whose columns of colored marbles and granite carried composite capitals. Beyond the orchestra, where Piranesi saw white mosaic marble paving, rose the rows of seats, of Greek marble,
159 presumably white. These were divided, in the usual way, by four radially set-out flights of stairs and a semicircu-

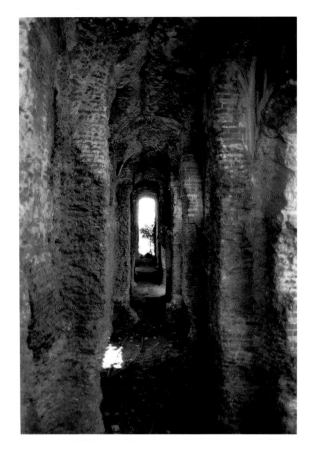

158 *South Theatre, stage building, interior, looking southwest (1987)*

lar walkway, paved with white marble slabs, two-thirds of the way up; perhaps thirteen hundred people could be accommodated.

Thus far nothing unusual, except perhaps for a stage divided into two levels by a low, broad step. But underneath the stage area are three parallel corridors extending almost the full width of the stage; of different sizes and set at varying levels, they are extensions of the tunnel that connects the Theatre with the Underground Galleries. Level changes are accommodated by interior stairs where the connector splits into three parts; in plan the system looks like an elongated, three-tined fork with a transverse, collective corridor at the southwest end. The largest, lowest tunnel runs underneath the forward edge of the orchestra, the middle one under the front part of the stage, and the uppermost, smallest

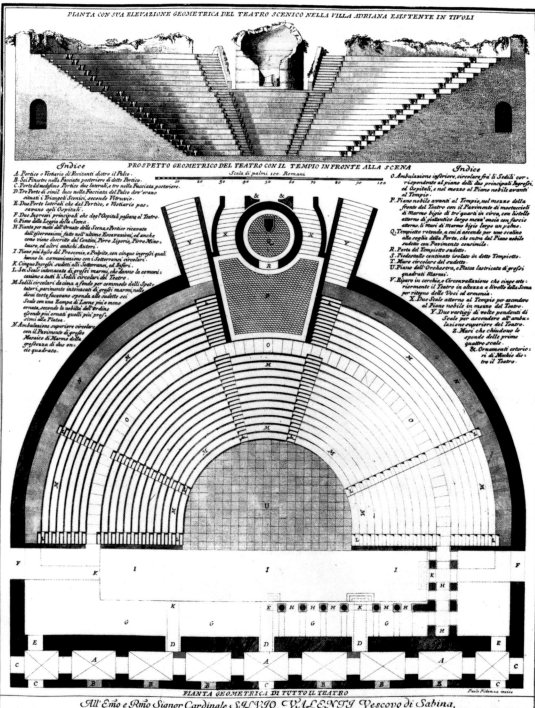

159 *South Theatre, auditorium and round building elevation, and restored plan (Pannini and Fidanza 1753)*

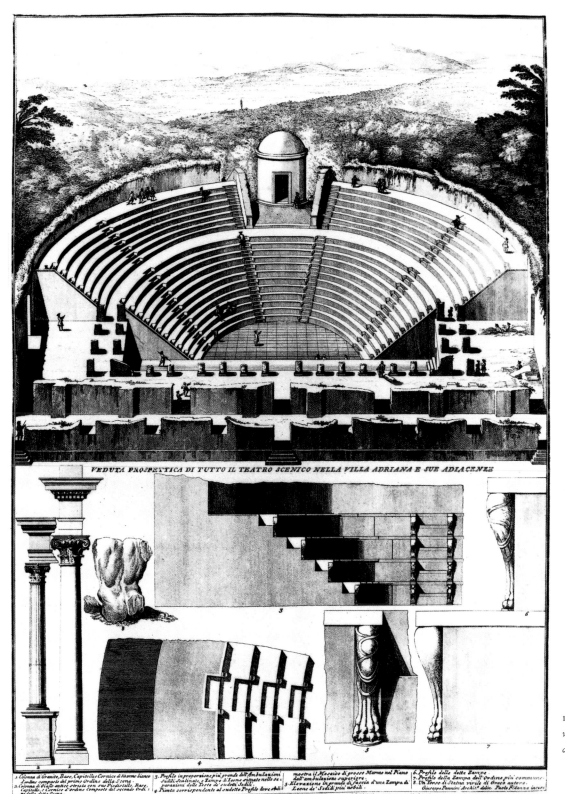

VEDUTA PROSPETTICA DI TUTTO IL TEATRO SCENICO NELLA VILLA ADRIANA E SUE ADIACENZE

160 *South Theatre, restored aerial view and building details (Pannini and Fidanza 1753)*

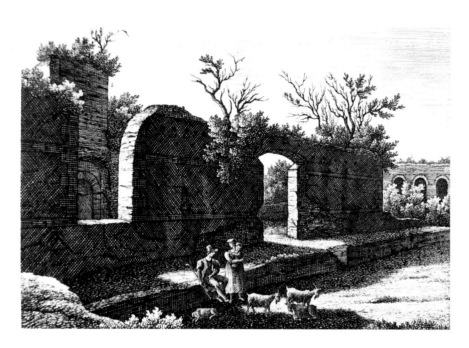

161 *Southern Hall, exterior looking southeast toward the South Theatre facade (Penna no. 113)*

one under the back part. From the upper two tunnels, broad flights of stairs rose into the theatre—those from the middle-level corridor ascend over the haunch of the lowest corridor to open onto the orchestra pavement, and those from the highest tunnel rose to the stage floor.

160 At the top of the Theatre, between the two central stairways and at the level of the median walkway, there were no seats, nor indeed was there any sloping construction. Instead there was a level, approximately trapezoidal precinct whose pavement lay close to walkway level. From this pavement, inlaid with gray marble in a pattern of rhomboids, rose the circular structure, about 6 meters in diameter, whose wall still stands in

see 311 part (seen, in Quarenghi's view, rising above the curved, buttressed wall of the auditorium). Its arched entrance, facing the stage, was tangent in plan at the point where the Theatre's outer wall would fall had it been built (it was suppressed here in favor of stairs rising up from the lower ground behind the Theatre). Ligorio-Contini report a four-column vestibule of colored marbles, and an eighteenth-century restoration supplies a dome. Some have thought that the structure was an imperial box,

but it is too far back, in plan, for this. Shrines or temples are found above the uppermost seats of Roman theatres fairly often, but eliminating a large section of seats in favor of a precinct or terrace set within the auditorium proper, and constructing stairs giving onto the precinct alone, is as striking a departure from earlier Roman practice as are the multiple connections of the performance areas with the corridors beneath them.

The Southern Hall, its ruins no longer visible, lies about 35 meters beyond the Theatre, whose facade appears in Penna's view. Ligorio-Contini give some sense 161
of it, and Piranesi provides a more detailed plan, in part confirmed (and considerably refined) by a plan made in the 1760s of the building's northwest cor- see 317
ner and the transverse internal entranceways to the large central space. The structure measured about 29 by 42 meters overall; its central space, where columns of smooth yellow marble were seen, was thought by Ligorio-Contini to be a temple. The outermost wall, upon whose ruins Penna's figure sits, contained entrances, gained by stairs, set on the major axes. Within this wall stood a second one, which in turn surrounded the numerous rooms set alongside the central hall. The axial entranceways were extended through all this encasing architecture to the hall, whose slightly curved southeast wall was apparently the only nonorthogonal plan element; numerous niches (one appears in Penna's view) contained statues, and the internal entrances to the main hall, placed on the building's shorter axis, were elaborately formed in high imperial fashion. The subterranean corridor coming from the Underground Galleries passes under the Hall to its north edge, then turns northwest to join the neighboring, smaller underground structure, mentioned above.

The enveloping corridors and many small rooms surely record a banquet hall; the needed dispositions are present. But unlike the other major dining venues at the Villa, there was no view; more than that, the diners were insulated from the outside world, and if the main hall doors were closed, proceedings would be private. The plan resembles somewhat that of the Epidauros banquet hall in Roman times and others more faintly, such as that at Troizen. In these places cult meals could

be taken in small rooms flanking or bordering central spaces; at Epidauros the Romans inserted into the original central peristyle a structure that was possibly used ritually for the bards' declamations. We think the Southern Hall may have been used similarly, that Hadrian, for his own purposes and in his own way, adapted earlier designs to make a place for ritual banquets and associated ceremonies of the kind common to the mystery cults so many Romans took to enthusiastically. If this interpretation is correct, the neighboring underground structure was a service facility, perhaps for cooking, since its plan, with its central area fully open to generous flanking spaces, the whole ventilated and lit by nine oculuses, is perhaps that of a grand kitchen with interconnecting spaces for different preparations, all functionally axial. And the connective corridor underneath the Hall seems to have had a branch leading upstairs into the Hall. At the other end of the underground building the beginning of a wide corridor has been seen, starting toward the cisterns, its destination unknown.

THE UNDERGROUND GALLERIES

This astonishing place, for Ligorio-Contini the Elysian Fields, for others Hadrian's underworld, the antithesis of the Villa's ingeniously spatial architecture, is quickly described. Four uniform passages, 840 meters long in all, join to form a trapezium whose central, major axis is about 300 meters (1,000 feet) long. The floors are buried in debris, and the seventy-odd original oculuses have been blocked, reduced in size, or covered with slabs, and four were lost in the collapse of a 25-meter stretch in the middle of the north leg. The passages, 5 meters wide and originally about 5 high, are bordered at least in part on their inner sides by a narrow, shallow channel 0.20 meters wide and 0.10 deep. On the outer side of the east passage, evenly spaced cuttings along part of the floor and wall show where stout wooden framing was anchored in the tufa; similar evidence is reported from the west passage.

The entire work was cut out of the tufa except for the stretches vaulted in concrete; alterations, all made much later, are confined to the oculuses and neighboring, crude interventions in the upper levels of the vaults. By and large the Galleries look much as they did in Hadrian's day, but with less light in them—though what there is produces dramatic effects—and with their width-to-height ratio altered by the accumulated refuse. They remain cool even on the hottest summer days, when in contrast to the air above they are almost chilly.

The Galleries are not technically cryptoporticoes, because they have no porticoes—that is, no ranges of vertical windows providing views of an abutting, lower area, like those of the one running along the Residence Fountains eastern wall. Nor are they the kind, illuminated by raking openings set in their vault haunches, that also require lower adjoining ground, such as those seen below the Residence and in the Peristyle Pool Building. Schematically, the Galleries resemble somewhat the cryptoportico at the east side of the Larger Baths, illuminated almost entirely by oculuses, but it is raised above the exercise ground immediately to the

162 *Underground Galleries, southwest passage, interior looking southeast (1987)*

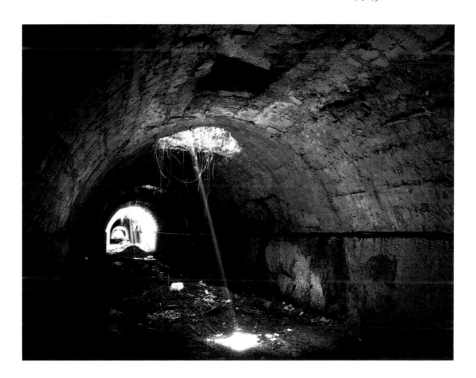

west and can easily be reached from ground-level entrances. The Galleries, completely interred, inaccessible to the public, are architecturally unrelated to surface-level Villa features.

Of all Villa structures they best bring into focus the scale of Villa engineering and construction, easily obscured when one examines buildings individually. To make the Galleries, nearly 20,000 cubic meters of rock were cut out, to be carted away or winched up through the broad oculuses, then distributed as fill or used in building, much more labor than that required by such far better known Roman works as the nearly 500-meter mountain tunnel bringing water to Saldae in Numidia or similar long tunnels elsewhere, mostly much smaller in section than the Villa Galleries. Apparently there were no stairs within the Galleries, no practical openings up and out; if this is correct, the nearest entrance would appear to have been by way of the steps and narrow tunnel leading from the South Theatre orchestra and stage. Another striking feature is the close fit of the trapezium plan to the site boundaries: centered between them, it opens outward just as they do. A major Roman creation, the Galleries are very unusual, not at all what might have been expected, given the nature of traditional urban and villa cryptoporticoes or that of the modest, narrow tunnels found at various sites. Instead they are the secluded, immense nucleus of an almost urban yet invisible armature, essential to Villa life.

COMMENTARY

Three regions, the Northern and Southernmost Ruins aside, make up the Villa. The first is the crowded lower area on government land, the second the precinct extending along the West Valley ridge from the West Belvedere to the far end of the Southern Range, the third the High Ground. Their topographical differences, described earlier, emphasize separate functions: elaborate provisions for more or less traditional villa life augmented by imperial duties; a clearly separate, elevated retreat with an easily secured perimeter, half a kilometer long but fairly small by Villa standards; and huge open spaces with few above-ground structures,

none of them for routine, conventional activities. So on lower ground Hadrian provided stations for daily life, for work, leisure, and entertainment, as well as accommodations for the court and for guests and the necessary support and service facilities. From these surroundings he could when he wished withdraw to the much more private West Valley ridge (a refuge of the kind often found in the neighborhood of grand royal establishments) with its own gardens and its views less of the Villa below than out across the Campagna. In the High Ground region, however, allusion and perhaps spiritual content took precedence over Hadrian the man and sovereign, over leisure or gratification.

Hadrian's attitude toward traditional Roman religion was conservative and curatorial; in this he resembled Augustus. The imperial cult he neither encouraged nor denied, though sometimes he refused, in part at least, the attendant veneration emanating chiefly from eastern civic bodies. The horrors of the fierce Jewish war were as much the result of long-standing apartheid as of Hadrian's policies, and he was tolerant of foreign cults. His interest in astrology was normal, at best quasi-religious, and not much weight should be given to the use of zodiacal symbols on some of his coins. But his initiation into the already very ancient Eleusinian mysteries — sometimes seen as a bow to tradition motivated by antiquarian tastes — is a strong indication of one aspect of his religious temperament. It was his nature to take such things seriously, to be concerned with death and the possibility and course of life thereafter, as he manifested publicly in his profound reaction to Antinous's death in Egypt in 130.

Hadrian's initiation at Eleusis probably took place when he was archon in Athens in 112/113. He was present at the ceremonies in 124, 128 (when Antinous was probably initiated), and 131, and had been in Eleusis on other business in 129. The rites, in celebration of Demeter and Persephone, began with a procession from Athens, Hadrian's spiritual and intellectual home, to Eleusis, where the secret, nocturnal ceremonies took place in the hall of the mysteries, the Telesterion. The cult was not a religion in the usual modern sense, for it was not exclusive and was based on profound experi-

ence, not on dogma; the same is true, in a general way, of many ancient spiritual practices, as for example the worship of Mithra and of Isis, which included ecstatic experiences and revelational beliefs played out in secret ceremonies enacted by and for hierarchically ordered initiates.

Eleusinian ritual cannot be recovered in detail, but beyond doubt the object was to create a unique, unforgettable drama that would animate a deep sense of spiritual renewal intended not just to fortify the initiates against life's perils but to purify and transform their mental states and prepare them for the ultimate ordeal. Plutarch says that "in mystery initiations one should bear up during the first purifications and unsettling events and hope for something sweet and bright to come out of the present anxiety and confusion." Aelius Aristides declares that the Eleusinian experience is "the most frightening and most resplendent of all that is divine for men." This cathartic instruction took one from a state of terror to one of bliss, as Aristides' contemporary Apuleius says (after remarking that he can't reveal any secrets) in a famous passage: "I approached the frontier of death, I set foot on the threshold of Persephone, I journeyed through all the elements and came back, I saw the midnight sun, sparkling in white light, I came close to the gods of the upper and nether worlds and adored them from near at hand." Other writers speak solemnly and reverently of mystic recesses, darkness and light appearing in sudden alternation, Pluto's grotto, frightening paths in the darkness that lead nowhere, holy views, and purification. Though naturally there were doubters, the mysteries were serious business, essentially eschatological but with philosophical overtones, deeply attractive to many intelligent, worldly men and women raised on an extensive literature of primeval belief in the trials and possible subsequent redemption of the dead in the underworld. Hadrian knew other cults—the worship of Isis and Serapis, for example, a connection documented by inscriptions and coins and by the images of Isis, and of Antinous as Osiris, found at the Villa. But his presence at the Eleusinian rite, the oldest and most prestigious mystery cult of the classical world, a vital

creation of the Greek culture he so admired, is the only surviving, certain evidence of his direct experience of an unofficial theology. Belief, in the modern sense of the word, does not seem to have been a requirement or even an important consideration, but whatever his private feelings were, Hadrian knew at first hand of the mysteries' spiritually therapeutic possibilities.

Among emperors, Augustus, initiated in 31 B.C., was Hadrian's only predecessor; Nero was rejected. More important is the classless attraction of mystery cults: at Eleusis, where some four thousand votaries could stand on the steps that lined the great Telesterion, working people, grandees, and slaves were initiated; in Egypt and other Near Eastern provinces, with their galaxy of cults, no religious or spiritual state was more popular. Something of this mentality had spilled over into the west well before Hadrian's day, but by then it was at flood tide. Strabo and Pausanias (an Eleusinian initiate) between them record some twenty sites east and west with underworld connections, thriving cult centers as well as places with chthonic oracles or traditions of descents into Hades; archaeology and other strategies extend the list. It follows that among those living and working at the Villa, of whatever rank or condition, many besides the emperor were cult members. Educated people knew of Aeneas's underworld experience and the relevant Neapolitan topography Virgil studied. At Delphi they could see the monumental, well-preserved paintings by Polygnotus of Odysseus's sojourn among the dead Pausanias describes in detail. And from there to Alexandria, by way of such places as Pergamon, Hierapolis, Baalbek, and back to Avernus and Cumae, the evidence of a Hades-struck world was inescapable.

Obvious evidence of religious activity at the Villa is limited. The temple, presumably used when receiving guests as they approached the Central Vestibule, is the only known traditional Roman religious building; the Doric Temple is the centerpiece of an evocative stage-set, though religious events there should probably not be ruled out. Several enclosed spaces with large statue niches would have been shrines. But many of the fifty-odd known Villa images of gods and goddesses were less religious objects than icons of traditional culture,

indispensable to the aura of imperial power; in this group, Hercules, Dionysus, Athena, Hermes, and Isis predominate, but quantitative ranking in Hadrian's time is unknown. Perhaps they did inspire devotion, but because they often stood alone outdoors they were not focal points of ritual worship. Nor were the imaginary, allusive landscapes of sculpture, waterworks, groves, and topiary, common to all grand villas, intrinsically religious.

But were there mystery cult buildings? The question is worth pursuing in light of the varied background of the Villa's large population, the emperor's own initiation, the bald statement in the HA—etiam inferos finxit—and above all the ecumenical appeal in the second century of spiritual renewal and the possibility of an existence after death. And it could be reasoned that provisions for the life of the spirit would be as important at the Villa as bathing or entertainment, so handsomely provided for in the Larger Baths and the North Theatre. The first step is to consider in general terms what might be needed; the second to speculate accordingly on the design and functions of High Ground structures. The Northern Ruins might conceivably be relevant, but their location near the Villa entrance strongly suggests, as has been said, the presence of administrative and military personnel; in any event, the terrain and what is known of the planning seem unsuitable.

The bedrock essentials of a mystery rite on the Eleusinian model are procession (the only public part of the initiation ritual), secret conclave, and celebration, a sequence requiring a lot of open ground as well as buildings. As the procession approaches the sealed-off meeting place, the presence of Hades (the god, whose name may not be spoken) and his underworld kingdom are represented by a real or simulated cave; at Eleusis this cave, the Plutonium, containing a shrine or Charonium, lies beside the processional way leading from the Lesser Propylaea (beyond which no outsiders were allowed to go) to the great Telesterion. The joyful, postrevelational celebration takes place elsewhere. Statues, paintings, and altars, though significant, are not so much venerated centers of attention as supporting players in the long perambulating rite Apuleius de-

scribes so elliptically. If mystery rituals based on those of the Eleusinian or some similar rite did take place at the Villa, the essential installations would be much the same: ample ground, indications of Hades and the land of the dead, and buildings for the mystery proper and postceremony banquet. If for the moment the HA and other ancient references are taken at face value, then a fabricated Villa underworld, with dark and frightening paths, can perhaps be contemplated provisionally.

In examining the evidence it is useful to recall that what was built for one purpose may have been adapted later to another and that typological expectations can be misleading—just because a building's plan is theatre-shaped, for example, doesn't necessarily mean that its functions are obvious. And the Villa is a telluric place, one where the earth and its contours and the regions below were major factors of life and experience. To say that it was simply a huge, luxurious country retreat devoted solely to the emperor's leisure is rather like saying that the Pantheon is a very large building with dramatic lighting effects. Although the suggestions that follow may be partly or even completely mistaken, not to hypothesize about the High Ground is to set Hadrian's temperament aside and fail to respond to the Villa's challenge.

Comparing the Villa theatres is instructive. The northern one was wedged in between an irregular hall-like space—lined on one side by large niches—that presumably led to external stairs rising to the uppermost circulation level, and the huge court on the opposite side, which the Theatre apparently overlapped (the result of a major planning change?). A rectilinear shrine stood outside the curving auditorium border and at least as high up as the top row of seats, in the usual way. And the elevated stage floor, well preserved, is carried on a spacious vaulted chamber from which a stair rises to stage level; no underground features are recorded. The South Theatre, on the other hand, stood alone, isolated save for the Southern Hall some 35 meters distant. The unusual, perhaps unique placement of its auditorium shrine and terrace, and the multiplications of its subterranean passages and connections, suggest either a quite different purpose from that of the North

Theatre—ceremony rather than entertainment—or the intention of accommodating both. The building is good evidence for the close connection, in the Greco-Roman world, of theatres with religion. Grand religious spectacles often filled big urban theatres, and adaptations of the basic architecture produced several theatres for religious use. Remains of these cult theatres, by no means always small, survive across much of the empire, some within sanctuaries, some next to rural temples or hallowed places, their stage walls suppressed on occasion in favor of a view from the seats to a shrine or sacred pool beyond.

We suggest that the purpose of the South Theatre may have been primarily religious, designed with underworld and perhaps celestial ceremonies in mind. The keys are the upper, central features, in particular the level precinct, and the six stairways descending from the orchestra and stage to the underground tunnels. On this reading the largely walled-off precinct was the place of the officiating hierarchs and initiates, Hadrian among them, who could arrive and depart privately. The extant plans (Pannini and Fidanza, Piranesi) are complemented by the vedute of Quarenghi and Smith.

see 159

see 311, 312

At the solstices, the sun sets here (41°56' north) at 7:39 P.M. in summer and 4:31 P.M. in winter; rising times are 4:24 A.M. and 7:25 A.M., respectively, delayed at the Villa by the terrain to the east. Cult ceremonies or drama would begin on stage; as night closed in, the focus would shift, as at Eleusis, to the underworld, a process perhaps aided at the Villa by lighting within the stairs leading underground. Then those entering the tunnels would experience something akin to the events the texts allude to, after which all would proceed to the Southern Hall (perhaps by way of the ramping tunnel leading up northwest, toward the Hall, from the parallel tunnels under the Theatre stage, to ground level). Although all this is conjecture, it may suggest that the Theatre and Hall may not have been for entertainment and secular banquets only, that they could suitably accommodate religious activities, and that their unusual features need thought.

The central question is, why are there three tunnels, of different sizes and at different levels, reached by six flights of stairs from the orchestra and stage and connected among themselves by subterranean ramps and stairways? The need to store and move scenery might explain them, but to bring scenery up onto the orchestra pavement, by way of steps facing the audience, seems odd; a more practical and efficient solution would be a traditional one such as that at the North Theatre—one large subspace with stairs near the ends of the stage platform. But if the South Theatre was used for cult observances, then devices for sound, light, and other effects would be needed, and perhaps the tunnels and stairs were built in part to facilitate moving them around as well as to frame votaries' simulated experiences of the underworld. That the Theatre was planned, at least in part, with those experiences in mind is in our opinion strongly implied by its subterranean tunnels, the orientation of the orchestra stairs, and the underground connections between the Theatre and the Galleries and with the ground toward the Southern Hall. These features suggest processions and peripatetic rituals; important relevant evidence exists elsewhere. Villa observances would not necessarily be Eleusinian in nature; any of several cults, or even a Hadrianic synthesis of unofficial beliefs, is possible. That the Villa would lack any provision for the popular religious gatherings that were then part of daily life is unlikely, given the Villa's varied and numerous personnel.

It is tempting to extend, in the imagination, cult activities into the neighboring Galleries, to seek there as well as below the Theatre places suggesting something on the order of "frightening paths in the darkness that lead nowhere" and appropriate liturgical settings. After participants descended from the orchestra to the middle Theatre tunnel, they could then be set on a mazelike path leading up and down and back and forth, a disorienting experience in the dead of night. From there they could be taken by way of the narrow connector tunnel to the southwestern arm of the dimly or intermittently lit Galleries, large enough for ceremonies and revelations and well suited to the passage of symbolic figures between files of onlookers.

The Galleries are not shown on Contini's plan of 1668 but do appear on that in the Ligorio and Contini publi-

cation of 1751, whose accompanying description refers to the Park Grotto avenue as the "valle degl'inferi" and to the Galleries as the "caverne grande degl'inferi," within which, as noted above, Ligorio places the Elysian Fields. Piranesi's plan is accurate and detailed, but the brief legend entries avoid identification. Ghezzi's measured longitudinal section and reverse ceiling plan of a three-oculus stretch, of 1742, and Pronti's interior view of 1795 are the earliest surviving visual records of Gallery interiors. Penna, in 1831 the first to mention the collapsed area in the middle of the northwest arm, revives the Park Grotto interpretation and is followed in this, in 1904, by Gusman, to the extent that he calls the Grotto the presumed entry to the underworld and on his Villa plan the Galleries area is marked "enfers?". In 1895, meanwhile, Winnefeld had scorned Ligorio's indentifications as arbitrary and fantastic. Crema in 1959 sees in the Galleries a refreshing gestatio, a suitable or specially made place for taking exercise. The most extended discussion, of 1973, where the cuttings for wooden framing are described, includes a solidly utilitarian interpretation of the Galleries that appears, with approval, in subsequent literature. And in 1988 the HA underworld was explained as an imaginary one of literary and allusive origins.

This condensed review points up the difficulties in-

163

see 396

163 *Underground Galleries, section and reverse ceiling plan by Ghezzi (1724)*

volved in interpreting the laconic HA phrase and the value of direct inspection of the surviving evidence (difficult work), as well as the polarization of opinion about the Galleries, which have been seen either as in some way representing the underworld or as strictly practical creations. But perhaps they were both, first functional and later the setting for experiences either religious or secular. By about 130, major construction at the Villa was nearing completion, and then—an intention perhaps long in the emperor's mind—the Galleries could have been converted in order to bring them into concert with the Upper Park and its purposes as well as with those of the Southern Theatre and Hall. Again, what follows is a mixture of fact and conjecture.

It is not necessary to believe that the Galleries served only one purpose. Building a place as vast as the Villa required many temporary installations—huge builders' yards, workers' quarters, provisions for stabling and maintaining work animals, endless workshops, access roads and perhaps tunnels later eliminated or converted, and so on. The Romans organized construction efficiently—the deft economy of brick and concrete construction is a case in point—and it would be natural, as it is today, to use structurally complete space for provisional purposes while work goes on. Revisions and changes in buildings as they went up or after they seemed finished were common at the Villa. It might be thought that the trapezium form does not represent an efficient planning response to the functional requirements involved in transportation and animal care, that central, parallel tunnels joined to the four diagonal connectors (if elongated) would greatly reduce the distance many hundreds, probably thousands of loads had to travel; other economical solutions are possible. Its very shape is odd. Does it have some meaning as a form, in a nonutilitarian or symbolic way?

As to practical matters, the Galleries are unlikely places for permanent stables. Much was known in antiquity about managing draft and riding animals, including the fact that underground stables were unhealthy for them. Horses, luxury animals, require much care; they were rarely used by the Romans for haulage and can hardly be imagined in the Galleries. They need

pasture and airing, protection from the rain and, if possible, from marked temperature changes, none of which the Galleries could provide; if the pavement was of stone or brick, horses can probably be ruled out entirely because it is so injurious to them to stand so. Whatever animals were stabled in the Galleries would have lived under far from ideal conditions and would have required extensive support systems. It is one thing to have feed bins and quite another to have enough food and water and bedding on hand for a large number of animals (the data suggest at least fifty-one large and eighty rather smaller stalls along the outer side of the long southeast arm).

If the North American standard horse is used as an example, a rough idea can be gained of what was needed by the donkeys or mules (small stalls) and perhaps oxen (large) in the Galleries. This horse, fifteen hands (1.5 meters) high and weighing about 1,000 pounds (454 kilos) eats half a bale of hay (11 kilos) and drinks 20–30 liters of water a day; the amounts of course vary, but the figure for 180 animals, scaled down somewhat, comes to something like 1,800–2,200 kilos of food and 4,000–5,000 liters of water a day. Clearing out—twenty to thirty minutes' work a day per animal, done faithfully and properly or the animals will be at risk—would mean disposing of perhaps 15–20 kilos of waste for each one; but where was it put? The very small channel, mentioned above, only 0.20 meters wide and 0.10 deep, could not serve (nor could it bring in clean water, under the circumstances). Space would be needed for storage, harness (bulkier and heavier than for riding horses), and for the ostlers and cleaners-out and their own facilities. Judging from military practice, a veterinarian would also be on duty; draft animals need more care than just feeding and cleaning out—of their hooves, for example. And where were the carts?

These perhaps tedious details may point up the complexities of the problem, compounded by airlessness and the apparent lack of entrances and exits. On the basis of what is known, the entire arterial underground road, including the Galleries, could be entered directly only by the Doric Temple area or next to the Water Court; another entrance must have existed in the South-ernmost Ruins. Not to have others seems impossible, not only because of delivery stops but also for traffic control, emergencies, and the smooth functioning of people and animals—all of them things the Romans usually administered masterfully. And there is no room for maneuvering cart teams in much of the artery, and precious little between transversely stabled animals and the Gallery walls opposite. On the evidence it is not easy, in the mind's eye, to make the system work well, and even harder to think of stabling draft animals, in continuing good health, within the Underground Galleries for any prolonged period.

But if the entire length of the Galleries was in fact given over to stables (it seems improbable), elaborate logistical features would be required; of these there seem, thus far, to be no traces. If heavy-duty haulage by so many animals (five hundred?) was not permanently required, no such comprehensive features were necessary. Supplies, separate from construction loads, presumably came into the Villa from the Via Tiburtina side; certainly goods from beyond the Campagna did. It is perhaps there, in the Northernmost Ruins, that Hadrian's mews should be sought, where the military and general administrative corps would logically have been located. The large courtyard building Piranesi records as occupying the northwest third of the complex bears the hallmarks of a large, military-style stable with an interior campus or open exercise ground; he calls it a palestra and says it was supplied with water and supported along at least two sides on subterranean corridors (good for clearing out, in the manner of basemented barns); his upper corridors are divided into stall-like compartments. It is possible, then, to think of the Underground Galleries as housing work animals only during intensive construction. If they were not filled with work animals, if stabling was not their primary function, why were they built on such a scale and in such an unusual form?

The HA passage—and, in order to omit nothing, he even made an underworld—should not be ignored. Its implications understandably do not concern textual scholars, and the possibility that Hadrian had some such place at the Villa is usually disregarded by historians,

sometimes derided. But on the face of it, the HA says he did make an underworld, and says it in a context implying that the work was marvelously or ingeniously fashioned. And it is reasonable to suggest that as some places named in the text were represented at the Villa in one form or another, the inclusion of an underworld should not be ruled out, automatically, as a fantasy. The Villa is said, in effect, to have had everything, which could imply some sort of programmatic universalism, stated perhaps by including built references not only to historical monuments but also to the dreaded but eternal unknown. Such a program, vague as its content will seem, fits Hadrian's temperament and inclinations; the Pantheon and the Antinous cult come to mind again.

To have the Acadine fountain, described by Diodorus Siculus, would be splendid: truthful texts cast into it floated, false ones sank. Without it, the accuracy of the HA passage remains questionable. Its fourth-century author interweaves selections from earlier writers with his own inventions, and he covers so much Villa ground so sparely that there is little from which substantial deductions can be made. His words about the underworld might reflect an interest in the haunted world of spirits; recently, irony has been suspected. But to us the description of the Villa seems solidly circumstantial (mire exaedificavit) and thus in a broad sense relaible. The whole paragraph, about Hadrian's appearance, his hunts and banquets, and his great Villa, holds together well and was perhaps lifted complete from an earlier author who knew whereof he spoke.

For cult observances the High Ground provides ample space for assembly, circulation, processions, and kinetic expressions of emotion. With its cavelike grotto, ceremonial theatre, shadowy tunnels spectacularly lit by moonlight, and ritual banquet hall, it was perhaps a whole text, so to speak, a synthetic creation in tune with the environment of late paganism, with its extravagant proliferation of divinities and rituals. If so, Hadrian and his people could invest the High Ground with meanings deeper and more personal than those evoked by traditional allusive garden-landscapes such as the Amalthaeum Cicero's friend Atticus created around the story of Zeus's nurse Amalthea, she of the cornucopia.

VI
Art

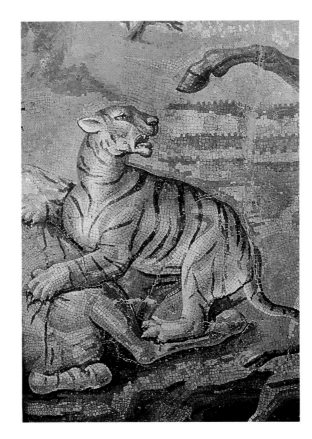

The artistic spirit of the Villa is best contemplated at the Scenic Canal. Its colonnades and sculpture (mostly modern copies of originals now in the Canal Block), necessarily incomplete, may not reflect the original scheme faultlessly, but with the Canal proper they comprise the only truly informative example at the site today of a basic Villa principle: the skillful, evocative fusion of figural art with architecture and the landscape. Because the evidence is incomplete, Hadrian's underlying intent is obscured. Even so, the effect is dazzling, and enough stands to suggest the conceptual nature of other artistically integrated ensembles once seen at the Villa, such as the Doric Temple Area, the Water Court, or the Stadium Garden.

In all of these, extended spatial opportunities invited movement, and that, together with pronounced multiplicities of parts, generated differing views and impressions. At the Scenic Canal, the elongated hairpin plan, with curved and straight ends, suggests that of the Roman circus, a perception strengthened by the spectator statues facing the water, by the colonnades like those atop a circus perimeter wall outlining the Canal's shape, and by the midwater platforms placed where goals would be. But a quality of mystery is added by turning the statues away from the living observer who walks beside the Canal and thus subordinating them to

164 *Villa floor mosaic (detail of 211); now in the Berlin City Museum*

165 *Scenic Canal, looking northwest (1987)*

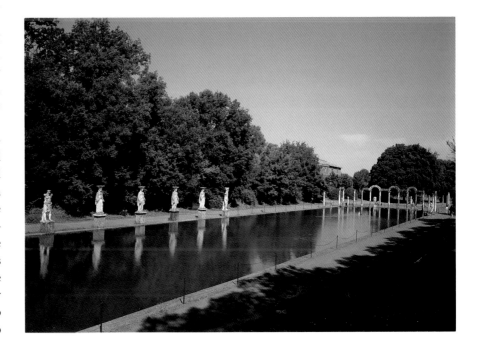

165

166
167

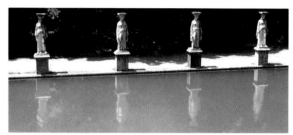

166 (top left) Scenic Canal, looking south from atop the Central Service Building (1956)

167 (bottom right) Scenic Canal, statues along the southwest edge, looking north (1987)

168 (top right) Scenic Canal, caryatids, looking southwest (1987)

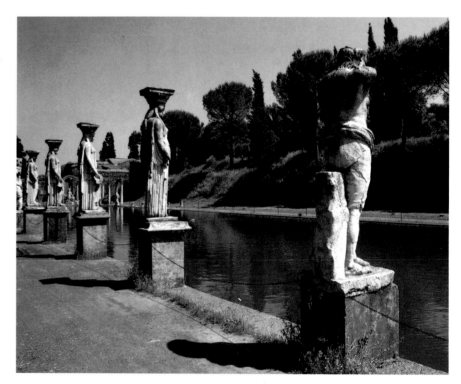

the expanse of water at their feet. That the statues can be faced only from across the water diminishes their relative scale and emphasizes their eerie interest in the Canal; this interposition of the water is accentuated by shifting reflections, changing with time and weather like the light and shade on the figures and columns. And the entire composition was the creature of the draw, a major Villa landscape feature paved with a silvery blue mirror, shaped like the draw itself and respectfully attended by its enchained, bordering vertical figures and columns that pulled the line of its circumference up from the ground.

Such lavish combinations of the arts, their individual works largely subordinated to overall compositions of many parts, required large open spaces, usually defined by architecture, with waterworks and gardens as natural components (evidence of planting survives behind the Canal caryatids and on the other side of the water). But elsewhere single works might be displayed—sculptural masterpieces in large exterior or interior niches, for example, or in columned aediculas on theatre stage buildings. Important paintings and mosaics were empaneled on walls as at the Island Enclosure or the Arcaded Triclinium eastern halls. No habitable space was left undecorated. All across the Villa, unpretentious painting enlivened the plastered walls and ceilings of ordinary rooms, their floors often done in simple mosaic. In the fancier chambers, colored marble inlay arranged in geometric patterns or elaborate mosaic covered the floors, painting and sometimes marble inlay the walls; stuccowork, or marble and glass mosaic, might spread across the vaults. Surviving evidence of figural and landscape painting, like that for painted exteriors, is extremely thin. Minor and luxury arts belong in the next chapter.

SCULPTURE

The wide range of sculptural styles and subjects at the Villa may be attributable in part to the collector's instinct but is rooted above all in the eclectic nature of High Empire culture, the result in turn of the Romans' well-developed historical consciousness, a condition indispensable to eclectic thought and preferences. In this

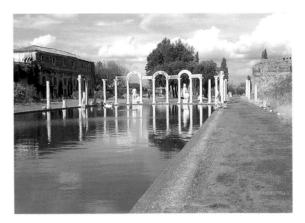

169 *Scenic Canal, looking northwest (1963)*

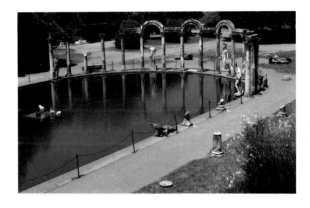

170 *Scenic Canal, north end, looking northwest (1987)*

sense the Villa is very much an empire creation, a place where non-Roman images mix handily with Roman ones, some of them, in architecture particularly, unseen elsewhere; the Villa displayed effectively that mixture of adopted and original ideas seen so often in Roman life. Villa sculpture did not comprise a collection or a museum so much as it expressed the historical awareness of the times and thus much of the scaffolding of contemporary civilization and education. That it did so in a grand fashion, with at least 250 statues (the actual number, much larger, is incalculable), should not obscure Hadrian's purposes, which included populating the Villa with these symbolic recollections of society's cultural foundations. In doing this he expanded upon a well-established tradition, as the Scenic Canal shows.

The thirty-five statues and recognizable fragments found in and near the Canal can be placed, somewhat

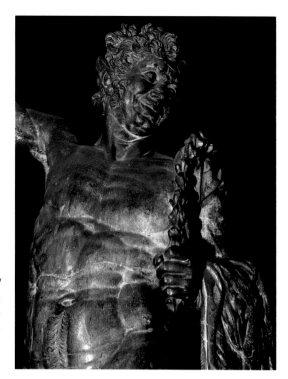

171 *Young Centaur, head and torso; now in the Capitoline Museum (Getty Center, Resource Collections)*

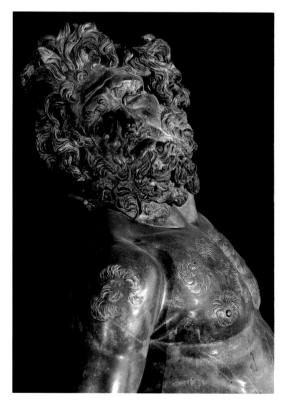

172 *Old Centaur, head; now in the Capitoline Museum (Getty Center, Resource Collections)*

arbitrarily, in the following topical categories (asterisks indicate images now standing outdoors).

imperial persons (2):
 Hadrian
 Julia Domna
gods, goddesses, and liturgical figures (9):
 Dionysus
 Athena
 *Hermes
 Isis (2)
 Apis-Isis
 Ptah
 priest
 figure sacrificing
historical and territorial references (10):
 *caryatid (4) 174, see 164
 *Tiber
 *Nile
 *crocodile
 river god
 panther's head (2)
mythological and legendary references (6):
 *silenus (2) see 167, 168
 *amazon (2) 175
 satyr
 Scylla group
other (4):
 *warrior
 male portrait
 child's head
 draped female figure

and fragments of a horse, a wing, a human hand, and a human leg. These figures are not seriously out of line with those for known Villa statues at large:

Hadrian (4) 176, see 7
an unidentified emperor
Sabina (2)
Antinous (8, 3 of them Egyptianizing) 177, 178
gods, goddesses, liturgical figures (37): see 378
 Egyptian, Egyptianizing (12, excluding Antinous) 179, 180
 other (25)
historical and territorial references (about 24) see 171, 173,

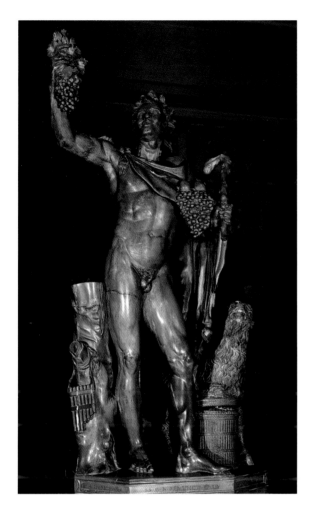

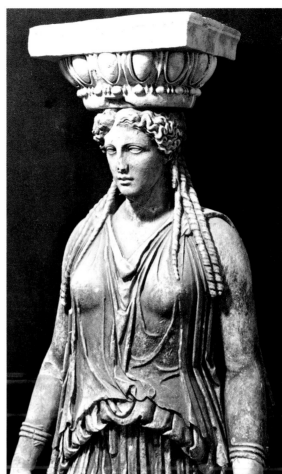

76, 381, 382

391

173 *(far left) Faun of red marble; now in the Capitoline Museum (Getty Center, Resource Collections)*

174 *Head of a Scenic Canal caryatid; now in the Canal Block*

175 *Amazon from the Scenic Canal; now in the Canal Block*

mythological and legendary references (about 30)
other (perhaps 35)

and 16 post-Hadrianic imperial portraits, Antoninus Pius to Julia Domna and her son Caracalla. Since the Canal images represent in a general way the topical composition of all the surviving Villa figural sculpture, and since that in turn forms a large sample (from many find-spots) of the original whole, the overriding topical characteristic of Villa art, in the present state of knowledge, seems beyond doubt to have been its comprehensive, eclectic nature. An obvious conclusion, perhaps, but it confirms that the Villa was in important respects a traditional kind of place and that in its art as well as its architecture and planning it is a grand document of high empire culture.

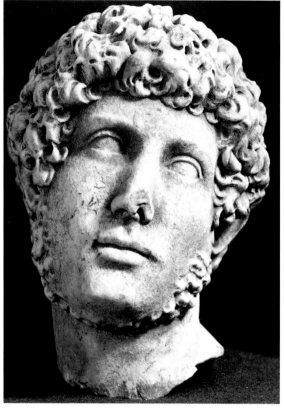

176 *(top left) Hadrian renatus(?) from the Scenic Canal; now in the Canal Block*

177 *(bottom left) Antinous relief; now in the Villa Albani*

178 *(top right) Antinous in Egyptian royal costume; now in the Vatican Museum*

179 *(bottom right) Isis; now in the Vatican Museum*

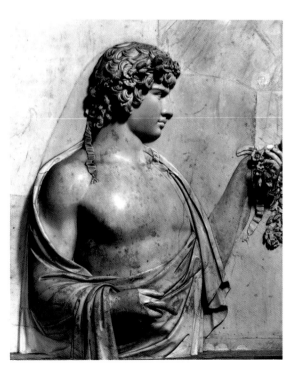

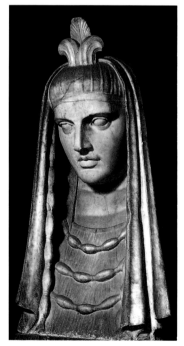

This state of affairs was a long time in the making. Statue-collecting and the indifference of wealthy collectors to subject matter are well documented. Certain of Cicero's dealings with Atticus, often quoted, bear repeating. Statues are bought for Cicero in Greece by Atticus, shrewd and very rich, and shipped to Italy. Among other items, Cicero asks for sculptured ornaments, remarking that if his purchases fill up his villa at Tusculum, he'll begin again at another of his properties. More than once he asks Atticus to send "anything suitable," specifying only the kind of marble he wants or the part of one of his villas to be decorated ("if it is fit for my Academy"). Once he requires a relief panel "for insertion in the stucco walls of the hall," without concerning himself with content. Another time he speaks of a set of statues "that would decorate a part of my palestra, making it look like a gymnasium"; that is, he wants statues of athletes, about as close to specifying subject as he ever gets.

He makes no bones about the fact that he considers statue-collecting a matter for the rich and successful, "for who could endure seeing these . . . villas [of a knight and a freedman] crowded with statues and paintings that were partly public property and partly sacred objects belonging to the gods?" But this was something of a pose, for by the mid-first century B.C. private persons often displayed imposing religious art. Not everyone approved of all this, as Sallust makes clear when he asks, "What man . . . can endure that our tyrants should abound in riches, to squander in building upon the sea and in leveling mountains . . . [and] join their palaces by twos or even more. . . . They amass paintings, statuary, and chased vases, and tear down new structures and erect others, in short misuse and torment their wealth in every way." Sumptuary laws curbed such extravagance only intermittently. Augustus set an example of comparative austerity, but after his death the floodgates opened wide.

Making figural and animal sculpture, garden ornaments, and architectural carvings employed thousands; sculptors with large studios and numerous assistants supplied an empire-wide market for statues. Greece (especially Athens), Asia Minor (with major centers

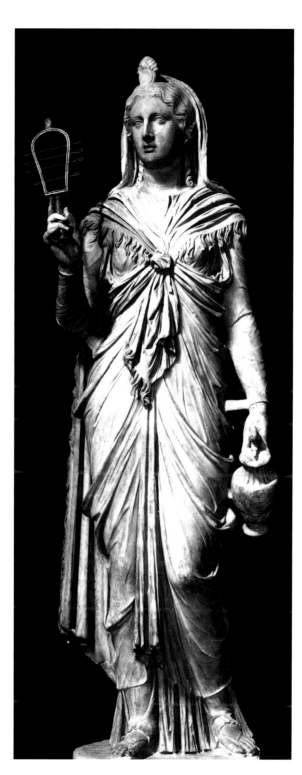

180 *Priestess of Isis; now in the Capitoline Museum*

such as Aphrodisias), and Italy led the field; Egyptian production centered on Alexandria. Fine marbles, white and colored, were quarried and distributed in quantity, and originals, copies of ancient masterpieces, and works done in the style of one or another great artist of the past were made on commission or speculation; this was in addition to antiques that came on the market and the sarcophagi decorated with figured reliefs so popular in Hadrian's day. Supply, demand, and the entrenched villa tradition all guided his hand to some degree.

Another force was at work, the one behind the long-lived Roman habit of furnishing urban features—forums, monuments, baths, theatres—so liberally with sculpture. What would a forum, whether in the capital or in some remote provincial town, be without its statues? Or, from the mid-first century onward, the vast public baths? Pompey had almost smothered his theatre and its portico with statues; victorious generals, and men who hoped for votes or approval or who were genuinely public-spirited, put up statues without number. Families, religious votaries, cliques, and members of various associations added to the huge, mute populations of Roman cities. These statues were history visible, talismans of the success and wealth not just of their donors but of the community. Hadrian did his share, as for example in the forum at Rome or around the perimeter of the Olympieion in Athens.

It was natural for him to invest the Villa with so varied and large an assembly of sculpture. The tradition was reinforced in him by his genuine interest in the provinces—Greece, Egypt, and Asia Minor in particular—and his purse was very long. He intended that the Villa be a complete place, from his point of view lacking nothing, and that could not be done without a full complement of carved images. As a result, he surpassed all earlier creations, even that of the legendary Lucullus, who by the 60s of the first century B.C. had

costly edifices, his ambulatories and baths, . . . paintings and statues. As for his works on the seashore and in the vicinity of Naples, where he supported hills over vast tunnels, girdled his residences with zones of sea water and with streams for fish breeding, and built dwellings in the sea itself . . . when Tubero the Stoic saw them, he called Lucullus "Xerxes in a toga." He

also had country estates near Tusculum with observatories and extensive open banquet halls and courtyards.

As Cicero makes clear, the more statues, in such places, the better.

At the Villa, the aesthetic qualities of individual pieces often mattered less than the subjects they depicted. Artistically admirable work could not by itself set the tone of the whole, for the intent was not to exalt Art but to assemble an unusually large repertory of images, and that repertory was so varied in style, workmanship, and allusive qualities that no one standard of value—even had one been contemplated—could have embraced it. Villa sculpture thus did not constitute a proper museum or collection in the modern sense: selection was not based on artistic merit, on any purely artistic theme or concept. And even work of high quality, where it existed, might be eclipsed somewhat by the uses to which it was put, for traditional art was often adapted to new functions.

The private nature of the place is borne out by the lack of evidence of state art, of historical relief or military subjects, dear to the Roman eye. The copies of famous works ("old masters or nothing") may speak to this also, for in private Hadrian might study relics of the past; perhaps the HA reference to famous places reflects their presence in some degree. These replicas have not much pleased modern critics, who have found them harsh and cold (if on the whole faithful to the originals), "depressing old master copies"; such observations are admissible, though artistic sensitivity and qualities of finish vary substantially from one piece to another. But the copies have their uses. The caryatids, for instance, preserve details otherwise lost, such as a duplicate of the *phialai,* or liturgical dishes, the Athenian originals once carried, and they extend into the second century evidence for the Roman fascination with the Greek column in human form, seen earlier on Roman coins, for example, or at Agrippa's Pantheon (the building whose decayed fabric Hadrian replaced entirely) and along the attic courses of Augustus's great forum.

But above all the copies are significant because they fall so efficiently into Hadrian's eclectic program, where they shed much of their awkwardness. This is because

they served an overriding, comprehensive idea made manifest, the Villa itself; they were not intended to endure the scholarly examination their historical significance requires today. Surely few cared, as they passed from one statue to another, that some were only copies, for each piece merged equally with the larger whole. Knowledgeable viewers would recognize that whole as an eclectic visual précis of Mediterranean history and memory reaching back a thousand years, a display implying that Roman culture (illustrated both by appropriate sculpture and by the Villa itself) was both its culmination and steward.

The relevance of Villa art—reproductions and originals—to the history and interpretation of classical art in general, under discussion elsewhere and in good hands, is not the primary subject here. Of course the evidence it gives for different periods and styles greatly aids scholars at a number of points, largely because Hadrianic work, at the Villa and in general, often harks back to the strengths and forms of the Greek masters as well as to many of their subjects. This art constitutes something of a classical revival, one with strong pictorial qualities seen, for example, in portraits in the dramatic treatment of hair and eyes, or in figures cut in relief so fully rounded as to be almost free of their backgrounds. Within this framework new subject types were created, such as an Athena image, the Sabina see 177 and Antinous portraits, and the three-dimensional personifications of the provinces. In Hadrian's day Greek artists were not at all limited to arid, lifeless duplications of popular antiquities and were often vigorously creative. Based on an ingrained classical order strongly and firmly expressed (a presence often credited to the philhellene emperor's taste and patronage), Hadrianic sculpture defines in the Antinous type "what is perhaps the last original achievement of Roman art under the overriding influence of classical form and style."

Although outstanding examples of these formal and stylistic affinities were singled out at the Villa for special treatment, in the overall scheme the integration of statues with architecture and landscape, mentioned above, was equally significant. In this quintessentially Roman alliance of spatial arts, landscape painting came to life at numerous places across the site. In these creations, with their complex interdependencies of constituent parts, the Villa's artistic character was chiefly expressed, as the Scenic Canal shows. The Canal is the focus of an unusually spacious composition, not just the prologue to the Triclinium. Much is lost—planting, colonnades, statues, probably arcading between the caryatids, and the elevated points roundabout from which the entire area might be seen. Walking beside the long Canal today seems the right way to see the place, but the Upper Park parapet, the Canal Block roof, part of the West Terrace wall, and the top of the Central Service see 166 Building once provided inclusive views. These revealed the Canal's relative size properly and the bonding of the hillside with the Triclinium, with the columns and statues merging imperceptibly into the whole, vertical brushstrokes in a colorful painting. But the most important feature of an overall view would be the disclosure of the landscape's authority over the whole scheme and its generative role in the scheme's creation.

Elsewhere, sculpture was used similarly, as in the Fountain Court region. Statues once stood in the niches along the Court wall that faces the part of the East Terrace leading to the Doric Temple area. At least five fountains played within the Court, and there and in and around the two Court Buildings an Antinous, a Dionysus, three other figures (one female, two male, one of the males with Dionysiac attributes), an idealized female head, and fragments of other statues have been found. All stood either near water or within the pavilioned Buildings, on an irregularly shaped site that surely included ornamental planting. Above the East Valley a statue of Heracles was found, and in neighboring cryptoporticoes were found a female head and an athlete, all once probably Valley-rim components of the Tempe simulation. East-West Terrace finds (exact original positions unknown) include images of Hermes, Harpocrates, Antinous as Osiris, two gladiators, Endymion, a woman in Egyptian dress, and several heads and fragments, presumably a small part of what once stood in this huge planted, encolumned area with its vast basin. Other examples include the Upper Park (grottoes and fountain walls without sculpture are most

unlikely), the south-facing pavilion of the Central Service Building (it implies gardens and their ornaments), and the suggestive presence of sculpture found between the Scenic Canal and the Central Vestibule (two Dianas, an Atalanta, a Fortuna). This evidence implies that specific topical programs did not necessarily govern choice of subjects.

see 50

see 171–173

The Doric Temple Area, whether or not it had fountains on the upper level as it did below, demonstrates as well as the Scenic Canal the combination of views and landscape with art typical of the Villa. The backdrop of the Tivoli hills and views to the Valley below gave the Temple almost as spectacular a setting as that of the Temple of Vesta riding above the Tivoli gorge. Indoor-outdoor settings at the Stadium Garden, the Water Court (Venus, Hypnos, nymphs, and a marine frieze, among other works), the Heliocaminus Baths (a kneeling Aphrodite beside the outdoor pool, Paris, and others), and the Southern Range, with its celebrated Centaurs, red marble Faun, Dionysus, and mosaics of animals all conform to the imperatives of integration. Some of these statues were found indoors, but others must have stood out among the gardens of the spacious peristyle and on the West Terrace extension below; water was in good supply, as the neighboring baths and the Reverse-Curve Pavilion pool show.

Evidence for the architectural display of statues, particularly in niches, is widespread. These arcuated hollows, their floors somewhat elevated, usually flanked by mouldings, sometimes by columns, are an important staple of Roman architecture. By creating individual spaces seemingly cut into walls, they focus attention strongly on the objects (often white) in their shadowed, sharply defined cavities. In-line files, in addition to the one along the Fountain Court forward edge, decorate the fountain wall next to the Underground Galleries, where statue niches apparently alternated with small cascades (water stairs) in the manner of the Scenic Triclinium curving wall. The niched wall just west of the Doric Temple Area semicircular structure, bordering a road rising to the south, may have held statues. Curving multiniched walls also appear in the Water Court axial and external nymphaea, the Residence triclinium,

and the circular rooms of bath buildings. Single interior niches, curved or sometimes rectilinear in plan, are common, and now and then a platform turns up that may once have supported a major work, as at the south end of the Fountain Court East. A few bases for freestanding statues survive, as at the foot of the Smaller Baths exterior north wall.

see 43

Groups and pairs of images, common in classical art, have survived. Popular because they fitted architectural schemes and symmetries neatly—muses, for example, for theatre stage buildings, or facing pairs flanking paths inside or out or any axial line—they strengthened historical associations or directional views, contributing to the ever-present Villa union of architecture, landscape, and figural art. The caryatids, sileni, and South Theatre muses have already been mentioned. Pairs include the Hermes-Mercury and Ares-Mars figures at the Scenic Canal, with their very similar classical trunks and legs. The neighboring Amazons are not truly paired but resemble each other fairly closely. In the Island Enclosure and Water Court mythical marine friezes, the rhythmic repetitions depend in part on pairings, and whenever facing niches are found, as in the Fountain Court West, statue pairs may be suspected. Tragedy and comedy, animal pairs, and the like have survived.

see 101

If in all this the frequency of Greek subjects may seem to overwhelm the Roman, it should be recalled that the Roman gods "were vague personalities, with . . . limited functions . . . not thought of as marrying, having children . . . [or] forming connections of love or friendship with mortals, or doing any of the things Greek imagination ascribed to the Olympians." In part because Roman gods were removed from human experience and cares, their images were less relevant to the Villa's recollective, culture-laden content than those of Greek deities and heroes, and in any event the fashion had long been to create in a grand villa a generalized impression of Greece past. Hadrian's scheme followed suit while making room for strong Roman emphases expressed in portraits, a vivid Egyptian presence, and nontraditional Roman subjects. The inclusion of these in strength separates the Villa's artistic program from those of its forebears.

Of the nineteen imperial portraits found at the Villa, none is pre-Hadrianic. The nearest thing is a larger-than-life head found in the Scenic Canal, at the north end, a fine Hadrianic copy or version of a late first-century B.C. portrait done in a cool Augustan manner in which individuality and idealization are effortlessly combined; its proposed identification as Marcellus, Augustus's nephew, who died in 23 B.C., may not be correct. One of the heads of Hadrian, found in the Scenic Canal north drain, is exceptional in that it was cut during his last years but shows him as a young man (in his early twenties?) without the familiar full beard; identification and dating rest largely on numismatic evidence. The discussion centering on it extends to speculation that it may show Hadrian as *renatus,* reborn "with the same soul in a new body" gained by sacrificing Antinous. Although this head does not resemble the Athens portrait, together with it and the still different London bronze head, it does suggest the outer artistic boundary of the large number of surviving images of Hadrian. Sabina's existing portraits indicate a more restricted range. They show in a delicate, unostentatious way a lady of the highest rank, sober and somewhat removed; they have been proposed as the centerpieces of Hadrianic classicism. One Villa portrait, superbly drawn and finished, conveys Sabina's gravity and rank without any loss of personality whatsoever.

The new Antinous type survives among his hundred-odd existing busts, statues, and relief figures and is reflected on numerous coins and medallions. None of the eight Villa examples remains at the site: three are in English collections, one each is at the Vatican and the Villa Albani. One, once at the Villa Albani, is probably the same as one now in the Louvre, one is in the Hermitage, and one is lost from sight—a typical distribution of Villa finds. Of these eight, three are Egyptianizing (one is of Antinous as Osiris, another may be, the third is incipiently pharaonic), one combines him with Dionysus-Bacchus and probably another (the lost piece) did also. The remainder (two heads and a bust) are somewhat idealized portraits. This subdivision by interpretive types, in line with the evidence from across the empire, is significant: Antinous was represented at

the Villa both as a human and as joined not only with an Olympian (a son of Zeus) but also with the ruling god of the Egyptian underworld.

Perhaps the original Antinous portrait was commissioned by Hadrian when he was in Greece in 131/132; he may also then have begun the mystery-rite temple to Antinous at Mantinea, of which Pausanias speaks and where quadrennial games were held in Antinous's honor. By then Antinoopolis, in size and grandeur equivalent to ancient Egyptian funeral sites and thus perhaps, in the popular mind, to the unending divinity of pharaoh, was well under way. There and in Greece, and soon in Asia Minor and in Italy, images of Antinous multiplied. But basic questions remain unanswered. On what grounds was Antinous raised to celestial rank? And what underlying artistic factors, independent of imperial and practical ones, gave birth to an unprecedented version of classical portraiture? There is some temptation to think that Hadrian simply ordered it, demanding work that satisfied his vision of something new of the highest quality, and that the masters brought him their proposals. That his novel buildings almost certainly were conceived in this way is not irrelevant, and the knowledge of sculpture ascribed to him in the texts should not be dismissed precipitately.

By the time of Hadrian's death in 138, the cult and image of Antinous were known, if not regarded with widespread enthusiasm, in Rome and its environs (the Antinous obelisk, erected on the Pincio in 1822, was probably brought from Egypt only in the early third century), for groups claiming Antinous's protection carried out appropriate ceremonials then at Lanuvium and Ostia. Whatever the degree of success or failure of the cult in Italy, the Villa has given up ample evidence of its existence and its underworld connections, another instance of the reflection there of major aspects, by no means all Roman, of empire culture. The cult was particularly popular in Egypt and took root in Asia Minor and Greece (all Antinous coins come from the Greek east). That it did not flourish in the Latin west is less surprising than the fact that it prospered at all and was the source of a new classical portrait type. Whatever Hadrian's program may have been, the inclusion

of Antinous portraits at the Villa is further evidence of the Villa's eclectic, inclusive character; the emperor, after all, had made Antinous famous, a symbol of hope, perhaps of renewal.

A historical near-parallel to Hadrian's reaction to Antinous's death and its results, instructive if at first thought incongruous, is the effect of Prince Albert's death on Queen Victoria and its artistic and popular consequences. The story, well known, revolves around the queen's deep grief, the public's genuine and even profound sympathy, and the astounding quantity and variety of Albertiana it produced. Albert's image — equestrian, standing, or sitting, of stone or bronze — was set up in at least twenty-five urban public spaces where he appears as a statesman, a scholar, a grand military commander, a medieval knight, and a Scottish chieftain — among other roles — as well as a prince. Other effigies appeared in memorial shrines, memorial bell and clock towers, and cathedrals. Painted portraits were common; some were in mosaic. Elegies and hymnlike songs were composed in his memory, and at the popular level his cult, for that was what in fact developed, was exploited in the kind of image-bearing, celebrity-generated gimcrackery so common today, from drinking mugs to playing cards, from scarfs to cheap dinnerware, an odd reward for a serious, hard-working man. All around the empire Victoria's admiration and grief were advertised on coins and medals and in inscriptions as well as by statues. Painters and photographers to the household repeatedly recorded the queen, often with her children, gazing at a bust of Albert.

Both men ascended to a celestial realm. Victoria knew Albert was in heaven, Hadrian (or his collaborators) declared that Antinous was a Greco-Egyptian deity. Both became symbols of values and aspirations highly regarded by their contemporaries. As the Prince Consort became after death a man for all Christian purposes, so Antinous merged with Osiris, Dionysus, Apollo, and Sylvanus, some of whose powers were attributed to him. Albert's ascent was aided by a solicitous public and capitalist entrepreneurship, Antinous's by Hadrian's energy, power, and purse and by those who saw a pro-

tector in the new young god. The qualities, real and supposed, of both men were defined and conveyed by sculpture. The queen in her palace contemplated effigies of Albert, and Hadrian might commune at the Villa with Antinous's shade; the sculpted figure of Victoria sometimes joins that of her husband, and Hadrian hunts with Antinous in an Arch of Constantine relief (where he sacrifices in the presence of a statue perhaps modeled on Antinous). Finally, Antinous's image, like Albert's, was brought low, vulgarized; in the end, both became scholars' property.

Antinous's story is so unusual that classical analogy fails, thus the Prince Consort. Both tales show how powerful a propagandistic and mnemonic force widespread sculpted human images can be and how readily and effectively sculpture can achieve dramatic effects. The pictorial moods of Antinous, for example, are so varied as to suggest a multiple personality, though this probably results less from attempts to probe and reveal his psyche than from the need to use many artists, few of whom worked from life or from an official example. Variety was inevitable among the images of a universally available deity. In making him into a god (a late, relatively weak one, but a no less astonishing creation for that), Hadrian and his agents naturally made sculpture their chief ally. Antinous became both a Greek and an Egyptian god and was shown as such, as guardian of the underworld he entered by way of the holy Nile and as a near-Olympian as well. Everything begins in Egypt: had Antinous drowned in the Rhone or the Po, Hadrian's plans, if any, would have been different and success far from certain. Death in the Nile sealed Antinous's posthumous fate, for on it was founded the emperor's offer to the world of a new god. On that basis his cult spread and his image proliferated — Egypt and Hadrian created the god, gifted artists the major images. Those at the Villa sat appositely with the other testimony to the nature of Hadrian's life and circumstances.

The Villa contained Egyptian sculpture because Hadrian, like all Romans, was interested in Egypt, a place stocked with alien flora and fauna and the home of strange monuments and practices. Some Egyptian

works at the Villa were religious objects connected with Antinous, some decorated gardens and fountains; like so much else there they contributed to the world-view the Villa represented. It was already fashionable in Hadrian's day to have Egyptian pieces; the Egyptian presence in wall decoration and on small objects had begun in the later first century B.C., and sculpture, obelisks, and shrines to Egyptian deities such as Isis followed. So the nearly thirty Egyptian statues known to have been at the Villa—enough to make a strong showing—represent a well-established branch of Roman taste. Transfer, as so often happens, diluted meaning (Hadrian, nominally king of Egypt, apparently did not absorb the Ptolemaic religious persona into his own as Caesar).

One or two statues bring to mind the HA reference to the provinces—Hadrian "fashioned the Villa . . . in such a way that he might inscribe there the names of provinces"—probably on statue bases, for the provinces would be personified. There was ample precedent for erecting them. In his theatre in Rome, Pompey displayed statues of the fourteen nations he had conquered, and Augustus portrayed all people in the Portico of Nations. Hadrian's durable interest in the provinces produced his great province series of coins, initiated under Trajan and culminating late in Hadrian's reign, and presumably inspired the bronze statues Pausanias says stood in front of the Olympieion's columns; the Athenians called them "the colonies," and Pausanias's context suggests that Hadrian put them up.

At the Villa the most likely candidate is the Nile composition found in the Scenic Canal because it has the necessary pose and attributes and closely resembles the Nile image on several versions of Hadrian's Egypt coins. Then there is the head of a Mauretanian extracted from the Bog by Hamilton in 1769, perhaps the same work as the presumed ruler-portrait of a Mauretanian now in the Vatican. Mauretania, a coin subject, was included in the Hadrian-inspired personifications of the provinces set up beside the Hadrianeum by Antoninus Pius shortly after Hadrian's death (it is now in the Conservatori Museum); the Hamilton head just possibly belonged to a representation of the province. The three

see 179, 180

known Villa Athenas cannot represent the province of Achaea, whose iconography is different, but the Villa's Ephesian Artemis could readily have been taken for the province of Asia, for although Ephesus was not the capital, it was the province's grandest city, known across the empire. This is all exiguous, but it is not unreasonable to think that statues of the provinces stood among Hadrian's vast, mute Villa congregation.

The appearance, subject, and location of each statue had to have the emperor's approval, so surviving works should give some indication of his program for Villa art. They show above all his appetite for the world he knew so well, and in this sense they do reflect his prodigious travels and knowledge of history and tradition. Because he included so many different subjects, and because great works were often unobtainable, a sprinkling of second-rate pieces was inevitable; in any event, a collection of masterpieces was not Hadrian's objective. He intended the eclectic result to show a microcosm of a finished world seen through his eyes, one in which Greek and Roman genius combined to create a cultural as well as a political commonwealth. We see nothing at the Villa of overweening self-exaltation (which some detect)—grandeur of scale and conception, and much originality, yes, but not a place for a god. The heroic touches, the splendid buildings, the myth-laden gardens and groves, the brilliant flow of waters all celebrated Caesar himself less than they celebrated Caesar's world, of which the Villa was an artistic transcription.

DECORATION

For painting and stucco the evidence is slight, for mosaic and marblework comparatively plentiful. The landscape situation is similar: almost nothing is known about Villa gardens and analogy must serve, but waterworks have left useful traces. Our objectives are to convey some sense of the original appearance and effects of floor, wall, and vault surfaces, and to suggest what gardeners and watermen, working with architects and sculptors, might have achieved. This may perhaps redress somewhat the impression the site gives today of a rustic estate strewn with bare, massive ruins of

almost uniform color and texture. The disappearance of so much decorative art and all landscape features other than the general contours of the terrain are the most preclusive of the Villa's many losses. No single room survives with its full decoration intact, and where edge-to-edge original surfaces do exist, such as floor mosaic or vault painting, the neighboring surfaces are usually bare.

The loss forever of the original visual impact of Villa spaces—particularly those frequented by the emperor and his circle—is dismaying. Integrating decorative arts intrigued artists and designers responsible for decorating raw construction. Drawings and descriptions made long ago of features now lost augment the surviving evidence, but some of those, said to be of Villa work, are not, and a few are incomprehensible. Much comparative evidence exists at other sites, and numerous clues remain in the Villa's structural fabric—cramholes for marble wall revetment (and the patterns they form), negative impressions of marble paving patterns left in concrete floors, and a large number of pieces of decorative marble fragments, diminutive and isolated patches of painting, and fallen vault mosaic tesserae. Fragments of brightly painted plaster and small decorative elements of stucco, glass paste, and marble, mostly turned up in modern excavations, are preserved in the Museo Didattico. Representative examples of these various survivals are discussed below.

181

Little figure painting survives, though a head may perhaps be represented, on a worn Museo fragment, within a small Fourth Style (third quarter of the first

181 *Lintel above an entrance to the bar in the Villa parking lot (1991)*

century) painted panel of a kind common elsewhere, for example in Fronto's house in Pompeii or in the Hall of the Landscapes of the Domus Aurea, and there are dim figures on Canal Block vaults. Late eighteenth-century impressions record groups of Mars and Tiber, Apollo and the Muses, and the triad of Minerva, Juno, and Venus, among other compositions; perhaps they were seen in the Hall of the Cubicles. They are so generalized as to make analysis futile, but they imply the existence of large scale figural work at the Villa. Except for sketchy impressions of birds and beasts on a vault in a room of the Canal Block, paintings of the animals so popular in Villa sculpture and mosaic are as yet unknown.

Evidence exists for two paintings architecturally organized: aediculas on the southwest wall of the Portico Suite gallery, shown by Piranesi, and in Hall of the Cubicles wall paintings with columnar divisions, copied when still visible in the 1920s. Delicately painted details of mouldings and plant life are preserved in the Museo Didattico, and important remains of architecturally inspired borders are visible in the Peristyle Pool Building and Larger Baths cryptoporticoes. With the exception of the isolated patches mentioned above and a remarkable painted niche in the Larger Baths, all other evidence for painting is as far as we know linear and geometrical: darker bands on lighter grounds mark off various rectangles and other shapes or divide surfaces into generous, often blank sectors. In some of this work rectangles are painted in various colors, either here and there or, in a few examples, across the entire surface. Socles, as at other sites, may be painted to imitate colored marbles; at the Stadium Garden north end, one such painting runs above a marble socle.

see 343

182

Little is certain about principles of painted ornament. Simple, repetitive pattern-making spreads across many wall and vault surfaces, some of it of negligible interest, even hackwork. More sophisticated designs appear in spaces the emperor and his circle would visit, such as the Stadium Garden room just mentioned. Broad blue-gray borders divide a yellow-cream ground rising from the painted socle, and at one position panels are separated sufficiently to accommodate a painted folding

door of two or more leaves. The socle is done in dull red, orange-yellow, and a watery green; all the colors (we give the present, faded ones) are in harmony with those of the socle marbles and the austere rectangles of the pavement, a portion of which has been restored. And the ceiling painting of the cross-vaulted room west of the Peristyle Pool, though not as well preserved, is of the filled-in rectangles type, apparently done in red, orange, and green units separated by white bands. These two examples suggest that banded geometric patterns do not necessarily indicate places of secondary importance. Rooms paved in marble or with elaborate, carefully made mosaic may well be classed as imperial (bath chambers could be exceptions); if rooms so paved had in addition marble socles, marble wall revetment, or vault mosaic, or any combination of these, they were presumably for the emperor and his retinue.

It is safe to say that plain geometric figures painted on walls or vaults were always repeated fairly consistently across entire surfaces, as for example on a considerable exterior stretch of the Central Service Building northernmost wall facing the Larger Baths. On a cream-tan background, red, orange, green, and blue lines were laid in to form oblongs, diamonds, and triangles from end to end in slightly irregular rhythms, and a few smaller shapes are painted in blue. Each diamond, whether vertical or horizontal, is constructed of equilateral triangles set base to base, and the double-lined figures between the largest diamonds and their enframing rectangles look exactly like drafting aids. The wider lines, in red and orange, are reinforced by narrower parallel lines in blue, the painter's version of multiple moulding surfaces. His straightedge controls the entire painting, but numerous variations in measurement occur and some golden section ratios appear. By so writing right across the surface in a lively, repeating script of juxtaposed orthogonal and diagonal lines, the wall gained character, as if a net of colored ropes had been cast over it. Later it was replastered and painted again, with thicker, less precise lines and even larger diamonds painted red.

The vault painting in the Scenic Triclinium west hall, though more refined, is based on the same principle of repeated geometric patterning. Blue bands di-

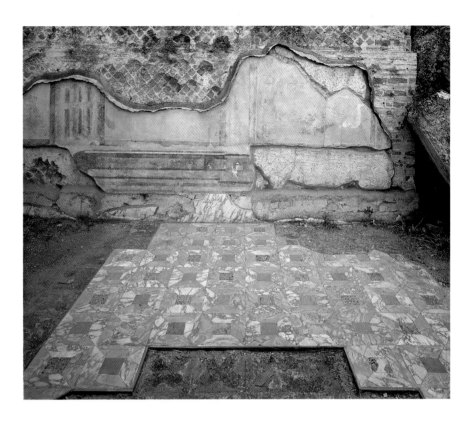

182 *Stadium Garden, pavement and painting at the north end (1987)*

183 *Central Service Building, painting on the north exterior wall of the forward row of cubicles (1987)*

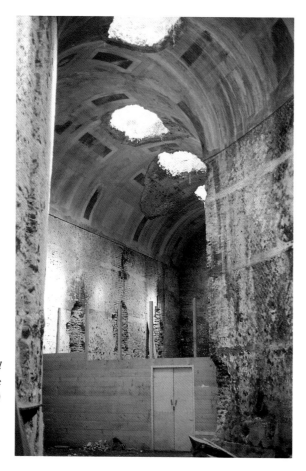

184 *Scenic Triclinium, painted vaults in the southwest chamber (1963)*

185 *Peristyle Pool Building, cryptoportico painting (1987)*

vide a yellow ground into rectangles (squares and oblongs alternating, a common Roman pattern) wherein white squares and purple oblongs are painted in turn; the scheme continues unvarying from front to back (adapting itself easily to the hall's dogleg plan) and from impost to impost. But here the squares contained some decoration from nature—stylized vegetation in the white squares, and elsewhere rosettes perhaps reminiscent of those of architectural coffering; the white squares also sported yellow discs. These small details, seen in the past, can no longer be made out. But what remains records a forceful composition whose purple oblongs, set first vertically, then horizontally, then vertically again (as read transversely across the vault curve), show how successfully the checkered color-blocks of wall painting were adapted to vaulting, in such a way as to state vigorously the shape and travel of the vault.

These examples emphasize the tectonic qualities of wall and vault painting. The influence of the architect and mason is paramount, and in the broadest sense these rectilinear patterns hark back to the earliest classical ashlar walls (Piranesi's interior view of the Portico Suite gallery shows imitation ashlar above the wall niches, whether painted or drafted in stucco isn't clear; imitation ashlar was fairly common on Roman buildings elsewhere). No scribe lines survive where the painting can be studied close up, but hurried work on the Central Service building wall has left its traces; presumably assistants worked in teams.

Other groups made linear wall and vault paintings of a quite different character, in which plain lines are doubled, and between them designs resembling architectural mouldings are added. Sometimes these moulding paintings, to use a convenient term, mark off rectangular surface areas, but some serve more elaborate schemes. Examples of both survive in the Peristyle Pool Building cryptoportico, in an area where generations of artists and visitors have left their names (the paintings are difficult to read, and our photographs necessarily mediocre). At one point three parallel bands, one above the other and separated in a near golden section ratio, run along the lower vault surface for a meter or two against a yellow ground; perhaps they framed a large

rectangle. The bottom, widest band has a repeated egg-like motif, in the middle one red diamonds in rectangles alternate with forms like bow ties, and the topmost band is a schematic version of egg-and-dart reminiscent of the miniature ionic cyma, found on the Esquiline, of gilded metal with chalcedony eggs.

Bits of architectural stucco survive both in place and in the Museo Didattico, and three vaults preserve stucco sheathing. Of these examples, only one is readily

187 accessible, that on a cross-vault in the Larger Baths, in a room about 12 meters square. Only the northwest and best preserved portion is usually illustrated, but parts of the north crown and northeast angle are also in place;

see 256 Piranesi gives a reverse-ceiling plan of the whole. It is symmetrically compartmentalized by repeated mouldings and broad bands of latticework; where these last reach the walls, architrave soffits are represented be-

188 tween the bands. The major fields, outlined in delicately modeled egg-and-dart, contained roundels with busts, and trapezoids and diamonds folded back from the groin lines enclosed victories. On the four barrel vault crowns mythological figures appeared within octagonal frames. Putti, tendrilized arabesques, various Bacchic

189 cult objects, dolphins, and scores of single blossoms, anemones perhaps, inhabit the bands. The entire composition was bordered by a narrow red ribbon, and yellow rosettes have been detected, but apparently all else was left off-white, unpainted. On a nymphaeum barrel vault below the Doric Temple a central square containing a large rosette is enframed by ever-larger squares, the bands between which alternately carry palmette and geometric motifs; of these, the outermost are spiky, the inner more roundly modeled. At least part of this

190 vault was painted. In the third example, in the Northern Ruins, a number of comparatively small rectilinear compartments, of various dimensions, are outlined in deep-relief mouldings but contain pencil-thin, linear geometric figures.

When evidence is as scanty and uneven as at the Villa, secondary features and small details assume added importance. This is the case with two niche vaults, the

191 eastern one in the Circular Hall north facade and one

192 in the Larger Baths round room; together they con-

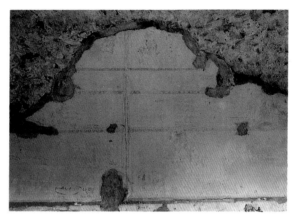

186 *Peristyle Pool Building, cryptoportico painting (1988)*

187 *Larger Baths, stuccoed vault (1987)*

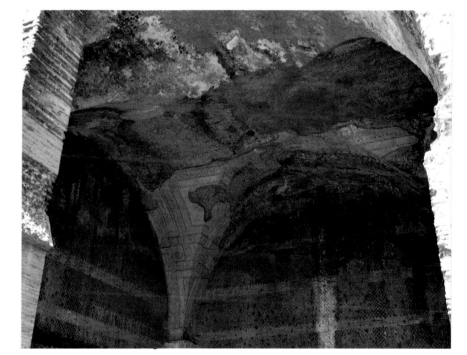

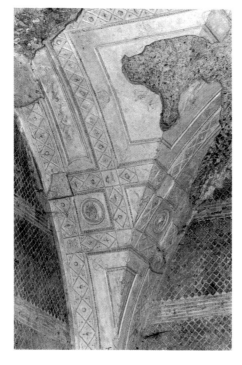

188 *(top left) Larger Baths, stuccoed vault, detail (1987)*

189 *(top right) Larger Baths, stuccoed vault, detail*

190 *(bottom left) Northern Ruins, stuccoed vault, detail*

191 *(center right) Circular Hall, north facade (1987)*

192 *(bottom right) Larger Baths, circular room, niche (1968)*

tribute substantial information. The Hall niche, one of a symmetrical pair flanking an entranceway, preserves in stucco eleven simulated shell channels and portions of two more. Rising, curved lines scored in the stucco between the channels at the bottom of the vault imply that the channels are concave, whereas they are in fact radial segments of the niche's curving surface. The implication of concavity was strengthened by projecting stucco ribs between the channels (the sharp edges have worn away). The crown is gone, and no traces of painting survive; that so much does remain is remarkable. The theme is common in Roman art.

193, see 289

The Baths niche, drawn close up by Ghezzi in 1742 and from a distance by Piranesi some years later, is partly sheltered, but its decoration is fading steadily. The vault surface, almost entirely preserved, was decorated with an elaborate shell-like painting in gilt, blue, possibly black, and other colors now indistinguishable. At impost level a tall band of gilt-painted anthemia is separated from the shell channels above by a horizontal garland. The seventeen painted channels alternate wide and narrow, nine and eight respectively, and the painted ribs, that end in weighty tassels, suggest the rope frame of a grand tent. The doubled, upcurving channel separations of the Hall niche appear here also, painted in at the bottoms of both sizes of channels as upcurving dark blue bands crowned by spiky ridges; shading may have reinforced the illusion of three-dimensionality. Above the spike lines Ghezzi depicts substantial bands of rosettes, now vanished. Halfway up the vault another tall band appears, also outlined in rising curves and stocked with dolphins and other shapes all painted in blue. Piranesi's drawing captures the underlying scheme exactly; Ghezzi's has greater detail but is more like an entry in an archaeologist's field notebook. Both record a final element that has all but disappeared: on both sides of the vault, garlands hang from the crown loop to the edge of the niche, first halfway down, then at impost level. Secondary loops are tacked along the semicircular niche edge, to which other garlands conform to make the outermost border.

Niches contained statues, as archaeology and ancient paintings show; for smaller niches, like those at the

193 *Circular Hall, north exterior niche (1987)*

194 *Larger Baths, circular room, drawn by Ghezzi (ca. 1742)*

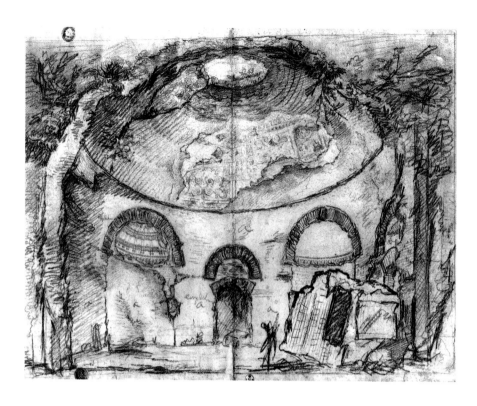

195 *Larger Baths, circular room, reversed drawing by Piranesi (ca. 1775)*

196 *Larger Baths, circular room, niche detail (1968)*

Circular Hall (about 1.8 meters or 6 feet wide), statues could be changed easily. That decorative themes in niches related to the subjects of their statues is to be expected, though perhaps this was not always the case. The shell motif, for example, though not neutral was thematically adaptable; something relating to the emperor's presence, such as a protective deity, would be appropriate there. In baths, Aphrodite-Venus, marine subjects, heroes, and athletes were traditional. It is impossible to derive a principle by comparing the two niches, but the fact that the more sober work is in a private area and the more opulent in the much larger Baths niche might suggest that the identification of the Baths as those for Villa workmen may be wrong, that the Baths were open to everyone. In any event, the dome of the circular room was also elaborately decorated, as Piranesi's drawing shows: he records a coffered upper level, a paneled central one (medium unknown), and a lower level covered in part at least with large scrolls that have all the earmarks of a mosaic design.

The principles of Villa decoration lie less in any consistency of technique or subject matter than in the kind of inconsistency defined by the application of all available techniques to a wide variety of themes and subjects without much regard for what goes with which; in that sense Villa decoration is one with Villa sculpture, ruled by the integration and interdependence of media and subjects. And niches, highly charged spatial devices that focus attention forcefully on their enframed and thus dramatized contents, reduce the sense of the presence of those structural realities their decoration masks. By compounding this effect with mosaic and marble-work, Roman artists and architects took a large step toward the visual dematerialization of solid structure achieved in later times. Other Villa evidence for this tendency exists, but before examining it, mosaic and marblework need brief examination.

When Seneca compares the baths of his time with the small, dark bath at the country house of Scipio Africanus, by then more than two centuries old, he remarks that "our ancestors did not think one could have a hot bath except in the darkness," and asks,

Who in these days could bear to bathe in such a fashion?

We think ourselves poor and mean if our walls are not resplendent with large and costly mirrors; if our marbles from Alexandria are not set off by mosaics of Numidian stone, if their borders are not made in difficult patterns, arranged in many colors like paintings; if our vaulted ceilings are not buried in glass; if our swimming pools are not lined with Thasian marble . . . and finally, if the water has not poured from silver taps.

These basic materials of Roman luxury decoration—including mirrors, water, and precious metal—were in use by the mid-first century. Porphyries and granites of various colors, serpentines, and basanite ("basalt") were shipped from Alexandria; the yellow-orange-red giallo antico, so evident in the Pantheon, came from a quarry in what is now northwest Tunisia; and a white marble, often used to line pools and steps (as in rooms 13 and 18 of the Smaller Baths), came from one at the island of Thasos. Other places shipped exotic colored marbles. The elder Pliny says that the theatre erected in Rome in 58 B.C. by M. Aemilius Scaurus had a stage building with one story faced with glass, and vault mosaic is apparently almost as old, with tesserae and gem-shapes of glass paste appearing in vaults before the end of the century. Mosaic of true glass, flinty and lustrous, apparently comes somewhat later.

Mosaic pavement, by Hadrian's time some four centuries old, survives at the Villa in a dozen complete floors (all in the Hall of the Cubicles except for one in the Portico Suite central space) and in several instructive stretches, most of which cover a square meter or two; none of these is "arranged in many colors like paintings." But a dozen or so mosaic pictures, presumably central features of Villa pavements, can be seen in Rome, and there is one in Berlin. Some have been rebordered and partly restored or reset; the authenticity of two or three has been questioned, and the suggestion made that among them there might perhaps be pre-Hadrianic collectors' pieces installed at the Villa for Hadrian. No Villa wall mosaic has yet come to light, but the empty recessed panels of the Island Enclosure ring wall and the Arcaded Triclinium eastern hall are possible locations, and mosaic was seen in the Scenic Triclinium extension wall niches. A vault mosaic of the third quarter of the first century B.C. remains in the southwest arm of the Republican cryptoportico, and traces of Hadrianic vault mosaics are discernible elsewhere; others were recorded in the past. Glass tesserae, and some pieces of their cement setting beds, were found fallen from the vaults of rooms 13, 17, and 18 of the Smaller Baths, and Scenic Triclinium vault tesserae have already been mentioned.

The repeated edge-to-edge pattern of the Portico Suite mosaic, which covers about 120 square meters and is partly restored, typifies Roman plain-style floor work. It is a simple but strongly stated scheme, and not without subtlety: the pattern lies diagonally athwart the room's axes, and the uneven shapes and sketchy management of the tesserae enliven what could otherwise be a cold, mechanical exercise and create the tactile quality without which mosaic loses much of its power. As in the Larger Baths niche and indeed all remaining Villa decor, the details are significant. Within a four-part border of white bands (the outer wider than the inner) laid beside narrower black ones, the floor is divided into squares by black chains of linked, pointed

197

197 *Portico Suite, central room, floor mosaic (1987)*

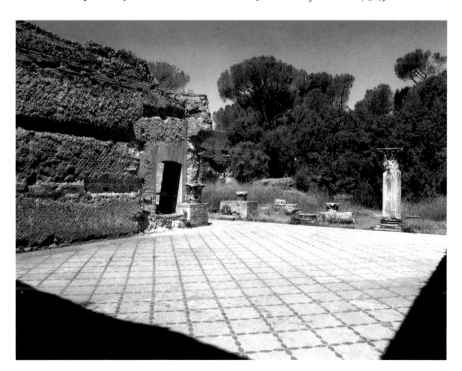

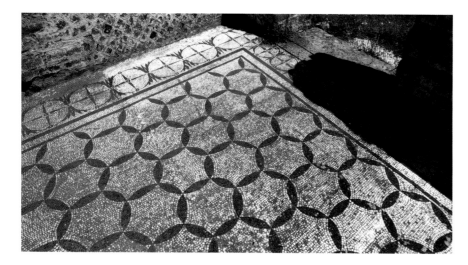

198 *Hall of the Cubicles, room 11, floor mosaic (1987)*

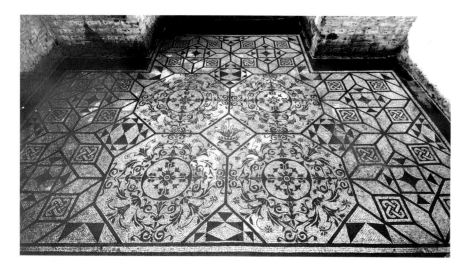

199 *Hall of the Cubicles, room 8, floor mosaic*

ellipses, rather like twists of wool, three to each square. But the tesserae within the squares are not aligned with the diagonally laid chains but are set, in a mildly irregular fashion, along the room's transverse axis. This contrast, together with double lines of white tesserae set along the curving forms of the chains, energize the straightforward geometry of the underlying scheme. And the floor is a good example of what might be called the structural quality of pattern mosaics: they help to define architectural spaces, whose palpable effects are thus reinforced.

The mosaic in room 11 of the Hall of the Cubicles is based on similar geometric principles, but the figures are different. In the border, black circles each with four spindle-shaped radial spokes are repeated in line (joined by links and leaves) like an elongated bracelet laid flat. In the field itself a pattern of circles interlocks like conjurors' rings, its overlapping twist-shaped portions in black and the rest off-white; the field and its border are separated by two black strips with a white band between them. The diagonals the scheme implies cannot carry from corner to corner because of the sexpartite division of the circles. Within the six-pointed stars the interlocking circles create, the tesserae are set unevenly along the room's transverse axis; because the curving black shapes are outlined by doubled rows of white tesserae, the eye reads two sets of circles — white ones and the black circumferences they border. Both this floor and that of the Portico Suite show how powerful the effect of simple repeating black-and-white patterns can be. But this effect is not generated by the repeated figures alone. What may appear to be solid lines and shapes are in fact constructions, made by placing one irregular cube next to another — not flush with it, but close to it. The resulting narrow, shallow interstices and the uneven tesserae edges and surfaces create fine-grained textures complemented both by the rippling effect the hand setting of different-sized cubes produces and by certain shapes defined by tesserae cut more or less to fit; both can be seen in close-up photographs. The effect is both more powerful and more subtle than the phrase "black-and-white pattern mosaic" suggests, and the results contributed strongly to the character of Hadrianic decor, as the Cubicle mosaics confirm.

These are splendid examples of High Empire surface art. Recently cleaned, they are in good condition. Several masters may have been at work, but all the floors contain vegetable and floral motifs, stylized yet wonderfully pliant and sometimes delicately drawn; even the most crystalline designs, in rooms 5 and 8, for example, center on notions drawn from nature. The twining garlands of room 9, discussed earlier, and the great circle of room 2, with its compass rose of brackets and scrolls centered on a leafy, pinwheel disc—a scheme seen in the early Hellenistic period—are outstanding. The floor in room 6 is a masterpiece, rational but fluid and sinuous, a linear relative of brilliant African color mosaics of the kind seen in the museums of Timgad and Algiers. In room 10, intersecting circles produce forms with four concave sides (similar to the Island Enclosure central feature's plan) which by a mosaic sleight of hand seem to be stretched out toward their circles' circumferences, hides nailed up to cure. In most of the rooms— 5 and 8 are exceptions—the central square contains the principal composition, and patterns of abstract features such as latticework or intersecting circles fill the three smaller, flanking areas. In room 3, where eight-petaled chrysanthemumlike blossoms repeat across the central field, the side spaces are powerfully energized by nearly a hundred black pots or baskets, lying on the white floor facing each other in groups of four, the near edges of their open tops ingeniously described and linked by circles of white tesserae.

Do these designs have meaning? Were the rooms perhaps intended for those whose professions and responsibilities are symbolized in the mosaics? The flowers and pots of room 3 might suggest a *topiarius*, a master landscape gardener; the same might be true of the garden of room 6, flanked by the latticed garden fences of Roman paintings. The prisms and the twisted-rope or simplified guilloche motif of room 5 could perhaps stand for a master architectural carver, a specialist in stereotomy and fine detail. The room 9 mosaic, with its wide-mouthed corner vases, garlands flowing from one location to another, and spinning forms of the central circle (a waterwheel?) and the side panels bring water management to mind. Room 2 suggests survey-

199
200
201
202a
202b
203
see 201

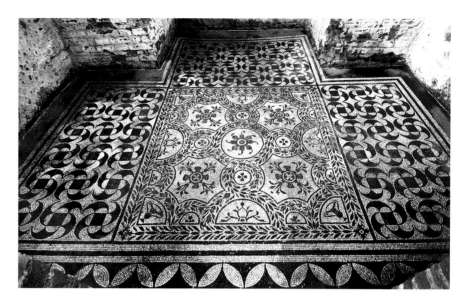

200 *Hall of the Cubicles, room 9, floor mosaic*

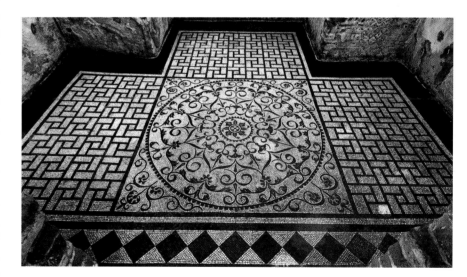

201 *Hall of the Cubicles, room 2, floor mosaic*

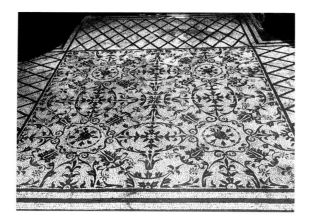

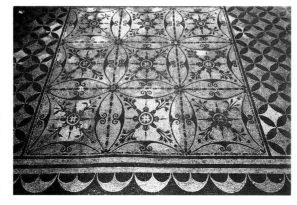

202 *Hall of the Cubicles, rooms 6 (top right) and 10 (center), floor mosaics (1931)*

203 *Hall of the Cubicles, room 3, floor mosaic*

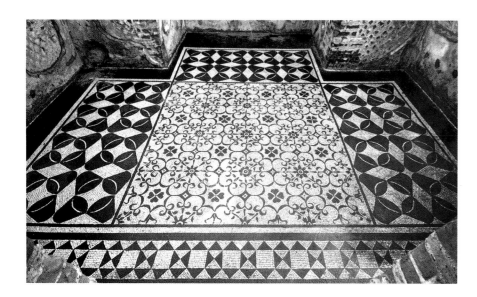

ing, the weather, and construction, a Vitruvian triad; room 8, vaguely, a table service complete with centerpiece. All this is speculative, perhaps pointless, but analyzing these floors by making comparisons with other mosaics elsewhere, essential to comparative art history, doesn't relate them to their human context, to Villa life and its content. In any event, using stylized leafy devices and abstract shapes to express specific themes and topics is as common a kind of artistic transposition in antiquity as later. see 199

Mosaic fragments record borders—including those that once framed centered emblemata or pictures—colors, and tesserae patterns. In the small chamber (a shrine?) just southwest of the Water Court vestibule, part of a checkerboard-pattern floor is preserved. The tesserae are small, the colors rich, autumnal in range, and the effect is that of a splendid quilt or afghan. A six-band border includes central channels with stylized castellated shapes (reminiscent of robust wall-and-tower mosaics elsewhere) set within a colored ground of tesserae graduating inward from red-orange to medium orange. The squares of the main field, marked out by lines of black tesserae set diagonally, each enclose nine more squares set one within another, in the manner of coffer mouldings, with stylized five-part rosettes at their centers. Both pattern and colors remain the same throughout, but color sequences vary. Typical square systems, inside the black ones, run white, yellow, orange, black, white, green, black, white, and orange; red, orange, white, black, green, white, black, orange, and yellow. The rosettes vary similarly. Because of the way the squares meet the border, the squares appear to continue under it. 204

Just west of the Residence basilica a stretch of a nine-band border survives. The bands run inward, in varying widths, in white, red, white, a simplified guilloche moulding in colors on a black ground, then white, red, white, yellow, and final rows of white against which some remaining white field tesserae abut diagonally. The ropes change colors as they pass under each other: red-yellow-white becomes green-gray-white, which then passes under red-rose/gray-white to turn into yellow-yellow-white, and so on. In a 205

206 room just east of the Fountain Court West a five-band
border of alternating white and black stripes encloses a
red, gray, and white field within which a picture, now
gone, was enframed in the same fashion. The field is
subdued but subtle. A rationally set red-and-white key
motif follows the innermost border band, but thereafter
the mostly oblong tesserae are set somewhat unevenly,
without regard to any precise color pattern, in a field of
small spots of color flowing across the floor to the pic-
207 ture border. A similar field, in the Larger Baths, of gray
and white more or less oblong tesserae, is a looser, wan-
dering construction, handsome nonetheless; it could be
post-Hadrianic. Mosaic-covered concrete slabs, fallen
perhaps from upper floors as at the Arcaded Triclinium,
can be seen also at the Stadium Garden. A fine, colored
208 vine and ribbon mosaic border and a mosaic panel of
fruits and ribbons with birds and butterflies survive in
the Vatican.

Of the mosaic pictures — more on these in chap-
209 ter XI — the best known is that of doves drinking from a
basin (found in the room opening off from the Circular
Hall to the northeast). It is a copy of a work by the Hel-
lenistic artist Sosus of Pergamon, famous in antiquity
for realistic floor pictures made with minute tesserae
(*opus vermiculatum*) that facilitated delicate, graduated
shading in the manner of painting. The other pictures
are difficult to study. Some, such as the three panels
with masks in the Vatican, taken from the Residence
peristyle, seem tepid set-pieces of rather coarse con-
struction (in part the result of heavy restoration). Typi-
cal of these is one with a mask of a young man flanked
by a lyre and an empty wine jug lying on the floor, all
in the foreground. Behind is a shelf carrying masks of
a woman, another young man, and the bearded father
common in comedy; earth colors predominate, with ac-
210 cents in black and white. Two other panels, each of a
landscape with goats and a deity or mythological figure,
are of better quality and belong to a popular genre of
peaceful, bucolic scenes with religious overtones.

Two wild animal pictures, in contrast, emphasize
action and menace. The one in the Pergamon Museum,
in Berlin, is well made and gives evidence of Sosus's in-
fluence (assuming that the Capitoline piece reproduces

204 *(top) Water Court, chamber
beside the northwest interior
border, floor mosaic, detail*

205 *(center) Residence, room
beside the basilica, floor mosaic,
detail (1987)*

206 *(bottom) Fountain Court
West, floor mosaic, detail (1987)*

207 Larger Baths, floor mosaic, detail (1968)

208 (far right) Residence, floor mosaic, border detail; now in the Vatican Museum (1992)

209 Circular Hall, chamber opening off to the northeast, floor mosaic; now in the Capitoline Museum (Getty Center, Resource Collections)

that correctly). A male centaur defends himself against a marauding tiger; the centaur's mate and a lion lie dead or badly wounded; in the background a leopard stands in a sere and threatening landscape. In a Vatican scene a lion attacks a bull by a waterhole in a less convincing but still energy-charged scene. Another work in the Vatican is mystifying: a lion (poorly drawn), a wild boar, a stage elephant, and two cavorting stags figure in a gently undulating landscape — its trees unlike any others we know of in Roman art — under a blue sky with scudding clouds, all of which strongly suggest postmedieval work.

Only bits of marble wall revetment survive, and none has been restored, but it is signaled all across the site by patterns of holes made when the metal cramps holding the marbles were extracted, as well as here and there by alignment shims (or their negative impressions in cement setting beds), as in the niche of room 7 in the Smaller Baths. Broken bits of thin marble facing, rising from floor level, are common, but unless there are cramp holes above they are probably the remains not of

wall revetment but of skirts or socles set below painted walls. Together with floor marbles, these fragments give a sense of the colors once seen on marble walls. But the general effect must be studied elsewhere, for example at Ostia or Herculaneum, where larger sheets of marble were used on walls than in pavements—just as at the Villa, as cramphole patterns and floor impressions prove. Footed marble pilasters, though not strictly speaking wall revetment, were sometimes used to divide large Villa walls rhythmically, as in the Arcaded Triclinium main east hall. And fragments of intarsia, made of delicately shaped small pieces of colored marbles set in neutral slate fields to form floral or architectural designs, probably wall decorations, can be seen in the Museo Didattico. Similar work is preserved in the Antiquario Palatino in Rome.

Grids of squares running from edge to edge determine almost all Villa marble pavement patterns. Inside the squares, designs and colors vary greatly, though variations within a given floor, if any, will repeat rhythmically across the whole. Internal division of the squares into balanced patterns of rectangles, triangles, and diamonds is common; internal octagons and circles are less so. Sometimes the squares lie flush one to another, sometimes they are separated by common boundary strips that together define the controlling grid. Marble and mosaic designs overlap: the pattern of the splendid alabaster latticework floor just below the Water Court north corner is the same as that in room 6 of the Hall of the Cubicles, where the entranceway borders of several rooms—3 in particular—suggest marble floors.

Two squares of the elaborate room 8 floor of the Smaller Baths, originally five by seven squares overall, have been carefully restored. Chips of the giallo antico wall revetment or socle are still in place; the blue floor outline is modern. Each square, including its borders 0.07 meters wide, is 0.75 meters on a side and contains fifty separate areas of color executed in five kinds of stone. The smaller border squares are of red porphyry, while the neighboring green ones and the ring around the central disc are of serpentine; both came from Egypt's eastern desert. The infilling between

210 *Residence, basilica, floor mosaic panel; now in the Vatican Museum (Getty Center, Resource Collections)*

211 *Villa floor mosaic; now in the Berlin City Museum*

212 *(left) Residence, basilica, floor mosaic panel; now in the Vatican Museum (Getty Center, Resource Collections)*

213 *(below) Smaller Baths, room 13, fragments of marble decor (1969)*

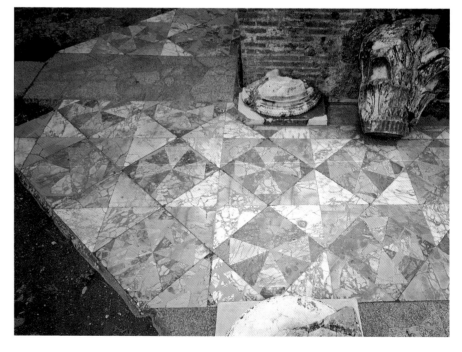

214 *(right) Arcaded Triclinium, square central room, eastern end, pavement and architectural elements (1987)*

215 *(above) Room by the Water Court north corner, alabaster pavement (1988)*

the square and the outer circle, and the central disc itself, are of giallo antico from Chemtou in Numidia; the gray and white marble of the borders and the inward-pointing triangles is probably a pavonazzetto from Caria in Asia Minor; and the sixteen sunburst triangles are of rosso antico quarried in southernmost Greece. In contrast, the subdued coloring and over-

see 214
lapping squares of the Arcaded Triclinium emphasize surface continuity, as does the austere pattern of the

see 182
Stadium Garden north room. Elsewhere, simple linear square-to-square rhythms are found, as in a room just

217
east of the Fountain Court East (where a stretch of

218
pavonazzetto base moulding survives) and in another near that with the alabaster floor just mentioned. But the complexity and strength of the Smaller Baths pattern were not unique, as the extraordinary colors and

219
spiky clarity found in a Peristyle Pool Building western room show.

The High Empire integration of decorative surface art with architecture enhances the sense of enclosure and gives a character to it as important at the Villa as the meaningful deployment of art and architecture in

220
the landscape. With their luxurious, polished surfaces and rich colors, marble pavements were essential to that integration, while at the same time they helped to bring about something of that suppression of structural realities familiar in major fifth- and sixth-century churches. Marble wall revetment, where it existed, was even more effective in this, and if vault mosaic was used, then the mechanism of implied dematerialization of solid structure was largely in place. Whether or not this was an effect Roman artists and craftsmen desired, their work certainly prefigures that of later times, for they often sheathed architectural surfaces completely with light-reflecting, brightly colored materials illuminated by both vertical and horizontal windows. Incomplete though it is, the evidence for this at the Smaller Baths is the most detailed at the Villa.

Because nearly half of the Smaller Baths interior

221
spaces are structurally complete, the evidence for their decoration is more valuable than it would otherwise be. And because the lighting system is better preserved here than in any Villa structure, including the Scenic

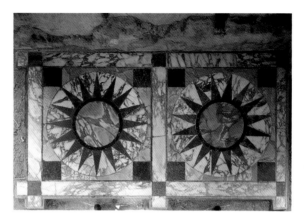

216 *Smaller Baths, room 8, marble pavement, detail (1987)*

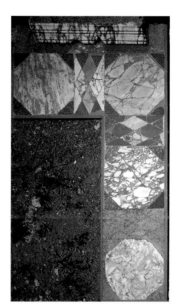

217 *Fountain Court East, marble pavement, detail (1987)*

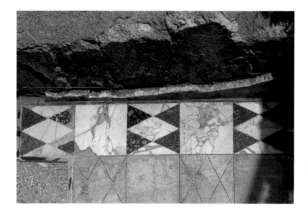

218 *Water Court, marble pavement, detail (1987)*

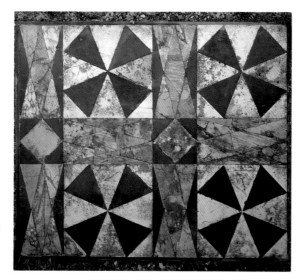

219 *Peristyle Pool Building, marble pavement, detail (1987)*

220 *Water Court, walkway southwest corner, pavement, detail (1988)*

Triclinium, some original effects can be inferred. Each room was roofed differently, some higher than others, so large windows could be placed up under the tallest vaults, as in rooms 9 and 13; oculuses were used in rooms 1, 10, 14, and 15; and room 8, that of the sunburst floor pattern just discussed, drew light not only from the adjacent east court but also through a lucarne, set above the center of the south wall and roofed with a raking, flat concrete slab that intersects the barrel vault at an acute angle. Clearly, the thirty light sources were carefully thought out; of them only the openings of rooms 10, 17, 18, 19, and 20 were typical oversized south-southwest bath windows. Evidence visible in the late 1960s and early 1970s establishes in some detail the kind of decoration the light enriched.

Three rooms could be restored in fair part. Room 1, an ell-shaped entrance corridor, was paved with off-white marble rectangles (0.22 by 0.36 meters, separated by narrow strips of rosso antico), their shorter sides staggered in adjacent rows in the manner of brick bonding. The marble wall revetment consisted in part at least of white marble, and the vault painting consists of red linear divisions and delicate circle motifs laid on an off-white overall ground. The vault of room 8, a passageway whose floor and wall marbles were described above, was painted in rectangles of red and orange-yellow, with yellow rosettes inside squares. The central space of room 13, the cold bath, or frigidarium, was paved (in part with reddish-purple porphyry) in patterns of small squares set within rectangles arranged swastikalike to form squares of 0.36 meters. In the center of this floor a square vertical shaft, about 1.75 meters deep, yielded numerous marble fragments, probably chiefly of wall revetment, of white and cream-colored marbles, giallo antico, portasanta (gray-orange), and green serpentine, as well as red, light green, green-gray, and bright blue vault tesserae of glass, rough cubes averaging 8 millimeters on a side, from the great cross-vault above. The steps, pools, and walls of the two cold plunges were all lined with white marble.

In room 18, a heated swimming pool, or tepidarium, the basin and its steps and walkway were all revetted with white marble; loose glass vault tesserae, a few blue

222

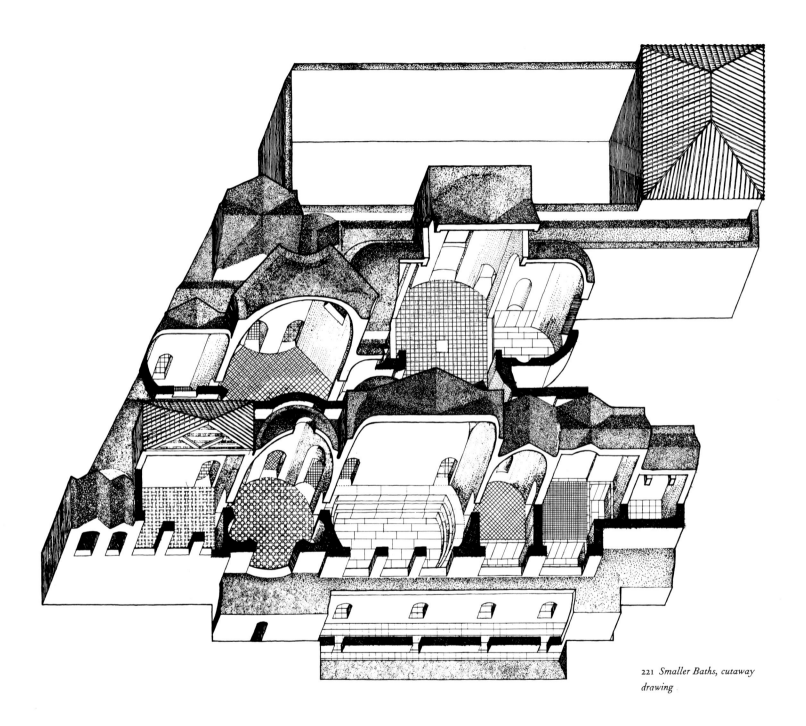

221 *Smaller Baths, cutaway
drawing*

222 Smaller Baths, room 1, vault painting (1968)

and experiential character of each successive space. The pavements and painting are traditional, but the vault mosaics are not; the wide tesserae spacing, recorded in the setting bed fragments, suggests that stage of experiment in the new medium seen elsewhere. Bright colors, in whatever material, appear throughout both popular and imperial Roman art. Save for their architectural decoration (of which there was little) and sculpture (only the Doryphorus, still at the Villa, is known), the Baths epitomize the artistic principles of Villa buildings wrought in the new vaulted architectural style; the interiors of the Water Court vestibule and nymphaeum, the Scenic Triclinium, and the other bath buildings, for example, all conform.

WATERWORKS AND LANDSCAPE

Incomplete though the evidence is for Villa architecture and art, it is more ample than that for the other two primary elements once just as important in Hadrian's plans: waterworks and landscape. Indications of a hundred-odd hydraulic installations survive, but although their typology and technology are mostly well understood, Roman artistic and atmospheric uses of water are not; and save for the broad contours of the terrain and some scattered evidence of planting, the extensive works of Hadrian's garden and landscape specialists have disappeared. Discoveries elsewhere, together with ancient paintings and literary evidence, suggest something of what Villa gardens, groves, and parks were like, but a comprehensive sense of original effects and views is beyond reach. One thing, however, is certain: artfully shaped earth, bearing waterworks and planting and punctuated with garden pavilions and stone ornament, provided from viewpoints both indoors and out statements of the Villa's cultural content as significant as those recorded by architecture and art.

The hydraulic regime was complex and sophisticated. Water entered from the southeast and was divided repeatedly to form a tapestry of fresh water across the entire Villa. The flow was regulated by cisterns and efficient plumbing: locally the supply could be continuous or provided, as needed, on demand. Fountains

but mostly red, were found in a heating cavity below the steps at the south end. Room 17, like rooms 19 and 20 a hot plunge, or calidarium, also gave up detached glass vault tesserae, all of them green, together with fragments of the setting bed that preserve green tesserae. Of the remaining rooms with evidence of decoration, 11 (a corridor), has pieces of giallo antico wall revetment and a restored section of paving of giallo antico and pavonazzetto set in a pattern of squares placed at 45° within larger, enclosing squares separated by strips containing lozenges, triangles, and small squares. Room 14, a passageway, was paved in large octagons of red, white, and black marbles with smaller ones in various colors. Room 16 (for oiling, an unctorium?) was revetted in part at least in white marble, and its floor pattern is preserved in the setting bed: circles were set in squares (0.60 meters) with strips between. The vaults of rooms 3 (a passageway) and 5 (a nymphaeum?) were painted, and in room 2 (a lavatory) coarse rosso antico paving tesserae were found.

The significance of these details lies in their sum. All interior surfaces of this brilliantly conceived building were decorated, many in varied and highly contrasting colors. Nothing of the structural surfaces seen today was visible, nothing at all. Just as no two rooms have the same shape, so no two were decorated in the same way: highly differentiated schemes and colors, lit in diverse fashions, dramatized the individual architectural

223 and grottoes of various sizes and types, bath buildings, ornamental pools, irrigation systems, and human and animal requirements were all accommodated; the used water discharged continuously through underground channels leading to the Aniene. Today an artesian well by the Scenic Canal and water electrically pumped from a source near the North Theatre serve the Villa's needs but produce a modest volume compared to that available in Hadrian's time. Then, the pressure, or head, required by jets and other dramatic effects, or by raised installations, was ensured both by the superior elevation of the incoming water supply and by the strategically located cisterns, as well as by efficient piping; the South-

see 13 ernmost Ruins aqueduct channel, for example, stood
224 some 24 meters higher up than the Scenic Canal surface and 35 meters higher than the Doric Temple platform (in theory, each 10 meters of height produces about 7 kilos of pressure). The generally descending nature of the terrain suggests that water-lifting devices, well documented elsewhere, were probably unnecessary.

Parts of the distribution system remain unknown, but solid evidence for the results survives throughout 225 the site. After crossing the East Valley, the main supply ran northwest, and as the density of construction increased with the fall of the ground, the ever expanding number of secondary branches and local pipelines created a largely subterranean pattern of deltafication; that the principal elements were probably in place early on has already been mentioned. The finished works were essential to Villa art and life and as elaborate as any Roman urban works.

Piranesi records (in his *Pianta* Commentary) forty-three installations, to which we can add another seventy-five or so. The total would presumably rise considerably if such unexcavated and unstudied features as terraces, the Upper Park, and the Northern and Southernmost Ruins were revealed in detail. In theory, the existing data can support a tentative typological breakdown, but the traditional categories present problems: the types merge sometimes one with another, some examples are outside the canon, and in a half-dozen large displays multiple elements are combined in ways

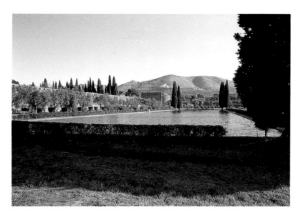

223 *East-West Terrace Pool (1983)*

224 *Scenic Canal, north end, detail (1987)*

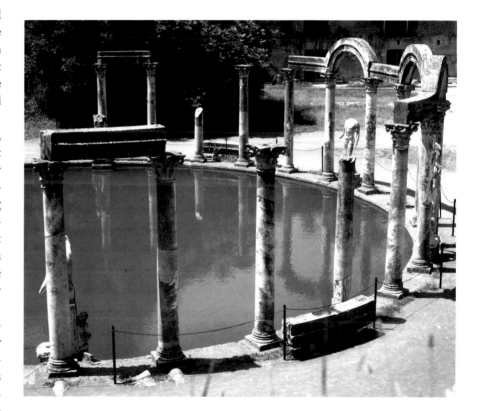

225 *High Ground, aqueduct*
(Penna no. 117)

rarely if ever seen elsewhere. Still, crude figures may be helpful. The Villa contained at least

12 large fountains, often called nymphaea (architecturally scenic and elaborate, each with several water elements and usually footed by wide basins or pools);

30 single fountains, not parts of the above (of various kinds, in chambers, courts, or niches, often with a single basin, spout, or jet or some combination thereof);

6 grottoes;

12 pools and basins;

7 channels;

6 bath complexes;

10 cisterns; and

35 lavatories.

The total of individual discharge points runs to at least three hundred for the first six categories alone. Aqueducts and drains are not included above; little is known about irrigation works or allocations for kitchens, barracks, stables, and the like.

In the grand, compound displays, water was a basic element of design, a generative artistic force, particularly when combined with architecture and sculpture. The Scenic Triclinium and Canal, where a deep grotto was combined with pools, water stairs, more pools, channels, and fountains, were described above. In the nymphaeum chamber of the Water Court, with its reverse-curve screen of columns, the four diagonal (single-spout?) fountains and the back-wall nymphaeum all focus on the vertical centerline of the whole composition, creating an intermittent ring of water, its hub marked by a centered pool or fountain flanked, just beyond transverse column screens, by a pair of pools or fountains. Six small, narrow spaces, set within the structural solids, were fitted with water; some were individual lavatories.

From just past the domical Court vestibule (with internal fountains) a shallow canal ran the length of the Court proper. Outside, abutting the Court's north corner, was the semidomed apsidal structure with its pool, all facing northeast, with all the marks of a nymphaeum, though restoration makes identification uncertain. It was also a belvedere, with a cantilevered balcony overlooking the East Valley similar to the one that once projected from the Residence Fountains northwest facade.

The back-wall nymphaeum, with its niches (alternately rectilinear and segmental), architectural framing, water stairs, and pool, is typical of the type, which is related to Roman stage design and found across the empire; it can be seen elsewhere at the Villa, for example, on axis with the Island Enclosure at the west end of the Fountain Court, and it compares readily with the Scenic Triclinium, the Residence triclinium, and in some degree the Small Baths northwest facade. As in many examples, the back-wall nymphaeum focuses on the space beyond it, binding the two together. The curve of the intermediating two-column screen is struck from the same centerpoint as that of the nymphaeum, and the podium-high niches (two line up radially with the columns) discharge water in obedience to this focal system down steep, curving steps into a broad segmental pool let into the pavement. The result is a forceful document of the increasing appearance, in imperial architec-

226

see 121, 123

see 114

see 27

see 43

227

ture, of cagelike spaces loosely defined by structure and given firm definition by the power of radial planning. The floor, walls, and piers throughout were sheathed with varied marbles, as were the nymphaeum niches, stairs, and pool; the main columns were white, the smaller nymphaeum ones colored. This decor set off the splash and sparkle of the water, whose main display appeared behind the column screen as the setting for a range of statues enframed in the traditional classical fashion.

At the Stadium Garden, by contrast, nearly the full repertory—a canal, pools, numerous spouts and jets, channels, cisterns, a grotto, and a theatre of water cascades and planting, thirty-odd features in all—lay within the long north-south enclosure. On the ground, however, this linear deployment was obscured by the north pavilion and its portico, another pavilion well to the south, and a large, shallow pool nearly filling the open square between them; transverse colonnades marked the three divisions. In general, the northern part was built first, then all of the southern structures and the central pool last. As a result, the Stadium was broken up into three nearly independent parts, unlike the traditional, quite open hippodrome gardens of Pliny or Domitian.

North water came in from the east, south from the southeast, where cisterns lay just above and behind the water theatre's rim; two more cisterns stood beside the southwest corner. The theatre, with eight wedge-shaped, stepped cascades placed between planting cavities also cut from the tufa and arranged in stepped sequences, was centered on a marble-lined grotto, with an internal spout, set at ground level. Channels ran around the top and bottom of the theatre, whose orchestra contained a semicircular pool with a jet (strong and high, as restored by the excavator) at its center. The cascades, once lined with white marble, are longer but less steep than the water stairs of, say, the Upper Park fountain wall or the Scenic Triclinium; by narrowing considerably as they descended, they somewhat increased water speed and depth. The lower semicircular channel continued northward, in two branches, close to the perimeter walls. At the opposite end of the Stadium, in the

228

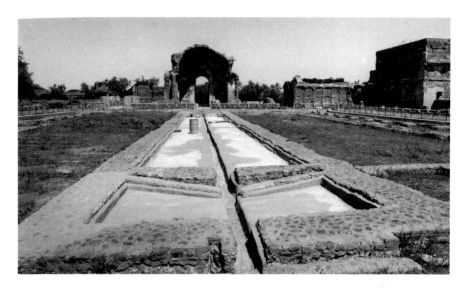

226 *Water Court, central channel, looking northwest (1985)*

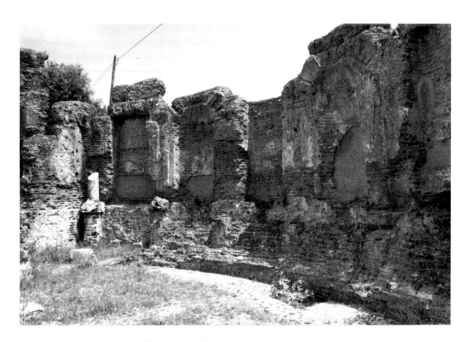

227 *Water Court, back wall of the main nymphaeum (1987)*

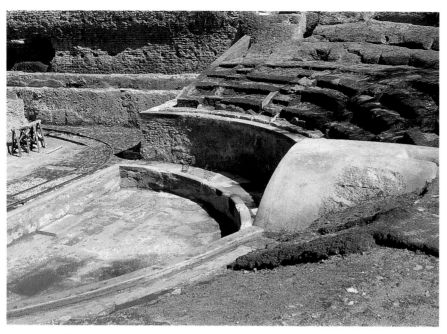

228 *Stadium Garden, curved
south end (1962)*

to keep cool for the emperor's comfort during the summer heat and presumably with a high evaporation rate. In reflecting the sky and the east-side facade it may have given a sense of expanded space to the corridor-like whole. Perhaps it had some ceremonial purpose or contained aquatic plants. To a degree, the pool and the adjoining Peristyle Pool Building suites suggest the somewhat similar relation between the sunken waterworks court of the Domus Augustana on the Palatine and its adjacent suites of rooms, but there the water flowed in a pattern of curving channels let into a solid masonry island itself set within a narrow rectilinear framing channel; there was no broad-surfaced pool.

The theatral principle appears also in the Residence Fountains, where stepped, semicircular terraces rose within a rectangular setting from a level space containing two fountain pools (later refashioned coarsely), beyond which a broad apsidal structure stands on axis with the theatre. The effect is that of a very large outdoor room, its volume defined chiefly by the two curving ends and readily gained from neighboring spaces. The details are obscure, but evidence survives of descending channels, and patches of blue paint can be seen on vertical wall fragments once parts of water-filled compartments. From a vaulted corridor running past the theatre's back wall it may have been possible to view the entire formal, axial composition.

At the Arcaded Triclinium, however, the various installations, though rationally disposed in plan, are relatively independent, presumably the result of the extensive changes made in the original building. Water washed over and down the unusual blocky form of the north fountain into its surrounding pool, cooling the air. Three fountains stood on the main structure's east-west axis, and curving water channels lay concentrically within the exedra walls in the manner of those of the Scenic Triclinium and the Stadium Garden theatre. In the southern exedra, two identical octagonal fountains, a little more than a meter high, rose from shallow octagonal pools outlined with vertical, white marble edging. At the Fountain Court the multiple waterworks, built at different times, are mostly independent of each other. The west nymphaeum is axially aligned with the

open area beyond the north pavilion, the canal, fed by spouts atop its border wall, was set between matching planting beds. Within the pavilion itself a fountainless square pool stood, presumably, below a corresponding roof opening, an *impluvium* below its *compluvium*. Crowding into each of the three central window openings along the sides of the pavilion was a seven-sided, single jet fountain. Twenty-two statue bases were found here, four in the south pavilion.

The central pool is something of a mystery because it nearly filled the open space and effectively blocked ready access to the north and south areas. Its western region was tailored to fit the existing wall configuration, minimizing passage space, and on the opposite side four large pedestals, set transversely, discouraged north-south traffic. Perhaps Hadrian and his people, toward the end of work on the Stadium Garden, set out to keep disparate activities north and south of the central pool largely separate, rerouting traffic through the chambers east of the pool (and also perhaps through those to the west). The basin was very shallow, just a thin sheet of water (over a splendid mosaic?), not easy

Island Enclosure, the 50-meter channel that connects the jet-centered octagonal pools follows the line of the long Court wall, and three distinctly different fountains between the Fountain Court East and the Portico Suite are placed at random. All of these were probably fed by way of an ingeniously designed chain of tanks and pipes set along the top of the Hall of the Cubicles northeast wall, where part of the system is preserved.

This review of major Villa water constellations illustrates the chief planning modes (centralized, theatral, linear, random), the repertory of basic design elements, and the various effects obtained from different combinations of those elements. Success lay in the effective and artistic administration both of the interval between outlet (spout, mouth, jet nozzle) and reception (basin, pool, channel, canal)—that is, of the water's visual, usually audible travel—and of its subsequent presentation, in many cases, in a comparatively still and level state. Texts, Campanian paintings, and remains at other sites suggest the presence, particularly in gardens and groves, of independent, freestanding single-spout fountains in addition to those still recognizable. Their visual mechanics were simple. A small jet rose from a basin, modest pool, or vase, or the water fell from a spout, more or less horizontally fixed, in a fairly short, graceful arc into a container below; with limited free travel, the water's shape decayed little in the air unless caught by a stiff breeze. Variety in design is recorded in the Scenic Canal crocodile, with the spout in its mouth, the flattened, miniature marble stadium basin (about 1.50 by 0.90 meters) in the Museo Didattico, and a square, altarlike fountain block standing at the east end of the Fountain Court.

Evidence for partly enclosed fountains, unlike the freestanding ones seen from restricted viewpoints, is comparatively thin. The single niche fountain was perhaps rare, though one of Republican date survives by the Residence Cryptoportico south corner, and the diagonally set Island Enclosure features may qualify. External single niches arouse interest, but without evidence for basins or other hydraulic necessities identification falters. Chamber fountains, in which the side of a room (or of a one-room building) opposite the

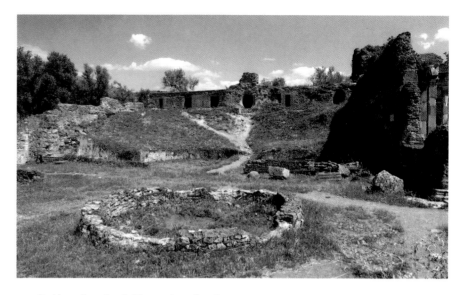

229 *Residence fountains, looking southeast (1987)*

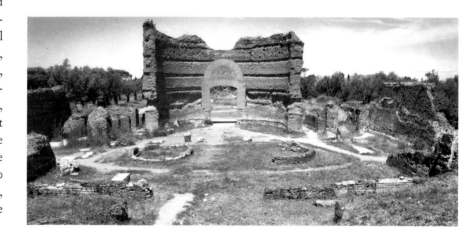

230 *Residence fountains, looking northwest (1987)*

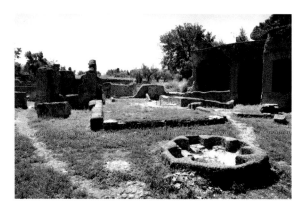

231 *Fountain Court, northeastern sector, looking southeast; fountains right foreground and left edge center (1987)*

232 *Nymphaeum and cistern beside the East Terrace curved wall (1987)*

single spout is usually left open, may have been more common. A Republican example, later altered and now wrecked, but apparently flanked by two smaller, apsidal chambers, stood about 80 meters due south of the Water Court, and a Hadrianic example, also badly decomposed, rose just behind the Upper Park fountain wall. Three fountains lie between the Residence triclinium and Fountains, and it may be that a number of other Villa rooms were fitted with fountains: in room 5 of the Smaller Baths, for example, or the Central Vestibule or the Scenic Triclinium side pavilions. Grottoes, necessary to any luxury villa, resemble chamber fountains, but because they were imitation caves, usually with rustic decor and a specific mnemonic and associative presence, they form a separate category. By Hadrian's day they had become quite unlike nature, as Juvenal says.

The Villa's grand scenic nymphaea rhythmically combine fountain and sculpture niches of different shapes in elaborate architectural settings. Their principal walls, usually curved but sometimes straight, might be flanked by subordinate chambers, and the plan center line was usually emphasized by an oversized niche; symmetry was absolute. This can be seen in the Scenic Triclinium and the back wall of the Water Court, though the nymphaeumlike qualities of the Triclinium are partly subordinated to other objectives. Niches could contain spouts or cascades, and the full panoply of classical enframement would have been worked around niches, basins, subordinate chambers, and sustaining walls. Artistic force came from the energetic, even turbulent presence of the several waters as they discharged from a high, marble-clad masonry wall, resembling that of a palace hall or theatre stage building, and then fell into a common basin or channel. Little in Roman imperial design so effectively symbolized the age.

A subdued example can be seen in outline on the facade of the cistern that hugs the East Terrace curving north wall (the upper story is modern). Two arched niches flank a taller central one; all contained spouts. Pilasters (perhaps columnar responds) apparently rose beside the central niche, and projecting consoles supported columns beside the others. The upper architecture is lost, but remains of a low, curving basin wall

232

survive in front of the facade. From the Doric Temple, which the nymphaeum faced across the Terrace, the water would seem to have been forced from the looming mass behind.

More elaborate was the semicircular Residence triclinium, complete with spouts and channels, and yet more so the nymphaeum (recently under excavation) situated on high ground 50 meters southeast of the Scenic Triclinium. Penna shows a structure, facing northwest, about 20 meters wide, of rectangular chambers flanking a deeper, broad semicircle centered on an arched niche set back in a rectangular apsidal form. Doorways apparently flanked the rectangle's forward walls, and then along each side of the curve, as it came forward, were two niches. The central niche and the westernmost one were fountains as the usual robbing holes recorded in Penna's view show; the easternmost niche, by Penna's time lost, presumably contained a symmetrical fountain. Either a second story or a form of attic rose from substantial structural supports; no marble architectural members appear, but beyond doubt they once articulated, together with sculpture, the entire composition. Nicely sited at the end of the Upper Park wall, looking out over the falling ground, the building epitomizes the Roman scenic nymphaeum. At the same time, the Villa's major pieces owe much to the results of past experience, surviving at the site not only in the Residence Cryptoportico fountain but also in the Residence Quadrangle fountain, later reworked, and the complex under the Doric Temple, at East Valley level (recently restored).

In its present state, the evidence suggests that in full operation the system included at least three-quarters of a hectare (about 1.5 acres) of open water. That some pools contained fish seems inevitable because of the abundant literary and archaeological evidence, though no wide-mouth pots, set horizontally into the sides of fishpools below water level and common in Roman times, seem to have survived at the Villa; perhaps some were covered up during restoration. The thought occurs that the Bog, with its Hadrianic drain, may have been the remains of an artificial lake, like Nero's in Rome but less grand; judging from the texts, streams would

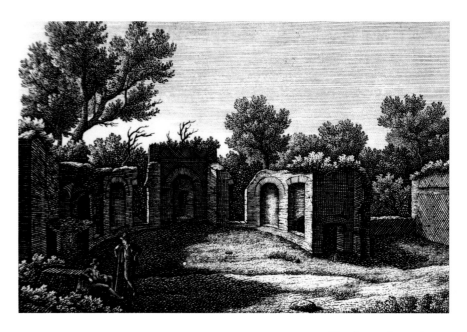

233 *Nymphaeum above and southeast of the Scenic Triclinium (Penna no. 102)*

not have been out of place within the Villa. Cool water entering the site was kept so in underground reservoirs and above ground in cisterns whose thick walls and vaults were not for stability alone. Open water provided or suggested cooler air and opportunities for swimming, and fountains set all across the site made refreshing locations easy to find. And although the specifics of planting beside pools and canals and in gardens are little known, the powerful cooling potential of turf and greenery should not be overlooked.

The Villa's elaborate, varied water regime suggests tentative observations, not about Roman water management, a familiar topic, but about the Roman use of water in motion to vitalize architecture (to a degree rarely if ever seen since) and enhance the landscape while tempering the air. Water was deployed and shaped not only as a functional necessity but also as an artistic medium in its own right, the equal, in the major fountain displays, of the architecture and sculpture that enframed and embellished it. Water in motion, with its attendant range of familiar, reassuring sounds and lightstruck corruscations, is a palpable thing, stimulating sensations fixed media cannot. Waterworks were

indispensable to the Arcadian leisure country estates provided, but the prodigious quantity of water that spent itself across the Villa was also an integral part of the Villa's statement about the sophisticated, knowing Greco-Roman culture of the age. Water, tamed and then deployed at will, both entertaining and symbolic, sustained Villa life in more ways than one.

Efficient irrigation (including fountain run-off) and above-ground water delivery were ensured by terrain that also dictated the basic structure of Villa landscaping; the natural contours and their substantial alteration have already been pointed out. Few details are visible, but the texts, particularly Pliny's, and the pictorial and archaeological evidence from Pompeii and other Campanian sites, are quite comprehensive and give a good idea, within limits, of the kind of work done by Villa designers and gardeners.

Pliny, an intelligent and logical if complacent man, wrote the description of his Laurentine villa about the year 100, then the one of his Tifernum villa five or six years later. Small as his places were compared to Hadrian's Tivoli creation, and relatively more compact, they foreshadow it substantially. Half of the first letter deals with the setting and the grounds, somewhat less of the second, and both include much detail. Pliny is alert to sun, shade, and wind, to heat and cold, and to views from windows, colonnades, and towers, and at one point describes a view from a seaside dining room back across an inner hall, a colonnaded courtyard, and the villa entrance to the distant woods and mountains. In another dining room the view from one side is of an abutting terrace, the meadow beside it, and open country beyond, while from a different position he can see an adjacent part of the terrace and the treetops rising above the wall of his elaborately planted stadium garden some distance away. These and similar passages emphasize the care taken with vistas framed by architecture; the desire to bring architecture and nature together is strong. But Pliny is aware that the effects his grounds make were as deliberately contrived as the luxurious provisions for his indoor comfort (he is proud of both): at one point he speaks of an area of imitation rusticity within his stadium garden.

There are meadows, fields, and perhaps lawns and grass; hedges and pergolas; cypresses, plane trees (sycamores), and groves; laurel and other shrubs; vines (both ivy and grape) and a kitchen garden with herbs; among the other fruits figs and mulberries; and roses and violets. Part at least of the hedges were of box, as was the topiary, some of it scattered about the stadium garden and cut into the various shapes and letters described earlier. And of course there were fountains, streams whose velocities and courses were controlled by valves, and hydraulic conceits. At one end of the stadium garden a vine trained over slender columns shaded a stibadium from which water gushed "as if pressed out by the weight of the diners." Elsewhere diminutive fountains flanked marble seats.

Campanian pictorial and archaeological evidence bears all this out and more. To Pliny's fruits it adds lemons, dates, pomegranates, cherries, plums, pears, crab apples, quinces, apricots, wild strawberries, citrons, peaches, and various kinds of nuts; to his flowers and flowering shrubs poppies, daisies, lilies, bachelor's buttons, irises, myrtle, viburnum, and oleander, among others. Excavation reveals irrigation by channels and other methods, as well as many terra-cotta planting pots. Beds and their edging, bedding and planting patterns, and some garden tools and an 8-meter ladder survive in recognizable states. Orchards and vineyards, grafting and pollarding (discussed in agricultural texts before Pliny's time) are well in evidence, as are some indications of espaliering, perhaps of lemon trees and roses. Of great importance are the villa grounds seen so often in the landscape paintings fancied by Roman artists and their clients. They range from the ideal or wishful, often with unmistakable religious overtones, to the literal, and are as important to villa landscape studies as the relevant ancient texts.

The physical evidence recovered at the Villa in recent years has already been described: planting pots on both sides of the Scenic Canal, beds and cavities in the Stadium Garden, the small, centered garden of the Island Enclosure, the large tree-planting pits cut from the tufa underlying the Water Court. What was planted is thus far unknown. Our discussion of Villa gardens

and landscape is necessarily derived from the possibilities inherent in terrain, terracing, and outdoor spaces defined by neighboring buildings and by courtyards. Above all, it rests on traditions explicit in ancient evidence of the kinds just sampled. Generalized deductions cannot give specific form to the Villa grounds, but they may help to restore, in the mind's eye, something of that overriding artistic unity the site lost long ago.

Of the common small plants, grass is the hardest to pin down. *Gramen*, or grass, is a fairly common word in pastoral literature, but literal, descriptive authors, Pliny in particular, use *herba* (small plants, including grasses and herbs). Trimmed lawns are possible but unlikely. *Pratum* (a meadow) and its diminutive *pratulum* are used, becoming lawns in some translations, but the paintings reveal nothing of them and repeatedly show grasses rising at random, unkempt. Trimming and shaping were probably reserved for plant management, hedges, and topiary, and meadows small or large seem to have been the nearest things to lawns. Mossy ground is mentioned fairly often.

Together with vines and fruit trees, flowers took center stage. A highly developed flower culture flourished in a favorable climate and was nourished by abundant water supplies. Luxury villas were literally florid, and evidence such as that for hothouses (Martial's Entellus has one made of glass), perforated setting-out pots (allowing roots to breathe), and the archaeologists' recovery of clever watering techniques all indicate advanced working methods. But there seems to be no sign in the paintings, usually so detailed, of cut flowers, of a bouquet in a vase. Flowers apparently served two purposes only, perfumes aside: as garden or potted color and for garlands. Making garlands was big business at Pompeii, as it must have been elsewhere, for the Romans wove and hung flowered and sometimes fruited swags for all manner of private and public purposes. The Villa cannot have lacked them, and they may have been everyday furnishings, regularly replaced when the emperor was in residence.

Knowledge of kitchen and vegetable gardens is expanded by Roman cookbooks, particularly the one that goes under the name of Apicius, and by menus writers

234

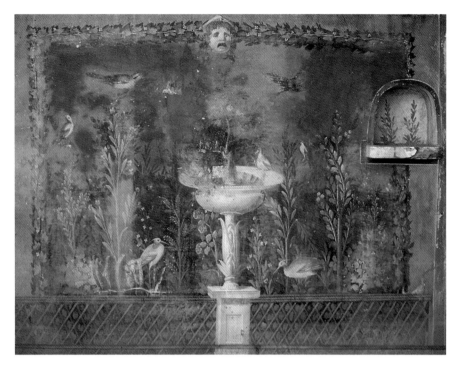

234 *Pompeii, House of Venus Marina, garden painting (1959)*

record. The list of fruits and vegetables known to the Romans is long, and many herbs were grown; there were however no potatoes, tomatoes, bananas, oranges, or many of the berries now common; most spices came from beyond the frontiers. The West Valley and the vicinity of the Southernmost Ruins are likely places for Villa kitchen gardens, which would presumably have been for the use of the emperor and his circle, the needs of the large support staffs being supplied chiefly from the outside. For vineyards and orchards the evidence is detailed; propagation and care were highly developed. The Villa site is not good for viticulture, but orchards, both functional and ornamental (particularly of lemons), are good Villa candidates.

Ivy was ubiquitous, trellised for shade and ornament, garlanded live from tree to tree, trained to beehive-shaped mounds. Cicero speaks of a landscape gardener who has "enveloped everything in ivy" at a villa where in the garden the Greek statues "seem to be in the same business [as the topiarius], advertising their ivy." Acan-

thus, with its shiny, spiky leaves of dark green, was popular, as were a variety of shrubs both normal and dwarf. Box hedges outlined major planning lines.

Villa soils, only now being studied, were different from those in the neighborhood of Vesuvius, whence so much garden evidence comes and from whose rich soil up to four crops a year might be brought in, partly because of the granules of water-retaining pumice spread through it. Villa gardening practice, however, was much like that of the south, with practical improvements. Cost was presumably not a concern, and the water supply was more reliable and more copious because of efficient delivery and drainage (part of the natural supply and runoff routes were deflected or destroyed during massive earth-moving and heavy construction for the huge, walled-up terraces). Practical matters of planting, bedding, transplanting, applying humus, and other procedures, refined over the centuries, were directed by gardeners, experts by any measure; Hadrian would enroll the best.

A superior water supply system did not eliminate hand watering. Then as now a wide range of plants grew in terracotta pots of as many sizes as exist today. Because even the largest ones—and they could be very large, suitable for oversized shrubs and small trees—were portable, the gardeners or their master could create new effects at will, indoors or out, seasonally or according to the time of day or the emperor's entertainments, with a few pots or with masses of them; tree-moving brings the Versailles contrivances to mind. Portability also meant that color palettes could easily be altered and that the relations of scale within, say, a courtyard, might be manipulated at will. And pots with brightly colored blooms, placed toward one side of a windowsill or by the edge of a small pool, or the first crocuses, in small pots beside a south-facing wall, are satisfying sights and doubtless always have been.

Gardens, shrubs, coppices, and groves stood upon the grand terraces and, presumably, in the Upper Park. The need to mark lines of view, including approaches to garden structures and waterworks, presupposes herm-guarded allées. Courtyard spaces, as in the Residence and its adjacent Quadrangle, on the strength of evi-

dence elsewhere (again, principally in Campania), contained gardens. The nearly square plot lying between the Arcaded Triclinium and the Smaller Baths was a garden: the ground is flat, part of a fourth, west wall remains, and the niched north wall of the Baths falls nicely into the role of garden backdrop. The Knidian gardens described by "Lucian" arouse interest in the area beside and near the Doric Temple, and the comparatively isolated enclave of the Southern Range cannot have lacked impressive planting, particularly in its large peristyle court. Thin sheets of marble, set edge up, outlined small beds; a bed of curving plan at Pompeii is both edged and divided internally by files of single bricks. Low, thin marble walls—sometimes marble-faced concrete walls, as in the Stadium Garden north area—enclosed large beds. see 100

Fences appear repeatedly in the paintings, all apparently of wood and often with diamond-pattern latticework. Seats, including those in unwalled exedras, were indispensable, as were waterworks, sundials, and, of course, sculpture. Enclosed pavilions appear in paintings, and light gazebolike structures of wood can be postulated. Judging from the paintings and the significance of views and viewing, towers (perhaps only low ones), or possibly raised platforms, were a necessity. Obelisks, planting pots and tubs, and, presumably, urns stood about; mazes are possible. Herms, altars, and small shrines shouldn't be ruled out, given the religious or mythological basis of the pastoral tradition such places celebrated. And there had to be colonnades and arbors, and bridges over streams and channels, as well as aviaries and contrived habitats for other species.

The largest landscape features were meadows and groves, natural contrasts to the gardens with their varied contents and relatively small scale. Pliny refers to his groves and meadows in the middle distance, between his gardens and the land well beyond his property. If the proposal that buildings near the Southernmost Ruins ambulatory were for hunting parties is correct, then that area and the land further south would have been well grown over, their paths informal and narrow. In general, the built-up parts of the Villa contained the more formal, precise planting, the outer parts

apparently the more natural and unassisted, with the incidence of trees in natural patterns apparently increasing to the south. If this is correct, the Villa combined a kind of quasi-urban center with an ample stretch of country beyond, one that could be easily reached and where an ambulatory looked out over undulating, comparatively untended ground, a place perhaps to ride and hunt.

Some viewing places are obvious, among them the Belvederes, elevated terrace rims, and the heights of the Fountain Court West and South Theatre. Other towers and elevated platforms may have stood elsewhere, and the Arcaded Triclinium roof terrace cannot have been unique. Balconies faced the Residence northeast court and the middle reaches of the East Valley,

and overlooked the northern half of the Scenic Canal area; regularly spaced lines of heavy-duty consoles (at upper-story levels) or of the deep wall cavities that held and stabilized them, may signal others. Axial views within buildings or out from them (those of the Island Enclosure, Stadium Garden, or Scenic Triclinium, for example) are common. Axial landscape views, in contrast, are hard to trace, but the ingrained Roman habit of focusing attention on significant goals by means of carefully contrived axes, as at the Park Grotto, ensures their presence. Some immediate encounters with major views can be found: arriving at the far edge of the East-West Terrace, for example, or the revelation of the East Valley upon leaving the Water Court. To see, suddenly, from the top of the Scenic Triclinium east stairs, the

235 *View northeast from the West Belvedere; Tivoli at upper right (1987)*

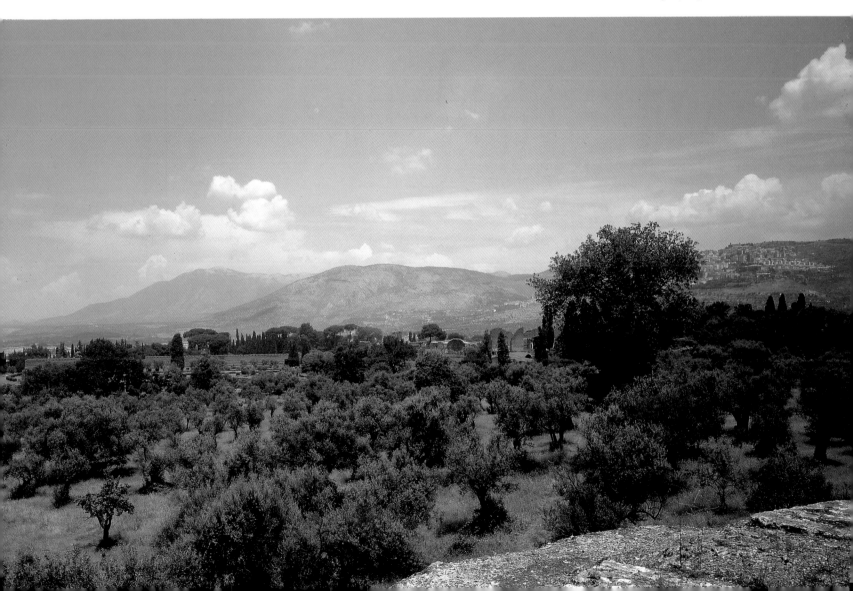

large High Ground nymphaeum rising up in the middle distance may have been a major Villa prospect. As with architecture and art, no overriding pattern or style was imposed on the Villa landscape; that alone invalidates the comparisons, made from time to time, of the Villa with Versailles and other grand estates. The Villa's complex spatiality, the great variety of its features and effects, provided multiple orientations and experiences. Its master plan is not a diagram but a concept, born of High Empire culture, that Hadrian expressed in art.

Although that concept inevitably included elements of the traditional idyllic landscape often seen in Roman wall painting, it may be a mistake, in trying to make up for the lack of evidence at the Villa, to rely chiefly on the poetic mythology of a simpler, carefree time, by Hadrian's day a stock in trade perhaps somewhat stale. The Villa is too large and too diversified for one landscape principle to have been applied throughout, and the alliance of customary art and architecture across the site with original and highly unusual works suggests comparable conjunctions in the landscape. In other words, the pastoral condition was continued but infused with original themes. Cicero, in a passage about the subject in a letter to his collaborator Atticus written in 61 B.C., asks for a description of Atticus's elaborate concoction celebrating Amalthea, a nurse of Zeus: "I wish you to write to me about your Amalthaeum, of its decoration and the [imaginary] landscape you have devised [*toposthesia*]." Cicero is thinking of the artistic conception of a topos, the manner of its interpretation and rendering into visible form. It follows that sophisticated patrons, or their artists, conceived solutions more or less at will; witness Sperlonga, or the imagery of Augustus's Forum, or the presentation of Titus's victory on his arch. At the Villa the landscape incorporated complex tableaux, executed as Hadrian wished. The Scenic Canal and Triclinium alone prove this, and if our suggestions about the Underground Galleries and South Theatre have merit, then they, too, give evidence of the Villa's compounding of the history of the art of allusion with inspiration.

The lack of comparable physical evidence contrasts strongly with the abundance of pastoral paintings and the substantial ancient literature, examined and argued over for centuries. Nero's Domus Aurea helps, with its lake, flocks, and factitious villages, but of the landscapes themselves nothing remains. At this point it is useful to recall that the Villa was Hadrian's, that his taste and experience dictated its themes and creations, and that he was the begetter of the Pantheon and other astonishing works. Much at the Villa is predictable, but much is not because of Hadrian's creative bent and his curiosity about the world. Unfortunately, plans and photographs reveal almost nothing of his landscape art, of its animating, allusive presence.

VII

The Villa in Use

Approximately nine hundred Villa rooms and corridors are known; two-thirds are well enough preserved to be recognizable and the rest were recorded in the past, chiefly by Piranesi. Whatever the original number, the nine hundred alone imply heavy staff responsibilities, and these, together with the setting and nature of Villa life, are the subjects here. Details of upper-class Roman daily activity and of the make-up and duties of an imperial household are available elsewhere; our objects are to suggest Villa requirements and something of the Villa's original milieu, and to comment on its meaning.

STAFF AND SERVICES

Inscriptions and texts refer to staff titles and duties. No numbers exist either for particular service categories or for the Villa population as a whole, but the Villa's size and complexity and the emperor's civil and household needs required a large service establishment run by specialists. Information about such operations can be gleaned from Roman authors and from buildings at the Villa and elsewhere, and factors common to the management of great estates are relevant. Only a broad and somewhat lopsided outline is possible, but from it emerges an impression of the work involved.

The texts suggest that Hadrian cared little for fuss

and might appear unguarded in public, in the forum or at the baths, for example, so Villa security could have been minimal; the only apparently serious threat to his rule took place at the beginning of his reign, and how serious it was is in doubt. But for a senior security officer, a proper Villa force when Hadrian was in residence would consist at least of a detachment at the junction of the Villa entrance road with the Via Tiburtina and others at the main gate and southern entry point, plus a perimeter line of men placed either at regular intervals or in groups at key points, or perhaps in some combination of both. Ten-meter intervals over a perimeter of about 5 kilometers (taken from the Bog to the Southernmost Ruins and from one Valley to the other) would require 500 men, and the several detachments say 80 more, in all somewhat more than one cohort (480 men). With rotating rosters, headquarters duty, and the like, a minimum ideal force of two cohorts, drawn from the nine-cohort praetorian garrison in Rome, is not improbable.

Day labor, if needed, might be recruited locally. The scale of ordinary provisioning (of slaves, general-purpose workmen, menials) is suggested by the basic army food ration of just under 1.5 kilos of wheat a day per man, or nearly 20 metric tons a month for a cohort; this was augmented by salt, oil, and wine and other essentials, by vegetables, meat, and fish when possible. Villa laborers and lesser functionaries would presumably have been as well fed as soldiers. As for horses, the nearly 700 of a first-class cavalry regiment (an *ala*) of 500 men needed 100 metric tons of hay and grain per month. Hadrian's hunters would have been pampered, and upper echelon officials and servants could expect a fine table.

Behind these bare figures lie the shadowy realms of procurement, payment, storage, and distribution. Ample evidence survives elsewhere of the kinds of record keeping such activities generated. Villa inscriptions record two bookkeepers (*tabularii*) and another a recorder or archivist (a *commentariensis,* specialty unknown). Many laborers and specialists (these with one or more clerks each) must be assumed, for all the food, fodder and other daily needs could not have

been grown or made at the site and a high quality of supply services and maintenance presupposes its own management staff. Some comparative material may be useful. The Boboli Garden (13 hectares) requires forty-odd gardeners, and at Levens Hall, south of Kendal in Cumbria, the immense topiary displays and the 14.5 kilometers of hedges enclosing them are trimmed each autumn by three specialists working for three months. At Chatsworth, the vast estate of the dukes of Devonshire, a staff of 170 keeps the place up and serves the family; at the Getty Museum in Malibu (26 hectares), two-thirds of the staff consists of gardeners and security people. Twelve gardeners toil at the Vatican (44 hectares, of which 12 are irrigated for gardens), and 12 work full-time at Dumbarton Oaks (4 hectares). These figures, taken with the Villa's size (about 120 hectares), of which a third to a half was given over to gardens and a landscape carefully maintained, suggest the scale of the Villa's staffing needs.

Money matters—construction costs, payroll, and other expenses—are unrecoverable. The hoard said to have been found in 1881 (or 1887) "hidden in a room under stairs" of the Fountain Court West (2,672 coins of silver alloy all inscribed SENATUS P. Q. R. ROMA CAPUT MUNDI) sounds promising, but it can't be traced and the inscription is unknown to specialists. Non-Villa figures suggest part of the range of Hadrian's costs. He promised 2 million sesterces for the Forum Baths at Ostia, finished by Antoninus Pius, paid about 22 sesterces a foot for a good public road, and 110,000 sesterces for gold and silver statues for Lanuvium. Fronto, it will be recalled, was given an estimate of 300,000 for an up-to-date bath building; Pliny gave a million to his native Como for a library. Extravagant private mausoleums might cost as much as 500,000, and it was not uncommon to spend 50,000–100,000 on them. If the forty major Villa buildings cost, on average and including fittings and decor, 500,000 each, a conservative figure, the total comes to 20 million, but even if that figure is tripled to include all other construction, landscaping, and art and decor expenses, the sum seems too little (and in any event excludes the incalculable cost of luxury items such as the sources describe in other settings

and that have been found elsewhere). Lucullus in the early 60s B.C. had paid 10 million for a villa at Misenum, and later on Pliny the Elder, writing in the 70s, speaks of a villa worth three times that, contents included.

Both slaves and freedmen were part of any Roman grandee's extended family. By the second century the slave supply had shrunk; highly intelligent specialist slaves were greatly prized and could be very expensive, costing 100,000 sesterces and more. Hadrian improved the lot of slaves not only by prohibiting castration but also by closing the slave prisons and reducing appreciably the authority of their owners, once absolute, over their human chattels, a policy his successor strengthened. House slaves usually fared better than field hands or miners (whose lot could be hideous) and were more often manumitted; some freedmen became wealthy and powerful. Nothing at the Villa proves absolutely that slaves were there, though it is hardly possible that there were none; and although Hadrian, unlike his predecessors, did not use freedmen much for civil purposes, they are natural candidates for Villa management and senior household responsibilities. For slaves or for free labor, the Service Quarters, with their layered repetition of some two hundred rooms holding at least three or four persons each, housed a huge work force in spaces more airy and spacious than some *columbaria*-like earlier structures, Horace's "narrow cells." A similar scheme, but with larger rooms, exists at the Central Service Building, though there the unlighted, relatively airless back rooms are suitable more for storage than for human habitation. Whether for people or goods, both of these large buildings show that methodical Roman repetition of identical or nearly identical volumes seen so frequently elsewhere.

Hadrian's desire to have service staff properly cared for may be demonstrated elsewhere than at the Service Quarters. The Larger Baths have been thought a service staff facility, in large part because of the underground connection between them and the southern extremity of the Quarters (though this may have been provided for the large number of attendants and technicians the Baths required). But if the suggestion is correct—and the urban size (about 3,400 square meters) and character

of the Baths makes it attractive—then Villa labor and junior staff bathed and exercised in surroundings as up-to-date and luxurious as any at the Villa; on this reading the Smaller Baths would be for senior staff and visitors. The North Theatre (larger than the one to the south), on low ground and well away from the Residence, is a likely candidate for staff and all-Villa entertainment (the town of Tivoli, a steep 4 kilometers away, had an amphitheatre). Roman devotion to baths and festivals was accommodated at the Villa much as it was in a small city or town.

Baths sum up the complexity of Villa services. Wood had to be cut and delivered to what must have been sizable stockpiles: at Misenum an endowment in perpetuity supplied four hundred cartloads of wood per year for the public baths. Fires had to be laid, lit, tended, and raked out. In addition to ordinary janitorial work and maintenance, the sophisticated plumbing, water heating apparatus, and air circulation systems had to be kept in good working order. Oil (preferably warmed), exercise equipment, and masseurs and perhaps barbers were provided, as were such personal items as towels, strigils, sponges, and the services of those who oiled and scraped one's body. Doorkeepers opened and closed the premises, looked after the waterclock, and called out the hours; attendants staffed the dressing rooms and lavatories. It may have required sixty to eighty people to serve the Larger Baths, which were surely open more than the two hours usually cited for Roman public bathing, the eighth and ninth (1:15–3:45 in midsummer, 12:45–2:15 in midwinter), given the particular rhythms of Villa life and the need to provide numerous services continuously, on into the night.

Staffs of specialists and servants managed all primary Villa activities, such as riding and hunting, dining and banqueting, looking after guests, entertainment and performances, Villa administration, and the emperor's civil and household organizations. Locations for the elaborate dinner parties to which Hadrian was devoted are evident, but other than the possibilities inherent in the subterranean complex just north of the Southern Hall, where are the imperial kitchens? It is an oddity of Roman archaeology that preparation areas for the

banquets ancient writers so often refer to or describe have apparently never been securely identified. Serving a grand dinner to many guests is not only a culinary but a management art, and the few Villa kitchens thus far identified are small cooking areas in utilitarian buildings; most of those found at Pompeii and Ostia are equally modest. It may be that modern ideas about kitchens get in the way, that too much is expected; and it is true that Roman cooking was often done on grills over the simplest of stoves, sometimes outdoors. But a great hotel kitchen today, all equipment aside, shows how many chefs, assistants, lines of assembly, and storage and preparation areas are needed to serve up a large banquet, requirements that must in some way and to some degree have been met at the Villa. When Seneca says that cooks brought food out to the diners, he may refer to steam-table trolleys; the passage shows that the cooks have come from another place, where their creations were prepared.

From these scattered data and possibilities a sense emerges of the elaborateness and scale of Villa staffing, of Hadrian and Sabina served as few have ever been, and of the orderliness of the entire service machinery (the Villa seems to have been an unmilitary place, but its organization by hierarchies of authority and subdivisions of specialties has a military flavor). It was all at the service of the emperor's personal and civil needs, a complex structure requiring little oversight, able to accommodate any schedule or program Hadrian might prefer.

LIVING AT THE VILLA

All his life Hadrian was surrounded by people. From the time he went into the army, in 94 or 95, he was assigned to well-ordered institutional units, first in minor roles but soon as a commander (of ever larger organizations), becoming governor of Syria before his accession in 117. During this ascent, the number of people who wanted something from him increased steadily, and much of Hadrian's responsibility as emperor lay in acting on unceasing requests for his aid or approval and for legal decisions and action on matters large and small;

in an important sense, government was shaped by petitioners. When he traveled with a large retinue, as on the Nile trip of 130, preparations began more than a year before. One is reminded of the empress Catherine's Volga trip of 1767, with its entourage of almost two thousand, and of her Tauride tour twenty years later (6,000 kilometers in six months), which required two hundred carriages. Advance preparations rivaled Hadrian's. Continuous relays of couriers kept the empress in touch with Saint Petersburg and other centers, and she worked most days for several hours, on her river galley or in her traveling coach, and at stopping points, on correspondence of all kinds as well as administrative and legal papers. She traveled with her household servants and civil staff, guardsmen, the court, the waiting couriers, members of the Saint Petersburg diplomatic corps and, on the Tauride tour, even the emperor Joseph II. In its essentials Catherine's official life resembled Hadrian's: wherever she was serious work had to be done, so leisure was rarely prolonged and she lived at the center of a swarm of servitors and courtiers, agents and officials.

Hadrian's life was just as full but somewhat less formal, largely free of the stifling protocol and courtiers' intrigues of later times. If the literary tradition is correct, he was approachable and democratic and could be witty and sometimes charming; a certain informality at the Villa, natural to country life, can safely be inferred. Social occasions often centered on serious conversation, when he might be waspish and sarcastic. Much time would be spent on planning the Villa and selecting its contents—he wasn't like Cicero, willing to take whatever Atticus sent—and the belief that he painted, drew, and modeled seems well founded; a Villa studio and a retreat for study and writing would be needed. But he had to combine leisure with work, and the excellent memory, appetite for detail, and knowledge of administrative matters the tradition also records are amply confirmed by the extensive and more specific testimony of inscriptions and other nonliterary evidence.

This mixture of leisure and work is reflected in the Villa plan: buildings for work and for at least some ad-

ministrative personnel are in or beside the Residence, the central core of the vast establishment. They include the Library and its adjacent basilica, the Ceremonial Precinct, various chambers in and next to the Residence, and perhaps the Hall of the Cubicles. These buildings belong to the early years, which suggests both that from the beginning Hadrian expected to work at the Villa and that when not traveling he used it often. He and the empress might sleep in the Southern Range or elsewhere, their personal servants perambulating accordingly—Pliny had at least sixteen sleeping rooms at his Laurentine villa—but their primary quarters were in the Residence. These were not secluded, however; privacy in the modern sense was unknown to Roman aristocrats (and the parvenus who imitated them), and their grand houses were thronged with people of all classes. The west-corner Residence suite, with running water in the central room, the two symmetrical bedrooms each with an anteroom (the traditional Roman equality of space for husband and wife), and its two single-person lavatories connecting directly with the sleeping rooms, was hardly an isolated wing of the kind so often found in mansions and palaces in later times. Silence, it goes without saying, could be obtained with a word or gesture.

If the literary sources report Hadrian's private life accurately, rest and contemplation took second place at the Villa to serious and prolonged exercise and discussion, frequently in the company of his inner circle and friends (the much-prized peace and tranquility Pliny and others find at their country estates were not given over to idleness and solitude, for except for study their days were much taken up with exercise and the company of friends). The sources repeatedly emphasize Hadrian's physical activities, his strength and his experience of harsh conditions. Only his love of banquets—which must be taken to include the inevitable debates as well as the food—and serious attachment to the arts get as much attention. These same themes are emphasized in the Villa's planning, buildings, and works of art, to which the necessary service and official structures are clearly subordinated save in the Residence area. So the Villa is in part a response to the

236

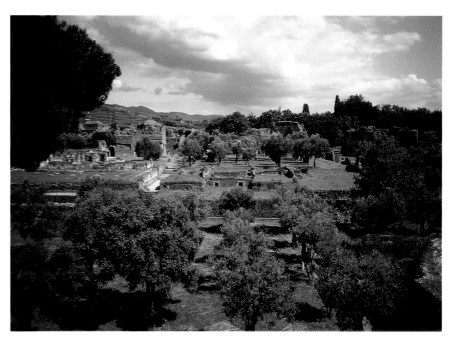

236 *View of the Residence from the Fountain Court West, looking southeast (1992)*

traditional country preoccupations of Roman patricians of the empire, shaped on a huge scale to accommodate fully Hadrian's particular passions.

"He rode and walked a great deal and always kept himself in training"—so the HA. Dio adds that "he hunted as often as possible" and was very skillful at it though seriously injured more than once. Hadrian was devoted to his mounts and dogs; in southern Gaul he built a tomb for a favorite hunter and placed an inscribed stone on it. He selected men known for their strength and daring for his hunting teams, and in Bithynia he founded a town and called it Hadrian's Hunts (Hadrianotherae) to commemorate a successful bear hunt there. Pliny hunted from his villas to stay in condition, and Hadrian would do the same and would work out at the baths and swim there and elsewhere. The habits of a lifetime were continued at the Villa, and the opinion, long held, that Villa land stretched far to the south from the Southernmost Ruins, would be justified if Hadrian rode and hunted there.

The HA line just quoted precedes some sentences about hunting that conclude with the remark that "he

237

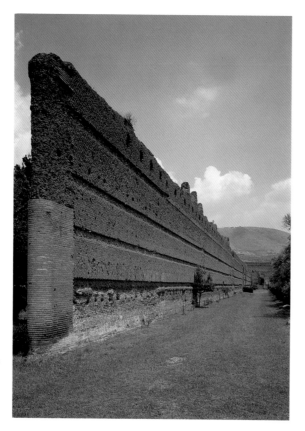

237 *Ambulatory Wall, south side looking east (1987)*

the amici and guests. Gift-giving, in which Hadrian is said to have "surpassed all rulers," was expected. He was a good eater, much attracted to food, and in his youth at least a lover of wine, as he himself seems to have said. Since he greatly enjoyed music and may have played an instrument, concerts may be inferred; they are known elsewhere. The mention of poets brings Juvenal to mind because he commended Hadrian's patronage to his fellow artists, implying that the emperor was the only worthwhile patron there was; did he read his biting words before Caesar? Performers could use the transverse space just in front of the Scenic Triclinium stibadium and the courtyard facing the Residence triclinium, but perhaps the HA passage refers to theatre performances given before or after dining. Readings, recitations, and discussions of literary and grammatical questions were the norm; perhaps demonstrations of popular, elaborate mnemonic systems were given. The tenth hour (3:45 P.M. in summer, 2:15 P.M. in winter) was the traditional time for dinner, but this was probably not insisted on at the Villa; later dinner parties were common elsewhere. The wide choice of banquet locations suggests that some were named, like Lucullus's Apollo, his room or rooms for the most extravagant meals. Whether Hadrian employed a master of pleasures, as some other emperors did, is unknown. The management of a major banquet, on the emperor's birthday (January 24; Sabina's is lost) or for a major festival, with scores or even a hundred diners, required careful planning and close supervision. At such times the ubiquitous service corridors and passageways would be crowded indeed. Hadrian is said to have made sure that all diners got the same food.

He is also said to have had opinions on all subjects and to have tormented specialists with endless questions; he was intelligent and well educated and studied the Greek and Latin languages and authors assiduously. Villa discussions and debates presumably centered on his interests, of which the tradition records a love of archaic literary style and preference for earlier writers over Cicero, Sallust, and Virgil. He wrote much prose, some of it quite obscure, but his attempts at poetry were not always insignificant; he contributed to the stream of

always shared his hunts with his friends." The next sentence says that "at his banquets he always furnished, according to the occasion, tragedies, comedies, certain farces, players on stringed instruments, readers, or poets." This is followed immediately by the celebrated brief description of the Villa, so that the entire passage may be seen as encapsulating Hadrian's chief concerns if the words about the provinces and the allusive place names are taken to represent the Villa's artistic and cultural content. In other words, the HA compiler apparently records the essentials of the program underlying the entire place. The words about conditioning and hunting are backed up by inscriptions as well as other texts, the allusive names have been justified at least partly above, and those about banquets nicely fit the archaeological evidence.

Like riding and hunting, banquets were attended by

pamphlets and poems circulated in defense of differing viewpoints about literary and other matters, including topics of the kind frequently explored at banquets. He was friendly with philosophers and rhetoricians, among them Epictetus and Favorinus, as well as with artists and learned men, many of them Greek. They may not have found the relationship entirely comfortable, for he could pose awkward questions, as when once at a banquet he asked for the names of ten men competent to hold supreme power. He was always ready to debate: at the Alexandria Museum "he proposed many questions to the professors but answered them all himself," or so the story goes.

Banquets and lesser meals out in the Villa grounds, within arbors or beside open waters (both seen in paintings and mosaics), perhaps under awnings or in tents according to season and weather, are likely. And an essential, time-honored villa activity also took place outdoors: the perambulating discussions Roman authors make so much of (Cicero often speaks of them); Villa opportunities were many. Strolling from the Residence directly to the Southernmost Ruins takes about half an hour, but even now much of interest appears along the way and few would make the trip without stopping. In Hadrian's time it would be unlikely that sights fundamental to the Villa's purpose and meaning would fail to arouse curiosity and provoke comment, to stimulate discussion about one or another classical topos, its origins and implications. This helps to explain the Roman need to give the names of famous places and deities, mainly Greek, to all manner of structures and landscape locales: however little one of these creations resembled the original (if ever there was one), the allusions themselves were sufficient to connect their owners with wellsprings of a long-lived culture cultivated Romans had adopted as their own. In the "marvelously constructed" Villa grounds and buildings, art fortified literature and history.

Groves provided shade, and ambulatories and colonnades gave protection from wind and rain and were often placed east-west to give summer shade; Horace speaks of porticoes "lying open to the shady north." Files of columns supporting roofs were regular Villa features—around the entire interior perimeter of the East-West Terrace, beside the Scenic Canal, and within courtyards large and small. They are gone now except for some restored columns, but recollecting them is essential to a sense of the Villa's appearance and amenities. That many colonnaded porticoes once stood in the grounds is substantiated by their frequent appearance in both paintings and texts. They were not necessarily level but might rise up slopes: Statius says Pollius Felix had one that "climbs slantwise up the cliff" and continues along the top with "a long line of roof" at his Sorrento villa.

Cicero's observation that great estates were "crowded with statues" applies with force to the Villa, where a large proportion stood in gardens and grounds. Judging from abundant finds elsewhere, marble figures lined paths, stood (usually on pedestals) before some colonade columns, and decorated gardens, fountains, and grottoes. Muses and nymphs predominated, but other mythological and pastoral characters (save for heroic deities) which did not fit, seem unlikely. Popularity is sometimes revealed: at other sites, seventy versions are known of a bowing satyr inviting a seated muse to dance. Most of these works are moderately sized, and many were fountain pieces. Water ran or spouted from marble treetrunks and from vases, water jugs, amphoras, wineskins, and small basins, often held by the figures themselves. Both animal and corporeal mouths—even sometimes those of portrait heads—might spout water; the Benghazi Venus, truncated along the upper thighs, appeared to rise from the pool in which she once stood. And the sea motifs of the Island Enclosure and Water Court friezes, the dolphins of the Arcaded Triclinium capitals and the Larger Baths stucco ceiling, as well as the Scenic Canal water creatures suggest similar work in the Villa landscape, which was also the natural habitat of animal statues and groups that evoked the wild and often brutal forces of nature Roman artists and patrons relished.

The many birds seen in Campanian wall paintings imply the presence of various species in Hadrian's gardens and grounds. Housekept birds are well documented, with songbirds the favorites, and Statius de-

scribes a talented parrot often given the run of the house. These birds might be put out, in their cages, in the gardens, like the one shown in the paintings from Livia's Prima Porta villa. Dovecotes were common, and peacocks, much admired, were kept in spacious cagelike enclosures. Pools attracted geese and ducks, fairly easily domesticated, and aviaries were built for pleasure. Varro's elaborate, famous aviary, at his villa near Cassino, sheltered ducks, and his guests, dining outdoors, could watch the birds swimming in their protected pool. The Romans romanticized swans, but apparently no record survives of keeping them on villa waters. Ostriches, eagles, and other relatively exotic birds, popular captives of princes, were well known and aroused much curiosity.

Only a sketchy sense of the sights in the Villa grounds emerges from the preceding paragraphs. Whether this analogous evidence can be interpreted as suggesting a Hadrianic version of a *paradeisos* of the kind Xenophon attributes to the Persian kings—huge enclosed tracts containing all manner of flora and fauna—is moot. Scholars think that the Persian works and their Hellenistic progeny persuaded the Romans to create similar parks, but present knowledge of Roman practice, based on archaeological and pictorial evidence, suggests that the connection was tenuous, that Roman parks were more selective and pastoral. But if the Villa grounds did reflect eastern royal practice, they had to include spacious runs and habitats for wild animals. It may be that in Hadrian's mind pictorial representations—sculpture groups and mosaics—were just as effective for his purposes.

Comfort and luxury for Hadrian, Sabina, and their friends and guests are taken for granted, and much analogous evidence for the details survives. Baths were heated in all weather and hot air or steam also circulated, well regulated, under floors elsewhere, for example upstairs at both the Fountain Court West and the west rooms of the Peristyle Pool Building; in other places charcoal braziers served. A ready access to cool water, such as the running water in the Residence suite, was probably provided in other luxury chambers; the strikingly cooler air of cryptoporticoes and under-ground passages has been mentioned. Snow and ice not only chilled the emperor's wine in his cellars but were mixed with wine in drinking cups and chipped into wine bowls, practices Seneca scorns. Ice and snow may also have had palliative if not medical uses, as Saladin's gift of snow from Mount Hermon to King Richard, lying fevered and seriously ill in his camp outside Jaffa in mid-August 1192, suggests. And perhaps ice was used to cool the air: at Oak Alley, an estate in Saint James parish near Vacherie in Louisiana, where summer temperatures range up to 40° (104°F.), 160 kilos (353 pounds) of ice a week were used in season to cool the dining room (with the aid of a leather punkah).

Interior spaces were lit after sundown with wax or tallow candles, or oil lamps, often in standing or hanging clusters, which produced soft, partly shaded effects unknown in intense artificial light. Large, tall, elaborately carved marble bases for candles and lamps, found at the Villa and later reworked, stand in the Vatican and Ashmolean museums; presumably these were placed in large halls. Flickering light on polished marbles, glass mosaic, and opulent materials would have been very effective; Hadrian's bedroom, whether at the Villa or elsewhere, with its worn portrait of the young Augustus and other sculpture, comes dimly into view. Candles or lamps enclosed in bronze screens or lampglass might be fixed or carried outdoors, and participants in nighttime celebrations and ceremonies carried torches. The Villa gates, like those on the Palatine, would be lit all night.

238

see 384, 385

To discuss uncommon and costly materials and objects (normal in great houses), such as rare marbles and metals, gems and jewelry, sumptuous clothing, exotic food and spices, and furniture and other objects of ivory and unusual materials, would only summarize what is already detailed in print. But two points need attention—the social and political functions of opulence and the advanced applications of certain materials, glass, for example, which demonstrate the exceptional abilities of artists and artisans at Hadrian's call.

As to the first matter, Hadrian had the best not only because he was rich but also because he embodied the state and had to live accordingly. In earlier times luxury had been roundly condemned often though in-

effectively, but as the imperial system solidified and the symbolic role of the emperor expanded, imperial palaces and villas grew in size and magnificence. Client princes, provincial bigwigs, leading artists and sages, and the powerful amici expected, and got, receptions and entertainments at the Villa in surroundings only Caesar provided. For Hadrian, the Villa was likely the preeminent symbolic imperial locus, not the palace on the Palatine, creation of the fearsome Domitian; Hadrian seems to have disliked it and made only minor changes to it, which says a lot, given his love for architecture and powerful urge to enhance the capital. And unlike Tiberius, Gaius, Nero, and Domitian, he built no new palace.

Palaces and great villas were strewn with glass objects and installations. Glassblowing—shaping the molten mix by inflation—had appeared in the first century B.C., and although it did not supplant traditional methods of casting, cutting, and building up glass objects, it vastly expanded the artistic and technical possibilities of the medium. Soon glassblown creations, in ranges of color and form hitherto unimagined, were produced in quantity; a surprising number survive whole or nearly so, and the best are beyond question works of art. Architects and artisans expanded the decorative and practical uses of glass, using it in floors, windows, and doors, and for mosaic, inlay, and imitation gems set in stuccowork, while glassblowers produced striking and technically masterful pieces. They challenged other specialists, such as portraitists and cameo makers, and might include, in their bowls and flasks and vases gold foil, snippets of contrasting, varicolored glass, loops and trails of glass thread, and other innovations and conceits. Meanwhile, ordinary glass tableware, seen in Campanian painting, and comparatively plain glass storage bottles in various sizes and shapes, continued to be stock items. They might, however, rest next to a small glass animal or a fancy, prized glass drinking cup.

Some glass has been recovered at the Villa. Vault tesserae and glass paste fragments at the Museo Didattico are mentioned above; recent excavations have turned up other valuable bits. In the Stadium Garden central

238 *Candelabrum, one of the Barberini Candelabra; now in the Vatican Museum*

area, glass paste tesserae, mostly blue but with white, orange-red, bright yellow, green, and transparent tesserae mixed in, were found, and the north pavilion there produced some thin, flat, more or less triangular pieces of glass paste, 2–4 centimeters on a side, turquoise and orange in color, that must be parts of wall or ceiling inlay. And an intact isosceles triangle of glass, with a base of 0.213 meters, recovered in the southeast section of the Island Enclosure, is probably a windowpane.

Inconsequential as these bits and pieces may seem, they confirm what texts and discoveries elsewhere make clear: glass, at the Villa as elsewhere, was valued not only for its transparency but also for the brightly colored and light-reflecting surfaces desired by those who wished to live in luxurious, up-to-date surroundings. Glass paste imitation jewels, dating from the mid-first century, survive in a vault fresco from Nero's first palace in Rome, the Domus Transitoria, and part of a remarkable glass and marble floor from the same monument lies under the Temple of Venus and Rome: beneath a dome (now lost), and reaching out into four axial corridors that intersected its circular supporting wall, is a pavement made of small triangles and diamonds of deep red, dark green, and azure glass together with others of off-white marble. About that time glass, in its mosaic mode, began to spread over vaults, as Seneca says, and onto columns and fountains. Pliny had glass doors, some apparently of the folding kind, and glazed windows were common; glass had come into its own.

Some record exists of Hadrian's taste in luxury materials. The bronze roof tiles of the Pantheon were gilded, as were ceilings in his Athens library, decorated also with alabaster. In the sanctuary of Hera at Argos he dedicated a peacock made of gold and "gleaming gems" to the goddess, and the cult statue of Zeus he erected in the Athens Olympieion (brought to completion by him) was of ivory and gold. From the great north niche of the Belvedere palace at the Vatican, by the famous pinecone fountain, the peacocks of gilt bronze, once fixed to bronze railings at his Mausoleum, have recently been moved indoors. Votive offerings and furniture Hadrian gave to various sanctuaries caught Pausanias's eye, and the "remarkable excellence" of a

basilica he built at Nîmes in honor of Plotina is recorded in the HA. Herodes Atticus aspired to a Hadrianic level of generosity: among his many gifts and benefactions, for example, were the statues of gold and ivory placed inside the sanctuary of Poseidon at Isthmia, among which were four gilded horses with ivory hoofs.

Had Hadrian wished to rule from Tivoli, few practical considerations would have intervened. But he was prepared to observe tradition and the niceties of official behavior, and he treated the senate with respect, consulted it punctiliously, and created new members sparingly. He liked to ride and could reach Rome easily from the Villa: "He always attended regular senate meetings if he was in Rome," the HA says, "or in the neighborhood." At Tivoli he was within the distance from the capital allowed those of senatorial rank when the senate was in session, and because public as well as private affairs not requiring convocations or hearings had always been managed from great houses, no legal or traditional barriers prevented him from handling day-to-day government business at the Villa. It would be wrong to think of the emperor issuing arbitrary decrees from seclusion at the Villa, but much correspondence and routine business had to be done there; state occasions presumably offered other opportunities.

Hadrian's time at the Villa alternated between otium and negotium. Even admitting the temperamental and intellectual distance between Hadrian and Vespasian, Suetonius's description of Vespasian's day is instructive:

He arose very early, even when it was still dark. Then, after reading his letters and the reports [*memoranda?*] of the senior staff [*officia*], he would admit his friends, and as they greeted him he dressed himself and put on his shoes. After taking care of whatever business was at hand, he went riding; then he rested, with one of his several mistresses Then he went from his private quarters to the baths and [from there] to dinner.

"Whatever business was at hand" covers a lot of ground. Hadrian's dictation was taken down in shorthand and passed to the copyists and if necessary to translators. His own papers were filed in the records office (*tabularium*) or in his personal chest (*scrinium*); messengers (*viatores*) delivered the originals. Formal

meetings, in addition to discussions in various locations with the amici and other advisers, were inevitable. The basilica, with its appropriate form and elegant decor, close to the centrally located Library, may have served, and the large southwest room of the Ceremonial Precinct, its dais centered against the broad, curving back wall, is suitable for convocations as well as audiences. Staff cubicles, between the Precinct and the Water Court, and along the Residence northeast wall, have been noted. The present state of the evidence suggests that most official duties were discharged in or near the Residence, leaving the rest of the vast Villa for serious leisure, otium filled with incident and possibilities often shared, apparently, with others.

COMMENTARY

Palace architecture is hard to find at the Villa. Other than the formal entrance to the Central Vestibule and a few Residence area features, only the Circular Hall and its broad southeast annex seem to qualify; the rest of the plan is too unfocused and episodic to be that of a palace. The great Palatine halls of state and imposing facades are missing, and such official facilities as there are—a small part of the Villa overall—are tucked out of sight, the reverse of the Palatine arrangements, where the public areas lying along two sides of the Domus Flavia (linked by a common peristyle) are largely separated from the private quarters, half of which lie in a secluded lower story.

A palace is a highly visible, symbolic monument representing the nation. Nothing now visible at the Villa fits this description. All emperors had residences away from Rome and conducted business there just as they did on their travels; Augustus, for example, sometimes did so at Tivoli, in the porticoes of the Temple of Hercules Victor. Tiberius stayed away from Rome, but his villa at Capri was not a palace. Domitian might rule from his villa at Albano, and Trajan worked while at Civitavecchia, but the palace of the Caesars remained in Rome, the fixed locus of the sovereign's mystique and authority. In the second century palatium, when used to mean the palace in Rome, began to break loose

from its primary meaning—the Palatine hill—and in the third century Dio can say that when an emperor is away from the capital his local residence is called a palace. The generalized meaning has replaced the original one, which explains in part why the word palace is sometimes applied to the Villa. Future discoveries may alter the present ratio of private to official Villa space, but for now the word palace seems inappropriate.

The Villa is also often called a town or is said to resemble one, because of its size (greater than that of many Roman towns) and large number of buildings, several of them of distinctly urban character, for example, the Canal Block, Larger Baths, and North Service Building. Seen today from the slopes of Monte Ripoli, the site does look like an overgrown, long-abandoned relic of a large town, its buildings apparently set more or less in line northwest-southeast. Pliny saw the villas of Laurentium similarly, saying that a pleasing variety of them lies along the shore, from which, or from the sea, "they look like a number of cities." But though the influence of high imperial urbanism is apparent here and there, the Villa is not an urban place. It does not have a town plan and lacks a forum, capitolium, and market and shops with their social and economic activity indispensable to town life. The numerous open public spaces so evident in towns—plazas, peristyles, large exedras, shop-lined porticoes, and interconnecting thoroughfares and byways—where people of all classes and occupations came together daily, are missing, for the Villa contained only two groups of people, the few who were served and the many who did the serving. All this is obvious but bears repeating because the sole connection between the Villa and actual towns is the Villa's size.

By the time Hadrian began to build at Tivoli, the Domus Aurea, which in size and to some degree in general conception prefigured the Villa, had all but disappeared. When he was a young boy the Flavians began the amphitheatre and Baths of Titus within the Neronian perimeter, and soon afterward Domitian added commodious gladiators' quarters and a large practice ring. Trajan finished the job by placing his huge baths directly over one of Nero's chief structures, up on

the Esquiline just northeast of the Flavian works. What-ever Hadrian may have learned of the Domus Aurea, he knew well at least one of his predecessors' grand extramural estates, Trajan's near Civitavecchia. The site, which may be that now called Terme Taurine, lies about 4 kilometers northeast of the port town (founded by Trajan) and some 190 meters higher up. It is a safe as-sumption that like Pliny, Hadrian admired the place, with its thermal waters — Antonine emperors followed suit — for evidence survives of alterations and additions he made after Trajan's death, when the property would have passed to him.

see 124

Only part of the site is visible, but evidence of possible connections with the Villa survives. A large peristyle, presumably by the entrance, extended on one side into a smaller one to form a re-entrant space be-tween two sets of buildings, one and perhaps both of them bath structures. In any event bath chambers prob-ably of Republican date lay on the smaller peristyle's extended axis and also to the right; the arrangement bears a general resemblance to the way the Villa's Cen-tral Vestibule's east extension lies between the Smaller and Larger Baths. Among the various canonical rooms on the right are a basilica-like cold pool chamber and beside it a second one, a huge vaulted space some 22 meters long that may be Hadrianic. To the south, lying beside a long, wide corridor, are the remains of a library, longer and narrower than that at the Villa but otherwise of the same functional design; what may have been a reading room, with a patch of its marble and glass pavement still visible, comes next. The corridor then turns west at a right angle, where a structure with a plan much like that of the North Service Building stood; other chambers and suites, some of irregular plan, lie beyond it. Roundabout all these spaces, from the library to the south, are the telltale villa secondary corridors and service rooms, and further on there is a cryptopor-tico and then a huge reservoir. Of all known imperial sites, only that at Civitavecchia yields comparative ma-terial of this kind. In an ideal world, Hadrian's villa at Palestrina, just south of the town, would be excavated, but much of it lies beneath a modern cemetery. His Baiae villa site is unknown.

As a major document of Greco-Roman culture, the Villa has uses other than its immediate but traditional one — a country setting for leisure and the cult of allu-sion. But if those other uses are sought — the value of its artistic evidence and the significance of its underlying meaning and historical position — questions crowd in and speculation quickens. What did Hadrian want, other than established effects and an appropriate magnifi-cence? Do the site and its art suggest anything about such intentions? What are the possibilities? And is the Villa of use today, and if so in what way? Final answers are out of reach, but something of a consensus, sen-sible and largely pragmatic, has evolved about sources and meaning. It centers on the conviction that however unusual aspects of the Villa and its art may be, it is best explained as an elaborate, expanded version of the aristocratic luxury villas of the past, conceived for the same purposes and characterised by the same allusive mechanisms. Hadrian's interests and talents are credited with giving the Villa its particular character, but tend to be seen as secondary to the momentum of the luxury villa tradition. The possibility of connections between the emperor's travels and Villa buildings is on the whole eyed somewhat warily, and few if any now hold that recognizable reproductions were built. We think these propositions are mainly correct but probably somewhat limiting, that more can be said, perhaps profitably.

Hadrian built not so much out of self-esteem as from a lively, genuine concern for the art of architecture. He was unlike Domitian, who had "the disease of building" and built out of a fanatic egoism, or Nero, who ac-quired Greek masterpieces through looting. He went to the Villa not just for a change but to work on the place as well. Cicero and Pliny made close supervision their business, but Hadrian's involvement was deeper and his knowledge and critical faculties were more sophisti-cated. The Villa offered greater opportunities for direct expression than most of his urban monuments, and whatever his role in planning individual Villa buildings, the frequent changes made during construction and the alterations and additions made to structures thought finished were surely the result of his interventions and instructions. His overall concept of the Villa may have

been formed gradually as he came to envisage it as a statement of his world, a distillation in art and architecture of its culture. However much like other great villas Hadrian's may be in some respects, the differences set it significantly apart.

Considering the Villa in the light of Hadrianic art generally, not as a semiautonomous object whose only proper comparative environment is that of other luxury villas, helps define and explain this distinctiveness. It is a quality often seen in Hadrian's other personal works and in official structures, commissions, and gifts, as the sources — surviving buildings, texts, inscriptions, archaeological discoveries, and coins — make clear, all dubious and routine attributions aside. Hadrian's architectural oeuvre mixes staid, traditional buildings with a variety of novel designs born of a willingness to break with tradition previously unknown in the classical world, so that in an important sense the Villa typifies the state of contemporary architecture. So, too, the Villa's size, for like the Pantheon and Mausoleum it surpasses that of its predecessors. And was Antinoopolis one of the largest cities begun from scratch in antiquity, perhaps the largest? Variety and great size seem common Hadrianic characteristics: his best known works are bigger than those of others, and though rooted in tradition, as all classical and classicizing architecture must be, they often carry classicism into new territory. Similar principles apparently governed Hadrian's acquisition and deployment of so much sculpture and other art. New work and old, originals and copies, of widely diverse origins, were intended from the beginning to stand in and among the buildings and out on the grounds, essential actors in Hadrian's combined theatre of the arts.

So the Villa may express, in one place, Hadrian's artistic philosophy. It filled out his architectural horizon in going beyond, in its highly original buildings, anything seen elsewhere; it was a laboratory. Embellishing Rome and many other cities and towns, Athens in particular, with building after building, meant responding and conforming to local cultural and social expectations, but at the Villa he could create anything buildable free from those concerns. That his travels and experi-ence of the world fueled this process, that original Villa works were based on his own thinking and advanced sense of design, seems inescapable; if our suggestion that Hadrian knew Herodium and that it prefigured the Island Enclosure is correct, then something of his interest in historical transference, in creative renovation of the past, becomes clear. His devotion to Egyptian art, which included commissioning Roman interpretations of Egyptian sculpture, seems similarly based. So a contribution the Villa can make toward a better understanding of the second-century artistic temper is part of its usefulness, not the least because high imperial art and architecture obstinately refuse to assemble under single rubrics of style or symbol.

These thoughts suggest the question of universality, of whether the Villa relates on some level to the universals implied by the Pantheon rotunda's shape and space. Did Hadrian attempt or intend to include in the Villa examples of every major representable aspect of the empire? It is impossible to say. But the HA compiler, or his source, thought so ("in order to omit nothing"), and the volume of Egyptian and Egyptianizing sculpture, in the hands of so ardent a philhellene and in direct confrontation with Greek masterpieces, is provocative. Hadrian's interest in Egypt was normal, but perhaps the high proportion of Egyptian art at the Villa is not. The Romans owned everything, including Egypt, and this as much as religious involvement may explain this stylistic anomaly of Villa art. Long study of the place, its architecture, sculpture, and decor, induces a strong awareness of the empire resources from which it was formed and an increased appreciation of Hadrian's role as emperor, as the overlord of those resources, in its creation, and thus of the possibility that the site deliberately reflects the nature of his realm as much as it records his personal experience and interests.

Hadrian lived in an age of enthusiastic tabulation, when paintings and mosaics showed the Nile with its people and flora and fauna, or the exact details of plants and birds — an age of compilations, lists, and records written, painted on walls, and inscribed in stone and metal. Milestones, complete with mileage, marked the immense state road system at regular intervals. Roman

maps, until recently underrated, though diagrams, are functional. Comparing the Villa plan with the Peutinger Table (a late twelfth-century copy of a large, late imperial road-and-town map showing almost the entire empire), with its irrational latitude-longitude relation, brings out strongly the stretched, elongated character of both the plan and the map and raises the faint possibility of cartographic influence on Villa planning, but attempts to relate the plan to schematic graphic impressions of the empire have led to nothing; the same holds true of ancient cosmological systems. If the Villa plan houses an inner meaning, it is not expressed literally; but the possibility that some larger concept is lodged there, as the site plan is implied by that of the Smaller Baths, should not be overlooked.

Attempts to identify the Villa's underlying purpose and meaning, its historical position and utility, are hindered by imperfect knowledge of it. Modern plans remain incomplete, their deficiencies unknown, and so fragmented a site, plan and contents both, has inevitably produced fragmented studies; much remains to be discovered about the Villa's complex order. Some ground, however, may be gained by comparing the Villa with Hadrian's other masterpiece, the Pantheon, and by considering it as a cultural testament, whether or not that was what Hadrian intended. Both topics center on his profound philhellenism, which went well beyond attachment to Greece and Greek culture and the appointment of Greek intellectuals to high office. The unambiguous record of his hope for Greek and Roman parity, the concept Plutarch cherished, is Hadrian's most impressive legacy. He opened doors long closed and made clear his vision of a society based on the partnership of the two peoples. This was not done by legislation or by declaring union—he was more subtle and astute than that—but by splendid symbols and scores of practical decisions. To call him "more a Greek than a Roman" is a little strong, but it points toward the heart of the matter. A long evolution toward Greek recognition and reestablishment preceded him, but it was he who gave it its fullest expression.

For this achievement the Villa evidence is an essential but largely unused resource for High Empire history. The stylistic and chronological range is immense, from the Doric Temple to the Smaller Baths, from the Townley relief of a Greek boy restraining a horse to the imperial portraits. That Hadrian never scrupled to make copies or imitations makes his deliberate intention to display the empire's artistic content—the Greek element in particular—all the clearer. The western provinces are absent because in the Roman mind they had no culture (witness Florus's squib). Egypt had something to tell, particularly about intangibles, but Greece was the seat of learning and literature, of the art of a presumably nobler age of incomparable aesthetic values.

The Villa is specific about these things while the Pantheon conveys them in their universal aspects. They make an instructive pair because both express Hadrian's thought and attitudes and reflect the mood of the age, though in contrasting ways. The Pantheon's public, unitary space, dedicated to all the gods, describes a timeless cosmic order; the Villa contains a complex, detailed statement, in a private setting, of that order, of the things seen in it and what they stand for. The Pantheon's ideated horizon and vault of heaven suggest a peaceful, unified realm of classical lands under the surveillance of the gods; at the Villa the cultural framework of that realm was made visible in a complementary statement about the interaction of Greek and Roman thought and experience. No other monuments are as typically Hadrianic as these, not the least because their Greek content is so much to the fore. The HA description, seen in this light, contains a gnomic definition of the Greco-Roman empire. Roman authority is made implicit by the context and by the inclusion of the provinces, and of the examples given of places most famous, five are classical Greek locales, one, in Egypt, originated in Hellenistic times, and the last region, Hades, was everybody's property.

The Villa's testamentary quality is unique. It is an essential document of the later classical world, strongly seconding the literary record of contemporary attitudes. Preoccupation with earlier classical works evokes strange judgments of it—a curiosity, a dead end, bizarre (common), outrageous, an idiosyncratic collection of

miscellany—and explains a certain reluctance to recognize its artistic and historic value. The Villa needs careful study as a place of remembrance because remembrance is a primary objective of so much Roman literature and historical manipulation. Recollection reinforces the sense of the passing of time, which both the Villa and the Pantheon strongly imply; they are of a particular time but recollect and record its irresistible movement. A primary exhibit of high-empire artistic and intellectual, even social, values, the Villa is also a practical source, recording things otherwise unknown, from such details as the caryatids' ceremonial plates, long since broken off from the Athenian originals, to the actual appearance of villa features familiar from the literature but not seen elsewhere. Finally, artists and architects since the late fifteenth century have drawn on the Villa as an artistic and intellectual bank account that has been standing at compound interest, like Franklin's dollar, for centuries. That part of the Villa's story continues.

In his last year Hadrian fell gravely ill at the Villa. The succession troubled him, and as with Augustus his early choices fell away. According to the tradition he made his will and longed to die but continued to work; he may have tried to kill himself. On 25 February 138 a compliant senate ratified his adoption of Antoninus, and later he was taken to Baiae, where he died on 10 July. Antoninus brought his remains to Rome, and the young Marcus Aurelius took charge of the funeral rites.

The emperor Hadrian . . . was extremely religious . . . and contributed very much to the happiness of his various subjects. He never voluntarily entered upon a war, but he reduced the Hebrews beyond Syria, who had rebelled. As for the sanctuaries of the gods that in some cases he built from the beginning, in others adorned with offerings and furnishings, and the bounties he gave to Greek cities, and sometimes even to foreigners who asked him, all these acts are inscribed in his honor in the sanctuary at Athens common to all the gods.

VIII

Survival and Rediscovery

After Hadrian's death the record thins and soon stops. A few brickstamps and imperial portraits may suggest use of the Villa by his successors. The last secure evidence dates from the time of Caracalla (211–217), and at some point thereafter the Villa ceased to be an imperial property. In the fourth century the HA compiler and Aurelius Victor knew of it, presumably from earlier writers. Over the centuries the site was ransacked and plundered, and much marble was consigned to the lime kilns, though some statues and architectural elements were carted up to Tivoli and put to use there. But from the thirteen centuries that preceded the rediscovery of the Villa in 1461 no other solid evidence survives. Villa connections with the design of later villas and palaces, however, are unmistakable.

AFTER 138

Thus far the Villa has produced nine Antonine portraits: one of Antoninus Pius (138–161), two each of Marcus Aurelius (161–180) and his co-emperor Lucius Verus (161–169), and one of each of their respective empresses—Faustina, her daughter the younger Faustina, and her granddaughter Lucilla—as well as

one of the empress Crispina, consort of Commodus (180–193). Seven Severan portraits have also turned up: one of Septimius Severus (193–211), one of his empress, Julia Domna, and five of their son Caracalla. So either the Villa was used on and off for eighty years after Hadrian's death or imperial procurators or other functionaries added portraits as required; that only two Antonine and no Severan brickstamps have been found may strengthen the second possibility. A handful of stamps from the early fourth century records minor interventions: one comes from the Ambulatory Wall and another from the Residence basilica, but the findspots of the others are unknown.

Tivoli was a major stronghold in the mid-540s during the heavy fighting for Rome between the Goths and the imperial army. Belisarius occupied it but lost it in 544 to King Totila. Then, in December 546, "Totila and his barbarians broke up the siege [of Rome] and [returned] to the city of Tibur . . . and they decided to rebuild the fortress there with all their might, for they had dismantled it previously." The suggestion that the king may have camped out at the Villa, down at Campagna level and some distance from his hilltop fortress, seems untenable on grounds of safety. But the Villa, hard by the Tiburtina and clearly visible from the steep Tivoli slope, would have been impossible to ignore, an inviting source of lime (marble could be burned on the spot) and perhaps of stone blocks; Totila had the manpower and the need. Part of a kiln of later date survives on the ground floor of the Peristyle Pool Building west suite, a reminder of how much Villa marble was turned into lime over the centuries. Squatters left signs of habitation, date unknown, in the Smaller Baths room 18; a floating population of outcasts during lawless times is likely. The immense effort systematic despoliation required is conspicuously recorded at the Ambulatory Wall, where four-fifths of the bricks embedded in it—eight end-to-end bands each five courses high and nearly 200 meters long—were chiseled out, and hacked-open chases and crudely enlarged pipe holes at the Smaller Baths document typically frenzied searches for metal.

The Villa's place in the history of architecture and art before the Renaissance is another matter: the record, neither complete nor fully understood, is preserved in general outline. Its central features have to do first with the Villa as the outstanding exemplar of an evolutionary product distinguished by highly irregular plans with numerous independent and semi-independent buildings and pavilions set about in huge parks, and second with a continuing interest in luxury villas. Any knowledgeable architect or artist examining the Villa in Hadrian's day or in Antonine or Severan times would have seen immediately its firm connection with the long tradition of grand country estates stretching back at least to the mid-first century B.C. and exemplified by such extravagant works as those of Lucullus, Nero, or Domitian. By no means did all high- and late-empire luxury villas follow the pattern so elaborately defined by Hadrian, but many did, and in due time palace architecture itself was affected accordingly. Meanwhile, huge villas continued to be built, in both Rome's environs and the western provinces, the products of self-indulgence, great wealth, and, in the case of private establishments, a desire to live in an imperial manner.

Antoninus Pius had villas at Lanuvium, 5 kilometers south of Lago di Nemi, and at Alsium, on the coast just below Ladispoli; neither has been recovered. The huge private villa of Sette Bassi, built between 140 and 160 close to the Via Latina in the outskirts of Rome, is an essentially orthogonal creation, with its three principal buildings set corner to corner around one angle of an artificially leveled garden or park measuring about 100 by 300 meters. A few structures lay scattered outside this perimeter, including a spur aqueduct run in from the neighboring Aqua Claudia, but the rectilinear constitution of the villa proper and the flat surface of its park, so inhospitable to pastoral imagery, disconnect it from any resemblance to Hadrian's work. The nearby villa of the Quintilii, begun about 150/155 beside the Via Appia, included numerous structures of varying plan and function dispersed across some 20 hectares that slope downward to the northeast. The baths, for example, were separate from the owner's quarters (which seem to have consisted of several independent buildings), and at the foot of one of two

grand parks—the other was circus-shaped—stood a monumental nymphaeum. These elongated parks were set at a slightly acute angle to each other, and in the area where they would have overlapped had they been extended, the residential buildings, baths, and some of the other separate structures stood, creating all in all a much looser and dispersed plan than that of Sette Bassi, one belonging to the same tradition as Hadrian's.

Even closer to that tradition is the seaside villa on the largest of the Brijuni islands, about 10 kilometers northwest of Pola. The villa was sited along the shore of a bay (the Val Catena) shaped like a somewhat bent index finger and begun in the first century, but much of it is later. The known principal buildings, which all faced the bay and were separated from it only by a presumably continuous system of broad terraces, were connected by gardens and porticoes. At various points along the shoreline, then, one found the chief residence, a huge, blocky mansion; a Doric exedra with three shrines and a covered, higher portico behind it; a grand 160-meter ambulatory; a portico garden open to the bay; and another exedra, fitted to an incurving stretch of seaside terrace in front of it. Behind this last, a secondary residence, centered on a triclinium open to the bay view, was joined, on the landward side, to a bath building. Artificial harbors faced each other at the bay mouth, one of them protected by a mole, and a park more than half as large as the Upper Park at Tivoli lay between the south harbor and the main residence block.

The importance here of the Val Catena villa lies in part in its numerous connections with Hadrian's, such as the building types and their irregular placement throughout, the shaping of the land by substantial terracing (at Val Catena along the shoreline), and the connective function of gardens. It lies also in its mixture of villa features often used to classify villa types: the single main block elevated on an artificial terrace, its blockwide facade portico, or the seaside location with buildings in a landscape of gardens and groves sloping toward the water. The Val Catena residence block compares readily with smaller versions of the kind seen in the final state of the Villa of the Mysteries at Pompeii and favored, for example, in the multistory edifices of Domitian's villa at Albano and Sette Bassi. The grand ambulatory resembles closely those of Tiberius's Villa Jovis and the Doric one of the villa at Anguillara Sabazia. Val Catena is in a sense a composite of Campanian seaside villa paintings, a panorama reminiscent of the landward view Pliny recommends. All of this suggests a kind of Hadrian's Villa assembled along a sinuous re-entrant line, a villa in which the bay, with its varied moods and seasons, has become the landscape, the feature that unifies the whole.

Both compact and dispersed villa plans from the third and early fourth centuries have been identified in and near Rome. A large estate begun early in the 200s (by Caracalla?) covered most of a hectare east and southeast of the Porta Maggiore. Its amphitheatre stands in part, its circus has been traced, and a great hall became in time the core of Santa Croce in Gerusalemme. A large bath building, restored when the site became an imperial palace in the time of Constantine (306–337), is known, as are cisterns, corridors, and various secondary chambers. The major buildings were set well apart (implying gardens and colonnades), and though some share nearly parallel major axes, no controlling orthogonal pattern is evident, unlike the plan of the early fourth-century villa at Centocelle ("ad duas lauros") on the Via Latina, whose identifiable parts are mostly rationally disposed around a central courtyard (though the curving exterior walls of the baths bulge well out from the main rectangular block in the fourth-century fashion). The villa of Maxentius (306–312), by the Via Appia not far from the Porta San Sebastiano, with its famous circus and dynastic mausoleum, appears from the remains of its residential area (laid over an earlier villa) to have been orthogonally conceived and unified, in part at least, by a 190-meter corridor developed from a pre-existing cryptoportico and an ambulatory; these works, however, are set obliquely to both the circus and the mausoleum, themselves axially at odds. A grand apsidal hall was provided for imperial functions, and the circus (never finished), intended for dynastic funeral games, suggests the palace circuses of Salonika and Constantinople. The tomb, appropriate to the Appia's history, was an innovation found also at the tetrarchal sites of Split and Salonika.

This brief, selective review confirms the survival in Italy of the grand luxury villa tradition and the preservation within it of the casual, apparently unsystematic planning, based on the importance of landscape and the absence of dominating central buildings, defined by Hadrian's Villa. Evidence of this survives also in the western provinces, the most remarkable being the early fourth-century site in Sicily near Piazza Armerina. A compact, inward-looking agglomeration, with an internal landscape of fountains (twelve at least) and mosaic pavement scenes throughout, it recognizes the outer world only through an arched monumental gateway. The familiar villa typology, expanded now by a newly arrived villa feature, the monumental basilica (set facing an elongated corridor) and by a trilobed triclinium, is tightly but erratically cemented to a central peristyle with a pool and fountains. Other late sites hint at dispersed planning, but the present evidence greatly favors orthogonal plans centered on highly visible mansions, whatever outbuildings or ingeniously designed baths might be included. In part this was due to the increase, in the west, in the number of very large villa-farms, for which dispersed, pavilioned configurations were unsuitable.

Although fourth-century sites other than that near Piazza Armerina, such as those at Marina di Patti in Sicily or Desenzano by Lake Garda, suggest that the Hadrianic version of the luxury villa was not yet defunct, better evidence is given by two later, western writers for whom multipart country estates are worthwhile subjects and who echo or invoke Cicero, Statius, and Pliny. The first is Ausonius, a consular and imperial governor from Bordeaux, who died about 395. He is an urbane observer of nature and of a way of life he finds comfortable and productive. In a fine poem on the Moselle and its sights, he describes riverside villas, with "their innumerable details and forms" and singular architectural beauty. He speaks of courtyards, towers, and countless columns, distinguishes among various settings, and finds the villas refined and imposing. Orchards, meadows, and gardens are common. That some if not all Moselle villas were composed of varied buildings independently sited is shown by his

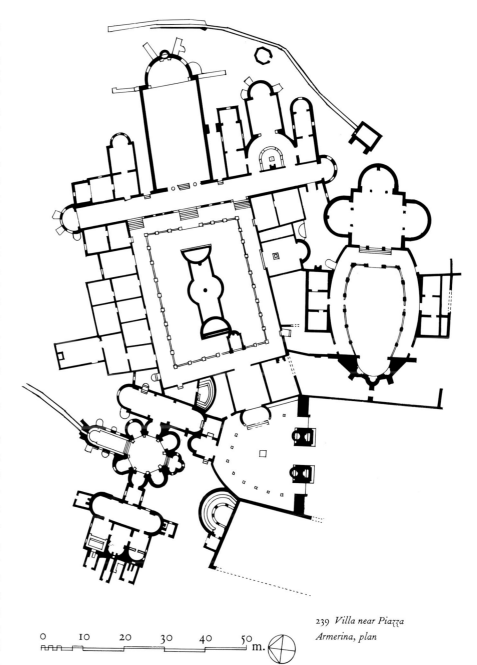

239 *Villa near Piazza Armerina, plan*

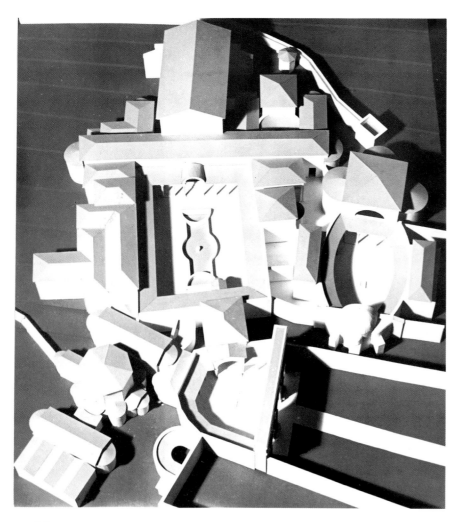

240 *Villa near Piazza Armerina, model (1961)*

description of shoreside baths. He refers to monuments in Ephesus and Alexandria and compares the charm and merit of the Moselle valley with the delights of Baiae (but adds that it lacks the excesses found there). He has an interest in architecture and refers to the chapter on builders or architects in Varro's *Hebdomades*, which has not survived, presumably a grave loss to the study of classical architecture.

Sidonius Apollinaris (ca. 430–480), also a Gallo-Roman aristocrat, describes in a poem a friend's riverside estate; his description is modeled on Statius and Pliny. He calls the place a *burgus* (castle); this is flattery, for although it had defensive walls, it was a farming villa. The buildings for the owner and his family and guests were dispersed in the Hadrianic way, however, for there are doubled colonnades, one atop a high ridge, and separate winter and summer residences and baths, all set in a landscape that inspired pastoral thoughts. The mention of gilded ceilings and the praise of the sumptuousness of the baths and sophistication of their plumbing would fit any second-century description of a luxury villa. In a long letter, Sidonius portrays a lakeside estate of his own, located perhaps near Clermont-Ferrand, in a fashion derived from Pliny's two letters (though at one point he lifts Statius's list of rare marbles whole). This detailed description is not given in such a way as to underwrite paper restorations, but it does specify plainly the main features of the kind of establishment we are tracing: numerous independent buildings, with meadows, woods, and pastures, fancy waterworks, colonnades, baths with a fine swimming pool that the author says might compare favorably with urban public structures, dining rooms and porticoes for seasonal use, fine views of the lake and mountains, a sort of cryptoportico and even a fireplace (camino) in a winter dining room. He knows something of builders and the design process and refers at one point to "architects of distinction."

With Sidonius the descriptive Roman villa literature expires; later references are either too vague or too brief. Olympiodorus, an Egyptian poet and historian from Thebes who visited Athens and Rome early in the fifth century, says of the Roman magnates of

the time that their huge dwellings include the features of a city—fountains, baths, temples, plazas, and race-courses. Perhaps he was influenced by the villa by the Porta Maggiore, or by the villa of Maxentius, for he was deeply interested in Rome's monuments, as was his contemporary Rutilius Namatianus (who in 416 or 417 visited the mineral springs within or near Trajan's Civitavecchia villa). In the late Roman legal codes, buildings and villas rarely appear as anything but types or as instruments of demonstration or argument. Procopius in his *Buildings* (late 550s) omits Italy—the work is probably unfinished—and in any event he is almost entirely concerned with Justinian's public works, but his pages on new work within the imperial palace in Constantinople impinge on our subject. The final literary word must be left to Venantius Fortunatus, a north Italian poet who died ca. 600 and who wrote poems in praise of villas; his focus, however, is mainly on agriculture and the duties of the priests in charge.

The complexity of early medieval architectural cross-influences in the Mediterranean world and a lack of studies of them preclude certainty about whether the Villa or concepts embodied in it may have affected Muslim and pre-Renaissance Christian buildings and palaces. Suggestions exist, such as the one that the plan of Santo Stefano Rotondo in Rome (second half of the fifth century) may be rooted "in late Roman villa design, ultimately Hadrianic in origin"; certainly the Island Enclosure fits the part. When more is known of the plans and structures of the *domuscultae,* agricultural estates with multiple buildings established in the eighth century in the Roman countryside and ruined in the Lombard wars, it may be possible to determine to what extent if any the imperial villa tradition was alive in central Italy. That these were large establishments is shown by the drafts of labor they—among other sources—supplied to Leo IV to build his new wall to protect the Vatican, begun in 848. The wall took four years to complete, and in the work force was a body of men from the domusculta at Capracorum, led by the estate's corrector or overseer; the site has been partly excavated.

The Great Palace of the emperors in Constantinople, begun by Constantine I and extended over a long period of time, is instructive not only because it embodied several of the features under discussion but also because it was a highly influential model or stimulus for Muslim, Norman, and Slavic rulers and hierarchs, sometimes even their source of artists and artisans. By the tenth century the Great Palace covered some 40 hectares of the sloping terrain between the city's Roman circus and the Marmara shore below. Its glitter and mystique lay at the heart of Byzantine artistic culture and imperial policy, which goes far to explain its protracted and wide-ranging influence. No building stands, but the archaeological evidence, scattered across the site and largely inaccessible today, was studied (excavation was limited) before 1940. Though not insignificant, the evidence is fragmentary and with few exceptions difficult to interpret. This deficiency is in a sense compensated for—it might be said to be overwhelmed by—the literary evidence, found in religious writings, historical chronicles, and above all in a *Book of Ceremonies* written by the emperor Constantine VII (913–959), which gives detailed accounts of imperial processions and ceremonies in the Great Palace and names well over a hundred halls, chapels, triclinia, chambers, and suites, only two or three of which can be matched with the piecemeal physical remains.

The architecture of a few buildings can be recovered in a general way: for example, an excavated peristyle with fine mosaics, the Chalke (Bronze House), described by Procopius—a vestibule first built perhaps by Constantine I but rebuilt and richly decorated with mosaics by Justinian I (527–565)—or the New Church of Basil I (867–886) that stood on a terrace in the Great Palace grounds and epitomized the five-domed Byzantine church. The texts, like Pliny's letters, encourage attempts at paper restorations, but so few physical data are available that anything more than generalized forms is usually impossible; conjecture and analogies flourish. Similarly, restored overall plans of the Great Palace are necessarily based on diagrammatic relations, among those buildings and suites whose names survive, deduced from an often obscure literature. Modern plans convey a sense of the palace's magnitude and

complexity but little of the gardens, the balconies and pavilions overlooking the city and the Marmara, or of the terraces, fountains, and streams, all reported in the texts, or of the numerous, inevitable service and supply structures.

But though the Great Palace plan and architecture are obscure, the successive episodes of the imperial ceremonies are not, and that is the great value of the texts for studying the history of luxury estates like Hadrian's. They specify the places included in the emperors' ritual itineraries and often describe the relevant ceremonies, sometimes giving details of the physical ambiance as well. Taken together, the texts portray a palace made up of scores of architecturally distinct locations, each the site of one or another religious or civil scene in the imperial drama, all interconnected by corridors, ramps, stairs, and colonnades and spread out across the ample, sloping terrain, every unit with a high-sounding name. This condensed definition of the underlying Great Palace configuration might pass, imperial duties aside, for that of the Villa. The basic principle is the same, for both were created for movement through space from one evocative cultural statement, made in art and architecture, to another, each unlike the rest. Each site distills its society and times into a concentrated array of appropriate themes and symbols.

No evidence connects the Great Palace and the Villa directly. Yet numerous typological and formal parallels exist in addition to the apparently disorderly plans and the pavilioned intermittency of varied experiences. Those of art and nature can in a general sense be equated; those of myth and Christianity are not far apart in a conceptual sense. The typological connection is typified by the duplication, in the Great Palace, of triclinia—there were at least five—one of them a grand circular structure, bound internally by eight large niches (the Chrysotriklinos, ca. 565–575) and vaulted over with a gored or segmented dome, of the kind seen at the Villa, sheathed with gold mosaic. A major semicircular building (the Sigma) recalls the Scenic Triclinium. A building called the Triconchos, its presumed plan reminiscent of that of the Villa's Arcaded Triclinium, may have extended from the Sigma's central axis. A Pan-

theon of unknown shape, a Hall of the Muses whose contents are unknown, an octagonal salon, and imperial apartments in various locations also recall the Villa.

At both sites the focal points, with their displays of contemporary cultural images, were executed by major artists and housed or enframed by master architects. Both places were imperially opulent—the Great Palace texts, like those that describe and praise the Hagia Sophia, dwell on this—and both were fitted out with the latest technological marvels, the waterworks, for example, at the Villa, dramatic automata in Constantinople. Both were energized by much the same artistic and cultural principles, the Villa for a secular sovereign with strong religious interests, the Great Palace for god-anointed rulers with secular responsibilities. Each accurately represented the high culture of its time while describing, and in the case of the Great Palace asserting, historical foundations of empire. The conceptual methods by which these things were done appear to have been, in their fundamentals, much the same at Tivoli as at Constantinople.

The possibility that the Alhambra (begun in the eleventh century) is in some way descended from the Villa has been strengthened by the suggestion that the Piazza Armerina villa may be part of the chain of connection. That early Islamic public buildings and desert residences were sometimes rooted in Roman villa design is accepted by many shows the direction scholarship may follow. From a Romanist's point of view the plans of grand establishments typified, for example, by the administrative palace at Kufa in Iraq (begun in the 670s) and that of Ashir in Algeria (eleventh century?) belong firmly to the tradition of large four-square Roman mansions and similar military structures and provincial palaces, built often in what later became Muslim lands. The Alhambra plan, in contrast, has no single end-to-end axis, and larger spaces are often set apart from each other by smaller ones. In addition, several oblique and off-center juxtapositions and numerous narrow, flanking corridors and small rooms emphasize the independence of each major space from its neighbors, so that the Alhambra, though compressed in plan, is experientially and volumetrically pavilioned. In those

241, 242

ways, whether by coincidence or not, the Alhambra is closely related to the Villa.

The story in a sense comes full circle in the courtyard of the Great Mosque in Damascus, in mosaics made by artists sent from Constantinople to the caliph by a Byzantine emperor in the late seventh century. Fragmentary and much restored, they include richly executed views of well-watered groves and gardens containing highly articulated, independently sited buildings, clearly invoking the legendary paradeisos mentioned earlier. Semicircular exedras, massed columns, and towers recall Roman architecture. Niches, fountains, and piled-up, balconied buildings, reminiscent of those in Campanian paintings, describe a luxurious, opulent dream world of palatine architecture. In one scene a majestic building rises from a terrace wall from which gushes forth a broad stream, an elaborate version of a Great Palace mosaic detail made perhaps two centuries earlier, in which waterfalls pour out beneath arches in the supporting wall of a high terrace that carries an elevated garden, a round tower or pavilion, and windowed halls — a Roman luxury villa scene.

241 *Damascus, the Great Mosque, courtyard mosaics (1969)*

RECOGNITION

Hadrian and the Villa figure in a fanciful account of the martyrdom of Saint Symphorosa, the *Passio sanctae Symphrosae*, probably dating to the mid-fifth century. According to one version, Hadrian, having completed a great building (*palatium*), proceeded to dedicate it by offering sacrifices. The gods replied that they were tormented by the prayers of the Christian widow Symphorosa and her seven sons; only when they had sacrificed would the gods smile on the emperor's dedication. Hadrian had Symphorosa and her sons arrested and brought before him at the Villa. When she refused to sacrifice, she was taken to the Temple of Hercules in Tivoli, tortured, and then thrown into the Aniene with a stone fastened around her neck. On the following day Hadrian executed her sons.

According to a tenth-century embellishment, Hadrian had a daughter who, after the execution of Symphorosa and her sons, became possessed by demons and

242 *Damascus, the Great Mosque, courtyard mosaic, detail (1969)*

wandered around their burial site. The emperor, too, was seized by fear and on the advice of his magi took refuge in the subterranean chambers of the Villa (*sub terra Palatio Tiburtino*) in the belief that he would die if he saw daylight. After nearly a year below ground he ventured out. The demons immediately took hold of him and vexed him until he died.

Although the *Passio* is a willful distortion of history (Hadrian's tolerance of Christians is well known), it nonetheless is noteworthy for mentioning the Villa, knowledge of which most likely came from the HA passage but may be based on direct experience of the ruins. The empty Underground Galleries, with their infernal associations, could easily have stimulated the imagination of a pious visitor shortly before the millennium.

The barbarian incursions and the attendant collapse of Roman authority in the course of the fifth and sixth centuries had dramatically changed the appearance of the Campagna. Agriculture, no longer secure and healthy, had diminished to the point where such

243 *Environs of Rome, detail of Tivoli and Hadrian's Villa, map by Eufrosino della Volpaia (1547)*

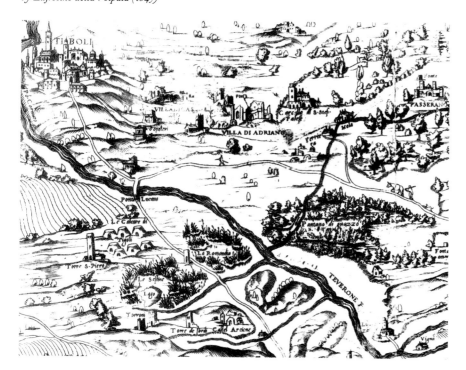

farmers as survived gathered in walled enclosures for mutual protection. Roman barons erected castles along the consular roads to control traffic and to exact tolls. Many of these fortifications, such as the Caetani stronghold on the Appian Way centered on the Tomb of Cecilia Metella, incorporated ancient sepulchral monuments. Tall watchtowers were also built as outposts and signal stations.

Eufrosino della Volpaia's map of 1547, which includes an early view of Hadrian's Villa, clearly shows how such structures projected from the rolling countryside between Rome and Tivoli. The fortified agricultural center of Castell'Arcioni guards the Via Tiburtina to the west of the Villa, while the Castello di Santo Stefano, centered on the church of the same name, commands the high ground to the south. Contending factions could not fail to recognize the strategic importance of the Ponte Lucano, which carried the Via Tiburtina over the Aniene just northwest of the Villa. The adjacent Tomb of the Plautii, dominating the bridge as it does, was fortified early on and changed hands repeatedly, both in the communal war between Rome and Tivoli and in feudal strife that extended into the fifteenth century. 243

The Villa was quarried for more than fifteen hundred years; many local structures were built partly or entirely from its spoils. The little twelfth-century church of Santo Stefano beyond the Villa's southern boundary appears to have been substantially constructed from Villa remains, as was the contemporary church of San Pietro in Tivoli, with its splendid set of cippolino columns supporting the nave arcades. At least one unusual marble, porporina di Villa Adriana, came to be associated with the ruins from which it was repeatedly extracted. In the sixteenth century, large tracts of the Villa were systematically dilapidated by crews in the service of Ippolito II d'Este, cardinal of Ferrara, who used the materials to build his sumptuous villa and gardens in Tivoli. In 1625–1630 the Bulgarini erected a villa within the Southern Range in a commanding position overlooking the West Valley, and early in the eighteenth century such substantial structures as the Casino Fede (situated next to the Doric Temple) and the casino of Liborio Michilli (the present-day Museo Didattico) 244 245

were constructed largely from materials collected on the site.

The desolation that spread over the Campagna in the early Middle Ages banished the delights of otium for a millennium. Banished, too, was any historical concern for the remains of Roman villas, whose hulking ruins figured among the more conspicuous features of the Campagna. It was only in the Renaissance, with its accompanying revival of humanist values, that the first stirrings of renewed interest in ancient villas arose. Fittingly, it was the humanist Flavio Biondo (1392–1463) and his patron, Pope Pius II (1458–1464), an early and sensitive admirer of landscape, who wrote the first postclassical descriptions of Hadrian's Villa.

Late in the summer of 1461 the pope and his retinue, including Biondo, traveled from Rome to Tivoli, along the way passing the beautiful springs of the Acqua Vergine at Salone. Several days later the pope made an excursion from Tivoli to the cloister of Santa Caterina on Monte Sant'Angelo, from which the group looked down upon the ruins of the Villa. In describing the scene, Biondo remarked on the Villa's size, so great that the locals had come to call it "Tibur vetus," old Tivoli, and identified the ruins as those of the HA description.

The pope went far beyond Biondo's description to meditate on the ephemeral nature of material splendor, introducing a topos that shaped later artistic and poetic responses to the Villa.

About three miles from Tivoli the Emperor Hadrian built a magnificent Villa like a big town. Lofty vaults of great temples still stand and the half-ruined structures of halls and chambers are to be seen. There are also remains of peristyles and huge columned porticoes and swimming pools and baths, into which part of the Aniene was once turned to cool the summer heat. Time has marred everything. The walls once covered with embroidered tapestries and hangings threaded with gold are now clothed with ivy. Briars and brambles have sprung up where purple-robed tribunes sat and queens' chambers are the lairs of serpents. So fleeting are mortal things!

These remarks call to mind the words of Sultan Mehmed II on visiting the Great Palace after the fall of Constantinople in 1453: "The spider serves as gate-

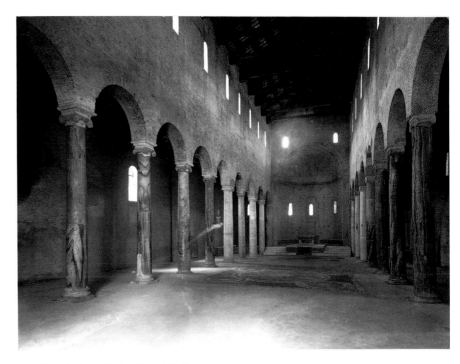

244 *Reused columns in San Pietro, Tivoli*

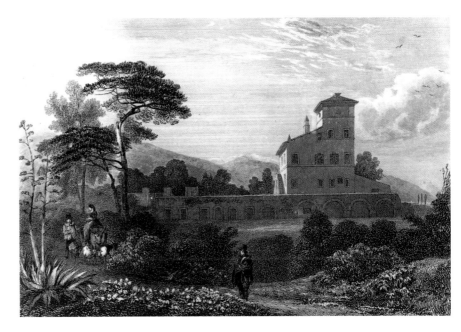

245 *Villa Bulgarini looking south, drawn by P. Dewint and engraved by W. B. Cooke (1845)*

keeper in the Halls of Khosrau's dome / The owl plays martial music in the Palace of Afrasiyab." The overgrown seating and stage building of the remote South Theatre convey a better sense of the appearance of the Villa in the pope's day than do the well-maintained ruins now open to the public, but today at the Villa, as in Penna's nineteenth-century print of the Island Enclosure, one can still happen upon coiling snakes and reflect on the organic growth and decay of empire.

The vast extent of the ruins alone would have attracted the attention of such humanists as Pius and Biondo, but the Villa's association through an ancient text with a renowned Roman emperor gave it special resonance. For all his emphasis on decay, the pope saw the Villa before the onslaught of generations of Renaissance treasure hunters, who wreaked untold damage on its fabric. His description makes it clear that the columns of several courtyards and porticoes still stood. His remarks on building typology, and particularly on the role of water, testify both to his sensitivity as an observer and to the condition of the ruins.

The classical heritage of Italy, dormant for cen-

246 *Island Enclosure*
(Penna no. 12)

turies, was first reevaluated through forgotten Latin texts eagerly sought by the protohumanists of the late fourteenth century—men like Petrarch and Boccaccio. Renaissance humanists Lorenzo Valla, Flavio Biondo, and others applied rigorous philological method to their analysis of ancient texts, but the romance of fragmented inscriptions moved others, like Felice Feliciano, to compose apocryphal texts that equaled those of the ancients in their elaborate style and studious correctness. The humanists' passion for literary fabrication spawned countless copies of inscriptions found, conveniently, in remote and unspecified settings. Archaeological fact and fantastic lore thrived as complementary facets of Renaissance antiquarian studies. The earliest descriptions and drawings of Hadrian's Villa admirably illustrate this fundamental dichotomy.

Around 1465 the Sienese architect Francesco di Giorgio Martini visited the Villa; there he made at least two measured plans now in the Uffizi, one representing the Island Enclosure and Fountain Court West and the other the Circular Hall. These were later revised by another draftsman who provided the illustrations for Francesco's manuscript treatise, now in Turin. A few pages before the drawings of the Villa appear in the treatise, Francesco describes his motivation for drawing ancient buildings, remarking on the effort he expended in measuring monuments on site.

Francesco's drawings are the earliest surviving graphic evidence of direct study of the Villa. His rough sketches in the Uffizi are essentially records of measurements he took on the site, whereas the more finished drawings in Turin show numerous changes. In place of the dimensionless lines of Francesco's Uffizi sketches, the Turin drawings define spaces with walls of uniform thickness. Two versions of the Island Enclosure appear in the treatise. In one, Francesco's assistant adds a pronaos to the Fountain Court West and sets chambers in the wall thickness between the two main spaces. The most remarkable retreat from archaeological accuracy is the integration and alignment along the same axis of two architecturally distinct structures.

The second version, further removed from Francesco's measured site study and from the actual remains

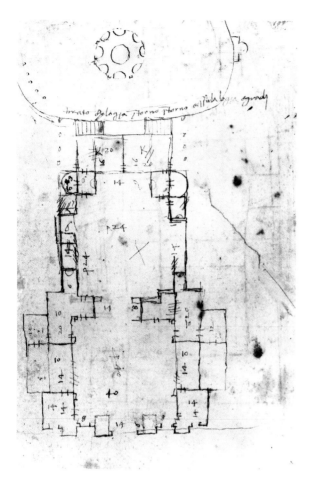

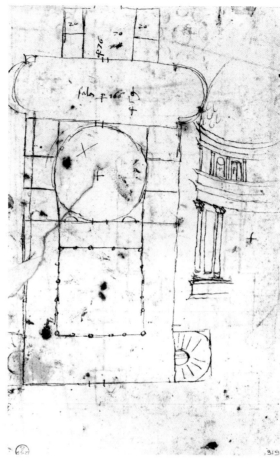

247 *Fountain Court West and Island Enclosure, plan by Francesco di Giorgio (ca. 1465)*

248 *Circular Hall, plan and section by Francesco di Giorgio (ca. 1465)*

see 91, 95 of the Fountain Court West and the Island Enclosure, clearly reveals the critical attitudes of Renaissance architects toward their ancient sources. Francesco's assistant transforms the Fountain Court West beyond recognition, drastically simplifying its interior, closing its northern entrance with an apse, and opening an approach from the south, thus effectively reversing its orientation. He makes four major changes to the Island Enclosure, reducing its peristyle from forty to sixteen columns, diminishing the relative size of the central unit, introducing a gratuitous peripteral colonnade around the center, and articulating the perimeter wall exterior with niches. These changes transform the central island into a round temple or memorial within a sacred precinct, closely resembling Bramante's later design for the Tempietto.

Similar changes appear in Francesco's plans of the Circular Hall. An adjacent courtyard, square in the Uffizi sketch, is rectangular in the treatise. More significantly, the alternating windows and paneled wall sections in the second story of the Hall are accurately recorded in the sketch but omitted in the more finished drawings. 251, see 69 see 71

Francesco transforms his ancient model, reorganizing it in terms of his proportional systems and imagination. His disdain for the formal integrity of his source

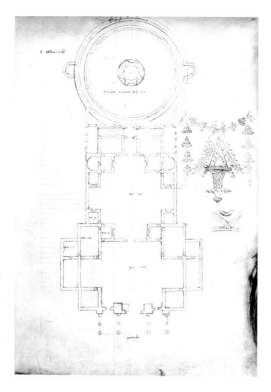

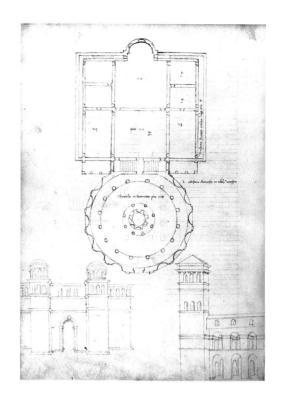

249 *Fountain Court West and Island Enclosure, plan in the Codex Salluziano*

250 *(far right) Fountain Court West and Island Enclosure, plan in the Codex Salluziano*

251 *Circular Hall, plan and section in the Codex Salluziano*

was not unusual; concern for archaeological accuracy was a later development. Rather, as a penetrating analysis of Renaissance interpretations of the Pantheon has shown, Francesco's critical attitude is characteristic of fifteenth-century architects, many of whom noted obvious discrepancies between Vitruvian theory and practice and corrected their drawings of the ruins to reconcile the inconsistencies they encountered.

At about the time Francesco was sketching at the Villa, another Renaissance architect, Giuliano da Sangallo (1443–1516), made drawings at the site. Giuliano is perhaps best known for the design of the Villa Medici at Poggio a Caiano, erected in the early 1480s. He arrived in Rome as early as 1465, the date on the title page of the collection of his drawings known as the Barberini Codex, and stayed there for at least seven years before returning to his native Florence. None of the drawings in the codex appears to have been exe-

cuted before 1488, and the collection seems to have grown slowly over thirty years. Giuliano probably sponsored and directed the project, assisted by members of his workshop. His numerous drawings after Roman architectural monuments and designs for palaces and villas provide a well-documented look at late fifteenth-century attitudes toward the antique.

The Barbarini Codex is one of the earliest and most impressive systematic collections of architectural drawings. It comprises more than sixty-nine drawings of ancient monuments in Rome, the Campagna, Naples, and more distant sites, such as Orange. Giuliano's guiding spirit is seen in the format and presentation of the codex pages. Plans and renderings combining orthogonal projection and perspective allow the observer to grasp the three-dimensional organization of the buildings represented, but this illusionistic impression of space is often achieved at the expense of current ideas of accuracy and precision. Giuliano enlarged decorative details pertaining to the monuments represented in plan and perspective, placing them to one side, where he also recorded surviving inscriptions. Details of the orders, as well as mechanical inventions and original architectural designs, fill in the pages, each crammed with dramatic single views, multiple renderings of a particular subject, or disconnected themes.

Because firsthand knowledge of ancient architecture was available to a limited circle in the late fifteenth century, sketchbooks such as the Barbarini Codex played an important role in educating aspiring architects. In an age that lacked printed architectural treatises filled with illustrations, sketchbooks were invaluable means by which explicit data on buildings and projects were transmitted, studied, and circulated by generations of architects.

The emphasis on accuracy and Vitruvian correctness gave way to greater flexibility and latitude by 1500. Appreciation of the plurality and diversity of Roman architecture coincided with the exploration of complex imperial monuments, such as the Domus Aurea in the 1480s. Hadrian's Villa attracted similar attention, and it is not surprising that it figures on three pages of the codex. A plan of the Scenic Triclinium appears on one,

and the tombs near the Via Tiburtina figure on another. But perhaps the most engaging of Giuliano's drawings after the Villa is his sketch of the vault stucco in the Larger Baths. This drawing, one of five disposed about the sheet, admirably illustrates the close relations between Renaissance antiquarian study and architectural design.

At the upper right is a measured drawing of a Doric capital of the Theatre of Marcellus. To the left is a

252

252 *Stuccoed vault in the Larger Baths, on a page from Giuliano da Sangallo's Barberini Codex*

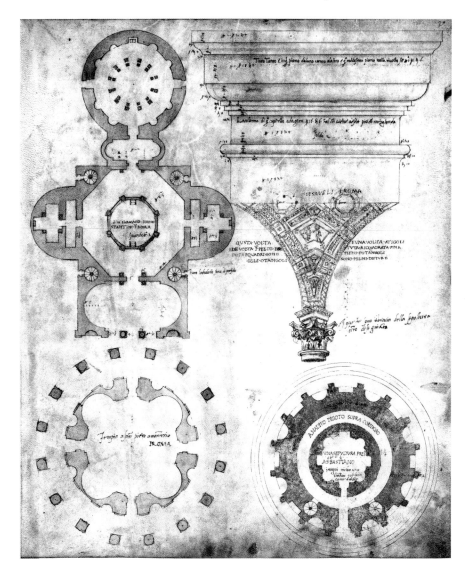

plan composed of the bizarre union of two late antique monuments: the Lateran Baptistry and Santa Costanza. At the lower left appears the plan of the most influential *all'antica* building of the High Renaissance, Bramante's Tempietto. To the right, apparently added later as a comparison with the Tempietto, is the plan of a circular tomb on the Via Appia. Giuliano's sketch of the stuccoed vault from the Villa stands out from the other drawings because of its perspective rendering. The vault is viewed along a diagonal, and the soaring arches that rise from the Corinthian capital meet the pilaster strip above in an artful, if somewhat confusing, clash of scale and planes. Giuliano's written notation documents the presence of figures within the geometrical compartments.

This sketch appears to be the earliest surviving record of such ornament. Giuliano applied the knowledge gained at Hadrian's Villa and elsewhere to the decoration of buildings in Florence, notably the Palazzo Scala. This palace, under construction between 1473 and 1480, contains stuccoed vaults all'antica that closely resemble those recorded in Giuliano's drawing. Vasari credited Giuliano with bringing the technique of casting vaults with decorative patterns to Florence.

Vasari also reports that Morto da Feltre (ca. 1474–1512), a follower of Pinturicchio who specialized in stucco decoration, "passed many months at Hadrian's Villa in Tivoli drawing all the pavements and grottoes of that site, both below and above ground." Unfortunately, none of Morto's drawings after the Villa have been identified, but the intense interest generated by the stucco decoration at the Villa in the first decades of the sixteenth century is evident in Raphael's workshop.

Bramante, Raphael, and other Renaissance artists are known to have studied the remains of the Villa. In his biography of Bramante, Vasari wrote that during his first years in Rome, before he received major commissions, Bramante set about systematically drawing ancient buildings in Rome and its environs. In particular, Bramante "measured what was at Tivoli and Hadrian's Villa . . . of which he [later] made great use." A letter dated April 3, 1516, from Pietro Bembo, secretary to Pope Leo X, and addressed to Cardinal Bibbiena, refers to Raphael's Villa studies. In describing the artist's visit to Tivoli, Bembo wrote that Raphael saw "both the old and the new, and all that is beautiful in this district."

Although no graphic records of these artists' Villa studies have been identified, their works document the vital significance of the Villa as a source for the formulation of High Renaissance style. Bramante's Tempietto provides a revealing example. This central-plan shrine, as known from Serlio, was to have been set like a jewel within a circular colonnade. Bramante's conception of a domed tholos within a circular courtyard has no precedent among fifteenth-century buildings. The Island Enclosure at the Villa provided a Roman example of such a concentric arrangement. Moreover, Bramante may have recalled Francesco di Giorgio's drawings of

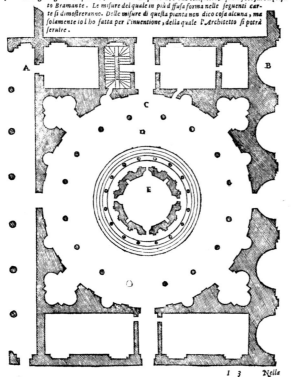

253 *Bramante's Tempietto, plan by Serlio*

253

see 95

this feature, which he almost certainly saw in the 1490s when the two architects met in Milan. Although the Island Enclosure was but one of several Roman sources Bramante assimilated in formulating his unique Tempietto design, it illustrates the Villa's role as a reservoir of imaginative architectural forms awaiting rediscovery and creative interpretation. The Renaissance revival of the villa gave architects a powerful stimulus to study ancient villa remains at first hand. The lessons learned, particularly by Bramante and Raphael, opened up a new approach to landscape design.

Baldassare Peruzzi, who worked closely with Bramante, carried out an extensive survey of ancient buildings. These investigations led him to conclude that Vitruvius did not account for many of the most beautiful works of the ancients. As early as 1505 Peruzzi assisted Bramante on the new design for Saint Peter's, the first Renaissance building to rival the scale and complexity of vaulted imperial monuments. Among Peruzzi's numerous architectural drawings now in the Uffizi is a sheet of studies after Roman and Early Christian buildings, several of which relate to the Saint Peter's design. Most of the left-hand portion of the sheet is given over to a plan of the Basilica of Maxentius, whose longitudinal axis has been extended, linking it to a domed crossing with four satellite spaces aligned along the diagonals.

254 *(margin)*

Next to Peruzzi's transformation of the Basilica, taking on something of the appearance of marginal notes in a manuscript gloss, are three smaller sketches. Two of these are renderings of a prominent feature of Hadrian's Villa that seems partially to have inspired the Saint Peter's scheme: a plan and reconstructed interior of the Water Court nymphaeum. As interpreted by Peruzzi, the four rooms disposed along the nymphaeum's diagonal axes function as satellite spaces, which he transforms in configuration and scale. In spite of its small size, Peruzzi's reconstruction of the nymphaeum interior effectively conveys the enveloping mural and vaulted systems, as well as a remarkable monumentality of scale.

see 114 *(margin)*

The painted vaults discovered in the Domus Aurea exerted a powerful influence on Raphael and his fol-

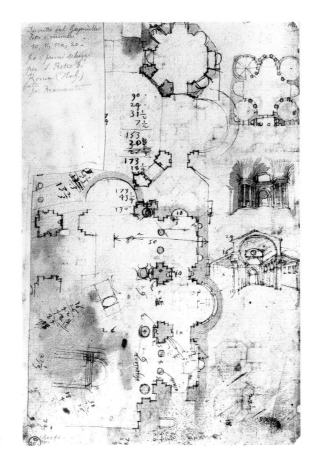

254 *Water Court nymphaeum and Basilica of Maxentius in Rome, drawn by Baldassare Peruzzi*

lowers, especially Giovanni d'Udine. When Raphael visited Tivoli he was probably drawn to the Villa as much by the vault stuccoes as by its architectural form. It is significant that Baldassare Castiglione's letter of April 1516, which documents the artist's interest in the Villa ruins, was addressed to Cardinal Bibbiena, for whom Raphael had designed a private bath, or *stufetta*, in the Vatican, completed later that summer. The walls and vaulted ceiling of this exquisite chamber are decorated all'antica, entirely with *groteschi*. The organization of its vault compartments closely resembles that of the Larger Baths stuccoed vault at the Villa, prompting speculation that Raphael visited the site with this commission in mind. That Raphael's ancient source

was clearly associated with a bath building makes it particularly appropriate.

In 1520 Giovanni d'Udine, who excelled in executing grotesque stucco work, decorated a similar bath chamber for Pope Clement VII in Castel Sant'Angelo. The stucco bands that border and divide the vault are decorated with the same pattern used on the framing bands of the Larger Baths vault at the Villa. In fact, Giovanni's name is scratched into the surface of the stucco there, testifying to his close study of this vault. The creative assimilation of ancient ornament by Raphael and his followers, as well as the Villa's crucial role in the process, is sensitively assessed by Bellori:

255

In this villa of Hadrian, superb even in its ruined state . . . Raphael of Urbino and Giulio Romano devoted much study at a time when their remains were [better] preserved; thus, whosoever wishes to view ancient paintings will admire them also in the ornament of the Vatican Loggie by Giovanni da Udine and other pupils of Raphael, the modern Apelles, as well as at the vigna Madama on Monte Mario, in the Palazzo del Te in Mantua, and in other works by Giulio Romano.

Several anonymous drawings depict a quadrant of the same vault represented by Giuliano da Sangallo, rendered in a mixture of perspective and orthogonal projection. Another records in detail a second vault stucco that survives in the substructures of the Doric Temple. Such ornament continued to attract the attention of artists and architects for the next three centuries, as drawings and prints of the same stuccoes by

Charles-Louis Clérisseau, Piranesi, and Viollet-le-Duc demonstrate. 256

Renaissance interest in Hadrian's Villa peaked in the mid-sixteenth century. Palladio's guide to the antiquities of Rome, published in 1554, included a reference to the Villa based largely on the celebrated passage in the HA. A drawing of the Island Enclosure, one of several sketches Palladio probably made in 1554, displays his overriding concern for symmetry and hierarchy of forms. Like Francesco di Giorgio, Palladio projected his principles of design onto the ruins, construing them in such a way as to confirm his artistic preconceptions. Palladio was then collaborating with Daniele Barbaro on a new edition of Vitruvius, the first to be illustrated by experts with firsthand knowledge of Roman architecture, and his drawings of the Villa should be seen against this background. 257, see 95

Another of Palladio's plans represents the Larger and Smaller Baths with remarkable accuracy. Palladio clearly delights in the rich variety of geometrically differentiated halls, particularly those ranged immediately behind the west facades of the Bath buildings. These sequences of vaulted spaces anticipate the monumental enfilade of rooms on the *piano nobile* of Palladio's Palazzo Thiene in Vicenza. Palladio's plans of the two Baths show esteem for their asymmetrical and nonaxial disposition of spaces that is in marked contrast with his treatment of the Island Enclosure and his reconstructions of the great imperial *thermae* of Rome. 258, see 106

Other Renaissance architects paralleled Palladio's use of enfilades of interlocking rooms. At about the time Palladio was measuring the Villa baths, Francesco Primaticcio was designing a remarkable suite of rooms in France for Charles de Guise, cardinal of Lorraine. Vasari remarked that the configuration of *appartements*, grottoes, and staircases at the château de Meudon so closely resembled ancient baths that they could be called *terme*. Vasari's use of this term is highly complimentary and illustrates the appeal of all'antica design beyond the confines of Italy.

In 1567 Philibert Delorme (ca. 1510–1570) published *Le premier livre de l'architecture*, a treatise that had important consequences for the development of Renais-

255 *Larger Baths, detail of stuccoed vault showing signature of Giovanni d'Udine*

sance architecture north of the Alps. It is significant here because it is the first printed architectural treatise to illustrate Hadrian's Villa. In a discussion on cornices, Delorme provides a woodcut of an unusual decorative frieze described as lying at the Villa. The accompanying description reveals Delorme's attitude toward ancient architecture and its relevance to contemporary practice; he singles out the Villa frieze to show how the ancients departed from the Vitruvian canon and to encourage others to enrich their classical designs. This willingness to expand and enrich the classical canon is equally evident in Delorme's designs for a new order of architecture appropriate to French materials and requirements.

Delorme's firsthand knowledge of ancient architecture derived from his extended stays in Rome in the years 1532–1536 and 1553–1560, in the course of which he probably made repeated visits to the Villa. One of his patrons in Rome was Cardinal Marcello Cervini, an amateur archaeologist who excavated at the Villa. Moreover, the French faction in the College of Cardinals at this time included Ippolito d'Este, who may have directed Delorme's attention to the Villa. And Delorme was introduced to the circle of Baldassare Peruzzi, whose criticisms of Vitruvius seem to have struck a responsive chord. A sketch by Baldassare's son Sallustio of an ornate column base from the Villa displays an interest in rich, sinuous forms that parallels Delorme's.

That Delorme's treatise is the only Renaissance architectural publication to mention Hadrian's Villa is not without meaning. Though we have ample evidence that Peruzzi, Palladio, Michelangelo, and others closely studied the Villa, their drawings never appeared among Renaissance handbooks and print collections of ancient architecture. Why is this, and how did it affect the reception of the Villa? Antiquities illustrated in the major treatises tend to conform essentially to the prescriptions of Vitruvius, something that could never be said of the Villa's masterworks. It is significant that Delorme, and not Serlio or Palladio, saw the uncanonical character of the Villa's architecture in a positive light. Still, the fact that measured drawings of the Villa did not

259

260

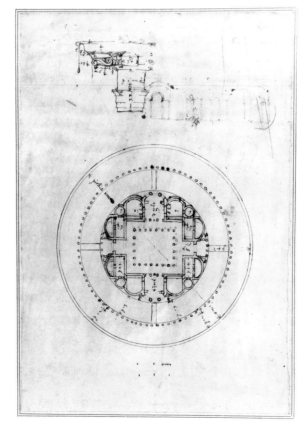

256 *Larger Baths, stuccoed vault, print by Piranesi (1778; Getty Center, Resource Collections)*

257 *Island Enclosure, plan by Palladio (ca. 1554)*

258 *Larger and Smaller Baths, plans by Palladio (ca. 1554)*

259 *Villa decorative frieze, woodcut by Philibert Delorme (1567)*

appear in published form until late in the seventeenth century meant that the Villa's influence was restricted to those who knew the site at first hand. Although this undoubtedly limited the Villa's influence, it also meant that the architects who did know the site had experienced it for themselves and did not rely on two-dimensional graphic abstractions prepared by others as aides-mémoire. They made their own sketches and measured drawings, and these were ultimately more reliable and vivid.

PIRRO LIGORIO

When Palladio was measuring the Island Enclosure, Baths, and other Villa buildings he probably met Pirro Ligorio, a Neapolitan architect and antiquarian who played a decisive role in the study of the site. Ligorio not only wrote the first comprehensive description of the Villa but also prepared the first measured plan of the entire site. Moreover, it was Ligorio who assigned the sonorous HA names to specific parts of the Villa, thereby determining the way artists and scholars would refer to them down to the present day. His interpretation of the Villa's remains, though at times colored by his fertile imagination and store of antiquarian lore, was nonetheless based on direct experience gained from the excavations he carried out there sporadically between 1550 and 1568. Indeed, these excavations have been called "the first large-scale modern archaeological dig."

Ligorio's reputation as an antiquarian led Ippolito d'Este, cardinal of Ferrara, to appoint him his personal archaeologist in 1549, with the primary mission of supervising the cardinal's growing collection of classical sculpture. Cardinal d'Este's appointment as governor of Tivoli that year expanded the scope of Ligorio's responsibilities. Once the Villa site came into the cardinal's possession, Ligorio began to ransack its ruins for ancient statues, scores of which entered his master's collections over the next three decades. In 1560, when construction began on the celebrated villa and water garden Cardinal d'Este commissioned Ligorio to design in Tivoli, digging at Hadrian's Villa seems to have

intensified to meet increased demands for marble revetment, building materials, and statuary. The cardinal's account books record payments to workers digging for statuary at the Villa in 1560, and one expenditure made in 1566 even documents the purchase of picks, shovels, and sledgehammers "to be given to the workers who are digging in the ruins of Hadrian's Villa."

Although the fragmentary evidence cannot support a detailed picture of Ligorio's excavations at the Villa, his manuscripts suggest that like most Renaissance archaeologists he was an opportunist, digging where he had good reason to expect easy and spectacular results in the form of statuary. Ligorio and the cardinal tolerated no opposition to their exploitation of the site; proprietors of two vineyards near the Water Court were expelled by armed guards, imprisoned, and banished from their land when they attempted to block the excavations. Judging from find-spots of statues mentioned in his written descriptions of the Villa, Ligorio's crews made concerted efforts in the North Theatre and its environs, the Island Enclosure, the Fountain Court, the vicinity of the Larger and Smaller Baths, the Scenic Triclinium, and the Water Court. Other evidence suggests that Ligorio also excavated—or at least cleared—the Southern Range and the South Theatre. Where he did not actually dig, he systematically explored, recording his observations in writing as well as in drawings, a few of which survive.

Pirro Ligorio's description of the Villa, the *Descrittione della superba e magnificentissima Villa Tiburtina Hadriana,* dedicated to the cardinal of Ferrara, was published only posthumously in 1723. He began to draft it shortly after 1549 and presumably had completed it by 1568, the date of his transfer from Rome to Ferrara. Although Ligorio's manuscripts were not published until the eighteenth century, they were nonetheless well known in the sixteenth and seventeenth centuries and exerted a powerful influence on subsequent study of the Villa. The *Descrittione* appears substantially to be Ligorio's own work, but other manuscripts enrich his account with information, some of it patently fabricated, probably compiled after Ligorio's departure from Rome and, in the case of one variant, after his death.

260 *Sketches, including a column base from the Villa, by Sallustio Peruzzi (before 1573)*

The manuscripts leave no doubt that Ligorio intended to publish a comprehensive plan along with his treatise.

At nearly ten thousand words, the *Descrittione* is more extensive and specific than the descriptions of Pius II and Palladio. Ligorio first sets forth the orientation and extent of the Villa, remarking that it surpassed the Seven Wonders of the ancient world. He then takes a crucial step by quoting the HA passage, which he interprets as a reliable key to identifying the ancient functions and symbolic meanings of specific buildings. Indeed, from this point Ligorio moves through the ruins from north to south, examining each complex in turn and applying the topographical references embedded in the ancient text to them. When he cannot identify the ruins by direct references to the HA, he resorts to his own formulations, often supported by spurious analogies. The Apsidal Hall, for example, is identified as a meeting place of Stoic philosophers, due to its

proximity to the Ambulatory Wall, which Ligorio associates with the Poecile mentioned in the text. With a ponderous display of antiquarian erudition, he explains the reference to the Painted Stoa in Athens, where the followers of the stoic philosopher Zeno met. In other instances, as when he designates the Water Court as "Piazza d'Oro," Ligorio adopts names already in use. Ligorio's choice of resonant but inaccurate names stuck, with the result that most continue to be applied.

Much as the nomenclature Ligorio applied to the Villa proved to be a mixed blessing, so the manuscripts associated with his name exerted both negative and positive influences on Villa studies. Ligorio's account of the Villa, especially as set forth in the largely autograph *Descrittione*, preserves a wealth of accurate firsthand observations, particularly concerning the find-spots — and by implication the original placement and setting — of statuary. He was an acute observer of architectural structure. He correctly surmised the existence of the Scenic Canal, for example, whose presence continued to be questioned by archaeologists into this century. In many instances Ligorio's observations of lost details such as marble pavements and stucco ceilings constitute our only records of them. At the same time, however, his imagination often led him astray, and the authority of his name, associated with the work of his fanciful editors, gave credence to numerous erroneous interpretations and fanciful building names.

That Ligorio was preparing a measured plan of the Villa — the first in a series continued, in turn, by Contini and Piranesi — is certain. Repeated references to such a plan appear in his manuscripts. In the published version of the *Descrittione*, Ligorio, describing the Southernmost Ruins, promises that "the disposition of these structures will be shown on the PLAN, which we will draw as best we can." In another manuscript variant of the *Descrittione*, Ligorio remarks on the limitations of words in describing the complex three-dimensional relations of the Southern Range. "But if Our Lord be willing, we will show everything in the drawing that is being made, for there are loggias ranged above loggias, apartments, lavatories, bathrooms, double rooms, one story piled on top of another, and stairways of beauti-

ful design, all of which require illustration rather than more words."

Ligorio's general plan of the site was either never completed or lost, but some of his drawings may be identified as preparatory studies for small portions of his survey. A sketch plan of the area between the Canal Block and the West Belvedere survives among Ligorio's manuscripts in Turin. This sheet shows signs of having been drawn freehand on the site: the portico of the West Belvedere is indicated in a summary fashion, the nonorthogonal relation of the walls defining the West Terrace has been approximated (perhaps by means of magnetic compass bearings), and one or two measurements are recorded. 261

Two sheets in the Royal Library at Windsor, representing the plan of the Southern Range, are of particular interest. The first is a sketch that Ligorio appears to have drawn on the site, the technique and graphic conventions are identical to the autograph sketch in Turin. The second, a more finished version of the same subject, was prepared on a drafting table, probably by another hand. A seventeenth-century inscription on the verso of the finished plan records that both drawings were originally taken to France by a certain Monsu d'Autreville, who had acquired them from a dealer in Ferrara, where they presumably had been taken by Ligorio in 1568. They then passed into the collection of Cassiano dal Pozzo. 262 263

Another drawing at Windsor, representing the stuccoed vault and mosaic pavement of a room in the Southern Range, may also be associated with Ligorio. The stuccoes were studied by other Renaissance artists, including Giovanni d'Udine, Luzio Romano, and Giovannantonio Dosio. The fragmentary evidence of the stuccoes surviving in situ, together with portions of the pavement recovered in the eighteenth century, confirm Ligorio's accuracy. 264

Ligorio's plans of the Southern Range, which correspond closely to his observations recorded in the *Descrittione*, are revealing illustrations of his much-debated accuracy and reliability as an antiquarian. There is no doubt that these ruins were far better preserved in Ligorio's day than in ours, providing him with more complete evidence for reconstruction. Nonethe-

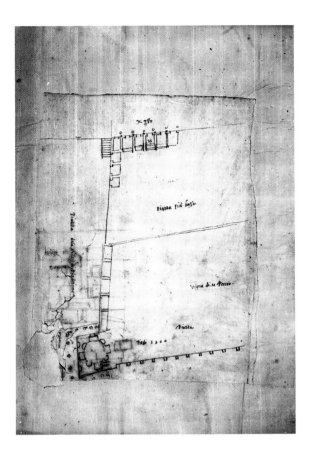

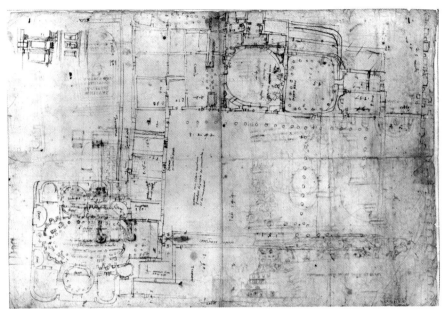

261 (top left) West Belvedere and Canal Block,
plans by Ligorio

262 (top right) Southern Range, plan by Ligorio

263 (bottom) Southern Range, plan after Ligorio

less, Ligorio allows his imagination to play a much greater role in reconstruction than would be acceptable today. A comparison of the Reverse-Curve Pavilion as reconstructed by him and as drawn by Palladio is instructive. No doubt influenced by his predeliction for oval-plan structures, which he employed in his designs for the Villa d'Este and the Casino of Pius IV, Ligorio reconstructs the Reverse-Curve Pavilion as a grand colonnaded hall of oval configuration. In contrast, Palladio shows greater respect for the evidence of the ruins, which certifies a circular base.

In many respects Ligorio's attitude toward the Villa remains is similar to those of Francesco di Giorgio and Palladio, for all three view the ruins creatively and seek in them both stimulus for their original designs and confirmation of their artistic theories. Although care should be exercised in generalizing on the basis of a few fragments of Ligorio's master plan of the Villa, enough is known of his creative approach to the task

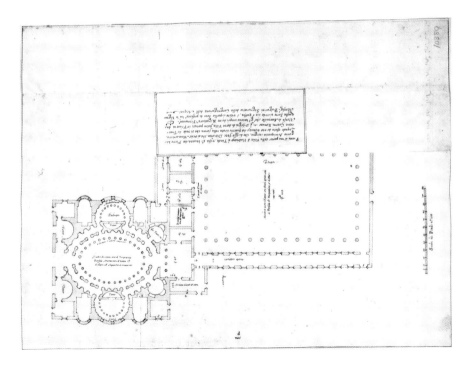

265

264 *Southern Range, vault and pavement designs, follower of Ligorio*

of archaeological reconstruction at other sites, notably Palestrina, to permit a tentative characterization of his method. Unlike Palladio, who tends to impose his values of visual hierarchy and symmetry on the ruins, Ligorio is more inclined to improvise virtuoso variations on themes suggested by the remains. Both architects multiply columns and introduce nonexistent features, but whereas Palladio uses such features to unify and to aid in scanning a vast site like Palestrina, in Ligorio's work their effect is more fragmentary and distracting. Ligorio's reconstruction of the Reverse-Curve Pavilion is the visual counterpart of the emphasis placed on bizarre and unusual features of the Villa in the *Descrittione*, a Mannerist attitude that continued to interest Baroque architects. By any account, Ligorio's most creative reconstructions of the Villa are the three-dimensional ones found in his designs for villas and fountains, which are considered here with other examples of the Villa's influence on the history of landscape design.

THE SEVENTEENTH CENTURY

Not until 1668, more than two centuries after Pius II visited the Villa, was the first comprehensive site plan published. The large fold-out plan and its accompanying text were long attributed to Pirro Ligorio, but both are the work of Francesco Contini (1599–1669), an architect active in the service of Cardinal Francesco Barberini, to whom his publication is dedicated. Contini made liberal use of Ligorio's manuscripts in the key that accompanies his plan, but the published plan is clearly the result of his own independent survey. In his introduction Contini mentions the difficulties presented by the site:

I went to the place, observed that it occupied a hill surrounded by two valleys roughly six miles in circumference, and I saw that the majority of the ruins were so covered by earth and debris that their foundations could not be made out; indeed, most of the ruins were overgrown by dense and thorny thickets. Such obstacles revealed to me the difficulties I would encounter in producing a plan. . . . I began to excavate in order to reveal foundations, I cut through all obstacles, and more than once fell into holes and openings

266–275

in those rugged areas and vineyards. Through such diligence I also found several subterranean roads, by means of which one can go under cover from one part of the Villa to another, as you see indicated on the plan, which I finally drew with the greatest accuracy possible, considering that the passage of time has erased many parts of the site.

Antonio Del Re, writing not long before Contini set to work, elaborates on the difficulties that confront anyone wishing to measure the Villa. "The site is so extensive and the buildings so numerous and large that they have made an immense ruin, above which shrubs and large trees have grown and formed a forest, which prevents one either from drawing a plan or an elevation from the valleys."

It has generally been assumed that the survey work preparatory to Contini's plan was carried out in the period immediately preceding the plan's publication in 1668. But in fact the survey was undertaken more than thirty years earlier, in 1634. The earliest and most eloquent evidence that Contini was at work on the site in the 1630s is a lost graffito in a cryptoportico on the northwest flank of the Residence, copied early in the nineteenth century by Sebastiani, which underscores the arduous labor involved in the survey.

Other documentary sources in the Barberini archives confirm that Contini was at work as early as 1634; several payments to him in connection with the survey are recorded between that date and 1636. The last of these specifies that Contini and the engraver Domenico Parasacchi spent fifty-two days at the Villa between June 1635 and March 1636. Another unrelated payment made in 1637 speaks of a finished plan, which was sent together with its accompanying key (*libretto*) to England. An inventory of 1649 records another plan of similar dimensions executed in pen and wash, also accompanied by its "libretto delle discrittioni." In all likelihood this was Contini's original master plan on which the engraving of 1668 was based. Its presence in Cardinal Barberini's palace for at least fifteen years before the middle of the seventeenth century suggests that it would have been known to the artists and antiquarians who gathered there, men such as Bernini, Pietro da Cortona, Nicolas Poussin, and Cassiano dal

265 *Plans of the Circular Hall, Reverse-Curve Pavilion, Fountain Court West, and other Villa structures, by Palladio (ca. 1554)*

266–270 *(top row) Contini plan
of the Villa, pls. 1–5 (1668)*

Pozzo. Cassiano was Cardinal Francesco's secretary, and his Museum Chartaceum, a comprehensive antiquarian survey that included two of Ligorio's Villa drawings, would have been accessible to Contini.

The most striking aspect of Contini's plan is its pronounced southern extension, which takes in the ruins on the Colle di Santo Stefano. Contini's decision to include these ruins doubtless reflects their inclusion in Ligorio's manuscript descriptions of the Villa, which he studied.

Contini appears to have followed Ligorio in other matters as well, and in one instance his misinterpretation of Ligorio's accounts led him to place the nonexistent so-called Latin theatre at the north end of the East Valley. Ligorio had described the North Theatre correctly but rather vaguely, placing it below the terrace occupied by the Doric Temple. Contini mistook the remains of the North Theatre, which in his day was flooded, for a *naumachia* (ampitheatre for the staging of naval

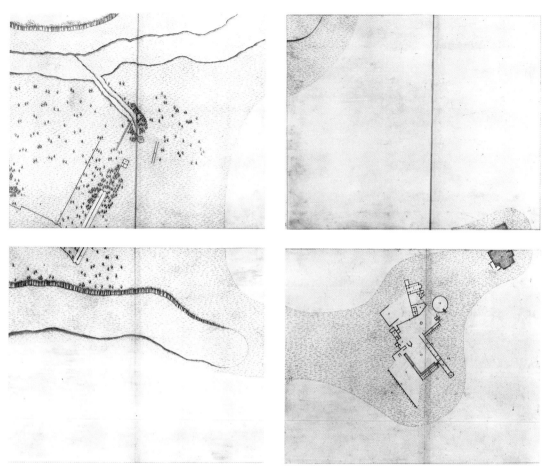

271–275 *(bottom row) Contini*
plan, pls. 6–10 (1668)

battles). As a result, he still needed to account for the theatre mentioned by Ligorio, which he did by inventing one, replete with an elaborate scenae frons, in the East Valley. Later versions of this plan, especially the popular edition of 1751, perpetuated this error, repeated as recently as 1961.

Apart from the confusion about the North Theatre, however, Contini's plan reflects his exacting work in surveying the site. On occasion he corrects Ligorio

with information revealed in the trenches dug to reveal foundations. For example, where Ligorio describes the Island Enclosure as being oval with an octagon at its center, Contini correctly describes it as circular and notes the presence of the concentric moat. Contini's research also seems to have revealed the existence of the Scenic Canal. His exploration of part of the network of subterranean galleries underlying the Villa is confirmed both by his discovery of chambers below the

Upper Park now thought to be intended for snow stor-
age and by his inclusion in his plan of the Underground
Galleries and numerous cryptoporticoes.

Contini clearly strove for accuracy in recording the
Villa's relation to the landscape and in documenting the
interplay between its constituent parts and the overall
design. Comparison with another reconstruction of the
Villa underscores the care Contini took in preparing his
plan. A fantastic bird's-eye view of the Villa painted by
Giulio Calderone once adorned a palace wall in Tivoli.
The original has been lost, but it is known from two
later versions: a drawing of 1657 by Gismondo Stacha
and a late eighteenth-century print by Domenico Pal-
mucci. It is virtually impossible to identify the major
features of the Villa in Stacha's drawing, which employs
graphic conventions present in the prints reconstruct-
ing ancient Rome by Ligorio and Etienne Dupérac
but reduces them almost to caricature. By comparison,
Contini's plan is a model of clarity; in spite of its imper-
fections, it provided a graphic overview of Hadrian's
grand design for the first time since antiquity. In the
process Contini stimulated the creative imaginations
of a new generation of architects, such as Francesco
Borromini (1599–1667), who were attracted to the Villa
by its innovative interpretation of spaces and classi-
cal forms.

276

276 *Villa reconstruction by
Gismondo Stacha, after a lost
painting by Giulio
Calderone (1657)*

While Contini was preparing his plan of the Villa
for Francesco Barberini he was engaged in another
archaeological survey for the same patron. With the
mathematician Gaspare Berti, Contini carried out the
difficult task of measuring subterranean galleries in
the Catacomb of Domitilla, off the Via Ardeatina. As
he would do a year later at the Villa, in 1633 Contini left
a graffito recording his presence in one of the catacomb
crypts. Contini's plans were published in *Roma sotter-
ranea* (1632), a landmark of Early Christian archaeology
by Antonio Bosio, the "Columbus of the Catacombs."
Contini's colleague Berti was also present at the Villa
in 1633, when he wrote a letter to Cassiano dal Pozzo
describing an excavation that had revealed a number of
marble columns "suitable for making statues," as well
as "the remains of a beautiful temple with many niches
and mosaics." Berti recommended that the absent Con-
tini be advised that the excavation was in progress. The
connection between Contini and Berti is significant be-
cause Berti also served as model-maker to Borromini,
with whom he must have shared his intimate acquain-
tance with the Villa.

In 1634, the same year Contini began his survey of
the Villa, Borromini received his first independent com-
mission, to build the monastery and church of San Carlo
alle Quattro Fontane. Throughout his career Borromini
drew inspiration from ancient architecture in the for-
mulation of his innovative designs. Although the most
persuasive evidence for Borromini's study of ancient
monuments is found in his executed buildings, other
accounts underscore his debt to antiquity. Pier Leone
Ghezzi, writing shortly after 1740, mentions seeing an
album of Borromini drawings after ancient architecture.
In certain respects Borromini's lost album no doubt re-
sembled older Renaissance codices like that of Giuliano
da Sangallo, described above. Judging from Ghezzi's
description, however, Borromini's selection of antiqui-
ties differed from Giuliano's, for Ghezzi describes beau-
tiful moulding profiles that looked like Borromini's in-
ventions, suggesting that he drew examples that broke
rather than confirmed the rules. Borromini's interest in
unusual, non-Vitruvian forms is confirmed by another
source, Orfeo Boselli, who once accompanied Borro-

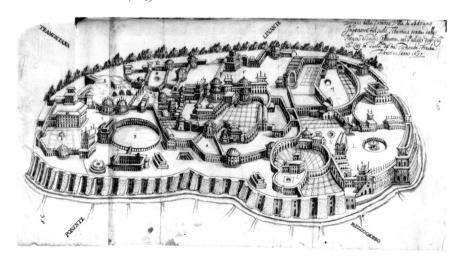

mini to view an ancient capital newly brought to light in Rome and recorded that they "were struck . . . to see with what beautiful novelty and variety the ancients treated architecture."

Borromini's interest in antiquity is further documented by Fioravante Martinelli, author of the informative guide *Roma ricercata nel suo sito* (1644), who records that Borromini owned an annotated copy of Ligorio's *Antichità romane*. Martinelli and Borromini became close friends and on at least one occasion inspected an excavation site together; the later editions of Martinelli's *Roma ricercata* and one of his manuscripts extensively annotated in Borromini's hand reflects his opinions about architecture. The most explicit references to Borromini's study of antiquity, however, are contained in one of his own publications, the *Opus architectonicum*, published posthumously in 1725. The *Opus* gathers Borromini's designs for the Monastery of the Filippini together with a commentary written by the architect and his patron Virgilio Spada. Among the numerous references to ancient monuments in the *Opus* is one to the Villa, which Borromini cites as a source for the diagonal disposition of the corner pilasters in the monastery's oratory.

I wanted to follow . . . the practice of the ancients, who would not dare to rest a vault directly on a wall, but who instead rested its entire weight on columns or piers which they planted in the corners of the room, so that adjacent walls served only to buttress these piers, as one can observe in Hadrian's Villa, S. Maria degli Angeli in the Baths of Diocletian, and elsewhere. . . . Thus in the corners of the interior of said Oratory I placed four pilasters diagonally . . . which helped to support the vault and put less strain on the exterior walls.

Clearly, Borromini has in mind Villa solutions like the stuccoed chamber of the Larger Baths and Fountain Court West. In both the Larger Baths and the Oratory the placement of the orders softens the corners and emphasizes verticality.

Borromini's remarks reveal much about his interpretation of ancient architecture. When confronted by structural problems he draws on great vaulted Roman spaces to devise innovative solutions and uses ancient sources to justify his creative license. Antiquity becomes at once a stimulus to and a justification for his highly personal work, which can never be confused with the sources that inspired it. Borromini underscores his artistic independence in the introduction to the *Opus:* "I would not have committed myself to that profession [architecture] with the idea of being merely a copyist." Borromini's imaginative use of rounded corners to establish a seamless mural structure that more effectively envelops the space it encloses, as in the Oratory and the Chapel of the Propaganda Fide, is in fact one of the most distinctive features of his style. Secure in his artistic creativity, Borromini proudly acknowledges ancient designs as a source of inspiration. Though he draws extensively on antiquity, Borromini rejects restricted and dogmatic views of classical architecture, seeing it instead as open-ended, full of complexity and contradiction. In reacting to the prevailing more orthodox Vitruvian view of classicism, Borromini was naturally drawn to examples that offered the variety and novelty he so admired, and nowhere was there such a concentration of these as at the Villa.

Borromini's reputation rests solidly on his designs for churches, and four of these, San Carlo alle Quattro Fontane (1634–1641), Sant'Ivo alla Sapienza (1643–1660), Santa Maria delle Sette Dolori (1646), and San Giovanni in Laterano (1646–1650), illustrate the extent to which the Villa stimulated him. His use of the orders in the interior of San Carlo reveals a clear debt to Hadrianic architecture. The seamless columnar screen pressed against the apparently yielding mural structure recalls the free-standing columns of the Water Court nymphaeum both in plan and in details. Borromini adapted the sinuous entablatures and spatial transparancy of the Hadrianic nymphaeum to create a compressed space defined by a dynamic mural system animated by the irregular column spacing. The unusual composite capitals with inverted volutes so prominent at San Carlo were perhaps suggested to Borromini by similar capitals in the Water Court nymphaeum.

Sant'Ivo consciously stands in the tradition of great centralized vaulted spaces that extends back to the Hadrianic Pantheon, an affinity particularly evident

277

278, see 398

277 San Carlo alle Quattro Fontane, composite capital with inverted volutes, print from De'Rossi (1711)

comparison with Sant'Ivo. Luigi Rossini's print captures the billowing, canopied effect of the Hadrianic vaulting that Borromini adapted, rendering it taut and unified. It may even be that the spectacular effects of illumination descending from hidden sources above the Scenic Triclinium axial extension suggested to Borromini the imaginative lighting using mirrors he proposed for the high altar of Sant'Ivo.

Santa Maria delle Sette Dolori is entered by a vaulted vestibule, similar in plan to the octagonal hall of the Smaller Baths and the Reverse-Curve pavilion. In all three structures a centralized space is defined by mural systems composed of alternately convex and concave segments flowing together and forming seamless, sinuous masonry envelopes. Borromini's adaptation and creative transformation of these and other central-plan structures at the Villa cannot have escaped Francesco Contini when he was charged with completing work at Santa Maria delle Sette Dolori in 1659.

Borromini's extensive renovation of the Lateran Basilica prompted a learned contemporary, Cesare Rasponi, to criticize his design for having broken the sound rules of the ancients. One of the features to which Rasponi most vigorously objected was Borromini's use of convex bays to round off the corners formed by the intersection of the nave arcades with the entrance wall. In reply, Borromini's friend and patron Virgilio Spada wrote an unpublished memorandum refuting Rasponi's criticism and asserting that Borromini's solution had sound ancient precedent. "The ancients often employed such means," Spada wrote, "as can be seen in the drawings of Hadrian's Villa belonging to Cardinal Barberini, where no fewer than a dozen tempietti composed of curved lines may be seen." The drawings to which Spada refers were most likely the preparatory studies for Francesco Contini's plan of the Villa, which, as we have seen, was visible in the Palazzo Barberini by the mid-1630s.

The work of Carlo Rainaldi (1611–1691) is also indebted to the Villa. Nowhere is this more evident than in his masterpiece, Santa Maria in Campitelli (1663– 279 1667). Along the central transverse axis the nave opens up left and right into broad, deep chapels, producing a cross-shaped volume. Beyond this main spatial vessel,

when the stepped Sant'Ivo profile is viewed from the nearby dome of the Pantheon. Within Sant'Ivo, however, Borromini's Hadrianic references relate more explicitly to Villa features than to the Pantheon. The hexagonal plan of Sant'Ivo is generated by an equilateral triangle whose sides are extended outward by means of alternately semicircular and trapezoidal volumes, answering one another across the resonant central space in exquisite Baroque counterpoint. Borromini's geometry and his use of a colossal order to articulate the walls, which sinuously contract and expand about the central space, are original and without ancient precedent. But the segmented vault that soars upward and ultimately resolves the energy generated in the lower zone recalls the Villa's gourd or pumpkin vaults.

The Water Court vestibule, though octagonal in plan, is vertically organized like Sant'Ivo. In the vestibule, the alternately semicircular and rectangular niches dilate the central space. The vault was not hemispherical, like the Pantheon, but was divided into concave segments whose lines of intersection rise from columns originally set at the corners of the octagon. The result was an interior of pronounced vertical unity, comparable in essence to Sant'Ivo.

The Scenic Triclinium vault, paneled and gored with concave forms between its meridian curves, also bears

the nave narrows sharply where boldly projecting columns frame a vista to the domed crossing and apsidal sanctuary beyond. The church's enclosing wall narrows progressively from entrance to apse, but in measured steps of expansion and contraction that halt at the narrowest, furthest part of the building. Triads thrive, and dramatic effects of illumination unify a design whose ultimate purpose is to focus attention on a venerated icon centered in the apse wall.

see 91, 76

Two unusual vaulted pavilions at Hadrian's Villa, the Fountain Courts West and East, display similarities in planning, suggesting that Rainaldi studied them in preparing his design for Santa Maria in Campitelli. The original appearance of the Fountain Court West is uncertain, but its ground plan is clear. A primary square volume expands into spacious transverse recesses, once vaulted over but not up to the height of the central vault; symmetrical recesses were also located along the main axis. Beside all four of these, footings for columns stand in the main space, close to the walls. The second space, like the first, is square, was originally vaulted, and is expanded by rectilinear niches. The axis view, framed by two large windows, may by analogy be thought to have focused on a statue placed in the farthest recess. One more connection between Rainaldi's church and the Fountain Court West should be noted: high, narrow vaulted spaces—blind structural corridors—ran transversely between the two Fountain Court main spaces, and at Santa Maria in Campitelli, Rainaldi placed a similar structure, also curved in elevation, over the truncated passageway between the main nave and the domed space beyond.

A neighboring structure, the Fountain Court East, was similarly planned but entered on its axis directly through a convex columnar portico that calls to mind the facade of Pietro da Cortona's Santa Maria della Pace. The main hall had transverse recesses, and beyond it were internal side passages flanking a large axially placed window. Then came the second space, slightly oblong in plan and larger than the first, without niches but with a broad semicircular apse containing a raised platform and statue base.

The Villa structures and Rainaldi's church served

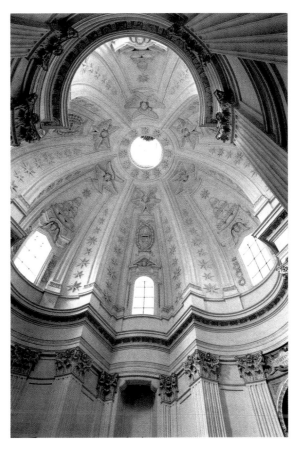

278 *Sant' Ivo alla Sapienza* (*1992*)

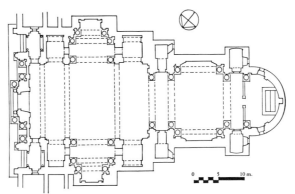

279 *Santa Maria in Campitelli, plan*

different functions, but all three designs embody similar design principles: unified composition made up of hierarchically joined volumes, scenic focus on final climactic elements, and spaces, enlarging and diminishing symmetrically, that underscore the controlling axis. Although no drawings or written accounts document Rainaldi's study of the Villa, the architectural evidence suggests an inspired Baroque translation of an ancient text written in brick and concrete. As with Alexander Pope's translation of Homer, the relation between these ancient pavilions and Baroque churches is emphatically "parallel, tho' not the same."

IX

The Draftsman's Vision

The eighteenth century was the golden age of antiquarian and artistic study at the Villa. More systematic excavations were undertaken, with more spectacular results, than at any time since Pirro Ligorio's explorations in the mid-sixteenth century. Travel between northern Europe and Italy greatly increased following the War of the Spanish Succession in 1714, and the Grand Tour became an important component of a young male aristocrat's education. Although Paris had outstripped Rome as a center of artistic patronage, Rome's unparalleled collections of classical and High Renaissance art ensured that it remained the primary locus of artistic exchange throughout the century.

VEDUTISTI

Visiting the Villa was a somewhat different experience in the eighteenth century from what it had been two centuries earlier in Ligorio's day, when the entire site had been the exclusive domain of the cardinal of Ferrara. In the course of the seventeenth century the ground occupied by the Villa had fallen into the hands of some forty-five landowners, whose tenant farmers cultivated fields and pastured sheep within irregular enclosures, their picturesque outbuildings nestling among the ruins. Some ruins later provided the foundations

for permanent buildings, like the Casino Fede and the casino Liborio Michilli erected over the Service Quarters' north corner. Both buildings stand, Casino Fede functioning as the Villa's administrative center, Casino Michilli serving admirably as the Museo Didattico. Their construction in the early eighteenth century resulted in the discovery of important works of sculpture, which revived interest in the archaeological potential of the site.

Around 1725 Count Giuseppe Fede bought as much of the site as he could, but even within his contiguous holdings — formerly the property of eighteen owners — the ruins were separated both visually and physically by fences and hedgerows. A plan of 1770 conveys a clear impression of how the site was cut up into a mosaic of individual fields. To either side of this plan the draftsman, Giovanni Ristori Gabbrielli, included views of the agricultural structures Fede erected on his estate. In addition to such surviving buildings as the Casino Fede, these *vedute* document others, such as the "Casa de' Vignaroli," which stood beside the North Theatre. The agricultural landscape captured by Ristori Gabbrielli survives almost intact on the periphery of state-owned land, especially in portions of the Northern and Southern Ruins, but more than a century of clearing and excavation has largely eliminated it from the central area of the site.

Count Fede planted the long cypress avenue leading up to the East-West Terrace from below his casino, now one of the most picturesque features of the Villa. In spite

281, 282

280

283

280–282 Count Fede's properties at the Villa, plan by Giovanni Ristori Gabbrielli (1770)

of the count's efforts at consolidation, at century's end the Villa was still broken into seven large private holdings further subdivided by the enclosures of numerous tenant farmers. This explains why eighteenth- and nineteenth-century visitors to the site saw the Villa only in its fragmentary condition and why their descriptions stress the sequential—as opposed to the overall—nature of their experience. Their remarks emphasize the briars and creepers, the snakes and scorpions, and the difficulty of comprehending the site. Luigi Rossini's comments about the Villa are as applicable today to the condition of the ruins beyond state-owned land as they were to the entire Villa in 1826: "At present this Villa is reduced to undergrowth, in many places impenetrable, and to vineyards in which one is not allowed to excavate."

Testimony to the increasing numbers of artists, antiquarians, and foreign travelers who visited the Villa, often on their way to admire the superb water garden of the Villa d'Este at Tivoli, appears in the numerous signatures inscribed on Villa walls and vaults, especially in the cryptoportico of the Peristyle Pool Building. These constitute an impressive listing of mid-eighteenth-century artists, including Sebastiano Conca, Hubert Robert, Quarenghi, and Piranesi. New publications, notably that of Ligorio-Contini in 1751, provide further evidence of increased interest in the Villa. The scholar Charles De Brosses, who visited Tivoli in 1739, seems to have taken Contini's plan with him and to have visualized the Villa as a seventeenth-century French château with gardens in the manner of André Lenôtre, replete with "grands bosquets" and "belles pièces d'eau." De Brosses also comments on discoveries of fine statuary that were made "daily" at the Villa and cites several notable examples he had seen in Rome and Paris.

One of the first eighteenth-century visitors to leave a substantial record of his antiquarian studies at the Villa was the Roman painter Pier Leone Ghezzi (1674–1755). Although Ghezzi visited the Villa repeatedly, his dated drawings indicate that he made at least two extended stays, one in 1724 and the other in 1742. It was during the first of these that most of his archi-

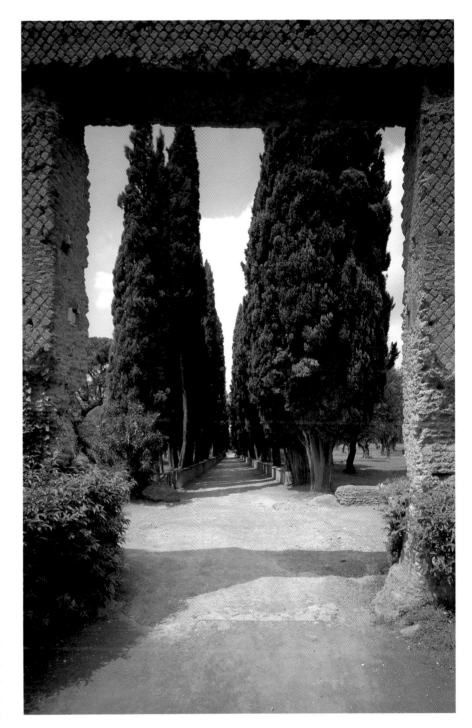

283 *Cypress avenue planted by Count Fede, seen from the Ambulatory Wall (1987)*

tectural views were drawn. Ghezzi was interested not only in the more familiar ruins of the Villa, such as the Island Enclosure, of which he made a measured plan, but also in such lesser-known structures as the North Service Building (represented in six sketches) and the Underground Galleries. His drawing of the Underground Galleries, illustrating how the passages were illuminated by oculuses placed at regular intervals, reveals its basic structure with exemplary clarity. Unlike some antiquarians of his day, Ghezzi was always concerned with recording things "as they actually appear," a frequent comment in his explanatory notes. This may be why, on his second extended visit, he was so put out with the inaccuracy of Contini's plan: "I took with me

the plan made by Contini . . . and finding nothing in it that corresponds to what one sees, I conclude that it is made of ideas."

Another of Ghezzi's drawings, dated 1742, is a meticulous analysis of the masonry technique employed in the construction of a wall at the Villa. He carefully recorded his measurements of the bricks and tufa blocks of which the wall was fashioned and went on to explain how its structure prevented the intrusion of damp and cold. During the same visit he also drew the painted decoration of a niche in the Larger Baths circular room; the sketch records details found in one of Piranesi's drawings in the Uffizi. Ghezzi remarked that the colors had faded from exposure; they are so weathered today that only part of the design can be read, and that with great difficulty. Ghezzi was motivated to document features in danger of vanishing, as is evident from another of his sketches, depicting the Larger Baths stuccoed vault and captioned: "This is a vault adorned by stuccoes and reliefs finished in a marvelous way which may be seen at Hadrian's Villa in Tivoli. . . . At present one sees little because foreigners have stolen the reliefs and the rest has fallen. . . . I made the present record assuming that within a short time there will no longer be any trace of the many beautiful things that exist in this Villa."

In contrast to his analytical renderings, some of Ghezzi's sketches display a more picturesque mode of presentation, as seen in a drawing of 1724 representing the Larger Baths and the Central Service Building. His emphasis on their ruined state, underscored by the shrubs crowning the fallen vaults, is echoed in another caption: "From these drawings of its famous ruins, the skeleton clearly reveals what the body was like."

Ghezzi's sensitivity to the picturesque qualities of the Villa reflected a growing interest in ruins set within a classical landscape. In the seventeenth century, Poussin and Claude had drawn inspiration from the Tivoli countryside. They were joined by the Bambocianti, Dutch painters whose landscapes were less idealized and more concerned with the direct study of nature. Among these artists were Pieter van Laer, Cornelis van Polenburch, and Philipp Peter Roos, called Rosa

284 *Island Enclosure, plan by Ghezzi (1724)*

284
285
see 194
286
287

da Tivoli because he lived for a time nearby, sleeping in a ruin, perhaps part of Hadrian's Villa. In 1627 two of the Bambocianti, Arrigo Blomaert and Nicholas Wolf, wrote their names in the Peristyle Pool Building cryptoportico. More than a century later directors of the French Academy in Rome, especially Nicholas Vleughels and Charles Natoire, fostered an interest in direct landscape study by encouraging the *pensionnaires* to draw from nature and taking them on sketching trips near Rome. In the autumn of 1755 Natoire wrote that his pensionnaires "presently are all scattered drawing in different parts of Rome so as to take advantage of the late autumn; some architects have drawn plans at Hadrian's Villa near Tivoli, where, among the antiquities, they claim to have observed many subjects appropriate for their studies."

By 1756 both Hubert Robert and Jean-Honoré Fragonard were in residence at the French Academy, engaged in formulating a new interpretation of the landscape in which ruins play poetic roles. In 1760 both artists made repeated visits to the Campagna below Tivoli, using as a base the Villa d'Este, which the Abbé de Saint-Non had rented for the summer. Robert's signature, dated 1765, is inscribed on a niche set into the north flank of the Circular Hall. The results of their sketching trips rank among the sublime landscape drawings of any age. In one of Fragonard's views the ruined North Theatre seating forms a concavity embracing a group of ancient cypresses that anchor the composition on the right. The Casino Fede, seen against an enfolding screen of boughs, occupies the center, while to the left several figures emerge from the shadowy depths of the Theatre's vaulted substructures. The airy, arching silhouettes of great trees activate the skyline, completing a compelling image of natural beauty nourished by fragments from the remote past. By the mid-eighteenth century the Villa's remains, rising from a wild and luxuriant setting, encouraged the layout of picturesque landscape gardens in which sham ruins played prominent roles.

Another of Fragonard's sketches captures the embracing concavity of the Scenic Triclinium soaring vault. Robert's drawing of the same structure takes greater liberties, including the invention of coffering

285 *Villa masonry, study by Ghezzi (1742)*

286 *Larger Baths, stuccoed vault, drawing by Ghezzi (1742)*

287 *Larger Baths and Central Service Building, view by Ghezzi (1724)*

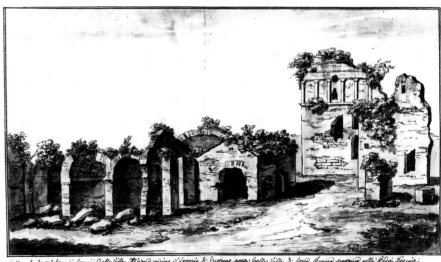

288 *Peristyle Pool Building cryptoportico, signatures of 1627 of Arrigo Blomaert and Nicholas Wolf (1987)*

289 *(far right) Circular Hall, northwest facade, niche, signature of 1765 of Hubert Robert (1987)*

290 *North Theatre, view by Fragonard (ca. 1760)*

291 *(below right) View evoking the Scenic Triclinium, by Robert (ca. 1760)*

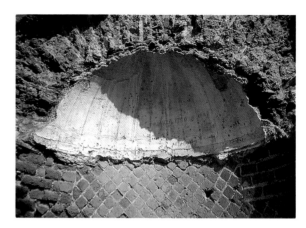

in the vault, where it never existed. Robert also exaggerates the depth of the axial extension in a way that calls to mind his project for enlarging the Grande Gallerie of the Louvre (1796) and his painting of the same gallery in ruins. Robert animates the great Triclinium hemicycle with rustics and transforms its massive overhanging vault into a delicate canopy of vines rustling in the breeze.

292 In 1775 the French painter Louis Chaix sketched a charming view of the Larger Baths. The immediacy of his composition results from its unusual angle of vision, off-center, near the ground, subsuming the viewer. Views like these bring the experience of the Villa close to the modern observer in ways that measured drawings, ground plans, and photographs usually cannot hope to do. They convey a vital immediacy and a sense of the organic interaction between natural forces and man-made structures that are essential ingredients of the place. This is why visitors react to the Villa differently from archaeological sites like Ostia or Pompeii where the bond between nature and artifact has, of necessity, been irreparably broken.

ARCHITECTS

 Interest in the Villa landscape, seen in so many of the vedute, was paralleled in drawings by architects concerned to record its ruins. Many of their efforts at depicting the Villa are virtually indistinguishable from drawings made by painters with whom they visited the site; other measured drawings and ground plans reveal their more specialized interests. Charles-Louis Clérisseau (1722–1820) is a case in point. Clérisseau visited the Villa repeatedly in the 1740s and 1750s, often with other painters, such as Claude-Joseph Vernet, and architects, such as Robert Adam and Piranesi. To judge from one account, Clérisseau drew on his experience of the Villa in an unexecuted project for a garden at Santa Maria di Sala, near Padua. In 1767 he prepared a design for the Abbé Filippo Farsetti, a Venetian prelate who wanted "an extensive garden which would represent the ruins of a Roman imperial residence in the style of Hadrian's Villa near Rome."

292 *Larger Baths, central hall, view by Chaix (ca. 1775)*

 The most pictorial of Clérisseau's drawings after the Villa depicts the Larger Baths rotunda. A fallen fragment of vault coffering anchors the right foreground while a picturesque arrangement of reliefs, architectural fragments, and figures holds down the left. Beyond looms the shadowy concavity of the circular room, its vault pierced by an oculus. Below the vault he takes liberties with the arrangement of niches and openings. He places an ample niche, flanked by smaller portals, at the center, while in reality the disposition is the reverse — a smaller central opening flanked by larger niches. Clérisseau's adjustments were likely determined by his desire to provide a strong focal concavity at the visual terminus of his composition. Comparison with Piranesi's drawing of the same feature is instructive. 293

 Another of Clérisseau's drawings shows the Central Service Building framed by the vaulted lobby of the Larger Baths. Here again he takes liberties. The arched openings of the Central Service Building should extend uninterrupted through the lower two stories, but Clérisseau draws a double arcade. Moreover, the stucco

see 195

294

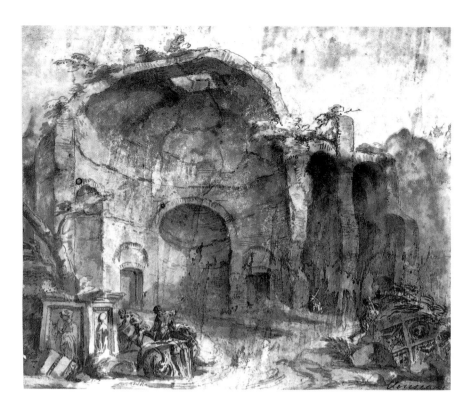

293 *Larger Baths rotunda, view
by Clérisseau (ca. 1756)*

294 *Central Service Building
framed by the stuccoed vault of the
Larger Baths, view by Clérisseau
(ca. 1756)*

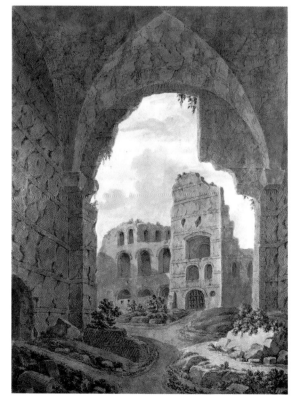

appears to cover the entire vault surface, when in fact by his day it no longer survived.

At least three sketches by Clérisseau depict the vestibule of the Water Court, one viewed on axis from outside the confines of the Court and two viewed obliquely from within. All display subtle uses of modeling to convey the three-dimensional geometry of cylinders and octagons underlying its design. As one would expect of a trained architect, Clérisseau paid close attention to structure, particularly the arches — set into the facets of the drum — that mark the springing of the vault. These sketches probably date from 1756, when he accompanied the Scottish architect Robert Adam and the painter Allan Ramsay to the site. During his Roman sojourn Adam had studied under Clérisseau, and it is no coincidence that his sketches of the same feature resemble those of his drawing master so closely.

295

296

Adam's description of his time sketching at the Villa is worth quoting for its characteristic eighteenth-century flavor. In April 1756, Adam visited Tivoli "to view Hadrian's Villa, make drawings and inspect some people I have working there, as I am making an exact plan of it." It seems that a friend, named Hervey, insisted on accompanying the artists,

protesting that he would not be troublesome to us and that whilst I drew he would sit by me and read, which accordingly he put into execution. *Tom Jones* was the book pitched on as the most proper for such a scene and we hugged the lovely Sophia amidst the ruins of that ancient place and found the weather so fine and the work so agreeable that we stayed there six days, being twice the number intended.

At least twelve sheets by Adam depicting the Villa survive. Several of the drawings not only represent the same subjects depicted by Clérisseau but share compositional similarities, which suggests that they were executed by Adam as exercises in architectural rendering assigned to him by Clérisseau. The similarities are especially striking in two drawings of the Larger Baths. Adam's sketch of the Larger Baths rotunda repeats the alterations Clérisseau made. Adam's view of the Central Service Building framed by the lobby of the Larger Baths, while obviously related to Clérisseau's compo-

297

298, see 294

sition, is more faithful to the subject. Not only does Adam depict the arched openings of the Central Service Building correctly, as uniting its two lower stories, but he also records the gaps in the stuccoes of the framing vault.

In addition to these drawings, Adam made two sketches of the partially fallen Larger Baths cross-vault. Here he experimented with diagonal viewpoints and compositions, one sketch emphasizing the verticality of the space, the other stretching the vault to produce an impression of horizontal extension. Adam's interest in thermal architecture at the Villa is also expressed in two Smaller Baths interior views, one representing the octagonal hall and the other the cold plunges. In an effort to capture the richly varied spatial complexities of these interiors, Adam here introduces other distortions: in the octagonal hall he widens his angle of vision and partly flattens out the sinuous walls, while in his view of the hall with the cold plunges the enveloping walls seem to be projected onto a concave surface rather than onto a flat plane. At the time he made these drawings, Adam was contemplating a publication on Roman baths, a subject he eventually set aside to pursue his interest in the remains of Diocletian's Palace at Split. The influence of this early interest in baths may be seen in his subsequent domestic designs, in which a remarkable variety of different geometrically configured rooms are arranged to form rich spatial sequences.

Two of Adam's three sketches depicting the Water Court vestibule closely resemble one of Clérisseau's drawings, and may, like those of the Larger Baths, have been drawn at Clérisseau's recommendation. The third, which brings the viewer close into the area once covered by the vestibule, arbitrarily depicts some of the bays in violent foreshortening to convey the curvature of the walls, with the result that the bays seem to be of different size when in reality they are equal. Two more sketches reveal Adam's relative inexperience as a draftsman: his view of the Circular Hall fails to capture the animation of that structure's curving plan, and the manipulation of perspective in his drawing of the Fountain Court West produces distortions of scale and space. The last of Adam's sketches, a view into the

299
300

301

302

303, 304

305

306

307
308

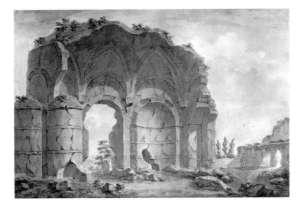

295 *Water Court vestibule, interior, view by Clérisseau (ca. 1756)*

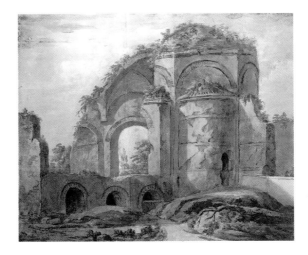

296 *Water Court vestibule, exterior, view by Clérisseau (ca. 1756)*

297 *Larger Baths, rotunda, view by Adam (1756)*

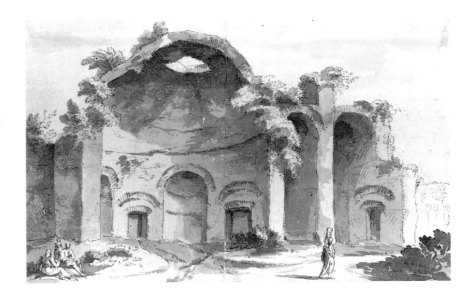

298 (top left) Central Service
Building framed by the stuccoed
vault of the Larger Baths, view by
Adam (1756)

299 (top right) Larger Baths,
central hall, looking northwest,
view by Adam (1756)

300 (bottom right) Larger Baths,
central hall, looking northeast,
view by Adam (1756)

301 (bottom left) Smaller Baths,
octagonal hall, view by Adam (1756)

302 (opposite, top) Smaller Baths,
room 13, view by Adam (1756)

303 (opposite, center) Water Court
perimeter wall and vestibule,
looking south, view by Adam (1756)

304 (opposite, bottom) Water
Court vestibule, exterior, view by
Adam (1756)

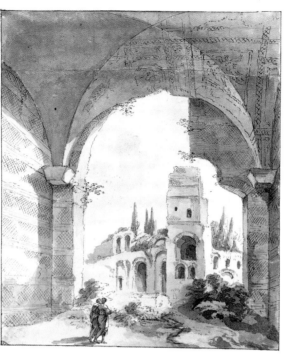

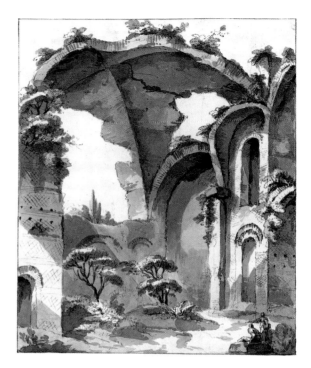

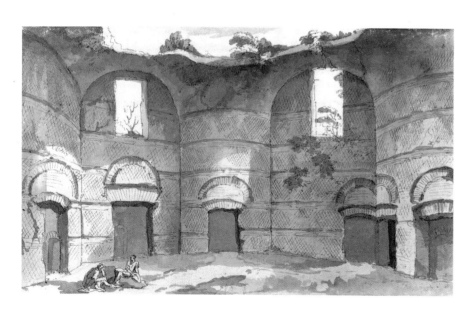

Scenic Triclinium axial extension, displays a mastery of see 341 chiaroscuro bearing comparison with that of Piranesi's later, etched view. Adam's use of foreground figures in this and his other sketches also evokes Piranesi, though Adam's pastoral shepherds are more classically proportioned and deployed than Piranesi's attenuated rustics and posturing tourists.

Among the numerous drawings generally attributed to Adam's office is a tracing of Ligorio's Southern Range plan. The draftsman has taken great pains to record every detail of the original, including inscrip-see 263 tions. Ligorio's drawing had belonged to Cassiano dal Pozzo, whose collection eventually passed to Cardinal Alessandro Albani. Albani allowed artists and architects access to his library, where Adam probably copied it. In 1762 Adam's brother James secured the Albani drawings for George III and they entered the Royal Library at Windsor. Adam's copy is notable in documenting his interest in others' work at the Villa; it also illustrates how Rome provided foreign architects opportunities to confront both its ancient monuments and their associated artistic and antiquarian traditions.

Adam's Villa drawings exhibit a freedom and creativity appropriate to a young architect in training, eager to stockpile an inventory of forms to which he might refer later when formulating designs. For this reason, his sketches are rather summary in execution, capturing essential relations of mass and space, light and shade, eschewing the formality and details of measured surveys. His motivation is clearly architectural rather than antiquarian.

The difference between these attitudes is evident in see 157, 159 three prints illustrating the South Theatre published in see 160 1753 by the Italian architect Giuseppe Pannini. They are dedicated to Cardinal Silvio Valenti, who served as secretary of state and inspector of antiquities under Pope Benedict XIV. In his capacity as inspector Valenti commissioned Pannini, the son of the well-known view painter Gian Paolo, to undertake a thorough investigation of the South Theatre. Pannini's measured drawings were etched by Paolo Fidanza, whose plates include extensive captions illuminating Pannini's method and aims:

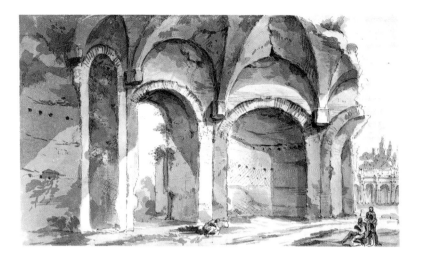

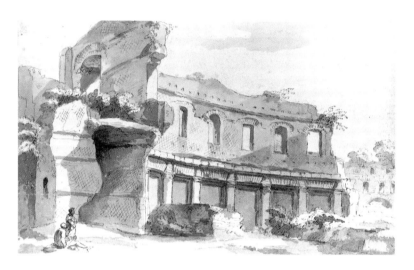

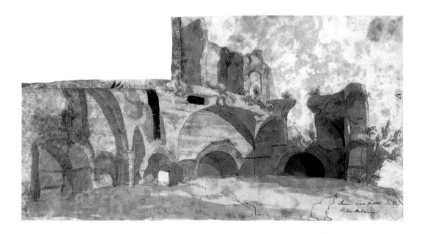

Following your orders, and having moved to Tivoli in order to study the Scenic Theatre newly revealed among the ruins of Hadrian's Villa, I took its measurements and established its plan and section with that degree of exactness that the present state of the edifice permitted. In spite of the fact that part of it has been destroyed by time, enough evidence remains to permit me to reconstruct its original appearance with moral certainty. In order to accomplish this task with greater precision, I had to dig deep trenches to identify the remains of the foundations, which I found capable of supporting a double colonnade of granite and giallo antico of the Composite Order in front of the scene wall, as was seen in the time of Pirro Ligorio and Francesco Contini, who mention it.

The first of the three folio-sized plates contains the plan of the South Theatre accompanied by an elevation of the seating and the circular shrine in their ruined state. The second print presents three elevations of the Theatre: a reconstruction of the seating and shrine that corresponds to the elevation on the first plate, an elevation of the scenae frons as it then stood, lacking its columnar screen, and a reconstruction of the scena with its two-tiered portico restored. The third print includes a perspective view of the Theatre seen from the north, with the stage building cut away to reveal the full extent of the orchestra. Below this scene Pannini provides measured details of the seating, the orders of the scena, and the torso of a statue presumably found during his investigations.

Pannini's primary concerns were to record accurately what he found on the site and to reconstruct plausibly the original appearance of the building on the basis of careful examination of the fragmentary remains. Both his archaeological method and his antiquarian aims are substantially different from Adam's creative and architectural motivations. Pannini's mechanical abstraction of architectural form, along with Fidanza's hard-edged technique, combine to produce images that appear dry and lifeless in comparison with Adam's more animated sketches, full of texture and of dramatic chiaroscuro. Indeed, the spare geometrical abstraction of the Theatre shrine reconstruction calls to mind some of Giuseppe Valadier's essays in neoclassical church design more than a generation later.

In spite of their limitations, Pannini's prints of the South Theatre are a watershed in Villa studies. For the first time, published measured drawings and reconstructions of a major Villa architectural feature reached the public. In this sense Pannini's modest study prefigured the archaeological monographs devoted to Villa structures, such as recent ones on the Stadium Garden and the Island Enclosure.

A decade after Adam's study at the Villa another Scot, Charles Cameron (ca. 1740–1812), visited the Villa in the course of a stay in Rome between 1766 and 1769. Like Clérisseau before him, Cameron was later called to Russia by Empress Catherine the Great, whose attention was caught by his sumptuous publication of 1772, *The Baths of the Romans*. Cameron reproduced Palladio's reconstructions of Roman baths, adding to them measured drawings of his own and many of decorative details. As an ornamental coda, he included a group of plates representing stucco ceilings, seven of which he assigned to the Villa.

It had long been thought that these stuccoes reproduced by Cameron and later by Nicolas Ponce recorded ceilings, traces of which had survived into the eighteenth century but had since been lost. In fact, however, Cameron's designs were adapted from the inventions of Francesco Bartoli (ca. 1675–ca. 1730). Hundreds of Bartoli's drawings were collected by Richard Topham and deposited at Eton in 1737, and often consulted by artists and architects. Included among the Eton subjects are three entire walls, twenty-one figural paintings, and twenty-five mosaic pavements and ceilings purportedly from the Villa. We now know, however, that none of these is reliable: "Bartoli absorbed impressions of Roman vault decoration from personal observations and drawings by others, and recombined the elements to create a design that was entirely his own." Although Cameron's prints reconstructing ceilings at the Villa are not reliable, his enthusiasm for Roman stucco, together with the Renaissance ornament he studied in Rome, formed the basis for his rich plastic style of mural and vault decoration so much in evidence in his Agate Hall at Tsarskoye Selo, a vision of Roman splendor designed for the empress.

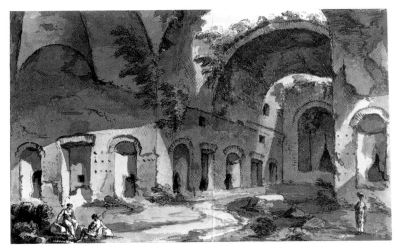

Interest in the Villa continued in the 1770s. The British architect Thomas Hardwick (1752–1829), a pupil of Sir William Chambers, accompanied by the painter Thomas Jones and a certain "Signor Giacomo," visited the Villa in the fall of 1777. According to Jones's account, "Late in the Evening Hardwick and Sig'r Giacomo, both of them Architects, arrived at the same house [in Tivoli] from Rome, we sup'd and passed the night very agreeably." Jones relates that on the next day he "went with Hardwick and Giacomo attended by our Cicerone with a basket of provisions down to Villa Adriana where we took the dimensions of some of the Apartments, made sundry sketches, and dined." Several of Hardwick's Villa sketches survive; moreover, two drawings made by his companion the Bergamask architect Giacomo Quarenghi (1744–1817), who later practiced extensively in Russia, have also been identified.

One of Hardwick's drawings provides a revealing comparison with a sketch by Quarenghi. The central feature of Hardwick's composition is a measured plan of the Scenic Triclinium, with a frontal elevation to the right of the plan. Ranged above are partial sections of other ruins, including the Smaller Baths, the Apsidal Hall, and the Fountain Courts East and West. Hardwick's precisely rendered elevation of the Scenic Triclinium is remarkably similar to Quarenghi's spontaneous sketch, drawn on the site, prompting speculation that Hardwick may have copied it. Quarenghi's other sketch of the Villa, depicting the South Theatre, is similarly spontaneous. Here he emphasizes the corrugated

305 *(opposite, top) Water Court vestibule, interior, view by Adam (1756)*

306 *(opposite, center) Circular Hall, view by Adam (1756)*

307 *(opposite, bottom) Fountain Court West, looking east, view by Adam (1756)*

308 *(above) Scenic Triclinium, axial extension, view by Adam (1756)*

309
310

311

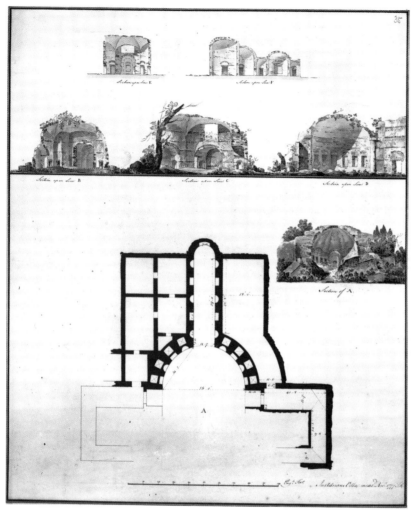

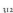

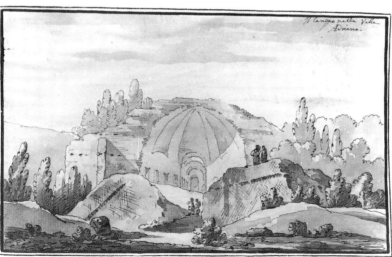

texture and ochre coloring of the Theatre shrine, framing a vista across the Campagna to Rome, where the dome of Saint Peter's projects above the horizon. A watercolor sketch of the same feature by John "Warwick" Smith, dated 1795, employs transparent washes to capture the warm tonalities of the ruined masonry and the sweep of the distant prospect.

Hardwick no doubt felt entitled to incorporate Quarenghi's Scenic Triclinium view within his own more formal composition because the two friends had sketched together at the Villa. Sketches by John Soane (1753–1837), drawn two years after Hardwick's, illustrate how such drawings circulated. Soane and Hardwick collaborated for a time in Rome in 1778, when Soane very likely saw Hardwick's drawings after the Villa. The two had a falling-out; Hardwick returned to England in May 1779. Soane's plan of the Larger and Smaller Baths is dated 1780, suggesting that it and other measured drawings of Villa structures may have been made after drawings in Quarenghi's possession. These sheets admirably illustrate the critical role drawings played disseminating information about the Villa and the way the site itself, by attracting architects from throughout Europe, facilitated the exchange of ideas and theories of design. The vaulted interiors of Soane's Bank of England and design for a royal palace in Hyde Park owe more than a little to his understanding of the Villa, even if they were based on Hardwick's and Quarenghi's studies.

Although most of the artists and architects who visited the Villa in the eighteenth century seem to have contented themselves with drawing a few of its more spectacular features, shortly after mid-century more comprehensive surveys arose. It is a singular fact that, unlike the principal monuments of Roman architecture in Rome, for which plans and elevations were available in numerous publications, no measured drawing of a Villa building had been published in the first three centuries that followed its rediscovery. Drawings after the Villa circulated, but to judge from architectural treatises and standard collections of plates illustrating and reconstructing Roman buildings the Villa might never have existed. Although the formidable problems posed

by the site contributed to the lacuna, the Villa simply did not lend itself to illustrating the fine points of Vitruvian classicism. Knowledge of the Villa therefore tended to come either from direct experience or from the dispersal of drawings made on the site. The sense of amazement and discovery aroused in those architects who visited the site undoubtedly intensified the Villa's impact.

In the second half of the eighteenth century at least four separate efforts were made to remedy this situation with accurate surveys. Three of these, attempted by architects at the French Academy in Rome, were never printed; important portions of a fourth survey, carried out by Piranesi, appeared between 1766 and 1781.

By the 1750s Piranesi was eagerly sought by and in close touch with French architects. Today he is often regarded primarily as a printmaker and antiquarian, but in his day Piranesi was recognized as a creative architect, and his provocative designs, such as his fantasy plan for a *Magnifico Collegio*, influenced a new generation of architects, especially in France. One such group, perhaps at the suggestion of Piranesi or Clérisseau, was preparing a survey of the Villa in 1754–1756. Marie-Joseph Peyre (1730–1785), Peyre's brother-in-law, Pierre-Louis Moreau-Desproux (1727–1793), and Charles de Wailly (1730–1798) collaborated on the survey, which apparently was never finished. Sebastiani, writing early in the nineteenth century, relates that the three architects worked

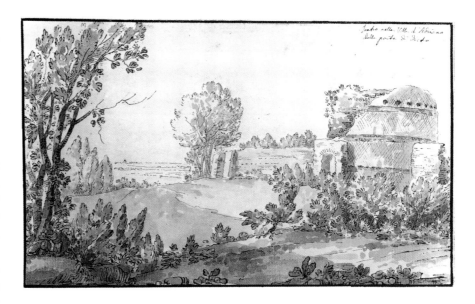

with incredible devotion, frequently for days at a stretch over a period of several years. The preliminary sketch of their plan was drawn to the scale of about one fathom per league, embracing an area 625 fathoms long by 325 wide [ca. 1,120 × 600 meters], all full of buildings. But either because the plan was surveyed at different times or because it proved too difficult to identify the structures linking one building to another, they were unable to join the separate parts together and for this reason the plan was never published.

Reflections of this work may be found in plans of Villa structures by Laurent-Benoît Dewez (1731–1812) and Pierre-Adrien Pâris (1745–1819). In 1756 de Wailly and Moreau-Desproux were asked to draw the Doric Temple soffit in an attempt to resolve contradictory interpreta-

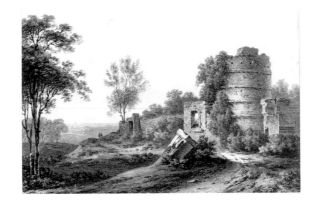

311 *South Theatre, looking west, view by Quarenghi (1777)*

312 *South Theatre, looking west, view by Smith (1795)*

309 *(opposite, top) Scenic Triclinium, plan and frontal elevation by Hardwick (1777)*

310 *(opposite, bottom) Scenic Triclinium, view by Quarenghi (1777)*

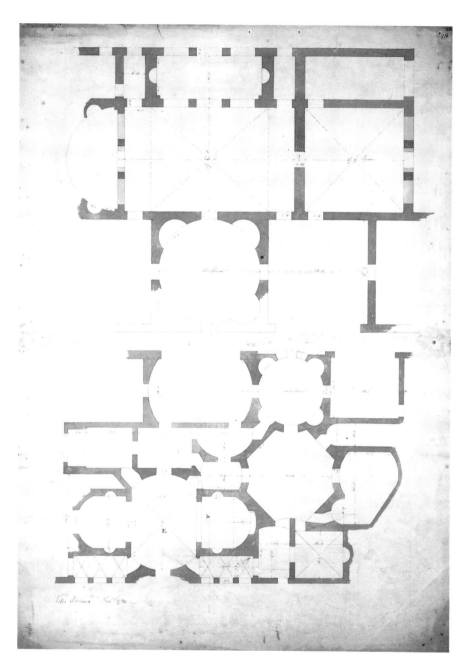

313 *Larger and Smaller Baths, plans by Soane (1780)*

tions of Vitruvius's passage on the Doric order found in the publications of Perrault and Blondel. Clérisseau owned a plan of the Villa that was offered for sale after his death in 1820. Because it is lost it is impossible to say whether the plan represented his own work on the site or reflected the survey of his younger French colleagues.

The influence of the Villa is evident in Peyre's early projects as well as in the buildings de Wailly designed after leaving Rome. In 1756, while in Rome, Peyre designed an Academy based in almost equal measure on Piranesi's *Magnifico Collegio* and on the Villa. Perhaps the most remarkable feature of the Academy project is Peyre's use of rooms of different shapes and sizes compressed to form cellular configurations of great geometric variety, reminiscent of the Smaller Baths. Around 1763 similar dispositions begin to appear in French domestic design, representing a shift from reliance on the simple enfilade to complexities of interlocking rooms. In the *Oeuvres d'architecture* (1765), Peyre singled out the Roman use of service corridors below ground and imaginative toplighting for ground-floor rooms, both present throughout the Villa, as features particularly worthy of imitation. The central court of de Wailly's Château de Montmusard (designed in 1764 but never completed), appropriately labeled "Temple d'Apollon," is an inspired columnar allusion to the Circular Hall, while his unexecuted design of 1782 for the Château d'Enghien, near Antwerp, features an ornamental pool inspired by the Scenic Canal.

In 1762 Jacques Gondoin (1737–1818), a pupil of Blondel, seems to have taken up the survey begun by Peyre, Moreau-Desproux, and de Wailly. Three Villa graffiti bear witness to his intense work there in 1762– 1763. From one of these graffiti it appears that Gondoin was assisted by a man from Tivoli. Quatremère de Quincy's account of Gondoin's project clearly indicates its vast scope:

314–316

The complex of ruins [forming Hadrian's Villa] occupies several square miles. Establishing the locations and the relationships of all these monuments to one another, restoring elevations to the plans, working with a chain measure through this labyrinth of debris required a special genius, almost of divi-

nation. Moreover, to proceed successfully with such a survey one should possess the terrain [to be measured]. M. Gondoin resolved nothing less than to acquire the land, and he would have done so had innumerable obstacles not intervened. He persisted in gathering within his portfolios every detail that the nature of the site allowed him to record. Then, with a rare generosity, he gave them to his friend Piranesi, who was then occupied with a similar project.

Gondoin's plan may be reflected in the work of a Danish architect, C. F. Harsdorff, who made eighteen measured plans of the ruins at the very time Gondoin was working at the Villa. Although many of these plans record such major complexes as the Island Enclosure, Water Court, and Scenic Triclinium, others document less familiar ruins, such as the Southern Hall, Central Vestibule, and North Service Building. The comprehensiveness of his drawings, their French inscriptions, and their date of execution (1762–1763) strongly suggest that they may either be copies of Gondoin's site studies or were prepared in collaboration with him.

After leaving the incomplete results of his survey in Piranesi's hands, Gondoin returned to France, where he designed such classical buildings as the Ecole de Chirugie in Paris (1769–1775), which included a nymphaeum-like fountain of Aesclepius. In the years before the French Revolution Gondoin must have prospered, if, as his biographer reports, he tried to buy the entire Villa site when he returned to Rome in 1775. He eventually retired to his country estate on the Seine at Vives-Eaux, near Melun. Here, according to Quatremère de Quincy, he "retired from the world in the midst of the woods that surrounded him, and spent his whole time in giving his tastes and studies an asylum worthy of the arts, which became for him in a small scale what the Emperor Hadrian had made on a large scale, the abridged collection of all the memories of his journeys." On the eve of the Revolution the terraces, cascades, and parterres of Vives-Eaux had been laid out, though the house was unfinished. Gondoin survived the Terror by masquerading as the poor gardener of the estate, living on the grounds and patiently awaiting the end of the Revolution. His château and gardens at Vives-Eaux have not survived, but they were not the last evocation of Hadrian's Villa to be laid out in France.

317

314 *Residence Quadrangle, cryptoportico at northwestern corner, signatures of 1763 of G. B. Piranesi and Jacques Gondoin (1988)*

315 *(left) Peristyle Pool Building cryptoportico, southwest corner, Gondoin's signature of 1763 (1987)*

316 *Fountain Court West, upper chamber, Gondoin's signature of 1763 (1987)*

317 *Southern Hall, plan by Harsdorff (early 1760s)*

PIRANESI AND ARCHAEOLOGY

Of all the artists, archaeologists, and architects who have studied Hadrian's Villa throughout the past five centuries, Giovanni Battista Piranesi emerges as the most inspired interpreter. Piranesi first visited Rome in 1740 at the impressionable age of twenty, and he never recovered from the experience. After settling permanently in Rome in 1747, he devoted his life to the systematic investigation of the city, especially its ancient monuments. He transformed the medium of etching, producing powerful images of unparalleled detail, size, and grandeur. These prints circulated widely, both as loose sheets and as bound volumes; some, like the *Antichità romane* (1756), brilliantly synthesized the antiquarian erudition of the preceding three centuries.

Through Piranesi's indefatigable labor, generations of scholars, tourists, architects, and armchair travelers never fortunate enough to visit Rome themselves came to see the city, and to understand Roman architecture, through his remarkable vision.

For three hundred years following the rediscovery of the Villa the authority of Roman architecture remained unchallenged across Europe. Architects might disagree over which examples were most relevant and about their interpretation, but there was universal agreement that the study of Roman remains—on the site or through publications—constituted an essential part of their professional training. For all practical purposes ancient architecture meant Roman architecture, for it was Roman sites that were accessible and published, by no one more systematically and analytically than Piranesi. The primacy of Roman principles of design began to be debated by the middle of the eighteenth century, however. The increased awareness of ancient Greek monuments brought about by the publications of the Comte de Caylus, Le Roy, and Stuart and Revett led architects to stress the noble simplicity of Greek architecture at the expense of the more complex Roman achievement.

Architectural theoreticians such as Marc-Antoine Laugier, following the lead of the philosopher Jean-Jacques Rousseau, urged a return to primal sources. The presumed origins of architecture in the Greek orders and the primitive sources of Greek temple design were viewed as honest and straightforward, while Roman architecture, which often employed the orders for decorative as well as structural purposes, were criticized as lacking clear relations between form and function. From this premise there developed a revolutionary new aesthetic, Neoclassicism, that valued rationalism over invention, simplicity over complexity. Piranesi reacted with polemic statements, asserting the historical and aesthetic primacy of Roman architecture over Greek. This preoccupation extended to the end of his life, when, already ailing, he traveled to Paestum to study its celebrated temples in order to establish that they were Etruscan rather than Greek and therefore the legitimate precursors of Roman monuments. Few have noticed

that at precisely this time Piranesi was also engaged in publishing a Roman site, Hadrian's Villa, which for him had come to represent the ultimate expression of the vitality and variety embodied in Roman architecture.

Piranesi's printed views of the Villa are well known, but scholars have tended to view them in isolation from his other efforts at recording its remains. Substantial evidence exists to support the view that in the last years of his life he was preparing a comprehensive publication of the Villa which was to have been the summation of his long study of Roman architecture. His death in 1778 came before he could complete the vast project, with the result that significant parts of this study were either lost or remained unpublished, while other fragments issued posthumously by his son, Francesco, have been generally ignored. Focusing on the great plan of the Villa published by Francesco in 1781, we attempt to reconstruct the intended organization, scope, and goals of the project.

318 Piranesi's interest in the Villa peaked just before 1778, but he worked there throughout his life. A graffito of 1741 in the Peristyle Pool Building cryptoportico documents his presence a short time after his arrival in Rome. In the 1740s and 1750s he made repeated sketching expeditions to Tivoli, often in the company of such foreign artists as Clérisseau and Adam. Piranesi's biographer Jacques-Guillaume Legrand provides a colorful account of one such outing to the Villa, which can be dated within the period 1743–1753, when Piranesi was accompanied by both Clérisseau and the landscape painter Claude-Joseph Vernet. Legrand recounts that in drawing and measuring the Villa they

were obliged to cut their way through the undergrowth with hatchets, and then to set fire to the area they had cleared so as to burn out the snakes and scorpions. These precautions, so necessary in order to draw in peace, were no less valuable than a license for sorcery would have been with the local rustics; for until the inhabitants grew used to their presence, if no one harmed the artists it was because no one dared to come near them.

Toward the end of his account, in describing the last years of Piranesi's life, Legrand reports that when drawing at the Villa, Piranesi and his assistants "were always

318 *Peristyle Pool Building cryptoportico, G. B. Piranesi's signature of 1741 (1981)*

up at sunrise, satisfied with a frugal meal and a straw mattress placed in the midst of the rich fragments." A damaged graffito of 1765 situated in a half-buried corridor of the Residence stresses the difficulty of the work: "G. B. Piranesi restudied these ruins to discover and draw the plan . . . an almost impossible task because of the great exertion and suffering it entailed."

see 314

Other graffiti attest to the activity of Piranesi's collaborators. One in the eastern arm of the Residence Cryptoportico is a memento left by the architect Benedetto Mori ("B. Mori from 1769 to 1774"), who assisted Piranesi during the last twelve years of his life. The name of Francesco Piranesi, followed by the date 1771, records the presence of the artist's son, thirteen at the time. These graffiti document intense work on the site between 1765 and 1774, and confirm Legrand's assertion that the Villa plan was the fruit of ten years' work.

319

The time and effort Piranesi invested in surveying the site must have been immense. When the Villa plan of 1906 was drawn, it took a team of forty student engineers six months to survey less than half the area covered by Piranesi's. If, as Quatremère de Quincy relates, Gondoin presented Piranesi with his incomplete results, they may have saved him time by allowing him to check his measurements against them.

In 1781, three years after Giovanni Battista Piranesi's death, his son, Francesco, issued the great plan entitled *Pianta delle fabriche esistenti nella Villa Adriana*. Piranesi scholars have neglected the plan because of its attribution to the less gifted Francesco, and archaeologists have dismissed it as a work of fantasy. New evidence, however, shows the plan to be substantially the work of Giovanni Battista Piranesi, deserving recog-

*319 Peristyle Pool Building
cryptoportico, F. Piranesi's
signature of 1771 (1987)*

320–326

*320 Villa plan, published by
F. Piranesi (1781)*

nition as the watershed study of Hadrian's Villa and a key document in the history of archaeological site description.

Piranesi's plan is printed on six folio sheets, and these, when mounted together, extend over 3 meters. The large scale of the plan (1 : 1000), together with Piranesi's unparalleled etching technique, permitted him to delineate every component of the Villa in detail.

A small portion of the plan representing the Water Court, here printed to scale, illustrates the wealth of information Piranesi presents. Sophisticated conventions—solid lines for existing structures, lighter ones for missing features—allow distinctions to be made between verifiable remains and conjectural reconstructions. These distinctions are evident in the Water Court nymphaeum and are also employed to indicate the theatre invented by Contini. Piranesi employed dotted lines to distinguish between the elaborate system of subterranean roads, corridors, and chambers and the ground-level structures.

327

Viewed together, the six grand plates that comprise the *Pianta* vividly convey a sense of organic relations between the architectural features of the Villa and the terrain. The great area covered by the plan (the north-south dimension measures more than 2 kilometers) ensures that the landscape dominates, though it does not obscure, the architecture. Here Piranesi the architect and planner, perhaps influenced by his contemporary Giambattista Nolli, emphasizes the topography of the Villa. In contrast to Contini, Piranesi manipulates shading masterfully to cast into relief the valleys and ridge lines that define the site. It should be noted that the contours of the site are illuminated not from one direction only, as if by the sun, but from several directions at once.

Another of Piranesi's illusionistic touches is immedi-

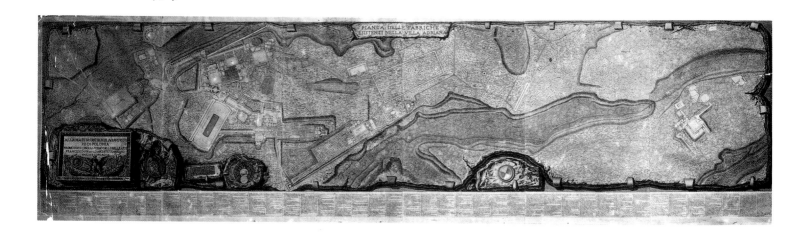

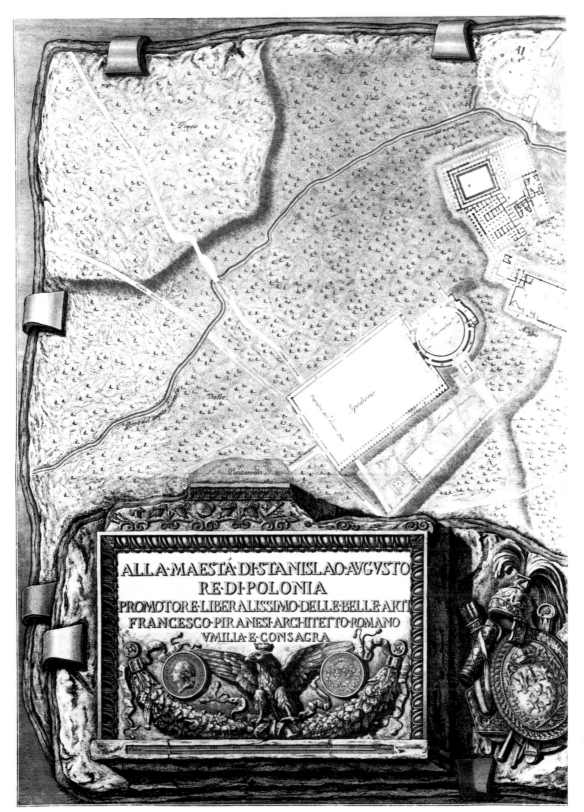

321 *The Piranesi plan, pl. I (1781; Getty Center, Resource Collections)*

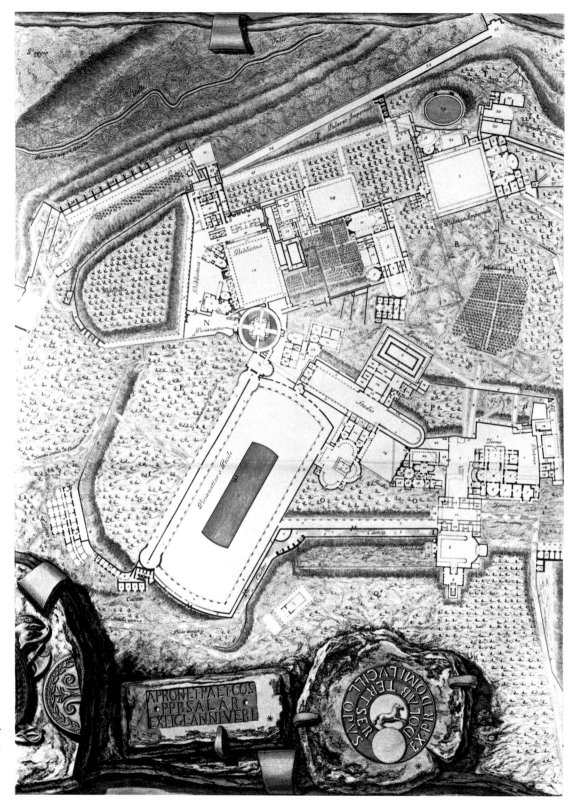

322 *The Piranesi plan, pl. II
(1781; Getty Center, Resource
Collections)*

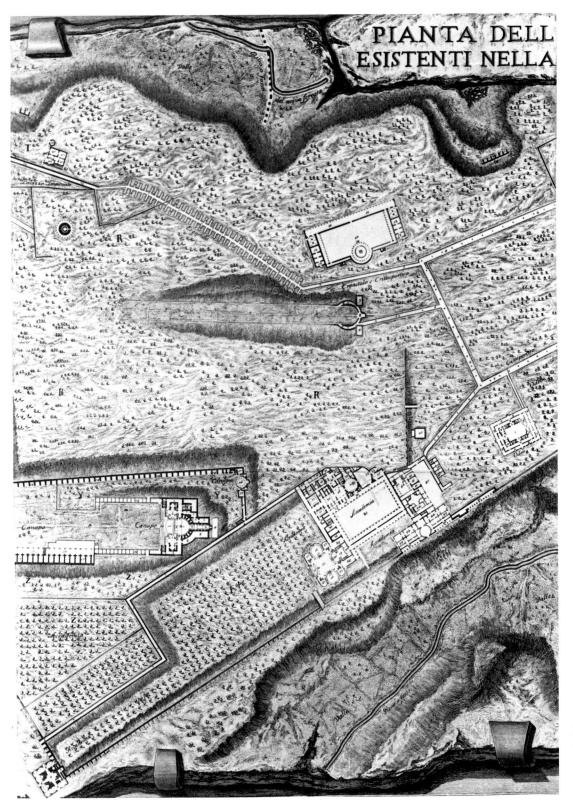

PIANTA DELL
ESISTENTI NELLA

323 *The Piranesi plan, pl. III
(1781; Getty Center, Resource
Collections)*

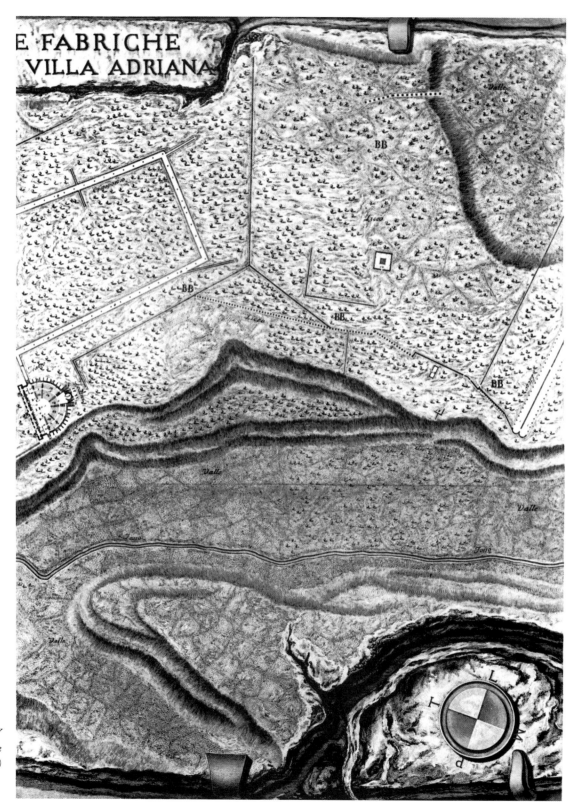

324 *The Piranesi plan, pl. IV*
(1781; Getty Center, Resource
Collections)

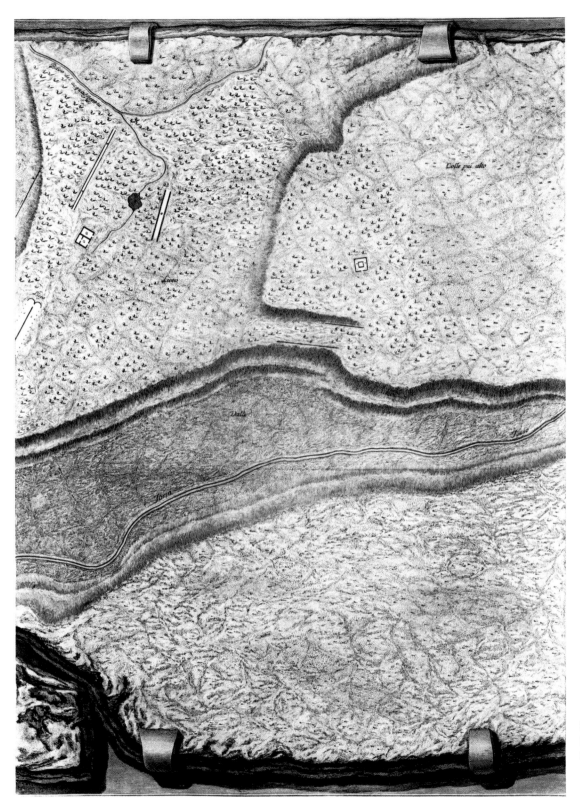

Colle più alto

Luco

Valle

Fosso

Fosso

325 *The Piranesi plan, pl. V
(1781; Getty Center, Resource
Collections)*

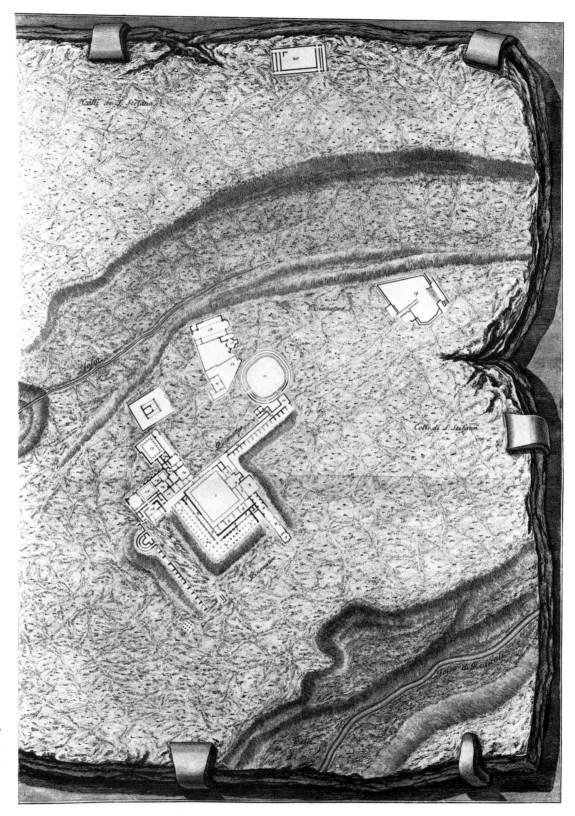

326 *The Piranesi plan, pl. VI
(1781; Getty Center, Resource
Collections)*

ately evident: the entire plan appears to be inscribed on a long marble slab, its worn and irregular borders secured to a wall by metal cramps. This is an obvious reference to the great Marble Plan of ancient Rome, fragments of which inspired Piranesi's site descriptions after 1756. The apparently thick edges of the slab play against the regular borders of the *Pianta*'s plates, enhancing the illusion that the plan is incised on marble rather than printed on paper. Piranesi further emphasizes this effect by superimposing other fragments, such as the dedicatory inscription and brickstamps (at the bottom of plates I and II) and the Doric column drum and base inscribed with the compass points (at the bottom right of plate IV), on top of the main slab.

The wealth of graphic information on Piranesi's plan is greatly complemented by an extensive commentary of 434 entries (transcribed in our appendix), which provide identification and analysis of almost every Villa feature. The Commentary far surpasses those of Ligorio and Contini. It organizes the remains of the Villa into twenty-one nodes or areas, each of which is introduced and then examined in detail, often room by room. The information it contains divides into four categories: identifications based on presumed functions of the remains, often fanciful; full and usually accurate descriptions of each feature, frequently recording details since lost; valuable records of find-spots of works of art; and indications of the property ownership of each area, from which it is possible to reconstruct how the site was divided in Piranesi's day. This original and magisterial document, every phrase of which conveys the authority of Piranesi's antiquarian erudition and polemical passion, is not the work of the twenty-three-year-old Francesco.

The Commentary raises questions of authorship relevant to the plan as well. Francesco's signature and the date of publication—three years after Piranesi's death—have, until recently, naturally caused scholars to attribute the *Pianta* to the son. A remarkable preparatory drawing in the Certosa di San Martino in Naples, with notes and passages in Giovanni Battista's hand, leaves no doubt that he, not Francesco, designed the *Pianta*. We are convinced that Giovanni Battista etched

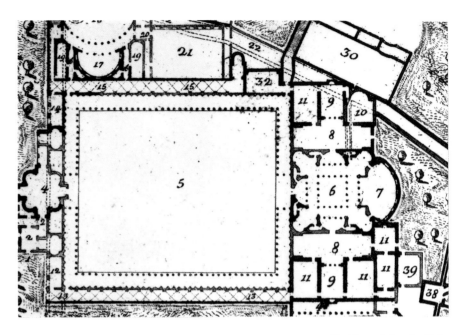

327 *The Piranesi plan, detail of pl. II, the Water Court, printed to size (1781)*

the plates, except for certain details, such as the dedication to the king of Poland, which were added by Francesco. And in comparison with Francesco's rather heavy-handed rendering of comparable subjects, such as his plan of Pompeii (1785), the *Pianta* appears more richly textured, relying for effect on subtle gradations of line thickness rather than on overwhelming chiaroscuro contrasts.

The Naples drawing sheds important light on the background of Piranesi's published plan of the Villa. It has been exhibited twice since its identification in 1938, but its implications haven't been followed up; in particular, it has never received scrutiny in relation to the *Pianta*, for which it is clearly a preparatory study. This enormous drawing is identical in scale to the published plan, and its six large sheets correspond exactly to the *Pianta* plate divisions. The second of the six joined sheets bears the date 1777, which, together with extensive passages in Giovanni Battista Piranesi's hand, effectively eliminates any question about his responsibility for the *Pianta*'s overall design. When viewed close-up the Naples drawing is seen to be a palimpsest, showing successive layers in different media, in addi-

328

329

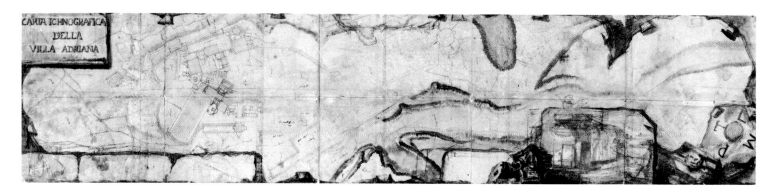

328 *The Piranesi plan, Preparatory drawing (1777); permission granted by the Ministero per i Beni Culturali e Ambientali*

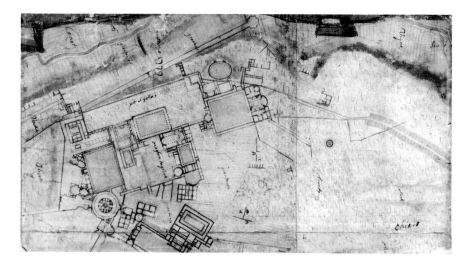

329 *The Piranesi plan, preparatory drawing, details of the Island Enclosure, Water Court, Park Rotunda, and other Villa structures (1777); permission granted by the Ministero per i Beni Culturali e Ambientali*

332 *(opposite, bottom) The Piranesi plan, preparatory drawing, details of the Underground Galleries, South Theatre, Platform Structure, and Park Grotto (1777); permission granted by the Ministero per i Beni Culturali e Ambientali*

tion to erasures, cancelations, and notations written in several hands. If the relation of the preparatory drawing to the published plan is to be properly understood, the mixture of media and hands needs sorting out.

To our eyes four principal stages or phases are present in the drawing. The first is the most refined, consisting of the precise delineation (laid out in fine black pencil with drafting instruments) of the principal Villa buildings. It represents the initial transfer, perhaps by Benedetto Mori, of the numerous measured drawings executed on the site. Also at this time were added the most important topographical features, including the watercourses of the East and West Valleys (rendered in blue wash) and the major terraces (in yellow wash). This initial stage appears to have been followed by a masterful freehand rendering in gouache of the feigned marble borders, cramps, and decorative flourishes, undoubtedly by Giovanni Battista. At this time the title was drawn over the underlying survey, as were striking architectural fragments and the view of the Tomb of the Plautii, all illusionistically shown as if drawn on separate sheets of paper laid over the fictive marble slab.

In a third stage Piranesi made corrections and added notes in red chalk. For example, he shifted slightly the position of the wind rose and made numerous notations of land use (for example, "vigne, oliveti, granoturco") as guides for etching the conventions for different plantations on the copper plates. He also added other suggestions (for example, "per regola, più basso, scuro più profondo") about adjustments to be made in etching

the plates. In the fourth and final stage, another hand—using a fine steel pen—inked in some architectural features, assigning to them numbers corresponding to the Commentary of the printed plan.

If we read the evidence correctly, shortly before his death in 1778 Giovanni Battista supervised the transfer, by means of a tracing, of the Naples drawing to the copper plates from which the *Pianta* was printed. Other differences between the Naples drawing and the published plan, such as the elimination of the view depicting the Tomb of the Plautii, probably occurred as Giovanni Battista etched the plates, in the course of which he often introduced variations on his preestablished designs. All that remained for Francesco to do after his father's death was to revise the Commentary, etch it, and add the dedication to the king of Poland.

Piranesi's Commentary states that the *Pianta* was to have been accompanied by other, more detailed plans of individual nodes and the system of subterranean corridors, as well as by a general plan showing the relation of the Villa to other ruins near Tivoli. Evidently these were never printed, but it is likely that, together with the great plan and the sixteen Villa prints and drawings, they were intended for a volume on the antiquities of Tivoli. Such a volume would have resembled those he devoted to Albano and Cori, which appeared in 1764. In light of his references to other buildings in the Tivoli region it is reasonable to suppose that the Hadrian's Villa material was to have been amplified by representations of such celebrated Tiburtine monuments as the Temple of Sibyl, the Villa of Maecenas, and others for which prints exist. Following the models of Piranesi's earlier publications on Albano and Cori, the Tiburtine volume, if realized, would have included a written commentary on the plates. The Villa Commentary, presumably drafted by Piranesi, was adapted by Francesco: the Commentary is etched on plates separate from the plan.

In his last decade, Piranesi produced ten printed views of the Villa, some of them the fruit of earlier preparatory studies drawn on the site in the company of such artists as Clérisseau and Adam. Four such preparatory drawings survive, as well as six other sheets representing portions of the Villa for which no cor-

330 *(top) The Piranesi plan, preparatory drawing, details of the North Theatre, Northern Ruins, and Doric Temple Area (1777); permission granted by the Ministero per i Beni Culturali e Ambientali*
331 *(center) The Piranesi plan, preparatory drawing, detail of vignette of the Tomb of the Plautii (1777); permission granted by the Ministero per i Beni Culturali e Ambientali*

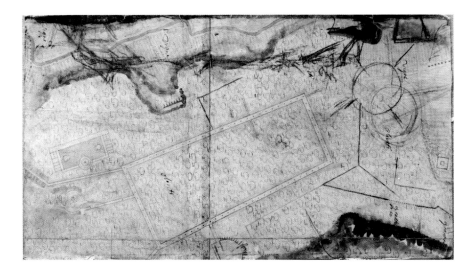

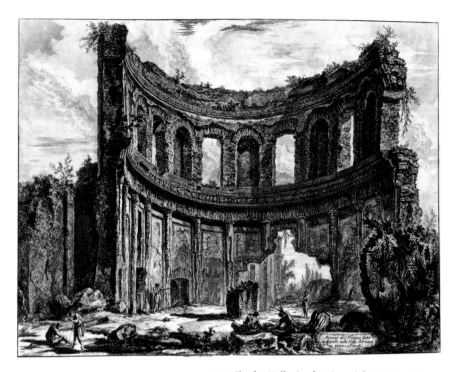

333 *Circular Hall, view by Piranesi (1768; Getty Center,
Resource Collections)*

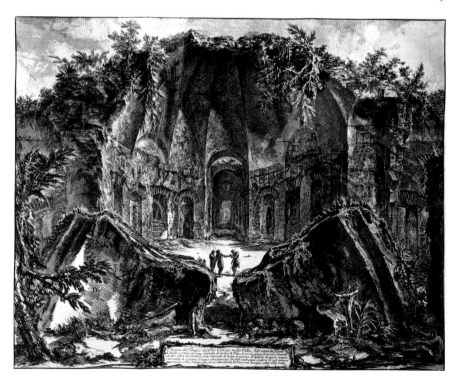

334 *Scenic Triclinium, view by Piranesi (1769)*

responding view was ever printed. This makes a total of sixteen architectural subjects, the largest concentration of monuments outside of Rome in Piranesi's *Vedute*. Piranesi's Villa works splendidly illuminate his unique fusion of documentary accuracy and interpretative genius.

The earliest Villa etching (1768) depicts the Circular Hall, identified as a Temple of Apollo. In Piranesi's day, as today, only half of the building stood. In 1769 Piranesi printed his frontal view of the Scenic Triclinium. He represents the concave and flattened gores of the complex vault with remarkable clarity and uses the symmetrical chunks of fallen masonry to close the foreground. 333 334

Piranesi's etching of the East-West Terrace (1770), perhaps more than any of his other Villa representations, conveys its magnificent setting. A dramatic diagonal recession of the Ambulatory Wall quickly draws the eye to the mountains south of Tivoli, dominated by Monte Ripoli, providing a background to the more elevated eastern portions of the Villa. In the middle ground a shepherd pastures his flock on the site of the Terrace's axial reflecting pool. An emphasis on architectural containment and envelopment in the later prints replaces the dominant role played by landscape in this relatively early work. 335

From the same year is the spectacular print depicting the Larger Baths main hall, viewed from the southeast. Piranesi's composition stresses the picturesque contrast between the over-arching forms of the massive cross-vault and the delicate natural swags of hanging vines that artfully fill in the masonry gaps. Two more prints appeared in 1774. The Apsidal Hall appears in deep foreshortening with raking light casting the apse semidome in sharp relief. In his etching of the Central Service Building, Piranesi also uses raking light to emphasize the rich surface textures of the walls, composed of opus reticulatum, and the articulation of the upper level by engaged pilasters. Light streams through the ruins, entering through gaps in the upper terrace opened up by fallen vaults. 336 337 338

In 1776 Piranesi published his print of the wall enclosing the Water Court eastern side. Not only the 339

overall composition of the finished print but many de-
tails, such as the placement of trees, figures, and even
the space intended for the caption, are determined in a
340 preparatory drawing. The two most important compo-
sitional features missing from the sketch—the framing
tree and feathery clouds at the right—were evidently
etched freehand onto the plate.

341 In the same year Piranesi produced his etching of the
axial extension of the Scenic Triclinium, for which there
342 is a preparatory study in a private collection. This print
displays his characteristic use of foreshortening and
chiaroscuro effects, especially in the light that streams
down from the vault openings. His sketch is concerned
less with strong contrasts of light and shadow and more
with working out the compositional problems posed by
foreshortening. Both the drawing and the print none-
theless accurately record such details as the mosaics in
the vault and structural features. One of these, the flat-
tened arch in the left foreground, beneath which the
water from the terminal cascade originally flowed on its
way to the Scenic Canal, must have been observed be-
fore 1771, when, as Piranesi notes, it was covered over.

343 The Portico Suite gallery, much like the palatial in-
teriors that figure so prominently in Baroque stage de-
sign, is also punctuated by alternating passages of light
and shadow in Piranesi's rendering of 1777. This space
has changed little since the eighteenth century; a com-
see 75 parison of Piranesi's print with a modern photograph
provides a measure of his archaeological accuracy and
reliability. As with most of the views, Piranesi manipu-
lates scale and proportional relations while faithfully
recording essential structure and ornamental details.

344 Piranesi's print depicting the Smaller Baths octagonal
hall, perhaps the last of the Villa Vedute to be etched, is
a tour de force of architectural rendering. A handsome
345 red chalk sketch is clearly a preparatory study. Through
his unparalleled mastery of composition, light, and
shadow gained in the course of a lifetime spent observ-
ing Roman architecture and capturing its essence on the
etched plate, Piranesi brilliantly renders the undulating
masonry envelope that moulds this centralized space
in a way that no photograph can convey. The remark-
able foreshortening of the three-dimensional arches set

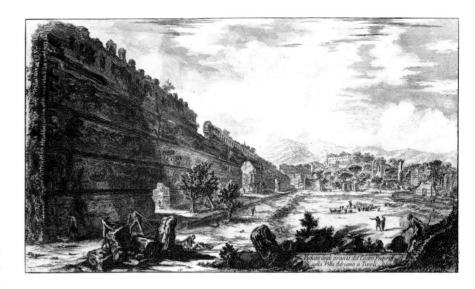

335 *Ambulatory Wall and East-West Terrace, view by Piranesi
(1770; Getty Center, Resource Collections)*

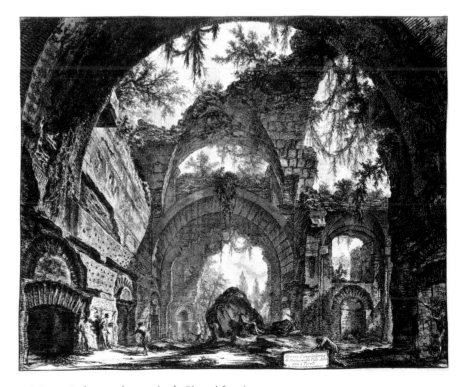

336 *Larger Baths, central room, view by Piranesi (1770)*

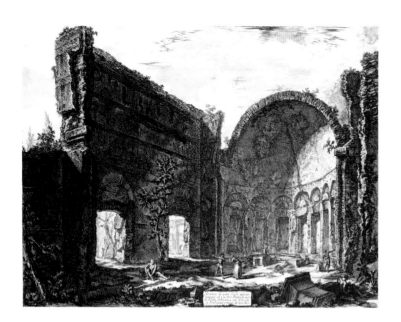

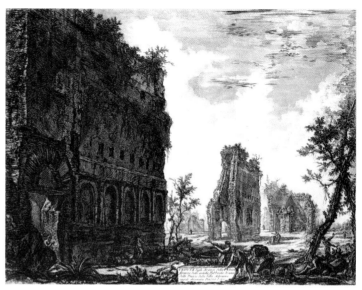

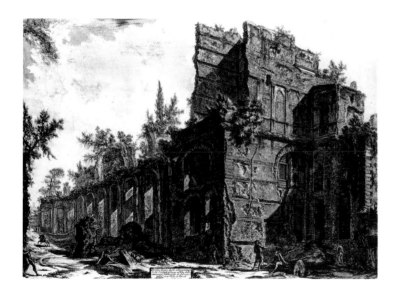

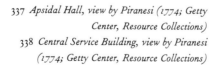

337 *Apsidal Hall, view by Piranesi (1774; Getty Center, Resource Collections)*

338 *Central Service Building, view by Piranesi (1774; Getty Center, Resource Collections)*

339 *Water Court, perimeter wall, inner face, view by Piranesi (1776; Getty Center, Resource Collections)*

340 *Water Court, perimeter wall, inner face, preparatory drawing by Piranesi (ca. 1775)*

in the convex wall to the right is particularly strik-
ing. His interpretative talents suit especially the organic
nature of the structure, whose walls appear to pulse
with movement while its vaults arch upward like the
boughs of mighty trees meeting in an airy crown of
foliage.

Piranesi's sketches after the Villa provide the most
direct and eloquent testimony of his abiding interest in
the site. Perhaps the finest of these drawings is a red
chalk sketch depicting the Larger Baths circular room.

Piranesi's bold strokes and subtle shading capture the
space moulded by the masonry concavity, conveying
both the essential structure of the building and its pic-
turesque appearance. He records the delicate painted
ornament that adorns the dome and niches below, con-
firming many of the details Ghezzi noted in his sketch
of 1742, as well as a mass of fallen masonry in the right
foreground. In contrast with Clérisseau's and Adam's
drawings of the same feature, Piranesi accurately repre-
sents the arrangement of wall openings.

Another handsome red chalk sketch depicts the Ser-
vice Quarters. Piranesi has chosen to represent the
long, curving facade of this structure from the north-
west to emphasize its commanding elevation above the
West Valley. The composition is reminiscent of Pira-
nesi's views of the Colosseum and Pantheon, wherein
curving exterior walls dramatically recede into the dis-
tance. A third sketch, executed in red over black chalk,
represents the Island Enclosure. The rising mass of
the Fountain Court West projects at the left while the
walls of the island proper occupy the rest of the field.
The composition of this sketch again recalls that of
another of Piranesi's Colosseum views, in this case one
of its interior, in which substructures projecting in the
foreground are enveloped by sweeping arcs of ruined
seating.

Piranesi's autograph sketch of the Island Enclosure
appears to have been copied by an unknown drafts-
man who succeeded in capturing the essential relation
of forms, if not the technical mastery, of the original.
This copy, along with three other drawings after Pira-
nesi's sketches of the Villa by the same hand, lack the
power and authority of the master. Nonetheless, they

<div style="margin-left:2em">see 195</div>

<div>346</div>

<div>347</div>

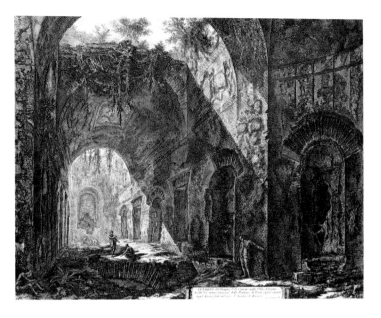

341 *Scenic Triclinium, axial extension, view by Piranesi (1776;*
Getty Center, Resource Collections)

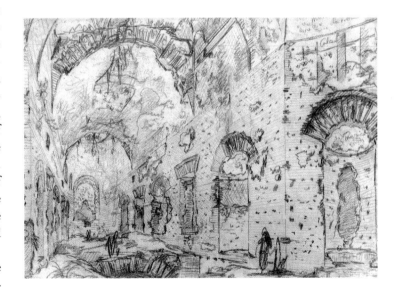

342 *Scenic Triclinium, axial extension, preparatory drawing by*
Piranesi (ca. 1775)

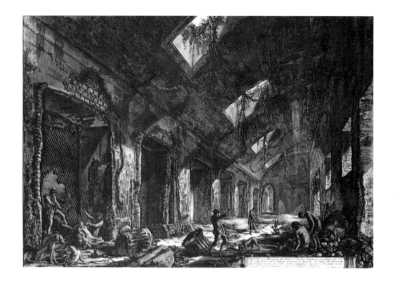

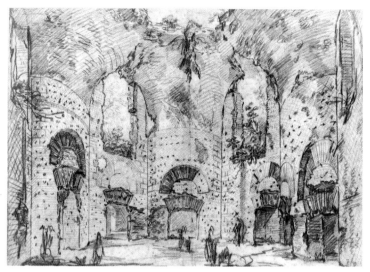

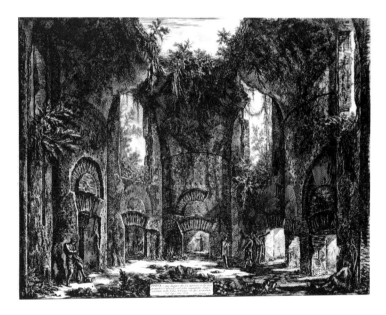

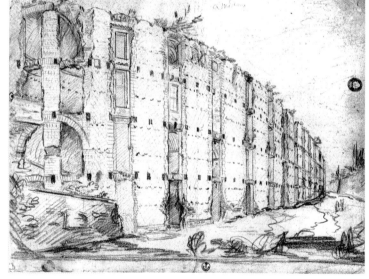

343 *(top) Portico Suite, gallery, view by Piranesi*
(1777; Getty Center, Resource Collections)

344 *Smaller Baths, octagonal hall, view by*
Piranesi (1777; Getty Center, Resource
Collections)

345 *(top) Smaller Baths, octagonal hall,*
preparatory drawing by Piranesi (ca. 1775)

346 *Service Quarters, looking east, drawing by*
Piranesi (ca. 1775)

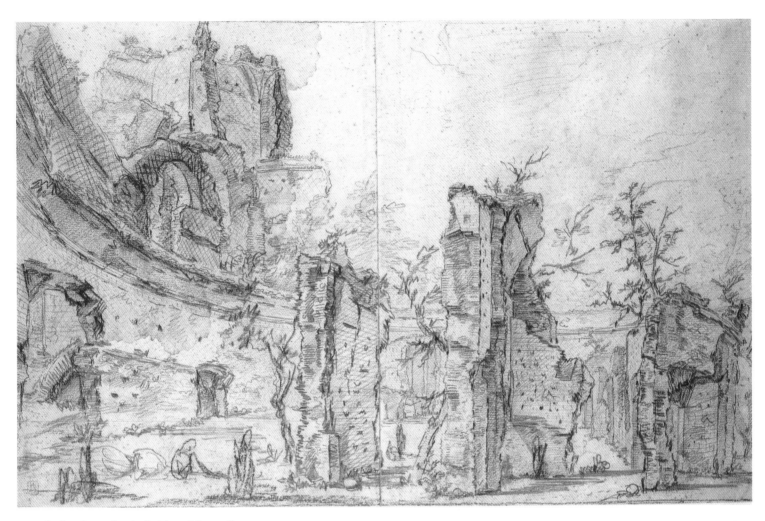

347 *Island Enclosure, drawing by Piranesi (ca. 1775)*

increase our understanding of Piranesi's activity at the Villa and document his interest in structures not among the printed views and autograph drawings. The second of these depicts the interior of the North Service Building, looking northwest toward the main entrance. The third drawing shows the West Belvedere, surmounted by the farmhouse and dovecote added by Sebastiano Soliardi at the end of the sixteenth century and removed in 1881. These additions cause the ruin to resemble another farmhouse, the Casale del Barco, built by Cardinal Luigi d'Este in nearby Bagni di Tivoli about 1585. The last copy shows the main cross-vaulted hall of the Larger Baths, viewed from the southwest. The draftsman's point of view in this drawing differs from that in Piranesi's magnificent print, drawn from the southeast.

Once they are viewed together, rather than in isolation, Piranesi's representations of the Villa constitute a major theme within his oeuvre, one that grew in significance as his career matured. Moreover, these images constitute a fresh mode of seeing as well as documenting the past. In addition to providing invaluable records of the ruins at the Villa and their relation to the surrounding landscape, Piranesi's views, and especially the

Pianta, constitute important documents in the history of archaeological site description, significant as much for how they interpret the evidence as for what they record.

With far greater rigor and authority than in any of his earlier antiquarian studies, Piranesi applies principles he first began to formulate in the mid-1750s. He applied his archaeological method developed in the course of compiling the *Antichità romane* to his work at the Villa. No longer is he content to represent the exteriors of individual buildings, as in the *Vedute;* these he supplements with analytical drawings, plans, and sections. Further, he fleshes out ruined or vanished structures by means of conjectural plans and whenever possible employs ancient literary sources, as in the *Pianta* commentary, in which he uses the HA nomenclature to interpret the function and meaning of some of the Villa's components. Most important, he brings all these means to bear on his ultimate end: a complete reconstruction, as in the *Pianta*.

The act of translating ruined walls into archaeological plans, a task usually performed in the eighteenth century by artists and architects, led to a new kind of graphic abstraction. This process, especially in the hands of a master draftsman such as Piranesi, blurred the line between archaeological fact and inventive fantasy. A comparison of Piranesi's archaeological plan of the Villa and his fantastic reconstruction of the Campo Marzio of 1762 reveals similar relations of form, though one is substantially factual and the other largely visionary. In the Campo Marzio plan Piranesi's vision of Roman grandeur takes its point of departure from the abstract geometrical conventions of the ancient Marble Plan. The fragmentary state of the real Marble Plan suggests the fantastic configurations of his lapidary vision. Piranesi's plan of the Villa, however, permits the ruins to speak more directly; in this archaeological mode they function as documents rather than as metaphors. Piranesi remarks in the dedication to the *Campo Marzio:* "Before anyone accuses me of falsehood, he should, I beg, examine the ancient [marble] plan of the city . . . [and] the . . . Villa of Hadrian at Tivoli."

348

349

350

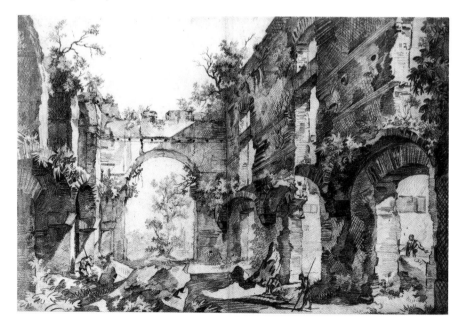

348 North Service Building, interior, looking north, anonymous draftsman after Piranesi

More than any other ancient site known in the Renaissance, the Villa embodied the richness and variety of Roman imperial architecture. Certain Renaissance architects, Francesco di Giorgio, for example, found this variety troubling and, looking at the Villa through Vitruvian glasses, felt the need to bring the Villa into conformity with prevailing interpretations of Roman architecture. Piranesi, in contrast, emerged as the champion of the virtues of complexity, which he opposed, especially later in life, to Johann Winckelmann's emphasis on the "noble simplicity and quiet grandeur" of ancient art, an interpretation essential to the formation of the Neoclassical dogma. Ironically, Winckelmann's view of antiquity was predicated in no small part on sculpture found at the Villa, for example, the celebrated Antinous relief in the Albani collection. At a crucial juncture in the history of Western art the Villa maintained its role as a touchstone, providing evidence and justification for both sides in the boiling controversy over the primacy of Greek or Roman forms.

Winckelmann's austere vision of antiquity, championed also by Laugier and Le Roy, constituted nothing less than a sweeping repudiation of that characteristic Baroque exaltation of creative license that lay at the core of Piranesi's conceptual genius. The sophisticated pavilions of the Villa are far indeed from Laugier's Vitruvian hut. Piranesi viewed the diversity and inventive power of the ancients as an inspiration for creative design in his own day; paraphrasing Sallust, he dismissed his critics by proclaiming, "They despise my novelty, I their timidity." His plan of the Villa and the intended publication of which it is part must be viewed in this light. Piranesi's concluding remarks on his great plan provide an admirable summary of his views and, we might add, of our work. "One cannot avoid concluding that the buildings of this Villa surpassed all others as much for their magnificence and ornament as for their pleasing and bizarre forms, from the study of which architects may derive considerable benefit."

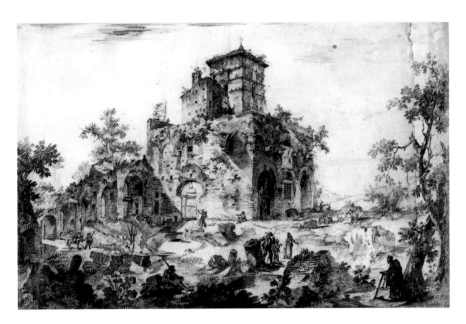

349 *West Belvedere, anonymous draftsman after Piranesi*

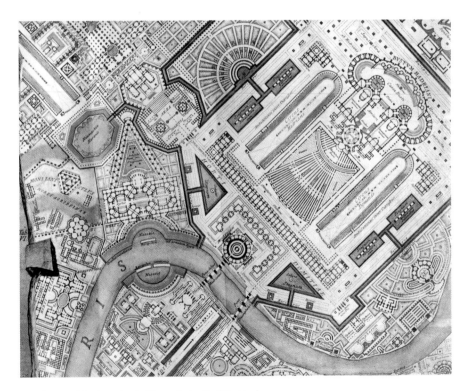

350 Campus Martius, *plan by Piranesi, detail of Hadrian's Mausoleum and environs (1762)*

X

The Landscape of Allusion

The Renaissance revival of the villa as an architectural type was predicated in large part on ancient literary accounts and on substantive remains. The Renaissance conception of the ancient villa, however, was influenced more by literary descriptions than by what little was known of its physical form. The desire of Renaissance patrons to revive the rural otium celebrated by such writers as Cicero and Pliny usually provided the primary stimulus to the architects they employed. In spite of the enthusiasm generated by such texts, however, no trace existed of the physical remains of the villas belonging to Cicero, Horace, Pliny, or any other classical author. The extraordinary influence exerted by Hadrian's Villa on Renaissance villa and landscape design derives from the fact that, unique among the villas of antiquity, its owner and creator was known through the HA.

The powerful combination of classical text and pastoral image gave Hadrian's Villa a resonance it would not otherwise have achieved. It is important to emphasize the obvious—that what Renaissance visitors saw and reacted to was not what Hadrian intended but rather the transformation wrought by time on his vision. For this reason the original relation between the HA text and the Villa, assuming there ever was one, was critically skewed. The resulting dichotomy led inevitably to interpretations far more creative than imitative.

The HA passage does not actually describe the Villa, and in listing major parts leaves their appearance to the reader's imagination.

The Villa's connection to the renowned but enigmatic emperor and its setting in a landscape of natural beauty ensured that generations of artists, writers, and patrons visited it. Significantly, most of them came out to the Villa from Rome, leaving the city behind to experience the Villa's ruins set within fields where rustic shepherds tended their flocks and farmers' plows turned up tesselated pavements and fragments of statuary. There, for a time, visitors were transported into a three-dimensional Arcadian setting; rather like shepherds in a painting by Poussin or Claude, they wandered over the vast site strewn with mementos of the past. For more than four centuries people came to the Villa to speculate on its form, to muse on its imperial associations, and to ponder the implications of its decay. What they saw established connections between landscape and antiquity that emerged as a central manifestation of the pastoral.

THE PASTORAL REFRAIN

Poetic and visual expressions of the pastoral most commonly include certain essential elements: verdant fields, evoking a *locus amoenus*, populated by placid sheep and carefree shepherds. But in addition to the natural components of the pastoral, architectural forms often appear to telling effect. The shrines that animate so many idyllic painted landscape compositions provide ample evidence that in antiquity architecture played a prominent role in visual expressions of the pastoral. Renaissance artists such as Giorgione and Giulio Campagnola included architecture as a passing—and usually distant—reference to a more structured world, the familiar reality in fundamental contrast to the pastoral.

Some of the greatest landscape painters of the classical tradition introduced ruined architecture into their compositions, none more hauntingly than Claude Lorrain. His *Landscape with Nymph and Satyr Dancing* offers a distillation of his beloved Campagna, replete

with wandering goats, a Roman bridge and temple, and distant vistas to the horizon. Here is nature in its most pleasant guise, peopled by carefree figures and enriched by ancient ruins. The composition goes beyond the mere representation of natural forms, for on them the weight of human history and tradition has been subtly imposed, producing a highly allusive landscape.

The introduction of architecture, especially in ruins, adds a dimension that makes explicit some contradictions within the pastoral tradition. Much of what the pastoral stands for becomes obvious through contrast: the simplicity and beauty of a life in nature always imply the complication and harrassment inherent in city life. The growth and promise of new life evoked in green fields must simultaneously prompt thoughts of mortality and decay as nature passes through its inevitable cycle. Ruins of humanity's past glory emerge as a potent visual foil to the present perfections of the pastoral scene.

Hadrian's Villa strikes us as a singular example within

351 Landscape with Nymph and Satyr Dancing, *by Claude Lorrain, Toledo Museum of Art (1641)*

351

the pastoral tradition. From its inception the Villa was a pragmatic manifestation of the pastoral. Architecture is not merely cerebral or sensual because it must always serve a practical function. So although Hadrian certainly saw his villa both as an Arcadian retreat and as a metaphorical expression of his culture and travels, it also had to serve as a minimal center of his official duties. The Villa embodies the contradictions of the pastoral mode within itself: it was simultaneously Hadrian's alternative, rural seat of government and his escape from the cares of Rome and empire.

Any man's time and accomplishments will pass, whether he leads the simple life of a shepherd or the sophisticated life of an emperor. In Hadrian's grand design the struggle between the human desire for immortality and the inexorable cycles of nature endures. Generations of artists who visited the site below Tivoli were inspired to see landscape and antiquity as complementary, powerfully allusive forces. Their exploration of the relations between humans and the natural environment through the lens of architectural ruins enriched expressions of the pastoral in literature, painting, and landscape design.

The revival of classical forms that emerged as a central accomplishment of the Renaissance involves a vital, creative process of translation or imitation by which a writer or artist remakes in personal terms what was lovingly learned in active commerce with past masterpieces. Several centuries later, the English Augustans viewed the architectural forms of classical antiquity primarily through the medium of Renaissance translations codified in the treatises of Serlio, Palladio, and others. Their vision of landscape was likewise based on classical texts, many visually translated—not illustrated— by such seventeenth-century painters as Claude and Poussin. The eighteenth-century landscape of allusion therefore had as two primary sources poetry and painting.

In landscape gardening, an artistic medium in its own right, the forms of nature are moulded and given meaning through association with works of architecture and sculpture. The viewer's response may be enhanced by literary, historical, and sacred allusions. In many instances such sacred allusions were also topographical, providing another level of classical association. The most influential garden theorists of the eighteenth century, among them Alexander Pope and Joseph Addison, were poets steeped in classical literature. Gardens laid out following their principles expressed an ideal poetic conception of nature that constituted the primary stimulus for what became, in the process, a revolutionary visual aesthetic.

The most influential English landscape theorists and gardeners were at their ease with Latin verse and were often architectural dilettantes of considerable erudition, but this did not mean that they were content merely to illustrate specific classical texts or to erect reproductions of Roman buildings. Literal copies of classical temples began to appear in English gardens only after the middle of the eighteenth century. For the generation of Pope and William Kent it was enough to suggest a correspondence without realizing absolute visual congruity; to do so would in fact have been the death of the poetic landscape.

Roman taste had sanctioned copies of original works of art, especially of statues by Greek masters, recognizing the copies as admirable in their own right. The context and function of such copies, however, invariably differed from the originals. Witness the caryatids that line the Scenic Canal; today they appear reflected in see 133 the shimmering water of the Canal and outlined against the shadowy concavity of the Scenic Triclinium rather than silhouetted against the Attic sky, a transformation that cannot fail to affect our perception of their form and meaning. Hadrian's contextual transformation of the Erectheum caryatids was paralleled in a later age by James "Athenian" Stuart's garden folly at Shugborough, modeled on the Arch of Hadrian in Athens.

It is important to see the Augustans' concern for generalized evocative topographical allusions against the background of their ancient Roman predecessors. As early as Varro appears testimony to the fashion among wealthy Romans for attaching exotic names to their villas: "They do not think they have a real villa unless it rings with many resounding Greek names"; the Latin word for gardener, topiarius, derives from the Greek

word meaning place. Atticus's Amalthaeum, at his villa in Epirus, was named after the legendary site on Mount Ida where Zeus was raised. The Amalthaeum comprised a grove, a stream, and a sanctuary, together clearly forming a planned landscape composition Cicero was eager to imitate on his own villa grounds. In one of Cicero's letters we read that Brutus's villa at Lanuvium included a Eurotas and a Persian porch. Brutus's Eurotas referred to a river flowing through Sparta, his Persian porch to a portico commemorating the Spartan victory over the Persians.

Brutus's choice of Spartan landmarks for inclusion in his garden reflects more than his familiarity with them. It is a personal statement expressing political and philosophical affinities with Spartan liberty, as contrasted to the servility of the Persians under an absolute monarchy. Similar moral and political values were expressed in eighteenth-century English gardens, notably at Stowe. If the appearance and nomenclature of English gardens recalled such classical locations as Palestrina or Posillipo, and by extension the order and grandeur of Augustan Rome, the landscape of Hadrian's Villa reflected a similar regard for yet more venerable sites, such as Tempe, with its poetic associations of a golden age of pastoral ease.

Hadrian's Villa, as represented in the HA passage, provided Renaissance patrons and the landed aristocracy of eighteenth-century England with a model for creating great landscape gardens studded with monuments named for famous places. Three prominent themes emerged from reading the text and viewing the Villa's remains, themes intertwined through history like the strands of ivy that form natural garlands pendant from its ruined vaults. The first embraces allusions to named places whose associations convey symbolic content. The second involves references to decay and mortality, evident in the ruins themselves and in the underworld of the HA. The last entails generalized allusions to the actual ruins of the Villa, acknowledged as a legitimate theme in its own right. These strands appeared repeatedly in examples of villa and landscape design from the Renaissance through the eighteenth century.

RENAISSANCE VILLAS

To effect the revival of the ancient villa, both in letter and in spirit, Renaissance architects needed to satisfy two prerequisites: to study surviving Roman villa structures in order to identify their constituent elements and to master the architectural vocabulary of Roman antiquity, together with its syntax, grammar, and inventive idiom. Vasari wrote of fifteenth-century architects that "there was yet wanting to their rule a certain freedom which, without being exactly of the rule, is directed by the rule." His interpretation of "rule" in architecture ("the process of measuring works of antiquity, and considering the plans and ground-works of ancient edifices in the construction of modern buildings") makes it clear that classical monuments were the ideal standard against which the quality of modern architecture was measured.

Bramante and such later Renaissance architects as Peruzzi appreciated antiquity less for its regularity and conformity to rule than for its variety and novelty. They were rarely guilty of receiving classical values passively; instead, every selection or deviation from the classical repertory took on the value of a fresh critical judgment. But it was also the virtue of Renaissance architects that they recognized the continuity of architectural experience.

In the opening years of the sixteenth century, Rome offered all the conditions necessary for the development of a monumental style of architecture in the classical tradition. The wealth that flowed into the papal court and the papacy's political pretensions combined to encourage architectural programs of a scale unseen since antiquity. The grandiose building complexes projected by popes constituted a radical departure from traditional architectural practice. To integrate large spaces and many-faceted building masses into an organic whole, High Renaissance architects turned for inspiration to complex examples of Roman architectural design, such as Palestrina and Hadrian's Villa. From their study of these and other ancient remains, Bramante and Raphael formulated new principles of villa design that stressed relations between architecture and the natural environment. They turned the traditional

Italian villa inside-out, moving away from a prismatic block focused on an internal courtyard and introducing more permeable exteriors open to the landscape.

The earliest monumental example of this shift is Bramante's design for the Cortile del Belvedere (1503). Branching off from the old nucleus of the papal palace to the south, Bramante projected two long parallel corridors arranged in tiers that ascended the sloping terrain, finally to meet the older Villa of Innocent VIII (1484–1487). The space enclosed by these corridors and the preexisting villa and palace structures was a narrow rectangle, divided into three courts of unequal dimensions by a stairway and a monumental ramp. The axial alignment of the Belvedere Court was emphasized by a number of focal points. Among these were the terminal exedra of the upper court, the nymphaeum of the intermediate court, and a fountain basin taken from the Baths of Titus in the lower court. A drawing made around the middle of the sixteenth century clearly shows the cumulative visual effect of axiality produced by these design features. Much as occurs in the Stadium Garden and the Scenic Canal at Hadrian's Villa, these elements, especially the nymphaeum and exedra, con-

352

cave forms that draw the eye inward in the path of the axis, serve a directional function.

Bramante's design for the Belvedere Court has a double significance. It was revolutionary from the point of view of existing traditions of fifteenth-century architecture, and it constituted a radical departure from previous approaches to the design of monumental architecture: "By reaching out over the entire width of the papal territory, Bramante's Cortile introduced a new architectural concept into the development of the Vatican that brought an end to the medieval tradition of agglomeration about a central core. The growth of the palace, which previously had been centripetal or inverted, became at this moment centrifugal or expanding."

The scale of the Belvedere Court (about 325 meters along its major axis) does not begin to rival that of Hadrian's Villa, but a few comparisons with portions of the Villa suggest its monumental extent. The enclosed space of the Belvedere is longer again by a third than the East-West Terrace. Superimposed on a plan of the Villa, the Belvedere spans the distance between the nymphaeum of the Residence Quadrangle and the Water Court, between the Doric Temple and the Island Enclosure, between the Central Vestibule and the Scenic Triclinium. Much like the design of the Villa, Bramante's architecture works with the natural contours of the land, orchestrating the spaces that climb the shoulder of the Vatican Hill and effectively exploiting the views it offers.

Bramante's patron, Julius II, sought to rival the accomplishments of the ancients and to raise a new Rome of the Church that would surpass in magnificence that of the Rome of the Caesars. To this end the pope's architect drew inspiration from many ancient sources, principal among them the imperial residence on the Palatine. In unifying the diverse functions of the Belvedere Court, which included gardens, fountains, areas for spectacles, accommodations for the display of statuary, service areas, imposing ramp and stair systems, viewing platforms, and long passages linking separate structures, Bramante was likely influenced as well by the remains of Hadrian's Villa, the only well-preserved ancient villa of comparable complexity. The remains of

352 Vatican, Belvedere Court, view attributed to G. B. Naldini (ca. 1552–1553)

the Villa also carried with them the cachet of Hadrian's name, an association that would have appealed to Julius, who saw himself as a new Caesar and whose building programs were rich with imperial imagery.

Bramante's revolutionary design for placing the Tempietto within a circular courtyard perhaps suggested by the Island Enclosure of Hadrian's Villa has already been described. His pupil Raphael appears to have drawn from the same source in designing the Villa Madama (1516+), the most ambitious High Renaissance revival of an ancient Roman villa. The discovery of Raphael's written program for the Villa Madama proves that his design was intended to breathe three-dimensional life into classical texts — Pliny's descriptions of his Laurentine and Tuscan villas — and in the process to reestablish direct and meaningful relations between villa architecture and the surrounding landscape. Elevated on the east slope of Monte Mario, the Villa Madama enjoys a magnificent view over the Tiber valley and to the Appenines beyond. Only a small fragment of Raphael's grand project was executed, and his designs were substantially altered following his death in 1520, but the program and numerous drawings permit a reconstruction of his overall design.

353 A plan by Antonio da Sangallo the Younger illustrates the main features of the Villa Madama. Its center was to have been a circular courtyard about 32 meters in diameter, which would have fit comfortably within the Island Enclosure ring colonnade. Above the main block of the Villa Madama an open-air theatre was projected, and to the north, beyond a great vaulted loggia and a secret garden, a terrace in the form of a hippodrome was laid out. As we noted in discussing Bramante's Tempietto, circular courtyards were unprecedented in fifteenth-century architectural practice. Among available ancient sources were two at Hadrian's Villa: the Island Enclosure and the Circular Hall. The likelihood that Raphael was struck by the Island Enclosure while visiting the Villa in 1516 is strengthened by an early study he completed that year for the Villa Madama courtyard that includes a ring colonnade. The fragment of the court that was eventually built employs engaged rather than free-standing columns and in this respect

353 *Rome, Villa Madama, plan by Antonio da Sangallo the Younger (ca. 1520)*

resembles the Circular Hall. Though the Circular Hall is significantly smaller than the Villa Madama court, its distributory function provided an instructive model for the core of Raphael's design.

The theatre was undoubtedly suggested by Pliny's animated description of spectacular views from his Tuscan villa, and Raphael naturally consulted Vitruvius on the geometric basis of Roman theatre design. Still, the only available examples of ancient theatres functioning as parts of villas were the North and South Theatres at Hadrian's Villa and a third associated with the so-called Villa of Brutus, also in the neighborhood of Tivoli. Among the ancient statues assembled in the Villa Madama secret garden, a few yards from the site intended for the theatre, stood the celebrated group of the Muses, which had been found in the South Theatre. Their transfer to the Villa Madama was coincidental, but it underscores the relation between the ancient Villa and its Renaissance counterpart.

Although the terminal exedra of Bramante's Belvedere Court invited views over the lower terraces to the medieval nucleus of the Vatican Palaces and the new Basilica of Saint Peter's, the vista was limited by the enclosing corridors that marched down the hillside. In contrast, the Villa Madama theatre would have permitted views out over the villa's tiled roofs to take in an ample arc of surrounding landscape. Architecture and landscape were to function as mutually supportive components of a vast, structured composition. The two approach axes, from the city (north-south) and from the Tiber (east-west), would have intersected at the center of the circular court; radiating outward, particu-

larly to the north and east, these axes were to govern the disposition of terraces, gardens, and fountains that gradually gave way to natural forms unshaped by the human hand.

Raphael's grand design was never realized; during the disastrous Sack of Rome in 1527 the allies of Charles V did extensive damage to the portions already erected. By coincidence, in the same year the emperor's painter-architect, Pedro Machuca, designed a grand palace with a central-plan courtyard adjacent to the Alhambra in Granada. Machuca had visited Italy, where on the evidence of style he appears to have gravitated to Raphael's studio about 1517, when the Villa Madama design was under way. Machuca's activities in Italy are poorly documented; we can only conjecture that through Raphael he became familiar both with the Villa Madama design and with its ancient sources, including Hadrian's Villa.

The circular court at the core of Charles's new palace at Granada consciously evokes Hadrian's Island Enclosure: significantly, its diameter is identical to that of the Island Enclosure (42 meters). While it differs from the Island Enclosure—notably in the number of columns (thirty-two) and in a Doric order of two stories—similarities of shape, dimension, and function prevail. Charles's courtyard is elevated above the rest of the palace and access to it carefully controlled, much as at the Island Enclosure.

Hadrian's Spanish connections, martial reputation,

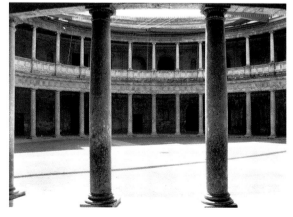

354 *Granada, Palace of Charles V, courtyard (1992)*

and extensive travels would have been known to Charles; the Tiburtine Villa was familiar to Castiglione and other ambassadors at the imperial court. By 1527, with Spanish advances in the New World and the capture of Rome itself, Charles ruled a vast empire that surpassed in extent the Roman empire on which it was partially modeled. Both empires united many diverse ethnic groups and cultures under common rule. For Charles, the circular court of the Alhambra symbolized the global sweep of his dominion, with his commanding presence as its sole center: "If the round courtyard was to have been a peristyle garden and its plants imported from all over his two empires, the pertinence of the circular form of the courtyard to his claim to global rule would have been very clear. If that was the case, the shape of the garden into which he retreated would have symbolized the burden from which he withdrew for relaxation and renewal."

As we have seen, the antiquarian studies of Raphael, which may have stimulated Machuca's design for the palace at Granada, were pursued by others, notably Pirro Ligorio. Ligorio was much more than a bookish antiquarian; in his designs for pleasure villas and water gardens he translated into Renaissance idiom the spirit of antiquity. The gardens of the Villa d'Este at Tivoli and the Casino of Pius IV in the Vatican, both of which he laid out in the third quarter of the sixteenth century, stand among the supreme accomplishments of Renaissance architecture and landscape design.

In 1550, Cardinal Ippolito d'Este appointed Ligorio his antiquarian and began to acquire the land on which the Villa d'Este gardens would be laid out between 1560 and 1572. Although the general conception of these gardens was probably under discussion as early as 1550, it took more than fifteen years to acquire the rest of the land and to secure a sufficient water supply; only then could the site be adorned with fountains, grottoes, pools, and exotic plants. In these years Ligorio continued his investigation of the Villa, and what he learned there substantially influenced both the form and symbolic content of his designs for the Villa d'Este.

Before the mid-sixteenth century water had played a relatively modest role in Italian Renaissance gardens;

waterworks on the scale of those at Hadrian's Villa had not been attempted. During his excavations at the Villa, however, Ligorio became intimately acquainted with part of the sophisticated hydraulic system that distributed abundant supplies of water throughout the site, feeding the scores of fountains, grottoes, and pools. He also studied how Roman designers employed water with architecture to great effect, using the sound of water and its reflective qualities to animate space and to create sequences of visual and symbolic forms linked by its flow. It is telling that at the Villa d'Este Ligorio employed wall fountains of a decidedly architectonic character, in which statuary often plays a significant but subordinate role, rather than the free-standing sculptural fountains of the Tuscan Renaissance tradition. Ligorio's extensive use of sculpture to provide the Villa d'Este fountains with iconographic resonance may of course also be related to the statues he found in fountain settings at Hadrian's Villa. Even Ligorio's use of color in his fountain designs, often of mosaic and painted stucco, can be related to Villa remains of wall and floor mosaics, pumice stone, crustae of various kinds, and basins tinted aquamarine.

The steeply sloping hillside occupied by the Villa d'Este presented the landscape designer with very different opportunities from those offered by the gently rolling site of Hadrian's Villa. In laying out the cardinal's water garden Ligorio established a tightly structured axial environment that contrasts with the more informal and oblique relations at Hadrian's Villa. Although he drew inspiration from Roman prototypes, Ligorio transformed his sources to create a garden of distinctly Renaissance character. For this reason one looks in vain for one-to-one correspondences between the two designs, finding instead at the Villa d'Este the use of allusion and allegory to evoke the spirit of antiquity. In one or two instances we are inclined to see traces of specific features of the Villa in Ligorio's design, but no direct quotations. The celebrated Hundred-Fountain Walk, for example, may recall the long terrace wall of the Fountain Court, and the Oval Fountain at the Villa d'Este may have been suggested to Ligorio by the oval east of the Water Court.

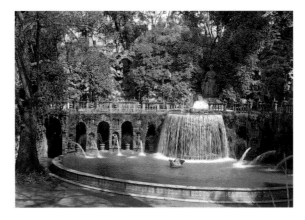

355 *Tivoli, Villa d'Este, the Oval Fountain (1555–1572)*

More telling, however, is Ligorio and his patron's use of iconography based in significant part on geographical allusions, especially to Tivoli and Rome. A major cross-axis of the Villa d'Este, marked by the Hundred-Fountain Walk, connects the Oval Fountain, adorned with allegorical sculpture identifying the fountain with Tivoli, to another fountain representing ancient Rome. The two are linked by three streams of water, representing the three rivers—the Tiber, the Aniene, and the Ercolaneo—that flow toward Rome. Ligorio's three-dimensional simulacrum of the ancient city, evoking his own graphic reconstruction printed in 1561, is silhouetted against the western horizon, where in the distance the domes of papal Rome shimmer. Ligorio knew the passage in the HA according to which Hadrian might bestow the names of celebrated Greco-Roman monuments on portions of his villa, and Hadrian's reported passion for collecting, as it were, reproductions of buildings and places whose very names ring with hallowed associations may well have prompted Ligorio and his patron to do likewise.

During this period Ligorio also designed an exquisite garden pavilion in the Vatican, the Casino of Pius IV (1558–1563). This small retreat, a five-minute walk from the Belvedere Court, was intended not for extended sojourns but rather for brief visits to escape the constraints of the papal palace's more formal surroundings. The emphasis is on seclusion—access is restricted to two arched openings aligned with the major axis of an

355

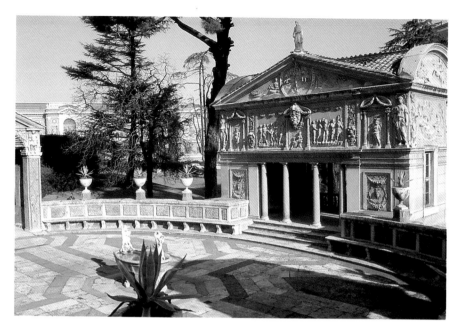

356 *Vatican, Casino of Pius IV,
portico and oval court
(1558–1663) (1974)*

356

oval court. Two structures face each other across the minor axis of this oval: to the west the casino proper nestles into the thickly wooded hillside, while to the east a loggia raised above a fishpool looks out over the surrounding gardens to the papal palaces beyond. The planar courtyard facades of the casino and loggia are profusely decorated with figural stuccoes, introducing a dimension of relief that recalls ancient sarcophagi. From sixteenth-century documents we know that some fifty ancient statues adorned the casino; most of them were removed not long after by Pope Pius V, who objected to these pagan relics.

The oval courtyard may have been suggested to Ligorio by another Villa feature: the Reverse-Curve Pavilion, which he had incorrectly reconstructed as an oval-plan structure. In function, however, the casino resembles even more the Island Enclosure. The designs of both structures emphasize seclusion and containment, and both employ water to reinforce the detachment of what lies within from that without. The decorative program of the casino may also allude to the Island Enclosure: its entrance portico contains a painted frieze

of a chariot race similar to the Island's sculptural frieze, a copy of which survives among Ligorio's drawings.

Ippolito d'Este maintained close ties with France, and through him Jacques Androuet du Cerceau the Elder may have become familiar with the Villa. Du Cerceau, who spent the years 1538–1544 in Italy, supervised the publication of books and suites of engravings representing Roman ruins. Between 1545 and 1550, a member of his workshop probably made the earliest printed representations of a specific Villa structure, the plan and facade elevation of the Scenic Triclinium that appear in a set of engravings known as the *Temples et habitations fortifiés*.

357

The engraver erroneously reconstructs the Scenic Triclinium as a central-plan structure, its semicircular plan doubled to form a domed rotunda. The accompanying elevation depicts the dome with a smooth hemispherical profile and an oculus, and completes the structure with a palatial facade of Serlian inspiration. The ruins provide no justification for such a reconstruction; instead, they serve as a point of departure for the design of an original and distinctively Renaissance central-plan configuration. The French engraver seems to have worked second-hand from drawings after the Villa that may have come into du Cerceau's possession, for his unusual reconstruction of the Scenic Triclinium reproduces an arrangement known from a North Italian model book of ca. 1530. By the middle of the sixteenth century, the circulation of drawings, model books, and prints across national boundaries disseminated knowledge of the Villa to a select but influential group of architects and patrons.

The influence of the Island Enclosure may be traced in several of du Cerceau's designs for châteaux that followed his return to France. Fortified country houses surrounded by moats were still common in the sixteenth century. The geometric clarity and perfect symmetry of the Island Enclosure no doubt suggested to du Cerceau the possibility of constructing châteaux based on a concentric design of island, moat, and outbuildings in harmony with the principles of Italian Renaissance architecture. Around 1556 he designed the *rocher*, an artificial island cave of the Muses, and hermitage of

358 the Maison Blanche at Gaillon for Cardinal Charles de Bourbon. These additions to an earlier château were surrounded by a canal and provided settings for isolated contemplation and small theatrical performances. The rocher in particular recalls Hadrian's island retreat.

To well-informed Renaissance observers the remains of the Island Enclosure may have evoked Varro's aviary. His description appears in his treatise on agriculture, the *Rerum rusticarum*, closely studied in the Renaissance. The most striking feature of Varro's bird sanctuary, a circular island with a tholos surrounded by a canal and a ring colonnade, figures prominently in an engraving of 1559 made after Pirro Ligorio's reconstruction. Such a concentric arrangement offered an ideal means of providing seclusion within large gardens and appears in many designs: two particularly sophisticated formulations are the central parterre of the Villa Lante at Bagnaia (ca. 1568) and Giulio Parigi's Isolotto in the Boboli Garden (1617–1618).

If the geometric clarity of the Island Enclosure and the axial symmetry of features like the Water Court appealed to numerous Renaissance architects, the more organic, sequential relations of Hadrian's Villa initially proved less influential. Most Renaissance architects and landscape designers, even ones who, like Ligorio, aimed for complexity, preferred to work within a relatively simple governing scheme that stressed axiality and a hierarchy of forms. Among the few exceptions is the Sacro Bosco at Bomarzo, which shows the influence of the Villa. Bomarzo, a small hill town north of Rome, was the feudal stronghold of a branch of the Orsini. The town is dominated by the brooding mass of the Orsini palace, which looks out southward over a valley drained by a small stream. The thickly wooded slopes of the valley mask Etruscan tombs cut into tufa outcroppings. It was in this wild setting, redolent of remote antiquity and powerful numinous forces, that Pier Francesco (Vicino) Orsini began to lay out his gardens in 1552. Between his retirement in 1567 from both military service and the court of Rome, and his death in 1584, Orsini devoted himself to creating his extravagant gardens.

These exploit the irregular contours and unfold se-

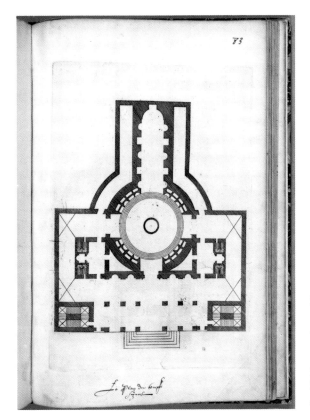

357 *Fanciful plan of the Scenic Triclinium, workshop of Jacques Androuet Du Cerceau the Elder (1545–1550)*

358 *Château of Gaillon, the* Rocher *and Maison Blanche, view by Du Cerceau (ca. 1556)*

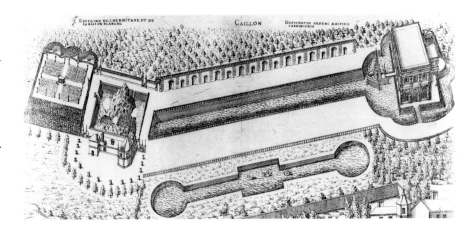

quentially in a manner similar to those of the Villa. As a result, visitors have no clear idea of where they stand in relation to the whole, and the garden's modest scale (3.5 hectares, a tiny fraction of the area occupied by Hadrian's Villa) seems much larger than it actually is. Much as at the Villa, axes are used to organize discrete groupings of structures, not to impose rigid unity on the scheme. In certain portions of the garden extensive terraces were laid out, extended toward the valley by means of substructures. Water, grottoes, and hybrid architectural monuments give order to the garden, but beyond all else it is sculpture, much of it carved from living rock, that dominates the place and lingers in visitors' memories. Some of the organizational principles of the Villa appear to have been adapted at Bomarzo, but it was the Villa in its ruined state, overgrown and strewn with hulking fragments rising from the underbrush, that seems most relevant to Bomarzo. When Ligorio was beginning to excavate the site, Hadrian's grand design was obscured by undergrowth, and the sheer expanse of the site prevented an overall view. To visitors exploring the Villa, the experience may have recalled the fantastic dreamlike visions of the woodcut illustrations to Francesco Colonna's *Hypnerotomachia Poliphili* (1499).

Much as the physical appearance of the Villa seems to have influenced Bomarzo, so the idea of the Villa, summarized in the familiar HA passage, may be reflected in the complex iconography of Bomarzo. One of the explanatory inscriptions that probably stood near the original entrance refers to the marvels to be seen; another compares these marvels to the seven wonders of the ancient world. The impact of Bomarzo depends, in significant part, on the often playful references it makes to familiar, canonical monuments in the world at large. Orsini's ability to shock and amuse his audience was based on defiance of the expectations they had formed through their familiarity with classical texts and more orthodox Renaissance gardens. The most obvious example is his play on Bramante's terminal exedra of the Belvedere Court, that paragon of High Renaissance classicism, which Orsini willfully deforms, its stereo-

metric clarity blurred and its precise courtly refinements clothed in rustication.

In another part of the garden visitors confront what appears to be an overturned facade of an Etruscan tomb hewn from living tufa. Within the tympanum is a seemingly archaic relief of tritons, in fact a deliberate Renaissance exercise in falsification, the more interesting for its derivation from the well-known frieze of marine figures in the Island Enclosure. The frieze was partly visible in situ; by the mid-sixteenth century, portions of it were displayed in Rome and Tivoli and repeatedly drawn by Italian and northern European artists. If it was intended for the visitor to recognize the source of the pseudo-Etruscan frieze, then we have an instance within Bomarzo of a formal allusion to Hadrian's Villa. Masked in the mantle of an archaizing style, much as Orsini's play on the Belvedere Court exedra was sheathed in rustication, this reference is in keeping with the complex literary allusions of the garden's iconography.

This iconography displays the most significant debt to the Villa. Of the landscape incidents intended to be experienced sequentially, several were apparently linked in order to evoke a descent into Hades. Dominating the uppermost terrace of the gardens is a mysterious structure, half mausoleum, half funerary chapel, ringed by a circle of stone markers adorned by death's heads. One source asserts that Vicino dedicated this feature to his young wife, Giulia Farnese Orsini, who predeceased him. From this upper level of the tomb stairs descend to a lower terrace shaped like a hippodrome, along the way passing a statue of Cerberus, guardian of Hades. The hippodrome recalls the East-West Terrace in its orientation and proportions, and the statues of harpies with fish tails and bat wings that adorn it may have been suggested by one of Ligorio's manuscript descriptions of the Villa in which similarly bizarre statues are mentioned.

Set into the lower retaining wall of this terrace is the mouth of Hades itself. This monstrous mask, like the overall gardens of Bomarzo, functions iconographically on several levels. We cannot avoid reading it as a direct reference to the underworld of the HA. It would

359

see 101

360

361

362

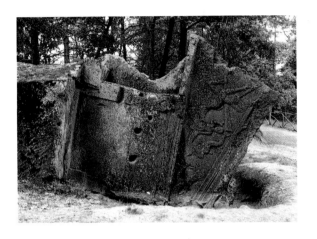

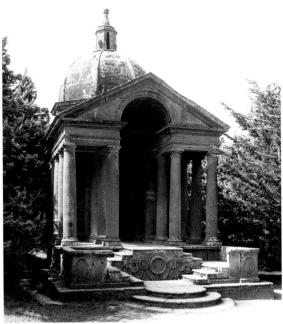

359 (far left) Bomarzo, false
Etruscan tomb

360 Bomarzo, monument to
Giulia Farnese Orsini

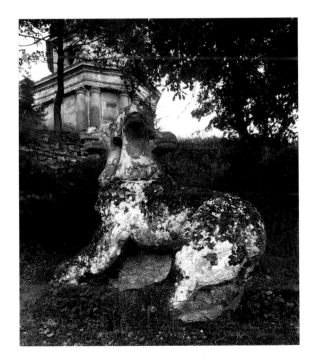

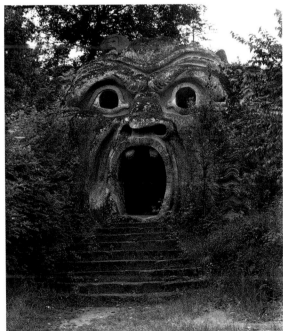

361 (far left) Bomarzo, statue of
Cerberus

362 Bomarzo, mouth of Hades

appear that Orsini, like Hadrian, wished to include an underworld itinerary among the marvels of his gardens. Playing on Dante and in keeping with Orsini's bizarre sense of humor, the inscription above the gaping mouth of Hell read "Forsake all cares you who enter." The substitution of "cares" for the "hope" of the *Divine Comedy* wording is appropriate, for the mouth leads not to the dark corridors of Dante's *Inferno* but to a modest chamber containing a stone bench and table. Here again the idea of a table set within a grotesque mask may have been suggested by another variant of Ligorio's Villa description.

The underworld, described most famously by Homer and Virgil, is an important classical topos. In ancient myth the periodic return of Proserpine to Hades provided the explanation for the annual cycle of growth and decay. In Virgil's *Eclogues* mortality intruded into Arcadia, that mythical realm of happiness and perfection. This darker aspect of the pastoral was taken up again in the Renaissance by Jacopo Sannazaro, in whose vision of Arcadia architectural forms, including tombs, figure prominently. Bomarzo recalls the "revered and sacred wood," the setting for Sannazaro's *Arcadia* (1504). The contrast between fertility and organic decay, between the bliss and the melancholy of pastoral sentiment, naturally found expression in the iconography of landscape gardens like Bomarzo.

The stimulus of Hadrian's Villa was most potent in the mid-sixteenth century, especially during Ligorio's excavations. By the closing years of the century, even as the villas of the Roman aristocracy began to occupy the more elevated portions of Rome and to climb the Alban Hills, the influence of Hadrian's retreat waned. Ligorio's research on the Villa remained unpublished, and within a few years new growth had covered his excavations. The revival of the ancient villa was accomplished fact, and patrons were generally more concerned with nuances of contemporary style and functional needs than with achieving prevailing notions of archaeological accuracy.

The Medici, Borghese, and Ludovisi villas, in their extent and the rich collections of sculpture formed to adorn them, recall Hadrian's Villa, but the relation is generic, not specific. The great villa the Pamphili laid out beside the Via Aurelia beginning in 1644 incorporated cryptoporticoes and made extensive use of vaults decorated with stucco reliefs, inspired as much by Nero's Domus Aurea as by Hadrian's Villa. Alessandro Algardi's stuccoes, especially those of the Hercules Gallery, show the influence of stuccoed ceilings at the Villa, a debt noted by the seventeenth-century art historian Giovanni Pietro Bellori. On the lower level of the Villa Pamphili, Algardi opened windows into the barrel vaults in a manner that strongly recalls the Peristyle Pool Building cryptoportico.

It is in the Villa Albani, designed to house the extensive collection of classical sculpture assembled by Cardinal Alessandro Albani, that we next see a conscious effort to emulate Hadrian's Villa. In 1758 the cardinal appointed his friend and protégé Johann Joachim Winckelmann librarian and antiquary. Winckelmann's role and his relationship to Albani parallels that of Ligorio to the cardinal of Ferrara, with repercussions hardly less significant for the legacy of the Villa.

Shortly before he engaged Winckelmann, Albani had begun to build a sumptuous *villa suburbana* outside the Porta Salaria as the ideal setting for his collections. Carlo Marchionni's design owes more to Renaissance than to ancient Roman architectural precedent, but in significant respects it stands at the end of a long tradition of antique revivals based in no small part on Hadrian's Villa. The close integration of architecture and sculpture at the Villa Albani recalls the source of so many of the finest works in the cardinal's collection, nowhere so evident as in the Hall of Antinous. A spirited sketch by Marchionni studies the placement of 363 the celebrated relief bust of Antinous unearthed at the Villa in 1735. Paolo Anesi's frescoes in the same room depict fanciful reconstructions of the Villa; in one scene Hadrian and Antinous preside. The free-standing semicircular portico facing the main block of the Albani villa, where numerous works of Egyptian art were displayed, was called the Canopus, an accepted allusion both to the Egyptian site and to Hadrian's.

By far the most striking architectural features of the

Villa Albani are pavilions in the form of temple-front
364 projections set to either side of the main building. Here
the new taste for Greek art championed by Winckel-
mann in his publications, which laid the theoretical
groundwork for Neoclassicism, is evident, though in a
hybrid form more reminiscent of Piranesi's nearly con-
temporary *Parere*. What seems most remarkable in these
pavilions is the mixture of Greek and Roman forms,
which excavations revealed had co-existed so effec-
tively at Hadrian's Villa. Away from the main building
365 Marchionni constructed a ruined temple, composed of
disparate fragments, that underscores the enduring re-
lation between ruins and the landscape.

AUGUSTAN ENGLAND

By the mid-sixteenth century English travelers had
visited Hadrian's Villa, recorded their impressions, and
returned to their estates to lay out landscape gardens of
distinctly classical inspiration. An entry of 1645 in John
Evelyn's diary indicates that he saw the Villa only from
a distance, and the principal feature of the gardens he
later designed for Henry Howard, duke of Norfolk, at
Albury Park, Surrey, relates specifically to the gallery
of Posillipo, near Naples. Still, Evelyn's description of
the duke's "villa at Alburie where I designed for him the
plot for his Canale and Garden, with a Crypta through
the hill" recalls ancient villas. Evelyn's cryptoporticus
366 survives at Albury Park, as do monumental terracing
and traces of the original plantings of acanthus, box,
and bay — eloquent testimony to early enthusiasm for
classical landscape forms.

Edmund Warcupp's extensive description of the Villa,
written in 1660, clearly reflects his careful study of the
site and documents the condition of specific ruins, such
as the Ambulatory Wall. He interpreted what he saw
very much in terms of the HA, and his gloss on the
ancient passage is significant for what would follow in
the next century:

Spartianus also declares it in the life of Adrian, saying that he
in that his Villa caused draughts or as we may better say the
similitudes of the most celebrious places of the world to be
made, causing them afterwards to be called after the proper

363 *Proposal for mounting the
Antinous relief above a Villa
Albani fireplace, sketched by
Marchionni (ca. 1760)*

364 *Rome, Villa Albani,
tempietto*

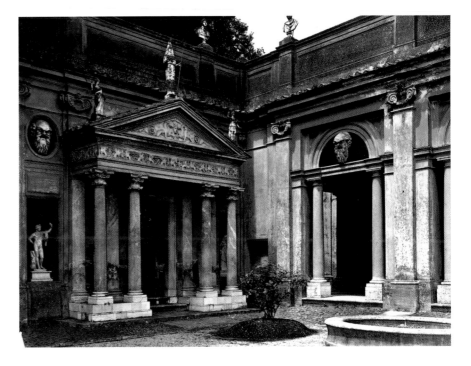

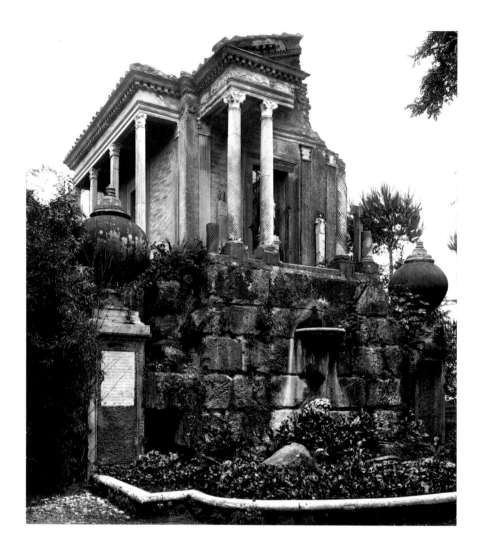

365 *Rome, Villa Albani,*
sham ruin

366 *Albury Park, Surrey, terraces*

names of the imitated places: as among others, the Liceum, Aristotles School in Athens, the Academy of Cicero, the *Prytaneum* or counsel house of Athens, the Temple of Thessalia, a place wonderfully pleasant having trees and meadowes marvellously delectable, wherin birds of diverse kinds sing continually with excellent melody: the *Canopus* of Egypt, a place wherin the God of that name was worshipped; and the like Fabricks made and nominated in imitation of the true. He further saies, that he there caused to be erected the place of representation of hell: all which things were undoubtedly accomodated and adorned with all conveniences and endowments, so that one might well comprehend at the first view, that, which in itself comprehended every one, that is, Pictures, Statues, Figures, Inscriptions, pourtrayes of men, wherewith every of those places were illustrated either with some notable writing, or heroick action.

Warcupp's commentary underscores the relations among architecture, informal landscape, garden sculpture, and explanatory inscriptions, all essential ingredients of the English landscape garden as it came to be formulated in the first half of the eighteenth century.

To a great degree, the analogy between the culture of classical Rome and that of the Augustan Age in England was based on real and imagined affinities between the history, economic development, and literature of the two periods. Augustan literature is generally associated with the reign of Queen Anne (1702–1714) and with such poets as Dryden, Pope, and Thomson, whose themes and metrics were consciously modeled on the verse of their counterparts in Augustan Rome, particularly Virgil and Horace. A preoccupation with classical themes was by no means limited to Queen Anne's day; it may indeed be seen as a fixed point of artistic reference that unifies English literature and the visual arts throughout the first half of the eighteenth century.

The analogy between Rome and England also found expression in the landed English gentry's emulation of their ancient counterparts, men like Cicero and Pliny the Younger. Throughout his life Pliny was a man of affairs and letters, an active and beneficent citizen of his native Como, as we have seen, and a good manager of numerous country estates. In combining these activities effectively and gracefully, Pliny seems to anticipate

perfectly the English Augustan type—a government
official or banker, shuttling between London and his
country house in Surrey or Wiltshire, adept at writing
a speech or a letter in prose or verse, able to quote
Virgil or Horace aptly, and like his Roman counterpart
a builder, planter, and farm manager. Like Pliny, who
restored a temple of Ceres on his Tuscan property, Lord
Arlington, a protégé of Charles II, built a new church in
Euston Park at John Evelyn's suggestion. Neither was a
major achievement, and both were motivated by a mix
of piety and pride—but thanks to such men the coun-
try world of ancient Italy and modern England was the
richer.

Of all eighteenth-century landscape gardens, Stowe,
in Buckinghamshire, is certainly the most complex,
offering an immense variety of vistas expressing a mul-
titude of themes—poetic, political, and moral—truly
"A work to wonder at." The pride of Stowe is its rich
display of temples and related garden structures, once
numbering almost forty. The architectural pavilions are
set within an extensive landscape; the gardens (as dis-
tinct from the surrounding parkland) cover 162 hect-
ares, an area larger again by a third than Hadrian's
Villa. While many temples at Stowe carried the names
of classical divinities, others were dedicated to such ab-
stractions as Liberty, Friendship, and Virtue, and still
others commemorated historical personages and events,
commenting on contemporary politics as well.

The gardens at Stowe were laid out in the early eigh-
teenth century by Charles Bridgeman in a geometric
style much indebted to the French formal gardens of
Le Nôtre. A generation later Bridgeman's crisp, or-
thogonal relations began to be blurred by William Kent,
who preferred to create more natural effects by exploit-
ing the contours of the site. In pursuing this approach
Kent followed Pope's dictum to "consult the Genius
of the place in all." It is significant that Kent's vision
of landscape was essentially classical, based in almost
equal parts on Claude Lorrain's pictorial distillations of
the Campagna and on his own experience of the Roman
countryside and such sites as Hadrian's Villa when he
resided in Italy between 1709 and 1719.

In 1733, at the very center of Stowe, Kent began to

367

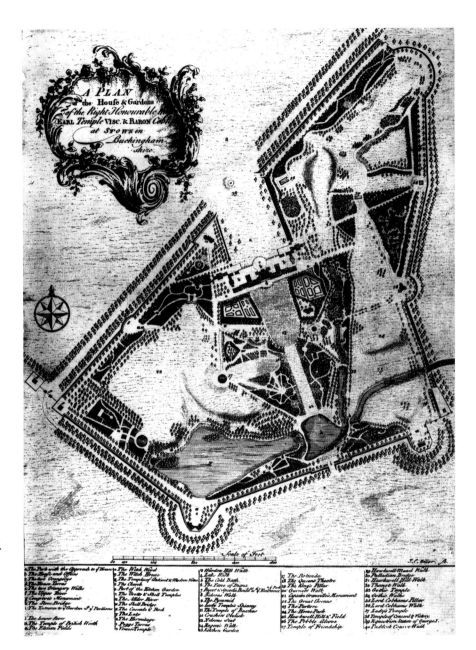

367 *Stowe, Buckinghamshire, plan of gardens (1769)*

lay out the extended landscape composition known as the Elysian Fields. One of Kent's first steps was to dam a natural rivulet that drained this declivity in order to create the sluggish, reed-clogged stream he called the Styx. On one side of the Styx, set high above the stream, he placed a Temple of Ancient Virtue, a spare Ionic structure expressing in architecture the austerity of Greek heroes whose busts were enshrined within. Three of these — Homer, Socrates, and Epaminondas — had also appeared in Pope's "Temple of Fame," while the fourth, the Spartan lawgiver Lycurgus, was included for his associations with liberty. Just as Brutus had invoked the Spartans in his garden, so the Augustans also identified themselves with Sparta, casting the French in the role of the Persians.

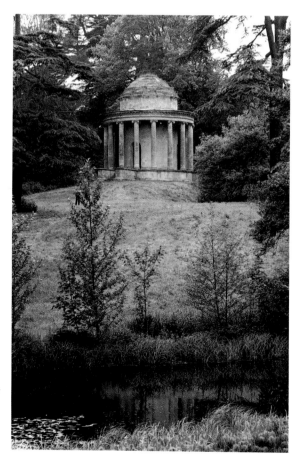

368 *Stowe, the Temple of Ancient Virtue*

If so far the mood of Kent's Elysian Fields had been profoundly classical, Virgilian with just a trace of an English accent, its second component, the Temple of Modern Virtue, breaks with the steady elegiac measure and brings the landscape composition more into line with a satire by Pope. Built as a ruin, in shambles, the temple was presided over by the headless statue of Robert Walpole, arch-enemy of the Whig opposition, of which Lord Cobham, Stowe's owner, was a leader. Unfortunately, the temple no longer survives, but it is familiar from numerous descriptions and prints. Surely this is the contemporary counterpart in gardening of Pope's mock-heroic visit to the underworld in "The Dunciad." And this should not surprise us, because Pope was consulted on the work at Stowe.

On the opposite side of the Styx, Kent placed the third, culminating monument of the Elysian Fields, the Temple of British Worthies. This is laid out in the form of an exedra articulated by sixteen niches containing busts of English rulers, philosophers, writers, and architects. The empty oval niche in the pyramid once contained a head of Mercury, the messenger god who leads the souls of heroes to the Elysian Fields. Cobham's political views determined the selection of Worthies, and together they represented an ideal standard against which to measure contemporary leaders. In this temple the visitor is confronted with an eighteenth-century counterpart to the underworld scene in the *Aeneid,* where Rome's glorious future is foretold by the shades of its heroic past. From what is known about Hadrian's Underground Galleries and their relation to other features of the Villa it is clear that they exerted no direct formal influence on the Elysian Fields at Stowe. It seems likely, however, that the underworld of the HA passage was known to both Cobham and Pope and that it may have provided the locus classicus for an elysium embedded in the grounds of this great estate.

In 1780, Charles Cameron designed a Temple of Friendship at the czar's summer palace of Pavlovsk, a Doric tholos set into a *jardin anglais.* Cameron's temple consciously alludes to Stowe, both in its dedication (a structure of the same name survives there in ruins) and in its general appearance, recalling the Ionic rotundas

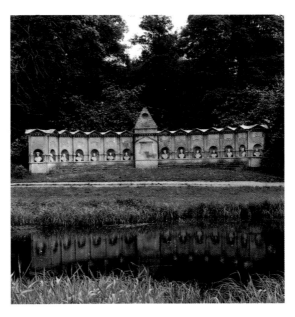

371

by Sir John Vanbrugh and William Kent. Cameron's use of the Doric order doubtless reflects the growing enthusiasm for Greek architectural forms, but it may also be traced to his knowledge of the Doric Temple at the Villa. In the complex genealogy of the tholos as a motif in the history of Western architecture, the Doric Temple of Hadrian's Villa emerges as a key monument, mediating between Athens and Rome, antiquity and the Renaissance.

Kent's Elysian Fields remain the most complete expression of classical elegiac themes. But Stowe should not be thought unique in this respect, for there are other eighteenth-century landscape gardens where the contrast of fertility and mortality in nature plays a major role, with certain elements of an underworld itinerary. One of these, Rousham Park, near Oxford, was taking form at Kent's hands at about the same time as Stowe. Unlike the vast extent of Stowe, Rousham occupies a small, irregular plot of 6 hectares. A principal architectural feature, an arcaded terrace, was intended to recall the vaulted substructures of the Roman shrine of Fortuna Primigenia at Palestrina, the ancient Praeneste, from which the terrace takes its name. Large cinerary urns line Kent's Praeneste, a pyramid graces one of the lower walks, and a description of 1750 mentions "Proserpine's Cave," a grotto that boasted statues of Pluto, Proserpine, and attendant figures. Dominating the view from the Rousham terrace is Peter Scheemakers's copy of the *Dying Gaul*. Set against the wide expanse of peaceful landscape, this statue intro-

369 *(far left) Stowe, the Temple of Modern Virtue, print (1750)*

370 *Stowe, the Temple of British Worthies*

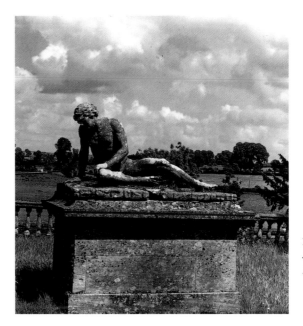

371 *Rousham Park, Oxfordshire,* Dying Gaul, *by Scheemakers (1741)*

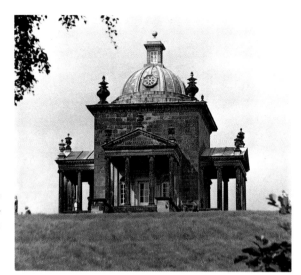

372 *Castle Howard, Yorkshire, the Temple of the Four Winds, by Vanbrugh (1726)*

duces an element of contrast, a melancholy meditation on mortality, prompted no doubt by the mortal illness of the proprietor, Gen. James Dormer, at the time the statue was erected. A preliminary sketch by Kent depicting Scheemakers's statue set above a sarcophagus underscores this theme.

Kent was not the only landscape designer to incorporate elegiac themes in the iconography of eighteenth-century English gardens. Part of the circuit of the garden at Stourhead, in Wiltshire, included a miniature Hades of Virgilian inspiration. But it is at Castle Howard, Yorkshire, that we see the most monumental expression of Elysium. Here, from 1726 onward, Charles Howard, third earl of Carlisle, opened up a vast landscape composition to the east of his newly completed house, both conceived on an epic scale. Along the brow of a hill, the earl had Vanbrugh build a viewing platform crowned with an elegant Temple of the

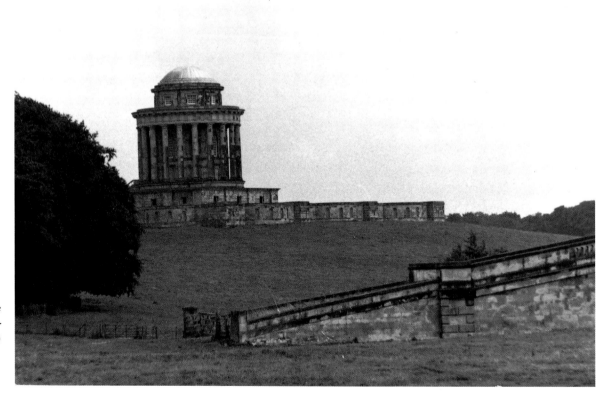

373 *Castle Howard, the Mausoleum, by Hawksmoor (1728–1738)*

372 Four Winds, recalling in placement and function the West Belvedere of Hadrian's Villa. From this vantage point the observer surveys an ample arc of landscape 373 anchored at one end by the earl's mausoleum. At the center of this vast panorama stands a pyramidal monument to an ancestor, Lord William Howard, silhouetted on the skyline nearly a mile away, and at the opposite end of the vista rises the cupola of Castle Howard. The mausoleum, intended for the remains of the earl and his descendants, is by Nicholas Hawksmoor. In placing his own memorial in a landscape setting studded with other family and funereal associations, the earl went further than any of his contemporaries in realizing an Elysium at once a sublime poetic and pictorial composition and a living reality.

If Hadrian's Villa provided a model for extensive English landscape gardens incorporating topographical allusions and elegiac themes, it also provided a precedent for placing garden structures of distinctly different styles in a garden setting. In 1757, Sir William Chambers began to remodel the Royal Gardens at Kew, designing an impressive array of pavilions. In addition to a Gothic cathedral, he built classical temples dedicated to Arethusa, Augusta (the Dowager Princess of Wales), Bellona, Aeolus, Pan, Solitude, and the Sun. Into this landscape he also placed more exotic structures evocative of the Orient, including the Pagoda, Mosque, Alhambra, Menagerie Ting, and House of Confucius. Chambers's remarks in *Designs of Chinese Buildings,* published in the year work began at Kew, indicate that the Villa, viewed through the lens of the HA, was both inspiration and justification for this richly pavilioned landscape. "Adrian, who was himself an architect, at the time when the Grecian architecture was in the highest esteem among the Romans, erected in his Villa, at Tivoli, certain buildings after the manner of the Egyptians and of other nations."

Were the Mausoleum at Castle Howard or the temples at Stowe and Kew merely identical copies of specific classical prototypes they could never convey the multiple levels of meaning that make them so satisfying. The process of adapting, not simply adopting, the forms of the past to suit current times and whimsies gave Augustan patrons opportunities to provide new interpretations and reverberations of what had come before. Much like Hadrian, Cobham, Carlisle, and Augusta preferred allusions to venerable monuments rather than literal imitations of them. The dynamic translation of classical architecture, pastoral themes, and landscape settings in eighteenth-century England yielded enduring images that transcend limitations of time and geography.

XI

Art Dispersed

Escaping centuries of abuse and neglect, a substantial body of art from the Villa has survived more or less intact. A recent catalogue of sculpture from the Villa lists 173 statues definitely found on the site and an additional 105 of less certain provenance. Both the quantity and the quality of the surviving sculpture are impressive. The modern visitor to the Villa, however, will not see most of it; fewer than 25 works, most from the excavation of the Scenic Canal in 1951–1954, are displayed in the Canal Block. Today Villa art is scattered from Malibu to Saint Petersburg, and the effects of this dispersal on the history of art constitute one of the most influential aspects of the Villa's legacy.

RECOVERY AND EXILE

The following account of the discovery and removal of the Villa's portable art is selective. We wish to illustrate how relentless despoliation over many centuries paradoxically enhanced its reputation while diminishing its fabric. This extraordinary afterlife of the Villa results in large part from the periodic recovery and critical reception of works of art that once adorned it.

Dispersal of the Villa sculpture may have begun immediately upon Hadrian's death. The removal of especially desirable objects and furnishings to other imperial

residences would be natural. It is reasonable to conjecture that bronze statues were melted down, and the absence of any record of a bronze statue found on the site prompts speculation that bronzes may have been removed long before the collapse of the empire. The archaeological recovery of much marble statuary from the Villa shows that its contents were probably not systematically despoiled in antiquity. Although it is impossible to calculate what proportion of the Villa's artistic contents has been lost to vandalism and the lime kilns, the evidence of the eighteenth-century excavation of the Bog suggests that such losses must have been considerable.

As we have noted, the citizens of Tivoli used the Villa throughout the Middle Ages as a quarry for building materials and architectural *spolia*, evident in the portal of the twelfth-century church of San Silvestro and the portico of Piazza Palatina. Among the first statues recorded as taken from the Villa for display elsewhere are two also removed to Tivoli. These are the twin Egyptianizing telamons of red granite that probably came from the neighborhood of the Scenic Canal and were placed beside the entrance to the bishop's palace in Piazza San Lorenzo. The date of their removal is uncertain, but it was probably in the fifteenth century and certainly before they were drawn by Giuliano da Sangallo around 1504–1507.

For three centuries, before their transfer to the Vatican Museum, these statues figured among the notable curiosities of Tivoli. Raphael must have seen them when he visited there in 1516, and his painted telamons in the Stanza dell'Incendio likely were inspired by them. Michelangelo admired them and declared that they alone justified a trip to Tivoli. A sketch made by William Kent between 1709 and 1719 records the appearance of one of the telamons set close to the arched opening of a street in the medieval quarter of Tivoli. As with their counterparts in Rome — Marforio, Pasquino, Madama Lucrezia, and other ancient statues displayed on public streets — the telamons were given names by the local populace: I Cioci, perhaps a humorous reference to *ciociari*, peasants who worked the land to the south of Tivoli in the neighborhood of Frosinone. In 1779 the telamons were wrenched from their picturesque urban setting to grace the precise Neoclassical forms of Michelangelo Simonetti's Sala a Croce Greca in the Museo Pio-Clementino at the Vatican.

The initial transfer of the telamons from the Villa to Tivoli conformed to a common medieval practice of setting up ancient statues, considered to be marvels, in public places. In the Renaissance, ancient statues came to be appreciated less for their totemic qualities than for their intrinsic beauty. Classical sites began to be ransacked in the search for buried statuary, and the rich vied with one another in forming collections. The earliest record of such excavations at the Villa dates from the pontificate of Alexander VI Borgia (1492–1503), when Ligorio states that a remarkable group of eight seated Muses was taken from the South Theatre. Under Pope Leo X (1513–1521) these were moved first to the Vatican and then to the Villa Madama, where Martin

374 *Egyptianizing telamon from the Villa, drawn by Kent*

374

375

376

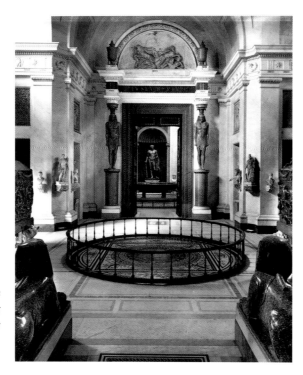

375 *Vatican Museum, Sala della Croce Greca, Egyptianizing telamons flanking a doorway*

376 *Muses from the South Theatre, drawn at the Villa Madama by Heemskerck (ca. 1532–1535)*

van Heemskerck sketched them. They remained at the Madama until around 1670, when they were acquired by one of the great collectors of the seventeenth century, Queen Christina of Sweden. Following her death in 1689 they passed to Prince Livio Odescalchi and are recorded in a palace inventory of 1714. At some point in the seventeenth century the statues were restored in the rather free and imaginative fashion of the time, which, to judge from the execution, may have been carried out by a follower of Bernini. In 1724 the Muses were sold to Philip V of Spain, who transported them to Madrid, where they grace the Prado.

In the course of the first half of the sixteenth century, collectors continued to search for buried statues at the Villa. In 1535 Alessandro Farnese dug in the Island Enclosure, unearthing numerous fragments of the marine frieze, which he displayed in his gardens on the Palatine Hill. Five years later, Cardinal Gianvincenzo Caraffa found statues of Diana, Atalanta, and Fortune in the Residence, and in 1550 Cardinal Marcello Cervini extracted a marble frieze from an undetermined place. Ulisse Aldovrandi, writing in 1551, mentions that Marcantonio Pelosi uncovered a fragment of a group of horses on the western slope of the East Valley. This group, much restored, is now in the Villa Borghese.

All of these excavations appear to have been quite limited, and none contributed significantly toward understanding of the site. This stands in stark contrast to the efforts of Pirro Ligorio. As the cardinal of Ferrara's antiquarian, Ligorio was naturally motivated by the desire to add to the collection of ancient statuary his patron was assembling in his garden on the Quirinal. At the same time, Ligorio took care to record what he saw in the course of his excavations, and his observations have ever since provided a starting point for modern students of the Villa.

Ligorio's first campaign, begun in 1550, revealed notable works of sculpture, including a youthful Hercules sent to the cardinal's brother, Duke Ercole II, in 1551, a headless Venus found in 1551, and a statue of Hadrian unearthed in 1554. Cardinal Maffei, writing from Rome to Cardinal Jean du Bellay in 1551, commented on Ligorio's excavations: "By now Pirro has

excavated all of Hadrian's Villa for the cardinal of Ferrara and has found twelve statues, including nude and draped figures." Maffei is precise about the number of statues found and distinguishes between draped and undraped figures. In just one year and with limited means Ligorio could hardly excavate the complete Villa, but because his patron owned all of the vast site he could range more widely over the ruins than his predecessors.

During successive campaigns Ligorio extracted more sculpture from Hadrian's Villa to enrich the cardinal's collections. In 1560 payments are recorded to Domenico Martelli in compensation for his work "digging for statues at Hadrian's Villa." In 1566, when Ligorio was no doubt distracted by his design responsibilities at the Villa d'Este, a certain Vincenzo Stampa appears to have been engaged as his foreman to supervise work on the site. Vincenzo, together with his brother Giovanni Antonio, was active in Rome as a dealer in antiquities. As work on the Villa d'Este progressed, much sculpture from the Quirinal garden was brought to Tivoli to adorn the halls and fountains. Important fragments of the Island Enclosure frieze were set into the Rometta fountain; today the originals are back at the Villa and have been replaced at the fountain by casts.

377

A detailed inventory made following the cardinal's death in 1572 documents the presence in his residence at Tivoli of thirty-eight statues known to have been found at the Villa. Other works found there remained in Rome, while yet others were sent to Ferrara and are not accounted for in the inventory. Most of the sculpture brought to Tivoli by the cardinal remained together until the eighteenth century, when his heirs sold important groups to private collectors in England and to Pope Benedict XIV, who acquired nine of the best statues for the Capitoline Museum. One of these may have been the faun that inspired one of Nathaniel Hawthorne's last works, *The Marble Faun*.

In the half-century that followed the excavations sponsored by the cardinal of Ferrara, no serious efforts were made to explore the site of the Villa and no significant discoveries of ancient sculpture appear to have been made there. This situation changed in 1623, when Pope Urban VIII appointed his nephew

Antonio Barberini governor of Tivoli. Antonio and his brother Francesco continued the program of study and site exploration that had lapsed after the death of Antonio's illustrious predecessor, the cardinal of Ferrara. Francesco Barberini's support of Contini's survey and printed plan of the Villa has been noted. While Contini was preparing his plan, and perhaps as a result of the trenches he dug, a pair of marble candelabra see 238 were unearthed in the Southern Range, which then as now belonged to the Bulgarini family. Shortly after their discovery, Monsignor Bulgarini made a gift of them to Antonio Barberini, and thus they are known as the Barberini Candelabra. In 1766 the English banker and art dealer Thomas Jenkins acquired them from the Barberini heirs. After failing in his efforts to export them to English clients, Jenkins sold the candelabra in

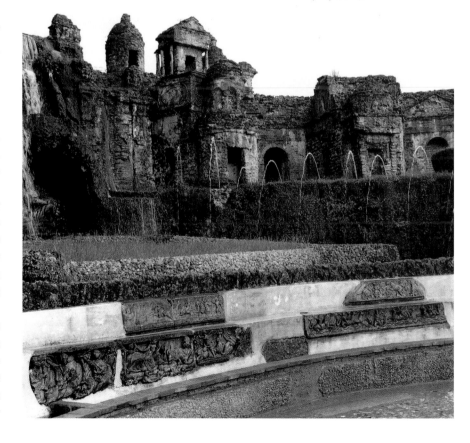

377 *Tivoli, Villa d'Este, the Rometta Fountain, showing casts of the Island Enclosure frieze (1988)*

1770 to the Vatican Museum, where they stand in the Galleria delle Statue.

Candelabra of this height (10 *palmi,* or 2.23 meters) and complexity are seldom found and provide a rare glimpse of high-quality imperial furnishings. Above triangular bases adorned by three full-length relief figures rise richly detailed shafts covered by acanthus leaves, somewhat resembling three Corinthian capitals stacked one above another and crowned by a shallow vase. This apparent organic growth is in sharp contrast to the prismatic forms of the bases. It is important to recognize that much of what is admirable is the result of restorations made in 1766 by Bartolommeo Cavaceppi when the candelabra were in Jenkins's possession. More will be said about restorations shortly; as they appear today, the candelabra reveal as much about eighteenth-century attitudes toward antiquity as they do about taste in Hadrian's day.

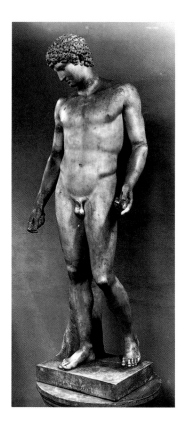

378 *The Albani Antinous,*
excavated in 1730 by Count Fede;
now in the Capitoline Museum

With the election of Innocent X in 1644 the Barberini family was supplanted by the Pamphili, who immediately undertook an ambitious building program, intending to surpass their predecessors. Central to this program was the construction of a vast country house just outside Rome along the Via Aurelia, modeled in part on Hadrian's Villa. Like the facades of their predecessors' villas, notably those of the Medici and the Borghese, the casino of the Doria-Pamphili was enriched by ancient statues and reliefs. In their effort to secure appropriate sculpture, in 1645 the Pamphili sent agents to scour ancient sites, including Hadrian's Villa. Perhaps at this time the family acquired three fragments of the Island Enclosure marine frieze. Numerous references in the Doria-Pamphili archives refer to the acquisition of marble and statues from the Bulgarini, who were as anxious to satisfy the Pamphili as they had been the Barberini.

"LOVE FOR ANTIQUITY"

The excavations carried out by Count Fede, Liborio Michilli, and Francesco Antonio Lolli between 1724 and 1742 were the first undertaken during the eighteenth century to uncover sculpture of outstanding quality. The contiguous holdings of Fede and Michilli embraced the Bog, the Doric Temple, the East-West Terrace, and the Service Quarters, and all of them yielded important statues. Michilli eventually sold the statues he uncovered to Pope Benedict XIV in 1742 in exchange for the tobacco monopoly in Rome.

Count Fede and his heirs dealt actively in antiquities, and important statues known to have been in their possession, such as a Cupid and Psyche drawn by Pompeo Batoni, remain unaccounted for. Other celebrated works, such as the Capitoline Flora, were sold to Benedict XIV in 1744. Among the statues found was a bust of Hadrian, formerly in the Townley Collection and now in the British Museum, which figures in a sketch by Thomas Jenkins.

Fede also uncovered two representations of Antinous. The first was a Hadrianic variation of an early fourth-century Hermes, excavated in 1730. This was ac-

378

quired by Cardinal Albani, but within three years he sold it to Pope Clement XII, who was assembling outstanding works for the new Capitoline Museum. Before being placed in the Capitoline, the Antinous was restored by Pietro Bracci, an outstanding sculptor of the period. Later in his long career Bracci executed major commissions, including the Tomb of Benedict XIV in Saint Peter's and the main sculptural component of the Trevi Fountain, both in the style of Late Baroque Classicism. His experience of restoring ancient sculpture—shortly before working on the Capitoline Antinous he repaired the Arch of Constantine—influenced his style greatly. He restored the left arm and leg of the Antinous; a charming drawing of 1780 by Jean Grandjean depicts an eighteenth-century connoisseur pointing out the juncture of the ancient marble with Bracci's addition.

Almost from the day of its discovery the Capitoline Antinous was much admired. The sculptor Agostino Cornacchini, who compiled an inventory of Cardinal Albani's collection in 1733, remarked that it was priceless, deserving to rank with the finest antiquities. In the 1740s a full-scale marble copy was carved for Louis XV of France, and reduced versions in bronze, marble, and plaster were frequently made in the late eighteenth and early nineteenth centuries. The Antinous figured among the statues ceded to France in 1797 and was displayed in Paris until its return to the Capitoline in 1816.

In 1735, Fede discovered another Antinous, a half-length bas-relief depicting him in profile. Like the Capitoline Antinous, this statue was also acquired by Cardinal Albani, who gave it pride of place in his villa outside the Porta Salaria. Shortly after its discovery Ridolfino Venuti declared it superior; later it was ranked with the Laocoön and the Belvedere Apollo. This was due largely to the enthusiastic assessment of Winckelmann, Albani's antiquary, who believed that it represented the supreme accomplishment of Hadrianic art, and—his highest praise—was worthy of comparison with sculpture from the "best times"of classical Greece. Winckelmann seems to have been moved by the melancholy expression of Antinous; he identified with the subject, and in his portrait by Anton von Maron holds an engraving of the relief.

379 *The Albani Antinous, drawing by Grandjean (1780)*

Throughout the eighteenth and nineteenth centuries, the Albani Antinous was praised by visitors, among them Edward Gibbon and Nathaniel Hawthorne. One unidentified English milord on the Grand Tour paid Pompeo Batoni to paint his portrait standing next to a copy of it. Along with many other antiquities, the relief was expropriated by the French in 1798 and returned only after 1815. In this century the critical acclaim of the Antinous is much diminished, both in reaction to its sweet sensuality and because its present owners, the Torlonia, have kept it secluded.

About the same time that outstanding discoveries were being made by Lolli, Michilli, and Fede in the northern part of the Villa, equally spectacular works were unearthed in the Southern Range. In the winter of 1736–1737, Monsignor Giuseppe Alessandro Furietti (1685–1764) obtained excavation rights from Simplicio Bulgarini, not, as was common, on the basis of a division of spoils but on the payment of a mod-

380 *Portrait of an Englishman posing with a copy of the Albani Antinous relief, by Batoni (early 1760s)*

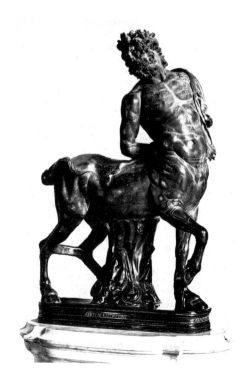

381 *Statue of an Old Centaur, found in 1736 by Furietti in the Reverse-Curve Pavilion; now in the Capitoline Museum*

est fee once and for all. Furietti began to dig in the Reverse-Curve Pavilion, where in 1736 he found two centaurs carved of gray marble. The Centaurs—one old, the other young—were recognized as pendants, and this, together with the fact that they were signed by Greek artists (Aristeas and Papias of Aphrodisias, in Asia Minor), stimulated much interest in them. The statues are probably copies commissioned by Hadrian of bronze originals. 381, 382 see 171, 172

Shortly after the discovery of the Centaurs engravings appeared in a sumptuous publication edited by Giovanni Girolamo Frezza, who employed the best artists to prepare drawings for his print makers. Not only is Batoni's depiction of the young Centaur exceptionally faithful to the original, for example, but his subtle handling of contour, silhouette, and tonality effectively captures its three-dimensional qualities. Furietti kept the Centaurs in his Roman residence, where important visitors such as Charles de Brosses came to view them. Benedict XIV attempted to purchase them for the Capitoline Museum and is reported to have been so irritated by Furietti's refusal to sell that he declined to name him cardinal. For his part, Furietti reportedly feared becoming known as "Cardinal Centaur" if he agreed to give the statues up. In any event, Furietti received his cardinal's hat only in 1759, from Benedict's successor, Clement XIII, and when he died in 1764 the statues were sold to the pope by his heirs and placed in the Capitoline Museum. In the following year, the pope issued a medal designed by Ferdinando Hamerani to celebrate his gift to the museum. 383

Furietti's excavations brought another important statue to light, but we are less well informed about the circumstances. This is the Faun in rosso antico that Benedict XIV gave to the Capitoline Museum in 1746. In style the Faun is similar to the Furietti Centaurs, and it has been plausibly suggested that like them, it is a copy of a bronze original made by Aphrodisian sculptors. The appeal of the statue derives as much from the Faun's evident joie de vivre as from the color and texture of its fine-grained, wine-red marble. see 173

In 1737, near the Circular Hall, Furietti made another spectacular find, the celebrated mosaic of doves rest- see 209

ing on the lip of a bronze basin, now in the Capitoline Museum. A mosaic of the same subject, by the Hellenistic artist Sosos, active in Pergamon, is described by Pliny the Elder. "Among these mosaics [by Sosos] is a marvelous dove drinking and casting the shadow of its head on the water. Other doves are pluming their feathers in the sun on the lip of a goblet." The presumed recovery of a work by an artist named in classical literature was hailed as a triumph of archaeology.

As is the case with another famous work mentioned by Pliny, the Laocoön, antiquarians were understandably slow to recognize that what had been discovered was a splendid copy of the original composition. Thousands of tiny stone tesserae—as many as sixty per square centimeter—produce remarkable ranges of color and shadow, as well as a convincing illusion of three-dimensional space and varied textures. The discovery led Furietti to publish an illustrated book on mosaics in 1752. In 1765 the mosaic came to the Capitoline Museum along with other Villa mosaics found at the same time that had been set into two bronze tables with the arms of Pope Benedict XIV. The recovery and public display of the Dove Mosaic also contributed to the remarkable growth and popularity of a new artistic genre, the *mosaico minuto*, which flourished in the late eighteenth and early nineteenth centuries. Small mosaics, often suitable for brooches and pins, as well as larger tabletop compositions, were produced in large numbers for tourists. No fewer than twelve versions of the Dove Mosaic have been catalogued, and at least one other feature of Hadrian's Villa, the Underground Galleries, was also depicted.

During his extended residence at the French Academy in Rome between 1762 and 1771, the French sculptor Clodion drew inspiration from examples of Egyptianizing statues discovered at the Villa and exhibited in the Capitoline Museum. Clodion's attention may have been directed to the Villa and its antiquities by Piranesi. In the 1760s Clodion modeled a terracotta statuette after the colossal Antinous represented in the guise of Osiris, now in the Vatican. Early in the next decade he produced a graceful variation in terra-cotta on the theme of an Egyptian priestess holding a portable

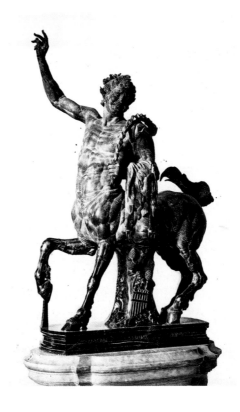

382 *Statue of a Young Centaur, found in 1736 by Furietti in the Reverse-Curve Pavilion; now in the Capitoline Museum*

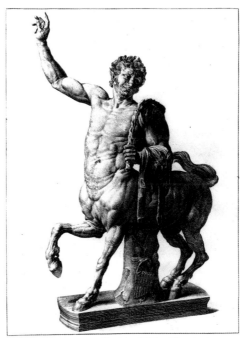

Centaurus e marmore Ægyptio inter Hadrianæ Villæ rudera in agro Tiburtino repertus Mense Decembri 1736. Ab Ill.mo et Rev.mo Præsule Josepho Alexandro Furietto.

Franciscus Pozzius delin. *Hieronymus Frezza fed Romæ 1739*

383 *The Young Centaur, engraving after a drawing by Batoni (1739)*

shrine. Among his models was a black marble statue found at the Villa in the early eighteenth century and displayed in the Capitoline Museum until its transfer to the Louvre in 1797. Clodion transforms the hieratic poses of his ancient sources into a more relaxed and open composition radiant with life.

One of the most important events in Villa annals occurred in 1769, when the Scottish painter and dealer Gavin Hamilton, assisted by Piranesi, initiated excavations in the Bog. Locals called this low-lying area on the northern fringe of the Villa the Pantanello. The East Valley stream (and perhaps part of Hadrian's waterworks) drained into the Bog depression, and the marshy site had frustrated Lolli's earlier attempts at excavation; in 1724 he ceased digging after investigating only a third of it. In 1779 Hamilton wrote to the English collector Charles Townley, who had acquired several pieces from the Bog, describing the circumstances of his excavation. Hamilton's letter provides vivid details and is worth quoting at length:

In the year 1769 I employed my Sculptor to go with another man to Villa Adriana in search of Marble to restore Statues. He was conducted to Pantanello, being the lowest ground belonging to the Villa and where antiently the Water that served the Villa was conducted, so as to pass under ground to the River. When he returned to Rome he told me he had found several fragments, heaped round the above Lake of Pantanello, many of which were of excellent Workmanship. His description raised my curiosity so much, that the day following I went with my Sculptor to visit this misterious spot. Upon enquiry I found that this place was the property of Signr Luigi Lolli and that it had been dug by his grandfather at a great expence and with some success; the precious fragments that were found at that time were sold to the Cardinal Polignac who transported them to France, and at his death I am told that the Antiquities were purchased by the King of Prussia. The only thing of value that remained with the family was a bust of Hadrian now in your collection. I endeavoured to know of different people at Tivoli if Lolli had finished his cava, or if part remained untouched. Various were the answers of those who knew nothing but by tradition, but nothing satisfactory could be learned. — In this dilemma I returned to Pantanello to look over my fragments, and take a survey of the Lake, surrounded on all sides with high ground, and no hopes left of draining it, but by a deep Channel, so as to carry off the water to the River Anio; my hopes were great, and nothing certain but the expence. Love for antiquity overballanced every after concern. I then returned to Tivoli, made my bargain with Signr Luigi Lolli, took chaise for Rome—hastened out the best diggers I could get and set to work, cutting my drains through the vineyard of Sigr Domenico de Angiolis where in some degree it had been made in the time of Lolli about 60 years ago. He insisted on having a sum of money, for leave to clean out this old drain. I thought his demand unreasonable, upon which an order was sent to my man not to proceed any farther. A law-suit commenced which lasted some months and which I at last gained in the Tribunal of the *Consulto*. I then got to work with my Aquilani who in a short time found a passage to an antient drain cut in the tufo. This happy event gave us courage in the hazardous enterprise, and after some weeks work underground by lamp-light and up to the knees in muddy water, we found an exit to the water of Pantanello, which tho' it was in a great measure drained, still my men were obliged to work past the knees in stinking mud, full of toads and Serpents and all kinds of vermin. A beginning of the Cava was made at the mouth of the drain, where formerly Lolli had planted his pump, which we found choaked up with trunks of trees and marble of all sorts, amongst which was discovered a Head now in the possession of Mr. Greville. This was followed by the vase of Peacocks and Fish now in the Museo Clementino. A fine Grayhound, a Ram's head and several fragments were afterwards discovered, when all of a sudden to our great mortification the rest appeared to have been dug by Lolli. This put a full stop to my career, and a council was held. In this interval I received a visit from Cavr Piranesi of a Sunday morning. Providence sent him to hear mass at a Chapel belonging to the Conte Fede, the Priest was not ready, so that Piranesi, to fill up time, began a chat with an old man by name Centorubie, the only person alive that had been a witness to Lolli's excavations, and had been himself a digger. He was immediately conducted to my house at the Villa Michilli now the property of the Canonico Maderni. After the old gentleman was refreshed we sett out for Pantanello, and in our way heard the pleasing story of old times. A quarter of an hour brought us to the spot. Centorubie pointed out the space already dug by Lolli and what remained to be dug on this occasion, which was about two thirds of the whole; he added, that Lolli abandoned his enterprize merely on account of the great expenses that attended it, and on account of the difficulty of draining the Lake which he never compleated. This Story gave new light and new spirits to the

depressed workmen, a butt of the Canonico's best wine was taken by assault, 40 Aquilani set to work, with two Corporals and a superintendant, two machines called Ciurni were got to throw out the Water that continued to gather in the lower part of this bottom. It is difficult to account for the contents of this place consisting of a vast number of trees cut down and thrown into this bottom, probably out of spite, as making part of some sacred wood or grove, intermixed with statues etc. etc, all which have shared the same fate. I observed that the Egyptian Idols had suffered most, being broke in minute pieces, and disfigured on purpose; the Greek Sculptor in general has not so much incurred the hatred of primitive Christians and Barbarians. As to Busts and Portraits I found most of them had only suffered from the fall, when thrown into this reservoir of water and filth; what were thrown in first and that stuck in the mud are the best preserved. Intermixed with the trees and statues, I found a vast quantity of white marble sufficient to build a lofty Pallace, a great number of columns of Alabaster much broke, as likewise of giallo antico and other precious Marble, to which I may add broken vases, basso-rilievos, ornaments of all sorts, in a word a confused mixture of great part of the finest things of Hadrian's Villa. These were thrown promiscuously into this bottom, which by degrees had formed a small lake vulgarly called Pantanello, the diminutive of Pantano.

It is worth noting that Hamilton's motivation for excavation stemmed from his desire to find ancient marble suitable for restoring statues, reflecting his activities as a dealer. The marble—"sufficient to raise a lofty Pallace"—Hamilton found in such quantity suggests the possible existence near the Bog of a major structure marking the northern entrance of the Villa in antiquity. It could also be that the columns and marble blocks Hamilton found account for the missing structure of the temple beside the Service Quarters, barely a trace of which survives. Hamilton's observations about the circumstances in which the ancient remains were found are intriguing. Whether the marbles were gathered for lime-burning or in Christian anger is unknown.

Hamilton's letter shows how archaeology was perceived and practiced in the eighteenth century. Any excavator, especially a foreigner, had first to secure the cooperation of local authorities and property owners; dealers have been compared to the agents of mineral prospecting companies, negotiating prospecting rights.

James Dallaway, writing in 1800, provides a useful summary of such excavation arrangements:

The Pope gives his permission for this kind of adventure, upon the following conditions. When an excavation is made, the antiquities discovered are divided into four shares. The first goes to the Pope, the second to the "Camera" or ministers of state, the third is the lessee's of the soil; and the last is the right of the adventurer. His holiness sometimes agrees for the pre-emption of the whole; and sometimes all the shares are bought in by the contractor before the ground is opened.

It was not uncommon for the landowner to require additional compensation for concessions of different sorts, as Luigi Lolli did in demanding payment for permission to purge an ancient drain. Faced with his exorbitant demands, Hamilton's only recourse was to the law, which resulted in the loss of valuable time and money. While work was under way, it was essential that the sponsor of the dig remain on site, both to oversee the hired labor and to ensure that any valuable artifacts found were not spirited away. That is why Hamilton took up residence in the Casino Michilli. By the mid-eighteenth century, many ancient ruins had been plundered extensively for more than three centuries, and Hadrian's Villa was no exception. Before negotiating an excavation permit and paying for the necessary labor and machinery, therefore, it was important for an excavator to acquaint himself with the history of the site in question. Hamilton's failure to do so almost resulted in failure; he was saved only through the timely intervention of Piranesi and the long memory of Centorubie.

Hamilton's letter lists more than seventy individual works of sculpture he took from the Bog. One of these, a handsome bust of Hadrian probably dating from early in his reign, is now in an American private collection. Among statues taken to the Vatican galleries, the Villa Albani, and private collections in England and Russia, Hamilton notes that "a great number of Fragments of Vases, Animals of different sorts, and some elegant ornaments and one Collosial head" had come into Piranesi's possession. From these fragments he seems to have fashioned several of the most extravagant and influential objects associated with Hadrian's Villa. No fewer than twelve plates in Piranesi's sumptuous publi-

see 7

cation *Vasi, candelabri, cippi, sarcofagi, tripodi, lucerne, ed ornamenti antichi* (1778) illustrate works he says were found in the Pantanello. Perhaps the most remarkable of these are two candelabra in the Ashmolean Museum and the so-called Warwick Vase, on display in the Burrell Collection in Glasgow.

384, 385 The Oxford Candelabra were purchased from Piranesi in 1775 by the connoisseur Sir Roger Newdigate. Two years later, Newdigate presented them to the Radcliffe Camera, where, shortly after their installation, they were described as constituting "a perfect school in themselves, of Sculpture and Architecture." The candelabra are triangular in plan and just under 2 meters tall. They are extremely complex and richly ornamented; by comparison, the Barberini candelabra seem to be the

essence of simplicity. One has as its principal sculptural component three elephant heads that provide a base for a tapered block carrying reliefs of Minerva, Hercules, and Silvanus, while three cranes are set on the corners of its counterpart. When the surfaces of the two are examined closely, it is evident that they are composed of hundreds of fragments joined with great skill. It is equally evident that by far the greater part of these fragments are not ancient but eighteenth-century creations.

The Warwick Vase takes its name from George Greville, earl of Warwick. Greville acquired this magnificent object from Sir William Hamilton, British ambassador to Naples, who had purchased it from Piranesi, arranged for its repair, and brought it to England in 386

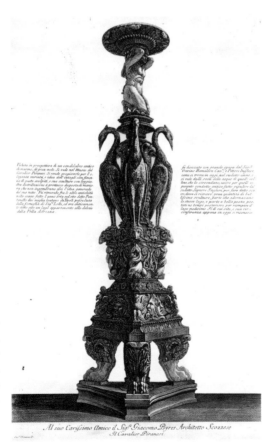

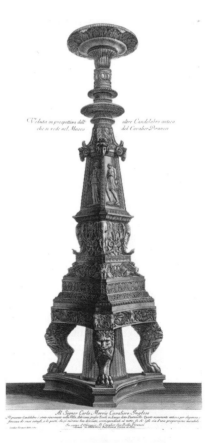

384 *Candelabrum with cranes, assembled by Piranesi from fragments found in 1769 in the Bog; now in the Ashmolean Museum, Oxford; print by Piranesi (1778; Getty Center, Resource Collections)*

385 *(far right) Candelabrum with elephant heads, assembled by Piranesi from fragments found in 1769 in the Bog; now in the Ashmolean Museum, Oxford; print by Piranesi (1778; Getty Center, Resource Collections)*

1774. The vase is of heroic proportions: 1.7 meters high, 2.11 meters in diameter, with a capacity of 308.5 liters. Because it is embellished with reliefs of Bacchic subjects—satyr masks, thyrsi, a panther skin, vine tendrils—Piranesi was prompted to speculate that it may originally have stood in a temple dedicated to Bacchus at the Villa.

The condition of the vase closely resembles that of the two Oxford Candelabra in that it is a brilliant pastiche, for many of the fragments date from the eighteenth century and are of remarkable quality. An account of Piranesi's restoration methods stresses the integration of new passages with original fragments. "Being discovered in pieces, an artist at Rome formed a mass of clay of its shape and dimensions, and, fixing the pieces together by adhesion to the clay, united them afterwards more formally, and supplied the deficient masks." In 1775, Hamilton reported that all of the fragments, old and new, had been set into a matrix of Carrara marble.

As a dealer in antiquities Piranesi specialized in such ornamental objects as vases, candelabra, and architectural friezes and largely avoided the more competitive and problematic market for figural sculpture. Prevailing taste did not run to fragments, and it was standard practice for Piranesi, Hamilton, Jenkins, and other dealers to restore missing portions of the works they offered for sale; many restoration specialists flourished in Rome. Piranesi employed the best, including Lorenzo Cardelli and Francesco Antonio Franzoni. According to Piranesi's biographer Legrand, Piranesi trained these men, providing them with models he made himself. Cardelli produced chimneypieces of the sort illustrated in Piranesi's *Diverse maniere d'adornare i cammini* (1769) for the British market and could carve the most refined architectural details. Franzoni's skill in representing animals—many on display in the Vatican Sala degli Animali—would have lent itself well to the restoration of the delicate cranes on one of the Oxford Candelabra.

Both the expectations of eighteenth-century collectors and the prerogatives of the dealers who catered to their taste far exceeded the bounds of appropriate restoration procedures today. Their aim was a seam-

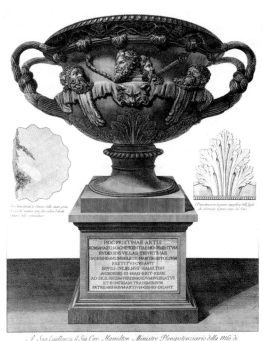

386 *The Warwick Vase, assembled by Piranesi from fragments found in the Bog in 1769; now in the Burrell Collection, Glasgow; print by Piranesi (1778; Getty Center, Resource Collections)*

less, apparently intact object, and to this end they were prepared to supply missing parts and provide surfaces and patina virtually indistinguishable from the original fragments. This could, and often did, involve considerable flights of inventive fantasy, especially by restorers guided by Piranesi's authority and intuitive decisions.

Ten years after Hamilton's spectacular discoveries in the Bog new excavations were initiated by Cardinal Mario Marefoschi in the northeast corner of the Residence, on land owned by Count Centini, the heir of Count Fede. As papal censor, Marefoschi had approved the publication of Cardinal Furietti's book on mosaics, and his reading of it perhaps stimulated him to seek fame and fortune by the same means. In any event, Marefoschi's efforts were rewarded by the discovery

of a remarkable group of figural mosaics, among the most outstanding works of art found at the Villa. Piranesi's *Pianta* Commentary gives precise indications of the findspots: the basilica, its ample antechamber, and a contiguous room to the south.

In January 1779, Marefoschi's diggers uncovered five rectangular panels in the basilica: one now in Berlin representing centaurs battling wild beasts, three in the Vatican depicting pastoral scenes, and one apparently lost. A month later, clearing the antechamber, the workmen discovered a square mosaic panel representing four theatrical masks set within a broad white field framed by an elaborate frieze of vines. Two more square panels, also depicting theatrical masks, were found in the room to the south. Antonio Canova, who visited the Villa in 1780, saw these mosaics and commented enthusiastically on the frieze, which he called "una meraviglia." These three panels, together with one of the pastoral scenes, were restored and installed in the Gabinetto delle Maschere of the Vatican by Pius VI.

see 211 In pictorial terms, the Berlin scene of centaurs fighting lions and tigers is the most ambitious of the group. The dramatic effects of foreshortening, particularly apparent in the raised front legs of the centaur, and the convincing illusion of spatial recession conveyed by the skillful use of overlapping and of color gradations make it a tour de force. The artist achieved dynamic symmetry by balancing the fallen centaur with the wounded lion, whose death agonies engage the viewer sympathetically and aesthetically. The spirited composition, the high emotional pitch, and the classical subject all appealed to an audience that delighted in the paintings of Vincenzo Cammucini, Hamilton, and Anton Mengs, and looked upon the revival of large-scale mosaic compositions as one of the great accomplishments of the period. In 1780, Cardinal Marefoschi commissioned a remarkably accurate print reproducing this panel, further enhancing its reputation and perhaps providing the inspiration for several variations on the theme.

see 212 The Vatican scene of a lion savaging a bull relates to the Berlin panel in both theme and style. The foreshortened bull and the cow recall the Berlin centaur. The mosaicist has clearly striven to emulate painting; wit-

ness the reflections and effects of shading in the pond, as well as the transparency of the water, through which the cow's hind hooves are visible.

Two companion mosaics, representing pastoral scenes, are very different in mood. Both panels depict goats and sheep in landscapes dominated by rustic shrines that are framed by sacred trees and adorned with bronze statues of divinities. The goats in the panel with the standing statue graze along the banks of a stream. see 210 One crosses a narrow bridge to approach a shrine, perhaps to Bacchus, with a votive plaque before it. The animals in the other panel, with a seated statue, appear 387 to be disposed about the edge of a spring or pond. Before the statue is an altar prepared for sacrifice, while in the background a shrine is set within its sacred precinct, where a votive offering hangs from a pilaster. Both scenes are variations on compositions familiar from Campanian murals and from stuccoes such as those of the Villa Farnesina. In 1779, however, such paintings had only begun to emerge from Pompeii and other sites buried by Vesuvius, and the Marefoschi mosaics offered fresh interpretations of a venerable classical theme, the pastoral.

The idyllic scene with a seated statue has been arbitrarily joined, in its current setting in the Vatican, with three panels representing theatre masks. This arrange- 388–390 ment is the result of Andrea Volpini's restoration and does not accurately reproduce the appearance of these mosaics in antiquity. Contemporary descriptions record that each scene was set within an ample field of plain white tesserae and that these fields, in turn, were enclosed by ornate friezes of vine leaves; Penna's invaluable prints illustrate the original appearance of the mask panels. In combining four distinct panels symmetrically, Volpini was obviously not concerned with fidelity to archaeological context. Indeed, the results somewhat resemble those statues restored by using fragments—often a head—of other pieces.

Volpini's delicate vine tendrils intertwined with the heraldic devices of Pope Pius VI unquestionably do violence to the spare simplicity and generous proportions of the white ground that once surrounded each panel. They also clash with the Hadrianic border, with see 208

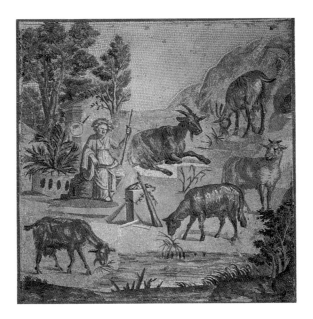

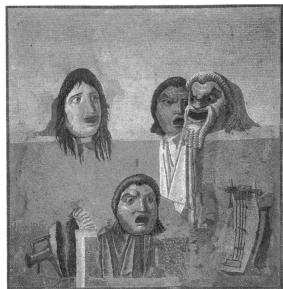

387 (left) Pastoral scene, with a seated statue, mosaic found in 1779 by Marefoschi in the Residence basilica; now in the Vatican Museum (Getty Center, Resource Collections)

388 Theatre masks and a lyre, mosaic found in 1779 by Marefoschi near the Residence basilica; now in the Vatican Museum (Getty Center, Resource Collections)

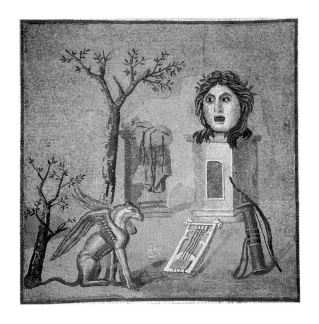

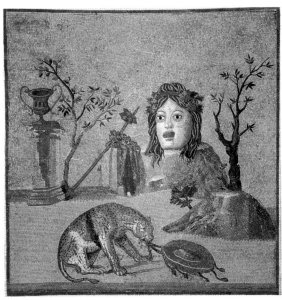

389 (left) Theatre mask and a griffin, mosaic found in 1779 by Marefoschi near the Residence basilica; now in the Vatican Museum (Getty Center, Resource Collections)

390 Theatre mask and a panther, mosaic found in 1779 by Marefoschi near the Residence basilica; now in the Vatican Museum (Getty Center, Resource Collections)

its rich porphyry ground and illusionistic ribbons executed in giallo and verde antico. Nonetheless, Volpini's restoration of these mosaics ensured their preservation, and their display in the Vatican made them available to generations of artists and scholars.

COLLECTORS AND DEALERS

As the century drew to a close, the Villa ruins continued to be ransacked in the search for works of art. In 1790 two major pieces of sculpture were uncovered in the vicinity of the Casino Fede. The circumstances are obscure, for no public accounts survive, such as those heralding the Marefoschi excavations a decade earlier. The two statues—a Discobolus and a Hercules—were soon in the hands of Thomas Jenkins, whose earlier efforts to export the Barberini Candelabra had come to naught. As the principal English banker in Rome, he had invested his profits since the 1760s in the lucrative if risky market in antiquities, often in partnership with Gavin Hamilton, James Byres, and others. Jenkins lost his fortune in 1798 with the French occupation, but in 1790 he was at the height of his powers, negotiating with two of the most wealthy and discerning English collectors of the period, Charles Townley and the marquis of Lansdowne.

Townley had been a good customer of Jenkins for nearly two decades, and many of the statues in his extensive sculpture gallery, depicted by Johann Zoffany around 1781, had passed through Jenkins's hands. Given pride of place in the left foreground of Zoffany's painting is the Discobolus, a Roman work inspired by a Greek original by Myron. Perhaps because of their long-standing relationship, Townley seems to have been given first choice of the two statues and chose the Discobolus on the basis of drawings and a written account sent from Rome by Jenkins. The statue was restored by Carlo Albaccini, and Jenkins must have known that the head belonged to another statue. Moreover, in order to achieve a novel composition, he had the head set in such a way as to look forward rather than backward. This results in a generally awkward effect, in part because the statue has two Adam's apples. Townley

seems never to have suspected that anything was amiss and regarded the statue as his last great acquisition.

The Lansdowne Hercules was found in much better condition than the Discobolus, though modern restoration has shown that its condition was not quite so pristine as Jenkins's initial description suggested. "A statue of a young *Hercules*, large [as] life, holding the lion's skin in one hand, and the club in the other, head never broke off, has both its hands & feet, wants nothing of consequence but a piece of the leg between the part under the knee and above the anckle" The statue was in fact found broken at the ankles, and Jenkins's restorer, perhaps Albaccini, made extensive modifications in order to allow the damaged legs to support the body's weight. An iron reinforcing bar running from the base to the right buttock was inserted, and to hide the bar, Hercules' lion pelt was extended to the rear, obscuring what in antiquity would have appeared as a free-standing leg. Missing portions of both arms were also replaced, and the surfaces of the new marble inserts were abraded throughout to approximate weathering.

The Lansdowne Hercules is probably a Hadrianic copy of a Greek original of ca. 340 B.C., generally ascribed to Skopas. Townley came close to this assessment in 1792 when, in complimenting Lansdowne on his purchase, he observed that "tho it is probably a repetition of some esteemed original, it appears from the Style of the hair & the general character of the work to have been executed by some good Greek artist anterior to the time of the Caesars." Townley's remarks reflect the preference for Greek art that prevailed as the Neoclassical style swept across Europe in the wake of Winckelmann's publications.

By the 1790s the papacy had taken steps to limit the flow of major antiquities from the Papal States, so it is remarkable that a statue of this significance was exported. Ennio Quirino Visconti, the papal commissioner of antiquities, systematically reviewed all statues that came on the Roman market and reserved the best for the Vatican Museo Pio-Clementino, which he was enlarging. The absence of an export license for the Hercules suggests that Jenkins may have resorted to some subterfuge involving bribery or smuggling or a com-

bination of the two. It is significant that Jenkins did
obtain a license for the Townley Discobolus, which,
being in poorer condition than the Hercules and a sub-
ject already well represented in the Vatican Museums,
posed fewer problems.

On its arrival in England in 1792 the Hercules was
brought to Lansdowne's house in Berkeley Square. The
house had been designed by Robert Adam in 1762, but
its sculpture gallery was built only half a century later,
following designs of Robert Smirke. It is fitting that for
nearly a century the Hercules was displayed in a splen-
did Neoclassical house derived in part from Adam's
studies of Hadrian's Villa, where the statue once stood.
Today the Hercules is exhibited in a building—the gen-
eralized reconstruction of the Villa dei Papiri in Malibu,
which houses the classical collection of the J. Paul
Getty Museum—that further compounds its resonance;
an eighteenth-century restoration of a Hadrianic copy
of a Greek original stands within a twentieth-century
revival of a first-century Roman villa.

The preceding account of important works of art
discovered at the Villa illustrates how, in the course
of the eighteenth century, antiquarian dealers came to
play progressively greater roles in the exploitation of
archaeological sites. A list of sixteen dealers drawn up
in 1768, the year before Hamilton began to dig in the
Bog, includes many figures already encountered: Pira-
nesi, Cavaceppi, Nollekens, Jenkins, Fede, and Hamil-
ton. Significantly, the list was prepared by Monsignor
Braschi (the future Pius VI), who, together with Gio-
vanni Battista Visconti (the father of Ennio Quirino),
supervised the formation of the Museo Clementino.
The list is remarkable in providing the addresses of
the dealers' studios, many in the neighborhood of the
Spanish Steps, which was frequented by foreign visi-
tors. The frontispiece of Bartolommeo Cavaceppi's *Rac-
colta* shows his studio and accurately depicts vigorous
restoration work under way. The impression is of an
active sculptor's studio rather than a display gallery.
In contrast, Piranesi exhibited his antiquities—fully re-
stored—in a "museum" that occupied several rooms of
his residence in the Palazzo Tomati nearby.

Piranesi, ever on the lookout for new sources of

392

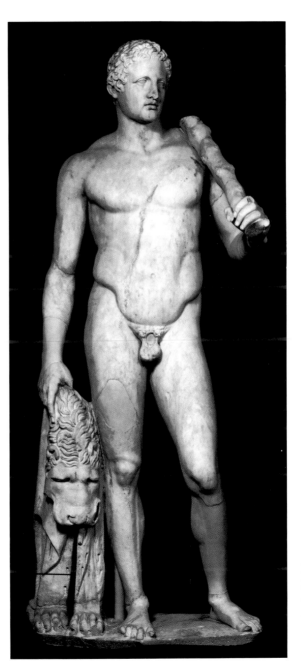

391 *The Lansdowne Hercules,
found in 1790 in the Doric Temple
Area; now in the J. Paul Getty
Museum Collection, Malibu*

392 *Studio of Bartolomeo Cavaceppi, frontispiece to his* Raccolta *(1768)*

money, shrewdly saw that his flourishing trade as a printmaker, coupled with his reputation as an antiquarian and his excellent relations with foreigners, could provide an ideal foundation for dealing in antiquities. His disappointment at not being appointed Winckelmann's successor as superintendent of papal antiquities perhaps made him more active as a dealer; the opportunities presented by Hamilton's discoveries in the Bog undoubtedly contributed. James Grimston, writing to William Bucknall in 1771, remarked of Piranesi that "it is immense the sum of money he has got by the statues, vases, tripods etc that he has found by searching among the Ruins of the Villa Adriana." Piranesi must have paid relatively little for the fragments he acquired from Hamilton, and after supervising their restoration he was able to sell them at great profit. Sir Roger Newdigate, for example, paid Piranesi 1,000 scudi for the Oxford Candelabra, a sum comparable to what Hamilton, Jenkins, and others charged for complete statues.

As a dealer, Piranesi enjoyed one great advantage over most rivals: his ability to use the prints that had made his reputation to stimulate interest in antiquities he offered for sale. This is particularly true of the *Diverse maniere* and the *Vasi, candelabri, cippi*, both of which functioned effectively as sales catalogues, by representing both objects that had entered princely collections as well as others described as being on exhibit "nel museo dell'autore." Piranesi was remarkably successful in marketing his antiquities. English collectors predominated but important sales were made to other foreigners. A number of objects from Hadrian's Villa, for example, were sold to the Empress Elizabeth of Russia through her agent General Schouvaloff. The first volume of Cavaceppi's *Raccolta* (1768) very likely gave Piranesi the idea of illustrating the works of art that had passed through his hands. Piranesi's inclusion of objects available for sale and his practice of dedicating many plates to foreign collectors, however, were clearly intended to function as advertisements as much as to advance antiquarian knowledge.

Piranesi's claims in the *Vasi, candelabri, cippi* for many objects he offered for sale appear willfully to mis-

see 386

represent them as substantially intact works of ancient art. The caption below one of the plates illustrating the Warwick Vase is a case in point; the vase is cited as an example of "the perfection of the arts in the age of Hadrian." A detail from the same plate, apparently chosen to illustrate the refinement of the antique carving, depicts the acanthus leaf decoration on the base, which in fact contains no surviving ancient fragments. Piranesi undoubtedly kept records of the restorers he employed, and these may have provided the basis for the attributions his son, Francesco, made in 1792 in his catalogue of antiquities sold to Gustavus III of Sweden, at least five pieces of which came from the Bog and eight from elsewhere in the Villa. The Oxford Candelabra, the Warwick Vase, and the other restored objects found in the Bog express Piranesi's remarkable vision of antiquity as much as they reflect the age of Hadrian. Because of Piranesi's brilliant improvisations these objects have assumed great significance for the history of art.

Piranesi's lucrative activities in restoring antiquities should be contrasted with his attitude toward architectural reconstruction in the *Pianta*, where financial gain was not a significant factor. Unlike the plates of the *Vasi, candelabri, cippi*, which blur the distinction between original and restored fragments, the plates in the *Pianta* employ contrasting graphic conventions to indicate his conjectural reconstructions.

In evaluating the reliability of Piranesi's reconstructions, it is important to stress that he had access to evidence that no longer survives. This is true of both the Villa's architectural remains and the marble fragments from the Bog. The shattered and decayed condition of many fragments may have prevented their use in restorations made for sale. Yet the existence of unused fragments undoubtedly shaped Piranesi's vision of the intact originals and may have provided justification for the carving of passages today correctly identified as eighteenth-century restorations but incorrectly dismissed as fantastic.

Both the *Pianta* and the *Vasi* reflect Piranesi's extensive experience with ancient architecture and ornament, and in a real sense his restorations and reconstructions represent his distillation of the spirit of Hadrianic architecture and design. Just as some err in accepting Piranesi's vision of antiquity uncritically, as objective and free from personal interpretation, so it is ill-advised to dismiss his vision as misleading and innocent of modern archaeological method. Piranesi must be read critically, with a view to separating archaeological fact from fiction, and his pioneering efforts should be treated with respect both for what they can tell us about antiquity as well as for the eloquence with which they tell it.

At Piranesi's death in 1778 an inventory listed more than one hundred objects in his museo in the Palazzo Tomati, as well as two hundred more kept in a warehouse in the Campo Vaccino (the Roman Forum). Piranesi's son, Francesco, was eager to dispose of these, many of which came from Hadrian's Villa, and for several years he negotiated with collectors interested in acquiring the entire collection. Pius VI visited Piranesi's museo in 1782 and acquired a group of objects for the Vatican, but in the end the bulk of the collection was sold to Gustavus III of Sweden for the princely sum of 6,253 zecchini. The king had made an extended visit to Rome in 1783–1784, and in February 1783 he appointed Francesco his agent "for that which concerns the Fine Arts and Antiquities." In 1785 the Piranesi antiquities, including at least thirteen objects from the Villa, arrived in Stockholm, where they form the core of the classical antiquities collection in the Nationalmuseum.

As a result of the spectacular discoveries made at Hadrian's Villa in the eighteenth century, works of art associated with the Villa exerted an added attraction for collectors throughout Europe. The Furietti Centaurs provide an instructive example. They are mentioned in a letter of 1765 sent by the sculptor Joseph Nollekens in Rome to the English collector Thomas Anson (1695–1773). Anson, a founding member of the Society of Dilettanti, eagerly sought antiquities for both Shugborough, his family seat near Stafford, and his townhouse in St. James's Square. As Anson's agent in Rome, Nollekens wrote to report on a shipment of seven crates containing sculpture sent to Anson by way of Leghorn.

The other five casses with plaister figures amongst which there is casts of the two famos Centaurs of the late Cardinal

Furiety which as bin cast for the first time. for which they would not sell casts of them under the price of one hundred crowns the pare which is very dear according to the value of plasters in Rome. But as I saw that there was others who agreed to go to the same price & casts that never was seen in England for both the varyty and fineness I thought you would not be against it. The origenals which are in black marble and of most exquisite workmanship as within this two months bin sould to the Pope for the price of thirteen thousand crowns. The Pope as made them as a present to the gallery in the Campidoglio. The Furyty family as bin offered 20000 crowns by som Inglish, I beleve it was commission for the king but they could not git licence to take them out of Rome.

The casts described by Nollekens still stand in the entrance hall at Shugborough, from which James Stuart's folly based on the Arch of Hadrian in Athens is visible in the distance.

When original works were not available, casts were often sought, especially for ornamental purposes. By 1800 copies of Villa sculpture in Coade Stone had been placed in at least two Georgian gardens, An-

393 *Pavlovsk, Cameron's Centaur Bridge of 1779 (1993)*

glesey Abbey in Cambridgeshire and Buscot Park in Oxfordshire. As pendants, the Furietti Centaurs naturally lent themselves to decorative schemes. One pair of plaster casts was installed in 1780 at the entrance to the Royal Academy premises in Somerset House. In 1779, Charles Cameron, the memory and associations of Hadrian's Villa no doubt still fresh, placed marble copies of the centaurs in the park at Pavlovsk, outside Saint Petersburg. Two pairs of centaurs, picturesquely sited at each end of a little bridge, provide a Roman touch to the prospect of Cameron's Cold Bath Pavilion. In the early nineteenth century, bronze copies of the Furietti Centaurs were used in a similar manner to frame a bridge in the park at Malmaison, the residence of Josephine Bonaparte. When Alexander I of Russia walked in the garden at Malmaison during his visit to Paris in 1815 shortly after Josephine's death, he would have seen the centaurs familiar to him from Pavlovsk.

In much the same way, fragments of the mosaics Cardinal Furietti unearthed at the Villa were dispersed throughout Europe. The garland border that originally framed the Capitoline dove mosaic was acquired by Cardinal Albani, who had it set into two tables. He later gave the tables to Prince Christian-Frederic of Saxony, who took them to his court in Dresden, where they are in the Albertinum.

Other mosaics found by Cardinal Furietti were acquired by Matthew Brettingham the Younger, who between 1747 and 1754 acted as the agent of the earl of Leicester, for whom he was amassing an extensive collection of antiquities at Holkham Hall in Norfolk. Brettingham's account of Holkham and its contents mentions three Furietti mosaics, which, like the one given to Christian-Frederic and those donated by Benedict XIV to the Capitoline Museum, had also been set into tables. In the library at Holkham is another mosaic, depicting a lion attacking a panther, which the earl acquired in 1716–1717 on his travels in Italy. The subject resembles that of the Marefoschi mosaics, though its specific provenance is unknown. The mosaic is placed above the mantle, an early example of a genuine antiquity employed by a British patron as the centerpiece of a decorative scheme. The placement may be a reflec-

393

tion of Marchionni's similar decorative use of antiquities in the Villa Albani, designed when Brettingham was in Rome.

Works of art associated with the Villa were also displayed in garden settings. William Kent used statues of Caesar, Pompey, and Cicero reputedly found at Hadrian's Villa to provide a suitably Roman accent in the exedra he designed for Lord Burlington's estate at Chiswick. Daniel Defoe, writing in 1742, considered the statues and their provenance worthy of notice: "to terminate this view are three fine antique statues, which were dug up in Adrian's garden at Rome, with stone seats between each; and on the back of the statues is a close Plantation of Ever-greens, which terminates the Prospect."

Of the many works of art found at Hadrian's Villa none has been reproduced more often, at different scales and in different media, than the Warwick Vase; its popularity appears to have been surpassed only by the Portland Vase, known from countless imitations in Wedgwood. Perhaps the best-known facsimile of the Warwick Vase is the full-scale bronze copy placed beside the Cambridge Senate House, cast ca. 1830 by Edward Thomason of Birmingham. An earlier copy in iron had also been cast in Birmingham in 1816–1817. Three versions were shown at the Great Exhibition of 1851; many reduced copies were fashioned in porcelain and silver. Twelve ice pails reproducing the Warwick Vase in silver-gilt were made by Paul Storr in 1812–1814 for the Prince Regent; for the commission Storr made use of the measured engravings in Piranesi's *Vasi, candelabri, cippi*. Among the more important versions in the United States are the Clinton Vase in the Great Hall of the New York Chamber of Commerce (1817) and the Webster Vase in the Boston Public Library.

The repeated discovery of spectacular works of art for more than four centuries amplified the reputation of Hadrian's Villa, and the dispersal of its portable contents extended the Villa's artistic reach around the globe. The export of the Villa's material splendor went hand in hand with that of abstract but equally powerful ideas. Its imagery expressed universal themes—divine authority, empire, the pastoral, and the transience of human glory—that knew no borders. In each period taste has shaped a view of the Villa, at times the artifacts themselves. These relations were inevitably reciprocal, and in the eighteenth century, when the Villa remains were perhaps most subject to creative interpretation, its dispersed art played a crucial role in defining taste and in spreading the classical ideal.

XII

After 1800

Conditions at the Villa, and artistic and intellectual perceptions of it, changed greatly in the nineteenth century. Many internal property barriers were removed in the early 1870s, when the government of the new kingdom of Italy purchased half the site—four hundred years after Pius II and Biondi had identified it. Until then, a sense of the totality of the heavily built-up areas was hard to come by (true today of the extensive tract still in private hands); in this light, Piranesi's work appears all the more remarkable. But well before the state intervened Italian artists and scholars who worked at the Villa, stimulated both by new scientific and rational attitudes and by Napoleonic excavations in Rome and archaeological progress at Pompeii, saw Hadrian's Villa differently from their predecessors. To them the Villa was a place to be recorded in detail, one to be approached in a more scientific manner, and as a result they attempted to discuss it largely without the historical romanticism common in earlier times. From 1860 onward, Giuseppe Fiorelli put the Pompeii excavations on a systematic, technically advanced basis, opening the way to methodical investigation and scholarship. This came about at the Villa only slowly, however, for few regarded it as a primary site. Architects, on the other hand, have for a century and a half now studied and drawn Villa buildings and in the present century use Villa forms freely.

NEW READINGS

As the nineteenth century began, the closed intellectual world of papal Rome was adjusting to new ideas brought by the Napoleonic government. After the papal restoration of 1814, Vatican control of arts and letters waned. A generation of scholars born in the last decade of the eighteenth century approached Hadrian's Villa with a new sensibility toward the organization of knowledge. The work of such archaeologists as Antonio Nibby (1792–1839) and Luigi Canina (1795–1856) was more rational than that of their predecessors. Moreover, they thought of themselves as part of a larger scholarly community that embraced the world beyond the Papal States. Two graphic artists of the same generation, Luigi Rossini (1790–1857) and Agostino Penna (active 1827–1846), took up the study of the Villa where Piranesi left off, but with different didactic aims and expressive goals.

In 1820 the young Nibby was appointed professor of archaeology at the University of Rome. His early work on classical topography, beginning with a translation of Pausanias, aimed to provide a full repertory of ancient literary sources, postclassical documents, and visual evidence bearing on each site. Nibby describes his concern with original sources and his diligent search for documents in the preface of his commentary on a map of the environs of Rome, published in 1837. The title of this topographical gazeteer, *Analisi storico-topografico-antiquaria della carta de'dintorni di Roma,* expresses Nibby's methodical examination, which set the study of archaeological sites in the neighborhood of Rome on a new, more scientific footing. His commentary was based on the cartographic skills of Sir William Gell, whose survey of the Roman Campagna — the first there to apply systematically the principles of triangulation — was published in 1834.

Nibby's systematic examination of the Campagna led him to the Villa, which figures prominently in his *Viaggio antiquario ne'contorni di Roma* (1819), published with a site plan adapted from Piranesi. In 1827 his expanded account of the Villa appeared under the title *Descrizione della Villa Adriana,* which takes account of such ancient sources as the HA and extends the site's history into the Middle Ages, making a case for the Ostragoth king Totila's army having been quartered at the Villa. He also points out that most authors who had treated the Villa had done little more than copy one another, a comment on the pervasive influence of Ligorio's manuscripts.

Nibby was a careful observer, and his work is full of useful information. He organizes the Villa ruins into twelve nodes whose designations are strongly indebted to the HA. He also makes every effort to employ accurate nomenclature; in discussing the Island Enclosure, for example, he urges the reader to avoid the name Teatro Marittimo, preferring Natatorio instead.

Nibby looks critically at existing scholarship, pointing out inconsistencies with the evidence. He notes cautiously that no traces remain of the so-called Latin Theatre and remarks of the Southern Hall that its plan precludes the possibility that it was an Odeum. In discussing the Underground Galleries, Nibby observes that although Piranesi described the walls as brick, portions are in fact cut through the tufa. Piranesi is corrected again when, describing the scattered remains beyond the Southernmost Ruins, Nibby notes that a church Piranesi mistook for a triclinium dates from the thirteenth century.

As one would expect, Nibby incorporates information gleaned from recent excavations, such as traces of a road, uncovered in 1824, leading to the temple beside the Service Quarters. He includes sensitive comparisons, as when he remarks on the similarity in plan between the Park Rotunda and Hadrian's Mausoleum in Rome. Significantly, he also makes comparisons with contemporary architecture, relating, for example, the tombs near the Via Tiburtina, which he identifies as the ancient entrance to the Villa, with Antonio Asprucci's portal of the Villa Borghese.

Nibby was also an archaeologist; as papal commissioner of antiquities he directed excavations in the Roman Forum between 1827 and 1832. At his premature death in 1839 he was succeeded as commissioner by Luigi Canina, a Piedmontese architect active in Rome for more than two decades. Canina first came to Rome in 1818, meeting Nibby and Gell. His first archaeological essay appeared in 1825 in the *Bullettino*

dell'Instituto di Corrispondenza Archeologica, founded to coordinate international archaeological research. In that year Canina succeeded Antonio and Marco Asprucci as architect to the Borghese. In this capacity he designed the Egyptian propylon and obelisks near the Laghetto of the Villa Borghese (1825–1827) and the Ionic propylon outside the Porta del Popolo (1827–1828).

394

The propylea were part of a comprehensive plan for the expansion of the seventeenth-century villa toward the Via Flaminia, described and illustrated in a publication of 1828. Canina explicitly compares his work at the Villa Borghese to Hadrian's Villa. "Considering that the Villa Borghese, more than any other, approaches Hadrian's Villa in extent and in the variety of its buildings—which include a fortress, a hippodrome, and various temples in the manner of the ancients—it was fitting as well that there should be a building similar to those of the Egyptians, in imitation of the Canopus of the Villa Adriana." Later on he argues that just as the scale of Hadrian's Canopus differs from the original, so the Borghese propylon differs from its sources in scale and composition. Gell invented hieroglyphic inscriptions for Canina's sphinxes, obelisks, and gateways.

As his profusely illustrated publications multiplied, Canina became an international figure. He went to England, visiting the Crystal Palace in 1851. His interest in the history of architecture embraced monuments and traditions of wide geographical and chronological range, and he selected and displayed them as if for an exhibit in a mid-nineteenth-century natural history museum. His multivolume survey of ancient architecture, *L'architettura dei principali popoli antichi considerati nei monumenti* (1834–1844), treated the buildings of Egypt, Greece, and Rome from historical, theoretical, and descriptive points of view. Canina's sensitivity to different architectural traditions make him a percipient interpreter of Hadrian's Villa, itself an outstanding monument of cultural syncretism.

Embedded in the fifth and sixth folio volumes of Canina's monumental publication of ancient sites in the vicinity of Rome, published in 1856, is an extensive discussion of the Villa. The text is reinforced by a detailed site plan based on Piranesi, as well as by twenty-five plates that both document the site as it appeared in his day and reconstruct its ancient appearance. As one would expect from an architect of Canina's erudition and catholic tastes, his reconstructions betray a wide range of sources, perhaps most evident in his treatment of the Island Enclosure. Crowning the island proper is a variation on the Choragic Monument of Lysicrates, of the late fourth century B.C.; in the background looms the Fountain Court West, whose flank appears to refer to Luigi Politti's restoration of the Basilica of San Paolo fuori le Mura necessitated by the disastrous fire of 1823.

395

During the first four decades of the nineteenth century printed views of Hadrian's Villa proliferated as never before. The site increasingly attracted visitors, and the demand for inexpensive views of its picturesque ruins grew proportionally. This demand could not be met simply by reissuing Piranesi's views of the Villa, for by 1800 the plates had been removed by Francesco Piranesi to Paris and were not returned to the papal press until 1839. Graphic artists of no great distinction exploited this situation, among them Luigi Frezza, Antoine Poggoli, Domenico Pronti, and Angelo Uggeri. Pronti's mediocre view of the Underground Galleries indicates the relatively poor quality of these small-format prints, which nevertheless played an important role in spreading awareness of Hadrian's Villa.

396

Unlike Pronti and most other vedutisti of this period,

394 Rome, Villa Borghese, Egyptian propylon of 1825–1827, by Canina (1985)

Luigi Rossini made a substantial contribution to the Villa as a subject in the history of art. Born in Ravenna and trained in architecture in Bologna, Rossini came to Rome in 1814, the year papal rule was restored. Ponderous works such as Nibby's exhaustive compilations of classical sites and Gaetano Moroni's 103-volume *Dizionario di erudizione storico-ecclesiastica* gave the Roman intellectual climate a decidedly academic tone. Pope Gregory XVI (1831–1846) encouraged new excavations, hoping to enrich the more specialized and systematic collections he was forming in the Vatican—the Museo Etrusco Gregoriano (which opened in 1837) and the Museo Egizio Gregoriano, inaugurated two years later. In the latter, many dispersed works of Egyptianizing art from Hadrian's Villa were assembled.

Rossini's Rome was a city whose contrasts were perhaps most eloquently expressed in the biting satire of Giovan Giocchino Belli's sonnets. As an artistic center, Rome was divided into two camps. In one were proponents of Neoclassicism, artists of the stature of Canova, Thorwaldsen, and Ingres (director of the French Academy from 1834 to 1841). On the other side, a younger generation, with Romantic tendencies, that included the German Nazarenes mocked the classical curriculum of the conservative Accademia di San Luca. This was also the Rome of Keats and Shelley, of Byron and Turner.

Rossini was conscious from the start of Piranesi's legacy; the title of his first major series of large-scale prints, *Le antichità romane*, issued between 1819 and 1823, acknowledges the great work of the same title published by his illustrious predecessor in 1756. Rossini scrutinized Piranesi's compositions, as comparisons between his work and the *Vedute di Roma* make clear. In 1826 he published the second volume of his study devoted to the cities and archaeological sites of the Roman Campagna, the *Antichità dei contorni di Roma*, which contains nine views of Hadrian's Villa as well as a general site plan, again derived from Piranesi.

Four of Rossini's prints represent features of the Villa also depicted by Piranesi: the Apsidal and Circular Halls, the Larger Baths, and the extension of the Scenic Triclinium. In all of these it is immediately ap-

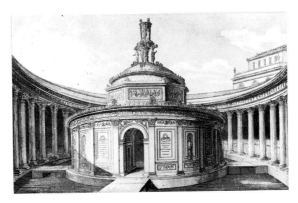

395 *Island Enclosure, reconstruction by Canina (1856)*

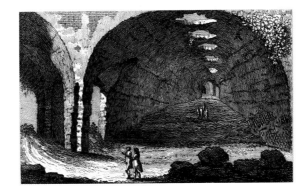

396 *Underground Galleries, print by Pronti (1775)*

parent that Rossini has adapted Piranesi's compositions and points of view with only minor adjustments. Significantly, he employs framing devices to distance the viewer somewhat more than does Piranesi, who uses the same features to include and make the observer part of the scene. Comparisons reveal that Rossini mutes somewhat Piranesi's dramatic chiaroscuro effects, aiming instead for a more balanced range of tonalities that results in more clear and distinct—if less spectacular—images.

Although Rossini's figures play nearly identical compositional roles to those of Piranesi, their appearance and actions are worlds apart. In place of Piranesi's attenuated figures, the disposition of whose limbs seems to be governed by the same organic forces of growth and decay that determines the irregular contours of

397

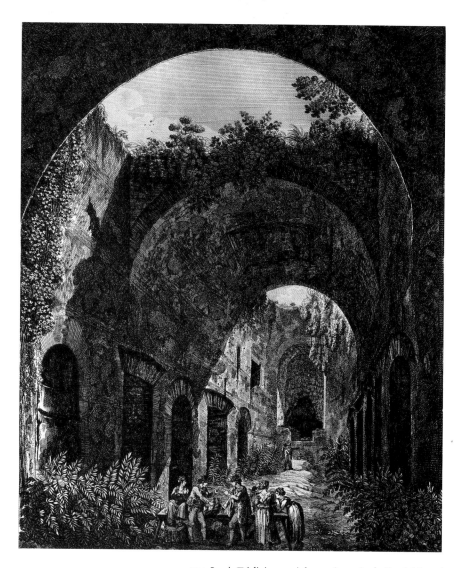

397 *Scenic Triclinium, axial extension, print by Rossini (1824)*

vines and tree trunks, Rossini has introduced real people, usually sturdy peasants or bourgeois gentlemen who wear top hats and are accompanied by ladies with elaborate bonnets. The peasants engage in vigorous action: they dance the tarantella in the Apsidal Hall or attack snakes beneath the vaults of the Larger Baths. Most of these figures were drawn by Bartolommeo Pinelli, with whom Rossini collaborated from 1817 until 1835. The group occupying the foreground of the Scenic Triclinium view closely resembles one of Pinelli's compositions from his own suite of engravings, the *Costumi pittoreschi* of 1815.

Rossini's prints sometimes depict Villa features for which there is no corresponding printed veduta by Piranesi. His etchings of the Island Enclosure and of one of the tombs, however, do resemble Piranesi's powerful drawings of the same subjects. In the case of three other Villa subjects for which no precedent by Piranesi existed, Rossini achieved original results. In one of these, a view of the Scenic Triclinium vault, Rossini conveys the interrelation of supporting walls and soaring vault panels, an effect that eludes the camera. Rossini's print of the Fountain Court West captures its dense layering and imparts a clear sense of its structure and spatial organization. A view of the West Belvedere is perhaps the most successful example of the integration of Pinelli's figures with Rossini's architectural settings. Rossini's composition pulls us in to the hulking platform of the Belvedere with its crowning dovecote: the ramp up to the West Terrace partially encloses a courtyard animated by Pinelli's rustics, some of whom converse while others engage in a spirited game of *morra*. The print underscores the extent to which imposing Villa features had, over the centuries, been transformed into farm buildings.

The most ambitious and comprehensive study of the Villa in the early nineteenth century is Agostino Penna's four-volume *Viaggio pittorico* (1831–1836). The first two volumes contain 137 views of the Villa as it appeared in Penna's day, accompanied by a fold-out plan derived from Piranesi. Penna's talent did not approach Rossini's, but because his object was not to dazzle the eye

398

399

400

so much as to document faithfully the physical appearance of the ruins in a straightforward fashion, Penna's prints constitute an invaluable record. As a topographer he does not command Nibby's erudition, but because his commentary—a page is devoted to each plate—is keyed to specific graphic images, it calls the reader's attention to important features now lost or overlooked by later scholars.

Penna's introduction to the first volume of the *Viaggio pittorico* singles out four authors whose Villa studies deserve praise (Ligorio, Contini, Piranesi, and Nibby) and states that he intends to build on their accomplishments. In his commentary he evaluates these and other authors who wrote about the Villa and its art, contesting opinions where he does not agree. He provides an overview of the site's history and a summary of excavations, and he pays particular attention to brickstamps and techniques of construction. In presenting the remains of the Villa he follows an itinerary, so that each view—and its caption—leads to the next feature, as if the reader were strolling through the site with Penna as cicerone. From the beginning guidebooks of Rome had taken the form of itineraries, and Penna was familiar with contemporary guides by Vasi and Nibby that continued the tradition. For nearly three centuries these guidebooks included printed views, but Penna's textual itinerary, by marching hand in hand with his illustrations, surpasses earlier publications. It is important to note that Penna was responsible for both the text and the illustrations in the first two volumes of the *Viaggio pittorico;* such close coordination was exceptional among Roman guidebooks.

Penna's contribution to the documentation of the Villa is multifold. His pictorial survey is comprehensive, in many instances providing the only illustrations of such important features as the Park Rotunda, the Southern Hall, the East Terrace cistern, and others. His 401, see 232 commentary on his view of the cistern and nymphaeum facing the Doric Temple shows how his text amplifies the information conveyed in his illustrations:

Cistern serving the Nymphaeum: This reservoir, supplied with water so as to feed two zones, to the East and the West, is built of bricks treated to resist humidity; the facade toward

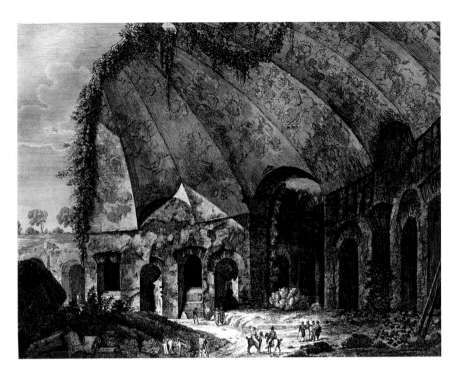

398 *Scenic Triclinium, print by Rossini (1824)*

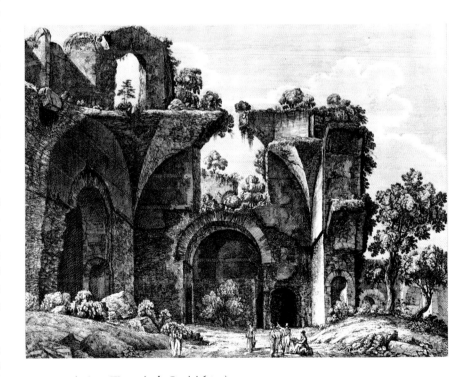

399 *Fountain Court West, print by Rossini (1824)*

the North is adorned with three niches that still exist and may have served as decoration for a fountain, drawing from this very reservoir. The walls of the cistern survive only up to a height of 18 *palmi* [4.02 meters], on which Count Fede built a small building today called the *Granaretto* [barn]. Near this reservoir (at the Number 1) are remains of a stair in very ruinous condition, adorned with niches and covered with stucco, of which there still survive traces. By means of this stair one rises to an extensive plane, which today carries the name of the Library garden. In the substructure of the retaining wall (at Number 2) is a channel cut into [the masonry] which follows beneath the stair and must have gathered water from the springs. At its end the stair is connected to a substructure supported by three large niches, now obscured by briars and brush, which do not permit one to understand properly its use and direction; each of these niches is circa 21 *palmi* [4.69 meters] wide. At the end of these niches there was an almost circular room observed by Piranesi, the form of which would lead one to call it a bath, which today has completely disappeared. From this room ran a wall, which following the edge of the Library garden, ended at the *Natatorio* [Island Enclosure], as one can see better on the plan.

Continuing our trip, following the avenue shaded by cypresses, we come to observe the remains of the famous . . . *Portico del Pecile* [Ambulatory Wall].

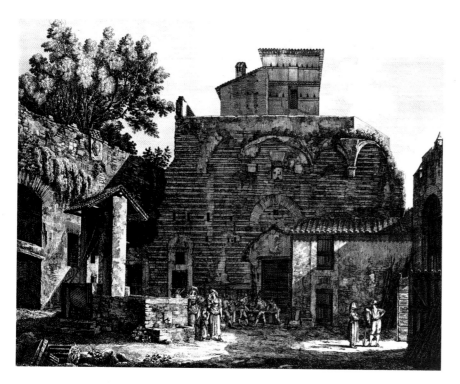

400 *West Belvedere, print by Rossini (1826)*

This view admirably illustrates the relation between the cistern and the ramp substructures. Penna takes pains to distinguish ancient masonry from that of the Granaretto above. The reader is led through the picture by the figure groups in a manner following Penna's text. The East Terrace umbrella pines and underbrush effectively relate the ruins to the landscape in this part of the Villa. Penna's sensitivity to the site extends to its contours; his prints frequently illustrate changes in level that complement the two-dimensional conventions of site plans. In his itinerary, Penna provides the dimensions of the principal architectural features shown and records findspots of major works of art.

The other two volumes of the *Viaggio pittorico* compile the artistic contents of the Villa, including sculpture, painting, mosaics, and other ornament, in 143 plates. Penna was thus the first to reunite on paper the dispersed art of the Villa with its architectural remains, an accomplishment to which all subsequent scholars are deeply in debt. The works of art are presented in

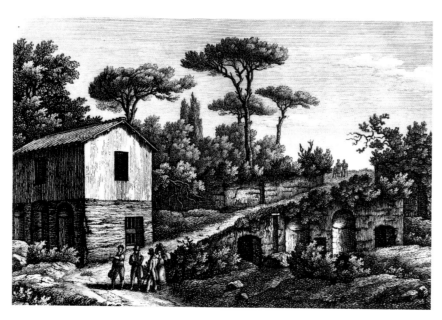

401 *East Terrace, cistern (Penna no. 7)*

the order of their rediscovery, and Penna even includes lost works known from reproductions in earlier books. Equal weight is given to presumed Greek sculpture, Roman statues, and Egyptianizing art. This illustrated catalogue, remarkably complete for its time, naturally contains lapses, including much of the sculpture found by Hamilton in the Bog that passed to collections in England and Russia. In order to complete volumes 3 and 4 Penna employed other draftsmen, but his manuscript shows that he made the preparatory drawings for most of the engravings.

In its scope and systematic character the *Viaggio pittorico* fulfills Penna's wish that it rank with the most important works on the Villa. His commentary on the architecture was not surpassed until Winnefeld's monograph of 1895, and his visual documentation of the site continues to be fundamental. Scholars continue to build on his catalogue of Villa art and illustrations of dispersed works.

Not only artists responded to the Villa. In 1807, shortly after his eleven-month circuit of the Mediterranean recorded in his *Itinerary from Paris to Jerusalem,* François-Auguste-René de Chateaubriand took up the theme. With both the substantive remains of the Villa and the HA passage in mind, he transformed his property in Vallée-aux-Loups, 11.5 kilometers southwest of Paris, between Chatenay and Sceaux, into an evocation of his life and travels. He embellished his château there with a Grecian porch supported by caryatids and planted his park with Lebanon cedars, Jerusalem pines, laurel from Granada, and a magnolia from the Empress Josephine's garden at Malmaison.

Chateaubriand's descriptions of his visit to Hadrian's Villa in 1803 shed light on his interpretation of the site. While there, he was caught in the rain and took cover in one of the Baths.

A vine had penetrated through fissures in the arched roof, while its smooth and red crooked stem mounted along the wall like a serpent. Round me, across the arcades, the Roman country was seen in different points of view. Large elder trees filled the deserted apartments, where some solitary black-birds found a retreat. The fragments of masonry were garnished with the leaves of scolopendra, the satin verdure of which appeared like mosaic work upon the white marble. Here and there lofty cypresses replaced the columns, which had fallen into these palaces of death. The wild acanthus crept at their feet on the ruins, as if nature had taken pleasure in reproducing, upon the mutilated *chefs d'oeuvre* of architecture, the ornament of their past beauty. The different apartments and the summits of the ruins were covered with pendant verdure; the wind agitated these humid garlands, and the plants bent under the rain of Heaven.

While I contemplated this picture, a thousand confused ideas passed across my mind. At one moment I admired, at the next detested Roman grandeur. At one moment I thought of the virtues, at another of the vices, which distinguished this lord of the world, who had wished to render his garden a representation of his empire. I called to mind the events, by which his superb villa had been destroyed. . . . While these different thoughts succeeded each other, an inward voice mixed itself with them, and repeated to me what has been a hundred times written on the vanity of human affairs. There is indeed a double vanity in the remains of the Villa Adriana: for it is known that they were only imitations of other remains, scattered through the provinces of the Roman empire. The real temple of Serapis and Alexandria, and the real academy at Athens no longer exist; so that in the copies of Hadrian you only see the ruins of ruins.

Throughout this passage Chateaubriand underscores his ambivalence: *serpent, deserted, solitary, palaces of death,* and *mutilated* balance *retreat, garnished, satin, pleasure, ornament, beauty, garlands,* and *rain of Heaven.* Here abound the contradictions implicit in the pastoral tradition: complexity and simplicity, urbanity and rusticity, reality and artifice, vanity and humility, the temporal and the eternal.

Chateaubriand concludes his meditations with these remarks:

Many travellers, my predecessors, have written their names on the marbles of Hadrian's Villa; they hoped to prolong their existence by leaving a souvenir of their visit in these celebrated places; they were mistaken. While I endeavored to read one of the names recently inscribed which I thought I recognized, a bird took flight from a clump of ivy, and in so doing caused several drops of water from the recent rain to fall: the name vanished.

Here again is a preoccupation with mortality that in-

forms so much of the pastoral mode: be you shepherd or emperor, everything passes. The ruins of Hadrian's grand Villa poignantly express the struggle between the desire for immortality and the inexorable cycles of nature.

In exploiting the Villa as a vehicle for his romantic sentiments Chateaubriand returns to a theme introduced three and a half centuries earlier by Pius II. Chateaubriand celebrates the power of the Villa's remains to evoke echoing associations, and he views the human condition through the lens of its ruined architecture. His insistence on the transience of humanity and human accomplishments constitutes a poetic foil to the other, more rational and positivist strain of nineteenth-century culture that sought to document, objectify, and reconstruct the past.

In 1803, the year Chateaubriand visited the Villa, the Duke Braschi-Onesti bought the considerable portion of the site Count Fede had acquired in the early 1700s. To the Fede property the duke added the West Belvedere and the adjacent olive groves to the north and east; it was the Braschi property that was conveyed, in December 1870, to the state. Pietro Rosa, one of Canina's students, who helped to arrange the sale, became the first superintendent of excavations in Rome and its environs. Work at the Villa in the 1870s was somewhat sporadic, unscientific by Fiorelli's standards, but Rosa and his people uncovered part of the Residence Quadrangle, together with its pre-Hadrianic nymphaeum, as well as Residence peristyles and the pillared hall of the Ceremonial Precinct. In 1881 they cleared the Hall of the Cubicles, part of the Fountain Court, and the Island Enclosure and removed the sixteenth-century structure that had been built atop the West Belvedere where its tholos had once stood. Much sculpture, whole and fragmented, was found.

Rodolfo Lanciani, a serious scholar who was also a successful popularizer (he wrote the first modern guidebook to the Villa), took over in 1883, and although he remained in charge for twenty years, effective work at the Villa ceased in 1890, resuming only in 1913. Among the evidence of Villa art he discovered in the 1880s is the splendid copy of Polykleitos's Dionysus, found

under a staircase adjacent to the Residence Quadrangle. He cleared, for example, the Portico Suite and the rest of the Quadrangle but was unable to proceed to the Stadium Garden, the Smaller Baths, and the still-hidden "Canopo" of Ligorio-Contini and Piranesi, presumably because of lack of funds. He cared greatly for the site. In a popular description of the Villa included in his much-read *Wanderings in the Roman Campagna* (1909), he remarks that it would "soon be deprived of [its] harmonious combination of picturesqueness and archaeological interest" unless the government came to its aid. He also says that he took "such pains . . . to keep the olive grove in a wholesome condition that we could almost cover the expense of repairs and excavations with the proceeds of the crop . . . a venerable old giant (on the West Terrace) . . . known under the name of 'l'Albero Bello' . . . would yield in good seasons as much as ten ordinary trees."

The long-range effects of the state's purchase were as important as the excavations and discoveries made under Rosa and Lanciani. Pillage was ended, and what at the time seemed to be the most worthwhile part of the Villa became officially a curatorial responsibility and remains so (the fate of the ruins, had they all remained in private hands, cannot be known, but the history of such places, such as that of the Torlonia holdings near the Tiber mouth, does not inspire confidence). The new site conditions soon attracted popularizers and scholars, and in 1904–1905 specialists from the Royal School of Engineering surveyed the site and established precise relations among many of the major buildings and proper contour lines.

The purchase of 1870 gave scholars new opportunities. Two-thirds of the Villa's major buildings—many looking much as they had in Ligorio's day—could now be examined in a single archaeological zone. The first description of the site to appear after 1870 was by Gaston Boissier, a popularizer whose *Promenades archéologiques: Rome et Pompeii* (1880) contains seventy pages on the Villa; the work went through many editions (the eighth appeared in 1904). Modern Villa scholarship begins with the sober, reliable work of Hermann Winnefeld, published in Berlin in 1895,

402, 403

whose site plan includes ruins on private land (the High Ground, Southern Range and Hall, South Theatre, Underground Galleries) and some discussion of them. Winnefeld had a keen eye, and his descriptions and analyses hold up well, as do his building plans, many of them superior to those published earlier. Then came Pierre Gusman's impressive book of 1904, which contains many valuable photographs and drawings from photographs, as well as photogravure plates of works of art. Gusman is less the archaeologist and more the historian of art than Winnefeld; the two books are complementary.

By the time of the First World War, anyone with access to Winnefeld's and Gusman's books could gain a clearer idea of the Villa than had been possible since ancient times. Important though the vedute are, the new photographs were often more useful to dispersed scholars studying the ruins. An international scientific audience appeared, limited in number but not in enthusiasm for the site, and slowly the Villa came to be included in the list of places in and near Rome that a cultivated visitor must see; in 1901, for example, members of the McMillan Commission, including Charles McKim, Daniel Burnham, and Frederick Law Olmsted's son Frederick, Jr., charged with improving the District of Columbia park system, visited the Villa during a study tour of European cities, villas, and gardens. After the war, Giuseppe Lugli published important articles on the pre-Hadrianic villa (1927), the Villa in late antiquity (1932), and the West Belvedere (1940), while Herbert Bloch's great work on brickstamps appeared in 1937, the year Italo Gismondi made the Villa model (the one now at the Villa is an updated version of 1955). Heinz Kähler's influential book of 1950 energized Villa studies once again. It begins with an overall view of the site and descriptions of a half-dozen of the most advanced designs, followed by analyses of their spatial and architectonic qualities—the heart of the book—and concludes with a perceptive discussion of Hadrian and his intentions; the plans are good, as are the analytical drawings (often reproduced); there are no other illustrations. Salvatore Aurigemma's work of 1961 is less rigorous, but because it covers most of the site and Villa ruins, art, and vedute

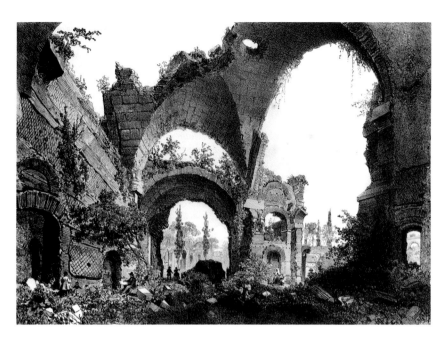

402 *Larger Baths, central hall, lithograph by P. and F. Benoist (1870)*

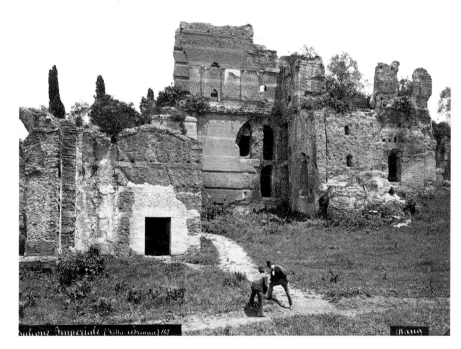

403 *Central Service Building, looking east (ca. 1880)*

are well illustrated, it has been equally influential. In the past two decades the number of serious publications has risen sharply, as our notes and Bibliography record.

It is a curious fact that few writers, in contrast to scores of architects and artists, have found the Villa attractive. Chateaubriand is an exception, as in this century are Marguerite Yourcenar and Eleanor Clark. Clark spent a year in Rome as a girl and returned in 1947 with a novel in mind. But she quickly turned to the city itself, and in 1952 produced one of its finest, most lively portraits, *Rome and a Villa;* Frank Brown was her cicerone. She explored the entire site, peering down through the High Ground oculuses and reveling in the superb art of the Hall of the Cubicles mosaics, everywhere registering details as well as grand effects; she really did look, a difficult thing to do that requires many long visits and exceptional concentration. Her themes are love, death, and Hadrian's circumstances and complex nature. The metaphor is brilliant and wide-ranging, the style vivid and poetic. Her view of the second-century world is very much her own but generous and apposite.

She finds the site subtle and brooding, the Villa the tomb of the Roman Empire. Art is pitted against nature, with Hadrian the referee; his architecture is "a long Mozartian invention that will never run out of motives." She is as good as anyone on space, surface, and light, and her observations on portraits, particularly of Antinous and Hadrian, go beyond scholarship. The novelist takes over sometimes, she spins some lively stories, and like everyone else who writes about the Villa (including ourselves), she makes errors. But the overall effect is lasting because of her acute intelligence and perceptions. Her work is rather like Piranesi's but in another medium, and like his it provokes thought about the Villa of a different order from that stimulated by scholarly description or analysis.

ARCHITECTS AND THE VILLA

Enthusiasm for the Villa as a source of architectural inspiration ran high among Renaissance and Baroque architects such as Raphael, Ligorio, and Borromini but waned thereafter. It reappeared to a degree in Robert Adam, and powerfully in Piranesi, but Piranesi's great contribution was to record, interpret, and publish the site (Canina did the same, but more modestly); Piranesi's work is echoed in such imaginary architecture as a view of a grand interior, with waterworks and much sculpture, by Charles Percier (Prix de Rome, 1786). The drawings made by young French and American architects trained in the Beaux-Arts tradition and sent to Rome, valuable evidence for the Villa in their own right, are restoration studies based in part on the archaeological evidence but do not prefigure their authors' subsequent creations. It is in the young Le Corbusier's Villa sketches of 1911 that the enthusiasm of long ago first reappears, a quality seen also in works by Louis Kahn, who studied the Villa in 1951 (Frank Brown was also his guide).

In the early nineteenth century, stimulated probably by the French excavations made during the Napoleonic occupation of Rome, Prix de Rome winners trained in architecture at the Ecole des Beaux-Arts often sought sites outside the city. The sanctuary at Palestrina, for example, was the subject of work (a mémoire and a series of drawings were required) sent to Paris as early as 1811; the Pozzuoli market (the "Temple of Serapis") followed in 1817, and the two free-standing Tivoli temples in 1820. But the first Beaux-Arts architect to work at the Villa was Pierre-Jérôme-Honoré Daumet (Premier Grand Prix 1855), who studied the ground ("les palais impériaux") lying between the Doric Temple Area and the far side of the Water Court, including the North Service and Peristyle Pool Buildings. The results, submitted in 1859, included a plan of the existing remains and an accurate if generalized restored version of them, as well as a spectacular panorama of the ruins seen from the northeast and northwest. From this last he worked up an elaborate restored view of his chosen ground which, save for a campanile rising from the Fountain Court West and topped by a facsimile of the Athenian Tower of the Winds, is perhaps the best of the many Villa restoration views. 404

Daumet's subsequent career was long and influential. At the Ecole des Beaux-Arts he inaugurated, together with the sculptor Eugène Guillaume, courses wherein

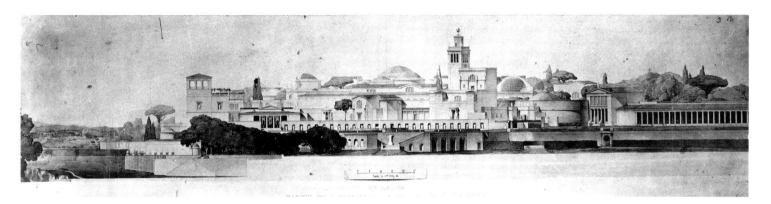

404 *Villa ruins, Daumet's restored panorama, looking southeast (1859)*

architecture, sculpture, and painting were taught to-gether, and of his pupils four were architects who won the Prix de Rome and worked at the Villa, during over-lapping terms, from 1876 to 1893. Paul Blondel was the first; he prepared actual state and restored plans of the Island Enclosure, good work considering the condition of the ruins. Then came Charles Girault, who spent six years in Rome and chose the Water Court and its en-virons. His submission drawings of 1885 comprise the expected actual state and restored plans (excellent work but with inventive passages in the plans) plus transverse and longitudinal sections of the ruins and restorations of both. In these last two he includes trees and fountain basins, statues up on the internal, free-running entabla-tures, bath windows, and vault paintings perhaps best described as free-style Neronian, with other ceilings in-fluenced by the graphic work of Ponce, Piranesi, and Canina. He covers the main south nymphaeum hall with a heavy masonry dome lit by an oculus.

The third Daumet pupil was Pierre-Joseph Esquié, who chose the ground between the Doric Temple Area and the Water Court, about half of the area his patron had surveyed thirty years before. Perhaps Daumet asked for this because meanwhile, with the acquisition of the central part of the Villa by the state, the Helio-caminus Baths had been partly cleared and a number of details clarified elsewhere. Esquié, whose work was completed in 1887, also produced a restored longitudi-nal section running along a line between the Fountain Court Buildings through the Residence Fountains; as

usual, the infill is eclectic — in the Library, for example, the niches contain statues and an invented transverse barrel vault is coffered in the manner of the vaults of the Basilica of Maxentius and Constantine. Then came Louis-Marie-Henri Sortais, the only one of the four to work outside Daumet's territory. Among his twelve submission drawings of 1893 (his excellent work on the Scenic Triclinium is discussed above) are the usual two plans, of the Scenic Canal and Triclinium and their en-virons. That of the ruins is a valuable record, but the restoration plan is heavy-handed, unlike the Triclinium drawings, and its Canal is necessarily inaccurate. After Daumet's time one more Prix de Rome architect tried his hand at the Villa: Charles-Louis Boussois, who in 1913 sent in twelve drawings of the Scenic Canal and its setting, among which is a restoration view toward the Triclinium facade based in part on Canina's and Sortais's work.

The work of the French was continued, as if on cue, by American architects trained in the Beaux-Arts tradi-tion who had won Prize Fellowships in architecture at the American Academy in Rome. The first was Philip T. Shutze, who arrived in Rome only three years after Boussois had finished his work; he began serious study at both the Pantheon and the Villa almost immediately. His work, like that of the other Americans who focussed on the Villa, was almost certainly suggested and to some degree guided by Gorham Phillips Stevens, an architect who had graduated from the Massachusetts Institute of Technology and had worked for McKim, Mead, and

405, 406

407, 408

409

see 144

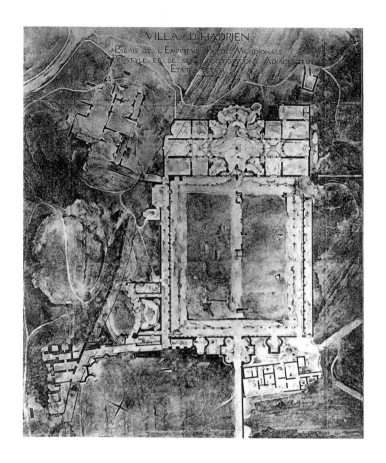

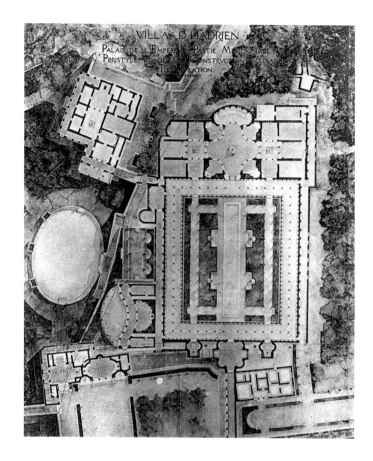

405 *Water Court, plan of the ruins by Girault (1885)*

406 *Water Court, restored plan by Girault (1885)*

407 *Water Court, longitudinal sections by Girault (1885)*

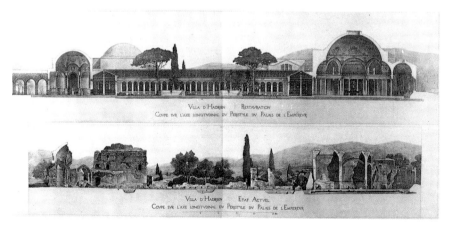

White, a man with strong classical and archaeological interests; he was at the American Academy from 1912 to 1932, its director from 1919. Shutze's main Italian interest was in later Renaissance and Baroque architecture, with strong emphasis on villas. But he acquitted himself well at the Tivoli Villa, where he measured the Island Enclosure and produced a plan (extending to the nymphaeum at the Fountain Court west corner), a north-south section of the whole, and a handsome section of the Enclosure; his work would surely have pleased Daumet.

At the same time, Raymond M. Kennedy was busy at the Smaller Baths; he made a workmanlike but somewhat regularized plan and a romanticized section of the kind popular in Beaux-Arts ateliers. Just as Kennedy's work was published, in 1919, James H. Chillman, Jr., began an original and important study of the Arcaded Triclinium, including a north-south section in part the basis of an etching made by Stevens of an interior view looking east. Then, in the early 1930s, the last three American studies were made. Kenneth B. Johnson worked at the Doric Temple Area and made a restored plan of the Temple and its curved enclosure, with an imaginary pool and garden lying below to the east. He also produced a striking, if inventive, elevation of the whole looking west; his work has been recognized only recently. Last, Henry D. Mirik studied and published the Larger Baths and Walter L. Reichardt the Central Vestibule and its environs. With them, the eighty-year involvement of Beaux-Arts architects with the Villa ends.

Aside from their value as records of Beaux-Arts techniques and ideals applied to Roman antiquities, these French and American works, most of them published, made restored plans and architectural views of Villa buildings, on the whole based on sound factual knowledge, available to the architectural public; the decor is fanciful, but the solids and spaces are more accurately recorded than in anything done before. They also demonstrate the continuity of interest in the site, long-lived and often intense, up to the moment of modernism's victory. But as the twentieth-century Beaux-Arts drawings were being made, architects of a very different

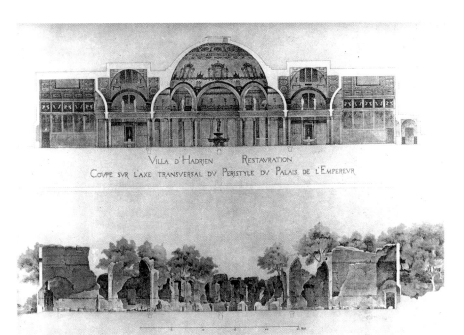

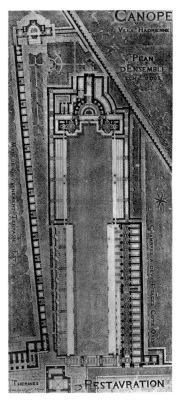

408 *Water Court nymphaeum, sections by Girault (1885)*

409 *Scenic Canal and Triclinium, restored plan by Sortais (1893)*

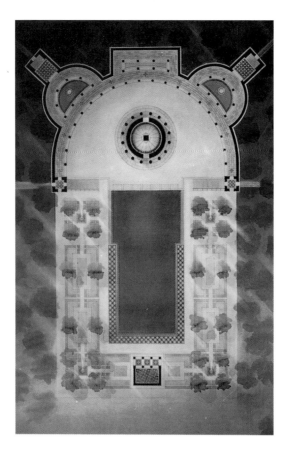

410 *Doric Temple Area, two restorations by Johnson (1932)*

stamp were also studying the Villa, for it continued to attract architects of remarkably diverse talents. Their perceptions of the Villa differ in significant respects from those of architects who had visited the site in previous epochs. Le Corbusier, himself trained in Beaux-Arts methods and the first major figure of the modern movement to devote careful study to the Villa, is a prominent example.

In 1911, at twenty-four, Le Corbusier left the office of Peter Behrens for an extended period of travel recorded in his book *Le voyage d'Orient*. After following the Danube south and making his way to Istanbul, Le Corbusier began a slow return to France, stopping at major cities and archaeological sites in Greece and Italy. Late in October he went to the Villa, an experience that exerted a powerful influence on the development of his architectural theory and design.

One of the sketchbooks Le Corbusier carried on his travels contains thirty-seven pages of pencil sketches of Villa ruins. These, together with his terse but often penetrating captions, record his response to the site. The captions make it clear that he had with him the 1909 edition of Baedeker's guide to central Italy and Rome, which he consulted in identifying individual ruins. Later, he lifted the site plan of the Villa from

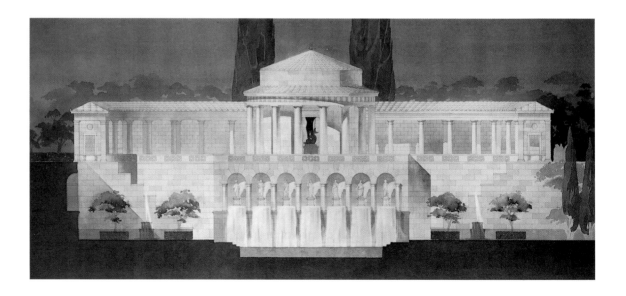

Baedeker and used it to head the chapter entitled "The Lesson of Rome" in *Vers une architecture* (1923). It seems probable that he was also familiar with Gusman's monograph of 1904 on the Villa.

Le Corbusier's response to the Villa reflects the boundaries of the archaeological zone; in his sketchbook he drew only ruins situated on state-owned land, and the sequence of his sketches generally follows Baedeker's itinerary. His first sketch in the series depicts the Ambulatory Wall and the expanse of the East-West Terrace. The curving profiles of Monte Ripoli and the Tivoli hills close the composition, in which, with eloquent economy, he captured the union of architecture and landscape. He later reproduced this drawing, among others, in *Vers une architecture*, commenting that "at Hadrian's Villa the levels are established in accordance with the Campagna; the mountains support the composition, which indeed is based on them."

He employed his sketchbooks for a variety of other purposes. Some drawings, such as the view of the Ambulatory Wall and another depicting the Smaller Baths, mediate between pictorial vedute and architectural aide-mémoire. Others are more analytical, and through them we observe him coming to terms with the complexities of Hadrianic architecture. Repeatedly he drew plans, sections, and perspective views of major Villa features, such as the Residence Quadrangle and the Water Court, using his pencil to explore the design principles embedded in their ruined masonry. In one instance, he presents a sequence of arches and vaults, expressed as pure geometric forms, extracted from his studies of the Larger Baths and the Central Service Building. His later formulation of a rich architectural language based on standard elements appropriate for reinforced concrete construction may be traced in part to his studies of Hadrian's Villa.

Le Corbusier made several sketches of the Scenic Triclinium that reveal his fascination with the illumination of its axial extension. In one, he captures the dramatic contrast between the light streaming down on the terminal apse and the dark shadows of the vaulted corridor in the foreground. The caption suggests that he was attracted not merely by this play of light and shadow but

411 *Ambulatory Wall and East-West Terrace, sketch by Le Corbusier (1911)*

412 *Scenic Triclinium, axial extension, sketch by Le Corbusier (1911)*

also by the resulting quality of mystery. On the facing page he drew an analytical diagram of this vertical light shaft, to which he returned forty years later in designing the pilgrimage church of Notre-Dame-du-Haut at Ronchamp. There the side chapels are illuminated by hooded shafts that rise to gather the sun's rays and direct them downward, suffusing the dark, cavernous interior with light.

Historians of modern architecture have overlooked the crucial role played by Hadrian's Villa in stimulating Le Corbusier's poetic vision of architecture. Much as Piranesi had used the Villa to underscore the creative dimension of Roman architecture and its relevance to architects in his day, Le Corbusier invoked it as a stimulus to modern designers engaged in the creative transformation of the past. Characteristically, he exalts the Villa at the expense of the canonical set pieces of classical planning so admired by his teachers, steeped in Beaux-Arts traditions. At the Villa, he writes, "one can meditate . . . on the greatness of Rome. There they really planned. It is the first example of Western planning on the grand scale. . . . To walk in Hadrian's Villa and to have to admit that the modern power of organization (which after all is 'Roman') has done nothing so far—what a torment it is to a man who feels he is a party to this ingenious failure!"

Paradoxically, Le Corbusier's modernism was inextricably bound with his romantic vision of the past, especially of the Mediterranean tradition. As depicted in his sketches, the Villa exemplifies his oft-repeated definition of architecture—"the masterly, correct and magnificent play of masses brought together in light." Moreover, the Villa's grand scale, the creative use of elementary shapes in its design, and the consistent application of concrete in its construction made it directly relevant to Le Corbusier's theories of modern architecture.

It is worth noting that the influence of the Villa emerged again, late in Le Corbusier's career when, disillusioned with the machine aesthetic, he turned to a more elemental vocabulary to evoke organic forms. In such powerfully expressive monuments as the Ronchamp Chapel and the government center at Chandī-garh, India, heroically scaled to their natural environments, we discern formal as well as spiritual affinities with the Villa. The sequence of massive vaults sheltering the Chandīgarh Palace of Justice recalls his sketches of the Central Service Building. Similarly, the coarse texture of rough concrete he employed at Chandīgarh evokes the ruined masonry of the Larger Baths recorded in another of his early drawings. Shorn of revetment and overgrown with creepers, the bare walls of the Villa take on an organic quality that ties them to the earth. Le Corbusier's rough-cast concrete surfaces, apparently shaped by centuries of wind and rain, achieve a similar timeless quality.

Similarities between the Villa plan and the one Frank Lloyd Wright made in 1938 for Florida Southern College at Lakeland seem to suggest that Wright knew and used Hadrian's plan, but the evidence is ambiguous. Villa plans were readily available, for Winnefeld, and Gusman in particular, were accessible in libraries, and perhaps Piranesi as well. Le Corbusier had included the plan in his *Vers une architecture;* the volumes containing the works of French Beaux-Arts winners of the Prix de Rome were often found in architects' offices, perhaps Canina's books also. In 1910, Wright and Mrs. Cheney, based in Fiesole, spent several months inspecting Italian art, sculpture, and architecture, but there seems to be no detailed record of what they saw; judging from Wright's later polemics, he was repelled by traditional Italian architecture.

Comparison of the two plans cannot settle the matter. The Villa plan does not contain diagonal lines (much emphasized in discussions of Wright's design methods) unless the 60° deflection of the Angled Terrace from the East-West Terrace qualifies. And the angled axes are not joined to each other like Lakeland's covered walkways, whose traffic flows largely unimpeded from building to building. The Lakeland plan, based on a grid, is resolutely geometric and linear, rigid and inflexible, though the Water Dome (a reflection of the Island Enclosure?), of large circular form, and the semicircular theatre, facing a stadium-shaped swimming pool (the Scenic Canal?), hint at the Villa. Seen from the air, the site does suggest an uncluttered version of the Villa, but

413

if the plan is superimposed on Hadrian's, none of the angles matches even approximately, and the drawing-board quality of Wright's work contrasts vividly with the dense and comparatively erratic Hadrianic forms. But if Wright did in fact absorb the Villa's frame into his memory, then not only the Lakeland plan but perhaps Taliesin West, Broadacre City, a dozen other projects, and even the Ocotillo Camp are in some slight degree Villa progeny. High-empire planning forms were well known to later nineteenth-century architects, as Wright's late 1880s plan of the Cooper House shows.

If prevailing notions of order and harmony shaped Renaissance architects' responses to the Villa, their twentieth-century counterparts have interpreted its remains in ways that reflect distinctly modern perceptions of formal structure. Perhaps more than any other ancient site, the Villa lends itself to fragmentation; because visitors necessarily experience the Villa sequentially, multiple and provocative formal relations arise. No single point offers a comprehensive view of the ruins; memory must integrate the fragments. Sketch plans of individual buildings drawn on the site invite re-integration into collage-like images that resemble early Cubist compositions of Braque and Picasso.

Even site plans of the Villa, such as the one reproduced by Le Corbusier in *Vers une architecture*, prompt rearrangement. Villa plans without contours cease to record three-dimensional architectural relations, and assume the quality of pictorial abstractions. An example of this is Edmund N. Bacon's plan in his *Design of Cities* (1967). Only the central portion of the Villa is shown, and the buildings there float freely on the page without contour lines to anchor them to the undulating terrain. Axial lines superimposed in color render the plan even more abstracted. Bacon's commentary acknowledges dynamic relations between the parts and the whole: "The solution of an ever-expanding problem by the fragmentation of its parts into units which are treated separately is possible only up to a certain point. Beyond this the demands of scale require reintegration."

Notable examples of the Villa as a site from which elements can be freely extracted occur in the work of Louis Kahn. In 1951 Kahn spent three months at the

414

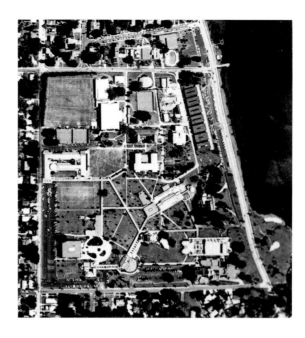

413 Lakeland, Florida Southern College, by Wright (begun 1938)

414 Cooper House, plan by Wright (early 1880s)

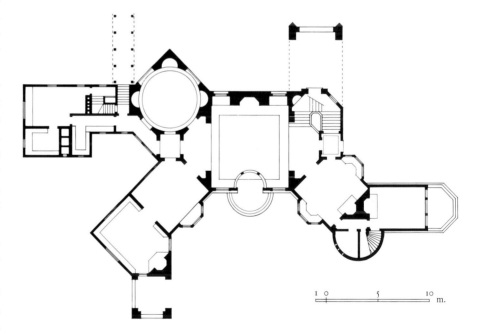

10 5 10 m.

American Academy in Rome, when he visited the Villa. Thomas Vreeland recalls that the Villa was "a style of architecture of which Kahn was most fond." Afterward he continued to muse on the site as he explored the essence of a "place of the immeasurable" in his designs.

Kahn had been trained at the University of Pennsylvania when it was the leading Beaux-Arts school in the United States. He valued the "musty old folio editions of the great architecture of the past" jettisoned by Penn's new dean, Holmes Perkins, in his zeal to redirect the school toward modernism. Many of these volumes found their way into Kahn's office, where they inspired some of his best-known work.

In 1960, when he was designing the Salk Institute at La Jolla, Kahn proposed to use Hadrian's Villa as a model for a complex of dining halls and residences known as the Academy, which was never built. Vreeland, who assisted Kahn on the Salk project, relates how,

With the book open to this late Roman plan of great richness and variety, I tried repeatedly to please my employer with my design.

415 *Vreeland's intervention in the Salk Institute plan for Kahn (1960)*

But each time I could feel from the expression of disgust on his face how far I had failed. So I decided to "fix" him and, outlining on a piece of tracing paper the highly irregular easily-recognizable property lines of the Salk site, I laid it over the book and, regardless of the scale difference, traced just that part of the older plan which appeared within the lines. When Kahn walked back into the room, his face lit up, and he congratulated me on an excellent design, not at all recognizing my plagiarism—at which point we all burst out laughing!

415

Kahn admired Piranesi's *Campo Marzio* plan, which in its turn was inspired by the Marble Plan. Vreeland's tracing resembles fragments of Piranesi's Plan both in its irregular outline and in the way familiar buildings are reconfigured by being truncated arbitrarily. His graft of the Villa plan onto the institute site stimulated a new phase in the design. Specific references to the Villa were left behind and replaced by more general principles of hierarchical distinction and integration achieved by Kahn's subtle manipulation of scale, geometry, materials, and connecting elements.

In retrospect, the work of Kähler, Clark, and Kahn of 1950 and 1951 appears as important to the Villa's architectural legacy as that of 1781 (Piranesi's plan) and 1870 (the state purchase), for since then the Villa, for the first time, has appeared frequently in published architectural discourse and the inspiration of its forms has been acknowledged by architects to a degree unknown since the seventeenth century. In appreciating the Villa's architectural potential, architects on the whole have been ahead of scholars, whose works rarely explore the topic (which seems also to have been largely absent from the classroom until the 1970s; even then Pliny's villas, Split, and Piazza Armerina probably received more attention).

In 1960, Charles H. Moore published the first discussion, in the United States at least, of Villa architecture written by an architect for architects; it is a brief, lively, and romantic evocation, its central point (the basic geometry of Roman design) based in part on Le Corbusier. Other citations of the Villa followed, for example those by Bacon in 1967, noted above, and by Colin Rowe and Fred Koetter, who contrast the Villa with Ver-

sailles (the "triumph of generality") and define the Villa as a "miniature Rome, a nostalgic and ecumenical illustration of the hybrid mix which the Empire presented." And the collection of essays that appeared in Paris in 1982, on Roman villas (Pliny's in particular) and their effect on architectural invention and reconstructions on paper from the Renaissance to the present, though it doesn't include Hadrian's creation, is a significant contribution to villa studies. The final essay, by Pierre-Yves Balut, on architects, archaeologists, and their restorations, which makes important points about villas in the Western imagination, centers in part on Leon Krier's version of Pliny's seaside villa (more Hadrianic, save for the site, than not).

Architects today (James Stirling, Oswald Mathias Ungers, Robert Mangurian, and Michael Graves, for example) often find what they want at the Villa. Long known only from vedute, the site now lives again not only in words and photographs but in architecture itself, to which its geometries, unique buildings, and extraordinary architectural panorama can contribute. And pavilioned landscapes, perennial features of public and private art, one of whose major modes Hadrian defined, also help to clarify what it was that he accomplished.

PAVILIONED LANDSCAPES

The buildings and grounds of Monticello preoccupied Thomas Jefferson for more than fifty years. He began work in the late 1760s, replacing his first house there, after 1796, with the present one — the last portico columns were set up in 1823 — and over the years he added outbuildings, ornamental and farm gardens, orchards, a vineyard, workshops, and an extensive network of roads. He designed everything himself and attended to (and documented) nearly every detail. Work slowed when he was away in France (1784–1789) and during his presidency (1801–1809) but revived when he returned; repeated rebuilding and lavish hospitality eventually bankrupted him. He planned much more than he built, and the Monticello of his imagination is a signal event in the story of an idea almost as old as building itself — the pavilioned landscape.

He owned and studied the major books on architecture (greatly favoring Palladio though rejecting the grand central block typical of Palladian villas) and works on antiquities such as those by Wood, Castell, Stuart and Revett, Desgodetz, and Clérisseau, Piranesi's friend and Jefferson's collaborator on the Virginia capitol design. He knew Greek, Latin, French, Italian, and Spanish and owned and studied many classical authors, among them Varro, Cicero, Vitruvius, both Plinys, Suetonius, Dio, and the HA; in his old age a visitor found him reading Pliny's letters. He observed contemporary Parisian architecture closely, and while traveling in France, Holland, England, and northern Italy he studied gardens and farming methods as well as architecture and antiquities; from France he returned with an expanded vision of what his house and estate might express. Because the site itself and Jefferson's intellectual life are well documented, the skein of influences and intentions from which Monticello is woven is largely clear. And because Monticello like Hadrian's Villa exemplifies the pavilioned landscape, comparing the two may help define the Villa's historical position and sharpen the sense of its significance in the world of ideas expressed by combining art and nature.

Although the Villa was probably not one of Jefferson's direct sources, the two sites have much in common, partly because they share a collateral ancestry he knew from his studies. He chose his site (about 400 hectares, to which he added later) for its marked topographical identity and splendid views, as well as for its privacy, and began work by leveling the hilltop. In

416 *Monticello, looking south from the south terrace, with Montalto at the right (1986)*

time he circled this summit, with its main building and extended western lawn, with four roads, at descending levels, intersected by radial ones leading upward. Lengthy terraces were cut into the south slope, also at descending levels; one buttress wall is of Roman scale. The main house was served by below-grade galleries, lit in part like Pliny's and Hadrian's cryptoporticoes; stables and other functional spaces also lie below the level of the house and lawn. Pavilions (at least one a large-windowed viewing-point) and other small-scale structures stood atop the terrace rims. In the best of times the staff numbered about 120, most of them slaves who farmed or made such necessaries as nails (one of Jefferson's estate-based business ventures). He had a deer park, a fishpond, and an ornamental pool, and he planted and cultivated according to the most advanced principles, assiduously seeking out seed and cuttings, for he was a farmer and gardener as well as a surveyor, inventor, architect, and designer; he even developed a stratigraphical method of archaeological excavation.

Because of his classical studies and his knowledge of English gardens (he and John Adams made a tour of them in 1786), his imagination projected for Monticello allusive villa features. When young he hoped for a grotto—inspired perhaps by Pope's verse and his creation at Twickenham—where a spring rose on the Monticello north slope. Typically, he wrote out his thoughts. The area would be cleared and terraced and the water allowed to fall in a cascade, and a marble reclining figure beside it on the grass would be inscribed to the water nymph and celebrated by lines from Horace. Later, again typically, he changed his plans, now favoring a grotto cave, moss-covered within and decorated by shiny pebbles, where the water would fall into a basin. Trees and flowering shrubs would be planted, and the view to the land below and beyond kept open. He also designed a square tempietto, with no internal structure, four Tuscan columns on a side and roofed with a stepped pyramid like those that cover his Monticello cisterns. Another design shows a domed pavilion with an Ionic portico.

Also when young he designed a 36.5-meter observation tower, square in plan and rising in four undecorated

stages of diminishing height and breadth, in the manner of a Roman lighthouse. Later, when he thought of placing a tower atop Montalto (nearby but higher than Monticello), he made several designs, one a slender, staged tower with classical embellishments, all rather like certain colonial church steeples with domed lanterns. but he gave these up in favor of a column twice as high as Trajan's, "preferable to anything else. It should be 200 f. high & have a hollow of 5 f. in the center for stairs to run up on the top of the capital balustrading"; perhaps the idea came from the Italian sculptor Giuseppe Ceracchi. This work, like Trajan's Column to be wrapped in a helical relief frieze, was apparently projected well before the creation of the Place Vendôme column.

Jefferson's eclecticism sprang from a long, steady increase in knowledge and understanding fueled by unflagging curiosity and from an ability to translate features from past cultures, Rome's in particular, into workable modern instruments: he found in history useful and persuasive ideas as well as lessons and precepts and had the intellectual and practical tenacity to reanimate them. Monticello's eclecticism demonstrates this and bears general comparison with that of Hadrian's Villa. Both sites are at once traditional and original, in some ways unique, and at both the land is shaped with an eye to viewpoints and the provision, or proposed provision, of discrete experiences and activities spread over uneven terrain among gardens and parks. And to the details given above of classical elements of planning and symbolism should be added Jefferson's art collection, which included a reclining marble Ariadne, a dozen busts of worthies, including six plaster copies of portraits by Jean-Antoine Houdon and his marble portrait of Jefferson himself, and another made by Ceracchi in the ancient Roman manner.

The gulf between Hadrian and Jefferson is bridged in part by the Villa and Monticello, where shared traits of character are displayed—deep interest in architecture and art, vital curiosity, uncommonly broad knowledge of the world, and recognition of the significance of the arts as cultural and biographical testimony. Each man devoted himself to the creation of an extensive estate

arranged for various activities and framed by natural beauty carefully managed—a pavilioned landscape. There they had books, music, and many opportunities for recreation, and could entertain in proportion to their splendid surroundings. Both reshaped uneven terrain—rebuilding and solving problems as they went—as the grounds were enlarged and stocked with art, architecture, and works by master craftsmen all illustrating the cultures of their respective times. These affinities, separated by many centuries but valid even so, are essential features of the long-lived and ubiquitous luxury villa landscape.

Besides money, time, and talent, such places require much land, preferably well watered; little can be done with modest sites because the necessary serial events lose their impact if they are too close together. Effective sites must open out to land beyond with topographical or intellectual interest—historical, literary, or mythological—so that distant views relate to the immediate landscape. Because the pavilions and grottoes and gardens are scattered, not on rational or geometrically aligned plans but at irregular intervals, encounters with them are unpredictably intermittent. The varied, dispersed events themselves, symbolic and allusive but familiar, make up visual texts; commentary is provided by peripatetic viewers.

Far more pavilioned landscapes exist than Monticello and those cited in earlier chapters because the urge to make them is so widespread; extending the selection may help to confirm the high standing, perhaps the paramountcy, of Hadrian's Villa within the type. A grand rival is the Qianlong emperor's Yuanmingyuan (Garden of Perfect Brightness), 10 kilometers northwest of Beijing, built in 1747–1772 from plans and designs by the Jesuit missionaries Giuseppe Castiglione and Michel Benoist on a site of about 380 hectares. The emperor, having seen a picture of a fountain (presumably Italian), decided on the basis of a model made by Benoist to add to the family summer palaces already on the site a European one set within pavilioned water gardens, the first major sector, with about one hundred buildings, of a creation eventually five times as large. Here he spent most of the year, residing in the Forbidden City only during the three winter months. His Yuanmingyuan was pillaged and then burned down in 1860 by French and British troops on Lord Elgin's order; the ruins are being studied by a Franco-Chinese team with a view to preservation and partial restoration (good pictorial documentation for many parts of the site survives).

The plans and alignment of almost all structures conformed to an underlying grid, but all water features, with the exception of a 40-by-150-meter reflecting pool and the orderly supply and drainage canals framing the site, were very irregular. The 7 kilometers of meandering shorelines in the European palace sector, which suggest the magnitude of Yuanmingyuan water surfaces, include those of its six islands, from the largest of which the European palace proper rose. Numerous pleasure pavilions, libraries, and temples stood across the site, and belvederes and towers—and a conical hill topped by a viewing pavilion—faced or overlooked the waters and gardens. There were Buddhist and Taoist monasteries. Waterfalls, fountains, monumental nymphaea, grottoes, obelisks, pyramids, relief stele, a labyrinth, and many bridges enlivened the whole. European forms, including an open-air theatre, were limited largely to the first sector, where the architecture was a free-wheeling interpretation of the Italian Late Baroque style. Some stele readily recall Piranesi's in the Piazza dei Cavalieri di Malta in Rome, and a grand hemicycle (the Palace of the Delights of Harmony) stood near a huge complex centered on an elaborate round aviary. Castiglione and Benoist drew on antiquity (Varro and Pliny at the least) and on many Italian monuments as well as on their own considerable ingenuity (the water regime may have been the most elaborate ever devised).

But concept and use are the most important connection with Hadrian's Villa. The Yuanmingyuan was not a center of government, unlike Versailles (to which it has been compared), which in its exaltation of the ruler is more like the Forbidden City than the Yuanmingyuan. The palace was instead a place for relaxation and contemplation away from the capital, a retreat where the emperor housed spiritual and intellectual counselors, a large collection of Chinese and Western art, several libraries, and many novel Western instruments and

mechanisms. Above all it was made for perambulation among an astonishing variety of views and tableaux, enframed or enhanced by still or moving waters, taken all together a model of the Qianlong's universe.

The concept of the whole, blending principles of European and Chinese inspiration, aims primarily for an aesthetic effect. Concern for making the occasional interior spaces (less than 1,000 square meters in all) truly habitable seems lacking. Functionality is subordinated to the spectacle offered the person strolling, not the stroller himself. It is up to him to move about; his effort and his movement are the essence of the visit. The garden is not like a palace, with grand views the eye can encompass as a whole, but like a collection of images of jardins à la francaise that the visitor travels through in succession, following a path characterized by contrasts of space, scale, and ambiance. With alternations of solid and void, high and low, closed and open, complex and simple, and effort and rest, the logic of the stroller's movement soon

417 *Forest Glen, National Park Seminary, pergola bridge from below (1990)*

becomes apparent, sometimes like the unfolding of a Chinese painting, sometimes in a series of scenographic tableaus that increasingly transport the spectator from surprise to astonishment.

With one or two adjustments, this fits Hadrian's Villa.

No less interesting, though much smaller, are creations by private persons. The painter Ilya Repin (1844–1930) called his villa by the Gulf of Finland, northwest of Saint Petersburg, Penaty, after the Roman penates, the gods of domestic storerooms and protectors of the welfare of the household. Recently restored, the estate centers on a main house with glass roofs, and set about the grounds are a number of wooden pavilions, among them a Temple of Osiris and Isis and a Tower of Scheherazade. Repin was an intellectual and knew what he was about, but less aware (and even unaware) enthusiasts have done well, so strong is the wish to see one's own pavilioned landscape. The National Park Seminary, a school for young women in Forest Glen, an area in Silver Spring, Maryland, is a parochial but worthwhile example. Begun in 1894 and slowly extended over about 35 hectares of rolling and sometimes steeply pitched terrain on both sides of Rock Creek, forty mostly small buildings are randomly dispersed around a shingle-style railroad hotel of the 1880s converted to school use, the shingles stuccoed over. In addition to such utilitarian structures as pumphouses, workshops, stables, and a power plant with a respectable tetrastyle Doric portico, there were once twelve or fifteen pavilions out in the grounds, residences executed in various architectural styles: a habitable windmill, a Swiss chalet, Japanese and American bungalows, an Indian mission, a would-be pagoda, a small colonial revival mansion, a gymnasium in classical garb, and a well-designed small castle.

Although these modest structures by themselves barely connect with the grand tradition, when they are taken together with the landscape — readable but heavily overgrown in part — and the implications of the remaining sculpture, the connection is strengthened. At least 2 kilometers of paths meandered through the gardens and groves, in general along the contour lines, and crossed Rock Creek here and there on low foot-

417 bridges. A higher, pergola bridge is 60 meters long; others, fully enclosed, are supported on loping, low segmental arches over irregular terrain. A water tower rose from high ground at the edge of the site, and close by once stood a wood-framed tower that likely supported an observation platform. Traces survive of narrow secondary paths leading in among the trees. The main paths sometimes widen into miniature plazas; in a rare case of formal planning, an oval ring-path is intersected by three straight ones set on its diagonal and transverse axes. Two fountains can still be seen. One, of formal design, stands in the middle of a circular plot in front of the ex-hotel, and the other is set grotto-like against a steep slope in a wooded area; the terrain, the pumphouses, and the water tower hint at more.

Few statues survive of what was not so long ago a large number. An enclosed theatre (the Odeon) was once furnished along its eaves lines with standing figures, of which in 1990 only one still stood, a well-executed female dancer or religious attendant. An oversize Minerva keeps to its glade, and nearby stands blind Justice, vine-covered and defaced by vandals. Six fin-de-siècle caryatids, carrying Ionic capitals and supporting a porch arcade, engagingly uphold the tradition by recalling the classical past in a modern style.

Literary evidence complements that of the later sites just as Varro, Pliny, the poets, and even the brief HA notice aid in understanding Roman villas. For example, Anna Thornton's diary is very informative about Monticello, and Al-Hamid Lahori's detailed description of court ceremonies under Akbar and Shah Jehan illuminates the pavilioned rock-landscape of Akbar's Fatehpur Sikri, the remarkable city west of Delhi he created in the 1570s and 1580s, just as the Byzantine *Book of Ceremonies*, mentioned earlier, reanimates the largely lost Great Palace in Constantinople. Memoirs of estate and court life are often relevant, as are novels whose authors, such as Trollope and Waugh, place their characters in grand landed establishments. In the *Dream of the Red Chamber*, of the mid-eighteenth century, an existing establishment, the Takuanyuan (Complete Garden), is to be greatly enlarged, and for this "the landscape talents among the secretaries of Chia Chen

[the head of the family] were able to draw up a plan whereby the original pavilions, towers, artificial mountains, halls, and verandas were utilised . . . craftsmen in gold and silver, and in brass and pewter . . . were assembled." In all such examples, people move across large areas from one locus or structure to another, each of different design from the others.

This is the age-old tradition, reaching back to Persian royal parks and perhaps to ancient walled Egyptian garden-villas, that Hadrian's Villa epitomizes. To compare the Villa with Disney amusement parks as some do is to ignore its function, originality, historical substance, and vital significance for the history of architecture and art. These comparisons confuse illusion with allusion and serve a growing tendency to regard the Villa as a bizarre place built solely for Hadrian's gratification and thus lacking serious intellectual or cultural content. Advertisements and films make increasing use of the Villa, and casual references to it in architectural discourse suggest that it is in danger of becoming an architectural catch-all, able to fit into anyone's ideas; the Villa may become a victim of its complexity and popularity, a place where new myths can be formed and broadcast unchallenged. Fortunately, serious work by Italian and foreign professionals continues — the Italians are generous with permits for qualified foreigners. Because the site is so large, archaeological triage will be needed, as will answers to vexing questions about the degree and kind of possible reconstruction that will inevitably arise in this age of simulacra.

The Villa's cardinal feature — the integration of varied arts in a grand pavilioned landscape — remains undefined. This is partly because the gardens and waterworks are little known, but mostly it is because Villa architecture, almost always dealt with separately in the literature and validated by a long list of masters from Francesco di Giorgio and Raphael to Le Corbusier and Louis Kahn, predominates in the Villa's legacy. Over the sculpture and mosaics, on the other hand, hangs a faint air of the second-rate, in part the result of making, knowingly or not, subjective comparisons and judgments about their quality (the proper basis for dis-

cussion of the purpose and meaning of Villa art is the Villa itself, however valuable external comparisons may be for the study of stylistic quality and change in the history of classical art). The Villa records artistic culture, as Hadrian saw it, in a broad historical range of appropriate images and symbols that did not have to be famous originals in order to be effective, for copies, literal or interpretive, could be accepted as equivalents of the originals.

In spite of the unsettled nature of the evidence, governing principles can be identified: for example, the integration of the arts, the episodic nature of varied experiences revealed by strolling about, and the empire-wide cultural and historical content that permeated the entire Villa. From these an operatic complexity is compounded, a multiplicity of meanings set out in a disordered, unclassical way in disregard of the metronomic and orthogonal regularity of so much traditional Greek and Roman planning. The result is entirely serious, just as Hadrian, its creator, was serious, unlike Nero, with his Domus Aurea's sham towns and countryside within the capital. The Villa was unmonumental and private, and though it would have been natural for Hadrian to think of it as potentially renowned, it was not at all like those direct public statements of his power and influence, the Pantheon and his gigantic Mausoleum. In this sense also the Villa is different from palaces of a later age where, in their great parks, deities and nymphs were only parts of conventional decor disposed in support of an autocrat's prestige.

In the story of pavilioned landscapes in general the Villa, because of its content, is a special case; among Roman villas it was the largest and most elaborate, with far more original features than the others. But what is most remarkable is its detailed portrait of the cultural foundations and imagery of empire: what monument says more about that world than the Villa? Other great works, such as the Ara Pacis, or Trajan's Forum and Column, celebrate individuals as executives of the Roman mission, but Hadrian, keen observer of the realm and its cultural content, created in his grand archipelago a parallel fabrication of reality apparently free of pro-

paganda. The Villa is the supreme artistic portrait of Roman civilization at its apogee, a place where the complexity and potential of Greco-Roman architecture and art abide, vital still.

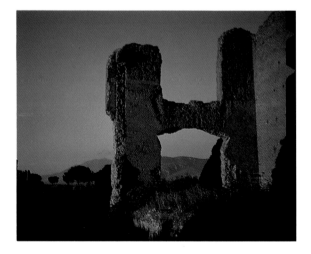

Piranesi's *Pianta* Commentary

Piranesi's plan is printed on six folio sheets with the Commentary arranged below in columns, seven per sheet. The Commentary is keyed to letters and numbers on the plan. Each entry in the following transcription records plate number, column number, and Piranesi's numerical designation. Commentary appearing below a given plate does not necessarily correspond to the Villa features represented above it. Because the second plate of the plan contains by far the greatest density of ruins, relevant Commentary necessarily extends to the plates that follow. Commentary entries relate to corresponding plan features as follows:

transcription numbers	refer to features on plate
1.1.1–1.7.16	1
2.1.1–4.7.57	2
5.1.1–5.7.5	3
5.7.6–6.2.14	4
6.3.1–6.3.7	5
6.4.1–6.5.20	6

PIANTA DELLE FABRICHE ESISTENTI NELLA VILLA ADRIANA

Indice delle Fabbriche

1.1 IPPODROMO, ovvero luogo di addestrar Cavalli, posto nella parte più depressa delle Fabbriche esistenti; che appartiene al Conte Centini erede del Conte Fede.

1.1.1 Ingressi nel medesimo.

1.1.2 Stalle rovinate, che servivano di sostruzione al Poggio superiore, al paro del quale era un'altro ordine di Fabbrica per uso, e commodo de' Cavallarizzi, Garzoni, ed attrezzi di Scuderia.

1.1.3 Poggio superiore all'Ippodromo.

1.1.4 Sostruzione del medesimo sulla strada antica.

1.1.5 Maggazeni per Orzo, Fieno, e Paglia.

1.1.6 Edifizio rotondo con quattro ingressi, investito da Nicchioni.

1.1.7 Muro di sostruzione al Poggio più alto Lettera A. Bisogna avvertire che l'Incisione più forte in tutta la Pianta indica i Muri esistenti, e quei scoperti nei diversi scavi: e la leggiera ciò che si è raccolto da frammenti de' Muri, in corrispondenza del totale degli Edifici. L'Incisione pontinata indica i Corridori sotteranei che passano sotto le Fabbriche.

1.2 NAUMACHIA, o Stagno per esercitarsi sulle Nave di Mare; e per esibire i Mostri, e Pesci Marini.

1.2.8 Portico di fronte all'Ippodromo, che dà l'Ingresso alla Naumachia.

1.2.9 Adito ad una delle Scale B.

1.2.10 Scale, che ascendevano alla Loggia coperta de' Spettatori C.

1.2.11 Loggia coperta.

1.2.12 Gradi per i sedili allo scoperto de' Spettatori, modernamente rinnovati in altra forma.

1.2.13 Vomitori, o scalette ne' gradi su[pra]detti.

1.2.14 Cordonate, che dal piano superiore scendevano nella Loggia coperta, e nel primo sedile de' Spettatori.

1.2.15 Luogo circondato dá Muri con Nicchie per ornamento della sostruzione.

1.2.16 Tempio di Nettuno soprastante alla Naumachia con due fronti.

1.2.17 Gradi del Tribunale del Tempio. Nel sito di queste rovine sono sparsi framenti di Colonne, Architravi, e Fregj di Marmo scolpiti, con corse di Animali, e Mostri Marini guidati dá Genj. Qui presso esistevano i Capitelli con delfini per Volute, che ora s'ammirano nel Museo Pontificio del Vaticano, e due dei Pilastri conserviamo nella nostra Galleria, quali ornamenti decoravano la Naumachia ed il Tempio sudetto.

1.3 TEATRO. Egli è in oggi diruto già disegnato dal Ligorio, e dal Contini. Alcuni Muri di esso si scoprirono nell'Anno 1775 nella Vigna pertinente al Seminario Vescovile di Tivoli; ad altri esistono nel Fossicello segnato D.

1.3.1 Fronte della Scena.

1.3.2 Portici ai Lati del Proscenio.

1.3.3 Pulpito.

1.3.4 Orchestra.

1.3.5 Portici esteriori ai gradi.

1.3.6 Scalette, che conducono à Sedili de' Spettatori.

1.3.7 Vestiarj, e Spogliatori degli Attori.

1.3.8 Luoghi per le Macchine della Scena.

1.3.9 Scale, che salgono a detti Edifizj.

1.3.10 Sentiero moderno, che passa il Fosso. Questo Teatro è all'uso Romano, imperocche è formato secondo i precetti di Vitruvio, con Pulpito basso, e amplo, a distinzione dell'altro, che viene in appresso, à il Timelio, o Pulpito alto, e stretto. Questo era tutto fabbricato sopra terra, sostenuto dalli Portici circolari descritti. L'altro parte era incavato, nel Monte, restando la sua Orchestra nel piano più depresso del terreno, che lo circonda. I Gradi poi che erano sopraterra venivano sostenuti da Contraforti, e quelli incavati nel Monte aveano un Corridore sotteraneo.

1.4 PALESTRA. Luogo dove si facevano esercizj per render robusto il Corpo, come la Lotta, il Salto, i giuochi del Disco, e de Cesti, ed altri. Sito che appartiene al Conte Centini.

1.4.1 Peristilio per lottare a scoperto con tre Portici semplici per commodo de' Spettatori, ed uno doppio per lottare a coperto.

1.4.2 Stanze per nudarsi, ungersi, e cretarsi i Lottatori, Saltatori, ed altri, che si esercitavano nel Ginnasio.

1.4.3 Scale, che ascendevano a piani superiori.

1.4.4 Sisto di due piani, il superiore con portici doppi in oggi diruti.

1.4.5 Portici, che circondano per due lati il primo piano del Sisto, e sostenevano le passegiate scoperte.

1.4.6 Corridori sotteranei, che servivano di sostruzione al sopraposto portico del Sisto. In uno di essi segnato E. scorre l'Acqua, la quale fa mostra alla Fontana nel sito F. detta ora di Palazzo.

1.4.7 Corpo di Fabbriche per diversi usi degli Atleti, con Portici interni doppi, e Portico esterno, che sostenevano l'Area di un Peristilio superiore.

1.4.8 Forma dell'Acqua, che si ripartiva ne' Lavatori, o Bagni di quei che si esercitavono nella Palestra.

1.5.9 Essedre quadrate, o Sale nobili, che erano ornate di Marmi, e Stucchi.

1.5.10 Stanze contigue a dette Sale, con Volte già ornate di Stucchi e Pitture, come si osservano ne' luoghi G. e H.

1.5.11 Adito di comunicazione alle Sale sudette, con Volta a finissimi Stucchi, come si vede ne' frammenti II.

1.5.12 Galleria, o Tablino ornato già di Statue, come da Nicchie esistenti. Nella Tribuna di mezzo quadro eravi collacata una Statua sedente, congetturandosi dal Piediestallo di Marmo greco, che ivi si osserva.

Conviene qui notare, che le Fabbriche di uso commune, come sono le indicate dell'Ippodromo, Naumachia, Teatro, Palestra, e Castro sono nella parte più bassa; all'incontro le seguenti del Ninfeo, Pisianatteo, Stadio, Vestibulo, Terme, e Canopo sono in piano medio. Per regolamento de' piani, o Aree delle medesime, parte sono introdotte nel cavo del Monte, come lo Stadio, le Terme, ed il Canopo, e parte con carichi di Terra, come il piano del Pisianatteo, verso la Valle, e i Giardini. Questi cavi hanno somministrato la materia per le Fabbriche composte per la maggiorparte di Tufi di colore leonato, uniti alli corsi de' Mattoni fraposti nella formazione delle Pareti.

1.6 NINFEO, ovvero luogo delizioso di Fontane, ora si possiede dal Conte suddetto.

1.6.1 Sostruzione del Poggio superiore ornata di Nicchie quadre ed intonacate di pomici, e tartari dipinti.

1.6.2 Continuazione della medesima con Nicchie semicircolari.

1.6.3 Cavea con fondo semicircolare, e Nicchie per Fontane ornate di pomici, e tartari dipinti d'azzuro, e verde; la quale serviva di prospetto ad un Viale.

1.6.4 Opposta sostruzione del Poggio, con Nicchie semicircolari per Fontane similmente ornate

1.6.5 Sostruzioni irregolari, che reggono un angolo del Poggio.

1.6.6 Tempio rotondo d'ordine Dorico, come da frammenti sparsi nel Poggio si riconosce: occupa il mezzo per far mostra ai varj aspetti del Ninfeo, e dedicato era alle Ninfe presidenti delle Acque.

1.6.7 Scala dei Tribunale del Tempio.

1.6.8 Recinto semicircolare del Tempio, con varie aperture.

1.6.9 Podj al piano del Poggio per riguardare le sottoposte Fontane del Ninfeo.

1.6.10 Corpo di Edifizio nobile a diversi piani per trattenersi presso il Ninfeo.

1.6.11 Stanza con volta ornata di finissimi stucchi, e grotteschi con fondo dipinto.

1.7.12 Scala che ascendeva ai diversi piani di detto Edifizio.

1.7.13 Portico che l'adornava.

1.7.14 Albergo con Portico per uso de'Castellarj, o Fontanieri del Ninfeo.

1.7.15 Adito di communicazione a diverse parti delle Fabbriche.

1.7.16 Conicoli per uso del Ninfeo.

Nel sito indicato nella Pianta con nome di Pantanello, presso l'Ippodromo, era luogo ove scolavano vicine sorgenti, e le Acque piovane. Quivi Mon.r Hamilton Pittore Inglese, tentò una cava, col dar esito alle Acque per mezzo di una Forma, e vi rinvenne nel fondo di esso un prodigioso numero di frammenti di Statue, frà Teste, Mani, Piedi, Vasi, Candelabri, Animali, Bassirilievi di ottima Scultura, Colonne di Giallo antico, e di Allabastro, ed altri Marmi mischi, nè tenendo conto de' Capitelli, Basi, Cornici, e Fregj intagliati, e rocchi di Colonne di Marmo ordinario, che rilassò nello stesso fondo. Questo ammasso di frammenti si pretende adunato per dispreggio di Religione, e per barbarie d'ignoranza, che pose in rovina la moltiplice quantità degli adornamenti, che avevano le Fabbriche della Villa, credendo in tal modo restassero distrutte, ed annullate per sempre.

2.1 CASTRO, o luogo per gli alloggiamenti de' Pretoriani, o guardie del Corpo. Sito in parte del Canonico Maderni, e della Camera Apostolica.

2.1.1 Corpo di guardia del Castro a diversi piani, il primo piano corrisponde a quello dell'Ippodromo descritto.

2.1.2 Scale, che ascendono ai piani superiori per communicazione a seguenti alloggiamenti.

2.1.3 Alloggiamenti degli Ufficiali delle guardie in Poggio più alto.

2.1.4 Sito, ove furono ritrovate dal Michilli le Statue dell'Arpocrate, della Flora, ed altre, che sono nel Museo del Campidoglio.

2.1.5 Sostruzione del Poggio superiore K.

2.1.6 Clivo congiunto alla Strada indicata incavato nel colle per ascendere all'adito delle Vie sotterranee L, le quali passavano nelle diverse parti della Villa. La sostruzione M. del Poggio del Pecile è formata a diversi piani, a seconda del clivo nel pianterreno de' quali si ripartivano i Cavalli, e le Guardie nelle Celle di sopra.

2.1.7 Sterquilinio, e Latrina per comodo delle Guardie.

2.1.8 Muro di sostruzione al Colle tagliato.

2.1.9 Contraforti nell'angolo del medesimo.

2.1.10 Tempio di Marte, come da Muri e, Frammenti scoperti nel lavorar la Vigna si è riconosciuto.

2.2 PISIANATTEO, o Portico doppio, e vario per ornamento di Pitture, è però chiamato Pecile; ivi i seguaci della Filosofia stoica si esercitavano nelle dispute. Sito, che in oggi possiede il Conte Centini.

2.2.1 Portico doppio a Pilastri diviso da Muro, riguardando un lato del grande Peristilio, e l'altro dell'Area opposta.

2.2.2 Teste del medesimo di forma quasi circolare che communicavano all'uno, e l'altro Portico.

2.2.3 Communicazione nel mezzo del Muro corrispondente alla Strada.

2.2.4 Portico semplice, che circonda tre lati dell'Area del grande Peristilio.

2.2.5 Essedra nel mezzo della testa a Levante.

2.2.6 Stagno, o Piscina nel mezzo del Peristilio.

2.2.7 Portico, che dal Peristilio communicava alle Fabbriche contigue.

2.2.8 Sisto, o Passaggio scoperto, con Podio sull'alloggiamento delle Guardie, che riguarda la Valle, esso communicava ai Portici del Peristilio, e all'altro Portico che proseguiva.

2.2.9 Dieta con Essedra ornata di Nicchie quadrate, con Passaggi in una testa del Portico doppio, e nell'Edificio circolare.

2. 2/3. 10 Edificio circolare con Portico ornato di Fontane per delizia; ha nel mezzo dell'/Area una Fabbrica esternamente circolare, con quattro piccioli Ponti, che passavano sopra l'Euripo, o Canale di Acqua, che scorreva trá il Portico, e la Fabbrica di mezzo.

2.3.11 Area quadrata, che ha in mezzo de' lati quattro Aditi, ornati innanzi di Colonne disposte in porzione di cerchio, i quali communicavano sopra i Ponticelli descritti. I Fregi di questa Fabbrica erano ornati con Bassirilievi rappresentanti corse sopra le Acque di Mostri Marini, Genj, Ucelli, e di altri Animali.

2.3.12 Cellule di trattenimento di vaga forma.

2.3.13 Passaggio in un Giardinetto, che ha di fronte una prospettiva ornata di Nicchie.

2.3.14 Nicchione di contro il pasaggio suddetto.

2.3.15 Scale, che dal Giardino salivano al Poggio, ed al piano di sopra del Portico rotondo.

2.3.16 Sostruzione del Poggio del Giardinetto.

2.3.17 Essedra con Nicchia, ove dal Conte Fede fù rinvenuto il Fauno di Marmo rosso, ora nel Museo Vaticano, come anche Frammenti diversi di Statue, e Marmi mischi in ogni parte di questo Edifizio. Ella è rivolta di fronte alla longa Area K. che è di fianco al Pisianatteo, che servir dovea di delizioso Giardino.

2.4 BIBLIOTECA Greca, e Latina, sito del Conte Centini.

2.4.1 Biblioteca Greca a due piani, le Pareti inferiori erano dipinte a Grotteschi.

2.4.2 Essedra, o Sala innanzi di essa, per commodo de' Studenti. La volta era coperta di Mosaico turchino.

2.4.3 Gabbinetti; in uno di essi restano nella Volta frammenti di Grotteschi.

2.4.4 Gradini, che dalla sottoposta Area della Biblioteca ascendevano all'Essedra indicata.

2.4.5 Scala, che scendeva al Giardinetto già descritto N.

2.4.6 Stanze per uso, e commodo della Biblioteca.

2.4.7 Galleria a due piani, ha nelle teste due Tribune con Volte dipinte a Grotteschi.

2.4.8 Scala, che ascendeva al secondo piano.

2.4.9 Biblioteca Latina con Tribuna.

2.4.10 Sala innanzi di essa.

2.4.11 Scale, che dall'Area innanzi la Biblioteca, vi si saliva.

2.4.12 Stanze di varie figura per uso, e commodo della Biblioteca.

2.4.13 Scale per salire al piano superiore.

2.4.14 Cavedio con Peristilio di Colonne per trattenimento, e passeggio de' Studenti.

2.4.15 Fontana sotto un lato del Peristilio.

2. 4/5. 16 Passaggi di communicazione coll'Edificio circolare / descritto, e nel Giardino N.

2.5.17 Altri passaggi a diversi luoghi.

2.5.18 Sostruzione, che pone in piano l'Area delle Biblioteche, ornata di portico con Nicchie.

2.5.19 Poggio inferiore, che conteneva un Giardino di delizia per li Studenti.

2.5.20 Scala, che dal Poggio inferiore saliva al Giardino.

2.5.21 Nicchie sotto la Scala per le Fontane.

2.5.22 Sostruzione intorno al Giardino.

2.5.23 Conserva d'Acqua con Nicchie esterne per Fontane.

2.5.24 Altra Conserva; Ambedue somministravano Acqua al Ninfeo, ed altrove.

2.5.25 Corridore sotterraneo di communicazione con quelli del Ninfeo. Questi Edificj delle Biblioteche sono rivolti all'aspetto del Cielo, secondo che Vetruvio nel trattato dell'Architettura distintamente descrive; dà che si conosce quanto fosse degli antichi Architettori la diligenza in conservare i precetti dell'Arte, affinche corrispondessero all'uso, e commodo già da Vecchi esperimentato in vantaggio della conservazione

de'Volumi, e del lume necessario, e continuato per gli Studenti, che giornalmente leggono.

2.6 STADIO, o luogo atto per la Lotta, ed altri Esercizj per render robusto il Corpo. Sito del Conte Centini.

2.6.1 Parte semicircolare con Sedili per li Spettatori.

2.6.2 Luogo per i Giudici, ed Arbitri della Corsa, e Lotta.

2.6.3 Portici per Lottare à coperto.

2.6.4 Corridore sotterraneo per passaggio alle contigue Fabbriche.

2.6.5 Cavedio con tre Essedre, o Emicicli con Portici intorno per commodo, e trattenimento per i Studenti della Setta Stoica.

2.6.6 Tempio del Nume, che questi adoravano.

2.6.7 Porta di Communicazione al Portico del gran Peristilio.

2.6.8 Ingressi con Gradini nel mezzo dell'Essedre, che dall'Area O. vi si ascendeva.

2.6.9 Celle negli Angoli.

2.6.10 Galleria, ch'era ornata di Marmi, e Bassirilievi.

2.6.11 Stanze nobili di trattenimento.

2.6.12 Sala con Colonne, e Porta, che entra nello Stadio.

2.6.13 Portici laterali all'Edificio.

2.6.14 Area quadrata con Nicchie quadre, e curve in un lato di essa, che formavano Edicole con Colonne, e adornavano l'esterna parte de' seguenti Bagni.

2.7.15 Passaggio a detti Bagni dal Peristilio.

2.7.16 Aspetto de'Medesimi.

2.7.17 Gradini, che dall'Area O. ascendevano all'ingressi.

2.7.18 Stanze de' Bagni, di varia, e vaga figura, erano nobilmente ornate di Marmi coloriti, e mischi.

2.7.19 Stanzini per laconici apoditeri parimenti di diversa figura.

2.7.20 Piccola Stanza semicircolare con Volta dipinta a grotteschi.

2.7.21 Sala principale di communicazione con i Bagni, e corrisponde al mezzo del seguente Peristilio.

2.7.22 Peristilio con Colonne da tre lati.

2.7.23 Cortili scoperti.

2.7.24 Sostruzione al Poggio superiore P.

2.7.25 Muro, che racchiude i descritti Bagni.

2.7.26 Corridore sotterraneo di communicazione alle parti della Villa. Sono degne di osservazione le parti di questi Edificj per la loro bizzarra

figura, e sembra che qui più d'ogn'altro siano in forma di quelli che se vedevano in Grecia, poiche i Romani altro Stadio non ebbero, che quello di Domiziano, e quello che unirono per gli Esercizj della Ginnastica nelle Terme.

3.1 VESTIBOLO, che conteneva l'Atrio, ed il Tablino, luogo ove si trattenevano quei, che vi visitavano l'Imperadore, prima d'essere ammessi al Saluto, e all'Udienza. Sito già de' Gesuiti, ora della Camera Apostolica.

3.1.1 Area piana innanzi di esso sostenuta da laterali sostruzioni.

3.1.2 Sostruzione al Poggio Q.

3.1.3 Gradi al Vestibolo.

3.1.4 Vestibolo.

3.1.5 Fontane laterali al detto con Nicchie.

3.1.6 Atrio con Ale, o Portici laterali, con fronte semicircolare, ed Essedra quadrata nel mezzo ornata di Colonne.

3.1.7 Ingresso dall'Atrio nel Tablino.

3.1.8 Tablino.

3.1.9 Edicola isolata con Gradi, e Portico innanzi. Ove erano li Immagini dei Dei. Lari e dell'Imperadore.

3.1.10 Alloggiamenti del Prefetto dell'Atrio, e degli Atriensi, — o Portinarj.

3.1.11 Area delli detti Alloggiamenti.

3.1.12 Adito, che dall'Atrio passava nell'Area suddetta.

3.1.13 Atrio Addito all'Area delle seguenti Terme, o Bagni.

3.1.14 Ingresso per quei, che dal grande Peristilio passavano al Palazzo Imperiale.

3. 1/2. 15 Strada antica, che dall'Area degli Allog / iamenti suddetti portava alle altre parti della Villa.

3.2.16 Ingresso del corridore sotterraneo, che dalla Strada degli Alloggiamenti delle Guardie communicava cogl'altri corridori per passare ai diversi Edifizj della Villa.

3.2.17 Sbocco con Gradi del medemo nell'Area delle seguenti Terme per coloro, che doveano passare all'altra parte dell'Area, ove erano gli Alloggiamenti de Liberti, e Villici, che restavano nella sostruzione del Pretorio. Per detto corridore non solo passavano le Famiglie rustiche, ma anche le Guardie, e le Sentinelle, che da Corridori sotto il Poggio P. seguente si repartivano ai loro posti in tutte le Abitazioni Imperiali. Questa parte, che dava l'ingresso alle Fabbriche del Palazzo Imperiale è quasi del tutto distrutta per cagione di

coltivare il terreno a Vignato. Ma da cavi ivi fatti si sono scoperti i fondamenti dell'Ale del Portico dell'Atrio, e del passaggio al Tablino. I rocchi di Colonne, e frammenti di Capitelli, Basi, Architravi, Fregj, e Cornici ivi ritrovate nel lavorare il terreno, ne confermano l'ornamento.

3.3 TERME, o Bagni Imperiali, sito della Camera Apostolica.

3.3.1 Area d'intorno a Bagni.

3.3.2 Ingresso principale a medesimi.

3.3.3 Peristilio.

3.3.4 Salone nobile di passaggio a diversi Bagni con frammento di grotteschi dipinto nella Volta.

3.3.5 Essedra laterale al Salone con Nicchie.

3.3.6 Stanza a crocera, con quattro Modiglioni, che sostengono la Volta ornata di finissimi Stucchi. Essa corrisponde di fronte all'Essedra suddetta.

3.3.7 Fenestre grandi per lume nella Camera: quella di mezzo ha sotto una Porta di communicazione ad un Corridore, che gira intorno le Camere de' Bagni.

3.3.8 Stanza circolare per uso di Apoditerio, o spogliatore nobile, con Nicchie, e Volta dipinte a Grotteschi Riceveva il Lume nel mezzo dell'Emisferio, e dalle Fenestre ornate di Colonne.

3.3.9 Stanze per Bagni con Fenestre rivolte a Ponente.

3.3.10 Adito per girare intorno à Bagni, per uso dell'Ipocausti, o Fornelli. Lo stesso sosteneva un terrazzo con Podio al paro delle Fenestre de' Bagni.

3.3.11 Stanze per attrezzi, e commodi de' Bagni.

3.4 PRETORIO Imperiale; luogo distinto per la situazione in un Poggio più alto della Villa; in prospetto de' Giardini, e de' Viali, dà quali si passava alle abitazioni dell'Imperadore, e della sua Famiglia; come anche da sotterranei Corridori. Egli è sopra sostruzioni di Celle per commodo de'Liberti, e Villici, ch'avean cura della Villa, e delle sue differenti parti. Il ripartimento di queste Celle si osserverà in altra Pianta, ove saranno indicate le Fabbriche sotterranee, che investono i diversi Poggi. Questa Fabbrica inferiormente appartiene alla Camera Apostolica, e superiormente a Sig. de Angelis di Tivoli.

3.4.1 Ingresso dall'Area de'Bagni descritti, alla Scala del Poggio P. Ove era un Giardinetto pensile.

3.4.2 Corridore, che serve di Sostruzione al Poggio suddetto, e univasi alla Scala descritta, ed ad altri Corridori sotterranei.

3.4.3 Adito del Corridore principale, che dall'Area di sopra indicata, sotterraneamente comunicava alle diverse Fabbriche Imperiali.

3.4.4 Diramamenti del medesimo Corridore.

3.4.5 Conicolo, che in fine di esso ha un Pozzo con pedature per ascendere al Poggio P.

3. 4/5. 6 Muro di Sostruzione al Poggio R. il più elevato sito della Villa, sparso di molte Fabbri / che per uso dell'Imperadore, e sua Famiglia.

3.5.7 Scala, che dal Giardinetto pensile del Poggio P. saliva a quello superiore del Pretorio.

3.5.8 Ingresso del medesimo Pretorio.

3.5.9 Emiciclo, che faceva fronte ad un Viale del disteso Giardino situato nella grande pianura del Poggio R. Egli serve di Porta di communicazione colla Scala, e col Giardino.

3.5.10 Stanze per i Portinari del Pretorio, e del Giardino.

3.5.11 Portici laterali al Peristilio del Pretorio, che ornavano l'aspetto rivolto al grande Giardino.

3.5.12 Peristilio del Pretorio. Nelle cave fatte dà Sig.ri de Angelis, si rinvennero rocchi di Colonne striate di Marmo Cipollino, con Capitelli d'ordine Dorico.

3.5.13 Corridore nobile intorno al Peristilio, con loggiati, che riguardano la sottoposta Area de'Bagni.

3.5.14 Sale nobili ed altre Camere di trattenimento. / L'uso di questo Pretorio poteva servire alle udienze dell'Imperadore nel grande Giardino, e alcuna delle Camere per Sala nobile, de' Pretoriani come Guardia del corpo.

3.6 PINACOTECA Imperiale, o Galleria di Statue, e Pitture. Ella è situata sul Poggio suddetto, e si unisce ad un corpo di Fabbrica, che superiormente servir potea d'Abitazione d'inverno. I piani di sostruzione del Poggio soprastante allo Stadio poteano contenere i Liberti della Corte Imperiale. Ora sito del Conte Centini.

3.6.1 Galleria scoperta, che ha di sotto un'altra chiusa per Pitture, la Volta, e le Pareti sono dipinte a grotteschi. Ne ripartimenti delle medesime erano appese le Tavole dipinte.

3.6.2 Galleria ch'era coperta da Portico isolato, e ornato di Colonne, nel basamento del quale dà un lato erano le Fenestre per illuminare il Portico chiuso, e dall'altro le Nicchie per le Statue.

3.6.3 Cavedio della Pinacoteca.

3.6.4 Ingresso alla medesima.

3.6.5 Passaggj dalla stessa alle contigue Abitazioni.

3.6.6 Corridori di adito alle Celle, e Sale.

3.6.7 Sala.

3.6.8 Cubicolo, o Camera dà Letto.

3.6.9 Cortile pensile per dar lume al Cubicolo.

3.6.10 Triclinio e Cenazione rivolta a Ponente.

3.6.11 Conclavi per commodo del Cubicolo, e Triclinio.

3.6.12 Camera di conversazione.

3.6.13 Loggiatti, che riguardono sopra lo Stadio per osservare i Giuochi.

3.6.14 Altre stanze per diversi usi.

3.7 PALAZZO Imperiale, o appartamento estivo. Questa Fabbrica è ne beni del Con. Centini.

3.7.1 Ingressi del Palazzo corrispondenti ai Viali del Giardino.

3.7.2 Stanza, e corridore che communicavano al Vestibolo del gran Peristilio del Palazzo.

3.7.3 Stanze per Portinari, ed ingressi nel Giardino.

3.7.4 Vestibolo ottagono corrispondente al mezzo del Peristilio.

3.7.5 Peristilio, luogo, che oggi chiamasi piazza d'Oro. Le Colonne del suo Portico erano di Marmo Cipollino, e Granito Orientale, alternativamente disposte. Quelle nelle Parete sono di Cemento ricoperte di finissimo Stucco. I Pavimenti erano di Marmo mischi. Scoperti Anni sono dall'indicato suo Posessore.

3.7.6 Oecio o Sala Corintia di vaghissima e capricciosa struttura, che stà di fronte al detto Vestibolo. I suoi ornamenti erano di Marmo mischio con Colonne di Granito.

3.7.7 Essedra nel fondo della Sala, con Nicchie incrostata di Marmo. Sembra aver servito di Tribunale.

3.7.8 Triclinj nobili, o Sale da mangiare.

3.7.9 Stanze ornate di Colonne con Nicchia nel fondo.

3.7.10 Cubicolo, che nel fondo ha un Semicircolo.

3.7.11 Stanze di parata, e commodi.

3.7.12 Picciolo Portico sul Giardino R.

4.1.13 Portici chiuso nel lato del gran Peristilio, che dal suddetto Portichetto conduceva all'Appartamento descritto.

4.1.14 Altro Portichetto, che servivva di loggia sul Giardino del Poggio sottoposto. S.

4.1.15 Altro Portico chiuso al lato del Peristilio per passare all'altre parti del Palazzo.

4.1.16 Passaggi dal Portico sud. ad una grand'Essedra.

4.1.17 Essedra con Nicchie per Statue, avea dinanzi un Portico con Colonne d'Ordine Corintio, come si ravvisa da Frammenti sparsi, e dall'Architrave, che stà in opera.

4.1.18 Area innanzi la detta Essedra circondata da un Podio, che riguarda sulla Valle sottoposta.

4.1.19 Stanze con fondo in porzione di Cerchio.

4.1.20 Stanza, che dal Portico dell'Essedra passava in una Galleria.

4.1.21 La medesima con Nicchie per Statue.

4.1.22 Aree con Podio innanzi riguardanti la detta Valle.

4.1.23 Scala, che scendeva alle Fabbriche sul Poggio del Giardino S.

4.1.24 Loggia coperta riguardante sulla Valle, ha sotto di se diversi piani di sostruzione per uso de'Liberti, e Servi Imperiali.

4.1.25 Portico di delizia nel descritto Giardino S.

4. 1/2. 26 Lungo Portico sostenuto da sostruzione con Tribune sul Poggio T. Egli serviva di passeggio e di communicazione dal Palazzo Imperiale / alli seguenti Ospitali. Le sue Colonne erano di Marmo bigio, e Striate con Capitelli d'ordine Corintio. Vi furono anche ritrovati varj frammenti di labri per Fontane nella Cava fattavi dal Conte Fede. Alcune di queste Colonne sono nel nuovo Museo Vaticano.

4.2.27 Adito al Corridore nel Poggio T. che communica agli Ergastoli de'Schiavi.

4.2.28 Stanze nel detto Poggio per i Portinari.

4.2.29 Piscina nel Poggio suddetto.

4.2.30 Alloggiamenti de'Liberti, e Famiglia dell'Imperadore. Questo Edificio è sul Poggio T. il piano superiore pareggiava quello del Palazzo.

4.2.31 Scala, che da detti saliva al Palazzo Imperiale.

4.2.32 Sala per trattenimento de'Liberti, ove attendevano gli ordini Imperiali.

4.2.33 Muri di Fabbriche rovinate nel Poggio descritto.

4.2.34 Gran Viale presso la Valle con Muri laterali, uno de'quali serviva di sostruzione al Poggio T. descritto.

4.2.35 Ricetto in testa del medesimo Viale ornato di Nicchie.

4.2.36 Corridore di sostruzione al Poggio V. che dall'adito 27. descritto communicava al seguente Ergastulo.

4. 2/3. 37 Muro di sostruzione al Poggio R. sopra del quale scorreva un ramo dell'Acque/dotto, che traversa la sottoposta Valle.

4.3.38 Conserva d'Acqua dalla quale si ripartivano i Canali in varie parti delle Fabbriche del Palazzo Imperiale.

4.3.39 Stanze per la munizione de'Fontanieri.

4.3.40 Corridore rovinato.

4.3.41 Portico rivolto al Ponente nella parte esterna del Palazzo descritto.

4.3.42 Muri, che racchiudevano Aree irregolari.

4.3.43 Avanzi di Fabbrica isolata, che restano nella Macchia del Conte Centini.

4.3.44 Altri avanzi di Fabbriche distrutte.

4.3.45 Edifizio in forma orbicolare con Portico intorno.

4.3.46 Avanzo di magnifica Fabbrica nel Poggio T. molto rovinato.

4.3.47 Stanze, ch'erano investite di Marmi.

4.3.48 Stanza nobile con volta a crociera, che ha ne lati due Nicchie semicircolari, e nel fondo una tribuna quadrata, ch'era parimente investita di Marmi.

4.3.49 Picioli Corridori laterali di essa.

4.3.50 Stanza di forma sferica.

Dalla forma di queste Stanze, ed investiture de Marmi, si conosce, che fosse luogo nobile ma per la grande rovina non si scorge quale fosse anticamente il suo uso.

4.3.51 Avanzi di sostruzione del Monte.

4.4 OSPITALI, o Abbitazioni per la Foresteria frapposte alle Abbitazioni Imperiali d'Inverno, e d'Estate. Luogo, che possiede il Conte Centini.

4.4.1 Vestibolo ornato di Colonne riguardante il Giardino Imperiale.

4.4.2 Stanze di communicazione col Vestibolo, e con ingressi sul Giardino.

4.4.3 Corridore, che dalle medesime Stanze si passava al Peristilio.

4.4.4 Portico, che unisce l'Abbitazione Imperiale con quella della Forestiera.

4.4.5 Peristilio.

4.4.6 Stanze di transito dal Peristilio all'Atrio.

4.4.7 Atrio con ale, e fondo in porzione di Cerchio, con Nicchie per l'Immagini del Tablino.

4.4.8 Stanze con passaggio all'Atrio, e al Giardino

4.4.9 Dieta di forma sferica con Nicchie per Statue, con ingresso sul Giardino della Foresteria

4.4.10 Conclavi con Porte sul Peristilio, e sul Giardino suddetto.

4.4.11 Oecio Corintio, o Salone per i gran Conviti con Colonne.

4.4.12 Stanze per commodo, ed uso del medesimo.

4.4.13 Giardino indicato.

4.4.14 Diversi aditi, che dal Giardino passavano a seguenti Bagni, ed all'Abitazione delle Famiglie.

4.4/5.15 Corpo di Fabbrica per Liberti, e Famiglie del/la Foresteria, e per i Ministri necessarj.

4.5.16 Salone con diversi ordini intorno di meniani per ripartire i Famigliari ne'varj piani delle Celle a volta tramezzate da'Solari.

4.5.17 Celle sud. con piccioli Spiragli per il lume.

4.5.18 Cenacoli, o Sale per la Famiglia degli Ospiti.

4.5.19 Stanza per il Custode.

4.5.20 Avanzi di Muri irregolari, che formavano diverse Aree, e Cortili per vario uso, e commodo.

4.5.21 Corpo di Fabbrica assai rovinato con Stanze di varia figura, che servir potevano di Bagno alla Foresteria.

4.5.22 Stanza di Bagno circolare, con Nicchie, e Fenestre ornate di Colonne, le quali riguardano il Ponente. Ha de passaggi nei Apoditeri, Laconici, ed altre parti del Bagno.

4.5.23 Portico, che circonda porzione de lati del medesimo Bagno.

4.5.24 Pinacoteca, o Galleria degli Ospiti, con Peristilio di Colonne interno, e Nicchie corrispondenti al mezzo dell'intercolunni. Essa resta al paro del Poggio del Giardino S. ma alquanto più depressa da'corpi delle Fabbriche della Foresteria, e dell'Imperiali descritte. Ha i passaggi ad un altro corpo di Fabbrica situato sull'istesso piano.

4.5.25 Portici di communicazione à quello, che si unisce all'Abitazione Imperiale.

4.5.26 Passaggi al Giardino S.

4.6.27 Aditi diversi al corpo di Fabbrica suddetto.

4.6.28 Stanze di passaggio alla Pinacoteca, ed il seguente.

4.6.29 Cavedio con tre Ale di Portico, e Fontana.

4.6.30 Conclavi intorno al detto.

4.6.31 Stanze di transito ad un picciolo Peristilio.

4.6.32 Peristilio con Pilastri Dorici di Marmo.

4.6.33 Portico chiuso quadrato con Volta esistente in X. ornata di Mosaico a varj colori; sopra del quale era un altro piano corrispondente al Giardino 13.

4.6.34 Conicoli sotterranei.

4.6.35 Forma d'Acqua.

4.6.36 Fontana incavata nel Muro.

4.6.37 Triclinio con Ale di Colonne di Travertino ricoperte di finissimo Stucco, e corrisponde nel piano del Giardino 13. Nel pavimento erano incassati cinque quadri di finissimo Mosaico, fra quali quello de'Centauri.

4.6.38 Conclave nobile con pavimento di Mosaico bianco, con fascie colorate, ed in mezzo un Quadro con Maschere sceniche racchiuso da un fatone con foglie graziosissime, e nastri gentilmente avvinti. Questo corpo di Fabbrica

è stato scoperto nella cava fatta dal Cardinale Marefoschi à favore degli Eredi del Conte Fede.

4.6.39 Altri Conclavi, con pavimenti a Mosaico.

4.6/7.40 Corridore sotterraneo, che serve di sostruzio/ne a dette Fabbriche, che restano al paro del Giardino S.

4.7.41 Area più depressa al paro di quella della Biblioteca.

4.7.42 Corpi di Fabbriche isolate scoperte in tempo della cava suddetta.

4.7.43 Sostruzione del Giardino S. ornata di Fontane.

4.7.44 Eliocammino, o luogo da scaldarsi al Sole, con Fenestre a Mezzo giorno, nella sommità della Volta, che è di un quarto di Cerchio dipinta a Grotteschi.

4.7.45 Triclinio, o Cenazione nobile.

4.7.46 Adito intorno di esso.

4.7.47 Conclavi con pavimenti di Mosaico ordinario.

4.7.48 Area ne'lati con Podio sopra i Poggi di sotto.

4.7.49 Cubicolo, che nel piano di sotto ha una Stanza con Volta, e Pareti investita da'Pomici.

4.7.50 Scala per montare a piani superiori.

4.7.51 Sbocco de'Sotterranei nel Poggio T.

4.7.52 Altre scale, che scendevano al Poggio del Ninfeo.

4.7.53 Portico sul medesimo Poggio rivolto alla Valle per commodo di quei, che dal basso della Villa venivano agli Ospitali.

4.7.54 Tempietto con due Edicole semicircolari.

4.7.55 Area al paro del Portico, che resta innanzi la Stanza ornata di Pomici.

4.7.56 Contraforti di sostruzione al Portico descritto.

4.7.57 Muri di sostruzione, che univano il Ninfeo con contraforti indicati.

5.1 CANOPO, o luogo delizioso per le Acque dedicato al Dio di questo nome il quale dagli Egizi fu inteso per Nettuno. Questa Valle è artefatta, ed appartiene alla Camera Apostolica.

5.1.1 Tempio semicircolare di Canopo con Volta investita di Mosaico bianco, e pareti incrostate di Marmo, e Nicchie interno semicircolari, e quadrate, ornate di Statue, e Fontane. Le Acque delle quadrate calavano nel piano del Tempio per mezzo de'Gradini ricoperti di Marmo bianco.

5.1.2 Penetrale scoperto in parte per introdurvi il lume, e riguardar da sopra le Fonti di Acqua, che scaturivano sotto le Statue ch'erano nelle Nicchie. In quella del fondo rivestita di Pomici era collocata la Statua del Dio Canopo.

5.1.3 Parapetto, o labro che racchiudeva tutte le Acque del piano del Tempio formando una gran Peschiera.

5.1.4 Parte anteriore del Tempio, che serviva di Portico con Colonne d'ordine Ionico di Marmo Cipollino. Da esso poteva osservarsi la delizia interna del Tempio, e quella del gran Canale esterno, che introduceva al medesimo.

5.1.5 Portici laterali al detto, ma più bassi, che sostenevano un'altro piano.

5.1.6 Scale, che ascendevano al piano superiore.

5.1.7 Stanze, o Gabinetti per trattenimento.

5.2.8 Stanza laterale al Tempio con Volta dipinta a riquadri, e feritore in essa per il lume. Aveva passaggio per mezzo di un Ponticello nell'altro lato a traverso del Penetrale.

5.2.9 Conserva d'Acqua incavata nel Monte.

5.2.10 Peschiera innanzi al Portico, che dal labro versava l'Acqua nel sottoposto gran Canale.

5.2.11 Canale per le Feste Canopiche.

5.2.12 Cordonate laterali del Canale di communicazione sopra i lastrici del Tempio, e de Poggi Y. Z. a quali servivano di sostruzione. Quivi facendo cavare i P.P. Gesuiti ritrovarono quelle Statue Egizie, che sono nel Museo del Campidoglio.

5.2.13 Sostruzione del Poggio Z. che forma due piani de Cubicoli con Volte dipinte, e con Portico sul Canale da dove le Meretrici, che accorrevano alle Feste Canopiche potessero osservarle.

5.2.14 Sostruzione nel Poggio Y. che sostiene il piano del Giardino R. Serviva per luogo d'invito a Solazzi, e Commessazioni delle Feste.

5.2.15 Scale, che ascendevano al Giardino suddetto, dal cui Podio sopra della sostruzione vedevansi i Giuochi Canopici.

5.2.16 Tempio di Ercole.

5.2.17 Abitazione per l'Edituo, o Sacristano, che parimente serve di sostruzione al Giardino Imperiale nel Poggio R.

5.3 ACCADEMIA, o Scuola di Filosofi Platonici, luogo piantato di Alberi dedicato alle Muse, ora appartiene parte alla Camera, e parte ai Bulgarini.

5.3.1 Muro di sostruzione nella Strada antica al Poggio Z.

5.3.2 Altri Muri di divisione nel detto Poggio per Giardini.

5.3.3 Contraforti della Cordonata a poggi superiori.

5.3.4 Tempio di Minerva, del quale non resta, che questo piano inferiore, che serviva di sostruzione per porlo al paro del Poggio A.A. Il superiore è

affatto diruto, solamente da framenti di Cornici, e Colonne striate di Marmo bianco si mostra, che dovea esser d'Ordine Dorico. Questra Fabbrica è chiamata Rocca Bruna.

5.3.5 Portici intorno del piano inferiore del Tempio ricavati da Fondamenti da Noi scoperti e da Modiglioni di Travertino esistenti su'Muri con porzione di Volta.

5.3.6 Ingresso dalla Cordonata nel Corridore, che gira intorno al Poggio Z.

5.3.7 Detto Corridore, che serve di sostruzione al Poggio A.A. artefatto per render il sito dell'Accademia in piano continuato.

5.3.8 Adito al Poggio suddetto in fine della Cordonata.

5.3.9 Stanza sottoposta ai Gradi del Tribunale, o piantato del Tempio, per i quali dal Poggio indicato salivasi.

5.4.10 Contraforti di sostruzione al detto Poggio, con Podio riguardante la Valle sottoposta.

5.4.11 Scala, che dal piano de contraforti saliva sul Poggio.

5.4.12 Scala a due Ali per salire all'Oecio seguente.

5.4.13 Fontana semicircolare di fronte a gran Viali de Platani.

5.4.14 Podio superiore alla Fontana.

5.4.15 Oecio Corintio, o Sala grande di vaghissima figura con Colonne, serviva per le dispute de Platonici, o Accademici. Il suo Pavimento era di Giallo antico di forma ottagona, tramezzato da quadrati di Marmo bianco. Quivi furono ritrovati i Centauri di Basalto, che sono ora nel Museo di Campidoglio.

5.4.16 Uditorj in forma di Cerchio escentrico, con Pavimenti di Mosaico giallo, questi sono più bassi del piano della gran Sala, che circondano

5.4.17 Gradi, che dalla suddetta Sala calavano quei ch'erano ammessi ad ascoltare le dispute.

5.4.18 Pulpito con Podio di Marmo al pari del piano della gran Sala, e gira d'intorno agli Uditorj; il suo Pavimento era di lastre quadrate di Marmo bianco, e Cipollino. Su questo Pulpito stavano in piedi i disputanti.

5.4.19 Altro Uditorio in forma quadrata con testa semicircolare riguardante la Sala.

5.4 / 5.20 Cinque Gradinate, che da più parti vi si poteva calare, ed aver communicazione con la / Sala grande ed altrove.

5.5.21 Pulpito semicircolare, o luogo per li Filosofanti.

5.5.22 Suggesto Imperiale in detto Uditorio.

5.5.23 Stanze per diversi usi, e commodi, ed hanno communicazione colla gran Sala, e sono di piano al pari di essa.

5.4.24 Stanze grandi laterali al detto Uditorio, per trattenere i Corteggiani che, seguivano l'Imperatore, servivano anche di passaggio ad altro parti, ed alla Sala grande descritta.

5.5.25 Peristilio a Pilastri con Portico doppio verso Ponente.

5.5.26 Vestibolo del Tempio seguente.

5.5.27 Cubicoli laterali al detto con Pavimento di Mosaico a varj Colori cavati dal Principe Gabrielli, e l'Antiquario Orlandi.

5.5.28 Atrio del Tempio con Nicchie per Statue.

5.5.29 Tempio di Apollo, con Pavimento di Mosaico ripartito a fasce, che formavano riquadri.

5.5.30 Penetrale del Tempio ove furono ritrovate le celebri Palombe di minutissimo Mosaico, che si ammira in Campidoglio.

5.5.31 Abitazione per l'Edituo, o Sacristano.

5.5.32 Zoteca, o Rimessa per le Vittime.

5.5.33 Stanze annesse per uso di essa.

5.5.34 Vestibulo dell'Abitazione seguente.

5.5.35 Atrio con ale di Colonne.

5. 5 / 6. 36 Stanze, o Abitazione per trattenimento dell' Imperatore, e sua Compagnia, qualora / andava ad ascoltare gli Accademici.

5.6.37 Sale nobili con Colonne rivestite di Stucco, quivi da Sig.ri de Angelis sono state tolte diverse tavole di Mosaici.

5.6.38 Scale, che salivano a secondi piani della Fabbrica.

5.6.39 Stanza con Scala a sotterranei fatti nel Monte, che communicano a diverse parti della Villa.

5.6.40 Area innanzi l'Abitazione dell'Accademici, Edificio in oggi interamente rovinato, ma solo scoperto da' cavi.

5.6.41 Vestibulo all'Atrio dell'Abitazione.

5.6.42 Atrio con ale, in una de'quali sono Nicchie per Statue, e poteva servire di Tablino.

5.6.43 Scale, che montavano a seti piani dell'Edificio.

5.6.44 Conclavi con Pavimenti di Mosaico scoperti, e cavati dal Sig. de Angelis.

5.6.45 Portici di sostruzione, che investivano il Monte per reggere il Poggio di questi Edifizj dell'Accademici.

5.6.46 Scala, che dal Poggio del Giardino Imperiale saliva all'Abitazione delli Accademici.

5.6.47 Prospettiva con Nicchie ornate di Pomici per Fontane dicontro al Pretorio descritto, frà quali scorreva il gran Giardino Imperiale.

5.6.48 Stanza con fornice investita di Pomici, e Tartari per Fontana.

5.6.49 Cisterne, o conserva d'Acqua per ripartirla a Giardini, Abitazioni, ed altro commodo.

5.6.50 Corridore con passaggj nell'Area suddetta.

5.7 ODEO, E TEATRO. L'Odeo era un luogo per far le prove della Musica, e delle Rappresentazioni del Teatro, ed esercizj de'Poeti. Questo Teatro ha la forma di quello usato da Greci. Il sito appartiene ai Marchesi Origo.

5.7.1 Area in mezzo dell'Odeo, che era coperta da tende a guisa di Padiglione Pretorio, dove si provavano le Favole prima di esporle in Teatro.

5.7.2 Portici intorno di esso.

5.7.3 Ingressi da Portici nell'Area dell'Odeo.

5.7.4 Stanze per commodi, ed usi necessarj.

5.7.5 Corridore sotterraneo, che dall'Odeo per mezzo di Scale si passava al seguente Critoportico.

5.7.6 Scale, che ascendevano alla Precenzione superiore del Teatro, da dove calavasi ne' Gradi.

5.7.7 Precenzione suddetta con Pavimento di Mosaico ordinario di Marmo bianco.

5.7.8 Scale trà Cunei per distribuirsi ne Gradi, o Sedili intonacati di Marmo Greco.

5.7.9 Precenzione inferiore con Pavimento di lastre di Marmo, che divideva i Gradi inferiori da superiori.

5.7.10 Edicola del Genio del Teatro nel piano di questa Precenzione. Il pavimento di essa, e dell'Area innanzi era di Marmo bigio a rombi, con fascia di Marmo giallo.

5.7.11 Scale, che ascendevano all'Area dell'Edicola.

5. 7/6.1. 12 Gradi intonacati di grossi Marmi, e Zampe de'/Leoni negli orti delle Scale de'Cunei.

6.1.13 Orchestra con Pavimento a quadrati di Marmo.

6.1.14 Spazio innanzi al Pulpito di piano superiore all'Orchestra.

6.1.15 Porte sotto il Pulpito con Gradini, che scendevano nel detto spazio.

6.1.16 Gradini, che calavano nell'Orchestra.

6.1.17 Logion, o Pulpito per gli Attori.

6.1.18 Scena con tre Porte ornate di quattro Colonne a due ordini, il primo di Granito, ed il secondo di giallo antico.

6.1.19 Proscenj

6.1.20 Spazio tra i Proscenj, e i gradi per i personaggj distinti, come più dappresso agli Attori.

6.1.21 Porte con Gradini per salirvi.

6.1.22 Portico dietro la Scena al piano del Pulpito, serviva per il vestiario, e trattenimento degli Attori, e superiormente per le Machine, che aggivano nel Teatro.

6.1.23 Porte con Gradini a detto Portico.

6.1.24 Corridore sotterraneo, che dall'Orchestra del Teatro si calava nel Crittoportico in tempo di Pioggia.

6.1.25 Contraforti della Cavea del Teatro intorno al muro esteriore, che circonda i Gradi per sostenere la spinta di essi nel sopraterra.

6.2 ERGASTULO, E CRITTOPORTICO. Era l'Ergastulo un ristretto per contenere i Schiavi destinati alle opere rustiche della Villa. Il Crittoportico era un passaggio coperto per ogni Staggione. Ambedue sono incavati nel Monte. L'incisione di essi è distinta chiara per esser Fabbrica sotterra.

6.2.1 Corsia, che divide le picciole Celle, illuminata dà feritore nella Volta.

6.2.2 Celle, che non ricorrono di fronte l'una all'altra. Il tutto ricoperto di Stucco.

6.2.3 Corridore, che passa al Crittoportico.

6.2.4 Crittoportico illuminato nella Volta da feritore rotonde. Egli è investito di opera laterizia per difenderlo dall'umido, ed intonicato di Stucco.

6.2.5 Corridore sotterraneo, che communicava all'Accademia, e al Giardino Imperiale.

6.2.6 Altro allo Stadio, acciocchè gli Spettatori si ricoverassero nel Crittoportico in tempo di Pioggia.

6.2.7 Stadio rustico incavato nel vivo del Monte.

6.2.8 Fontana con Portico in porzione di cerchio.

6.2.9 Conserve di Acqua per detta nel piano superiore

6.2.10 Tempio di Serapide con portico intorno, ed Atrio con Ale laterali.

6.2.11 Portico innanzi dell'Atrio.

6.2.12 Alberghi per coloro, che andavano agl'Oracoli.

6.2.13 Acquedotto, che traversa la Valle.

6.2.14 Sostruzione al Poggio, e muri rovinati.

6.3 LICEO, Il Liceo era uno de'Ginnasj presso la Città d'Atene, ornato di Portici spaziosi in mezzo di pianteggioni di Platani, e di Giardini, ove Aristotile soleva passeggiando insegnare la sua Filosofia, per la qual cosa vennero i suoi seguaci, denominati Filosofi Peripatetici.

6.3.1 Gran Portico doppio diviso da lungo Muro con teste formate di due essedre per commodo di sedersi, e riposarsi, le medesime davano il passaggio da un portico, all'altro.

6.3.2 Avanzi delle Abitazioni del Liceo, che due secoli e mezzo fà il Ligorio osservò esistenti i Fornelli, e l'Ipocausti per Bagni.

6.3.3 Sorgente del rivo chiamato Acqua Ferrata.

6.3.4 Rovine di Portici sotterranei, ora pieni di Acqua.

6.3.5 Spazio dei grandi Giardini.

6.3.6 Muri rovinati.

6.3.7 Edifizio quadrato, con fornice rovinato.

6.3.8 Prospettiva di Fontane, ornate di Pomici, e Tartari, sopra cui passava un'Acquedotto.

6.3.9 Acquedotto sopra Archi, e Muri, che sostenavano il Poggio B.B. de' Giardini.

6.3.10 Muri, sopra de'quali passava la diramazione del detto Acquedotto.

6.3.11 Rovine de'Muri.

6.3.12 Altre di un Edifizio, che non se ne scorge l'uso.

6.3.13 Rovine di un'altro Acquedotto.

6.3.14 Muri rovinati nel Poggio più basso.

6.4 PRITANEO, ovvero luogo della Villa Imperiale cosi detto a similitudine di quello di Atene, ove si radunavano i Senatori, e si facevano i Conviti publici in allegrezza de'grandi avvenimenti. Questa parte della Villa è la più alta di tutto il Colle, ed è ora denominata li Colli di Santo Stefano.

6.4.1 Peristilio ornato di Colonne scoperte nell'ultima Cava fatta dal De Angelis.

6.4.2 Fontana di bizzarra, e vaga forma nel mezzo di un lato del Peristilio, con cascata di Acqua intonacata di Marmi scoperti nella cava suddetta.

6.4.3 Stanze laterali alla medesima.

6.4.4 Corridore con Volta sostenuta da Piloni.

6.4.5 Essedra quadrata nel fondo del detto, con quattro Nicchioni per sedili.

6.4.6 Conclavi in un lato del Peristilio.

6.4.7 Portico triplice nel piano inferiore del Peristilio: Formava la sostruzione del medesimo, ed avea sopra un sisto a passeggio scoperto, che pareggiava al piano del Peristilio.

6.4.8 Fondo di un lato del triplice Portico chiuso, ed illuminato da Fenestre, in esso ancora restano Pitture a Grotteschi, che formano diversi riquadri, ne quali sono figurati alcuni Poeti Greci sedenti, con proprj nomi scritti di sopra.

6. 4/5. 9 Luoghi ove esistono i requadri de'grottes/chi, e l'incassi de'Bassirilievi frapostivi, che hanno in testa i cartelli, ne quali erano scritti i nomi delli Scultori, o la rappresentazione de'soggetti scolpiti.

6.5.10 Corridore con contraforti di sostruzione per communicazione al seguente Anfiteatro.

6.5.11 Anfiteatro diruto, del quale non esiste, che porzione de'Muri, che reggevano le Volte dei Gradi; ed interamente resta quello, che cingeva l'Area, la forma di esso non è ovale, come gli altri Anfiteatri antichi.

6.5.12 Triclinio magnifico, o Salone da mangiare ornato di Colonne.

6.5.13 Rovine di Edificio contiguo al detto.

6.5.14 Abitazione del Pritaneo.

6.5.15 Peristilio con Portico innanzi.

6.5.16 Oecj, o Sale ornate di Colonne.

6.5.17 Sostruzione al Poggio del triplice Portico del Pritaneo.

6.5.18 Avanzi di un Portico doppio a Pilastri molto rovinato.

6.5.19 Piscina incavata nel Colle con Scale per scendervi; i suoi Muri sono intonacati di opera signina, cioè di coccio pisto per reggere L'Acqua, la quale vi ha lassato un grosso Tartaro.

6.5.20 Corpo di Fabbrica nobile affato rovinato, questo terreno essendo ridotto a Campo, sovente l'Aratro scopre i suoi Pavimenti fatti a Mosaico.

6.6/7 AVVERTIMENTO AL LETTORE. Esibisce questa Pianta l'aggregato delle Fabbriche esistenti sopra un Colle disteso, e vario di Poggj della magnifica gran Villa edificata dall'Imperadore P. Elio Adriano, la quale dal suo nome fù chiamata Elia, e dal territorio di Tivoli Tiburtina. Le Fabbriche sono ritratte dal piano di ogni Poggio sopra quali s'inalzano. Elleno furono intitolate con nomi celebri de'luoghi maravigliosi delle provincie dell'Impero Romano, Come attesta Sparziano nella Vita di questo Imperatore: "Tiburtinam Villam mire exaedificavit itaut in ea, et provinciarum, et locorum celeberrima nomina inscriberet: velut Lÿceum, Academia, Prÿtaneum, Canopum, Poecilem, Tempe vocaret." Ed ogni qualvolta era sfacendato vi andava a Villeggiare, e secondo il costume dei Ricchi felici, vi Fabbricava Palazzi prendeva cura de'posti delle Statue, e delle Pitture. Ecco le proprie parole di Aurelio Vittore: "Diende, uti solet tranquillis rebus remissior, Rus proprium Tibur secessi, ipse uti beatis locu pletibus mos, Palatia estraere, curare Epulas, Signa, Tabulas pictas postremo omnia satis anxie prospicere, quae luxus lasciviaeque essent." Soggiunge l'addotto Sparziano "et ut nihil praetermitter etiam Inferos finxit." Occupa questa Pianta diverse Fabbriche esistenti un Colle disteso da Tramontana a Mezzo giorno, che ha di lunghezza circa tre mila passi, di larghezza un settimo nella più distesa parte: l'uno de lati della sua lunghezza è rivolto a Levante, e l'altro a Ponente verso la Campagna di Roma. Il sito denominato Tempe, e gli Inferi, come anche quello per le Selve, e Parchi degli Animali, dovea esser molto maggiore di quello immaginato intorno alle ritratte Fabbriche. In una Pianta generale, a parte si daranno gli Edifizj, che s'incontrano in questa parte dell'Agro Tiburtino. E per piena intelligenza di questa superbissima Villa, si incideranno le parte in grande di alcuni Edifizi, come altresi un altra Pianta delle Fabbriche, che investono il Monte, unitamente ai suoi sotterranei, i quali soltanto qui sono accennati con punti per non confonderli colle Fabbriche, che gli sono sopraposte. Conviene perfine persuadersi, che gli Edifizj di questa Villa superavano ogn'altro tanto per la loro magnificenza, che per l'ornamento, e per la loro vaga, e bizzarra figura: Dalle quali cose, molto possono profittare i Professori di Architettura. Nel basso della Pianta sono incise le iscrizioni de'bolli de'Mattoni, che sono contrasegnate con asterisco. Francesco Piranesi Incisore di S. M. il Re di Polonia & Architetto Romano disegnò, ed incise nel 1781.

Abbreviations

AA	*Archäologischer Anzeiger*
AAAH	*Acta ad archaeologiam et artium historiam pertinentia*
AB	*Art Bulletin*
AJA	*American Journal of Archaeology*
AMST	*Atti e memorie della società tiburtina di storia ed arte*
ANRW	*Aufstieg und Niedergang der römischen Welt* (Berlin, 1972–)
AR	*Architectural Review*
ArchCl	*Archeologia classica*
ARID	*Analecta romana instituti Danici*
ASA	*Archivio storico dell'arte*
BA	*Bolletino d'arte*
BASOR	*Bulletin of the American Schools of Oriental Research*
BC	*Bulletino della commissione archeologica communale di Roma*
BM	*Burlington Magazine*
BMC	H. Mattingly, *Coins of the Roman Empire in the British Museum*, Vol. 3: *Nerva to Hadrian* (London, 1936; reprinted with alterations, 1966)
CIL	*Corpus inscriptionum latinarum*
DOP	*Dumbarton Oaks Papers*
DOR	*Diario ordinario di Roma*
EAA	*Enciclopedia dell'arte antica*
EPRO	*Etudes préliminaires aux religions orientales dans l'empire romain*
ERE	*Les empereurs romains d'Espagne* (Paris, 1965)

FUR	G. Carettoni, A. M. Colini, L. Cozza, G. Gatti, *La pianta marmorea di Roma antica: Forma urbis Romae,* 2 vols. (Rome, 1960)
GBA	*Gazette des beaux-arts*
HA	*Historia Augusta (Scriptores historiae augustae)*
HSCP	*Harvard Studies in Classical Philology*
JDAI	*Jahrbuch des deutschen archäologischen Instituts*
JGH	*Journal of Garden History*
JHS	*Journal of Hellenic Studies*
JRS	*Journal of Roman Studies*
JSAH	*Journal of the Society of Architectural Historians*
JWCI	*Journal of the Warburg and Courtauld Institutes*
LCL	*Loeb Classical Library*
MAAR	*Memoirs of the American Academy in Rome*
MD	*Master Drawings*
MEFR/A	*Mémoires de l'école française de Rome/antiquité*
MemLinc	*Atti della Accademia Nazionale dei Lincei, Memorie*
MemPontAcc	*Atti della Pontificia Accademia Romana di Archeologia, Memorie*
MonAnt	H. D'Espouy, *Monuments antiques relevés et restaurés par les pensionnaires de l'Académie de France à Rome,* 3 vols. (Paris, 1906–1912), *Supplément* (Paris, 1923)
NS	*Notizie degli scavi*
PBSR	*Papers of the British School at Rome*
PECS	R. Stillwell, ed., *Princeton Encyclopedia of Classical Sites* (Princeton, 1976)
QITA	*Quaderni dell'istituto di topografia antica della Università di Roma*
RA	*Revue archéologique*
RE	A. F. Pauly, G. Wissowa, et al., *Realencylopädie der classischen Altertumswissenschaft*
RendPontAcc	*Atti della Pontificia Accademia Romana di Archeologia, Rendiconti*
RJ	*Römische Jahrbuch für Kunstgeschichte*
RM	*Mitteilungen des deutschen archäologischen Instituts, Römische Abteilung*
RP	R. Syme, *Roman Papers,* 7 vols. (Oxford, 1979–1991)
SCSH	*Smith College Studies in History*
SHA	*Studies in the History of Art*
TAPA	*Transactions of the American Philosophical Association*
TLS	*Times Literary Supplement*

Notes

In general, relevant entries in *EAA*, *PECS*, *RE*, and Richardson (1992) are omitted; notes are keyed to page numbers

3 building names: Raeder (1983) 275–276.
country villas: topical survey, and literature, in Mielsch (1987).
number of cities: 2.17.27.
restoration attempts: based on 2.17, from R. Castell, *The Villas of the Ancients Illustrated* (London, 1728), through H. H. Tanzer, *The Villas of Pliny the Younger* (New York, 1924), to *La Laurentine* (1982) and Ricotti (1987) 182–184 and figs. 35–37; textual commentary by Sherwin-White (1966) 186–199, who says that few restorations "are based on a clear understanding of Pliny's Latin" (197).
Tuscan villa: *Letters* 5.6; Sherwin-White (1966) 321–330.
Como: *Letters* 9.7.
otium: J.-M. André, *Recherches sur l'otium romain* (1962 = *Annales littéraires de l'Université de Besançon* 52); D'Arms (1970) 12–17, 70–72.
topiary: *Letters* 5.6.35. The goals, of box, are part of the allusive decor of his stadium-shaped garden; on such gardens, see A. Gieré, *Hippodromus und Xystus: Untersuchungen zu römischen Gartenformen* (Zurich, 1986).
earlier design: *Letters* 5.6.41.

4 its pool: *Letters* 5.6.36–37.
households require: because Pliny leaves most of these out, paper restorations are likely to be incomplete.

in turn: *Letters* 2.17.8.

white marble: *Letters* 2.17.9, 5.6.37–38.

mean and dark: Seneca, *Letters* 1.15.

place for study: Cicero, *On the laws* 2.1.

specially housed: the elder Pliny, *Natural History* 35.130.

public property: the elder Pliny, *Natural History* 35.26.

5 professions: *De Officiis* 1.151. On Roman architects, W. L. MacDonald in S. Kostof, ed., *The Architect: Chapters in the History of the Profession* (New York, 1977) 28–58.

more or less: Aulus Gellius, *Attic Nights* 19.10.1–4.

a philosopher: *Satyricon* 71.

bedrooms: *Satyricon* 26–78; G. Bagnani, "The House of Trimalchio," *American Journal of Philology* 75 (1954) 16–39.

Roman poets: Pavlovskis (1973), emphasizing nature altered by artifice.

Vitruvius: book 6, esp. 4–5.

Salpi: B. Neutsch, "Archäologisches Grabungen und Funde in Unteritalien," *AA* (1956) 289–292; M. Marin, "Scavi archeologici nella contrade S. Vito presso il lago di Salpi," *Archivio storico pugliese* 17 (1964) 167–224. (References courtesy of Alfred Frazer.)

Subiaco: G. M. De Rossi, "Note topografiche sulla villa di Nerone a Subiaco," *Lazio ieri e oggi* 9 (1973) 286–290; cf. Statius, *Silvae* 1.3.

Domus Aurea: MacDonald (1982) 20–46; Ward-Perkins (1981) 56–61.

6 *rus in urbe*: *Epigrams* 12.57.51.

woods: *Lives, Nero* 31.1.

status: D'Arms (1970); for villa life, Balsdon (1969) 193–210; on emperors' retreats, Mielsch (1987) 140–160.

Albano: G. Lugli, "La Villa di Domiziano sui colli Albani," *BC* 45 (1917) 27–78; 46 (1918) 3–68; 47 (1919) 155–205; 48 (1920) 4–69.

Civitavecchia: Torelli (1985) 112–119.

greenest of fields: *Letters* 6.31.15.

Palestrina: Coarelli (1982) 155–156.

imperial estate: K. Lehmann-Hartleben and J. Lindros, "Il palazzo degli Horti Sallustiani," *Acta instituti Romani regni Sueciae* 4 (1935) 196–227; G. Cipiriani, *Horti Sallustiani*, 2d ed. (Rome, 1982) 13–45; Boatwright (1987) 155–160; Richardson (1992), "not earlier than mid-second century" (203).

functionaries: *CIL* 14.3635–3637, concerning keepers of trial records and permits; both refer to the Villa. "Aelia Vila" appears in 14.3911.

from Tivoli: A. Plassart, *Fouilles de Delphes* 3.4 (Paris, 1970) no. 302.

found in Tivoli: *CIL* 14.4235.

indiscriminately: Syme (1986) 24.

Villa Tiburtina: HA, *Hadrian* 23.7; cf. Dio 69.17.1.

7 underworld: HA, *Hadrian* 26.5–6.

Athenian locales: Travlos (1971) and Camp (1986).

temple of Serapis: Strabo, *Geography* 17.1.16–17; cf. Seneca, *Letters* 51.3, and Juvenal 6.84.

Hadriani palatio: HA, *Thirty Tyrants* 30.

rumors arose: Pichlmayr (1966) 14.7; *Sextus Aurelius Victor's Brief Imperial Lives*, trans. E. B. Echols (Exeter, N.H., 1962) 17.

their emperor: Pichlmayr (1966) 14.11; Echols (1962) 17.

8 descriptive term: Millar (1977) 20, 41–42; p. 193, below.

emperor's autobiography: HA, *Hadrian* 1.1, 7.3, 16.1., among others.

Maximus: Syme (1971) 113–134; Benario (1980) 6–8; Syme (1986) 8.

Spartianus: Syme (1971) 73–74, 249.

brickstamp studies: Bloch (1947); M. Steinby in *RE, Suppl.* 15 (1978) 1489–1531.

problems: see, e.g., Boyle (1968) app. 2, 317–331, and F. Lepper and S. Frere, *Trajan's Column* (Gloucester, 1988) 236–238.

half the text: Bloch (1947) 87–256, Villa chronology 182–183.

common date: H. Bloch, "The Serapeum of Ostia and the Brick Stamps of 123 A.D.," *AJA* 63 (1955) 225–240.

other dates: Bloch (1947) 174.

excavated: see De Franceschini (1991) 5–16 for excavation history.

restoration: the illustrations in Penna 1, 2 (1831, 1833), when compared to modern photos, are instructive, e.g., those of the Ceremonial Precinct, Residence basilica, and the Water Court interior wall surface. Cf. Meiggs (1973) 5–7 and MacDonald (1982) 151, n. 19; the Island Enclosure vault in *AB* 68 (1986) 32, fig. 9, was built in 1955 (our fig. 4). See also Caprino (1976).

10 half a million: from A. D'Offizi, June 1987.

11 Canal finds: Aurigemma (1961) 100–133.

Hadrianic art: Hannestad (1986) 186–209; Strong (1988) 171–196. Raeder (1983) 253–315 analyzes Villa sculpture, Bartmann (1988) a specific format.

Museo Didattico: M. Lolli-Ghetti, "Tivoli—Villa Adriana: il nuovo museo didattico—centro visitatori," *Quaderni del centro di studio per l'archeologia Etrusco-Italica* 14 (1987) 133–178.

relative heights: see De Franceschini (1991) 314, 638, 652.

12 *Mémoires*: published in Paris; we cite *Memoirs of Hadrian*, trans. G. Frick and M. Yourcenar (New York, 1957).

Nobel: *TLS*, Aug. 13, 1974, 893.

errors: Yourcenar (1957) 334; Syme (1986); cf. Stadter (1980) 17.

uncritically: Yourcenar (1957) 300–301; cf. *The Observer*, Apr. 19, 1984, 19, and Syme (1986) 8–9.

thirty years: M. Yourcenar, *Les yeux ouverts* (Paris, 1980).

13 she mislocates: Yourcenar (1957) 251.

princes of Asia: Yourcenar (1957) 128.

so perceptively: Clark (1952) 129–183.

enchanting: Syme (1986) 22.

long time: Benario (1980) 13. Levi (1993) ch. 6 discusses the sources.

Hadrian's reign: Garzetti (1974) ch. 10, 681–700, 761–766; Thornton (1975).

long time: Benario (1980) 13.

in Rome: R. Syme, "Hadrian and Italica," *JRS* 54 (1964) 142.

14 Paulina: Dio 69.11.4.

at Athens: Castner (1988) 51–55.

archon: J. Carcopino's often-quoted description of the Athenians as "subtils courtisans de l'avenir" ("L'héréité dynastique chez les Antonins," *Revue des études anciennes* 51 [1949] 281) seems gratuitous, un-Athenian. On Hadrian and Athens, Oliver (1941); Walker and Cameron (1989); and Willers (1990).

Fronto: Champlin (1980) 94–96 for Fronto's opinion of Hadrian.

everybody's hands: *Letters to Marcus* 2.1.1.

pleased myself . . . lacked confidence: *Letters to Marcus* 2.1.1.

Fronto criticizes: Davies (1989) 71–90. Champlin (1980): "The historian is submerged by the panegyrist" (116).

15 Avidius Cassius: Garzetti (1974) 476–480.

ruined the armies: *Letters to Verus* 2.1, *Preamble to History* 10, 11.

demonstrable: Fronto, *Preamble to History* 10; V. Maxfield, *The Military Decorations of the Roman Army* (London, 1981) 147–148.

never after saw: *Preamble to History* 10.

the latter: Champlin (1980) 96.

detailed addresses: *CIL* 8.2532, 8.18052; M. Grant, *The Army of the Caesars* (London, 1974) 238–241, translates; cf. Bardon (1968) 405–409.

magnificent banquets: *Letters to Antoninus* 3.4.

learned discussions: *Letters to Antoninus* 3.4; Syme (1965) 243–253. Cf. Aulus Gellius, *Attic Nights* 16.13.4.

archaic way: *Letters to Verus* 2.1.9; on Hadrian's writing style, Bardon (1968) 394–414.

Suetonius: Wallace-Hadrill (1983), esp. ch. 4.

compell belief: HA, *Hadrian* 11.3; Syme (1986) 15.

bronze statuette: Suetonius, *Lives, Augustus* 7.1; Wallace-Hadrill (1983) 141.

glimpses of Hadrian: Wallace-Hadrill (1983) 198.

16 must be abandoned: Wallace-Hadrill (1983) 197.

Arrian: Stadter (1980) 32, 36, 49, 169, on the connection. See also E. L. Bowie in P. Easterling and B. M. W. Knox, eds., *The Cambridge History of Classical Literature* 1.4 (1989) 143–147.

reports: Stadter (1980) 12, 14, 32–33, 37. Cf. *The Greek Anthology*, LCL 3, no. 210, where a book on tactics by a certain Orbicius is said to have been in Hadrian's library.

Fronto: Stadter (1980) 44.

called yours: *Periplus* 1.3–4, quoted by Stadter (1980) 36.

Patroclus: *Periplus* 23.4, quoted by Stadter (1980) 38–39 and discussed by Lambert (1984) 249, n. 11.

palace forecourt: Aulus Gellius, *Attic Nights* 4.1.1.

by reason: Philostratus, *Lives of the Sophists* 1.8; cf. Dio 69.4.1.

thirty legions: HA, *Hadrian* 15.12.113; cf. 16.10.

biography: Philostratus, *Lives of the Sophists* 25; Wallace-Hadrill (1983) 78–79, 196–197. Trajan and Hadrian defrayed the travel expenses of Philostratus and his descendants;

Hadrian showered money on him.

traveled: Bowersock (1969) app. 2.

gray eyes: Evans (1969) 11–13.

Phlegon: HA, *Hadrian* 16.1; F. Jacoby, *Die Fragmente der griechischen Historiker* 2.B (1926) no. 257.

immediate circle: Bowersock (1969) 48–53, who says Hadrian was an intellectual.

on his feet: Dio 69.1.8.4.

imperial secretary: Philostratus, *Lives of the Sophists* 1.22 (Dionysius) and 1.24 (Marcus); for the rector, Millar (1977) 504–505.

17 Suetonius: Benario (1980) 88; Wallace-Hadrill (1983) 5.

philhellenism: Boatwright (1987) 202–212.

excerpts survive: as Book 69.

Aurelius Victor: Pichlmayr (1966), who includes the epitomist.

anecdote: Dio 69.6.3; Millar (1977) 3.

in Greek: Millar (1977) 6.

like shadows: *Letters* 98, cited by Millar (1977) 211.

advanced planning: B. A. Van Groningen, "Preparations to Hadrian's Visit to Egypt," *Studi in onore di Aristide Calderini e Roberto Pane* 2 (Milan, 1955) 253–256; Millar (1977) 34; Halfmann (1986) 65–89.

the government: "When the court left Italy for any length of time . . . it took its resources with it" (B. Levick, *The Government of the Roman Empire* [London, 1985] 87).

stone tombs: *Preamble to History* 10; cf. Appian, *Civil Wars* 2.86.

magnates: Herodes Atticus, e.g., whose biography Philostratus includes (*Lives* 2.1).

supposed bloodthirstiness: Champlin (1980) 94–98.

18 Dio: 69.11.1.

magnificent scale: HA, *Hadrian* 14.4.

Hadrian served: for his career before 117, see Gray (1919); Garzetti (1974) 377–380; and Benario (1980) 143.

outline: after Halfmann (1986) 190–210, whose chief innovation is to return Hadrian to Rome at the end of the third trip, about two years before the often proposed terminus of 134/135. For other views, see Wegner (1956) 33–44; Z. Yavetz, "Hadrian the 'Wanderer,'" in M. Rozelaar and B. Shimron, ed., *Commentationes ad antiquitatem classicam per-*

tinentes in memoriam B. Katz (Tel Aviv, 1970) 67–77; Garzetti (1974) 684–686, 764; Thornton (1975) 451–453; Benario (1980) 147–149; and R. Syme, "Journeys of Hadrian," *RP* 6 (1991) 346–357. On the possible influence of Hadrian's travels on Pausanias, who often mentions him, see Garzetti (1974) 393; Habicht (1985) 162–163 emphasizes Pausanias's own objectives.

a planner: HA, *Hadrian* 16.7; cf. 20.11–12.

immense labors: Pichlmayr (1966) 14.4.

19 Ostia: Meiggs (1973) 74–76, 135–141.

chief magistracy: Meiggs (1973) 75, 175–176.

farsighted methods: his successor "has no need to wear himself out traveling around the whole empire," for it is "very easy for him to stay where he is and manage the entire civilized world by correspondence" (Aelius Aristides, *Roman Oration* 33).

Christian inventions: Garzetti (1974) 435, and 434–435 on Hadrian and Christians, on which see also T. D. Barnes, *Tertullian* (Oxford, 1985) 154, 156, and pp. 205–206, below.

religious feeling: Price (1986), with a catalogue of imperial shrines and temples.

slaves: HA, *Hadrian* 18.10.

castration: Syme (1965) 245, citing Justinian's *Digest* 48.8.4.

executed: the four, all consulars—HA, *Hadrian* 7.1–2, Dio 69.2–5. A much-debated subject—summaries by Garzetti (1974) 383–384; Benario (1980) 71; and Syme *RP* 6 (1991) 399–400.

others: e.g., HA, *Hadrian* 23.8–9.

portents and omens: Wallace-Hadrill (1983) 189–197; Luck (1985), who translates numerous texts and includes demonology and divination.

horoscope: HA, *Hadrian* 16.7; T. D. Barnes, "The Horoscope of Licinius Sura," *Phoenix* 30 (1976) 76–79.

technical astrology: excellent guide in G. P. Goold's *LCL* edition of Manilius's *Astronomica* (early first century) (Cambridge, Mass., 1977) xvi–cv; R. Syme, "Astrology in the Historia Augusta," *Historia-Augusta Colloquium, 1972/1974* (Bonn, 1976) 291–309; Wallace-Hadrill (1983) 189–197.

private beliefs: Guarducci (1965) gives an overview.

Antinous: statues and coins aside, little is

known of him save that he came from Bithynia; supposition is unending. He appears in the HA: *Hadrian* 14.5–8, *Firmus et al.* 8.8. Dio 69.11.2–4 gives some details; both he and the HA tell of Antinous's death, Hadrian's grief, and the beginnings of the cult; further discussion and citations below, pp. 149–150. Antinous appears often in post-Hadrianic sources; see Lambert (1984). On homosexuality in Roman times see, e.g., R. MacMullen, "Roman Attitudes to Greek Love," *Historia* 31 (1982) 484–502; Wallace-Hadrill (1983) 183–185; and T. P. Wiseman, *Catullus and His World: A Reappraisal* (Cambridge, 1985) 10–14. Levi (1993) ch. 4 discusses Antinous.

20 death: HA, *Hadrian* 14.5–6; Dio 69.11.2. Accidental drowning is probably the correct verdict: Beaujeu (1955) 242–244; M. Malaise, *Les conditions de pénétration et de diffusion des cultes égyptiens en Italie* (1972 = EPRO 22) 422.
new city: E. Jomard, "Description d'Antinoë," ch. 15 in *La description d'Egypte* 2 (Paris, 1818), and pls. 53–61 in vol. 4 (1817; reprinted 1987); E. Kühn, *Antinoopolis* (Göttingen, 1913); H. I. Bell, "Antinoopolis: A Hadrianic Foundation in Egypt," *JRS* 30 (1940) 133–147; D. L. Thompson, "The Lost City of Antinoos," *Archaeology* 34.1 (1981) 44–50.
cult: the extensive literature can be found in Beaujeu (1955) and Lambert (1984). For Antinous's temple in Bithynium, see Price (1986) 266.
coin: Hannestad (1986) fig. 118; cf. *BMC* 396, Hadrian 1106 (pl. 76.6). Not all versions of the scene—Trajan hands the globe of the earth to Hadrian—show the discrepancy in height, e.g., *BMC* 236–237, Hadrian 1–4 (pl. 46.1–6).
avid hunter: HA, *Hadrian* 20.13; Dio 69.7.3, 10.2; J. Ayard, *Essai sur les chasses romaines* . . . (Paris, 1971) 173–182, 395–397, 523–527; Stadter (1980) 50–53.
Athenaeus: 677d–f (*LCL* 7).
Polemo: Strong (1988) 171; see also W. S. Anderson, "Juvenal: Evidence on the Years A.D. 117–128," *Classical Philology* 50 (1955) 155–157, on Hadrian's beard, and cf. Evans (1969) 11–13. "His hair was curled on a comb" (HA, *Hadrian* 26.1).
high policy: Hannestad (1986) 186–209;

Strong (1988) 171, 174–175, 194–196; cf. J. Fink, "Die Idee des römischen Herrschertums im Bildnis Hadrians," *Geistige Welt* 4 (1951) 153–160.
state portraits: Wegner (1956).
Athens: Willers (1990) 45–46, pl. 5.1–4; cf. Strong (1988) 171, fig. 105.
coin profiles: *BMC* 236–552, pls. 46–102; Sutherland (1974) 199, fig. 360.

21 scattered evidence: Bardon (1968) 393–447 is comprehensive.
Plotina: Castner (1988) 53.
oath: Eusebius, *Ecclesiastical History* 4.9.3.
autobiography: HA, *Hadrian* 16.1; R. Syme, "Hadrian's Autobiography: Servianus and Sura," *RP* 6 (1991) 398–408 gives some details.
wrote poetry: J. W. and A. M. Duff, *Minor Latin Poets*, 2d ed. (*LCL*, 1935) 444–447. HA, *Hadrian* 16.4 quotes Hadrian's deft reply to the poet Florus, who had written some lines beginning, "I don't want to be a Caesar / stroll about among the Britons"
soul: HA, *Hadrian* 25.9.
grammatical topics: Bardon (1968) 413–414; Wallace Hadrill (1983) 78–80.
epigrams: *The Greek Anthology*, LCL 1, 475 no. 332, 2, 359, no. 674; 3, 71 no. 137, and perhaps 217 no. 387.
opinion by Augustus: Wallace-Hadrill (1983) 84.
his speeches: P. J. Alexander, "Letters and Speeches of the Emperor Hadrian, *HSCP* 49 (1938) 141–177; Bardon (1968) 409–413.

22 anecdotes: Dio 69.4.1–5; Brown (1964).
the Moon: HA, *Hadrian* 19.2.
modeled: HA, *Hadrian* 14.8; Dio 69.3.2.
epitomist: Pichlmayr (1966) 14.2.
emperor enrolled: Pichlmayr (1966) 14.5.
repressive world: G. E. M. de Ste Croix, *The Class Struggle in the Ancient World* . . . (Ithaca, 1981) gives, at length, a Marxist view tempered, e.g., by P. A. Brunt in *JRS* 72 (1982) 158–163. See also R. MacMullen, *Enemies of the Roman Order* (Cambridge, Mass., 1966) chs. 5, 6, and Hopkins (1984) chs. 1, 4.

23 leading place: Toynbee (1934); Oliver (1941); Bianchi Bandinelli (1979) chs. 4–6; G. Bowersock, ed., *Approaches to the Second Sophistic* (University Park, Pa., 1974); Syme (1982); Wallace-Hadrill (1983) 181–185; Walker and Cameron (1989).

26 scores of villas: L. Quilici, "La carta archeologica e monumentale nel territorio del comune di Tivoli," *AMST* 40 (1967) 181–205 (offprint courtesy of the author), with a map showing villas and ruins; Neuerburg (1968) 288–297.

27 his Villa: Coarelli (1982) 44–73 has a good modern description. Levi (1993) ch. 1 discusses the Villa.
highest Villa point: presumably the gilded roof of the Temple of Jupiter in Rome (Pliny, *Natural History* 33.57), its peak about 65 meters above sea level, was visible under the right conditions. Frank Brown said that from the East-West Terrace rim Hadrian "could just barely not see the city" (V. Scully, *Architecture: The Natural and Manmade* [New York, 1991] 116).
Anio Novus: see T. Ashby, *The Aqueducts of Ancient Rome* (Oxford, 1935) ch. 9, with 277–280 on the section nearest the Villa, and pl. 5; the huge Anio Novus reservoir (fig. 31, a castellum), presumably part of the Trajanic renovations (Frontinus, *Aqueducts* 2.93), that lies almost exactly due east of the Villa, resembles in plan and structure the Platform Structure northwest chambers; might the Structure have housed the Villa's water administration and distribution center?
mostly underground: Cabral and Del Rè (1779) show on their map (dated 1778) the likely route; the plan in Nibby 1 (1819) facing p. 121 gives a less convincing one (he says his map was taken from Piranesi's *Pianta Commentary* 6.2.13 and 6.3.9, which though it shows the aqueduct remains then visible [Penna 2 (1833) 117 illustrates the eastern arches], doesn't include the area in question). Cf. Nibby (1827) 58–59 and Ricotti (1982) 32, n. 27, 43–45, and 45, n. 58. For the water supply of other Tivoli villas, see H. B. Evans, "*In Tiburtium usum:* Special Arrangements in the Roman Water System (Frontinus, *Aq.* 6.5)," *AJA* 97.3 (1993) 447–455.
Lanciani: (1909) 128.
Boissier: *Promenades archéologiques*, 8th ed. (Paris, 1904) 203–204.
Gusman: (1904) 64.
Ashby: (1927) 104.
Aurigemma: (1969) 6.
Sabina: Aurigemma (1961) 22; Coarelli (1982)

49; Ricotti (1982) 28; De Franceschini (1991) 637.

28 surfaced again: Coarelli (1982) 49; F. Sear, *Roman Architecture* (Ithaca, 1982) 172, 174.
grand scale: cf. MacDonald (1986) 135–136; Purcell (1986) 193; De Franceschini (1991) 635.
Villa perimeter: Ricotti (1982) discusses boundaries.

29 deliberately undercut: Ricotti (1982) 31.
group of tombs: Aurigemma (1961) 33; Ricotti (1982) 31.

30 in print: Ricotti (1982) pls. 1, 3, 5; cf. her "Criptoportici" (1973) pl. 1.
road system: Ricotti (1982) 28–30.
it went underground: Ricotti (1973) 228–244; De Franceschini (1991) 635.
main north entrance: discussed by Coarelli (1982) 52–53.

32 bathing after a journey: Pliny, *Letters* 2.17.26.
officers were quartered: Coarelli (1982) 53; cf. Winnefeld (1895) 35–38.
Ostia: Meiggs (1973) 305–308; cf. Boyle (1968) ch. 5.
Romantic ideal: but see Pliny, *Natural History* 4.29.
conventional Villa plans: on villa plans see F. Rakob, "Der Bauplan einer kaiserlichen Villa," in W. Hartmann, ed., *Festschrift K. Lankheit* (Cologne, 1973) 113–125.

33 Construction soon spread: De Franceschini (1991) 632 thinks Hadrian could not have occupied the renovated older villa for several years.
structures altered: e.g., Hoffmann (1980) 56–57, and pl. 21; Ueblacker (1985) pl. 17; cf. Ward-Perkins (1981): "the many changes of plans which (the Villa) underwent during . . . its construction" (476, n. 27).
earlier villa remains: Lugli (1927); Lavagne, "Villa d'Hadrien" (1973).
Pompeian houses: Ward-Perkins (1981) 185–186 on house-villa connections; cf. Richardson (1988) app. 2.

35 suite recalls: Pompeii: see preceding note.
Domus Aurea: MacDonald (1982) 37 and pl. 24, rooms 4–6.
Rabirius: the same, 67 and pl. 58.

36 scenic disclosures: Chillman (1924) 103–120; Brown (1961) pl. 90.

unexpected juxtapositions: De Franceschini (1991) 642.
outline: cf. Ricotti, "Criptoportici" (1973) 239; Ricotti (1982) 45; and De Franceschini (1991) 635, 637.

37 decisions: Kähler (1950) 170, n. 109, proposes pre-117 construction by Hadrian, but we know of no evidence for it.

38 hierarchies of forms: De Franceschini (1991) 619–629 ranks Villa spaces by types of decor.
parataxis: see G. Mansuelli, *Le ville del mondo romano* (Milan, 1958) 73.

42 cache of Villa marbles: Raeder (1983) 16–20.

44 alternative residence: C. Huelsen, "Der kleinere Palast in der Villa des Hadrian bei Tivoli," *Sitzungsberichte der Heidelberger Akademie der Wissenschaften*, Phil.-Hist. Kl. 13 (1919) 2–36.

46 oval arena: De Franceschini (1991) 2, 464.

47 Villa records: De Franceschini (1991) gives the physical details of most remaining Villa structures.
vaults: For Hadrianic building materials and methods, see Lugli 1 (1957); Blake (1973), where 237–356 are devoted to the Villa; MacDonald (1982) ch. 7; Giuliani, "Volte" (1975); and J.-P. Adam, *La construction romaine: Matériaux et techniques* (Paris, 1989) chs. 5–9.

49 modular grids: Boyle (1968) 151–237; Rakob (1983).

50 in Rome: MacDonald (1982) 65 and pl. 40, nos. 29, 30; Lugli (1946) pl. 8, no. 33; *FUR* 98–99 and pl. 31.
curvature of vaults: MacDonald (1982) 14–19; Ward-Perkins (1981) ch. 4.
arches rising: Hannestad (1982) 85.
in niches: Hornbostel-Hüttner (1979); MacDonald (1986) 242–243; cf. F. Rakob, "Ambivalente Apsiden—Zur Zeichensprache der römischen Architektur," *RM* 44 (1987) 1–28.

51 Smaller Baths: MacDonald and Boyle (1980) 24, fig. 23.

54 Vitruvian intercolumniations: Vitruvius 3.3.

56 cryptoporticoes: *Les cryptoportiques* (1973).
Pliny: *Letters* 2.17.16–17, 5.6.27–31, 9.36.3; Sherwin-White (1966) 195. It seems to have been used only once again in antiquity, by Sidonius, *Letters* 2.2.10.
a terrace: *Letters* 2.17.16–17.

58 flat-slab roofing: site observation, discussion with Edwin Thatcher; Ricotti (1988); cf. MacDonald (1982) 161, n. 49, and the fallen upper floor slabs in the Domus Augustana lower-level peristyle and in the northernmost room of the Baths of Caracalla main block.
made of wood: Vitruvius 2.9, 4.8.2; Meiggs (1982) 240–242.
individual types: G. Mansuelli, *Architettura e città* (Bologna, 1970) chs. 5, 6; MacDonald (1986) ch. 5.
Knidos: I. C. Love, excavation reports in *AJA* 72 (1968) through 77 (1973); E. La Rocca (1986) 20 and fig. 19.
Lucian: pseudo-Lucian, *Amores* 11–18.

59 Strabo: e.g., 7.14–15, 9.5.2.
Ovid: *Metamorphoses* 1.568–587.
was cut back: Ricotti (1982) 31; cf. Blake (1973) 251.
statue of Venus-Aphrodite: now displayed behind a Casino Fede window. The Temple restoration, of 1958–1959 (Aurigemma [1961] 44–45), is disputed.

60 artistic mechanisms: Lavagne (1988) 599.
West Belvedere: Lugli (1940).
freestanding towers: Lehmann (1953) 99–103, 106–107.
Piranesi: *Pianta* Commentary 2.1.10.

62 five-room suite: Winnefeld (1895) 90–91.

66 diverged markedly: Pannini and Fidanza (1753).
Ambulatories: that beside the East-West terrace is about one-seventh the length of the Roman mile; Ashby (1970) 106; Humphrey (1986) 686, n. 113a.
auditoriums: De Franceschini (1991) 640–641 derives the Hall from the Domus Flavia basilica, a different kind of building.

68 fire-brigade barracks: Boyle (1968) ch. 5; Meiggs (1973) 305–308.
mythological paintings: copies illustrated in Aurigemma (1961) figs. 190–192.
praetorian officers: Coarelli (1982) 53; cf. Ricotti (1982) 40–41.
Circular Hall: Lund (1982) fig. 7, plan of the early 1760s; Kähler (1950) 128–129.
Domus Transitoria: MacDonald (1982) 21–24, fig. 3 and citations.

70 has been suggested: Coarelli (1982) 52.

71 remain elusive: a study (by Martin Kleibrink) is in progress; Ueblacker (1985) 14, n. 63.

Marble Plan: *FUR* 83, 94–95, and pls. 25, 30; R. Staccioli, "Terme minore e balnea nella documentazione della *'Forma Urbis,'*" *ArchCl* 13 (1961) 97–99, pl. 40.2; F. Yegül, "The Small City Bath in Classical Antiquity . . . ," *ArchCl* 31 (1979) 113–114.

plan is reversed: Verduchi (1975) 92–95 and figs. 76–77.

75 common feature: e.g., Mielsch (1987) 68.

76 thoroughly studied: Hoffmann (1980).

Pliny: *Letters* 5.6.32; Sherwin-White (1966) 327–328, who omits the villa structure.

77 secluded places: Grimal (1984) 252–255; cf. Humphrey (1986) 568–571.

78 Dio: 69.7.1.

79 Vitruvius: 5.1.8.

the dais: Aurigemma (1961) 168, fig. 174. In plan it is about the size of a military tribunal, e.g., the later one in A. Birley, *Vindolanda* (London, 1977) 88, ill. 21, and Davies (1989) 47.

marble relief: Strong (1988) fig. 111.

clerestory: transverse section in D. Krencker et al., *Die Trier Kaiserthermen* (Augsburg, 1929) fig. 408; Coarelli (1982) 57 suggests a lightweight pavilion vault. Gusman (1904) 88 relates the Precinct to luxurious Greco-Roman houses.

aula palatina: Coarelli (1982) 59.

80 focused setting: cf. MacDonald (1982) 74 on Domitian enthroned in the Domus Flavia basilica.

East building: Kähler (1950) 107–108 and pls. 1, 5.

contributed its plan: Kähler (1950) 113.

Martial: *Epigrams* 3.58.56.

Pliny: *Letters* 2.17.12; Sherwin-White (1966), Pavlovskis (1973) 30. Augustus had a refuge at the top (*in edito*) of his Palatine house: Suetonius, *Lives, Augustus* 72.2; Wallace-Hadrill (1988) 81, n. 118, thinks it was a separate building.

villa scenes: Lehmann (1953) 99–103; cf. Purcell (1986) 193–195.

Damascus: see, e.g., H. P. L'Orange and P. J. Nordhagen, *Mosaics: From Antiquity to the Early Middle Ages* (London, 1966) pl. 86, and Hoag (1977) pl. 21.

difficult to read: Kähler (1950) 39–44, 112–117, and pls. 3–5; we were helped by discussions with Alfred Frazer and Friedrich Rakob.

small-roomed retreat: De Franceschini (1991) says that the Fountain Court Buildings form a monumental Villa entrance (475) and a kind of atrium (640).

82 carefully studied: Ueblacker (1985), from which details given here are taken; on the plan, see also Jacobson (1986) 72–75.

Pantheon: its diameter, northern orientation, and Augustan background all ally it with the Enclosure, which De Franceschini (1991) calls "a little Pantheon" (640).

to be seen: De Franceschini (1991) 185–198, 428–438, records the building's pavements.

84 friezes: Caprino (1985) 61–84.

maritime theatre: Nibby (1927) 33–35 rejects the name.

85 Domus Augustana: MacDonald (1982) 65–68 and pls. 58, 68 for the lower level court, 64–65 and pl. 40 for the upper level. Our discussion of the Enclosure's possible sources largely follows MacDonald (1993).

Pompeii: E. La Rocca et al., *Guida archeologica di Pompei* (Verona, 1976) 201–203, plan on 203.

have been likened: H. Herter, "Die Rundform in Platons Atlantis und ihre Nachwirkung in der Villa Hadriani," *Rheinisches Museum für Philologie* 96 (1953) 1–20; J. Ferguson, *Utopias of the Classical World* (London, 1975) 73–75.

Atticus: Cicero, *On the Laws* 2.1.1.

The Island: *Against Verres* 2.4.117; cf. Coarelli (1982) 83.

Sperlonga: A. F. Stewart, "To Entertain an Emperor: Sperlonga, Laokoon and Tiberius at the Dinner Table," *JRS* 67 (1977) 76–90 and pl. 12.1; Mielsch (1987) 108–110 and 171, n. 167; Neudecker (1988) 220–223 and pl. 3.

intriguing: W. Loerke, "Georges Chedanne and the Pantheon: A Beaux-Arts Contribution to the History of Roman Architecture," *Modulus* (1982) 50, 52.

large round tombs: H. Winfeld-Hansen, "Les couloirs annulaires dans l'architecture funéraire antique," *AAAH* 2 (1965) 35–63; Coarelli (1984) 354–359.

has been argued: Coarelli (1984) 143–145; De Franceschini (1991) 643. Archelaus I of Cappadocia (died in 17) built a palace on an island in the harbor of Elaeussa-Sebaste in Cilicia (*PECS* 294).

87 Herodium: Netzer (1981), from which the details given here are largely taken. See also V. C. Corbo, *Herodion 1: Gli edifici della regia-fortezza* (Jerusalem, 1989).

building program: Ward-Perkins (1981) 309–314; D. M. Jacobson, "King Herod's 'Heroic' Public Image," *Revue biblique* 95 (1988) 386–403.

Josephus: *Wars* 1.419–421, 1.265, *Antiquities* 14.359–360, 15.323–325.

simply a palace: *Wars* 1.419–421.

race course: Netzer (1981) 35–36 and fig. 85; cf. Humphrey (1986) 531.

Herodian specialty: Netzer (1981) 79–84.

hilltop palace: D. M. Jacobson, "The Design of the Fortress of Herodium," *Zeitschrift des deutsches Palästina-Vereins* 100 (1984) 127–136, and "Upper Herodium: A Fortress or Chateau?" *Bulletin of the Anglo-Israeli Archaeological Society* (1985–1986) 56–68; offprints kindly provided by the author.

Roman bath: one also at Herodian Jericho; see E. Netzer, "The Winter Palaces of the Judean Kings . . . ," *BASOR* 228 (1977) 1–13.

88 113 or 115: G. Downey, *A History of Antioch in Syria* (Princeton, 1961) 219, n. 85; cf. Gray (1919) 185–187. The Romans had taken Herodium in 73 (Josephus, *Wars* 7.163).

traveled south: Halfmann (1986) 190, 194.

connections with Rome: on Herod, see A. Schalit, *König Herodes: Der Mann und sein Werk* (Berlin, 1969).

resembles: noted by Jacobson (1986), "certain features in common" (71). Netzer (1981) alludes to the Villa in general terms (110).

89 miniature villa: Coarelli (1982) 61, (1984) 145; Ueblacker (1985) 53; De Franceschini (1991) 632, 634, 643.

argue against: Bloch (1947) 160, n. 123, records various opinions; see also Kähler (1950) 164, n. 73.

light and shade: Kähler (1950) 120, 121.

cosmological references: e.g., Stierlin (1984) 127–152, figs. on 150, showing a dome(!) over the Island peristyle to symbolize "un dieu

vivant" (151); cf. Turcan (1987) 45, n. 70.

geometrical web: Ward-Perkins (1981) 109 finds it bewildering.

square court: De Franceschini (1991) 628, 629, 630, 637 dates the wall to the Republic, but the forms argue otherwise.

He began: the plan analysis here is largely the work of B. M. Boyle, who generously allowed us to use it; cf. MacDonald and Boyle (1980) 19, n. 30.

90 exceptional: MacDonald and Boyle (1980) fig. 7.

governing principle: J. B. Ward Perkins and J. M. C. Toynbee, "The Hunting Baths at Lepcis Magna," *Archaeologia* 93 (1949) find "studied waywardness" (168) and even "deliberate anarchy" (192); Crema (1959) speaks of a "free association of spaces with varied configurations, one inserted in another" (404).

91 Cyrene: G. H. R. Wright, "Cyrene: A Survey of Rock-Cut Features South of the Sanctuary of Apollo," *JHS* 77 (1957) 300–310.

Piraeus: R. Ginouvès, *Balaneutikè: Recherches sur le bain dans l'antiquité grecque* (Paris, 1962) pl. 57, cf. pl. 53.

paired cold plunges: Pliny, *Letters* 2.11.7, describes just this arrangement: "the cold room, large and spacious, with two plunges [*baptisteria*] curving back from the opposite sides."

installations: MacDonald and Boyle (1980) 16–18 (hydraulic and heating fixtures), 22–26 (details of individual rooms).

92 Domus Flavia: Boyle (1968) 202–210, fig. 22, 2 pl. 6; MacDonald (1982) 54, pl. 40, nos. 7–9.

similar principles: MacDonald (1982) pl. 40, no. 27.

Pompeii: Blake (1930) pl. 22.4; cf. Becatti 2 (1961) pls. 68, 224.

circles are found: Blake (1930) pls. 3.1, 3.3, 5.2; an Ostian example in Becatti 2 (1961) pls. 75, 76.

the mosaicist: G. Salies, "Untersuchungen zu den geometrischen Gliederungsschemata römischer Mosaik," *Bonner Jahrbücher* 174 (1974) 1–178; C. Balmelle et al., *Le décor géométrique de la mosaïque romain* (Paris, 1985); cf. P. Cadet, "Les mosaïques géométriques de la Villa Hadriana," in R. Ginouvès, ed., *Mosaïque: Recueil d'hommages à Henri Stern*

(Paris, 1983) 93–95.

architect: Boyle (1968) esp. 210.

93 room 9: cf. Becatti 2 (1961) pl. 202.

examples survive: Blake (1930) pls. 22.1–2, 23.1, 3, 38; Becatti 2 (1961) pls. 64, 70, 71.

long way to go: but see now Yegül (1992).

94 now convex: on this topic see E. Lundberg, *Architekturens Formspråk* 2 (Stockholm, 1951) 510–514; Hansen (1961); and Rakob (1961).

belvedere: Coarelli (1982) says it was probably the monumental Villa entrance (71).

95 wooden roof: Kähler (1950) 84. Hansen (1961) 63 envisions an undulating vault of the kind over the Smaller Baths room 9. Coarelli (1982) says little remains (not seen by us) of the grand original cupola (71); the Gismondi model shows a structually daring domical vault rising from the 90-foot circle.

unusual features: plan and restorations by C. Girault, in *MonAnt* 3, pls. 207–210; the work was done in 1885. Additional information in Kähler (1950) 64–73; Hansen (1961); Giuliani, "Piazza d'Oro" (1975); Rakob (1967); Rakob (1983); and Jacobson (1986) 75–78. De Franceschini (1991) 147–159, 463–477, 634, on the basis of plan comparisons, chiefly with Hadrian's stoa and library in Athens, identifies the Court as a grand library, but its scale, plan, and quantity of running water makes this unlikely.

97 narrow walkway: plan in Giuliani, "Piazza d'Oro" (1975) 5.

vestibule: restoration drawings in Giuliani, "Piazza d'Oro" (1975) figs. 75, 77, 78; fig. 74 shows a restoration model.

timber and tile roof: Giuliani, "Piazza d'Oro" (1975) figs. 76–78; Aurigemma (1961) fig. 157 reproduces a restoration drawing of the doubled interior walkway bordering the open court.

Round Temple: C. C. Briggs, "The Pantheon at Ostia," *MAAR* 8 (1930) 161–169; Boyle (1968) ch. 7 and pls. 84–105.

99 garden: Jashemski and Ricotti (1992) 585–588, fig. 14.

hunting scenes: Conti (1970); Caprino (1985) 73.

mosaic pavement: color illustration in Aurigemma (1961) pl. 14.

100 standing free: restored thus by Rakob, in T. Kraus, *Die römische Weltreich* (Berlin, 1967 = *Propyläen Kunstgeschichte* 2) 192, and in Coarelli (1982) 59.

Many think: of those cited in the note to p. 95, above, Kähler and Hansen restore vaults, Rakob and Giuliani (pl. 1) do not. See also Ward-Perkins (1981) 473, n. 13, and Hannestad (1986) 394, n. 152 (possibly a light superstructure); Ricotti (1987) 180, n. 51 (vaulted); K.-K. Weber, "Gestalterische Überlegungen zu den Überkuppelungstheorien des Zentralraumes der Piazza d'Oro . . . ," *Architectura* 21 (1990) 101–107; and De Franceschini (1991) 469; Moneti (1992) suggests a wooden cupola.

still stands: apparently no detailed plan exists, but see Winnefeld (1895) pl. 6; C. Girault, in *MonAnt* 3, pls. 207–210; and De Franceschini (1991) 469–476, who says it is a nymphaeum-triclinium. Aerial views in Giuliani, "Piazza d'Oro" (1975) figs. 1, 3.

his declared interest: F. Borromini, *Opus architectonicum* (Rome, 1720–1725) 36; cf. P. Portoghesi, *Borromini* (London, 1968) 8–9, and Blunt (1979) 70, 99, 116.

enthusiasm: see the quotation on p. 225, below.

101 Neronian marble pavement: Lugli (1946) 507; Morricone Matini (1967) pl. 30, cf. pl. 17; MacDonald (1982) 234–235.

Ostia: Becatti 1 (1961) fig. 68, 2, pls. 52, 56, 61, 68, 217, 224; C. Paolini, *Ostia* (Bari, 1983) 158 (a painted ceiling).

long run: see, e.g., Germain (1969) esp. pls. 4, 17, 27; K. M. D. Dunbabin, *The Mosaics of Roman North Africa* (Oxford, 1978) pls. 33, 52, 62, and cf. 63; E. Marec, *Monuments chrétiens d'Hippone* (Paris, 1958) figs. 78a, 104a, 110, 203a.

Baiae: Rakob (1961); Jacobson (1986) 78–79.

La Conocchia: MacDonald (1986) 154, fig. 136.

Leonidaion: A. Mallwitz, *Olympia und seine Bauten* (Munich, 1972) 252–254.

Hadrianic domes: Brown (1964); Giuliani, "Volte" (1975) 51–53; MacDonald (1986) 235 for additional examples.

102 easily revealed: *Letters* 6.31.2.

very beautiful: *Letters* 6.31.13–15.

dinner parties: Balsdon (1969) 32–53; Ricotti (1985) 18–25.

villas each had: *Letters* 2.17, 5.6.

cenatio: Letters 5.6.21. At Pompeii the Villa of the Mysteries had three pairs of dining rooms (Richardson [1988] 398–399).

Trimalchio: Petronius, *Satyricon* 28–78, which in spite of its diverting detail—such as a zodiacal dinner service (35, 39), a mechanical roof (60), cleansing sawdust mixed with saffron, vermilion, and mica (68), a funeral march (78), and so on—is germane (W. H. Arrowsmith, *Petronius: The Satyricon* [Ann Arbor, 1959] 188–200; Ricotti [1985] 117–150); cf. Athenaeus, *The Learned Banquet.*

Statius: *Silvae* 4.2.

he approved: Juvenal 7.1–2 and cf. 7.20–21. In 15.38–46 he describes briefly an Egyptian civic banquet with many tables.

dining-room terminology: Vitruvius 6.3.8; Ward-Perkins (1981) 187–188, 476 n. to p. 188, is good on shifts of meaning; Richardson (1988) 397–399.

103 stibadium: Pliny, *Letters* 5.6.36; Martial, *Epigrams* 14.87; K. M. D. Dunbabin, "Triclinium and Stibadium," in Slater (1991) 121–148, figs. 28–30; L. B. Van der Meer, "Eine Sigmamahlzeit in Leiden," *Bulletin antieke beschaving* 58 (1983) 101–110.

space: HA, *Hadrian* 17.4.

ordinary people: 9.8.

same food: 17.4.

offered tragedies: 26.4.

music: Pliny, *Letters* 9.36.4; Fronto, *Letters* (*LCL* 2) 9; HA, *Hadrian* 26.4, cf. 14.9.

analysis: Kähler (1950) 55–64, 122–127, pls. 8–10.

follow suit: e.g., Aurigemma (1961) 64–65 and Ricotti (1987) 178–179, fig. 28. The building was not cleared until just after the First World War (Chillman [1924] 103–120 and pls. 50–60). De Franceschini (1991) says it was not a triclinium (646).

Palatine influence: MacDonald (1982) ch. 3, pl. 40, nos. 4, 5, 12–14, 44, and fig. 6 for the three possibly relevant halls.

first phase: Kähler (1950) 64 for the construction sequence; A. Giubilei, "Villa Adriana: Il cosidetto edificio con triplice esedra," *BA* 76, 64 (1990) 47–58. De Franceschini (1991) 632 sees this first phase as atriumlike and notes the presence of heating installations (620, 628).

105 solid exterior wall: so Kähler (1950) pls. 8, 9, but the remains suggest windows.

transenna: Kähler (1950) 58, pl. 10.

106 survive: Kähler (1950) 58–59, cf. 66 and 165, n. 115; discussions with Edwin Thatcher; MacDonald (1982) 161, n. 49; Ricotti (1988).

60°: Rabirius's outer, fountain chamber walls are segments of a circle struck from the center of the dining hall proper; his apsidal wall curve is a segment of a circle passing through that same center.

107 clerestory walls: suggested in Gismondi's Villa model.

variations in lighting: see the frontispiece of *MAAR* 6 (1927), reproduced in Brown (1961) pl. 90.

108 questioned: Neuerburg (1965) 240, and see Raeder (1983) 301–304.

garden-bordered colonnades: Hannestad (1982) 89–93; Jashemski and Ricotti (1987–1988) 156–162 and figs. 11–16, and (1992) 580–585.

like a hood: the juncture of semidome and barrel vault is similar to that seen in the apsidal side chambers of the Smaller Baths room 13.

holed coin: Gismondi's model shows circular windows in the facade—derived from Bramante's Genazzano nymphaeum?

Egyptian connection: investigated by Raeder (1983) 297–315; Lavagne (1988) 606–611; and Grenier (1990).

new quarter: Fraser 1 (1972) 35.

109 temple to Serapis: Fraser 1 (1972) 273, cf. 803–804.

built before 130: Bloch (1947) 141–144, 169; Aurigemma (1961) 127.

Strabo: 17.1.17; cf. Lucan, *Pharsalia* 10; other citations in Raeder (1983) 359, n. 523.

Seneca: *Letters* 51.3.

Juvenal: 1.26, 15.46.

oracular revelation: Fraser 1 (1972) 208, 253, 257, 263, 583–584.

110 canal: Fraser 1 (1972) 26, 200.

has survived: E. Breccia, *Alexandrea ad Ægyptum* (Bergamo, 1914) 134–139, and *Monuments de l'Egypte gréco-romaine* 1 (Bergamo, 1930) 40–41; Forster (1961) 193–196; Fraser 1 (1972) 41. The canal may have run a full kilo-

meter south of the temple to Serapis (Forster [1961] 189).

Marble Plan: *FUR* 1 (1960) 97–102, 2 pl. 31; Blake (1959) 106–107; F. Fasolo and G. Gullini, *Il santuario della Fortuna Primagenia* 1 (1953) 382–383, fig. 480; Nash 2 (1968) 510–511; Roullet (1972) 27, figs. 348–351.

ARCUS AD ISIS: F. Castagnoli, "Gli edifici rappresentati in un rilievo del sepulcro degli Haterii," *BC* 69 (1941) 59–69; Nash 1 (1968) 118 and figs. 122–124; Richardson (1992) 211–212.

Domitian: T. Mommsen, *Chronica minora* 1 (Berlin, 1892) 246; Blake (1959) 99.

in the area: Blake (1959) 107.

Domitianic: Lugli (1946) 514, pl. 8, no. 33; MacDonald (1982) 69.

Serapeum: Lavagne (1988) 606 finds little support for the name.

1950s: Aurigemma (1961) 100–133 and citations on 204; report in *AA* (1957) 311–348.

Aqua Virgo: Pinto (1986) 5–6; cf. Ovid, *Ex Ponto* 1.8.37–38.

towboats: Tacitus, *Annals* 15.37, who says the pavilions contained brothels; cf. Strabo 13.1.19 and Seneca, *Letters* 83.5.

111 swimming: stairs (lost during restoration?) are not visible in the available excavation photographs: Aurigemma (1961) fig. 87; Hannestad (1982) figs. 18–19 (he thinks it was a swimming pool). Blake (1973) speaks of steps "and landing places for small craft" (250).

Athenian: for these monuments see Travlos (1971) and Camp (1986).

Pausanias: 1.15.1–4.

Juvenal: 15.45, and note 1.26 and 6.84.

unlikely: but note C. Sweet, "Dedication of the Canopus at Hadrian's Villa," *AJA* 77 (1973) 229; Lavagne (1988) 604 has no doubt that the Canal is the Canopus of the HA.

Ligorio: Lanciani 2 (1903) 113.

Hamilton: list in Raeder (1983) 369–370.

Service Quarters: C. Fea, *Miscellanea filologica critica a antiquaria* 1 (Rome, 1790) no. 139.

also belonged: Grenier (1990) tracks all known and suspected Egyptian and Egyptianizing Villa works. He equates the Canal with the Mediterranean and the reflecting pool with the Nile Delta.

the floor: Ashby (1927) 109 thinks the Canal valley was created by excavation.

daytime sheen: the swans were a gift of the city of Zurich (Vighi [1959] 42).

Scylla: Aurigemma (1961) 110–111, figs. 125–130.

Boats: Canina 6 (1856) pl. 166; Blake (1973) 250.

113 almost flat: the section by A. Del Caldo, in Aurigemma (1961) fig. 131, though cavalier, conveys the basic form correctly; Sortais, *MonAnt* 3 (1912) pl. 214, while making the upper vault section too thick, does the same.

114 waterworks: Del Caldo, 127–133, figs. 131–133; cf. Vighi (1959) 40–46. Stierlin (1984) speaks of "rideaux aquatiques" (160).

colors: Aurigemma (1961) 102 (white); F. Sear, *Roman Wall and Vault Mosaics, RM* supp. 23 (1977) 111–112 (blue and green); Hannestad (1982) (yellow and red); Lavagne (1988) 604 (pale blue, turquoise, and green). Triclinium pavements: De Francheschini (1991) 297–314.

115 proto-Baroque: MacDonald (1986) ch. 8.

Dio: 69.7.3.

viewing place: but see Ricotti (1987) 176–177; Grenier (1990) 22–32 assigns specific pieces to the niches (diagramed in figs. 4–7).

psychosexual: Clark (1952) 165–167, who speaks also of "fakeries"; P. MacKendrick, *The Mute Stones Speak,* 2d ed. (New York, 1983) 370–372.

religious: C. Tiberi, "Il culto degli dei samothraci nel Canopo della Villa Adriana presso Tivoli," *AMST* 30/31 (1957/1958) 47–76; Stierlin (1984) 168, 171, sees Hadrian as a new Serapis.

116 two-part grotto: Vighi (1959) 46; Coarelli (1982) 68–69; Raeder (1983) 299–315; Ricotti (1987) 178–180; Lavagne (1988) 606–609.

archaeological testimony: Rakob (1964); Neuerburg (1965); Mielsch (1987) 121–126.

the texts: Lavagne (1988); cf. Hoffmann (1980) 64–65.

Muslim iwan: MacDonald (1986) 106–107; ills., e.g., in Hoag (1977) nos. 245, 274, 337, 352.

Sortais: in *MonAnt* 3 (1912) pls. 212–214 he restores the Triclinium facade and gives a Triclinium axial section with the lost vaulting, gores, and the northwest-southeast arches restored.

Le Corbusier: see pp. 320–322, below.

118 significant publications: Neuerburg (1965); Ricotti (1973); Lund (1982); Ricotti (1982); Lavagne (1988).

120 pilastered walls: probably incorrectly, according to Catia Caprino (conversation, June 1987).

121 external ring: Ligorio-Contini (1751) 18, Cap. 9, no. 3; Nibby (1827) 44.

122 Doric: Ricotti (1973) 235, n. 1.

porch: Ligorio-Contini (1751) 18, Cap. 9, no. 3.

Antinous: Raeder (1983) 361, n. 553.

decorated: Ligorio-Contini (1751) 25, Cap. 12, no. 2.

123 fantastic ornament: Neuerburg (1965) 242.

rustic stadium: *Pianta* Commentary 4.2.27.

pool: Ricotti (1973) 228, a water mirror; Penna 1 (1831), plan, no. 74, calls it a swimming pool.

entrance: Ligorio-Contini (1751) 25, Cap. 12.

the river's circuits: Virgil, *Aeneid* 6.439.

124 Temple of Serapis: *Pianta* Commentary 6.2.7.

Temple of Pluto: Penna 1 (1831) plan, no. 76.

Plutonium: Gusman (1904) fig. 70.

these buildings: Winnefeld (1895) 121–125.

127 Ligorio-Contini: (1751) 24, Cap. 11, nos. 38–39.

Piranesi: Commentary 5.7, and 5.7.1–4.

Gusman: (1904) 172, 174.

Penna: 1 (1831) 113 and plan, no. 66; cf. Nibby (1827) 55–57.

scarcely technical: D. S. Robertson, *A Handbook of Greek and Roman Architecture,* 2d ed. (Cambridge, 1945) 274; cf. Tomlinson (1983) 83.

originally embellished: Ligorio-Contini (1751) 24–25, Cap. 11, nos. 41–45.

Piranesi: *Pianta* Commentary 5.7.7.

parallel corridors: Ligori-Contini (1751) 25, Cap. 11, no. 43; Piranesi, *Pianta* Commentary 6.1.15; Ricotti, "Criptoportici" (1973) 245 246, pl. 11.

130 At the top: the details in this paragraph are found mostly in Ligorio-Contini (1751); Pannini and Findanza (1753); and Piranesi, *Pianta* Commentary 5.7–6.1.25.

1760s: Lund (1982) 49, fig. 4.

Ligorio-Contini: (1751) Cap. 11, nos. 38, 39.

passes under: Ricotti, "Criptoportici" (1973) pls. 1, 11.

Epidauros: Tomlinson (1983) 82–84.

Troizen: H. Lauter, *Die Architektur des Hellenismus* (Darmstadt, 1986) 237, fig. 40b.

131 underground structure: Ricotti, "Criptoportici" (1973) 246 and pl. 12; she suggests that the structures in this area were service and kitchen facilities attached to the Southern Range ([1982–1983] 292–293).

functionally axial: the three long, well-lit spaces are well suited to the in-line food assembly banquets require.

Elysian Fields: (1751) 26, Cap. 12, no. 7.

shallow channel: Ricotti, "Criptoportici" (1973) 237.

evenly spaced cuttings: Ricotti, "Criptoportici" (1973) 237–239.

132 immense nucleus: Ricotti, "Criptoportici" (1973) 236.

Hadrian's attitude: Beaujeu (1955) 111–176; W. den Boer, "Religion and Literature in Hadrian's Policy," *Mnemosyne* 4.8 (1955) 123–144; Garzetti (1974) 433–435.

imperial cult: Price (1984) 149–155, 216, 244, 251–256.

he refused: den Boer, 133.

tolerant: e.g., Witt (1971), esp. ch. 17.

zodiacal symbols: e.g., M. Grant, "A Capricorn on Hadrian's Coinage," *Emerita* 20 (1952) 1–7.

Eleusinian mysteries: background and interpretation in C. Kerényi, *Eleusis* (Princeton, 1967) and Burkert (1987); see also G. E. Mylonas, *Eleusis and the Eleusinian Mysteries* (Princeton, 1961) 224–285, and cf. M. Guarducci, "Adriano e i culti misterici della Grecia," *Bulletino del museo dell'impero romano* 12 (1941) 149–158.

antiquarian tastes: e.g., by Garzetti (1974) 433–434.

life thereafter: Guarducci (1965) 218.

and 131: for these dates, see K. Clinton, "Hadrian's Contribution to the Renaissance of Eleusis," in Walker and Cameron (1989) 56–58. An inscription records Hadrian's presence (*Inscriptiones Graecae* 2, 2d ed., 3620); cf. Jerome, *Ad magnam oratorum* 4. Hadrian's new bridge, just east of Eleusis, still stands, in the shadow of a freeway. A statue of Antinous as Dionysus survives in the Eleusis Museum (Clairmont [1966] 108).

not a religion: Burkert (1987) chs. 1, 2.

133 Plutarch: *On Reading the Poets* 47a; cf. Burkert (1987) 91 and 162, n. 11.
Aelius Aristides: quoted by Burkert (1987) 93.
Apuleius: *Metamorphoses* 11.23.6–8.
Other writers: quoted or cited by Burkert (1987) 89, 91, 92, 95, 97.
extensive literature: the tradition is virtually continuous from Homer's *Odyssey*, Book 11, to the writers just cited and beyond; see, e.g., M. Eliade, *Birth and Rebirth* (New York, 1958); Ferguson (1970) chs. 7, 8; and Luck (1985) 127–225; and cf. MacMullen (1981) 49–62, an astute dissection.
Isis and Serapis: Witt (1971) 235–236.
inscriptions: Witt (1971) 238 and notes.
coins: *BMC* 439.
Strabo: e.g., 5.4.5–6, 8.3.14–15, 13.4.14, 14.1.44; cf. 7.66, 14.1.11; he emphasizes earth openings that emitted sulphurous or other noxious fumes.
Pausanias: e.g., 2.31.2, 2.37.5, 3.25.5–6, 6.25.2–3; cf. 1.17.5, 2.13.3, 2.36.7, 8.32.4, 8.48.6.
Pausanias: 10.28.
Alexandria: Fraser 1 (1972) ch. 5.
Pergamon: C. Habicht, *Die Inschriften des Asklepieions* (Berlin, 1969 = *Altertümer von Pergamon* 8.3), introduction; cf. M. Le Glay, "Hadrien et l'Asklépieion de Pergame," *Bulletin de correspondance héllenique* 100 (1976) 347–372.
Hierapolis: Strabo 13.4.14; G. E. Bean, *Turkey Beyond the Maeander* (London, 1971) 236–238.
Baalbek: P. J. Alexander, *The Oracle of Baalbek* (Washington, D.C., 1967); apparently the large crypt and tunnels, under the west end of the so-called Small Temple, are little studied; cf. Price (1986) 155.

134 imperial power: Raeder (1983) 271–315.
predominate: Raeder (1983) 369–372.
intrinsically religious: Lavagne (1988) 258–264 for the stories implicit in these garden parks; cf. Grimal (1984) 316–318; Neudecker (1988) 9–11; and Joyce (1990) 374–375.
spiritual renewal: on the psychological reality of faith, see the wise words of R. Davies, *Fifth Business* (New York, 1977) 198–200.

135 close connection: Hanson (1959), esp. 3–5; MacMullen (1981) 18–22.
devices for sound: Ferguson (1970) 100; Burkert (1987) 97–98 and 164, n. 40, cf. 24; Lavagne (1988) 176–177. See also M. Bieber, *The History of the Greek and Roman Theater*

(Princeton, 1961) ch. 6; Witt (1971) 186–188; and cf. MacMullen (1981) 82 and the automated theatres and lighting effects in R. S. Brumbaugh, *Ancient Greek Gadgets and Machines* (New York, 1966) chs. 5, 9.
evidence exists elsewhere: at, e.g., Eretria, Tralles, and Ephyra in Epirus; C. R. Brownson, "Excavations of Eretria: The Underground Passage," *Papers of the American School of Classical Studies at Athens* 6 (1890–1897) 98–103; E. Fiechter, *Antike griechische Theaterbauten*, vol. 8; *Das Theater in Eretria* (Stuttgart, 1937); P. Auberson and K. Schefold, *Führer durch Eretria* (Bern, 1972) 46–52; G. Humann and W. Dörpfeld, "Ausgrabungen in Tralles," *Mitteilungen des deutschen archäologischen Instituts, Athenische Abteilung* 18 (1893) 395–413, esp. 407–408 and pl. 13 (nothing could be seen in June 1963); N. G. L. Hammond, *Epirus* (Oxford, 1967) 64–65; who cites publications by S. I. Dakaris, to which add *Antiquity of Epirus* (Athens, n.d.) 3–22. See also Ricotti, "Criptoportici" (1973) 245, n. 1, and cf. Pausanias 9.39.5–14. At Ephyra remains have been found of what may have been mechanical devices that produced startling effects. The literature cited here includes references to other theatres with remarkable subterranean installations, e.g., that at Magnesia on the Maeander; several were remodeled in Roman times. We are indebted to Carol C. Mattusch and Richard Mason for help with Ephyra.
religious gatherings: MacMullen (1981) 21–25.

136 accompanying description: 25–26, Cap. 6, nos. 7–11.
identification: Commentary 6.2.3–6, of which 6.2.4 refers directly to the Galleries.
Ghezzi: Vatican Library, Cod. Ottoboniano Lat. 3108, fol. 171.
Pronti: 1 (1795) 87.
Penna: plan, no. 77.
Gusman: 179; on his plan (61), the Park Grotto is labeled styx?.
Winnefeld: 53–54, but labels the Galleries inferi on his plan, no. 32.
Crema: 473. About then the Galleries were given over to mushroom-growing: Ricotti, "Criptoportici" (1973) 237.
extended discussion: Ricotti, "Criptoportici" (1973) 236–240.

subsequent literature: e.g., Coarelli (1982) 52 and Mielsch (1987) 153.
HA underworld: Lavagne (1988) 601, with a reference to the possibility that Ligorio's place of the underworld gods may not be fantasy because of the impression made by the underground pozzolana pits (Ricotti, "Criptoportici" [1973] 238) connected with the Galleries.
difficult work: Ricotti (1982) 30, n. 17. We have examined much of the northeast, northwest, and southwest Galleries. Portraits of emperors from Antoninus Pius through Caracalla found at the Villa suggest that the wood construction might be post-Hadrianic.
about managing: Vegetius 1.56; P. Vigneron, *Le cheval dans l'antiquité gréco-romaine* 1 (Nancy, 1968) 23–40 (on stable management), and 2 (1968) pl. 6; K. D. White, *Roman Farming* (London, 1970) 288–291; Hyland (1990) 49–60, 231–247.
rarely used: White (1970) 288.

137 data suggest: Ricotti, "Criptoportici" (1973) 238.
standard horse: we are indebted to Carol C. Mattusch for advice about horse management. Today, paddocks for the Bulgarini thoroughbreds lie over the northern Galleries area.
veterinarian: Toynbee (1973) 317–323.
maneuvering: Ricotti, "Criptoportici" (1973) pl. 5.
Piranesi: *Pianta* Commentary 1.4, 1.4.1–6.

138 come to mind: in this connection it is worth recalling that Fronto wished to propitiate Hadrian as he might Mars or the god of the underworld (*Letters to Marcus as Caesar* 2.1.1).
world of spirits: see, e.g., Nardi (1960) 178–179, with thanks to Bruce Frier; Hopkins (1983) 229–230; and Luck (1985) 165–171; cf. MacMullen (1981) 82–83.
irony: Lavagne (1988) 600.
kinetic expressions: "Not a single mystery cult can be found that is without dancing" (Lucian, *The Dance* 15); cf. Burkert (1987) 92, 94.
environment: MacMullen (1981) 73–79.
Amalthaeum: Cicero, *To Atticus* 1.16.

139 Scenic Canal: report on the 1950s work in *AA* (1957) with plans and photos.

141 evidence of planting: Jashemski and Ricotti

(1987–1988) 156–162, figs. 11–16, and (1992) 580–585.

wide range: facts about Villa sculpture given here are largely from Raeder (1983). Earlier surveys in Penna 3, 4 (1836); Winnefeld (1895) 150–168; Gusman (1904) 237–321; and Aurigemma (1961); additional illustrations in Giuliano (1988). For Penna's work, see Baldassarri (1989). For the Canal Block collection, W. Helbig, *Führer durch die öffentliche Sammlungen klassischen Alterümer in Rome*, vol. 4: *Museo Ostiense in Ostia Anitica, Museo di Villa Hadriana in Tivoli, Villa Albani* (Tübingen, 1972).

eclectic nature: Pasiteles (1st c. B.C.) emphasized it; K. Jex-Blake and E. Sellers, *The Elder Pliny's Chapters on the History of Art* (London, 1896; reprinted, 1966) lxxvii–lxxxii, and M. Borda, *La scuola di Pasiteles* (Bari, 1953).

a museum: Strong (1988) 65 on paintings and sculpture forming "a sort of museum"; cf. his "Roman Museums," in D. E. Strong, ed., *Archaeological Theory and Practice* (London, 1973) 247–264.

tradition: Neudecker (1988), esp. 5–30, 115–120.

142 categories: Neudecker (1988) 31–104.

145 wealthy collectors: Neudecker (1988) 115–117; Strong (1988) 105–107; Bartmann (1991).

Cicero's dealings: his taste in G. Beccati, *Arte e gusto negli scrittore latini* (Florence, 1951) 73–106; Raeder (1983) 287–289; Strong (1988) 60, 105.

sculptured ornaments: *To Atticus* 1.4.

anything suitable: *To Atticus* 1.8.9.

my Academy: *To Atticus* 1.4.

relief panel: *To Atticus* 1.10.

gymnasium: *To his friends* 7.23.

to the gods: *On the laws* 3.13.

in every way: *Cataline* 20.11.

146 Aphrodisias: Aphrodisian sculptors may have maintained Rome studios (Strong [1988] 106; cf. Raeder [1983] 236–238).

Pompey: Boëthius (1978) 205–206 and citations.

forum at Rome: Dio 69.7.4.

Olympieion: Pausanias 1.18.6.

halls and courtyards: Plutarch, *Lucullus* 39; see D'Arms (1970) 27–28, 184–186 for some of his properties.

in such places: the Villa of the Papyri, Herculaneum, e.g., with its eighty-odd statues of gods, kings, and famous men; and note Herodes Atticus's villa (Raeder [1983] 293).

new functions: Bartmann (1991).

copies of famous works: Toynbee (1934) xxiii–xxiv; Raeder (1983) 213–233, 239–240; Strong (1988) 60, 105–107; cf. Quintilian, *Institutio Oratoria* 10.2.3–7. Cook (1985) 14 illustrates a copy of an early Greek work probably made for the Villa that Charles Townley bought from Piranesi for £40.

old masters: M. Robertson in *JRS* 53 (1963) 231.

old master copies: J. B. Ward Perkins, lecture, spring 1957.

147 in good hands: e.g., Raeder (1983) 205–242 ("Stilanalyse") and Strong (1988) ch. 8. Toynbee (1934) xi–xxxi wears well.

classical revival: Toynbee (1934) xiii–xxiii; Strong (1988) 174–177. Bianchi Bandinelli (1970) 258–259 finds the Antinous type romantic, not classical.

form and style: Strong (1988) 175.

arcading: Hannestad (1982) 85 and fig. 27.

in the niches: Raeder (1983) 250–251. On Roman niches, Hornbostel-Hüttner (1979).

148 bases: Raeder 241–242.

pairs: Bartmann (1988) esp. 222–225.

marine friezes: at the Water Court and the Island Enclosure, Conti (1970) and Caprino (1985). M. Robertson *JRS* 53 (1963): "Only in [these] friezes [at the Villa] do sculptors find . . . a release [from] the heavy hand of classicism" (231).

Olympians: H. J. Rose, *Handbook of Greek Mythology* (New York, 1959) 306.

149 may not be correct: Raeder (1983) 92. Sheldon Nodelman suggests that it might be a portrait of Virgil, because of both its similarity to the Sousse mosaic and its sensitive, nondynastic forms.

numismatic evidence: *BMC* 1094 and pl. 75.5; cf. 603 and pl. 59.5 (better in Hannestad [1982] fig. 46).

in a new body: Hannestad (1982) 97–101 and (1986) 309.

surviving images: Wegner (1956).

Sabina's existing portraits: including the coins, *BMC* nos. 893–963, pls. 64–66, 90.

centerpieces: A. Carandini, *Vibia Sabina* (Florence, 1969); Strong (1988) 171, 174 disagrees.

Sabina's gravity: Giuliano (1988) 44.

Antinous type: L. H. S. Dietrichson, *Antinoos: Eine kunstarchäologischen Untersuchungen* (Christiana, 1884); Clairmont (1966); Meyer (1991). Lambert (1984), not well received because of its speculative and tendentious tone, nevertheless has good documentation and illustrations and a convenient catalogue. Clairmont's conclusions (several questioned by H. von Heintze in *Gnomon* 43 [1971] 393–398) stand up well.

coins and medallions: Lambert (1984) figs. 42–48.

Egyptian underworld: Herodotus 2.144 associates Dionysus with Osiris. Antinous the god discussed by Lambert (1984) 178–182.

commissioned by Hadrian: discussed by Toynbee in a review of Clairmont, *JRS* 57 (1967) 267–268. She suggests a Greek or Aphrodisian artist. The master sculptor who oversaw the immense production for Antinoopolis, wherever he was from, may have made the prototype.

Pausanias: 8.9.7–8.

Antinous obelisk: Boatwright (1987) 239–260, disproving Hannestad (1982); Meyer (1991) 175–178 and pls. 126–130.

Lanuvium: A. E. Gordon, "The Cults of Lanuvium," *University of California Publications in Classical Archaeology* 2.2 (1938) 44–46; Hopkins (1983) 213–215.

Ostia: Meiggs (1973) 378–379.

Antinous coins: Clive Foss generously advised us about these.

150 Albertiana: the curious can inspect the hundred-odd illustrations in E. Darby and N. Smith, *The Cult of the Prince Consort* (New Haven, 1983).

hard-working man: H. Hobhouse, *Prince Albert: His Life and Work* (London, 1984).

Painters: of Antinous, too: Pausanias 8.9.7.

brought low: Lambert (1984) figs. 3, 42, 43.

151 interested in Egypt: Roullet (1972).

king of Egypt: A. C. Levi, "Hadrian as King of Egypt," *Numismatic Chronicle* 8.6 (1948) 30–37, brought to our attention by Clive Foss. Pompey: n. to p. 146, above.

Portico of Nations: Platner-Ashby (1929) 426.

series of coins: Toynbee (1934) 24–160; *BMC* clxxiv–clxxxi; Strong (1988) 194–195.

Pausanias: 1.18.6.

Egypt coins: *BMC* 514–516; Strong (1988) fig. 126d.

Hamilton: Raeder (1983) 133.

coin subject: *BMC* 512–514, pl. 95.

Hadrianeum: Toynbee (1934) 152–159; Strong (1988) fig. 117.

myth-laden gardens: Raeder (1983) 293–294; cf. Mielsch (1987) 94–97, 137, 140.

comparatively plentiful: for decorative materials, Ward-Perkins (1981) 117–120; for Villa mosaic and marble pavements and marble wall revetment, De Franceschini (1991) 661–669.

152 Villa work are not: Joyce (1989) and (1990).

impressions record groups: Aurigemma (1961) 185 and figs. 190–192; cf. Gusman (1904) 216–218 and ills.

birds and beasts: Aurigemma (1961) fig. 5; Aurigemma (1969) 29.

Piranesi: *Vedute di Roma* (Rome [ca. 1748]) no. 133.

1920s: Joyce (1981) 33–34 and fig. 42.

blank sectors: skimpy vines in some, Aurigemma (1961) fig. 5.

principles: Joyce (1990) 370–371, 375–381 (decorated Villa ceilings).

154–155 large rectangle: Wirth (1929) 40 saw painted frames in the Fountain Court West.

chalcedony eggs: Cima and La Rocca (1986) 115–116, 129, pl. 28, fig. on 129, cf. 113 and pl. 23.

Larger Baths: Joyce (1981) 72, with the earlier literature; good color detail (printed upside down) in Giuliano (1988) 62.

Piranesi. *Vasi e candelabri* (Rome, 1778) 22.

nymphaeum barrel vault: Joyce (1981) 78 and fig. 78.

Northern Ruins: Joyce (1981) 75, 78, and fig. 79; cf. Aurigemma (1961) 47–48 and fig. 24.

157 Hall niche: apparently unpublished; the signature at the bottom is Hubert Robert's and dates probably from 1765; Douglas Lewis also noticed it.

theme is common: examples in Wirth (1929) 119 and pl. 28 and Toynbee and Ward Perkins (1956) pls. 2, 5; see also Hornbostel-Hüttner

(1979) figs. 3, 26, 33 and cf. Germain (1969) no. 174.

Ghezzi: in the British Museum, uncatalogued.

Piranesi: Uffizi inv. no. 98006NA, reproduced in Bacou (1975) 160.

tents: see n. to p. 189, below. Perhaps the Scenic Triclinium vault is intended to suggest a tent.

158 visual dematerialization: Ward-Perkins (1981) 120.

159 darkness: *Letters* 86.4.

silver taps: 86.6.

elder Pliny: *Natural History,* 36.114; probably mosaic is meant.

survives at the Villa: De Franceschini (1991).

has been questioned: Strong (1988) 183, n. 12.

collectors' pieces: Strong (1988) 183, n. 13.

Republican cryptoporticus: Lavagne, "Utilitas/ Decor" (1973) and "Villa d'Hadrien" (1973).

160 room 11: Aurigemma (1961) fig. 182.

close to it: thus overall photographs and painted copies of mosaics fail to record their textures; see, e.g., Becatti 1 (1961) pl. A.269.

more subtle: Clarke (1979) xix; cf. Strong (1988) 235.

161 splendid examples: De Franceschini (1991) 626 finds them "rather modest"; cf. Clarke (1979) xxii.

rooms 5 and 8: Aurigemma (1961) figs. 189, 185.

room 9: pp. 92–93, above; cf. the room 7 pavement in the House of the Yellow Walls at Ostia, Becatti 2 (1961) pl. 58, and Germain (1969) nos. 21, 141, 142.

room 2: cf. the House of Bacchus and Arianna pavement at Ostia (Becatti 2 [1961] pls. 75–76).

room 6: Aurigemma (1961) fig. 188.

Hellenistic period: e.g., at Ai Khanum, R. L. Fox, *The Search for Alexander* (Boston, 1980) 95.

Timgad: e.g., Germain (1969) no. 139.

room 10: Aurigemma (1961) fig. 194.

room 3: Aurigemma (1961) fig. 183.

garden fences: Jashemski (1979) figs. 94, 102, 117, 124, 125; cf. Morricone Matini (1967) figs. 19–20.

162 checkerboard-pattern floor: Aurigemma (1961) pl. 14; Giuliano (1988) 61, 167; cf. Germain (1969) nos. 59 (color, pl. 90), 171.

163 five-band border: cf. Morricone Matini (1967) pls. 28.26, 27, 31.

Larger Baths: Morricone Matini (1967) pl. 5.19.

concrete slabs: see p. 105, above.

Vatican: Aurigemma (1961) pls. 19–21, 28.

in the room: Piranesi, *Pianta* Commentary 5.5.30.

Sosus: Pliny, *Natural History* 36.184; K. Parlasca in *JDAI* 78 (1963) 256–293; cf. Strong (1988) 54–56, 73, and pp. 292–293, below.

tepid set-pieces: M. Robertson in *JRS* 53 (1963) 231; Strong (1988) 183 speaks of a revival.

three panels with masks: Aurigemma (1961) pls. 17–21 and fig. 176.

Pergamon Museum: Strong (1988) fig. 118.

164 lion attacks: Aurigemma (1961) pl. 16.

mystifying: Gusman (1904) fig. 323; Aurigemma (1961) pl. 29.

room 7: MacDonald and Boyle (1980) 15, fig. 19.

165 floor marbles: we've not seen F. Guidobaldi et al. on Villa marbles, cited by De Franceschini (1991) 22.

Ostia: Becatti 2 (1961) pl. 210, to which add the Seat of the Augustales.

Herculaneum: the House of the Telephus Relief in particular.

Antiquario Palatino: Morricone Matini (1967) pl. 33.

alabaster latticework: Lanciani (1909) 141–142 for alabaster steps and metal-framed marble-work.

Smaller Baths: these data are from MacDonald and Boyle (1980).

167 Arcaded Triclinium: very similar to Domus Augustana work (Morricone Mattini [1967] pl. 31.75–76).

170 seen elsewhere: in the Ostia Museum, e.g., room 12; see also Coarelli (1984) illustrations on 152–155 (details of wall mosaics).

Doryphorus: Raeder (1983) cat. I, 98.

ancient paintings: Jashemski (1979) ch. 3; Bergmann (1991).

literary evidence: A. R. Littewood, "Ancient Literary Evidence for the Pleasure Gardens of Roman Country Villas," in MacDougall (1987) 7–30, who on 22 finds the Villa outrageous.

hydraulic regime: see the notes to p. 27, above, as well as Aurigemma (1961) 58, 127–133; Neuerburg (1965) 97–101; MacDonald and

Boyle (1980); Hoffman (1980); and Ueblacker (1985); and cf. Gusman (1904) 66–68, and Mielsch (1987) 121–128, 172–173.

171 Today: Aurigemma (1961) 58.
water-lifting devices: J. P. Oleson, *Greek and Roman Mechanical Water Lifting Devices* (Toronto, 1984). De Franceschini (1991) 628 emphasizes the man-made nature of the water delivery system, but it was based on adaptation to the terrain.
traditional categories: Boëthius (1978) 194–195 and 237, n. 69, for background; Neuerburg (1965) 27–80 and catalogue nos. 189–204 for Villa fountains. See also T. L. Ehrlich, "The Waterworks of Hadrian's Villa," *JGH* 9.4 (1989) 161–176.

173 full repertory: Hoffmann (1980), esp. 32–36.
Domitian: MacDonald (1982) 68–69; on hippodrome or stadium gardens see Hoffmann (1980) ch. 11; Humphrey (1986) 568–571; and note to p. 3, above.
restored: Hoffmann (1980) pl. 33.
cascades: Hoffmann (1980) 28, 69; see also Neuerburg (1965) no. 204; Ricotti, "Criptoportici" (1973) fig. 3; and Lavagne (1988) 615, n. 92.

174 something of a mystery: Hoffmann (1980) 67; not a pool, Ricotti (1987) 179.
Domus Augustana: MacDonald (1982) 67–68 and pls. 58, 68.

175 long Court Wall: L. Bek, "Towards Paradise on Earth . . . ," *ARID* 9 (1980) 198–199, for a different interpretation.
system is preserved: Winnefeld (1895) 38, fig. 4. De Franceschini (1991) 652 interprets the tanks as rainwater catchments.
Campanian paintings: Jashemski (1979) figs. 93–95, 102, 104–106, 130, 266, 440, 470, 471.
marble stadium basin: De Franceschini (1991) 475 says it may be a model of the stadium she says stood in the East Valley, below the arena (634); it was found between the Larger Baths and the Central Service Building, Lolli-Ghetti (1987) 177.
single niche fountain: often mosaic-encrusted, Jashemski (1979) ills. 69, 72, 73, 240, and cf. 108.
Republican date: Neuerburg (1965) no. 193; Lavagne, "Villa d'Hadrien" (1973).

176 Republican example: Neuerburg (1965) no. 200; Penna 2 (1933) 127.
three fountains: Lugli (1927) 393 and fig. 147 in the 1965 reprint.
Grottoes: Lavagne (1988) esp. 257–366, 513–616; Lehmann (1953) 115–116, 204.
Juvenal: 3.17–18.

177 Penna shows: 2 (1833) no. 102.
Residence Quadrangle: Neuerburg (1965) no. 189.
Doric Temple: Neuerburg (1965) no. 189.
evidence suggests: e.g., Cicero, *To Atticus* 2.1, *To Quintus* 3.2, 3.97; Horace, *Odes* 2.15; Seneca, *Letters* 55.6; and Martial, *Epigrams* 10.30; cf. Pliny, *Letters* 10.7; D'Arms (1970) 248; Pavlovskis (1973) 47–48; and Jashemski (1979) 108–112.
wide-mouth pots: Sperlonga, Ricotti (1987) fig. 4; Conimbriga, House of the Jet Fountains; Pompeii, Jashemski (1979) fig. 178. See also Mielsch (1987) 23–32, 166 and Jashemski and Ricotti (1987–1988) figs. 10, 12, 14, and (1992).
artificial lake: Martial, *On the Spectacles* 2; sketch plan in Ward-Perkins (1981) fig. 26.
streams: Plutarch, *Lucullus* 39; Seneca, *Letters* 55.6, 89.20; Purcell (1987) 192–193.
cooler air: Statius, *Silvae* 1.2.154–157, 1.3.58; cf. Pliny, *Letters* 5.6.30; Grimal (1984) 297–298; and S. Giedion, *Architecture and the Phenomena of Transition* (Cambridge, 1971) 298.
cooling potential: it is said that an acre of turf has the cooling effect of a 70-ton air conditioner (1 hectare that of a 173-metric ton machine) (*New York Times* (May 19, 1991, E-19). Juvenal 3.18 regrets that marble had replaced green grass within grottoes.
reassuring sounds: Seneca, *Letters* 86.7, speaking of the baths; Pliny, *Letters* 5.6.23 (the murmur of tiny jets) and 5.6.40 (the sound of streams).

178 Arcadian leisure: Pavlovskis (1973) discusses the literary evidence for man-made villa luxury features.
Efficient irrigation: Ricotti (1989–1900); Jashemski and Ricotti (1992).
effects: Bergmann (1991).
imitation rusticity: *Letters* 5.6.35.
weight of the diners: *Letters* 5.6.36; Pavlovskis (1973) 32.

Campanian: data from Jashemski (1979); see also Lehmann (1953) and F. M. P. Francissen, "A Century of Scientific Research on Plants in Roman Mural Painting," *Rivisita di studi Pompeiani* 1 (1987) 111–122.
espaliering: suggested by root cavities at the foot of a Pompeian wall with appropriate nail patterns (conversation with Wilhelmina Jashemski, January 1988).
physical evidence: in Jashemski and Ricotti (1987–1988) and (1992).

179 Martial: *Epigrams* 8.68.
Roman cookbooks: J. André, *L'alimentation et la cuisine à Rome* (Paris, 1974); Ricotti (1983) where 207–218 are on Apicius. Pliny, *Letters* 2.17.15 mentions a vegetable garden.
garlanded live: Pliny, *Letters* 5.6.32.
beehive-shaped mounds: Jashemski (1979) 82.
Cicero: *To Quintus* 3.5.

180 Villa soils: Jashemski and Ricotti (1992) 595–597.
pumice: Jashemski (1979) 256.
"Lucian": *Amores* 11.18.
Pompeii: Jashemski (1979) 33.
Fences appear: p. 161, above.
sundials: Vitruvius 9.7 and 8 (including water-clocks); Lehmann (1953) 11–12; S. L. Gibbs, *Greek and Roman Sundials* (New Haven, 1976); Jashemski (1979) 112; De Caro (1987) fig. 31.
groves: Meiggs (1982) 274–278 on ornamental trees.
hunting parties: Ricotti (1982) 37.

181 to the south: cf. Tacitus, *Annals*, "wooded ground alternating with clear spaces and open landscapes" (15.42).
viewing places: not all views were artificial, as De Franceschini (1991) 638 claims.
major views: see Seneca, *Letters* 90.5, and Pavlovskis (1973) 15 for windows and their functions, as well as the inside-outside analyses of H. Drerup, "Die römische villa," *Marburger Winckelmann-Programm* (1959) 1–24 and "Bildraum und Realraum in der römischen Architektur," *RM* 66 (1959) 147–174.

182 elaborate concoction: Cicero, *To Atticus* 1.16.
Domus Aurea: Suetonius, *Lives, Nero* 31; Ward-Perkins (1981) 55–61.

183 available elsewhere: Balsdon (1969); Millar (1977) ch. 3, pts. 2, 3; Turcan (1987).

184 appeared unguarded: HA, *Hadrian* 17.6–8, 20.1; Dio 69.6.3, 7.2, 9.3, 10.1.

serious threat: HA, *Hadrian* 7.1–4 (note the mad servant in 12.5); Dio 69.1–5.

in doubt: HA, *Hadrian* 7.1–3, much discussed; see, e.g., Garzetti (1974) 383–384, 683 and Syme, "Hadrian and the Senate," *RP* 4, 296–299.

ideal force: augmented perhaps by the guards cavalry, the *equites singularis Augusti* (Millar [1977] 63).

food ration: Davies (1989) ch. 9.

hay and grain: Hyland (1990) 91–92; Davies (1989) 52 gives 53 tons of barley.

inscriptions: see p. 6, above.

Levens Hall: H. Hobhouse, *Private Gardens of England* (New York, 1986) 192–197, who stresses the high cost of topiary.

Money matters: scattered information in the texts, e.g., in Cicero, *To Atticus* 1.8, 1.9, 4.2 and *To Quintus* 3.2; in Pliny, *Natural History* 35.130, 136, 155–156; and in Plutarch, *Lives, Caius Marius* 34; comparative materials in D'Arms (1970) 179–180, no. 15; A. Burford, *Craftsmen in Greek and Roman Society* (London, 1972) 136–144; R. Duncan-Jones, "The Finances of the Younger Pliny," *PBSR* 33 (1965) 177–188, and (1982) 124–131, 157–163, 215, and ch. 5; and B. Ward-Perkins, *From Classical Antiquity to the Middle Ages: Urban Public Building . . .* (Oxford, 1984) 1–13.

hoard: Aurigemma (1969) 59, giving 1887, and (1961) 174, giving 1881; but see *NS* (1880) 479.

unknown to specialists: William E. Metcalf and Clive Foss kindly responded to our inquiries. See also De Franceschini (1991) 15.

Ostia: Duncan-Jones (1982) 157 no. 439.

public road: Duncan-Jones (1982), 157 no. 454.

Lanuvium: Duncan-Jones (1982) 163, no. 506; for sculpture costs see also Neudecker (1988) 115.

Fronto: p. 5, above.

Como: Duncan-Jones (1982) 157, no. 441.

luxury items: Petronius paid 300,000 sesterces for a fluorspar ladle (Pliny, *Natural History* 37.20); cf. Seneca, *Letters* 86.6–7.

185 Lucullus: D'Arms (1970) 184–186, no. 22.

three times that: Pliny, *Natural History* 36.115.

100,000 sesterces: Duncan-Jones (1982) 349, no. 3, cf. nos. 15, 16; one scholar brought 700,000 (349, no. 1).

freedmen: Millar (1977) 69–83.

narrow cells: *Satires* 1.8.8; cf. Tacitus's "nations of slaves" (*Annals* 3.53).

human habitation: De Franceschini (1991) 626 says the Canal Block housed slaves.

service staff: insolence and tale-telling for money were unknown (Dio 69.7.4); cf. HA, *Hadrian* 17.4, 21.3. For personal staffs, see G. Boulvert, *Domestique et fonctionnaire sous le Haut-Empire* (Paris, 1974), and Turcan (1987) 51–63.

amphitheatre: second century; C. F. Giuliani, *Tibvr: Pars Prima* (Rome, 1970) 239–243, and fig. 222 for the theatre in the precinct of the Temple of Hercules Victor.

Misenum: Duncan-Jones (1982) 215, no. 1309; cf. Pliny, *Letters* 2.17.26.

waterclock: Vitruvius 9.7; A. G. Drachmann, *The Mechanical Technology of Greek and Roman Antiquity* (Copenhagen, 1963) 182–193.

into the night: common elsewhere; Balsdon (1969) 29 gives the evidence.

subterranean complex: Ricotti (1978–1980) 292.

186 few Villa kitchens: Ricotti (1978–1980), 287–294. Pliny, *Natural History* 18.7 implies the existence of huge Roman kitchens.

Pompeii and Ostia: Ricotti (1978–1980) 239–272 (Pompeii), 273–279 (Ostia).

equally modest: the Pompeian Houses of the Vetii and the Dioscuri are examples of exceptions. Winnefeld (1895) 103–104 sensibly suggests that the building at the Fountain Court east corner (his pl. X, room B) may have been a kitchen.

Seneca: *Letters* 78.23.

petitioners: Pliny, *Letters* 6.31.2–12 records cases and details.

two hundred carriages: details of both trips in J. T. Alexander, *Catherine the Great* (New York, 1989) 107–111, 256–261.

approachable: HA, *Hadrian* 20.1; cf. 17.5.

witty: HA, *Hadrian* 20.8, followed by a jest; cf. 16.3–4, 17.6.

charming: Dio 69.2.6 [2].

inferred: Pliny, *Letters* 5.6.45, 6.32.14 (with Trajan at Civitavecchia).

sarcastic: HA, *Hadrian* 15.11, 16.8.

Cicero: *To Atticus* 1.4, 8, 9.

would be needed: implied in HA, *Hadrian* 1.5,

3.1, 14.8–9, 15.5, 16.1–7, 25.9–10, and by Dio 69.3.1–2, 4.3, and perhaps 17.3.

memory: HA, *Hadrian* 20.7, 9–10.

also records: HA, *Hadrian* 11.1, 4.9–12.

187 sixteen sleeping rooms: *Letters* 2.17.6–13, 20–24; Wallace-Hadrill (1988) 93–94.

privacy: Wallace-Hadrill (1988) 81, 96; cf. Pliny, *Letters* 2.17.24.

running water: according to Statius, *Silvae* 1.3.37, every bedroom of the Manilius Vopiscus villa at Tivoli was so equipped; Pavlovskis (1973) 17–18.

equality of space: Wallace-Hadrill (1988) 50–51. Cf. the comparable arrangement, complete with service corridors, in the House of Fabius Rufus in Pompeii: plan and illustrations in A. Barbet, *La peinture murale romaine* (Paris, 1985) 241–243. Such suites had a long run: see, e.g., J. S. Boersma, *Amoenissima civitas: Block V.ii at Ostia . . .* (Assen, 1985) 194–195, fig. 186, and the Piazza Armerina villa three-room suite that centers on a small semicircular courtyard and gives on to the southern part of the great trans-villa corridor (fig. 239 here).

gesture: cf. Hadrian's amphitheatre herald: Dio 69.6.1–2.

Pliny and others: *Letters* 5.6.41; cf. Martial, *Epigrams* 10.51, and Seneca, *Letters* 55.1.

strength: HA, *Hadrian* 26.1, Dio 69.10.3 [2].

harsh conditions: HA, *Hadrian* 10.2, 17.9.

HA: *Hadrian* 26.2.

Dio: Dio 69.7.3; cf. HA, *Hadrian* 2.1, 20.13, 26.3.

injured: HA, *Hadrian* 36.3, Dio 69.10.12.

devoted: HA, *Hadrian* 20.13.

tomb: the same, and Dio 69.10.2.

inscribed: *CIL* 12.1122.

teams: Mastor, e.g., one of Hadrian's hunting companions (Dio 69.22.2).

called it: Dio 69.10.2.

Doubts exist: W. Ramsay, *The Historical Geography of Asia Minor* (London, 1890) 155 (but 437); D. Magie, *Roman Rule in Asia Minor* 1 (Princeton, 1950) 616–617, and 2, 1476–1477.

Pliny: *Letters* 5.6.48.

188 entire passage: HA, *Hadrian* 26.1–5.

attended by: Dio 69.7.3. Cf. HA, *Hadrian* 9.7; he watched banquet costs closely, 22.5. Balsdon (1969) 41–53 and notes for etiquette, menus, etc.; see also D'Arms (1991).

surpassed: HA, *Hadrian* 17.5; cf. 17.3.

good eater: Fronto, *Letters to Antoninus* 3.4.

wine: HA, *Hadrian* 3.2, from the lost autobiography.

music: Fronto, *Letters to Antoninus* 3.4; cf. Julian, *The Caesars:* "Next entered an austere-looking man [Hadrian] with a long beard, an adept in all the arts, but especially music, one who was always gazing at the heavens and prying into hidden things" (311.C–D).

played an instrument: the flute, as HA, *Hadrian* 14.9, is translated, or the cithara, according to Camotti (1989) 54, who adds that Hadrian subsidized Mesomedes, a famous citharode, and supported his studies.

concerts: Camotti (1989) 53–54.

Juvenal: 7.1–3. On Hadrian, Juvenal, and other literary lights, see the brilliant passage in Syme (1986) 15–17; cf. Yourcenar (1957) 225.

mnemonic systems: *To Herrenius* (author unknown, traditionally Cicero) 3.28–40.

were the norm: Balsdon (1969) 44–49 gives the sources.

Apollo: Plutarch, *Lucullus* 41.5; thus choices, perhaps, not only of degrees of luxury but of topical inspiration as well.

other emperors: Suetonius, *Lives, Tiberius* 42.2, for example.

same food: HA, *Hadrian* 17.4, cf. 22.5.

had opinions: HA, *Hadrian* 20.7.

tormented specialists: HA, *Hadrian* 16.8, 9; cf. 15.11.

studied: Dio 69.3.1. He began Greek studies early and was called "the Greekling" (HA, *Hadrian* 1.5); his Latin pronunciation was laughed at, so he perfected it (3.1).

archaic: HA, *Hadrian* 16.5.

preference: HA, *Hadrian* 15.6.

quite obscure: HA, *Hadrian* 16.2.

189 defense: HA, *Hadrian* 15.11.

Epictetus and Favorinus: HA, *Hadrian* 16.10.

names of ten men: Dio 69.17.3.

story: HA, *Hadrian* 20.2.

in tents: Grimal (1984) 297; for Hellenistic royal precedents, E. B. Smith, *Architectural Symbolism of Imperial Rome and the Middle Ages* (Princeton, 1956) 110, and Ricotti (1989); cf. Cicero, *On Orations* 3.64.63, and Seneca, *On Good Works* 6.13.1.

Horace: *Odes* 2.15.

Statius: *Silvae* 2.2.30–31.

Cicero: *On the Laws* 3.13.

gardens and grounds: Ridgeway (1981) for Greek antecedents.

finds elsewhere: e.g., at the Oplontis Villa of Poppea (De Caro [1987]).

Muses and nymphs: D. K. Hill, "Nymphs and Fountains," *Antike Kunst* 17.2 (1974) and (1984) 90–91.

seventy versions: Hill (1981) 90.

Most of these: e.g., Jashemski (1979) ch. 2, 115–140, 301–305.

Water ran: Jashemski (1979) 43–49; Hill (1981) 89–91.

mouths: e.g., Hill (1981) fig. 10.

portrait heads: e.g., of Epicurus.

Benghazi Venus: in the University of Pennsylvania Museum.

patrons relished: De Caro (1987), "wild nature evoked in the cultured order of a garden" (129).

Statius: *Silvae* 2.4.

190 Varro: *De re rustica* 3.5.9–17.

much curiosity: Toynbee (1973) ch. 23 on birds in Roman times.

Xenophon: *Anabasis* 1.2.7, *Cyropaedia* 1.3.14, *Hellenica* 4.1.15, and cf. *Cyropaedia* 1.4.7; Strabo 5.2.5. Cf. De Franceschini (1991) 635, 642, 646.

west rooms: Hoffmann (1980) 14.

Seneca: *Letters* 78.23; cf. Petronius, *Satyricon* 31, and Ricotti (1973) 247.

Saladin's gift: S. Runciman, *A History of the Crusades* 2 (Cambridge, 1954) 72.

effects unknown: C. Elling, *Rome: The Biography of Its Architecture from Bernini to Thorvaldsen* (Tübingen, 1975) 529–531, and J. Tanizaki, *In Praise of Shadows* (New Haven, 1977) 35–38, on the artistic advantages of preindustrial lighting.

marble bases: Toynbee (1934) 234 and pp. 296–297, below.

detailed in print: e.g., by D. E. Strong, *Greek and Roman Gold and Silver Plate* (London, 1979) chs. 8, 9; R. Higgins, *Greek and Roman Jewellery*, 2d ed. (London, 1980); Cima and La Rocca (1986); Gnoli (1988).

live accordingly: Tacitus, *Annals* 3.55; La Rocca (1986) 3–35; Wallace-Hadrill (1988) 45–47.

191 Glassblowing: D. B. Harden, *Glass of the Caesars* (Milan, 1987) 87–91.

challenged: Harden, *Glass of the Caesars*, for optimum illustrations.

Stadium Garden: Hoffmann (1980) 8, 15 (tesserae), 42, and pl. 52.3 (inlay).

192 mostly blue: for the famous Egyptian blue, Lavagne (1988) 430–437; Wallace-Hadrill (1988) 74–75 on the rank order of colors.

Island Enclosure: Ueblacker (1985) 20, pl. 45.

survive in a vault fresco: Cima and La Rocca (1986) 125, pl. 45.

glass and marble floor: MacDonald (1982) 21–24.

Seneca: *Letters* 86.6.

columns: Jashemski (1979) 152.

fountains: Neuerburg (1965) 95–96 and nos. 22, 25, 26, 27, 28, 32, 37–39, 130; Jashemski (1979) 41–43.

Pliny: *Letters* 2.17.21, cf. 5.6.30.

Pantheon: MacDonald (1982) 110.

Athens library: Pausanias 1.18.9.

gleaming gems: Pausanias 2.17.6.

ivory and gold: Pausanias 1.18.6.

HA: *Hadrian* 12.2.

Poseidon: Pausanias 2.1.7–8.

sparingly: HA, *Hadrian* 8.7; Dio 69.7.1; R. J. A. Talbert, *The Senate of Imperial Rome* (Princeton, 1984) 50, 56, 168, 179, 296.

HA: *Hadrian* 8.6, cf. 3.1.

managed from great houses: for the setting, see Wallace-Hadrill (1988) esp. 54–56; cf. Vitruvius 6.5 and Millar (1977) 209.

Suetonius: *Lives, Vespasian* 21.

Whatever business: Millar (1977) 209, 328–331 shows how detailed this work could be; cf. 450–451, 558–560. Davies (1989), in recording the scale of military paperwork, suggests that of the imperial secretariats; cf. HA, *Hadrian* 11.1.

dictation: HA, *Hadrian* 20.7, cf. 20.11.

shorthand: Seneca, *Letters* 90.25; Millar (1977) 235.

copyists: Millar (1977) 235.

translators: Suetonius, *Lives, Augustus* 89.1; Eusebius, *Life of Constantine* 4.32.

tabularium: Millar (1977) 263–264.

scrinium: Pliny, *Letters* 10.65–66; HA, *Alexander Severus* 31.1.

viatores: Millar (1977) 68. Hadrian established a regular posting service (HA, *Hadrian* 7.5); he himself traveled rapidly (13.5).

193 Formal meetings: HA, *Hadrian* 18.1; cf. Pliny,

Letters 6.31.1-12, and Millar (1977) 268-269, cf. 120, 223.

Library: Gusman (1908) 66; Lugli (1927) 183-184; L. Bruce, "Palace and Villa Libraries from Augustus to Hadrian," *Journal of Library History* 21.3 (1986) 526-535, offprint kindly provided by the author.

Domus Flavia: MacDonald (1982) ch. 3.

Augustus: Suetonius, *Lives, Augustus* 72.2.

Albano: a palace (Purcell [1986] 195).

palatium: evidence in "Palatium," *RE* 18.3 (1949) 5-81, and S. Viarre, "Palatium 'palais,'" *Revue de philologie* 35 (1961) 241-248.

Dio: 53.16.5-6; cf. HA, *Thirty Tyrants* 30.27, and Aurelius Victor 15.

word palace: used, e.g., by Richmond (1969) 260; Ricotti (1973) 219, n. 1; and Stierlin (1984) 124-125, ch. 7; cf. Raeder (1983) 122-124, and Boatwright (1987) 141. Denied by Giuliani (1975) 4, with whom we agree; Millar (1977) 25, because he finds no Villa buildings suitable for the emperor's official duties; and Raeder (1983) 283, 351-352, no. 432.

called a town: the comparison of the Villa to a town or city begins with Pius II, appears first in English in Warcupp (1660) 315, and continues to be made, as, e.g., by De Franceschini (1991) 638, 657.

Pliny: *Letters* 2.17.27; cf. Sallust, *Cataline* 12.

does not have: MacDonald (1986) chs. 2-5 for these urban elements.

194 thermal waters: Rutilius Namatianus, *On His Return* 249-276.

part of the site: Torelli (1985) 115-117; not Trajan's villa, W. Heinz, "Die 'Terme Taurine' von Civitavecchia," *Antike Welt* 4 (1986) 22-43.

Palestrina: L. Quilici, "L'impianto urbanistico della città bassa di Palestrina," *RM* 87 (1980) 171-214. In 1795 the Antinous as Bacchus (Antinous Braschi), now in the Sala Rotonda of the Vatican Museums, was found there.

Baiae: HA, *Hadrian* 25.5; "the old villa of the Caesars" (D'Arms [1970] 106-111) is suggested by A. Maiuri, *The Phlegraean Fields*, 3d ed. (Rome, 1958) 68.

disease of building: Plutarch, *Lives, Poplicola* 15.5; cf. Pliny, *Panegyric* 51.

but to work: Kähler (1950) 21; McKay (1975) says that "in all likelihood, Hadrian . . . rarely visited or enjoyed" the Villa (132).

his interventions: this and the following sentence express suggestions made by Heinrich Hermann; cf. Seneca's "kingdoms" in his *Letters*, 89.20.

195 Athens: Willers (1990).

196 Peutinger Table: K. Miller, *Die Peutingerische Tafel* (Stuttgart, 1962, a reprint); *Tabula Peutingeriana* (plates) and E. Weber, *Kommentar* (both Graz, 1976).

Plutarch: *Political Precepts;* see Syme (1982) 14-15 and Bowersock (1969) 105-112. Plutarch, who was in Rome in the early 90s, dedicated a statue to Hadrian at Delphi. In his *Parallel Lives* he treats Greeks and Romans impartially.

more a Greek: Syme (1982) 16; cf. Syme (1965) 247.

long evolution: Bowersock (1969); Syme (1982).

Townley relief: Cook (1985) 14 and fig. 8.

Florus's squib: HA, *Hadrian* 16.3.

Pantheon: W. L. MacDonald, *The Pantheon — Design, Meaning, and Progeny* (London and Cambridge, Mass., 1976) ch. 4.

197 gravely ill: HA, *Hadrian* 24.1; Dio 69.17.1, 20.1, 22.1-4.

at the Villa, HA, *Hadrian* 23.7.

succession: Garzetti (1974) 334-410; Syme (1986) summarizes his own conclusions at 17-18.

longed to die: Dio 69.17.2, 69.22.3.

adoption: HA, *Antoninus Pius* 4.5-6.

his remains: HA, *Antoninus Pius* 5.1; D'Arms (1970) 104-105.

Marcus Aurelius: HA, *Marcus Aurelius Antoninus* 6.1.

all the gods: Pausanius 1.5.5.

198 the record: Block (1947) 173-175; Kähler (1950) 171, n. 2; Aurigemma (1961) 26-19; Raeder (1983) 282-284.

nine Antonine: Raeder (1983) 9, 56, 59, 65, 109, 121, 122, and II, 15, 19.

199 no Severan: Raeder (1983) 70, 72, 95, and II, 15, 19.

handful of stamps: Winnefeld (1895) 28-29; Block (1947) 175, 315.

heavy fighting: Hodgkin (1885) chs. 18-20; J. B. Bury, *History of the Later Roman Empire* 2 (London, 1931) ch. 19, sections 2-6.

dismantled it previously: Procopius, *Wars* 7.24.31-33.

suggestion: Nibby (1827) 7; Hodgkin (1885) 577.

room 18: MacDonald and Boyle (1980) 8.

population of outcasts: but the vast underground regions may have kept them away out of fear of resident spirits; cf. Plautus, *Mostellaria* (artificial house-haunting), and Pausanias 1.32.3-4 (the ghosts of Marathon). Nardi (1960) 178-179 and Luck (1985) 165-171 comment on ghosts and spirits in antiquity. See also p. 206, below.

but many did: De Franceschini (1991) 654 says that later villas were only imitations of Hadrian's.

huge villas: useful summary by Wilson (1983) 73-85.

Lanuvium . . . Alsium: Mielsch (1987) 88-89.

Sette Bassi: T. Ashby, "Classical Topography of the Roman Campagna, III. (The Via Latina); Section I," *PBSR* 4 (1907) 97-112; N. Lupu, "La villa di Sette Bassi sulla Via Latina," *Ephemeris Dacoromana* 7 (1937) 117-188; Bloch (1947) 256-268 and "Sette Bassi Revisited," *HSCP* 63 (1958) 401-414.

Quintilii: T. Ashby, "La Villa dei Quintilii," *Ausonia* 4.1 (1909) 48-88; sketch plan in Mielsch (1987) fig. 61.

200 seaside villa: Ward-Perkins (1981) 196-198, plan fig. 119.

incurving stretch: cf. the seaside "theatre" at Silin (E. S. P. Ricotti, "Le ville maritime di Silin [Leptis Magna]," *RendPontAcc* 43 [1970-1971] 135-148, and *EAA Supp.* [1970] figs. 907-908).

Anguillara Sabazia: Mielsch (1987) 54, plan fig. 28. Huge exedras appeared at least as early as 60 B.C., in Lucullus's estate on the Pincian (Coarelli [1989] 263-264), and were still in use in the early Middle Ages, ca. 810 (K. J. Conant, *Carolingian and Romanesque Architecture, 800-122*, 2d ed. [Harmondsworth, 1966] 60 and fig. 18), and in the Great Palace in Constantinople (the Sigma, p. 204, below).

large estate: A. M. Colini, "*Horti spei veteris, Palatium Sessorianum,*" *MemPontAcc* 8 (1955) 137-177; Mielsch (1987) 90-91, sketch plan fig. 63.

Centocelle: T. Ashby and G. Lugli, "La villa dei Flavi cristiani 'ad duas lauros,'" *MemPont-*

Acc 2 (1928) 157–192; Mielsch (1987) 91, plan fig. 65.

villa of Maxentius: G. P. Sartorio and R. Calza, *La villa di Massenzio sulla Via Appia* (Rome, 1976); L. Cozza, *La residenza imperiale di Massenzio* (Rome, 1980).

201 Piazza Armerina: Ward-Perkins (1981) 460–464; Wilson (1983), with an excellent summary (34–39) of the evidence for dating; MacDonald (1986) 274–283. A. Carandini et al., *Filosofiana: La villa di Piazza Armerina* 2 vols. (Palermo, 1982) focus on function, ownership, dating and mosaics.

Marina di Patti: Wilson (1983) 73, 75–77, plan pl. 48.

Desenzano: E. Ghislanzoni, *La villa romana in Desenzano* (Milan, 1962).

fine poem: *Mosella;* cf. Pavlovskis (1973) 33–39.

details and forms: *Mosella* 298–299.

202 Varro's *Hebdomades: Mosella* 305–307.

poem: *Carmen* 22.

burgus: Carmen 22.6.

In a letter: *Letters* 2.2.

of distinction: *Letters* 2.2.8.

Olympiodorus: A. Cameron, "Wandering Poets: A Literary Movement in Byzantine Egypt," *Historia* 14 (1965) 470–509; J. F. Matthews, "Olympiodorus of Thebes and the History of the West," *JRS* 60 (1970) 78–97, and Matthews (1975) 383–386. With thanks to Kenneth Holum.

203 features of a city: Matthews (1975) finds "the racecourses frankly hyperbolic" (384, n. 2).

Rutilius Namatianus: Pavlovskis (1973) 39–44.

Procopius: A. Cameron, *Procopius and the Sixth Century* (Berkeley, 1985) 84–86.

Venantius Fortunatus: Pavlovskis (1973) 52–53; cf. Cassiodorus, *Institutiones* 1.29. For Petrarch's Plinyesque villetta, see his *Family Letters* 13.8 and Coffin (1988) 9–10.

Hadrianic in origin: R. Krautheimer, *Three Christian Capitals* (Berkeley, 1983) 107.

domuscultae: P. Llewellyn, *Rome in the Dark Ages* (London, 1971) 207.

body of men: Llewellyn, *Rome in the Dark Ages,* 264.

Capracorum: J. C. Wickham, "Historical and Topographical Notes on Early Medieval South Etruria (Part One)," *PBSR* 46 (1978) 132–179.

Great Palace: described by Krautheimer (1975) 366–369.

Constantine I: Janin (1964) 108–113; G. Dagron, *Naissance d'un capital* (Paris, 1974) 92–97; C. Mango, *Le développement urbain de Constantinople* (Paris, 1985) 26–27.

influential model: see, e.g., Krautheimer (1975) 370 and S. Ćurčić, "Some Palatine Aspects of the Capella Palatina in Palermo," *DOP* 41 (1987) 144; the Slavic connection lies outside our range.

archaeological evidence: E. Mamboury and T. Wiegand, *Die Kaiserpaläste von Konstantinople* (Berlin, 1934), whose overall plan is found in A. M. Schneider, *Byzanz: Vorarbeiten zur Topographie . . .* (Berlin, 1936 = *Istanbuler Forschungen* 8); W. Müller-Weiner, *Bildlexikon zur Topographie Istanbuls* (Tübingen, 1977) 229–237.

Book of Ceremonies: text, translation, and commentary of Book I, chs. 1–93, in Vogt (1935–1940); A. Toynbee, *Constantine Porphyrogenitus and His World* (New York, 1973) 185–191, 601–604.

architecture: note also the Rhegium palace, on the Marmara north shore (late fifth/early sixth century), with independent buildings joined by courtyards and terraces (Krautheimer [1975] 370): he places it (371) in an evolutionary sequence running from Hadrian's Villa to Piazza Armerina to both the Medinat-al-Zahra, near Cordoba (Hoag [1977] 80–83), begun in 936, and the Great Palace.

excavated peristyle: Brett et al. (1947); Rice (1958).

Chalke: C. Mango, *The Brazen House: A Study of the Vestibule of the Imperial Palace of Constantinople* (Copenhagen, 1959 = *Arkæologisk-kunsthistoriske Meddelelser* of the Royal Danish Academy, 4.4).

New Church: Krautheimer (1975) 376–377, 525, n. 5.

paper restorations: Ebersolt (1910); Vogt 3 (1935).

overall plans: J. Labarte, *Le palais impérial de Constantinople et ses abords* (Paris, 1861); A. G. Paspates, *Ta byzantina anaktora . . .* (Athens, 1885); Ebersolt (1910); Vogt 3 (1935); S. Miranda, *Les palais des empereurs byzantins* (Mexico City, 1964).

204 Chrysotriklinos: Janin (1964) 115–117; Kraut-

heimer (1975) 242–243 assesses the building's historical position.

Sigma: Janin (1964) 424–426; cf. the detail in the Damascus Great Mosque mosaics, shown, e.g., in Grabar (1978) ill. 78.

Triconchos: Janin (1964) 116.

Pantheon: Janin (1964) 116.

Hall of the Muses: Janin (1964) 114.

Hagia Sophia: Procopius, *Buildings* 1.1.20–78, but more particularly Paul the Silentiary (H. Kähler and C. Mango, *Hagia Sophia* [New York, 1967] references on 71, quotations from Paul on 30, 33, 36, 45) and Agathias (J. D. Frendo, *Agathias: The Histories* [Berlin, 1975] 143–145 [= *Histories* 5.9]).

dramatic automata: Luidprand of Cremona, *Antapodosis* 6.5, trans. F. A. Wright, *The Works of Liudprand of Cremona* (London, 1930) 207–208); G. Brett, "The Automata in the Byzantine Throne of Solomon," *Speculum* 29.3 (1954) 477–487.

Alhambra: Krautheimer (1975) 369–370; Hoag (1977) 122–134; Grabar (1978) 130–131, 157.

suggestion: Krautheimer (1975) 370.

early Islamic: Krautheimer (1975) 370–371.

Kufa: Creswell (1989) 10–15, plan fig. 2.

Ashir: Hoag (1977) 74, plan fig. 76. Also in Algeria, the Qala of the Beni Hammas (beside the fortress of Takerboust in the Grand Kabylie and dating from the eleventh and twelfth centuries), with its large, shallow artificial lake, round buildings, and combination of eccentric and orthogonal axes, belongs in the broadest sense, accidentally or not, to the Hadrian's Villa tradition and is similar to the Villa in size (Hoag [1977] 74–76, plan fig. 80).

closely related: the Generalife pool and fountains (in Grenada) recall the north pool and fountains of the Stadium Garden.

205 Great Mosque: Creswell (1989) 46–73, begun in 706 by Al-Walid.

made by artists: Krautheimer (1975) 370–371. Great Palace comparisons, Rice (1958) 128–129, 133.

richly executed views: e.g., Hoag (1977) figs. 20–21 and Creswell (1989) figs. 35–37.

paradeisos: p. 190, above; Hoag (1977) says "the Koranic paradise is probably the subject" of the mosaics (27).

Campanian paintings: e.g., Lehmann (1953)

pls. 14, 17; cf. the Damascus details in Hoag (1977) fig. 21 and Creswell (1989) fig. 36.

Great Palace mosaic: Rice (1958) frontispiece, pl. 46A, and 131.

Passio sanctae Symphrosae: J. B. O'Connell, ed., *The Roman Martyrology* (Westminster, 1962) 149; T. Ruinart, *Acta Martyrum sincera* (Rome, 1713) 18–20.

embellishment: A. D. Nock, "Hagiographia," *Journal of Theological Studies* 28 (1927) 416; we thank Joe Solodow for this reference.

206 Tall watchtowers: Ashby (1908) 220; Lanciani (1909) 65–66.

Volpaia's map: T. Ashby, *La Campagna Romana al tempo di Paolo III: Mappa della Campagna Romana del 1547 di Eufrosino della Volpaia riprodotta dall'unico esemplare esistente nella Biblioteca Vaticana* (Rome, 1914); A. P. Frutaz, *Le carte del Lazio* (Rome, 1972) 1, 20–22, and 2, pls. 25–30.

Tomb of the Plautii: G. Tomassetti, *La Campagna romana antica, medioevale e moderna*, 6th ed. (Rome, 1979) 603.

Santo Stefano: W. St. Clair Baddeley, *Villa of the Vibii Vari near Tivoli at Colli di S. Stefano* (Gloucester, 1906) 3.

San Pietro in Tivoli: M. De Vita, "Il restauro della chiesa di S. Pietro in Tivoli," *BA* 36 (1951) 174–179.

porporina: F. Corsi, *Delle pietre antiche* (Rome, 1845) 145–146. Cf. Gnoli (1988) fig. 239 for *breccia di Villa Adriana*, correctly called *breccia Quintilina*.

Bulgarini . . . villa: the Bulgarini purchased the land centered on the Southern Range from the heirs of Bindo Altoviti ca. 1621; Lanciani (1909) 139. See H. N. Humphreys, *Rome and Its Surrounding Scenery* (London, 1845), for a print of the Bulgarini villa, and Belli Barsali and Branchetti (1975) 319 for a photograph.

Casino Fede: built in 1704; Belli Barsali and Branchetti (1975) 320.

207 Flavio Biondo: see B. Nogara, *Scritti inediti e rari di Biondo Flavio* (Rome, 1927) 194–202, for Biondo's letter dated September 24, 1461, to Gregorio Lolli, in which the Villa is described. Biondo's discussion of the Villa was included in the supplement to his *Italia illustrata*, dedicated to Pius II in the following year: F. Biondo, *Roma ristaurata et Italia illu-*

strata, trans. L. Fauno (Venice, 1542) 105. See also R. Weiss, *The Renaissance Discovery of Classical Antiquity* (New York, 1973) 106–108.

mortal things: Aeneas Sylvius Piccolomini, *Memoirs of a Renaissance Pope: The Commentaries of Pius II*, trans. F. A. Gragg (New York, 1959) 193, 328–329. The pope errs in stating that the Villa used water from the Aniene. Also see R. Rubinstein, "Pius II and Roman Ruins," *Renaissance Studies* 2 (1988) 197–203.

208 Palace of Afrasiyab: G. Necipoğlu, *Architecture, Ceremonial, and Power: The Topkapi Palace in the Fifteenth and Sixteenth Centuries* (Cambridge, Mass., 1991) 3.

Villa's association: E. Parlato, "L'iconografia imperiale," *Da Pisanello alla nascita dei Musei Capitolini: L'antico a Roma alla vigilia del rinascimento* (Rome, 1988) 82; J. R. Spencer, "Filarete, the Medallist of the Roman Emperors," *AB* 61 (1979) 550–561.

literary fabrication: J. Burckhardt, *The Civilization of the Renaissance in Italy* (London, 1965) 111; C. Mitchell, "Archaeology and Romance in Renaissance Italy," in *Italian Renaissance Studies*, ed. E. F. Jacob (London, 1960) 455: "in campestri loco ab accessu hominum remoto."

another draftsman: G. Scaglia, "Autour de Francesco di Giorgio Martini, ingenieur et dessinateur," *Revue de l'art* 48 (1980) 7–25, suggests that Guidoccio Cozzarelli may be one of the artists responsible for the drawings in the *Trattato*.

measuring monuments: cod. Torinese Saluzziano, 148, f. 71; Maltese 1 (1967) 275.

Francesco's drawings: see C. H. Ericsson, *Roman Architecture Expressed in Sketches by Francesco di Giorgio Martini* (Helsinki, 1980) 55–62; Maltese 1 (1967) 286–287; R. J. Betts, "On the Chronology of Francesco di Giorgio's Treatises: New Evidence from an Unpublished Manuscript," *JSAH* 36 (1977) 3–14; M. Harder, *Entstehung von Rundhof und Rundsaal im Palastbau der Renaissance in Italien: Untersuchungen zum Mantegnahaus in Mantua und zu den Traktaten des Francesco di Giorgio Martini* (Freiburg, 1991) 166–167; and H. Burns, "I disegni di Francesco di Giorgio agli Uffizi di Firenze," in *Francesco di Giorgio architetto*, ed. F. P. Fiore and M. Tafuri (Milan, 1993) 331–334, 353. Four sketches in the Uffizi

record Villa features: 319Ar (Island Enclosure and Fountain Court West), 319Av (Circular Hall), 320v (Island Enclosure and Fountain Court West), and 335r (Smaller Baths). These relate to drawings illustrating Francesco's architectural treatise in the Biblioteca Reale, Turin: Ms. Saluzzo 148, ff. 88v, 90r (Island Enclosure and Fountain Court West), 90v (Circular Hall).

210 Pantheon: Buddensieg (1971) 259–267.

Vitruvian theory: see L. Pellecchia, "Architects Read Vitruvius: Renaissance Interpretations of the Atrium of the Ancient House," *JSAH* 51 (1992) 377–416, esp. 390–400.

Poggio a Caiano: P. E. Foster, *A Study of Lorenzo de'Medici's Villa at Poggio a Caiano* (New York, 1974); S. Bardazzi and E. Castellani, *La Villa Medicea di Poggio a Caiano*, 2 vols. (Prato, 1981).

Barberini Codex: Hülsen (1910); Borsi (1985); A. Nesselrath, Review, *Zeitschrift für Kunstgeschichte* 52 (1989) 281–292.

211 sketchbooks: J. S. Ackerman, "Architectural Practice in the Italian Renaissance," *JSAH* 13 (1954) 4. For other sixteenth-century sketchbooks figuring the Villa, see T. Ashby, "Sixteenth-Century Drawings of Roman Buildings Attributed to Andreas Coner," *PBSR* 2 (1904) f. 123; A. Nesselrath, *Das Fossombrond Skizzenbuch* (London, 1993) ff. 8–11, 20; Hülsen (1933) 22, nos. 142, 192.

Scenic Triclinium . . . and the tombs: Vatican, cod. Barb. Lat., 4424, ff. 24, 41, reproduced by Borsi (1985) 137–208.

Guiliano's sketch: Vatican, cod. Barb. Lat., 4424, f. 41r, reproduced by Borsi (1985) 202.

Palazzo Scala: L. Pellecchia, "The Patron's Role in the Production of Architecture: Bartolomeo Scala and the Scala Palace," *Renaissance Quarterly* 42 (1989) 258–291.

212 Vasari credited Guiliano: Vasari 4 (1966) 152.

Morto da Feltro: Vasari 4 (1966) 517–518.

biography of Bramante: Vasari 4 (1966) 76.

in this district: V. Golzio, *Raffaello nei documenti, nelle testimonianze dei contemporanei e nella letteratura del suo secolo* (Vatican City, 1936) 42.

no graphic records: no High Renaissance drawings after the Villa appear to survive. See H. Günther, *Das Studium der antiken Archi-*

tektur in den Zeichnungen der Hochrenaissance (Tübingen, 1988).

Francesco di Giorgio's drawings: Rosenthal (1964) 71–72.

213 Roman sources: Rosenthal (1964).

Baldassare Peruzzi . . . Vitruvius: B. Cellini, *Opere, vita, trattati, rime, lettere* (Milan, 1968) 857–858; W. Lotz, "Mannerism in Architecture: Changing Aspects," *Acts of the XX International Congress of the History of Art* 2 (Princeton, 1963) 240.

Uffizi: Uffizi 529A; M. Licht, "I Ragionamenti—Visualizing St. Peter's," *JSAH* 44 (1985) 116–119; H. Wurm, *Baldassare Peruzzi: Architekturzeichnungen* (Tübingen, 1981) fig. 373; M. Tafuri, *Ricerca del rinascimento: Principi, città, architetti* (Turin, 1992) 219, n. 211; Moneti (1992) 86–88.

left-hand portion: the two features may have been unrelated studies, but their alignment on the page and the extension of the Basilica's flank to enclose one of the diagonal octagons strongly suggests conscious linkage.

Water Court nymphaeum: Peruzzi sketched another central-plan structure, probably Hadrianic, that may have influenced his reconstruction of the nymphaeum—the Chapel of the Holy Cross near the Lateran Baptistry (destroyed 1588); see Krautheimer (1980) 50–51.

Domus Aurea: N. Dacos, *La découverte de la Domus Aurea et la formation des grotesques à la renaissance* (London, 1969).

stufetta: H. Malme, "La 'stufetta' del Cardinal Bibbiena e l'iconografia dei suoi affreschi principali," *Quando gli dei si spogliano: Il bagno di Clemente VII a Castel Sant'Angelo e le altre stufe romane del primo cinquecento* (Rome, 1984) 34–50.

214 similar bath chamber: B. Contardi, "Il bagno di Clemente VII in Castel Sant'Angelo," *Quando gli dei si spogliano* (1984) 51–71; Joyce (1989) n. 36.

Giovanni's name: DAI photograph no. 66.2539; reproduced in De Franceschini (1991) xviii, fig. 3. Compare signature with N. Dacos and C. Furlan, *Giovanni da Udine (1487–1561)* (Udine, 1987) fig. 28.

works by Giulio Romano: G. P. Bellori, *Nota delli musei, librerie, gallerie, et ornamenti di statue e pitture ne' Palazzi, nelle case, e ne' giardini di Roma* (Rome, 1664) 64–65. Also see J. Schulz, "The Revival of Antique Vault Decoration," *Acts of the XX International Congress of the History of Art* 2 (Princeton, 1963) 90–92.

anonymous drawings: see S. Valori, *Disegni di antichità dell'Albertina di Vienna* (Rome, 1985) 155–163, for the drawings attributed by Egger to the Anonymous F. On the stuccoes these drawings depict, see Wadsworth (1924) 61–63.

Viollet-le-Duc: for Viollet-le-Duc's watercolor rendering of 1837 see *Le voyage en Italie de Viollet-le-Duc* (Paris, 1980) 133.

Palladio's guide: A. Palladio, *L'antichità di Roma* (Rome, 1554) 31. Palladio was undoubtedly aware of Pirro Ligorio's guide *Delle antichità di Roma* (Rome, 1553).

several sketches: four Villa drawings by Palladio are in the Royal Institute of British Architects—two plans of the Island Enclosure, a plan of the Larger and Smaller Baths, and a sheet of sketch plans of buildings, including the Circular Hall, the Reverse-Curve Pavilion, and the Fountain Court West. The drawings may date from an earlier visit in 1547; in a letter of that year Marco Thiene, a cousin of Palladio's patron M. A. Thiene, wrote that Palladio had been busy visiting Tivoli, Palestrina, Porto, and Albano. See Zorzi (1959) 18, n. 29, 99–100.

Francesco di Giorgio: a manuscript of Francesco's treatise in the New York Public Library (Spencer Coll. 181) is believed to have been in Vicenza and was probably consulted by Palladio. Daniele Barbaro refers to the treatise of "Francesco Sanese" in his edition of Vitruvius, on which Palladio collaborated. L. Puppi, *Scrittori vicentini di architettura* (Vicenza, 1971) 71, n. 233; A. Foscari and M. Tafuri, *L'armonia e i conflitti* (Turin, 1983) 151, nn. 82–83.

Daniele Barbaro: D. Barbaro, *I dieci libri dell'architettura di M. Vitruvio tradutte e commentati* (Venice, 1556).

Smaller Baths: other measured plans were drawn by mid-sixteenth-century architects (Valori, *Disegni di antichità*, nos. 304–305).

Palazzo Thiene: R. Wittkower, *Architectural Principles in the Age of Humanism* (New York, 1962) 80.

imperial *thermae:* see Palladio's studies of the Baths of Titus in Zorzi (1959) figs. 106–109. Vasari remarked: G. Vasari, *Le vite*, Milanesi ed., 7 (Florence, 1891) 411–412.

215 frieze: P. de l'Orme, *Le premier livre de l'architecture* (Rouen, 1648) Bk. 5, ch. 10, 213: "Pour monstrer mieux par example comme vous pouvez enricher vos mouleures, soit pour l'architrave, ou pied droit des portes ou fenestres, ievous mets encores cy-apres un autre façon d'architrave composé & fort antique: qui a esté trouvé dedans terre en la Ville-Adriano, pre de Tyuoly." Delorme's illustration appears to be based on a drawing at Windsor: Blunt (1971) 24.

stays in Rome: J.-M. Pérouse de Montclos, "Philibert de l'Orme en Italie," in *"Il se rendit en Italie": Etudes offertes à André Chastel* (Rome, 1987) 289–299.

Marcello Cervini: Lanciani 2 (1904) 116.

French faction: A. Blunt, *Philibert de l'Orme* (London, 1958) 5–6.

son Sallustio: Uffizi 677A. For other drawings of the Villa by S. Peruzzi, see O. Vasori, *I monumenti antichi in Italia nei disegni degli Uffizi* (Rome, 1980) nos. 159, 165–166.

Michelangelo: G. M. Zappi, writing in 1580, records that in the pontificate of Paul III, Michelangelo visited Tivoli "per prender disegni della Villa di Adriano" (V. Pacifici, ed., *Annali e memorie di Tivoli di Giovanni Maria Zappi* [Tivoli, 1920] 21). For the possible influence of the Villa on Michelangelo's design for Saint Peter's, see H. A. Millon and C. H. Smyth, "Michelangelo and St. Peter's: Observations on the Interior of the Apses, a Model of the Apse Vault, and Related Drawings," *RJ* 16 (1976) 197.

216 Palladio . . . Pirro Ligorio: Daniele Barbaro's *Vitruvius*, profusely illustrated by Palladio, was dedicated to Ligorio's patron Cardinal Ippolito d'Este. For Palladio's consultation of Ligorio's Mss., cf. L. Puppi, *Andrea Palladio* (Milan, 1973) 26, n. 116.

Ligorio not only: D. R. Coffin, "Ligorio, Pirro," *Macmillan Encyclopedia of Architects* 3 (New York, 1982) 9–11, provides a survey of Ligorio's career and a select bibliography. Also see R. Gaston, ed., *Pirro Ligorio: Artist and Antiquarian* (Milan, 1988), and L. R. Richardson, "The Contribution of Pirro Ligo-

rio to Classical Archaeology," *AJA* 95 (1991) 298–299.

modern archaeological dig: E. Mandowsky and C. Mitchell, *Pirro Ligorio's Roman Antiquities* (London, 1963) 7–8.

collection of classical sculpture: Ashby (1908); Raeder (1983) 191–204, who catalogues thirty-eight statues found at Hadrian's Villa and subsequently displayed in the Villa d'Este.

celebrated villa: Coffin (1960); C. Lamb, *Die Villa d'Este in Tivoli: Ein Beitrag zur Geschichte der Gartenkunst* (Munich, 1966).

217 picks, shovels: A. Venturi, "Nuovi documenti: Ricerche di antichità per Monte Giordano, Monte Cavallo e Tivoli nel secolo XVI," *Archivio storico dell'arte* 3 (1890) 196–206, esp. 198, 201. Another payment of 1567 documents the presence of the cardinal of Ferrara at the Villa (V. Pacifici, *Ippolito II d'Este Cardinale di Ferrara* [Tivoli, 1920] 127).

Descrittione: Ligorio/Graevius (1723) 8, par. 4; Ligorio's *Descrittione* was translated into French by Félibien des Avaux some time before 1702, when he read it to the members of the Académie des inscriptions et belles-lettres. See B. Rosasco, "The Sculptural Decorations of the Garden of Marly, 1679–1699," *JGH* 4 (1984) 105–106, n. 35.

exerted a powerful influence: see Ricotti "Ligorio" (1973), a thorough analysis of Ligorio's manuscripts on Hadrian's Villa, from which the details given here are largely taken.

other manuscripts: Ricotti "Ligorio" (1973) demonstrates that the manuscript of the *Trattato delle antichità di Tivoli et della Villa Hadriana* records revisions made in Ligorio's lifetime, while the manuscripts of the *Libro . . . delle antichità* were compiled posthumously.

Apsidal Hall: Ligorio/Graevius (1723) 11D.

218 Painted Stoa: Ligorio/Graevius (1723) 9B.

Piazza d'Oro: Ligorio/Graevius (1723) 13E.

Scenic Canal: Ligorio/Graevius (1723) 15E.

measured plan: Ligorio/Graevius (1723) 23B.

limitations of words: Vatican, cod. Barb. Lat., 5219, f. 135v.

general plan: already by the late sixteenth century Ligorio's plan was believed to be lost (Del Re [1611] 85).

sketch plan: Turin, Archivio di Stato, Ligorio/Antichità, XX, f. 91r. Cf. H. Thelen, "Der Palazzo della Sapienza in Rom," in *Miscellanea*

Bibliothecae Hertzianae zu Ehren von Leo Bruns, ed. F. Graff Wolff Metternich and L. Schudt (Munich, 1961) 301.

sheets . . . at Windsor: Windsor 10377r, 10389. On 10377v are sketches of the Water Court nymphaeum; see Moneti (1992) 82–84 and M. Beneš, *The Paper Museum of Cassiano dal Pozzo* (London, 1993) 134.

inscription: Blunt (1971) 76. Blunt attributes Windsor 10389 to Contini on the basis of similarities to the plan of 1668, which we dispute. Much more persuasive is the similar style of Windsor 10389 and Ligorio's autograph drawings in Turin.

drawing at Windsor: Windsor 10440; see Mariette De Vos's excellent discussion in De Franceschini (1991) xvi–xviii.

Giovannantonio Dosio: C. Hülsen, *Das Skizzenbuch des Giovannantonio Dosio im Staatlichen Kupferstichkabinett zu Berlin* (Berlin, 1933) pl. 61.

pavement recovered: portions of the pavement, excavated by Cardinal Francesco Furietti in 1736–1738, are now in the Capitoline Museum; cf. De Franceschini (1991) 339–340.

reliability: E. Mandowsky, "Some Observations on Pirro Ligorio Drawings of Roman Monuments," *RendPontAcc* 27 (1952–1954) 340.

220 Palestrina: P. Fancelli, *Palladio e Praeneste* (Rome, 1974); C. Burroughs, "Palladio and Fortune: Notes on the Sources and Meaning of the Villa Rotonda," *Architectura* 18 (1988) 59–91; H. Burns, "A Peruzzi Drawing in Ferrara," *Mitteilungen des Kunsthistorischen Institutes in Florenz* 12 (1965–66) 266.

Mannerist attitude: W. Lotz, "Die ovalen Kirchenraume des Cinquecento," *RM* 7 (1955) 7–99. The Mannerist painter Federico Zuccaro, a contemporary of Ligorio's, included a representation of the Scenic Triclinium in the decorative program of the Palazzo Farnese at Caprarola. The veduta appears in the Room of Hermathena (I. Faldi, *Il Palazzo Farnese di Caprarola* [Turin, 1981] 237).

site plan: F. Contini, *Adriani Caesaris immanem in Tyburtino Villam* (Rome, 1668), consisting of two plans, one small (54 × 19.5 cm.) and one large (220 × 78 cm.), accompanied by an eight-page key. The small plan is reproduced in Ricotti (1973a), fig. 1. A fold-out

version of Contini's plan appears in A. Kircher, *Latium: Id est, nova & parallela Latii tum veteris tum novi descriptio* (Amsterdam, 1671) 152–153. A much reduced version, based on the small plan of 1668, was published in 1751 (Ligorio-Contini [1751]).

Francesco Contini: Ricotti (1973a) 10. Francesco Barberini's younger brother Antonio served as governor of Tivoli from 1623 to 1645. See A. del Bufalo, *G. B. Contini e la tradizione del tardomanierismo nell'architettura tra '600 e '700* (Rome, 1982) 35–56, for a discussion of F. Contini's career. An eighteenth-century source connects Camillo Arcucci with the plan sponsored by Cardinal Barberini, but we have found no evidence to confirm this. Cf. C. Fea, *Miscellanea filologica critica e antiquaria* 1 (Rome, 1790–1836) 261, no. 139. On Arcucci, see J. Connors, "Virgilio Spada's Defence of Borromini," *BM* 131 (1989) 81–82.

many parts of the site: Contini (1668) title page.

221 from the valleys: Del Re (1611) 76; passage cited in Ricotti, "Ligorio" (1973) 46.

Sebastiani: Sebastiani (1828): "Urban VIII. Pont. Opt. Max. Anno XI. / Hadriani Imp Villae / Toto orbe celeberrimae / Antiquam faciem / Ex ruderibus Vix adhuc spartim exantibus / Francisco Card. Barberino jubente / Summo labore atque industria / Repraesentavit / Fran. Continus Romanus Anno Salutis 1634" (277–278). Lanciani (1909) 159 records other seventeenth-century graffiti.

several payments: Vatican, Archivio Barberini, Registro de' Mandati 1630–1636 — Card. Francesco Barberini Sr., Computisteria 80, f. 156r, no. 3789; f. 180v, no. 4050; f. 189v, no. 4164. We thank Miroslava Beneš for calling our attention to these documents, which seem first to have been noticed by Patricia Waddy.

Domenico Parasacchi: Vatican, Archivio Barberini, Registro de' Mandati 1630–1636 — Card. Francesco Barberini Sr., Computisteria 80, f. 156r, no. 3789: "SS.ri Siri li piacera pagare a m.ro fran.co Contini sc. 39 di m.ta sono p. saldo di una lista di spese fatte da 22 marzo 1636 a tt. il p.mo giug.o pross.mo passato, che si è trattenuto in Tivoli in sieme con Dom.co Parasacco p. Pigliar la pianta della Villa Adriana, e del Colle S.to Stefano impreso in d.a Villa de quali ne dovera pagare al med.o

Dom.co Parasacco sc. 22 p. compim.to di sc. 26 che deve hav.re p. giornate 52 che è stato fuori con d.o Contini p d.o serv.o a g.li 5 di giorno con f.e al conto dato, e soscrittij dal med.mo fran.co con ricevuta li 4 lugl. 1636 sc. 39."

libretto: M. Lavin, *Seventeenth-Century Barberini Documents, and Inventories of Art* (New York, 1975) 52, doc. 401: "a di 24 9bre 1637/ Donato e mandata in Inchilterra. / Una Carta grande long p.mi 20 larga p.m 7 con il desegnio della Villa Adriana con il suo libretto dentro" (III.Lib.Ric. 36–42, n.n. f. 159r). The dimensions (4.46 × 1.56 m.) are roughly twice those of the printed plan.

inventory of 1649: Lavin, *Seventeenth-Century Barberini Documents:* "Una Carta con la Villa Adriana fatta con penna et acquarella longa palmi venti quattro in circa, alta palmi otto e s'accoglie con un legno tondo col suo libretto delle discrittioni" (231).

artists and antiquarians: it may be possible to add Guarino Guarini to this list. Guarini was in Rome in the early 1640s, when his fellow Theatine Valerio Poggi could have introduced him to Cardinal Antonio Barberini. Poggi had served as *soprastante* in the construction of the Barberini Palace. Susan Klaiber notes the resemblance between the sausage-shaped choir wrapped around the oval presbytery of Guarini's San Lorenzo in Turin and the terminal feature of the Water Court nymphaeum ("Guarino Guarini's Theatine Architecture" [Ph.D. diss., Columbia University, 1993] 253). C. dal Pozzo: F. Haskell, *Patrons and Painters: Art and Society in Baroque Italy* (New York, 1971) 43–61. Among the dal Pozzo drawings at Windsor are two sheets illustrating the Island Enclosure frieze (C. Vermeule, "The dal Pozzo-Albani Drawings of Classical Antiquities in the Royal Library at Windsor Castle," *TAPA* 56 [1966] 41).

222 North Theatre: Vatican, cod. Barb. Lat., 4342, f. 45r; cod. Barb. Lat., 5219, f. 132r; Ricotti (1973a) 23–25.

naumachia: Contini (1668) key, A-6; Vatican, cod. Barb. Lat., 4804, f. 2r.

223 edition of 1751: Ligorio-Contini (1751) 2, no. A-6. For later references to the so-called Latin Theatre, see Piranesi's *Pianta* Commentary

1.3; Winnefeld (1895) 18; Gusman (1904) 206; and Aurigemma (1961) 39.

224 Gismondo Stacha: G. Gabrieli, "Il Palazzo Cesi a Tivoli," *AMST* 8 (1928) 262–268. Stacha's drawing is bound in Vatican, cod. Barb. Lat., 4426, f. 51; Palmucci's print is reproduced by Gusman (1904) fig. 55.

Catacomb of Domitilla: G. B. De Rossi, *Roma sotterranea cristiana* 1 (Rome, 1864–1877) 40.

Antonio Bosio: *Roma sotterranea* (Rome, 1632) 178, plans on 151b, c.

Colleague Berti: see J. Connors's article "Virtuoso Architecture in Cassiano's Rome," forthcoming in *Quaderni Puteani* 3.

niches and mosaics: G. Lumbroso, "Notizie sulla vita di Cassiano dal Pozzo," *Miscellanea di storia italiana* 15 (1876) 237.

model-maker: in 1640 Berti was reimbursed for materials used in making a model of the Oratorio dei Filippini (O. Pollak, *Die Kunsttätigkeit unter Urban VIII* 1 [Cologne, 1928] 441, no. 1790).

Pier Leone Ghezzi: Vatican, cod. Ott., 3107, f. 155; see R. Lanciani, "Memorie inedite di trovamenti di antichità tratte dai codici ottoboniani di Pier Leone Ghezzi," *BC* 10 (1882) 233, and L. Guerrini, *Marmi antichi nei disegni di Pier Leone Ghezzi* (Vatican City, 1971) 112.

treated architecture: O. Boselli, *Osservazioni sulla scultura antica dai manoscritti Corsini e Doria e altri scritti,* ed. P. D. Weil (Florence, 1978) 154.

225 *Antichità romane:* P. Portoghesi, *The Rome of Borromini* (New York, 1968) 4.

Roma ricercata: see C. D'Onofrio, *Roma nel Seicento* (Rome, 1969) xxv–xxvi, for an account of a visit Martinelli and Borromini made to examine antiquities on the Palatine in 1664. D'Onofrio also publishes Martinelli's manuscript guide of 1660–1663 with Borromini's annotations.

Opus architectonium: Borromini ([1725] 1964). See J. Connors, "Sebastiano Giannini: 'Opus Architectonicum,'" in *In urbe architectus: Modelli, disegni, misure — la professione dell'architetto, Roma, 1680–1750,* ed. B. Contardi and G. Curcio (Rome, 1991) 204–213.

exterior walls: Borromini ([1725] 1964) 10. Translation by J. Connors, *Borromini and the Roman Oratory: Style and Society* (Cambridge, Mass., 1980) 31.

interpretation: it should be noted that Borromini's analysis of Roman structure in this passage is incorrect; the walls are fully capable of supporting vaults without the insertion of corner columns. The removal of such columns at the Villa, for example in the Larger Baths, has not weakened the structure.

merely a copyist: Borromini ([1725] 1964) 5.

composite capitals: Blunt (1979) 70, fig. 55; I. Beck, "Il capitello composito a volute invertite: Saggio su una forma antica nella struttura borrominiana," *ARID* 6 (1971) 225–234; L. Steinberg, *Borromini's San Carlo alle Quattro Fontane* (New York, 1977) 208–217; Moneti (1992) 81.

226 using mirrors: M. Del Piazzo, ed., *Ragguagli Borrominiani* (Rome, 1968) 227–228.

Francesco Contini: del Bufalo (1982) 36–38.

Cesare Rasponi: C. Rasponi, *De Basilica et Patriarchio Lateranensi* (Rome, 1656) 83.

lines may be seen: C. Gütlein, "Quellen aus dem Familienarchiv Spada zum römischen Barock," *RJ* 19 (1981) 209; J. Connors, "Borromini at the Lateran," in J. Wilton-Ely and J. Connors, *Piranesi architetto* (Rome, 1992) 101.

Santa Maria in Campitelli: MacDonald (1986) 225–229.

228 not the same: *The Iliad* 4 (London, 1715–1720) 1042 (commentary on Bk. 13, verse 721: "It is not often that a Translator can do justice to Homer, but he must be content to imitate these Graces and Proprieties at more distance, by endeavouring at something parallel, tho' not the same").

229 spectacular results: Raeder (1983) catalogues 147 statues definitely found at Hadrian's Villa, of which 76 were uncovered in the eighteenth century.

Grand Tour: A. Burgess and F. Haskell, *Age of the Grand Tour* (New York, 1967).

forty-five landowners: Winnefeld (1895) 7; Contini (1668) key. A map of 1739 (Diego de Revillas, *Diocecesis et agri tiburtini topographia*) locates the most important villas and farm centers in the region. See Frutaz (1972) 1, 82–85, and 2, pls. 186–187; and M. Pedley, "The Manuscript Papers of Diego de Revillas in the Archive of the British School in Rome," *PBSR* 49 (1991) 319–324.

230 plan of 1770: Ristori-Gabbrielli (1770); he

prepared a revised edition of the de Revillas map in 1775. See De Franceschini (1991) 9–11 for an analysis of Ristori-Gabbrielli's plan.

cypress avenue: Count Fede definitely planted that part of the avenue that runs between his Casino and the East-West Terrace (Belli Barsali and Branchetti [1975] 320). For the tradition that Ligorio planted the cypresses that run north of the Casino, see C. Nispi-Landi, *Guida nuovissima a Villa Elia Adriana a Tivoli* (Rome, 1927) 68.

his casino: Ristori-Gabbrielli (1770) provides plans of this building. An inscription recording the visit of the Austrian emperor Joseph II in 1769 is displayed on the casino's southern flank.

231 seven holdings: Piranesi, *Pianta* Commentary 1.1, 1.3, 2.1, 3.1, 3.4, 5.3, 5.7.

not allowed to excavate: Rossini (1826) pls. 39 and 40. Winckelmann, who visited the Villa in 1756, commented on the underbrush and snakes: "Man muss sich den Weg durch Sträucher und Gebüsche voller Schlangen und Eidern machen" (W. Rehm, ed., *J. J. Winckelmann: Briefe* 1 [Berlin, 1952] 233).

numerous signatures: N. Dacos, "Visitatori di Villa Adriana," *Palatino* 9 (1965) 9–12; Lavagne "Villa d'Hadrien" (1973) 229–242.

New publications: E. Veryard, *An Account of Divers Choice Remarks . . . Taken on a Journey through the Low-Countries, France, Italy, and Part of Spain* (London, 1701) 207; J. Spon, *Voyage d'Italie* 1 (The Hague, 1724) 32–33; G. R. Vulpi, *Vetus Latium Profanum* (Rome, 1744) 389–427; F. Scotto, *Itinerario d'Italia* (Rome, 1747) 416–417; C.-N. Cochin, *Voyage d'Italie, ou recueil de notes* 1 (Paris, 1758) 104–105; R. Venuti, *Accurata e succinta descrizione topografica e istorica di Roma moderna* (Rome, 1766) 526–528; A. Manazzale, *Viaggio da Roma a Tivoli* (Rome, 1790) 16–28; G. Landucci, *Voyage de Rome à Tivoli, contenant les observations . . . sur les beaux monumens de cette ville, au quelle on a joint la description de la Villa Adrienne et celle d'Horace . . .* (Rome, 1792) 13–28.

belles pièces d'eau: C. De Brosses, *Lettres familieres sur l'Italie* 2 (Paris, 1931) 307–308.

Pier Leone Ghezzi: Guerrini (1971); A. Lo Bianco, "L'antico come citazione filologica e movente etico in Ghezzi pittore," in Lo Bianco (1985) 195–205.

two stays: Vatican, cod. Vat. Lat., 3108; British Museum, Dept. of Greco-Roman Antiquities, Ms. Add. 22001 (hereafter Ms. Add. 22001).

232 made of ideas: Ms. Add. 22001, f. 159; R. Lanciani, "Di un nuovo codice di Pier Leone Ghezzi contenente notizie di antichità," *BC* 21 (1893) 165–181.

masonry technique: Ms. Add. 22001, f. 159.

painted decoration: Ms. Add. 22001, f. 157.

exist in this Villa: Ms. Add. 22001, f. 158.

drawing of 1724: Vatican, cod. Vat. Lat., 3108, f. 174.

the body was like: Vatican, cod. Vat. Lat., 3108, f. 152.

Cornelis van Polenburch: A. Chong, "The Drawings of Cornelis Van Polenburch," *MD* 25 (1987) 3–62.

233 sketching trips: Carlson (1978) 62.

for their studies: P. de Nolhac, *Hubert Robert, 1733–1808* (Paris, 1910) 16.

Abbé de Saint-Non: Carlson (1978) 62; P. Rosenberg, ed., *Panopticon italiano: Un diario di viaggio ritrovato, 1759–1761* (Rome, 1986) 160.

North Theatre: Ananoff 2 (1961) 116 and fig. 234.

Scenic Triclinium: Ananoff 2 (1961) 119 and fig. 232.

Robert's drawing: G. K. Loukomski, *La Rome d'Hubert Robert* (Paris, 1930) pl. 77; H. Burda, *Die Ruinen in den Bildern Hubert Robert* (Munich, 1967) 59–65; B. Reudenbach, *G. B. Piranesi: Architektur als Bild—Der Wandel in der Architekturauffassung des achtzehnten Jahrhunderts* (Munich, 1979) 82–97.

235 Grand Gallerie: our thanks to Anthony Vidler for calling this relationship to our attention. A. Corboz, *Peintre militante et architecture révolutionnaire: A propos du thème du tunnel chez Hubert Robert* (Basel, 1978).

Louis Chaix: see J.-F. Mejanes, "A Spontaneous Feeling for Nature: French Eighteenth-Century Landscape Drawings," *Apollo* 104 (1976) 401–412. See Carlson (1978) 154 for a drawing by Joseph-Benoit Suvée of the same feature, also dated 1775.

Charles-Louis Clérisseau: McCormick (1990)

and "Piranesi and Clérisseau's Vision of Classical Antiquity," in Brunel (1978) 303–314.

Abbé Filippo Farsetti: J. Rykwert, *The First Moderns: The Architecture of the Eighteenth Century* (Cambridge, Mass., 1987) 290–294; M. Azzi Visentini, *Il giardino veneto tra sette e ottocento e le sue fonti* (Milan, 1988) 91–111; McCormick (1990) 114.

Larger Baths: Blair Adam, no. 548.

Central Service Building: Cambridge, Fitzwilliam Museum, no. 3666; reproduced by McCormick (1990) fig. 34.

236 Water Court: Cambridge, Fitzwilliam Museum, nos. 3642, 3668; St. Petersburg, Hermitage, no. 2564.

Allan Ramsay: J. Holloway, "Two Projects to Illustrate Allan Ramsay's Treatise on Horace's Sabine Villa," *MD* 14 (1976) 280–286; A. Smart, *The Life and Art of Allan Ramsay* (London, 1952).

exact plan of it: J. Fleming, *Robert Adam and His Circle in Edinburgh and Rome* (London, 1962) 204, and "Allan Ramsay and Robert Adam in Italy," *Connoisseur* 137 (1956) 78–84.

twice the number intended: J. Fleming, "An Italian Sketchbook by Robert Adam, Clérisseau and Others," *Connoisseur* 46 (1960) 189–190.

Larger Baths: London, RIBA, L12/5, no. 8.

Central Service Building: London, RIBA, L12/5, no. 7.

237 cross-vault: London, RIBA, L12/5, no. 9; Blair Adam, no. B/5673.

Smaller Baths: London, RIBA, L12/5, nos. 2, 4.

Diocletian's Palace: R. Adam, *Ruins of the Palace of the Emperor Diocletian at Spalatro in Dalmatia* (London, 1764).

Water Court: London, RIBA, L12/5, nos. 5, 6; Blair Adam, no. B/5705.

Circular Hall: London, RIBA, L12/5, no. 1.

Fountain Court West: Blair Adam, no. 620.

239 Scenic Triclinium: London, RIBA, L12/5, no. 3.

Southern Range: London, RIBA, Robert Adam Office, no. 100.

Cardinal Alessandro Albani: for a history of these drawings, see J. Fleming, "Cardinal Albani's Drawings at Windsor: Their Purchase by James Adam for George III," *Connoisseur* 142 (1958) 164–169.

three prints: Rome, Istituto nazionale della grafica (Calcografia), inv. no. 1441.

Giuseppe Pannini: Pannini succeeded Nicola Salvi as architect of the Trevi Fountain in 1751 and supervised the fountain's completion in 1760. See Pinto (1986) 187 and B. Contardi and G. Curcio, eds., *In urbe architectus: Modelli, disegni, misure — la professione dell'architetto, Roma, 1680–1750* (Rome, 1991) 415.

240 who mention it: Pannini and Fidanza (Rome, 1753) 1.

241 Charles Cameron: G. Loukomski, *Charles Cameron* (London, 1943); Rae (1971); T. Talbot Rice and A. A. Tait, *Charles Cameron* (London, 1967).
Baths of the Romans: published in London with text in both English and French.
Nicolas Ponce: N. Ponce, *Arabesques antiques des bains de Livie, et de la ville Adrienne, avec les plafonds de la ville-Madame, peints d'apres les dessins de Raphael, et gravés par les soins de M. Ponce* (Paris, 1789). Ponce never visited Italy; see Joyce (1989).
Francesco Bartoli: T. Ashby, "Drawings of Ancient Paintings in English Collections," *PBSR* 7 (1914) 1–62; P. Quarrie, *Treasures of Eton College Library* (New York, 1990) esp. nos. 187, 188.
entirely his own: Joyce (1990) 357–358.
Jones's account: A. P. Oppé, ed., "Memoirs of Thomas Jones," *Walpole Society* 32 (1951) 64–65.
Hardwick's drawings: J. Lever, ed., *Catalogue of the Drawings Collection of the Royal Institute of British Architects: G–K* (London, 1973) 94–95.
Giacomo Quarenghi: S. Angelini, *I cinque album di Giacomo Quarenghi nella Civica Biblioteca di Bergamo* (Bergamo, 1967) pls. 3, 20.

242 John "Warwick" Smith: Oxford, Ashmolean Museum, no. 1686.
Soane and Hardwick collaborated: P. de la Rufinière du Prey, "Soane and Hardwick in Rome: A Neo-Classical Partnership," *Architectural History* 15 (1972) 51–67.
Soane's plan: London, Sir John Soane's Museum, Drawer 45, set 3, item 5. See also P. de la Rufinière du Prey, *John Soane: The Making of an Architect* (Chicago, 1982) 155.
royal palace: Soane cites Hadrian's Villa as a source for the palace design; E. Kaufman,

Architecture in the Age of Reason (New York, 1968) 52.

243 *Magnifico Collegio:* Piranesi's design for a Magnificent College (ca. 1750) was inspired in part by the Island Enclosure, especially the circular moat.
was never published: Sebastiani (1828) 310.
Laurent-Benoît Dewez: for Dewez's drawings in the Archives générales du rayaume, Brussels, see S. Ansiaux, "Les dessins d'Italie de Laurent-Benoît Dewez," *Bulletin de l'Institut historique belge de Rome* 27 (1952) 7–15.
Pierre-Adrien Pâris: for Pâris's drawings in the Municipal Library, Besançon, see Mosser (1979) 114. Pâris taught Francesco Piranesi architecture and prepared a corrected edition of Desgodetz in the 1780s; see P. Arizzoli, "Pierre-Adrien Pâris," in Chastel and Brunel (1976) 244–245.
Doric Temple: Sebastiani (1828) 258–259.

244 Clérisseau: McCormick (1990) 239, n. 71. For a plan of the Southern Range by Clérisseau, see Huelsen (1919) 8–12, esp. pl. 1, and E. Berckenhagen, *Die Französischen Zeichnungen der Kunstbibliotek Berlin* (Berlin, 1970) no. 4946.
interlocking rooms: R. Middleton, *Neoclassical and Nineteenth-Century Architecture*, vol. 1: *The Enlightenment in France and England* (New York, 1987) 118–119.
imaginative toplighting: M. J. Peyre, *Oeuvres d'architecture* (Paris, 1765) 10, 32.
Montmusard: A. Braham, "Charles de Wailly and Early Neo-Classicism," *BM* 114 (1972) 670–685; Mosser (1979) no. 318.
Three Villa graffiti: located near the southwest corner of the Peristyle Pool Building cryptoportico, in an upper chamber of Fountain Court West, and in a cryptoportico near the northwestern corner of the Residence Quadrangle; see Lavagne, "Villa d'Hadrien" (1973) 229–242, where Gondoin's damaged graffito in the Residence Cryptoportico is transcribed and illustrated: "Gondoin a levé la plan de / la villa adrienne en / 1762 et 1763 / avec MM [. . .]Atti / de Tivoli / 1763" and (1985).
occupied with a similar project: Quatremère de Quincy (1834) 203–204.

245 C. F. Harsdorff: Lund (1982) 41–52.

memories of his journeys: Quatremère de Quincy (1834) 206–208.

246 most inspired interpreter: for general treatments of Piranesi's life and oeuvre, see Wilton-Ely (1978) and Scott (1975).
polemic statements: R. Wittkower, "Piranesi's 'Parere su l'Architettura,'" *JWCI* 2 (1938–1939) 147–158; Wilton-Ely (1978) ch. 4.
Paestum: Pane (1980).

247 Piranesi's interest in the Villa: see M. Lolli-Ghetti, "Giambattista Piranesi a Villa Adriana," in Giuliano et al. (1988) 183–219; J. E. Mortensen in *Giovanni Battista Piranesi: Drawings and Etchings at Columbia University*, ed. D. Nyberg (New York, 1972) 112–114; and J. Pinto, "Piranesi at Hadrian's Villa," *SHA* 43 (1993) 464–477.
graffito of 1741: S. Gavuzzo Stewart, "Note sulle Carceri piranesiane," *L'arte* 15–16 (1971) 56–74.
Adam: A. A. Tait, "Reading the Ruins: Robert Adam and Piranesi in Rome," *Architectural History* 27 (1984) 524–533.
dated . . . 1743–1753: J.-F. Méjanes, "C. L. Clérisseau," in Chastel and Brunel (1976) 93.
come near them: J.-G. Legrand, *Notice historique sur la vie et les ouvrages de J. B. Piranesi architecte, peintre et graveur* (Bibliothèque Nationale, Paris, Ms. Nouv. Acq. Fr. 5968, f. 138v), transcribed in G. Erouart and M. Mosser, "A propos de la 'Notice historique sur la vie et les ouvrages de J. B. Piranesi': origine et fortune d'une biographie," in Brunel (1978) 235.
rich fragments: Erouart and Mosser, "A propos de la 'Notice historique . . . ,'" 245.
suffering it entailed: Sebastiani (1828) 277; Lavagne, "Villa d'Hadrien" (1973) 229–242 and (1985) 259–271.
Benedetto Mori: Pane (1980) 43; M. Lizzani, "Due dei tre Piranesi," *Capitolium* 27 (1952) 265–271.
the date 1771: located on the vault midway along the western arm of the Peristyle Pool cryptoportico.
ten years' work: Legrand, *Notice historique;* see also Brunel (1978) 251. This observation is contained in the supplementary notes to Legrand's biography, which were probably composed by E. Q. Visconti.

plan of 1906: Reina and Barbieri (1906) 313–317.

Pianta: Opera completa 23 (Paris, 1835–1839). Each plate measures 519–705 millimeters, resulting in overall dimensions of 3.114 × 0.705 meters. See J. Pinto, "Giovanni Battista Piranesi's Plan of Hadrian's Villa," *Princeton University Library Chronicle* 55 (1993) 63–84.

Piranesi scholars: The plan does not appear in Henri Focillon's fundamental study, *Giovanni-Battista Piranesi;* it is included in J. Wilton-Ely, *Giovanni Battista Piranesi: The Complete Etchings* 2 (San Francisco, 1994) 1098–1099.

248 large scale: the scale of 1,000 *palmi romani* below the dedication measures 219 millimeters. Because 1 *palmo romano* equals 0.2234 meters, the scale is 1:1020.

Sophisticated conventions: Piranesi, *Pianta* Commentary 1.1.7.

Giambattista Nolli: A. Ceen, *Rome, 1748: The Pianta grande di Roma of Giambattista Nolli in facsimile* (Highmount, N.Y., 1984).

255 Marble Plan: *FUR*, and E. Rodriguez Almeida, *Forma Urbis Marmorea: Aggiornamento Generale, 1980* (Rome, 1981).

preparatory drawing: Naples, Certosa di San Martino, inv. no. 7443. We thank Teodoro Fittipaldi for allowing Pinto to study the drawing in July 1987.

he, not Francesco: Legrand reports that G. B. Piranesi was partially responsible for the plates of the *Pianta* (Scott, [1975] 176–177).

plan of Pompeii: Francesco made two site plans of the excavations at Pompeii, in 1780 and in 1792; see J. Wilton-Ely, *Piranesi,* exhibition catalogue (London, 1978) 128.

exhibited twice: R. Pane, *L'acquaforte di G. B. Piranesi* (Naples, 1938) 18–19; E. Galasso, *Omaggio a Piranesi* (Benevento, 1968) 50; Bettagno (1978) 65.

identical in scale: the drawing has been cut into ten sheets, but the original was clearly a composite of six sheets, each approximately 520 × 710 millimeters. The plan has been glued to a stiff paper backing that prevented examination of its verso; it is in poor condition. The following comparative measurements taken from the Naples drawing and the *Pianta* confirm their identical scale: diameter of the

Island Enclosure (43 mm.), width of the East-West Terrace (95 mm.), major axis of the Water Court from vestibule to nymphaeum (100 mm.), and major axis of the Peristyle Pool court (51 mm.).

257 numbers corresponding to the Commentary: note, e.g., the number 1 assigned to the north arm of the Peristyle Pool cryptoportico.

more detailed plans: Piranesi, *Pianta* Commentary 3.4, 6.6.7.

intended for a volume: Bettagno (1978) 65.

Albano and Cori: G. B. Piranesi, *Antichità di Albano e di Castelgandolfo* (Rome, 1764); *Antichità di Cora* (Rome, 1764).

Tiburtine monuments: M. Campbell, ed., *Piranesi: Rome Recorded* (Philadelphia, 1989) nos. 61–63, 67–69, 72, 74, 75, 81, 83, 92, 105. Also see N. Miller, *Archäologie des Traums: Versuch über Giovanni Battista Piranesi* (Vienna, 1978) esp. 325–347, "Tivoli und die späten Veduten." It may be that not all of Piranesi's *Vedute di Roma* depicting monuments in the neighborhood of Tivoli were intended for a book on the subject. Piranesi reused one of his *Vedute* in his book on the *Acqua Giulia* (1761) in much the way we conjecture the Tivoli prints might have been re-employed. We thank John Wilton-Ely for this observation.

plates separate from the plan: we are indebted to Joe Aronson for this observation. The use of separate plates for the Commentary does not prove Francesco's intervention because Giovanni Battista often used separate plates for elaborate captions, presumably for easier revision.

preparatory drawings: two are in a private collection; see Bettagno (1978) 62–63 and Hazlitt, Gooden, and Fox, *Italian Drawings,* sales catalogue (London, 1991) 21–22, for color reproductions. A third is in Paris in the Ecole Nationale Supérieure des Beaux-Arts (no. 264v); see *Les dessins vénetiens des collections de l'Ecole des Beaux-Arts* (Paris, 1990) 146–147. A fourth, in Florence (Uffizi, Gabinetto dei Disegni, 96012), is reproduced in Bacou (1975) 170.

six other sheets: two autograph drawings in Florence (Uffizi, Gabinetto dei Disegni, 96006, 96008) are reproduced in Bacou (1975) 160, 167. A third is in Oxford (Ashmolean, 1043); see K. T. Parker, *Catalogue of the Col-*

lection of Drawings in the Ashmolean Museum 2 (Oxford, 1956) 522. Three sheets by a follower of Piranesi, most likely copies, are in the Royal Institute of British Architects (Grahame B. Tubbs, "Some New Piranesi Drawings," *Architectural Review* 51 [1922] 118–125).

258 documentary accuracy: for a positive assessment of Piranesi's accuracy in his archaeological prints see W. L. MacDonald, *Piranesi's Carceri: Sources of Invention* (Northampton, Mass., 1979); M. McCarthy, "The Theoretical Imagination in Piranesi's Shaping of Architectural Reality," *Impulse Magazine* (Winter 1986) 6–12, takes a negative view.

261 Larger Baths: Piranesi's drawing is reversed to aid in the transfer of his composition to the copper plate.

unknown draftsman: for opinions on the attribution of the Tubbs drawings, see the letters from R. Bloomfield and A. M. Hind in *AR* 51 (1922) 263; 52 (1922) 31. Bloomfield questions the attribution of the drawings to Piranesi, while Hind is "inclined to accept them as authentic." Hind observes that as preparatory studies for plates they are less strong and suggests that they may either be by Francesco, "who must have been devilling for his father in this period," or by some artist copying lost Piranesi drawings, "and my conclusion between Piranesi and the Devil is slightly in favor of Piranesi." We consider these drawings to be copies by an anonymous draftsman after lost originals by Piranesi. The Tubbs drawing depicting the West Belvedere was reproduced in H. O. Corfiato, *Piranesi Compositions* (London, 1951) fig. 61, and *Architectural Drawings from the Collection of the Royal Institute of British Architects* (London, 1961) 16.

264 dovecote: Lugli (1940).

Casale del Barco: Coffin (1979) 135–140.

act of translating: Wilton-Ely (1978) 48.

graphic abstraction: W. Oechslin, "L'intérêt archéologique et l'expérience architecturale avant et après Piranèse," in Brunel (1978) 395–418.

Campo Marzio plan: G. B. Piranesi, *Il Campo Marzio dell'antica Roma* (Rome, 1762); J. Wilton-Ely, "Utopia or Megalopolis?: The 'Iconographia' of Piranesi's 'Campus Martius' Reconsidered," in *Piranesi tra Venezia*

e l'Europa, ed. A. Bettagno (Venice, 1983) 293–304, esp. 296.

265 Francesco di Giorgio: Buddensieg (1971) 263–264. Francesco di Giorgio's drawings after the Island Enclosure and Circular Hall illustrate a similar process of transformation.
Johann Winckelmann: J. J. Winckelmann, *History of Ancient Art,* trans. A. Gode (New York, 1968) 327–339.
creative license: Wilton-Ely (1978) 66.
Sallust: G. B. Piranesi, *Parere su l'architettura* (Rome, 1765) pl. 6.
considerable benefit: *Pianta* Commentary 6.7. Piranesi's remarks were paralleled by Milizia, also writing in 1781: "quella magnifica Villa, che ancora fa lo stupore degli intendenti" (F. Milizia, *Memorie degli architetti antichi e moderni,* in *Opere complete* 4 [Bologna, 1827] 108).

266 Renaissance conception: Ackerman (1990) 28–29.
pastoral image: Pinto (1992).

268 official duties: Boatwright (1987) 138–150.
landscape of allusion: J. Pinto, "The Landscape of Allusion: Literary Themes in the Gardens of Classical Rome and Augustan England," *SCSH* 48 (1980) 97–134.
Literal copies: the Doric Temple at Hagley Park, based on Stuart and Revett's published drawings of the Theseum in the Athenian Agora, is the product of a later, more self-consciously Neoclassical sensibility.
Shugborough: for James Stuart's folly of 1761–67, see N. Pevsner, *Staffordshire* (Harmondsworth, 1974) 236, fig. 53.
Varro: *On Agriculture* 2.2.

269 Amalthaeum: Cicero, *Letters to Atticus* 1.16, 2.1.
Persian porch: Cicero, *Letters to Atticus* 15.9.
directed by the rule: Vasari 4 (1966) 5.
traditional Italian villa: see Ackerman (1990) ch. 3 for a survey of fifteenth-century Italian villa design.

270 Belvedere Court: J. S. Ackerman, *The Cortile del Belvedere* (Vatican City, 1954) 119.
centrifugal or expanding: Ackerman, *Cortile,* 137.

271 Villa Madama: D. R. Coffin, "The Plans of the Villa Madama," *AB* 49 (1967) 111–122; C. L.

Frommel, "Die architektonische Planung der Villa Madama," *RJ* 15 (1975) 59–87; C. L. Frommel et al., *Raffaello architetto* (Milan, 1984) 311–356.
written program: P. Foster, "Raphael on the Villa Madama: The Text of a Lost Letter," *RJ* 11 (1967–68) 307–312.
plan by . . . Sangallo: Uffizi 314A.
ring colonnade: Uffizi 1054A.
Villa of Brutus: Neuerburg (1968) 288–297.
Muses: Hubner (1908) 357–363.

272 grand palace . . . in Granada: E. Rosenthal, *The Palace of Charles V in Granada* (Princeton, 1985); M. Tafuri, "Il Palazzo di Carlo V a Granada: architettura 'a lo romano' e iconografia imperiale," *Ricerca di Storia dell'Arte* 32 (1987) 4–26, esp. 21.
Pedro Machuca: Rosenthal, *Palace of Charles V,* 11–18.
relaxation and renewal: Rosenthal, *Palace of Charles V,* 252.
Villa d'Este: Coffin (1960).

273 graphic reconstruction: H. Burns, "Pirro Ligorio's Reconstruction of Ancient Rome: The 'Antiquae Urbis Imago' of 1561," in *Pirro Ligorio: Artist and Antiquarian,* ed. R. W. Gaston (Milan, 1988) 19–92.
Casino of Pius IV: M. Fagiolo and M. L. Madonna, "La Casina di Pio IV in Vaticano: Pirro Ligorio e l'architettura come geroglifico," *Storia dell'Arte* 15–16 (1972) 237–281; G. Smith, *The Casino of Pius IV* (Princeton, 1977).

274 Ligorio's drawings: Vatican, cod. Vat. Lat., 3439, f. 52r; the painted frieze is reproduced in Smith (1977) fig. 80.
Suites of engravings: see H. Geymuller, *Les du Cerceau: leur vie et leur oeuvre* (Paris and London, 1887) 285–326; and Rosenfeld (1989) 133, n. 12.
Temples et habitations: Rosenfeld (1989) publishes the set in the Library of the Canadian Centre for Architecture (87-B9512). The plan and elevation of the Scenic Triclinium on ff. 83r and 84r, respectively, are reproduced as figs. 143 and 145.
Serlian inspiration: Rosenfeld (1989) 140.
model book: Rosenfeld (1989) publishes the model book, which is in the collection

of the Canadian Centre for Architecture (DR:1982:0020:001-033). The Scenic Triclinium plan is reproduced as fig. 144.
prints: other prints identified as representing Villa ruins were made in the second half of the sixteenth century. One in the Bibliothèque Nationale in Paris (Cabinet des Estampes, Vb54) carries the title "Palatium Hadriani Imp Tiburi." In spite of this inscription, it depicts ruins that do not correspond to any known Villa remains and belongs to a category of northern prints representing generalized ruins identified with specific sites. See Lanciani 2 (1904) 28 for the Bibliothèque Nationale print, which Myra Nan Rosenfeld informs us appears with a different title ("Palatium Caesaris") in the *Ruinarum varrarum Gallicanum* (Amsterdam, 1560), attributed to the Flemish artist Gerard De Jode. Another example is Hendrick Van Cleve's plate inscribed "Villae Hadriani prospectus" in the *Ruinarum vari prospectus ruriumq. aliquot delineationes* (Antwerp, ca. 1560–1589), reproduced in A. Grelle, *Vestigi delle antichità di Roma . . . et altri luochi: momenti dell'elaborazione di un'imagine* (Rome, 1987) 67.
designs for châteaux: Geymuller's fig. 32 reproduces a drawing in Recueil N, f. 13; for another similar design, see du Cerceau, *Premier livre d'architecture* (Paris, 1559) pl. 35.

275 Gaillon: J. A. du Cerceau the Elder, *Le premier volume des plus excellents bastiments de France* (Paris, 1607) 3–4; N. Miller, *Heavenly Caves: Reflections on the Garden Grotto* (New York, 1982) 57; W. Prinz and R. G. Kecks, *Das französische Schloss der Renaissance: Form und Bedeutung der Architektur, ihre geschichtlichen und gesellschaftlichen Grundlagen* (Berlin, 1985) 348–349. There is some evidence that the hermitage of the Maison Blanche at Gaillon was created earlier—a Mantuan envoy in 1509 or 1510 speaks of a "solitary hermitage" there (R. Weiss, "The Castle of Gaillon in 1509–10," *JWCI* 16 [1953] 11).
rocher: the Gaillon rocher can be related to the tradition of artificial mounts in Italianate gardens; see Lazzaro (1990) 56–57.
Ligorio's reconstruction: Coffin (1979) 348, fig. 231.
Villa Lante: Lazzaro (1990) 251.
Parigi's Isolotto: L. Berti, "Giulio e Alfonso

Parigi," *Palladio* 1 (1951) 161–164; Lazzaro (1990) 212, who notes the relation to the Island Enclosure.

Sacro Bosco: See Darnall and Weil (1984) 82–88 and Lazzaro (1990) 121–130 for surveys of the literature on Bomarzo. Note especially H. Bredekamp, *Vicino Orsini e il Bosco Sacro di Bomarzo* (Rome, 1989).

276 seven wonders: Darnall and Weil (1984) 36, 53.
falsification: J. P. Oleson, "A Reproduction of an Etruscan Tomb in the Parco dei Mostri at Bomarzo," *AB* 57 (1975) 410–411.
portions . . . displayed: Caprino (1985) 61–84.
Giulia Farnese Orsini: F. Sansovino, *Delle origini delle famiglie d'Italia* (Venice, 1679) 266.
Ligorio's manuscript: Vatican, cod. Vat. Lat., 5294, f. 11.

278 inscription: today the inscription reads "Ogni pensiero vo[la]." Giovanni Guerra's early seventeenth-century drawing records the original inscription: "Lasciate ogni pensiero voi ch'entrate." Dante's inscription in the third canto of the *Inferno* reads "Lasciate ogni speranza voi ch'entrate."
Ligorio's Villa description: Turin, Archivio di Stato, J.a.III, 22, f. 50.
Jacopo Sannazaro: J. Sannazaro, *Arcadia*, in *Sannazaro: Opere*, ed. E. Carrara (Turin, 1952).
Pietro Bellori: G. P. Bellori, *Le vite de'pittori, scultori e architetti moderni*, ed. E. Borea (Turin, 1976), 407. Cf. J. Montagu, *Alessandro Algardi* 1 (New Haven, 1985) 99–100.
cryptoportico: O. Raggio, "Alessandro Algardi e gli stucchi di Villa Pamphili," *Paragone* 22 (1971) 3–38, esp. 4.
Marchionni's design: J. Gaus, *Carlo Marchionni, ein Beitrag zur Römischen Architektur des Settecento* (Cologne, 1967) 19–66.
sketch by Marchionni: New York, Cooper-Hewitt Museum, inv. no. 1901.39.1327.
Canopus: S. Röttgen, "Die Villa Albani und ihre Bauten," in *Forschungen zur Villa Albani: Antike Kunst und die Epoche der Aufklarung*, ed. H. Bek and P. Bol (Berlin, 1982) 82–83, notes the similarity in plan relations between the Southern Hall and the South Theatre at Hadrian's Villa and the semicircular pavilion and casino of the Villa Albani. D. Coffin, *Gardens and Gardening in Papal Rome* (Princeton, 1991) 168, suggests that a cascade that

once ran behind the pavilion may have been a reference to the Scenic Canal.

279 *Parere:* G. B. Piranesi, *Parere su l'architettura* (Rome, 1765).
Evelyn's diary: for the reference to Hadrian's Villa, see J. Evelyn, *Diary*, ed. E. S. De Beer, 2 (Oxford, 1955) 397; see vol. 3, 496, for the reference to Albury Park.
Albury Park: D. Chambers, "The Tomb in the Landscape: John Evelyn's Garden at Albury," *JGH* 1 (1981) 37–54.

280 heroick action: E. Warcupp, *Italy in Its Original Glory: Ruine and Revival* (London, 1660) 315–316.

281 Stowe: G. Clarke, "The Gardens of Stowe," *Apollo* 97 (1973) 558–565; Hussey (1967) ch. 13.
Charles Bridgeman: P. Willis, *Charles Bridgeman and the English Landscape Garden* (London, 1977).
William Kent: M. I. Wilson, *William Kent, Architect, Designer, Painter, Gardener, 1685–1748* (London, 1984).

282 Persians: G. Clarke, "Moral Gardening," *Stoic* (1967) 118.
selection of Worthies: G. Clarke, "Grecian Taste and Gothic Virtue: Lord Cobham's Gardening Programme and Its Iconography," *Apollo* 97 (1973) 566–571.
Temple of Friendship: Rae (1971), 70, fig. 18.
alludes to Stowe: designed by James Gibbs in 1739; see Hussey (1967) 99, figs. 128–129.

283 Proserpine's Cave: K. Woodbridge, "William Kent's Gardening: The Rousham Letters," *Apollo* 100 (1974) 289.

284 preliminary sketch: J. D. Hunt, *William Kent, Landscape Garden Designer* (London, 1987) fig. 42.
Stourhead: K. Woodbridge, *Landscape and Antiquity: Aspects of English Culture at Stourhead, 1718–1838* (Oxford, 1970) 35.
mausoleum: Hawksmoor's design may also reflect the Trophy of Augustus at La Turbie.
Kew: the gardens at Kew recall the Villa in their extent (120 hectares) and relation to London.

285 of other nations: Sir William Chambers, *Designs of Chinese Buildings* (London, 1757), second page of unpaginated preface. Our

thanks to Richard Quaintance for bringing this to our attention.

286 recent catalogue: Raeder (1983).

287 *spolia:* it is impossible to identify the original location of these Hadrianic spolia, which may have come from Roman Tivoli or from other villas in the vicinity, but the Villa is a likely source.
telamons: Grenier (1989) 49–50 suggests that the telamons came from the pavilions flanking the Scenic Triclinium.
Giuliano da Sangallo: Huelsen (1910) 57, f. 41d.
Raphael: N. Neuerburg, "Raphael at Tivoli and the Villa Madama," *Essays in Memory of Karl Lehmann*, ed. L. F. Sandler (New York, 1964) 227–231.
Michelangelo: V. Pacifici, ed., *Annali e memorie di Tivoli di Giovanni Maria Zappi (Studi e Fonti per la Storia della Regione Tiburtina, I)* (Tivoli, 1920) 21.
William Kent: a sheet from Kent's sketchbook in the Victoria and Albert Museum, Dept. of Prints and Drawings, inv. no. E.896.1928, reproduced in Wilson (1984) 14, fig. 2.
I Cioci: an alternative derivation may be from *ciocco*, log, and by extension blockhead.
Michelangelo Simonetti: Meeks (1966) 72–74.
Ligorio: Graevius (1723) 19, E.

288 Martin van Heemskerck: C. Hülsen and H. Egger, *Die Römischen Skizzenbücher von Marten von Heemskerck* 1 (Berlin, 1913) pl. 35.
inventory of 1714: Hübner (1908) 359–363.
Bernini: For a discussion of seventeenth-century attitudes toward restoring sculpture, see Montagu (1989) ch. 7.
Madrid: K. M. Türr, *Eine Musengruppe Hadrianischer Zeit: Die sogenannten Thespiaden* (Berlin, 1971).
A. Farnese et al.: Lanciani (1909) 136–137; Raeder (1983) 9; De Franceschini (1991) 8.
garden on the Quirinal: Lazzaro (1990) 82–83.
Hercules: D. R. Coffin, "Pirro Ligorio and the Villa d'Este" (Ph.D. diss., Princeton University, 1954) 1, 9.
Cardinal Maffei: "Pirro ha cavato hormai tutta la villa di hadriano p. mons. Ill.mo di Ferrara et ha trovati da 12 corpi tra nudi e vestiti et tutta una seguita" (Paris, Bibliothèque Nationale, Collection Dupuy, Ms. 699, f. 20r-v).

We would like to thank Robert Gaston, who called this letter to our attention, and Michael Rabens, who kindly transcribed it for us.

289 Domenico Martelli: A. Venturi, "Nuovi documenti: Ricerche di antichità per Monte Giordano, Monte Cavallo e Tivoli nel secolo XVI," *ASA* 3 (1890) 198.

Vincenzo Stampa: Venturi (1890) 201; P. G. Hübner, *Le Statue di Roma: Grundlagen für eine Geschichte der antiken Monumente in der Renaissance* (Leipzig, 1912) 116–117; Lanciani (1904) 267–270.

detailed inventory: Ashby (1908) 219–256; Raeder (1983) 193–204.

Barberini Candelabra: Pietro Santi Bartoli quoted in C. Fea, *Miscellanea filologica critica e antiquaria* (Rome, 1790) 261. The discovery of the Barberini Candelabra in the Southern Range is also reported by Contini in the key to his plan (11.31); also see Ligorio-Contini (1751) 23.31. Bartolommeo Cavaceppi appears to be in error when he asserts that the candelabra were found "among the ruins of the Temple of Fortune at Palestrina in 1620"; see *Raccolta d'antiche statue, busti, teste cognite et altre sculture antiche* (Rome, 1772) pls. 58, 59.

Thomas Jenkins: B. Cassidy, "Thomas Jenkins and the Barberini Candelabra in the Vatican," *Bollettino dei monumenti, musei e gallerie pontificie* 10 (1990) 99–113. For Jenkins's activities as a dealer, see T. Ashby, "Thomas Jenkins in Rome" *PBSR* 6 (1913) 487–511, and B. Ford, "Thomas Jenkins: Banker, Dealer and Unofficial English Agent," *Apollo* 99 (1974) 416–425.

290 Bartolommeo Cavaceppi: S. Howard, *Bartolommeo Cavaceppi: Eighteenth-Century Restorer* (New York, 1982).

sent agents: Montagu (1989) 157.

marine frieze: M. Bonanno, "Nuovi frammenti del fregio del 'Teatro marittimo' di Villa Adriana," *ArchCl* 27 (1975) 33–40.

archives: J. Garms, ed., *Quellen aus dem Archiv Doria-Pamphili zur Kunsttätigkeit in Rom unter Innocenz X* (Rome, 1972) 202, 203, 209, 226, 228.

Lolli: see Raeder (1983) 40–41 and Ghezzi, cod. Ott. Lat., 3108, f. 152.

Cupid and Psyche: F. Ficoroni, *Roma antica* (Rome, 1741) 270. Batoni's drawing is illustrated in H. MacAndrew, "A Group of

Batoni Drawings at Eton College and Some Eighteenth-Century Italian Copyists of Classical Sculpture," *MD* 16 (1978) 131–150, pl. 23.

291 Capitoline Flora: Haskell and Penny (1981) 215–216.

Thomas Jenkins: S. Rowland Pierce, "Thomas Jenkins in Rome," *Antiquaries Journal* 45 (1965) 200–229.

Capitoline . . . Antinous: Haskell and Penny (1981) 143–144.

Pietro Bracci: Bracci's diary records his work on the statue in 1734 (C. Gradara, *Pietro Bracci, scultore romano, 1700–1773* [Milan, 1920] 99).

Agostino Cornacchini: H. Stuart Jones, *A Catalogue of Ancient Sculptures Preserved in the Municipal Collections of Rome* 1 (Oxford 1912) 396.

half-length bas-relief: Haskell and Penny (1981) 144–146; H. Meyer, *Antinoos* (Munich, 1991) 76–78.

Winckelmann: J. J. Winckelmann, *Monumenti antichi inediti* (Rome, 1821) 235–237.

Pompeo Batoni: A. M. Clark, *Pompeo Batoni* (Oxford, 1985) 289, cat. no. 230; Metropolitan Museum 03.37.1.

Furietti: I. Negrisoli, "L'opera storica-filologica-archeologica di S. Em. il Cardinale Giuseppe Alessandro Furietti," *Atti dell'Ateneo di scienze, lettere ed arti in Bergamo* 29 (1957) 89–97.

292 Centaurs: Haskell and Penny (1981) 178–179; see Piranesi, *Pianta* Commentary 5.4.15, for the findspot.

Giovanni Girolamo Frezza: G. G. Frezza, *Riproduzione di antiche sculture rinvenute nella Villa Adriana di Tivoli, disegnate da Stefano Pozzi, Nicola Onofri e Pompeo Batoni* (Rome, 1739–1740).

Charles De Brosses: *Lettres familiers sur l'Italie* 1 (Paris, 1931) 474. De Brosses, comte de Tornai et de Montfalcon (1708–1777), became the first president of the parliament of Burgundy.

Cardinal Centaur: U. W. Hiesinger and A. Percy, eds., *A Scholar Collects: Collections from the Anthony Morris Clark Bequest* (Philadelphia, 1980) 141–142.

Faun in rosso antico: Haskell and Penny (1981) 213–215.

mosaic of doves: see Piranesi, *Pianta* Com-

mentary 5.5.30, for the findspot; P. Cadet, "La mosaic aux colombes de la Villa d'Adrien," *Archeologia* 194 (1984) 71–76; Moorman (1987); and De Franceschini (1991) 337.

293 Pliny the Elder: *Natural History* 36.184.

illustrated book: J. A. Furietti, *De musivis* (Rome, 1752).

two bronze tables: C. Pietrangeli, "Munificentia Benedicti XIV," *Bollettino dei Musei comunali di Roma* 11 (1964) 49–54; Furietti (1752) pl. 4; De Franceschini (1991) 339–340.

mosaico minuto: Alfieri et al. (1981) 96, 152, 226–227.

Clodion: A. L. Poulet and G. Scherf, *Clodion, 1738–1814* (Paris, 1992) 316–322. We thank Anne Poulet for this reference.

Piranesi: Francesco Piranesi contacted Clodion shortly after arriving in Paris in 1799.

294 Gavin Hamilton: D. Irwin, "Gavin Hamilton, Archaeologist, Painter, and Dealer," *AB* 44 (1962) 87–102. See R. Lanciani, *New Tales of Old Rome* (Boston, 1901) 301–304, for a general treatment of Hamilton's archaeological activities.

Hamilton's letter: A. H. Smith, "Gavin Hamilton's Letters to Charles Townley," *JHS* 21 (1901), 307–311. For another account of Hamilton's excavation, see A. Miller, *Letters from Italy* 3 (London, 1776) 122–123.

bust of Hadrian: British Museum, no. 1896, see also drawing by Jenkins reproduced in Roland-Pierce (1965) pl. 17a.

Domenico de Angiolis: De Angelis owned the property adjacent to Lolli in the area of the Bog. Between 1769 and 1773 he also excavated in the Southern Range, from which he reportedly extracted twenty cartloads of mosaic fragments (Bulgarini [1848] 125).

295 prospecting rights: Scott (1975) 242.

before the ground is opened: J. Dallaway, *Anecdotes of the Arts in England* (London, 1800) 273–274.

bust of Hadrian: see D. von Bothmer, ed., *Glories of the Past: Ancient Art from the Shelby White and Leon Levy Collection* (New York, 1990) 211, no. 152.

296 *Vasi*: Focillon (1918) nos. 602, 603, 604, 614, 615, 623, 624, 629, 704, 705, 708, 709.

candelabra Warwick Vase: N. Penny, *Piranesi* (London, 1978) 92–93.

Sculpture and Architecture: letter of 1777 from George Horne to R. Newdigate, quoted by M. MacCarthy, "Sir Roger Newdigate and Piranesi," *BM* 94 (1972) 469.

eighteenth-century creations: for a detailed examination of the Oxford candelabra and the Warwick Vase, to which our account is substantially indebted, see J. Scott, "Some Sculpture from Hadrian's Villa, Tivoli," in Lo Bianco (1985) 339–347; and N. Penny, *Catalogue of European Sculpture in the Ashmolean Museum* (Oxford, 1992) 108–116.

297 thyrsi: pine-cone–tipped staffs carried by Bacchus and his attendants.

deficient masks: *Gentleman's Magazine* 2 (December 1800) 1144.

Legrand: Legrand, *Notice historique;* see also Brunel (1978), 241.

Lorenzo Cardelli: W. Rieder, "Piranesi at Gorhambury," *BM* 97 (1975) 582–586.

Cardinal Mario Marefoschi: Marefoschi (1714–1780) was a prominent member of the Jansenist circle under Pope Clement XIV. See H. Gross, *Rome in the Age of Enlightenment* (Cambridge, 1990) 282–283.

298 figural mosaics: following the discoveries of Cardinal Furietti and Domenico De Angelis, the Villa became known as a source for mosaics. For a full account of the Marefoschi mosaics, including illustrations, see De Franceschini (1991) 121–125.

findspots: Piranesi, *Pianta* Commentary 4.6.37–39.

Antonio Canova: A. Canova, *I quaderni di viaggio (1779–1780),* ed. E. Bassi (Florence, 1959) 130–131. See also A. De Montaiglon, *Correspondance des directeurs de l'Académie de France à Rome* 14 (Paris, 1905) 27, 35, 78, 95, for letters describing the mosaics and their condition.

Berlin scene: Berlin, Staatliche Museen. the *DOR,* 23.I.1779, reports the discovery of this mosaic; transcribed by Pietrangeli (1958) 147.

accurate print: see Pietrangeli (1958) fig. 20 for a reproduction of the print designed by Gaetano Savorelli and engraved by Antonio Cappellan. The print was reported in the *DOR* on 15.VII.1780.

variations on compositions: a mosaic in the Princeton Museum (K. Parlasca, "Mosaikfäl-

schungen," *RM* 65 [1958] pl. 55/2) and two variations in mosaico minuto (Alfieri [1981] 145, fig. 79, 180, fig. 3).

theatre masks: the *DOR,* 17.II.1779, reports this discovery; transcribed by Pietrangeli (1958) 148.

Penna's invaluable prints: see Penna 4 (1836) pl. 106; reproduced by Gusman (1904) fig. 316; De Franceschini (1991) 124–125.

300 Casino Fede: H. Ellis, *The Townley Gallery* 2 (London, 1836) 243, records a more specific findspot—the Pinacotheca (Arcaded Triclinium).

Discobolus and a Hercules: in the British Museum (inv. no. 250) and J. Paul Getty Museum (70.AA.109), respectively.

James Byres: B. Ford, "James Byres: Principal Antiquarian for the English Visitors to Rome," *Apollo* 99 (1974) 446–461. Byres acquired the Portland Vase and was Edward Gibbon's guide in Rome.

Johann Zoffany: Zoffany took liberties in representing Townley's collection (B. Cook, "The Townley Marbles in Westminister and Bloomsbury," *British Museum Yearbook* 2 [1977] 34–78).

Carlo Albaccini: Albaccini worked in Bartolommeo Cavaceppi's studio in the 1750s and later supervised the restoration of the statues in the Farnese collection before their transfer to Naples in 1787.

modern restoration: the statue was restored in 1955–1957 and in 1976 (Howard [1978] 3–5).

above the anckle: letter from Townley to the marquis of Lansdowne dated 27.XII.1792, in the Bowood Estates Office, Calne, Wiltshire (Howard [1978], 15).

Hadrianic copy: C. Vermeule and N. Neuerburg, *Catalogue of the Ancient Art in the J. Paul Getty Museum* (Malibu, Calif., 1973) 6–8.

time of the Caesars: Howard (1978) 15.

301 Lansdowne's House: see J. and A. Rykwert, *Robert and James Adam* (New York, 1985) 90–96, and D. Stillman, "The Gallery for Lansdowne House: International Neoclassical Architecture and Decoration in Microcosm," *AB* 52 (1970) 75–80.

list of sixteen dealers: S. Howard, "An Antiquarian Handlist and Beginnings of the Pio-Clementino," *Eighteenth-Century Studies*

7 (1973) 40–61, and "Giovanni Battista Visconti's Projected Sources for the Museo Clementino," *BM* 115 (1973) 735–736.

302 His disappointment: Wilton-Ely (1978) 111.

Villa Adriana: W. Rieder, "Piranesi at Gorhambury," *BM* 117 (1975) 586.

museo dell'autore: see Focillon (1918) no. 632.

Elizabeth of Russia: for the antiquities in the Hermitage see O. Neverov, "Giovanni Battista Piranesi, der Antikensammler," *Xenia* 3 (1982) 71–89.

Raccolta: Scott (1975) 244 suggests that Cavaceppi's publication may have influenced Piranesi.

303 perfection of the arts: "le sue ben'intese Sculture dimostrano la perfezione delle Arti del secolo d'Adriano" (Focillon [1918] no. 602).

catalogue of antiquities: see A. Geoffroy, "Essai sur la formation des collections d'antiques de la Súède," *RA* 29 (1896) 1–35, esp. 26–27.

inventory listed: C. Gasparri, "La Galleria Piranesi da Giovan Battista a Francesco," *Xenia* 3 (1982) 90–107; E. Kjellberg, "Piranesi's antiksamling i Nationalmuseum," *National Musei ärsbok* 2 (1920) 115. Some of the fragments in Piranesi's Museo found their way into Soane's collection (Wilton-Ely [1978] 119).

Francesco his agent: H. H. Brummer, "The Muse Gallery of Gustavus III," *Antikvariskt archiv* 43 (1972) 5.

Nationalmuseum: R. C. Lumetti, *La cultura dei lumi tra Italia e Svezia: Il ruolo di Francesco Piranesi* (Rome, 1990).

Nollekens wrote to report: letter to Anson, dated 26 July 1765, Stafford County Record Office, D619/P(s)/1/6/1. We thank Brendan Cassidy for this reference.

304 Coade Stone: A. Kelly, "Coade Stone in Georgian Gardens," *Antiques* (June 1993) 912–920.

Somerset House: J. Newman, *Somerset House* (London, 1990) 30–31.

Pavlovsk: A. Kuchumov, *Pavlovsk, Palace and Park* (Leningrad, 1975) pl. 35; S. Massie, *Pavlovsk: The Life of a Russian Palace* (Boston, 1990), pl. between 268–269.

Malmaison: Y. David, *The Malmaison* (Paris, 1966) 76.

Alexander I: we thank Guy Métraux for this observation.

garland border: cf. De Franceschini (1991) 342.

Matthew Brettingham: the younger Brettingham accompanied Stuart and Revett in Greece. Robert Furze Brettingham (1750–1806), Matthew's nephew and a friend of Robert Adam, visited the Villa in 1780 in the company of the French sculptor François Masson and the Danish architect Peter Meyn. Their signatures survive in the Residence Cryptoportico; see Lavagne "Villa d'Hadrien" (1973) 242.

account of Holkham: M. Brettingham, *The Plans, Elevations and Sections of Holkham in Norfolk* (London, 1773) 3, 10.

lion attacking a panther: A. Michaelis, *Ancient Marbles in Great Britain* (Cambridge, 1882) 316.

centerpiece: L. Lewis, *Connoisseurs and Secret Agents in Eighteenth-Century Rome* (London, 1961) 201. Brettingham met Cardinal Albani in 1752.

305 Chiswick: J. Charlton, *A History and Description of Chiswick House and Gardens* (London, 1958) 31. The three statues do not appear in Raeder's catalogue. Burlington's well-stocked library included Ligorio/Graevius (1723), which may have suggested the layout of certain water features in the garden. See C. M. Sicca, "Lord Burlington at Chiswick: Architecture and Landscape," *Garden History* 10 (1982) 52.

Daniel Defoe: *A Tour thro' the Whole Island of Great Britain* 3 (London, 1742) 288–289.

none has been reproduced more often: N. M. Penzer, "The Warwick Vase," *Apollo* 62 (1955) 183–188; 63 (1956) 18–22, 71–75.

versions in the United States: a copy by Boschetti in rosso antico is in the Toledo Museum; see A. Gonzales-Palacios, "I mani del Piranesi," *Paragone* 27 (1956) 33–48. Two bronze reductions are presently displayed in the William Paca Garden in Annapolis, Md.

307 commentary on a map: A. Nibby, *Analisi storico-topografico-antiquaria della carta de' dintorni di Roma*, 3 vols. (Rome, 1837).

Sir William Gell: W. Gell, *Topography of Rome and Its Vicinity* (London, 1834); E. Clay, ed., *Sir William Gell in Italy: Letters to the Society of Dilettanti, 1831–1835* (London, 1976).

Viaggio: Nibby (1819) esp. vol. 1, 120–138.

Descrizione: Nibby (1827).

Natatorio: Nibby (1827) 33–35.

Latin Theatre: Nibby (1827) 21–22.

Southern Hall: Nibby (1827) 55–57.

Underground Galleries: Nibby (1827) 57–58.

traces of a road: Nibby (1827) 17.

Park Rotunda: Nibby (1827) 44.

Asprucci's portal: B. Di Gaddo, *Villa Borghese: Il giardino e le architetture* (Rome, 1985) 120–123.

Luigi Canina: W. Oechslin, "Canina, Luigi," *Dizionario biografico degli Italiani* 18 (Rome, 1975) 96–101; cf. A. Muñoz, "Una gita di Antonio Canova a Tivoli," *AMST* 4 (1924) 209–212.

308 Egyptian propylon and . . . Ionic propylon: Meeks (1966) 115–118; Di Gaddo (1985) 157–176; J. S. Curl, *The Egyptian Revival* (London, 1982) 151.

Villa Adriana: L. Canina, *Le nuove fabbriche della Villa Borghese* (Rome, 1828) 12.

multivolume survey: L. Canina, *L'architettura antica, descritta e dimostrata coi monumenti*, 9 vols. (Rome, 1834–44).

folio volumes: Canina 5 (1856) 152–193; 6, pls. 142–175.

Frezza Uggeri: L. Frezza, *Nuova raccolta delle principali vedute antiche e moderne dell'alma città di Roma e sue vicinanze* (Rome, 1830); A. Poggioli, *Voyage pitoresque des antiquités et curiosités qui se rencontrent de Rome à Tivoli et à la Villa d'Adrien* (Rome, 1815); D. Pronti, *Nuova raccolta di 100 vedutine antiche della città di Roma e sue vicinanze* (Rome, 1775); A. Uggeri, *Journées pittoresque dans les environs de Rome*, 30 vols. (Rome, 1800–1804).

309 Luigi Rossini: N. Pirazzoli, *Luigi Rossini, 1780–1857: Roma antica restaurata* (Fusignano, 1990).

Gaetano Moroni: G. Moroni, *Dizionario di erudizione storico-ecclesiastica*, 103 vols. (Venice, 1840–1861).

Campagna: Rossini (1826) pls. 30–39.

310 Pinelli, with whom Rossini collaborated: P. Hoffman, L. Cavazzi, and M. E. Tittoni, *Luigi Rossini incisore: Vedute di Roma, 1817–1850* (Rome, 1982) 18.

Viaggio pittorico: Penna (1831–1836); vol. 1 appeared in 1831, vol. 2 in 1833, and vols. 3

and 4 in 1836. Penna had earlier published a series entitled *Venti vedute della Villa Adriana riunite in un libro* (Rome, 1827), the plates for which survive in the Calcografia.

fold-out plan: the plan was also issued separately; A. Penna, *Pianta della villa tiburtina di Elio Adriano augusto, secondo lo stato attuale delle rovine* (Rome, 1836). It is reproduced by Gusman (1904) fig. 63.

311 itineraries: e.g., M. Vasi, *Itinerario istruttivo di Roma antica e moderna* (Rome, 1818), and A. Nibby, *Itinerario di Roma e delle sue vicinanze compilato secondo il metodo di M. Vasi* (Rome, 1849).

Cistern: Penna 1 (1831–1836) 7.

312 other two volumes: the decision to expand the scope of the *Viaggio pittorico* beyond a description of the site appears to have been made only after the publication of vol. 2 in 1833.

313 his manuscript shows: Baldassarri (1988) 1–250.

Vallée-aux-Loups: *Guide Bleu; Paris: Hauts de Seine, Seine-St. Denis, Val de Marne* (Paris, 1968) 659; G. Poisson, *Guide des maisons d'hommes célèbres* (Paris, 1988) 60–65. Ann Gilkerson kindly visited the site for us and provided copies of periodical articles.

ruins of ruins: Chateaubriand (1969) 134–135 and *Recollections of Italy, England and America* (Philadelphia, 1816) 27–28.

the name vanished: Chateaubriand (1969) 90. For another interpretation of the Villa stressing the organic cycle of growth and decay, see M. Valery, *Voyages historiques, littéraires et artistiques en Italie* (Brussels, 1843) 504.

314 In 1803: the site's history since 1800 is sketched by Aurigemma (1969) 67–73 and Reggiani (1984). Excavation notices and reports appear in *NS*, founded in 1876. See also Pacifici (1984) and De Franceschini (1991) 17–18.

serious scholar: see, e.g., his *Storia degli scavi di Roma e notizie intorno le collezioni romane d'antichità* 2 (1903; reprinted Rome 1975; revised ed., Rome 1989ff.); 108–119 on the Villa.

popularizer: Lanciani (1909), e.g., where 127–150 concern the Villa.

first modern guidebook: *La Villa Adriana: Guida e descrizione* (Rome, 1906).

archaeological interest: Lanciani (1909) 149.

ten ordinary trees: Lanciani (1909) 145.

Torlonia holdings: they include Trajan's port, largely unexcavated; G. Lugli and G. Filibeck, *Il porto di Roma imperiale e l'agro portuense* (Rome, 1935); O. Testaguzza, *Portus: Illustrazione dei porti di Claudio e Traiano* (Rome, 1970). The British School at Rome has recently begun work in the area.

specialists: Reina and Barbieri (1906).

315 McMillan Commission: R. G. Wilson et al., *The American Renaissance, 1876–1917* (Brooklyn, 1979) 84, 85, n. 23.

Heinz Kähler: he worked in the same room, over the restaurant by the modern Villa entrance, where Bloch labored by candlelight in the 1930s.

316 Eleanor Clark: another is Adrienne Rich, whose "Villa Adriana" first appeared in *The Diamond Cutters* (New York, 1955).

quickly turned: described in the New York 1992 reprint of the 1950 original (viii).

subtle and brooding: (1992) 158.

run out of motives: (1992) 175.

Antinous and Hadrian: (1992) 186–191.

grand interior: a fascicle title-page in C. Percier and P. Fontaine, *Palais, maisons, et autres édifices modernes dessinés à Rome* (Paris, 1798), reproduced in P. Fuhring, *Design into Art: Drawings for Architecture and Ornament* 1 (London, 1990) no. 87.

sites outside: the Ecole des Beaux-Arts Library list entitled *Italia antiqua et monde romain* (n.d.) gives 23 projects at 14 sites submitted between 1811 and 1950, but it is incomplete. For official Ecole publications of student work, see Egbert (1980) 163–167.

Daumet: in *MonAnt* 3 (1912) pls. 197–204. See also Gusman (1904) 44, 57, 121, figs. 64–67. For the dates and ranks of the prizes awarded to Daumet and his pupils, see Egbert (1980) 184–187. D'Amato (1984) 66, n. 18, says that in the Ecole library there is a manuscript by Daumet entitled *La Villa Hadriana* written about 1870. Gusman (1904) 57 remarks that in the time of Daumet's pupils Russian architects also worked at the Villa, and that a Belgian architect, Carlo de Wulf, made a "fort curieuse" restoration of the Island Enclosure (not listed by Ueblacker [1985]).

317 Paul Blondel: in *MEFR* (1881) 63–67, pl. 2.

See also Gusman (1904) 57, 126, figs. 168–169.

Charles Girault: in *MonAnt* 3 (1912) pls. 207–210. See also Gusman (1904) 57, 115–121, figs. 149, 152.

Pierre-Joseph Esquié: in *MonAnt* 3 (1912) pls. 205–206. See also Gusman (1904) 54, figs. 68–69.

Louis-Marie-Henri Sortais: in *MonAnt* 3 (1912) pls. 211–214. See also Gusman (1904) 57, 145–156, figs. 202–203, 206–207, 210–211, and Aurigemma (1961) figs. 90–92.

Charles-Louis Boussois: *MEFR* (1913) 261–265 and pl. 4, and *MonAnt Suppl.* (1923) pls. 26–37. Aurigemma (1961) fig. 93 reproduces his Scenic Canal restoration.

Beaux-Arts tradition: Yegül (1991) 81–82, 88, 93, 112–115, who in fig. 9 shows an architecture Fellow of 1920 in his studio, with the Piranesi plan of the Villa on the wall.

Philip T. Shutze: in *MAAR* 2 (1918). See also E. M. Dowling, *American Classicist: The Architecture of Philip Trammell Shutze* (New York, 1989) 16–17, ills. 24–27, and Yegül (1991) 67–72.

Gorham Phillips Stevens: L. and A. Valentine, *The American Academy in Rome, 1894–1969* (Charlottesville, Va., 1973) 61–83; Yegül (1991) 21, 40, 107, 227, n. 7.

319 Raymond M. Kennedy: in *MAAR* 3 (1919). See also Yegül (1991) pls. 75, 76.

James M. Chillman: in *MAAR* 4 (1924); comments by Kähler (1950) 165, nn. 91, 95. See also Yegül (1991) pl. 60.

etching: frontispiece of *MAAR* 6 (1927); reproduced by Brown (1961) ill. 90.

Kenneth B. Johnson: Yegül (1991) pls. 72, 73.

Henry D. Mirik: in *MAAR* 11 (1933).

Walter L. Reichardt: in *MAAR* 11 (1933). See also Aurigemma (1961) ill. 98.

American works: most tended to be less thoroughly grounded in archaeology than French presentations.

320 *Le voyage d'Orient*: G. Gresleri, *Le Corbusier, viaggio in Oriente* (Venice, 1984).

powerful influence: we thank H. Allen Brooks for generously sharing his knowledge of Le Corbusier.

sketchbooks: now in the collection of the Fondation Le Corbusier, Paris. See the facsimile edition *Le Corbusier, voyage d'Orient* (New

York, 1988), esp. Carnet V (hereafter cited as Carnet V).

Baedeker's guide: K. Baedeker, *Guide to Central Italy and Rome* (Leipzig, 1909) 471–474.

321 "Lesson of Rome": Le Corbusier (1931) 149–173.

Ambulatory Wall: Carnet V, 34.

reproduced this drawing: in all, five Villa sketches were reproduced.

based on them: Le Corbusier (1931) 193.

Smaller Baths: Carnet V, 77.

Residence Quadrangle: Carnet V, 40, 41, 46, 47, 91.

Water Court: Carnet V, 85–87.

arches and vaults: Carnet V, 80–81.

Larger Baths: Carnet V, 63–65.

Central Service Building: Carnet V, 78–79.

Scenic Triclinium: Carnet V, 67–74.

322 ingenious failure: Le Corbusier (1931) 157–158.

Wright knew: V. Scully, *Frank Lloyd Wright* (New York, 1960) 30 (the Lakeland plan "would seem to have been derived . . . from the published plans of Hadrian's Villa"), and *Modern Architecture: The Architecture of Democracy* (New York, 1961) 31–32 ("It is certainly clear that Wright's plan . . . was closely derived from the plan of Hadrian's Villa"). Commentary by, e.g., D'Amato (1984) 60 and B. Gill, *Many Masks: A Life of Frank Lloyd Wright* (New York, 1987) 396–402.

several months: R. C. Twombley, *Frank Lloyd Wright: An Interpretive Biography* (New York, 1973) 90–93.

no detailed record: but see E. Kaufmann, Jr., "Crisis and Creativity: Frank Lloyd Wright, 1904–1914," *JSAH* 25.4 (1966) 292–296.

site does suggest: "perhaps the most uninspiring with which Wright has ever had to deal" (H.-R. Hitchcock, *In the Nature of Materials: 1887–1941, The Buildings of Frank Lloyd Wright* [New York, 1942, reprinted New York, 1975] 99).

323 angles: we are indebted to Ted Kingsley for his permission to paraphrase the results of his work on this topic.

Cooper House: N. Levine, "Frank Lloyd Wright's Diagonal Planning," in *In Search of Modern Architecture: A Tribute to H.-R. Hitchcock*, ed. H. Searing (Cambridge, Mass., 1982) 246–247; a Viollet-le-Duc house is cited as

a source (E. E. Viollet-le-Duc, *Lectures on Architecture*, trans. B. Bucknall, 2 [London, 1881, reprinted New York, 1987] 277–284), but P. Pinnell, "Academic Tradition and the Individual Talent: Similarity and Difference in the Formation of Frank Lloyd Wright," in *Frank Lloyd Wright: A Primer on Architectural Principles* (New York, 1991) 24–26, derives Wright's plan from the McKim, Meade & White Appleton house of 1883–1884; we owe this last reference to Michael Lawrence. Whatever its immediate ancestry, the Cooper plan contains a half-dozen common Roman shapes spread out on seven axes. Viollet was fascinated by Roman villas (Lectures IV and V) and had visited Hadrian's (see p. 214, above).

invite reintegration: E. N. Bacon, *Design of Cities* (Baltimore, 1974) 89.

324 American Academy in Rome: V. Scully, *Louis I. Kahn* (New York, 1962) 37.

Thomas Vreeland: T. Vreeland in *L.A. Architect* (February 1987) 7. Our thanks to Diane Favro for this reference.

architecture of the past: *L.A. Architect* (February 1987).

burst out laughing: *L.A. Architect* (February 1987). See D. S. Friedman, "Salk Institute for Biological Studies," in *Louis I. Kahn: In the Realm of Architecture*, ed. D. Brownlee and D. De Long (New York, 1991) 335. Vreeland's tracing is reproduced as fig. 441.

Campo Marzio: Kahn kept a reproduction of Piranesi's plan in his office.

rarely explore: J. Durm refers to Winnefeld and Gusman but gives the Villa only three paragraphs and three illustrations (*Die Baukunst der Etrusker: Die Baukunst der Römer* [Stuttgart, 1905] 509–513); D. S. Robertson, also widely used, less than a page, with two illustrations, one of them from Durm (in *A Handbook of Greek and Roman Architecture* [Cambridge, 1929, 2d ed. 1943] 314–316); L. Crema (1959) 466–483 is more generous, with twelve illustrations. McKay (1975) and Ward-Perkins (1981) do not rate the Villa a major monument; Mielsch (1987) is exemplary, as is the description by Coarelli (1982).

classroom: there were exceptions, as at Harvard, where in the 1940s and 1950s Kenneth Conant discussed the Villa in a course on ancient architecture attended by many architecture students.

Moore: (1960), reprinted, revised, in Moore and Allen (1976).

Le Corbusier: *Towards a New Architecture*, trans. F. Etchells (London, 1946), 145–147 (orig. publ. as *Vers une architecture* [Paris, 1923]).

Colin Rowe and Fred Koetter: *Collage City* (Cambridge, Mass., 1978) 90–94.

325 collection of essays: *La Laurentine* (1982).

Pierre-Yves Balut: *La Laurentine* (1982), 217–252.

James Stirling: his Neue Staatsgalerie, Stuttgart (1977–1984, with Michael Woodward), e.g.; C. Jencks, *Postmodernism: The New Classicism in Art and Architecture* (New York, 1987) 271–274. The planting is Piranesian (cf. our ill. 347).

Oswald Mathias Ungers: he refers to the Villa in his "Architecture of the Collective Memory," *Lotus International* 24 (1979) 4, reprinted in part in the *Harvard Architectural Review* 3 (1984) 106; he says Hadrian was an archaeologist.

Robert Mangurian: the theatral court in his South Side Settlement House in Columbus, Ohio, of 1980, refers to the Scenic Triclinium forms; see Mangurian (1993).

Michael Graves: lecture at the Catholic University, Washington, D.C., March 1988, invoking the Villa's multi-axial plan.

can contribute: see, e.g., A. Isozaki, *Villa Adriana* (Tokyo, 1981); in Japanese, with an English summary 8–9; Robert Mangurian and Mary-Ann Ray kindly sent xeroxes; Timberlake Foster and John McCarry helped with the Japanese.

Monticello: Lehmann (1965) chs. 10, 12; Adams (1983); McLaughlin (1988).

major books: on Jefferson's Library, see E. M. Sowerby, *Catalogue of the Library of Thomas Jefferson*, 5 vols. (Charlottesville, Va., 1955, reprinted 1983); W. B. O'Neal, *Jefferson's Fine Arts Library* (Charlottesville, Va., 1976). See also F. Kimball, *Thomas Jefferson, Architect* (Boston, 1916, reprinted 1968), for Jefferson's architectural books (he also had a large portfolio of loose prints and drawings).

visitor found him: Lehmann (1965) 61.

326 buttress wall: Adams (1983) fig. 159.

staff numbered: McLaughlin (1988) chs. 3, 4.

archaeological excavation: Lehmann (1965) 25 and notes to 24.

made a tour: McLaughlin (1988) 343–344.

grotto: McLaughlin (1988) 341–342.

square tempietto: Adams (1983) fig. 152.

domed pavilion: Adams (1983) fig. 150. On these and other garden structures, see W. L. Beiswanger, "Jefferson's Designs for Garden Structures at Monticello," *JSAH* 35.4 (1976) 310–312.

tower: on the towers, see Lehmann (1965) 159, 249; Adams (1983) 151, 159; and McLaughlin (1988) 153–160.

capital balustrading: see McLaughlin (1988) 159.

Trajan's Column: Jefferson would perhaps have been pleased by the full-sized copy, in concrete, at Astoria, Oregon, by the mouth of the Columbia River, with a sgraffito helical frieze of local early history that includes the Lewis and Clark Expedition Jefferson planned.

busts of worthies: he owned painted portraits of Bacon, Newton, and Locke, as well as of other notables from Columbus to Franklin, Washington, and Lafayette.

327 Yuanmingyuan: P. Huang, ed., *Yuanmingyuan* (Hong Kong, 1985), in Chinese and fully illustrated (we are indebted to John E. MacDonald for translating relevant parts); M. Pirazzoli-t'Serstevens et al., *Le Yuanmingyuan: Jeux d'eau et palais européens du XVIIIe siècle à la cour de Chine* (Paris, 1987), French and Chinese text.

underlying grid: excellent gatefold plan in Huang, *Yuanmingyuan*.

328 surprise to astonishment: P. Jonathan and A. Durand in Pirazzoli-t'Serstevens, *Yuanmingyuan*, 20.

Repin: G. Sternin and M. Karpenko, *Ilya Repin: Painting, Graphic Arts* (Leningrad, 1985).

Seminary: *Montgomery Journal* (26 June 1985) and information from Jeanne Fogle, a specialist. The U.S. Army (the proprietor since 1942) provided a six-page photocopy of a "History of Forest Glen" (ca. 1983).

329 Anna Thornton's diary: McLaughlin (1988) ch. 1.

Lahori's detailed description: W. J. R. Curtis in the *TLS* (30 August 1991) 16–17, reviewing W. E. Begley and Z. A. Dessai, *The Shah Jehan Nama of 'Inyat Kahn* (Cambridge, Mass., 1991).

were assembled: Tsao Hsueh-Chin, *Dream of the Red Chamber*, trans. Chi-Chen Wang (New York, 1989) 109.

compare the Villa: as have, e.g., Moore and Allen (1976) 82 and J. E. Stambaugh, *The Ancient Roman City* (Baltimore, 1988) 79.

films: Villa scenes of varying length are found, e.g., in *Von Ryan's Express* (1965), *La Clemenza di Tito* (1981), and *The Belly of an Architect* (1987).

popularity: C. Angelini in Giuliano et al. (1988) 221–223; travel section, *New York Times* (25 Aug. 1991); cf. Clark (1992) 11–13, written in 1974.

simulacra: A. D. Huxtable, "Inventing American Reality," *New York Review of Books* (3 Dec. 1992) 24–25; A. Carandini, "A Policy for Archaeology," *Liber* 2 (1989) 10 (as reprinted in *TLS* [15 Dec. 1989]). A fictional rebuilding of the Villa is described by A. Clarke and G. Lee, *Rama II* (New York, 1989) 74–87 (brought to our attention by Nicholas MacDonald).

Bibliography

Asterisks identify basic Villa publications

Ackerman, J. S. *The Villa: Form and Ideology of Country Houses.* Princeton, 1980.

Adams, W. H. *Jefferson's Monticello.* New York, 1983.

Alexander, P. "Letters and Speeches of the Emperor Hadrian." *HSCP* 49 (1939) 141–171.

Alfieri, M., M. G. Branchetti, and D. Petochi. *I mosaici minuti romani dei secoli XVIII e XIX.* Rome, 1981.

Ananoff, A. *L'oeuvre dessiné de Jean-Honoré Fragonard.* 2 vols. Paris, 1961.

*Ashby, T. "The Villa d'Este at Tivoli and the Collection of Classical Sculpture Which It Contained." *Archaeologica* 61 (1908) 219–256.

—————. *The Roman Campagna in Classical Times.* London, 1927; reprinted 1970.

*Aurigemma, S. *Villa Adriana.* Rome, 1961; reprinted 1984.

—————. *La Villa Adriana presso Tivoli.* 6th ed. Tivoli, 1969.

Bacou, R. *Piranesi Etching and Engravings.* Boston, 1975.

Baldassarri, P. *L'opera grafica di Agostino Penna sulla Villa Adriana.* (1989 = *Rivista dell'istituto nazionale d'archeologia e storia dell'arte* 11.)

Balsdon, J. P. V. D. *Life and Leisure in Ancient Rome.* London, 1969.

Bardon, H. *Les empereurs et les lettres latines d'Auguste à Hadrien.* Paris, 1968.

Bartman, E. "*Decor et duplicatio:* Pendants in Roman Sculptural Display." *AJA* 92.2 (1988) 211–225.

———. "Sculptural Collecting and Display in the Private Realm." In Gazda (1991) 71–88.

Bauplannung und Bautheorie der Antike. Berlin, 1983 = Deutsches archäologischen Institut, *Diskussionen zur archäologischen Bauforschung* 4.

Beaujeu, J. *La religion romaine à l'apogée de l'empire*. Vol. 1: *La politique religieuse des Antonins*. Paris, 1955.

Becatti, G. *Scavi di Ostia 4. Mosaici e pavimenti marmorei*. 2 vols. Rome, 1961.

Belli Barsari, I., and M. G. Branchetti. *Ville della campagna romana*. Milan, 1975.

Benario, H. W. *A Commentary on the* Vita Hadriani *in the* Historia Augusta. Chico, Calif., 1980 = *American Classical Studies* 7.

Bergmann, B. "Painted Perspectives of a Villa Visit: Landscape as Status and Metaphor." In Gazda (1991) 71–88.

Bettagno, A. *Disegni di Gaimbattista Piranesi*. Venice, 1978.

Bianchi Bandinelli, R. *Rome the Centre of Power: Roman Art to A.D. 200*. London, 1970.

Blake, M. E. "The Pavements of the Roman Buildings of the Republic and Early Empire." *MAAR* 8 (1930) 1–159.

———. "Roman Mosaics of the Second Century in Italy." *MAAR* 13 (1936) 67–214.

———. *Roman Construction in Italy from Tiberius through the Flavians*. Washington, D.C., 1959.

———. *Roman Construction in Italy from Nerva through the Antonines*, edited and completed by D. T. Bishop. Philadelphia, 1973.

*Bloch, H. *I bolli laterizi e la storia edilizia romana*. Rome, 1947. (A new edition is in preparation.)

Blunt, A. "Supplement to the Catalogues of Italian and French Drawings." In E. Schilling, *The German Drawings at Windsor Castle*. London, 1971.

———. *Borromini* (Cambridge, Mass., 1979).

Boatwright, M. T. *Hadrian and the City of Rome*. Princeton, 1987.

Boëthius, A. *Etruscan and Early Roman Architecture*. Harmondsworth, 1978.

Bonanno, M. "Nuovi frammenti del fregio del 'Teatro marittimo' in Villa Adriana." *ArchCl* 27 (1975) 33–40.

Borromini, F. *Opus architectonicum*. Rome, 1720–1725; reprinted, 1965.

———. *Opera del Cav. Francesco Borromini cavata da suoi originali cioè l'Oratorio, e fabrica per l'abitazione de PP. dell'Oratorio di S. Filippo Neri di Roma*, edited by S. Giannini. Rome, 1725; reprinted, 1964.

Borsi, F. *Giuliano da Sangallo: I disegni di architettura e dell'antico*. Rome, 1985.

Bowersock, G. W. *Greek Sophists in the Roman Empire*. Oxford, 1969.

Boyle, B. M. "Ostian Architecture." 2 vols. Ph.D. diss., Yale University, 1968.

Brett, G., W. J. Macaulay, and R. B. K. Stevenson. *The Great Palace of the Byzantine Emperors, First Report*. Oxford, 1947.

Brown, F. E. *Roman Architecture*. New York, 1961.

*———. "Hadrianic Architecture." In *Essays in Memory of Karl Lehmann*, edited by L. F. Sandler, 55–58. New York, 1964.

Brunel, G., ed. *Piranèse et les français: Colloque*. Rome, 1978.

Buddensieg, T. "Criticism and Praise of the Pantheon in the Middle Ages and the Renaissance." In *Classical Influences on European Culture, A.D. 500–1500*, edited by R. Bolgar, 259–267. Cambridge, Mass., 1971.

*Bulgarini, F. *Notizie storiche antiquarie statistiche ed agronomiche intorno all'antichisissima città di Tivoli e suo territorio*. Rome, 1848.

Burkert, W. *Ancient Mystery Cults*. Cambridge, Mass., 1987.

*Cabral, S., and F. Del Rè. *Delle ville e delle più notabili monumenti antichi della città e territorio di Tivoli*. Rome, 1779.

Camp, J. M. *The Athenian Agora*. London, 1986.

Caprino, C. "Restauri a Villa Adriana." In *Atti del congreso sui criteri e metode di restauri dei monumenti archeologici, Paestum 1974*, 62–71. Rome, 1976.

*———. "Fregi architettonici figurati." In Ueblacker (1985) 61–84.

Carlson, V. *Hubert Robert: Drawings and Watercolors*. Washington, D.C., 1978.

Castner, C. J. *Prosopography of Roman Epicureans from the Second Century B.C. to the Second Century A.D.* Frankfurt, 1988 = *Studien zur klassischen Philologie* 34.

Cavaceppi, B. *Raccolta d'antiche statue, busti, teste cognite ed altre sculture antiche*. 3 vols. Rome, 1768–1772.

Champlin, E. *Fronto and Antonine Rome*. Cambridge, Mass., 1980.

Chastel, A., and G. Brunel, eds. *Piranèse et les français, 1740–1790*. Rome, 1976.

Chateaubriand, F.-A.-R. de. *Voyage en Italie*. Paris, 1969.

Chillman, J. H. "The Casino of the Semicircular Arcades at Hadrian's Villa." *MAAR* 4 (1924) 103–120.

Cima, M., and E. La Rocca, eds. *Le tranquille dimore degli dei*. Venice, 1986.

Clairmont, C. W. *Die Bildnisse des Antinous*. Bern, 1966 = *Bibliotheca Helvetica romana* 6.

*Clark, E. *Rome and a Villa*. New York, 1952; reprinted, 1962, 1974, 1991.

Clarke, J. R. *Roman Black and White Figural Mosaics*. New York, 1979.

Clinton, K. "Hadrian's Contribution to the Renaissance of Eleusis." In Walker and Cameron (1989) 56–68.

*Coarelli, F. *Lazio*. Rome, 1982.

———. *Roma sepolta*. Rome, 1984.

Coffin, D. R. *The Villa d'Este at Tivoli*. Princeton, 1960.

———. *The Villa in the Life of Renaissance Rome*. Princeton, 1979.

Comotti, G. *Music in Greek and Roman Culture*. Baltimore, 1989.

*Conti, G. *Decorazione architettonica della "Piazza d'Oro" a Villa Adriana*. Rome, 1970 = *Studia archaeologica* 13.

*Contini, F. *Adriani Caesaris immanen in Tyburtino Villam*. Rome, 1668.

Cook, B. F. *The Townley Marbles*. London, 1985.

Crema, L. *L'architettura romana*. Turin, 1959 = *Enciclopedia classica* 3.12.

Creswell, K. A. C. *A Short Account of Early Muslim Architecture*, revised and supplemented by J. W. Allan. Aldershot, 1989.

Les cryptoportiques dans l'architecture romaine. Rome, 1973 = *Collection de l'Ecole française de Rome* 14.

Dacos, N. "Visitatori di Villa Adriana." *Palatino* 9 (1965) 9–12.

*D'Amato, C. "Villa Adriana: La costruzione dell'architettura e la memoria." In Paris (1984) 47–72.

D'Arms, J. H. *Romans on the Bay of Naples*. Cambridge, Mass., 1970.

———. "Slaves at Roman Convivia." In Slater (1991) 171–184.

Darnall, M., and M. Weil. "Il Sacro Bosco di Bomarzo: Its Sixteenth-Century Literary and Antiquarian Context." *JGH* 4 (1984) 1–91.

Davies, R. *Service in the Roman Army*. New York, 1989.

De Caro, S. "The Sculptures of the Villa of Poppaea at Oplontis: A Preliminary Report." In MacDougall (1987) 77–133.

De' Rossi, D. *Studio d'architettura civile di Roma.* 3 vols. Rome, 1702–1721.

*De Franceschini, M. *Villa Adriana: Mosaici — pavimenti — edifici.* Rome, 1991.

Del Re, A. *Dell'antichità tiburtine capitolo.* Vol. 5. Rome, 1611.

Duncan-Jones, R. *The Economy of the Roman Empire: Quantitative Studies.* 2d ed. Cambridge, 1982.

Ebersolt, J. *Le Grand Palais de Constantinople et le Livre des Cérémonies.* Paris, 1910.

Egbert, D. D. *The Beaux-Arts Tradition in French Architecture,* edited by D. Van Zanten. Princeton, 1980.

Ehrlich, T. L. "The Waterworks of Hadrian's Villa." *JGH* 9.4 (1989) 161–176.

Evans, E. C. "Physiognomics in the Ancient World." *TAPA* 59 (1969).

Ferguson, J. *The Religions of the Roman Empire.* London, 1970.

Focillon, H. *Giovanni-Battista Piranesi.* Paris, 1918.

Forster, E. M. *Alexandria: A History and a Guide.* 3d ed. New York, 1961.

Fraser, P. M. *Ptolemaic Alexandria.* 3 vols. Oxford, 1972.

Frezza, G. G. *Riproduzione di antiche sculture rinvenute nella Villa Adriani di Tivoli, designate da Stefano Pozzi, Nicola Onofri e Pompeo Batoni.* Rome, 1739–1740.

Frutaz, A. P. *Le carte del Lazio.* 3 vols. Rome, 1972.

Garzetti, A. *From Tiberius to the Antonines: A History of the Roman Empire, A.D. 14–192.* Rev. ed. London, 1974.

Gazda, E. J., ed. *Roman Art in the Private Sphere: New Perspectives on the Architecture and Decor of the Domus, Villa, and Insula.* Ann Arbor, 1991.

Germain, S. *Les mosaïques de Timgad.* Paris, 1969.

*Giubilei, A. "Villa Adriana: Il cosidetto edificio con triplice esedra." *BA* 64 (1990) 47–58.

*Giuliani, C. F. "Volte e cupole a doppia calotta in eta adrianea." *RM* 82.2 (1975) 329–342.

*———. Il lato nord ovest della Piazza d'Oro." *QITA* 8 (1975) 3–53.

*Giuliano, A., et al. *Villa Adriana.* Rome, 1988.

Gnoli, A. *Marmora romana.* 2d ed. Rome, 1988.

Grabar, O. *The Alhambra.* Cambridge, Mass., 1978.

Graevius, J. G.: see Ligorio (1723).

Gray, W. D. "A Study of the Life of Hadrian Prior to His Accession." *SCSH* 4.3 (1919): 135–209.

Grenier, J.-C. "La décoration statuaire du 'Serapeum' du 'Canope' de la Ville Adriana."

MEFR/A 101 (1989) 925–1019. Reprinted (repaginated) Rome, 1990.

Grimal, P. *Les jardins romains.* 3d ed. Paris, 1984.

Guarducci, M. "La religione di Adriano." In *ERE* 209–221.

Guerrini, L. *Marmi antichi nei disegni di Pier Leone Ghezzi.* Vatican City, 1971.

*Gusman, P. *La villa imperiale de Tibur (Villa Hadriana).* Paris, 1904.

Habicht, C. *Pausanias' Guide to Ancient Greece.* Berkeley, 1985.

Halfmann, H. *Itinera principum: Geschichte und Typologie der Kaiserreisen im römischen Reich.* Stuttgart, 1986.

Hannestad, N. "Über das Grabmal des Antinoos: Topographische und thematische Studien im Canopus-Gebiet der Villa Adriana." *ARID* 11 (1982) 69–108.

———. *Roman Art and Imperial Policy.* Aarhus, 1986.

Hansen, E. "La 'Piazza d'Oro' e la sua cupola." *ARID* suppl. 1 (1960).

Hanson, J. A. *Roman Theater-Temples.* Princeton, 1959.

Haskell, F. and N. Penny. *Taste and the Antique.* New Haven, 1981.

Herter, H. "Die Rundform in Platons Atlantis und Ihre Nachwirkung in der Villa Adriana." *Rheinisches Museum für Philologie* 96 (1953) 1–20.

Hill, D. K. "Some Sculpture from Roman Domestic Gardens." In MacDougall and Jashemski (1981) 81–94.

Hoag, J. D. *Islamic Architecture.* New York, 1977.

Hodgkin, T. *Italy and Her Invaders, 535–553.* Vol. 4. Oxford, 1885.

*Hoffmann, A. *Das Gartenstadion in der Villa Hadriana.* Mainz, 1980 = Deutsches archäologisches Institut Rom, *Sonderschriften* 4.

Hopkins, K. *Death and Renewal.* Cambridge, 1983.

Hornbostel-Hüttner, G. *Studien zur römischen Nischenarchitektur.* Leiden, 1979 = *Studies of the Dutch Archaeological and Historical Society* 9.

Howard, S. *The Landsdowne Herakles.* 2d ed. Malibu, 1978.

Hübner, P.-G. "Le groupe des Muses de la Villa d'Hadrien." *RA* 2 (1908) 359–363.

*Huelsen, C. "Der kleinere Palast in der Villa des Hadrian bei Tivoli." *Sitzungsberichte der Heidelberger Akademie der Wissenschaften,* Phil.-Hist. Klasse 13 (1919) 3–26.

———. *Il libro di Giuliano da Sangallo: Codice Vaticano Barberiniano Latino 4424.* Turin, 1910.

Humphrey, J. H. *Roman Circuses: Arenas for Chariot Racing.* London, 1986.

Hussey, C. *English Gardens and Landscapes, 1700–1750.* London, 1967.

Hyland, A. *Equus: The Horse in the Roman World.* London, 1990.

Isozaki, A. *Villa Adriana.* Tokyo, 1981. English summary, 8–9.

Jacobson, D. M. "Hadrianic Architecture and Geometry." *AJA* 90.1 (1986) 69–85.

Janin, R. *Constantinople byzantine: Développement urbain et répertoire topographique.* 2d ed. Paris, 1964.

Jashemski, W. F. *The Gardens of Pompeii, Herculaneum, and the Villas Destroyed by Vesuvius.* Port Washington, N.Y., 1979.

*Jashemski, W. F., and E. S. P. Ricotti. "I giardini di Villa Adriana: Rapporto preliminare." *RendPontAcc* 60 (1987–1988) 145–189.

*———. "Preliminary Excavations in the Gardens of Hadrian's Villa: The Canopus Area and the Piazza d'Oro." *AJA* 96.4 (1992) 579–597, with an appendix on Villa soils by J. Foss.

Joyce, H. *The Decoration of Walls, Ceilings, and Floors in Italy in the Second and Third Centuries A.D.* Rome, 1981.

———. "Nicholas Ponce's *Arabesques antiques:* A Problem in Eighteenth-Century Archaeology." *GBA* 113 (1989) 183–200.

*———. "Hadrian's Villa and the 'Dome of Heaven.'" *RM* 97 (1990) 347–381.

*Kähler, H. *Hadrian und seine Villa bei Tivoli.* Berlin, 1950.

Kapossy, B. "Zwei Anlagen der Villa Hadriana." *Gymnasium* 74 (1967) 34–45.

Krautheimer, R. *Early Christian and Byzantine Architecture.* 2d ed. Harmondsworth, 1975.

———. *Rome: Profile of a City, 312–1308.* Princeton, 1980.

———. *Three Christian Capitals: Topography and Politics.* Berkeley, 1983.

La Laurentine et l'invention de la villa romaine. Paris, 1982.

Lambert, R. *Beloved and God: The Story of Hadrian and Antinous.* London, 1984.

*Lanciani, R. *Storia degli scavi di Roma e notizie intorno le collezione romane d'antichità.* 4 vols. Rome, 1902–1912; reprinted, 1975.

*———. *Wanderings in the Roman Campagna.* Boston, 1909.

La Rocca, E. "Il lusso come espressione di potere." In Cima and La Rocca (1986) 3–35.

Lavagne, H. "Utilitas-Decor: Le cryptoportique républicain de la Villa de Hadrien." In *Les cryptoportiques* (1973) 167–186.

*———. "Villa d'Hadrien: La mosaique de voûte du cryptoportique républicain et les débuts de l'Opus Musium' en Italie." *MEFR/A* 85.1 (1973) 197–245.

———. "Piranèse archéologue à la Villa d'Hadrien." In Lo Bianco (1985) 259–271.

*———. *Operosa antra: Recherches sur la grotte à Rome de Sylla à Hadrien.* Rome, 1988 = *Bibliothèque des écoles françaises d'Athènes et de Rome,* fasc. 272.

Lazzaro, C. *The Italian Renaissance Garden.* New Haven, 1990.

Le Corbusier. *Towards a New Architecture.* London, 1931.

Lehmann, K. *Thomas Jefferson, American Humanist.* Chicago, 1947; reprinted, 1965, 1985.

Lehmann, P. W. *Roman Wall Paintings from Boscoreale in the Metropolitan Museum of Art.* Cambridge, Mass., 1953.

Leppert, M. "23 Kaiservillen, Vorarbeiten zu Archäologie und Kulturgeschichte der Villeggiatur der hohen Kaiserzeit." Ph.D. diss., Freiburg University, 1974 (not seen).

Levi, M. A. *Adriano Augusto: Studi e ricerche.* Rome, 1993 (not seen).

*Ligorio, P. *Descrittione della superba & magnificentissima Villa Tiburtina Hadriana.* In *Thesaurus antiquitatem et historiarum Italiae,* edited by J. G. Graevius, 8.4. Leiden, 1723.

*Ligorio, P., and F. Contini. *Pianta della Villa Tiburtina di Adriano Cesare.* Rome, 1751.

Lo Bianco, A. *Piranesi e la cultura antiquaria.* Rome, 1985.

Lolli-Ghetti, M. "Tivoli-Villa Adriana: Il nuovo museo didattico-centro visitatori." *Quaderni del Centro di studio per l'archeologia etrusco-italica* 14 (1987) 133–178.

Luck, G. *Arcana Mundi: Magic and the Occult in the Greek and Roman Worlds.* Baltimore, 1985.

*Lugli, G. "Studi topografici intorno alle antiche ville suburbane. VI. Villa Adriana. A. Una villa di età repubblicana inclusa nelle costruzione imperiali." *BC* 55 (1927) 139–204. Reprinted in part (139–149, 198–204) in G. Lugli, *Studi minori di topografia antica,* 384–397. Rome, 1965.

*———. "Studi topografici intorno alle antiche ville suburbane. VI. Villa Adriana. B. Le vicende della villa di Adriano al tardo impero." *BC* 60 (1932) 111–150. Reprinted in part (140–150) in G. Lugli, *Studi minori di topografia antica,* 397–403. Rome, 1965.

*———. "La 'Roccabruna' della Villa Adriana." *Palladio* 4 (1940) 257–274.

———. *Roma antica: Il centro monumentale.* Rome, 1946; reprinted, 1992.

———. *La tecnica edilizia romana con particulare riguardo a Roma e Lazio.* 2 vols. Rome, 1957; reprinted, 1968.

*Lund, H. "Eine Vermessung des 18. Jahrhunderts der Villa Adriana," *ARID* 10 (1982) 41–52.

MacDonald, W. L. *The Architecture of the Roman Empire.* Vol. 1: *An Introductory Study.* 2d ed. New Haven, 1982.

———. *The Architecture of the Roman Empire.* Vol. 2: *An Urban Appraisal.* New Haven, 1986.

*———. "Hadrian's Circles." *SHA* 43 (1993) 394–408.

*MacDonald, W. L., and B. M. Boyle. "The Small Baths at Hadrian's Villa." *JSAH* 39.1 (1980) 5–27.

MacDougall, E. B., ed. *Ancient Roman Villa Gardens.* Washington, D.C., 1987 = *Dumbarton Oaks Colloquium on the History of Landscape Architecture* 10.

MacDougall, E. B., and W. F. Jashemski, eds. *Ancient Roman Gardens.* Washington, D.C., 1981 = *Dumbarton Oaks Colloquium on the History of Landscape Architecture* 7.

MacKendrick, P. *The Mute Stones Speak.* 2d ed. New York, 1983.

MacMullen, R. *Paganism in the Roman Empire.* New Haven, 1981.

Maltese, C., ed. *Francesco di Giorgio Martini, trattati di architetura, ingegneria, e arte militare.* 2 vols. Milan, 1967.

Mangurian, R., and M.-A. Ray. "A Modern Survey of an Ancient Roman Villa." *Point of Beginning* 18.6 (1993) 10–20.

Mansuelli, G. A. *Le ville del mondo romano.* Milan, 1958.

Marble Plan: *See FUR.*

Matthews, J. *Western Aristocracies and Imperial Court A.D. 364–425.* Oxford, 1975.

McCormick, T. J. *Claude-Louis Clérisseau and the Genesis of Neoclassicism.* Cambridge, Mass., 1990.

McKay, A. G. *Houses, Villas and Palaces in the Roman World.* London, 1975.

McLaughlin, J. *Jefferson and Monticello.* New York, 1988.

Meeks, C. L. V. *Italian Architecture, 1750–1914.* New Haven, 1966.

Meiggs, R. *Roman Ostia.* 2d ed. Oxford, 1973.

———. *Trees and Timber in the Ancient Mediterranean World.* Oxford, 1982.

Meyer, H. *Antinoos.* Munich, 1991.

*Mielsch, H. *Die römische Villa: Architektur und Lebensform.* Munich, 1987.

Millar, F. *The Emperor in the Roman World.* London, 1977.

*Moneti, A. "Nuovi sostegni all'ipotesi di una grande sala cupolata alla 'Piazza d'Oro' di Villa Adriana." *ARID* 20 (1992) 67–92.

Montagu, J. *Roman Baroque Sculpture: The Industry of Art.* New Haven, 1989.

Moore, C. H. "Hadrian's Villa." *Perspecta* 6 (1960) 17–27. Reprinted as "Hadrian's Villa: A Whole World in a Circle and a Square." In C. Moore and G. Allen, *Dimensions: Shape Space and Scale in Architecture,* 79–84. New York, 1976.

Moorman, E. "Eine neue Fragment des Taubenmosaiks aus der Hadriansvilla in Tivoli," *AA* 1987) 412.

Morricone Matini, M. L. *Mosaici antichi in Italia. Regione prima. Roma: Regio X Palatino.* Rome, 1967.

Mosser, M. *Charles de Wailly, peintre architect dans l'Europe des lumières.* Paris, 1979.

Nardi, E. *Case "infestati da spiriti" e diritto romano e moderno.* Milan, 1960 = *Seminario giuridico della Università di Bologna* 25.

Nash, E. *Pictorial Dictionary of Ancient Rome.* 2d ed. 2 vols. London, 1968.

Netzer, E. *Greater Herodium.* Jerusalem, 1981 = *Qedem* 13.

Neudecker, R. *Die skulpturen-Ausstattung römischer Villen in Italien.* Mainz, 1988.

*Neuerburg, N. *L'architettura delle fontane e dei ninfei nell'Italia antica.* Naples, 1965 = *Memorie dell'Accademia di archeologica lettere e delle arti di Napoli* 5.

———. "The Other Villas of Tivoli." *Archaeology* 21 (1968) 288–297.

Nibby, A. *Viaggio antiquario de contorni di Roma.* 2 vols. Rome, 1819.

*———. *Descrizione della Villa Adriana.* Rome, 1827.

Nogara, B. *Scritti inediti e rari di Biondo Flavio.* Rome, 1927.

Oliver, J. H. "Documents Concerning the Emperor Hadrian." *Hesperia* 10 (1941) 361–370.

Pacifici, V. G. "I primi lavori a Villa Adriana dopo l'acquisizione allo Stato italiano (1872–1873)." *AMST* 57 (1984) 220–237.

Pane, R. *Paestum nelle acqueforti di Piranesi.* Milan, 1980.

Pannini, G., and P. Fidanza. Three prints of the South Theatre, Istituto Nazionale per la Grafica (Rome), Calcografia inventory no. 1441: (1) elevation of the auditorium ruins and plan of the entire structure; (2) perspective view of the building and architectural details; (3) elevations of the stage building (actual state and restored) and restored elevation of the auditorium. Rome, 1753.

Paris, T., ed. *L'antico come luogo della memoria.* Rome, 1984.

Pavolovskis, Z. *Man in an Artificial Landscape: The Marvels of Civilisation in Imperial Roman Literature.* Leiden, 1973 = *Mnemosyne* supp. 25.

*Penna, A. *Viaggio pittorico della Villa Adriana.* 4 vols. Rome, 1831–1836.

Pensabene, P. "Fregio in marmo nero da Villa Adriana." *ArchCl* 28 (1976) 126–160.

Piccolomini, A. S. *Memoirs of a Renaissance Pope: The Commentaries of Pius II,* translated by F. A. Gragg. New York, 1959.

Pichlmayr, F., ed. *Sextvs Avrelivs Victor De Caesaribvs.* Leipzig, 1966.

Pierce, S. R. "Thomas Jenkins in Rome." *Antiquaries Journal* 45 (1965) 200–229.

Pietrangeli, C. *Scavi e scoperte di antichità sotto il pontificato di Pius VI.* 2d ed. Rome, 1958.

Pinto, J. A. *The Trevi Fountain.* New Haven, 1986.

*———. "Pastoral Landscape and Antiquity: Hadrian's Villa." *SHA* 36 (1992) 179–195.

*———. "Piranesi at Hadrian's Villa." *SHA* 43 (1993) 464–477.

*———. "Giovanni Battista Piranesi's Plan of Hadrian's Villa." *Princeton University Library Chronicle* 55 (1993) 63–84.

*Piranesi, F. *Pianta delle fabbriche esistente nella Villa Adriana.* Rome, 1781.

*Piranesi, G. B. *Vedute di Roma.* Rome [ca. 1748–1778].

———. *Vasi, candelabri, cippi, sarcophagi, tripodi, lucerne, ed ornamenti antichi.* 2 vols. Rome, 1778.

Platner, S. B., and T. Ashby. *A Topographical Dictionary of Ancient Rome.* Oxford, 1929.

Price, S. R. F. *Rituals and Power: The Roman Imperial Cult in Asia Minor.* Cambridge, 1984.

Purcell, N. "Town in Country and Country in Town." In MacDougall, ed. (1986) 185–203.

Quatremère de Quincy, A. C. *Recueil de notices historiques lués dans les séances publiques de l'Academie royale des Beaux-Arts à l'Institut.* Paris, 1834.

Quilici, L. "La carta archeologica e monumentale nel territorio del commune di Tivoli." *AMST* 40 (1967) 181–205.

Rae, I. *Charles Cameron, Architect to the Court of Russia.* London, 1971.

*Raeder, J. *Die statuarische Ausstattung der Villa Hadriana bei Tivoli.* Frankfurt, 1983.

Rakob, F. "Litus beatae veneris aureum: Untersuchungen am 'Venustempel' in Baiae." *RM* 68 (1961) 114–149.

*———. *Die Piazza d'Oro in der Villa Hadriana bei Tivoli.* Munich, 1967.

———. "Der Bauplan einer kaiserlichen Villa." In *Festschrift Klaus Langheit,* edited by W. Hartmann, 113–125. Cologne, 1973.

*———. "Metrologie und Planfiguren einer kaiserliche Bauhütte." *Bauplannung und Bautheorie* (1983) 220–237.

Reggiani, A. M. "La politica degli interventi nell'Agro Romano: Il caso di Villa Adriana." In *Dagli scavi al museo: come ritrovamenti archeologici si costruice il museo,* edited by A. M. Reggiani et al., 103–113. Rome, 1984.

*Reina, V., and U. Barbieri. "Rilievo planimetrico ed altrimetrico di Villa Adriana eseguito dagli allievi della Scuola di Roma nel 1905." *NS* 8 (1906) 313–317.

Rice, D. T., ed. *The Great Palace of the Byzantine Emperors, Second Report.* Edinburgh, 1958.

Richardson, L. *Pompeii: An Architectural History.* Baltimore, 1988.

———. *A New Topographical Dictionary of Ancient Rome.* Baltimore, 1992.

Richmond, I. A. *Roman Archaeology and Art.* London, 1969.

*Ricotti, E. S. P. "Criptoportici e gallerie sotterranee di Villa Adriana nella loro tipologia e nelle loro funzioni." In *Les cryptoportiques* (1973) 219–259.

*———. "Villa Adriana in Pirro Ligorio e Francesco Contini." *MemLinc* 17.1 (1973) 1–47.

———. "Cucine e quartieri servile in epocha romana." *RendPontAcc* 51/52 (1978–1980) 237–294.

*———. "Villa Adriana nei suoi limiti e nella sua funzionalità." *MemPontAcc* 14 (1982) 25–55.

———. *L'arte del convito nella Roma antica.* Rome, 1985.

———. "The Importance of Water in Roman Garden Triclinia." In MacDougall, ed. (1987) 137–184.

*———. "Villa Adriana: Un singolare solaio piano in 'opus caementicium.'" *Palladio* 1 (1988) 15–26.

———. "Le tende conviviali e la tenda di Tolmeo Filadelfo." In *Studia Pompeiana & Classica in Honor of Wilhelmina F. Jashemski.* Vol. 2. *Classica,* edited by R. I. Curtis, 199–239. New Rochelle, N.Y., 1989.

Ridgway, B. S. "Greek Antecedents of Garden Sculpture." In MacDougall and Jashemski (1981) 7–28.

Ristori-Gabrielli, G. *Pianta e misura della possessione spettante al Conte Giuseppe Fede . . . posta nel territorio di Tivoli, nella quale si ritrovano diverse antiche fabbriche, e rovine della celebre Villa Adriana.* Rome, 1770.

Rosenfeld, M. N. "From Drawn to Printed Model Book: Jacques Androuet du Cerceau and the Transmission of Ideas from Designer to Patron, Master Mason and Architect in the Renaissance." *RACAR* 16 (1989) 131–145.

Rosenthal, E. "The Antecedents of Bramante's Tempietto." *JSAH* 23 (1964) 55–74.

Rossini, L. *Le antichità dei contorni di Roma, ossia le più famose città del Lazio: Tivoli, Albano, Castel Gandolofo, Palestrina, Tuscolo, Cora e Ferentino.* Rome, 1826.

Roullet, A. *The Egyptian and Egyptianizing Monuments of Imperial Rome.* Leiden, 1972 = *EPRO* 20.

Scott, J. *Piranesi.* London, 1975.

Sear, F. *Roman Wall and Vault Mosaics.* Heidelberg, 1977 = *RM, Ergänzungsheft* 23.

*Sebastiani, F. A. *Viaggio a Tivoli, anticissima città latino-sabina, fatto nel 1825.* Foligno, 1828.

Serlio, S. *Tutte l'opere d'architettura.* Venice, 1584.

Sherwin-White, A. N. *The Letters of Pliny: A Historical and Social Commentary.* Oxford, 1966.

Slater, W. J., ed. *Dining in a Classical Context.* Ann Arbor, 1991.

*Smith, A. C. G. "The Date of the 'Grandi Terme' of Hadrian's Villa at Tivoli." *PBSR* 46 (1978) 73–93.

Smith, A. H. "Gavin Hamilton's Letters to Charles Towneley." *JHS* 21 (1901) 307–311.

Stadter, P. A. *Arrian of Nicomedia.* Chapel Hill, 1980.

Stierlin, H. *Hadrien et l'architecture romaine.* Freiburg, 1984.

Strong, D. *Roman Art.* 2d ed. Harmondsworth, 1988.

Sutherland, C. H. V. *Roman Coins.* New York, 1974.

Syme, R. "Hadrian and Italica." *JRS* 54 (1964) 142–149 = *RP* 2 (1979) 617–628.

———. "Hadrian the Intellectual." *ERE* 242–253.

———. *Emperors and Biography: Studies in the Historia Augusta.* Oxford, 1971.

———. *Greeks Invading the Roman Government.* Brookline, Mass., 1982.

———. *Fictional History Old and New: Hadrian.* Oxford, 1986 = *RP* 6 (1991) 157–181.

———. "Journeys of Hadrian." *Zeitschrift für Papyrologie und Epigraphik* 73 (1988) 159–170 = *RP* 6 (1991) 347–357.

———. "Hadrian's Autobiography: Servianus and Sura." *RP* 6 (1991) 398–408.

Thornton, M. K. "Hadrian and His Reign." *ANRW* 2.2 (1975) 432–476.

Tiberi, C. "Il culto degli dei Samothraci nel Canopo della Villa Adriano presso Tivoli." *AMST* 30 (1957/1958) 47–76, and 31 (1959/1960) 15–40.

———. "L'Esedra di Erode Attico a Olympia e il Canopo della Villa di Adriano presso Tivoli." *Quaderni dello Istituto di storia dell'architettura* 31–48 (1961) 35–48.

Tomlinson, R. A. *Epidauros.* Austin, 1983.

Torelli, M. *Etruria.* 3d ed. Rome, 1985.

Toynbee, J. M. C. *The Hadrianic School: A Chapter in the History of Greek Art.* Cambridge, 1934; reprinted, 1967.

———. *Animals in Roman Life and Art.* London, 1973.

Toynbee, J. M. C., and J. B. Ward Perkins. *The Shrine of St. Peter and the Vatican Excavations.* London, 1956.

Travlos, J. *Pictorial Dictionary of Ancient Athens.* London, 1971.

Turcan, R. *Vivre à la cour des Césars.* Paris, 1987.

*Ueblacker, M. *Das Teatro Marittimo in der Villa Hadriana.* Mainz, 1985 = Deutsches archäologisches Institut Rom, *Sonderschriften* 5.

Vasari, G. *Le vite de' più eccelenti pittori scultori e architettori.* 5 vols. Florence, 1966.

*Verduchi, P. "Le terme con cosidetto heliocaminus." *QITA* 8 (1975) 55–95.

Vighi, R. "Villa Adriana e suo Canopo." *Rivista Pirelli* 8.6 (1957) 1–11.

———. *Villa Hadriana,* translated by J. B. Ward Perkins. Rome, 1959.

Vogt, A. *Constantin VII Porphrogénète: Le Livre des Cérémonies.* 4 vols. Paris, 1935–1940.

Wadsworth, E. L. "Stucco Reliefs of the First and Second Centuries Still Extant in Rome." *MAAR* 4 (1924) 9–102.

Walker, S., and A. Cameron, eds. *The Greek Renaissance in the Roman Empire.* London, 1989 = Institute of Classical Studies, *Bulletin* 55.

Wallace-Hadrill, A. *Suetonius: The Scholar and His Caesars.* New Haven, 1983.

———. "The Social Structure of the Roman House." *PBSR* 56 (1988) 43–97.

Ward-Perkins, J. B. *Roman Imperial Architecture.* Harmondsworth, 1981.

Weber, K.-K. "Gestalterische Überlegungen zu den Überkuppelungstheorien des Zentralraumes der Piazza d'Oro in der Villa Hadrian bei Tivoli." *Architectura* 21 (1990) 101–107.

Wegner, M. *Hadrian, Plotina, Marciana, Matidia.* Berlin, 1956 = *Das römischer Herrscherbild* 2.3.

Willers, D. *Hadrians panhellenisches Programm: Archäologische Beiträge zur Neugestaltung Athens durch Hadrian.* Basel, 1990 = *Antike Kunst, Beiheft* 16.

Wilson, M. *William Kent: Architect, Designer, Painter, Gardener, 1685–1748.* London, 1984.

Wilson, R. J. A. *Piazza Armerina.* London, 1983.

Wilton-Ely, J. *The Mind and Art of Giovanni Battista Piranesi.* London, 1978.

*Winnefeld, H. *Die Villa des Hadrian bei Tivoli.* Berlin, 1895 = *JDAI, Ergänzungsheft* 3.

Wirth, F. *Römischen Wandmalerei vom Untergang Pompejis bis ans Ende des dritten Jahrhunderts.* Berlin, 1934.

Witt, R. E. *Isis in the Graeco-Roman World.* London, 1971.

Yegül, F. K. *Gentlemen of Instinct and Breeding: Architecture at the American Academy in Rome, 1894–1940.* New York, 1991.

———. *Baths and Bathing in Classical Antiquity.* New York, 1992.

Yourcenar, M. *Memoirs of Hadrian.* New York, 1957.

Zorzi, G. *I disegni di antichità di Andrea Palladio.* Venice, 1959.

Sources of Illustrations

The Getty Center for the Fine Arts and the Humanities supplied the photographs listed below and underwrote a photographic campaign at the Villa; at the Center Jeanne Marty, Susan Wester, and Claire Lyons were most helpful. We are also indebted to Karin Einaudi of the Fototeca Unione at the American Academy in Rome, to Giorgio Vasari of Rome for color images made under our direction, to W. B. Lundberg for advice about early photographers at the Villa, and to the persons and institutions listed below; we took the photographs not otherwise credited. Numbers in parentheses identify items immediately preceding.

The drawings were evolved from our own measurements and observations and from Giuliani, "Piazza d'Oro" (1975), Hoffmann (1980), Kähler (1950), Ligorio-Contini (1751), Lugli (1927), Lund (1982), MacDonald and Boyle (1980), Netzer (1981), F. Piranesi (1781), Reina and Barbieri (1906), Ricotti, "Criptoportici" (1973), Ricotti (1982), Torelli (1985), Ueblacker (1985), Verduchi (1975), and Winnefeld (1895).

Aereofototeca — ICCD, Rome: 1, 29, 126, 146
Aeronautica Militare, Rome: 6
Alinari / Anderson, New York: 31, 178–180, 364, 365, 375
Lyman Allyn Art Museum, New London: 292 (1953.36)
American School of Classical Studies in Athens, Agora Excavations: 8

Index